FOURSOME

FOURSOME

Alfred Stieglitz, Georgia O'Keeffe,
Paul Strand, Rebecca Salsbury

CAROLYN BURKE

ALFRED A. KNOPF, NEW YORK, 2019

THIS IS A BORZOI BOOK PUBLISHED BY ALFRED A. KNOPF

Copyright © 2019 by Carolyn Burke

All rights reserved. Published in the United States by Alfred A. Knopf,
a division of Penguin Random House LLC, New York, and
distributed in Canada by Random House of Canada,
a division of Penguin Random House Canada Limited, Toronto.

www.aaknopf.com

Knopf, Borzoi Books, and the colophon are registered trademarks of
Penguin Random House LLC.

Grateful acknowledgment is made to the Yale Collection of American Literature,
Beinecke Rare Book & Manuscript Library for permission to reprint text excerpts from
letters by Georgia O'Keeffe to Alfred Stieglitz, from Alfred Stieglitz/Georgia O'Keeffe
Archive. Copyright © 2011 by Yale University. Reprinted by permission of
the Yale Collection for American Literature, Beinecke Rare Book & Manuscript Library.
All rights reserved.

Names: Burke, Carolyn, author.
Title: Foursome : Alfred Stieglitz, Georgia O'Keeffe, Paul Strand,
Rebecca Salsbury / by Carolyn Burke.
Description: First edition. | New York : Alfred A. Knopf, 2019. | "This is a Borzoi book
published by Alfred A. Knopf." | Includes bibliographical references and index.
Identifiers: LCCN 2018016794 (print) | LCCN 2018020035 (ebook) |
ISBN 9780525655367 (ebook) | ISBN 9780307957290 (hardcover)
Subjects: LCSH: Artist couples—United States—Biography. |
Stieglitz, Alfred, 1864–1946. | O'Keeffe, Georgia, 1887–1986. |
Strand, Paul, 1890–1976. | James, Rebecca Salsbury, 1891–1968.
Classification: LCC TR140.S7 (ebook) | LCC TR140.S7
B87 2019 (print) | DDC 770—dc23
LC record available at https://lccn.loc.gov/2018016794

Jacket images: (top) Alfred Stieglitz and Georgia O'Keeffe, 1936.
CSU Archives/Everett Collection; (bottom) Paul Strand and Rebecca Salsbury
at Lake George, c. 1923 by Alfred Stieglitz
Jacket design by Carol Devine Carson

Manufactured in the United States of America
First Edition

For Robert Gottlieb, avid reader

Contents

This book would not have come into being without the wholehearted collaboration of Lance Sprague. From the outset its interwoven narrative drew on his love of early photography and his insights as a practicing artist. In the seven years it took to write, he gave abundantly of his time, complementary talents, and irreverent sense of humor, particularly valuable on research trips. We often surprised each other, especially when processing the thousands of documents brought back from the archives. Together, we came to understand the convergences and divergences of our foursome's lives: I learned as much from him about the impact of aesthetic choices on private life as I did from our subjects. His artist's eye helped us select images to retell the story visually; our ongoing dialogue enabled us to grasp affinities in the foursome's artistic practice and imagine ways for readers to experience those complementarities through the choice and arrangement of the illustrations. For this and many other reasons, including his role as writer's accomplice, it is as much his book as it is mine.

OPENING

New York, 1921

OPENING

Alfred Stieglitz often said that taking photographs was like making love. The crowds that flocked to the Anderson Galleries to see his work in the winter of 1921 could not fail to note the entwining of creative zest and sexual desire in his portraits of an unidentified "Woman": This study of his model, dressed and undressed, made up a third of the long-awaited exhibition. Within days, it became the most controversial artistic event of the year. "Never was there such a hub-bub about a one-man show," a sympathizer recalled.

In the aftermath of the recent Red Scare and Harding's election to the presidency, Stieglitz's prints looked like an affront to society. To some critics, they were all but un-American—the artist's way of flouting Harding's plan to bring back prewar standards. (The country's greatest need, Harding had repeated during his campaign, was "not nostrums but normalcy; not revolution but restoration.") In the current political climate, the photographer's assertion of his right to display life uncensored was an act of defiance. "Stieglitz has not divorced his art from life," a critic wrote. If one were to find fault with his show, it would be with its "lack of reticence." Stieglitz, he concluded, "keeps nothing back."

On opening day, February 7, after braving the icy winds blowing down Park Avenue, Manhattan's cognoscenti gathered beneath the skylights on the fourth floor of a neoclassical building on the corner of Park Avenue and Fifty-ninth Street. Contemporary reports describe them standing as still as if they were in church. After the closing four years earlier of 291, Stieglitz's gallery (where New Yorkers first saw the most provocative modern artists), some thought that he had given up photography and his role as a guiding force in American culture. Recently, word had gotten around that he had been reinvigorated by his love for the artist Georgia O'Keeffe, that his photographs of her—identified only as "A Woman"—were sensational. "His resurrection," a critic announced, "is a staggering phenomenon, and in its *éclat*, dazzling."

Visitors entered the first room with a sense of anticipation. The photographer's warm-toned blacks and whites glowed so intensely against the red plush walls that some wanted to touch them. Stieglitz was holding forth in a corner, telling spellbound listeners about his struggle to win acceptance of photography as an affirmation of life. Gazing at his prints of Manhattan—Fifth Avenue swirling with snow, cabdrivers

watering their horses, Central Park on an icy night—people marveled at his way of "letting life be life," as he was heard to say.

Others were drawn to his scenes of modernity—backyards strung with clotheslines, half-finished construction sites, railroad yards in the snow. His recent work went beyond what was called "art photography," eschewing the pictorialist techniques then in vogue to reveal the subject itself. "They make me want to forget all the photographs I had ever seen before," a critic declared.

Moving into the next room, which was filled with portraits, visitors lingered over those recalling the great days of 291. Members of the Stieglitz group studied his prints of their circle: the artists John Marin, Marsden Hartley, and Charles Duncan; the critics Leo Stein and Paul

Alfred Stieglitz, *Georgia O'Keeffe—Torso,* 1918

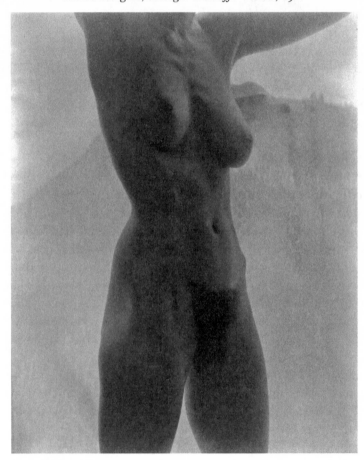

Rosenfeld; and the West Indian writer Hodge Kirnon, who had run the elevator at 291. Stieglitz's surrogate son, the photographer Paul Strand, stared back at those who stopped in front of his likeness on their way to the pictures of the notorious "Woman."

They encountered her in a grouping that showed her before one of her charcoal drawings. Dressed in a trim black jacket and hat, she looked away from the camera—a portrait of the artist as a young woman. Moving around the room, visitors met her in more intimate poses—her hat off, her tailored blouse unbuttoned, her dark tresses undone. In a warm palladium print, she reappeared in a white kimono whose delicate pattern complemented the dark tones of her hair. Studies of her elegant hands and fingers were grouped as a single portrait, as if these parts expressed the woman as a lover and an artist. On another wall, her hands touched her voluptuous breasts, weighing their contours or pressing them together—in a group labeled forthrightly, "Hands and Breasts." Another set of sepia-toned prints, "Torsos," compared her body to sculpture while simultaneously drawing the gaze to the dark **V** shape of her pubic hair.

Photographs marked by such intimacy had never been seen in public. They seemed to tell a story tracing the growth of the couple's affections. Stieglitz's portrait of this woman, one admirer wrote, "showed us the life of the pores, of the hairs along the shin-bone, of the veining of the pulse and the liquid moisture on the upper lip." To some, these prints were love poems.

Stirred by what they saw, visitors returned again and again; men asked Stieglitz if he would take portraits of their wives and sweethearts. But some found the photographs obscene. The group called "Hands and Breasts" offended one man, who ranted at the gallery's director that such photographs did not qualify as art and should be taken down. The review in *The New York Times* was laced with innuendos: In these "psychological revelations," it proclaimed, "a good deal of the primitive [was] getting the upper hand." Those who feared what might be found in their psyches were warned to keep away from Stieglitz. Other critics were more forthright: "The spirit of sex permeates the entire body of photographs."

For the rest of the month, while critics debated the merits of Stieglitz's prints and argued about photography's status as art, the public flocked to the show. Even those who had not been in the know now understood that the subject of his composite portrait was the young art teacher whose affair with the photographer had led to his leaving

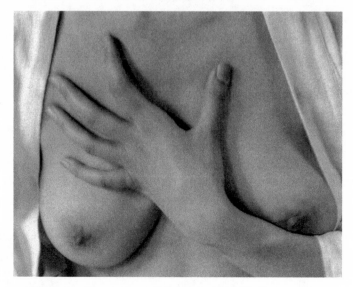

Alfred Stieglitz, *Georgia O'Keeffe—Hand and Breasts,* 1919

his wife. Reactions to this record of his feelings for his mistress varied from outrage on the part of some, including photographers for whom such frank treatment of the female body was unthinkable, to the awed response of a young woman who left the gallery in tears. "He loves her so," she said as she went out the door.

Searching for more measured ways to express themselves, some compared the portraits to old master drawings. Stieglitz's pictures of O'Keeffe were painterly, the critic Henry McBride observed; they put him in mind of canvases by Courbet or Rossetti. "He spends an immense amount of time making love to the subject before taking it," McBride added. But he referred to O'Keeffe not as an artist, but as Stieglitz's muse: "Mona Lisa got but one portrait of herself worth looking at. O'Keeffe got a hundred."

The gallery became a place to see and be seen. People returned in increasing numbers. The bolder among them joined the group in the corner where most afternoons Stieglitz held forth, explaining his desire to embody "universality in the shape of a woman." He talked almost nonstop, gesticulating and shaking his thick white hair to emphasize his belief that it was in the New World that a truly modern art like photography had found its home. Moreover, he believed that in his "Demonstration of Portraiture," there was "an interrelation of the parts to the whole and . . . a symbolism of all life."

Those who wondered what was being symbolized may have found some satisfaction in a review in *The Nation* by Herbert Seligmann, one of the Stieglitz clan. Stieglitz had "laid bare the raw material which . . . America has not yet dared to look upon," Seligmann wrote. "Love of the world leads him to the purest expression of it, to woman." Seen this way, his portrait of this woman evoked an innocence and receptivity "that have no home in [an] America" whose genteel standards kept it from embracing the truths of the body.

Paul Strand took up the defense in terms that gallerygoers were more likely to grasp—by praising Stieglitz's use of the camera. His essay "Alfred Stieglitz and a Machine" began circulating among New Yorkers keen to understand what the photographer was up to. His work was life-affirming, Strand wrote: "Stieglitz . . . accepted the machine, instinctively found in it something that was part of himself, and loved it." It was also groundbreaking. "These amazing portraits, whether they objectify faces or hands, the torso of a woman, or the torso of a tree, suggest the beginning of a penetration of the scientific spirit into plastic media."

Strand could also be heard arguing that he and his mentor were cultural "workers," that their works offered a means to identify "those hostile impulses of society which try to prevent every extension of the human spirit." Understood this way, the camera was an expression of "young desire . . . facing a world and social system which fears and thwarts and destroys."

These were fiery words, out of keeping with Strand's habitual reserve, but they appealed to Rebecca Salsbury, a vivacious young woman who accompanied him to the gallery to meet his mentor. In the throes of her own struggles with the social system's—and her mother's—opposition to the desires of strong-minded women like herself, Rebecca experienced their meeting as a turning point.

She listened to Stieglitz talk nonstop until closing time, as they strolled along Fifty-ninth Street to Columbus Circle, and for the rest of the evening at his favorite restaurant. What Stieglitz and his work revealed to her, she believed, was "affirmation, life kindled." Seeking to re-create herself as a modern woman, Rebecca would often compare herself to Georgia, as Paul compared himself to Alfred: He had just begun an extended portrait of Rebecca as his muse. But this sequence, which he never found satisfactory, was as much an homage to Alfred—and to his relations with Georgia—as a tribute to the woman who had just come into his life. The two couples would become "a tightly integrated four-

some, with admiration, competitiveness, in-jokes, and alliances passing in every possible direction between them."

At this stage, Stieglitz held uncontested sway over his protégés. He molded those who, like Rebecca Salsbury, were awestruck in his presence. Yet it was also true that intimates experienced his wrath if they crossed him. Years later, O'Keeffe recalled, "There was a constant grinding like the ocean. It was as if something hot, dark, and destructive was hitched to the highest, brightest star." In the interweaving of the two couples' lives and work, these extremes coexisted. Constellations on the horizon of homegrown modern art, they prodded, inspired, irritated, and encouraged one another as they grew into modes of relationship that none could have foreseen.

Their foursome became more entangled once Alfred began taking photographs of Rebecca—in an implicit rivalry with Paul, his disciple—and when Georgia told Rebecca that she and Paul had once been so close that they discussed living together. Without Rebecca's encouragement, Georgia would probably not have discovered New Mexico as her chosen terrain, nor would Paul and Rebecca have ended their marriage when he set out to attempt a more politically conscious photography in Mexico. And without Georgia as her model and surrogate sister, Rebecca would not have found her way to her own practice of art in the Southwest—the region that became, for both women, the antidote to Stieglitz's New York.

The idea for this book first took shape as I read through Rebecca's letters, in which the person she became under Stieglitz's tutelage sought to understand her role in the shaping of their foursome. Amplified by the correspondence in their respective archives, this narrative traces the relations of these four strong-willed people over several decades, in the hope of depicting the sometimes joyful, sometimes exasperated intermingling of their lives as artists, lovers, and friends. In the process of writing this book, I came to believe that my four characters' search to conciliate the often contradictory pulls of personal and artistic life still speaks to us a century later. Their story could not have been told from this vantage point without the collaboration that first made it possible—with the artist Lance Sprague. While I was writing about them, our discussions and discoveries nourished the process in ways that might have amused the four could they have watched us reweaving the complex mesh of their lives.

LINES AND LIVES

In the relations of lines to each other [one] may
learn the relation of lives to each other.

—Arthur W. Dow

Born in Hoboken
1864–1905

I was born in Hoboken. I am an American," Stieglitz declared in his Anderson Galleries catalog. In 1921, at a time of renewed patriotism, his German-Jewish origins made him seem doubly foreign. To those who questioned his right to speak for the country, he objected that he was as American as they were.

. . .

Hoboken, New Jersey, was then a middle-class town, which owed its prosperity to the steamship companies lining its docks. Edward Stieglitz had brought Hedwig Werner, his bride, to reside there in 1862, when so many of their compatriots lived in Hoboken that it was called "Little Germany." Edward purchased a three-story house with a view of Manhattan soon after Hedwig gave birth to Alfred, their first child, on January 1, 1864.

Born Ephraim Stieglitz in Münden, Germany, Alfred's father changed his name to Edward when he came to the United States after the 1848 revolution. Within a short time, he became a successful wool merchant and aspired to live like a gentleman. Hedwig never learned English well, but she passed on her love of the arts to her firstborn. Of their six children, Alfred remained his parents' favorite, even though he believed that he had been displaced by his twin brothers, Julius and Leopold, born when he was three. "[He] would spend the rest of his life," one biographer writes, "searching for a twin of his own."

Their house was full of guests, Stieglitz recalled, "musicians, artists, and literary folk, rather than business people. We had many books and pictures. Our dining room in Hoboken was in the basement. . . . I had my hobby horse there and while the men would drink, talk and smoke, I loved to sit on my horse, riding and listening to the conversation." His parents' hospitality made a strong impression: "They created an atmo-

sphere in which a certain kind of freedom could exist. This may well account for my seeking a related sense of liberty as I grew up."

The Stieglitzes moved to Manhattan in 1871, after the birth of their last child. Their brownstone on East Sixtieth Street had modern comforts like steam heat; the sparsely settled terrain near Central Park allowed Alfred the liberty he craved. Edward enrolled him at the nondenominational Charlier Institute for Young Gentlemen, where he was first in his class, despite his refusal to memorize the poems he was assigned in declamation, a talent in which he would always excel. The school emphasized a high-mindedness that was compatible with his father's rejection of Jewish beliefs in favor of a principled atheism.

Alfred learned as much at home as he did at school. Edward taught him his own hobbies, including billiards, a love of horsemanship, and a knowledge of wines, but he became angry when Alfred failed to satisfy his demands for excellence. Edward stressed ethical probity rather than spiritual training. That the family was Jewish was not discussed. At a time when Reform Judaism appealed to many of their middle-class brethren, the Stieglitz children thought of themselves as "ex-Jews," members of a small aristocratic tribe presided over by Edward.

Fortunately for her children, Hedwig was a woman of great warmth. She was also an avid reader, particularly of the German romantics—Schiller, Heine, Goethe, whose emphasis on the "living quality" of thought she shared with her son. As a boy, Alfred alternated between bouts of exercise and stints of reading everything from *Uncle Tom's Cabin* to Goethe's *Faust*. When Hedwig asked his opinion of *Faust,* he replied, "There are two things that attract me in it, Marguerite and the Devil." (A biographer notes that "in the pure and virtuous Marguerite he saw his mother—and in the clever, cavalier, powerful, and wicked Mephistopheles, his father.") Alfred was aware of Edward's nightly trips to visit the chambermaid. Rereading *Faust* in his teens, he was drawn to Helen of Troy, the Eternal Woman whose aura blended the stirrings of sexual feeling with the wish for unconditional love. He suffered so often from dark moods that family members called him "Little Hamlet."

Alfred's melancholy lifted every summer when the Stieglitzes repaired to Lake George, a step deemed necessary for his health and for his father's avocation, oil painting. They stayed at fashionable watering spots until 1886, when Edward purchased Oaklawn, an imposing Queen Anne house on the ten-mile stretch known as Millionaires' Row. This gabled mansion became the family compound, and, in time, the antidote to Stieglitz's life in New York.

He observed years later that he had been uprooted by his father's decision to take him out of the Charlier school to prepare for a career as an engineer—a profession in which he had no interest. Alfred was accepted by the City College of New York's engineering program but felt uprooted there, although he did well. In 1881, Edward decided to sell his business and live for a time in Germany, where, he believed, teaching standards were more exacting.

Stieglitz often said that his engineering course at the Berlin Polytechnic had meant little to him. At the time, while these classes did not stir his imagination, the discovery of a photography shop inspired him to learn the new medium. After buying a camera, developing trays, and a manual, he set up shop in his student quarters. Stieglitz believed that he had taken up photography as a free spirit; one might also see in his chosen medium one that avoided competition with his father.

The young man then began to take Hermann Vogel's Polytechnic classes in photography, where he worked diligently for the next two years, experimenting with the chemistry and optics of the medium—the effects of light on the reactions that take place in the printing process. Alfred soon outstripped Vogel's expectations, spending weeks printing his photographs of classical images, including a statue of Goethe with the muses of poetry, drama, and science beneath his feet.

Alfred's Berlin years afforded him an education in living differently from his father. (Ironically, it was Edward's business sense that produced in his son a fierce opposition to commercialism while providing his modest allowance.) Like his parents, he attended concerts, plays, and the opera, but he also frequented the racetrack and the Bauer Café, which was open day and night. It was the time in his life when he felt most free, with no social obligations and no one to interfere with his calling.

The young man was also free to dream about his feminine ideal. In a journal begun the day after his twentieth birthday, Alfred wrote that his idea of good fortune was to be loved, but that he despaired of finding someone who would do so. Like many twenty-year-olds, he was self-absorbed, moody, and keenly interested in the opposite sex. Although he claimed to have had his first sexual experience that year, it seems likely that his initiation did not take place until he was twenty-five, when he returned to Berlin from New York to show work in an 1889 exhibition timed to celebrate the fiftieth anniversary of photography's invention.

Judging by the photographs Alfred took that summer of a woman named Paula, he was in love with her, even though she was a prosti-

tute. *Sun Rays—Paula, Berlin* shows his model in a large feathered hat and her hair in a chignon (signs of respectability) as she sits writing at a table (another sign of respect). The light streaming through the blinds casts patterned shadows on the wall; the photographs behind her include Alfred's self-portrait, a head shot of Paula, and three valentines. This ode to domestic bliss, suggesting a Vermeer interior, symbolized his coming of age. (Stieglitz later said that he had fathered a child by another woman in Munich, to whom he sent an annual allowance.)

By then, Stieglitz was steeped in the *geist* of bohemian Berlin and the romanticism of German culture. Deeply impressed by Wagner, he believed in the idea of expressing the times through new forms of art. And while Goethe remained his favorite author, he was also reading Byron, Zola, Whitman, and Twain—reminders of his roots, like the American flag he placed above a portrait of his mother in an early photograph entitled *My Room*.

Yet being American would not have blinded him to the nascent anti-Semitism of the time, when the Christian Socialists made prejudice a plank in their platform and extremists called Jews a national threat. Anti-American sentiments were also freely expressed. After one of his teachers told the class that the recently completed Brooklyn Bridge would soon collapse, Stieglitz stood up for this marvel of Yankee engineering: "It was, after all, my America I was defending."

· · ·

Stieglitz returned to the United States in 1890 with a portfolio of photographs, a sense of culture based on the German model, and a command of photographic technique. What he lacked was a way to provide for himself. It was depressing to return to his parents' home, since Edward kept urging him to do something practical. He joined the Society of Amateur Photographers (known as the SAP) and attended its meetings, but collegiality did not compensate for the lack of a companion.

After nine years abroad, he was also suffering from culture shock. New York was noisy and crass, "the spiritual emptiness of life . . . bewildering." Worse, the country's materialist bent had infiltrated photography. The Kodak camera, recently introduced by George Eastman, seemed to redefine the practice of photography. Kodak's slogan, "You push the button and we do the rest," was an affront, Stieglitz recalled with a note of exasperation. "I had been brought up with the idea of the tripod and awaiting one's moment." At twenty-six, he felt like "a fish out of water," having remembered America like "a fairytale."

Stieglitz approached his first commercial venture in an equally unrealistic spirit. Soon after his return, an acquaintance persuaded him to become acting director of a firm specializing in three-color reproductions. He accepted despite his sense that he was unsuited to business, then persuaded two friends from Berlin, Joe Obermeyer and Lou Schubart, to be his partners. They would learn what they needed to know from their employees and become one family working for a common good—an approach recalling William Morris's utopianism.

At first, Alfred took no salary; the firm charged high prices and paid generous wages. But it soon became clear that their few customers—for calling cards and advertising posters—were more interested in cutting costs than in fine engraving. By 1895, after trying in vain to persuade their clients to respect quality, Alfred resigned and gave the workers his shares—a gesture combining his antipatriarchal stance with his anticapitalist ethos.

He had made a commitment two years earlier that would prove difficult to undo. At twenty-nine, Alfred became engaged to Emmeline Obermeyer, his partner's sister (she was twenty). Her background was similar to his (she had been educated in Europe); the Obermeyer fortune (the family-owned breweries) would alleviate the pressure to earn a living; Alfred's alliance with Joe, his future brother-in-law, would be cemented. But Emmy had little feeling for the arts and, judging by his photographs of her at Lake George, lacked the allure that had drawn him to Paula and would suffuse his portraits of O'Keeffe. Alfred agreed to marry Emmy once she assured him that her income (three thousand dollars per year) would cover their expenses; his father promised to match this sum. Everyone seemed pleased except the prospective groom.

A series of wintry scenes taken in New York that year convey the emotional weather of their union. Alfred grew fond of Emmy during their engagement, but in his view, once married, she turned prudish, at first refusing to let him caress her or photograph her in the nude. Emmy, who was not as impressionable as Alfred had supposed, must have hoped that he would accede to her wish for the life to which people of their milieu were accustomed—evenings at the theater, dinners with friends, trips to Europe. In his frustration, he lost patience when he came to see that Emmy could not be molded into the companion he desired.

Their wedding trip, a five-month tour of France, Italy, Switzerland, Germany, and Holland, became the occasion for Alfred to devote himself to photography while Emmy shopped. When she tried to please him by going on an expedition in the Alps, he left her behind because she was

too frightened to take the mountain railway. The scenes he photographed in Italy—street urchins, laundresses, gossiping neighbors—meant little to her. Emmy cared only for what to Alfred were frivolous things, preferring to patronize the best boutiques rather than immerse herself in art.

His disappointment is implicit in his portrait of a fisherman's wife taken in Holland during their trip, *The Net Mender*. This meditative image, recalling art by the Barbizon school, became one of his favorites. "Every stitch in the mending of the fishing net," Stieglitz wrote, "brings forth a torrent of poetic thoughts in those who watch her sit there on the vast and seemingly endless dunes." But life with Emmy brought forth no such thoughts. After their return to New York, she could not have helped noticing when Alfred gave pride of place in their salon to a framed print of *The Net Mender*.

In his view, their marriage failed to provide the rapport needed to nourish creative vision. Feeling more alone than ever, Stieglitz returned to the scenes of Manhattan begun the year before with *Winter—Fifth Avenue*, a photograph of a cabdriver urging his horses on through blinding wind and snow. This picture can be seen as a symbolic self-portrait: "He felt that the driver struggling against the blasts of a great storm represented his own plight as an artist in a philistine city." (And, one might add, in an unrewarding marriage.) Yet this image was also the start of a new phase in his work—and a fresh basis for "so-called 'American Photography.'"

Stieglitz's love of challenging subjects, such as street scenes shot in rain or snow, inaugurated the set of images that he hoped would comprise a portrait of the city. He intended to take one hundred photographs of New York, a project that would not only express his sense of reality but earn for photography the recognition long denied it as an art. While the series was never completed, some of its images are artistic milestones. *The Terminal*, a study of another cabdriver watering his horses, is both a tour de force and a spiritual statement: "A driver I saw tenderly caring for his steaming car horses in a snow-covered street came to symbolize for me my own growing awareness that unless what we do is born of sacred feeling, there can be no fulfillment in life."

At the time, his lack of fulfillment at home fed into his increasingly scrappy response to opposition. For the rest of the 1890s, Stieglitz would agitate to win recognition for photography as an art, despite its "mechanical" nature. Rather than reproductions of reality, he and a few like-minded men, he argued, were making "pictures" in which composition and perspective mattered as much as in painting. By claiming that

these "pictorial" prints had their own integrity, he was also writing off colleagues who did not endorse his view, those whose images evoked Impressionism to justify their work as "Art." True pictorialism aimed not at aesthetic effects, but at simplicity, which was "the key to all art—a conviction that anybody who has studied the masters must arrive at."

By 1892, when this statement appeared in *Photographic Mosaics*, Stieglitz was on a crusade to convert those colleagues whose work he deemed "technically perfect, pictorially rotten." He told a friend, "I would rather be a first-class photographer in a community of first-class photographers than the greatest photographer in a community of nonentities." But his idea of community would prove to be divisive. After two years as the unpaid editor of *The Amateur American Photographer* he was promoted to full editorship in 1895. Soon his policies made him so unpopular at the SAP that he was asked to step down. Stieglitz then claimed that *he* had chosen to resign: The problem lay with the SAP's divisions between the ruling "dress suits" and his allies, the "democrats."

But the situation was no better at the New York Camera Club, whose founding members, mainly hobbyists, had seceded from the SAP in 1888. In league with the like-minded from both clubs, Stieglitz waged a campaign to merge the two bodies into a new society, the Camera Club of New York. Its headquarters on West Twenty-ninth Street became his second home.

Stieglitz also hoped to turn the Camera Club into an arbiter of excellence in a journal to be called *Camera Notes;* given his editorial experience, the members decided he was the man for the job. The first issue appeared in 1897, its dark green cover embossed with a sunflower—an Art Nouveau motif that evoked a fresh start. It would contain only work showing "the development of an organic idea," he wrote, "a picture rather than a photograph, though photography must be the method of graphic representation."

"I had a mad idea that the Club could become the world center of photography," Stieglitz observed much later. To this end, he focused his energy on the politics of photography in Europe and at home, where, he believed, annual exhibitions of the best work were needed to win acceptance in the art world. The intensity of his focus, wielded through his editorship of *Camera Notes* and participation in shows as juror and artist, made him pictorialism's foremost spokesman. It also enabled him to spend most of his days at the club.

For a time, following the conception of their only child, Emmy's pregnancy brought about a thaw in their relations. They moved to a large

apartment at 1111 Madison Avenue, where she presided over the staff;
Alfred claimed a study on the understanding that nothing in it would
be disturbed. Katherine Stieglitz, known as Kitty, was born on September 27, 1898. Almost immediately, her father began taking her picture—in
Emmy's arms, at Lake George, and later, fashionably dressed, on city
streets with her equally fashionable mother. Alfred's record of Kitty's
development comprised the portrait he called *The Photographic Journal
of a Baby* when it was shown in London in 1900.

Stieglitz's idea of an evolving photographic portrait owed much to a
related medium, cinema. He said later of his images of O'Keeffe, "To
demand the portrait that will be a complete portrait of any person is
as futile as to demand that a motion picture be condensed into a single still." Years later, when Charlie Chaplin came to see the O'Keeffe
portraits, Stieglitz told him that the prints were the prelude to an idea
he had had in mind for years: a film of "all parts of a woman's body,
showing the development of a life." Only a serial portrait could provide
a full record. But when Emmy complained that he was making Kitty
self-conscious, Alfred photographed her less often.

As the subject of an extended portrait Manhattan was always available. In 1897, Stieglitz began a series of nocturnal images with *Reflections:
Night—New York,* a study of light shimmering on the pavement. The
next winter, convalescing from pneumonia, he left his bed at one a.m. to
photograph a desolate scene in Central Park—two rows of leafless trees
looming like specters in the lamplight. The halation (the blur or halo)
around the sources of light preserved their luminosity, he explained in
"Night Photography with the Introduction of Life," an article printed in
the 1898 *American Annual of Photography.* Another series, taken in the
rain at Madison Square, blends urban and pastoral elements in compositions that show an affinity with Arts and Crafts aesthetics. *Spring
Showers—The Street Cleaner* and its companion, *Spring Showers—The
Coach* share the linearity that would distinguish Stieglitz's photograph
of the Flatiron Building, on the south side of the square.

By 1900, Stieglitz was a dominant force at the Camera Club, a role
he worked vigorously to maintain. He showed his work there and published numerous articles on photography as well as a portfolio, *Picturesque Bits of New York and Other Studies;* he was a forceful juror in the
annual salons and exercised his influence in *Camera Notes.* According
to Theodore Dreiser, who interviewed him there, "His attitude toward
the club has come to be the club's attitude toward the world. He openly
avows that he has planned to accomplish three things: first, to elevate

the standard of photography in this country; second, to establish an annual national exhibition . . . third, to establish a national academy of photography."

Dreiser also wrote a feature on Stieglitz for *Success* magazine's "Life Stories of Successful Men"—a series including Andrew Carnegie, Marshall Field, and Thomas Edison. Stieglitz dominated the field of photography to such an extent that there was "no longer any dispute as to his leadership," Dreiser wrote. The critic Sadakichi Hartmann seconded his opinion: "Not only during my first visit but often since, it has seemed to me that artistic photography, the Camera Club, and Alfred Stieglitz were only three names for the same thing."

That next year, the English art critic Charles Caffin appraised Stieglitz's standing in *Photography as a Fine Art*. Stieglitz had received "a full share of knocks from antagonists," and was himself "an accomplished

Frank Eugene, *Alfred Stieglitz*, 1901

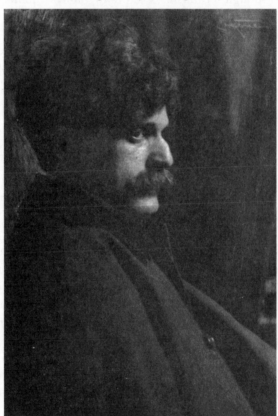

thumper," yet the role of spokesman had been forced on him by his preeminence. Caffin, who had once been critical of Stieglitz, now admired "the rare balance in him of scientific knowledge and artistic feeling." At the center of the volume, on the work of the most "advanced" photographers (including Gertrude Käsebier, Clarence White, and Frank Eugene), Caffin placed Frank Eugene's portrait of Stieglitz—as if he were, without question, photography's leading light.

. . .

By the time these assessments appeared in print, some of those who had been "thumped" by Stieglitz were plotting to challenge his leadership. But if he made any resolutions on January 1, 1900—his thirty-sixth birthday—they did not include plans for compromise. Given his need to dominate and his demands for loyalty, the pattern of volatile relations with colleagues would recur. Moreover, he thrived on controversy. Up to this point, he thought of his allies as photography's "democrats": In the new century they would become its "revolutionaries."

In 1900, resentment of his influence came into focus at the club. Members complained when he rejected their submissions to *Camera Notes;* they grumbled about his lack of respect for those who were not pictorialists. In response to complaints about his high-handedness, Stieglitz resigned from the vice presidency. And although the U.S. government had commissioned him to choose photographs for the Exposition Universelle in Paris that summer, he resigned from this post as well on learning that his selections would hang not in the Fine Arts pavilion but with the Liberal Arts (or crafts).

The only bright spot that spring was his meeting with the painter and photographer Edward Steichen, who had stopped in New York on his way to Paris. When the young midwesterner showed Stieglitz his prints, Stieglitz was so taken with Steichen's atmospheric images that he bought three and promised to reproduce them in *Camera Notes.* After asking Steichen if he meant to abandon the camera in favor of the paintbrush, he was reassured by his reply: "I shall use the camera as long as I live; for it can say things that cannot be said in any other medium."

That night, Alfred told Emmy, "I think I've found my man." Like Stieglitz, Steichen's background was European. His parents brought him from Luxembourg to the United States when he was two; he grew up in Milwaukee, a city with a large German population. Having saved enough from his work as a commercial artist to move to France, he

had a determination that reminded Stieglitz of his own. Over the next two years, their correspondence would keep Stieglitz informed of cultural trends in Paris while Steichen pursued his plan to photograph celebrities—a project that led to his famous portraits of Rodin.

Meanwhile, the conservatives at the club renewed their complaints about Stieglitz. That fall, he convened the members to make a politic (if self-serving) confession: "*Camera Notes* was a lie; its tone, assumed by the public to represent the tone and standard of the Club, was in reality far in advance of that of the larger body of Club-members." The group gave him a vote of confidence, but a few months later it endorsed a separation of powers: He would edit *Camera Notes,* while the conservatives would take charge of other business.

His opponents having won the day concerning exhibitions, Stieglitz accepted an invitation to choose American photographs for the Glasgow International Exposition of 1901. (Prints by Eugene, White, Käsebier, Steichen, and Stieglitz would dominate.) He also started looking for a new venue for a show of American photography. In November, Charles de Kay, the art editor of *The New York Times* and founder of the National Arts Club, told Stieglitz that his group could house such an exhibition in the club's Thirty-fourth Street mansion. Stieglitz agreed, provided he would have control over the selections and how they were hung.

That winter, Stieglitz announced the existence of a new society, the Photo-Secession. Who belonged? de Kay asked. "Yours truly," he replied. Others would be invited to join once the show was up, though the word *secession* might alarm Americans, who would think of the Civil War: "Photo-Secession implies a seceding from the accepted idea of what constitutes a photograph . . . in Europe—in Germany and in Austria—splits have occurred in art circles, the moderns calling themselves Secessionists. So Photo-Secession hitches up with the art world."

The provocative new name piqued Manhattanites' interest when *The New York Times* ran a piece on Stieglitz's nonexistent group. On March 5, opening night (which was mobbed despite terrible weather), he spoke on "Pictorial Photography and What It Means," and, after the lecture, he told a puzzled Käsebier that she was a Secessionist as long as she felt like one. Visitors noted that the show gave pride of place to Steichen.

Looking back at the 1902 show as the Photo-Secession's seminal moment, Stieglitz wrote, "Those of a similar mind and ideals found themselves unconsciously drawn closer and closer . . . these kindred spirits would act as a unit." But at the time, this sentiment was more of a wish than a reality. Ten days before the opening, he gave notice to

the Camera Club that he would resign as editor of *Camera Notes*. About to stir up controversy on his own terms, Stieglitz felt ready to "struggle" (one of his favorite words) on behalf of the new society. But rather than resign from the club, he remained a member and gave its address as that of the Photo-Secession, since neither he nor his allies had darkrooms.

A number of people soon decided that they, too, were Secessionists, even though membership was by invitation. (Stieglitz enraged a club member by telling him that he was not a Secessionist, even though three of his prints had hung at the National Arts Club.) For the rest of the year, he invited those whose work he admired to become fellows, seven of whom (including Steichen) formed the council that voted on other applicants. But what was the nature of their cause? Steichen observed that "no one but Stieglitz seemed to know just what 'Photo-Secession' meant."

Steichen returned to New York that fall with the aim of setting himself up as a portraitist. Stieglitz was proud that Steichen's photographs had been admitted to the 1902 Salon de la Societé Nationale in Paris, even though the jury refused to hang them because they believed that photography did not qualify as art. After two years in Paris, Steichen was a changed man. He had taken to wearing a large black hat and a cape, and, having gained confidence from his success in the art world and with the many women who fell for him, he had a bit of a swagger. Stieglitz's photos of the Photo-Secession show struck the young man as "rather helter-skelter"; he felt "a little belligerent" about the group in whose inner council he had been enrolled in his absence. But when Stieglitz outlined his plans for *Camera Work,* the new magazine in which he would feature Secessionists (starting with Käsebier) and critics like Caffin, Steichen agreed to come on board.

Soon the group was meeting regularly, often at Mouquin's, a French restaurant on Sixth Avenue at Twenty-eighth Street. Associates were invited to join (including Emmy, who contributed funds); Alfred was chosen as president, but finding the title "too ostentatious," accepted that of director. The Secession's aims were then clarified in *Camera Work*: "To advance photography as applied to pictorial expression; to draw together those Americans practicing or otherwise interested in the art, and to hold from time to time, at varying places, exhibitions not necessarily limited to the productions of the Photo-Secession." Stieglitz had founded the group because he was "battling . . . for a new spirit in life that went deeper than mere preoccupation with what is termed 'photography.'"

Steichen joined the battle for practical reasons. While he looked to

Stieglitz as an established master, he, too, needed to make his name. The support of the best-known spokesman for photography would prove invaluable. Stieglitz invited Steichen to his home; he introduced him at the club and to his family. But while Stieglitz recognized his talent, "he was not for a moment inclined to be a father figure to a handsome younger man." Still, Steichen valued Alfred's support as well as that of the Stieglitz clan, who told their friends of his skill as a portraitist.

Soon after Steichen rented a studio at 291 Fifth Avenue, near the club, he urged Stieglitz to devote the first issue of *Camera Work* to his work rather than Käsebier's. Stieglitz promised Steichen the next issue and enlisted him in the magazine's design. Steichen's plain gray cover set off the white letters of the title's Art Nouveau typeface, balanced by the Roman numerals used for each issue's number; he designed the back cover (a Kodak ad, despite Stieglitz's dislike of the firm) and selected the paper stock. Stieglitz made sure that the photogravures were of the highest quality. *Camera Work* was itself a work of art, a critic wrote—one marked by "the lover's touch."

As promised, the second *Camera Work* featured the work of Steichen, including his self-portrait and a portrait of Rodin, with appreciations by Caffin and Sidney Allen (a nom de plume for Sadakichi Hartmann), whose account of his visit to Steichen's studio called him photography's new champion. In Allen's view, Steichen's portrait of Rodin with his *Penseur* was a masterpiece—proof that this kind of photography corresponded "to the special necessities of a democratic and levelling age." Over its lifetime, *Camera Work* would devote three issues to Steichen and publish sixty-five reproductions of his work, more than that of any other photographer.

In the meantime, the Stieglitz clan extended their hospitality to the young man when he announced his plan to marry the singer Clara Smith. Alfred attended their wedding, and the couple spent their honeymoon at the Stieglitz home at Lake George. For the next few years, the two men worked harmoniously, and without pay, to promote the Photo-Secession and *Camera Work*. In addition to Stieglitz's allies at home, the review featured French pictorialist Robert Demachy and those British colleagues whose work he admired—Frederick Evans, David Octavius Hill, and J. Craig Annan. He displayed a range of photographers—those who favored unretouched images; the more painterly pictorialists like Steichen and Eugene, who manipulated their prints; and Käsebier, whose "artistic-commercial" portraits (Caffin's term) fell between these two approaches. The illustrations evoked a mood, the kind of Symbolist

brooding that seemed to support the claim that these machine-made images were works of art in their own right.

The first issue ran a defense of the medium by George Bernard Shaw, himself an amateur photographer. From then on, Stieglitz published lively critiques of his artists' work and essays on recent trends. He relied on Caffin to engage readers with his accounts of pictorialism and featured Hartmann's provocative essays until the author fell out with him. Stieglitz also favored inside jokes in the form of fables or jests—like "The ABC of Photography," by the critic J. B. Kerfoot. In another piece, Kerfoot combined inked silhouettes with word portraits of the Secessionists: Stieglitz was Alfred the Great, Käsebier "the Madonna of the Lens," and Steichen one of the group's "lions."

Stieglitz also spoke to *Camera Work*'s readers through a selection of his own prints. Of those that held special meaning for him, *The Hand of Man* (1902), a stark image of a train moving toward the viewer under billows of smoke, appeared in the first issue. The engine pushes forward on its own, as Stieglitz claimed that he had done; the title evokes fin de siècle debates about art in the machine age. Stieglitz's friends would have grasped its meanings, as well as the reasons behind the choice of his image of the Flatiron Building, featured despite his father's dislike of this edifice. "It is to America what the Parthenon was to Greece," Stieglitz insisted, "a picture of the new America." Perhaps he meant to imply that, like the Flatiron Building, *Camera Work* was itself an "amazing structure" combining "lightness" with "solidity."

By 1904, Stieglitz had worked himself into a state of exhaustion. He was about to go to Europe with Kitty and Emmy when Steichen took portraits of the six-year-old with each of her parents. Steichen's favorite shows father and daughter facing the camera with arms linked. In another, Alfred hovers while Kitty stares at the camera. She is more at ease in Steichen's portraits of her with Emmy, especially one in which their affection is implied in their stances (bodies turned to each other) and the visual rhyme of their loose white garments. Still, even though smiles were not common in such portraits, no one seems very happy, and none was taken of the three together. It is tempting to infer that the couple's lack of harmony disturbed their daughter, yet inappropriate to speak of "familial dysfunction"—since we cannot know if Steichen arranged their poses or if they struck their own.

A few days after arriving in Berlin, Alfred collapsed. He spent the next month reflecting on the last ten years. "During that period," he wrote, "I had witnessed the evolution of pictorial photography and watched its struggles against the hostile environment of ignorance, prej-

Alfred Stieglitz, *Kitty and Emmeline*, c. 1905–1906

udice, selfishness, vanity, conceit, intrigue, provincialism, and a host of other malign influences." On the subject of Stieglitz's hypochondria, a biographer notes, he "routinely exaggerated the gravity of his physical ailments to obtain sympathy, to secure his privacy from Emmy, and to provide the necessary background for his accounts of his heroic efforts on behalf of photography." In this view, periodic breakdowns were the means by which he translated his distress into bodily terms.

That same summer, Steichen wrote to say that he could not plan his future without Stieglitz's advice. When Stieglitz returned to New York in October, he learned that Hartmann had turned on him in a diatribe published in *The Photo-Beacon,* "Little Tin Gods on Wheels." While it did not mention Stieglitz by name, Hartmann's slurs were obvious: "pictorialists throughout the land," he asked, "will you any longer stand the undemocratic, un-American policy of these little T.G.O.W.?" Henceforth, he would give his support to Stieglitz's rival, Curtis Bell, who was gathering prints for an exhibition in December, to be known as the First American Photographic Salon. Stieglitz made a point of dismissing Bell's salon. In *Camera Work,* he sneered that Bell's jury examined ten thousand entries before choosing the more than three hundred substandard prints "with which the walls were literally plastered."

In response to the challenge, Stieglitz came up with the idea of an

international exhibition of photography to be held in 1906. With Stei-
chen's help, he planned to display the best that had been done in Europe
and the United States. For the next year, he scouted art galleries but was
forced to conclude that it would be impossible to secure an appropriate
space during the high point of the year, the spring season.

One night when Stieglitz and Steichen were conversing in front of
Steichen's studio building, they came up with an alternative. They would
rent rooms in which to hang the American and European sections of the
exhibition they had in mind. Steichen had recently moved across the
hall to a large studio with a skylight. His old studio was vacant; adjoining
it were two small rooms that the landlord might rent to the same ten-
ant. When Stieglitz expressed concern that they would not find enough
good images to keep the rooms open during the season, Steichen said
that they could show other works of art. Stieglitz signed a one-year lease;
Steichen volunteered to design the gallery and oversee the renovations.

In October, Stieglitz told the Secessionists about his plans for the
rooms at 291 Fifth Avenue, to be known as the Little Galleries of the
Photo-Secession. Soon the space would be called, simply, "291." A biog-
rapher writes, "Eventually, '291' came to be the mystical, numerological
symbol of the conflation of Stieglitz's personality, the gallery, and all that
it represented. One could never be quite sure, when Stieglitz uttered
the pregnant trinumeric formula, whether he was referring to the gallery
or to himself."

Portrait of 291

1905–1913

After a festive dinner at Mouquin's, Stieglitz and a few friends strolled up Fifth Avenue for the inaugural show at the Little Galleries of the Photo-Secession. The opening took place on November 25, 1905—"without the stereotyped press-view or similar antiquated functions" but with the sense that *little* implied a disdain for the status-conscious behavior common at such events.

After admiring the sign on the door, with the words *Photo* and *Secession* on each side of a golden disk, the gallery's emblem, they took the rickety elevator to the top floor. There they stepped into a hallway painted in pale blue, salmon, and olive gray, an intentionally *moderne* palette. In the larger of the two rooms, photographs were shown in dark frames on walls hung with olive gray burlap, complemented by olive gray curtains around the room at waist height to conceal storage. The smaller room balanced this color scheme with prints in white frames against the burlap on the walls. One hundred prints by thirty-nine of the Secessionists, including Steichen, Käsebier, White, and Stieglitz, hung in rows, with just enough space between to set off each print from those on either side.

Steichen's decor won approval from the Stieglitz group; others saw it as ostentatious simplicity. Charles FitzGerald, a supporter of the Ashcan School, fulminated in *The Evening Sun*, "The vanity of these people is unbelievable. The fopperies displayed in their work, their eccentric frames, the whimsical flourishes in which they habitually indulge, and their incurable gravity—all these are but symptomatic of their essential frivolity."

FitzGerald's disdain did not keep those who were curious about photography from finding their way to 291. Some fifteen thousand came during the first season, when Stieglitz exhibited the works of, among others, David Octavius Hill, Frederick Evans, White, Käsebier, and

Steichen—a retrospective followed by an issue of *Camera Work* with ten of his images. Stieglitz was pleased to note that sixty-one prints had sold in the first year, Steichen's sales outnumbering those of his colleagues.

The gallery became the place to see art that was new "in impulse and form," the progressive journalist Hutchins Hapgood recalled. "Persons from many different social groups went to '291'—rich, poor, conventional, bohemian, successful, unsuccessful, smug, contented, unhappy." Repeated exposure made them feel "more alive . . . more sensitive to reality." Another regular appreciated the sense of repose that he found there: "You forgot all about New York, the rush of the subway; and the struggle after the almighty dollar."

Given the gallery's location, prosperous New Yorkers sometimes found themselves mingling with the denizens of Greenwich Village. Three blocks north, on Fifth Avenue at Thirty-fourth Street, the grand buildings of the original Waldorf-Astoria Hotel provided a venue where women could appear without escorts. Nearby, Stanford White's Knickerbocker Trust building marked the area's ongoing change from residential to commercial. When 291 opened in 1905, White's firm was building equally grand headquarters a few blocks to the north for the rival jewelers Gorham and Tiffany. White visited 291 to see Käsebier's portraits of himself and Evelyn Nesbit Thaw, his mistress, a few months before her husband killed him—an event replayed in "the Trial of the Century," as it was called in the tabloids.

Brownstones in the area sheltered art galleries, photo studios like Steichen's, and small cafés catering to the locals. Stieglitz moved his "round table" from Mouquin's to the Holland House, a sumptuous hotel at Fifth Avenue and Thirtieth Street, whose marble staircase echoed the decor of its London namesake. Every day he and his guests repaired to the hotel restaurant, where the Louis Quinze furnishings must have seemed at odds with the style of 291. Emmy continued to provide an allowance for such occasions. About this time, Gertrude Käsebier photographed Emmy looking pensive: With her ring hand, she holds a portfolio embossed with the Photo-Secession's golden disk, the symbol of all that Alfred preferred to their union.

· · ·

Steichen grew restive after the success of his one-man show at 291. His portrait business was thriving, but it irked him to hear it said that having your picture taken by him was the thing to do. He told Stieglitz that he

would soon return to Paris, a turn of events that elated Emmy. Since the lease on 291 was about to expire, she and Alfred would be free to travel. "You can give up all that nonsense," she told him, "for without Steichen you can't go ahead." The next day, he signed the lease for two more years and agreed to manage Steichen's affairs in his absence. "Steichen had become the older man's most energetic ally, and sometimes he felt that he and Stieglitz carried the entire pictorial photography movement on their shoulders."

In a way, Steichen was right. Following his departure, while most Secessionists remained committed to the cause, relations among them became complicated due to professional rivalries. Some thought they had won the war: "The real battle for the recognition of pictorial photography is over," Joseph Keiley wrote in *Camera Work*. "The chief purpose for which the Photo-Secession was established has been accomplished."

But if the battle had been won, how was Stieglitz to pursue the vision that had inspired him to start the gallery? In December, a young woman showed up when he was feeling discouraged about what to do next. She introduced herself as Pamela Colman Smith, from London, where she published a magazine with contributions by Yeats, Gordon Craig, and other artists. After looking at her artwork, Stieglitz offered her a show to open on January 5, 1907. "Smith is a young woman with that quality rare in either sex—imagination," James Huneker wrote in *The New York Sun*. His review brought well-to-do New Yorkers; Stieglitz prepared a portfolio of Smith's paintings and watercolors.

It was a happy accident that his protégée possessed a gift prized in fin de siècle aesthetics—that of synesthesia. Pieces like *Beethovenesque* and *The Devil's Sonata,* Smith explained, were "thoughts loosened and set free by the spell of sound." Ideas of loosening and setting oneself free of restraints were everywhere in Symbolist art, but their link to sensual freedom had rarely been evoked by a pretty woman who was also an artist. We can see in Stieglitz's response to Smith an anticipation of his enthusiasm for O'Keeffe's drawings a decade later.

That spring, Alfred pursued his preoccupation with the topic "Woman" with Clarence White: Their collaboration was meant to demonstrate "the pliability of straight photography as a medium for portraiture and figure work." The men hired two models to pose for them—dressed, partly undressed, and in the nude. While some of their prints suggest classical statues, their soft-focus interpretation of "pliability" also hints at these artists' interest in the female body. Stieglitz published a portrait and the most evocative of the nudes in *Camera Work*.

During the 1907–1908 season, exhibitions at 291 shared a theme—the female figure. Stieglitz's stated purpose—to stir discussion among the Secessionists through the display of oils, drawings, watercolors, and sculpture—fit nicely with this theme, starting with Pamela Smith and culminating in the radical exhibitions sent from Paris by Steichen over the next few years. That the nude was a classic topos of art made it all the more appropriate to study its handling by contemporaries.

That winter, Steichen and Stieglitz had their first major misunderstanding when the younger man learned that Pamela Smith would be the first nonphotographer featured at 291. Since Steichen's return to Paris, he had been choosing representative drawings by Rodin to inaugurate the gallery's nonphotographic exhibitions, but Stieglitz had preempted him.

The two men patched things up that summer, when Steichen introduced Stieglitz to the Lumière Company's autochrome process, which enabled one to take color photographs. (Autochromes were made by applying grains of colored starch to a glass plate, subjecting it to pressure, then adding silver bromide. The result, a glass transparency resembling a Pointillist painting, was viewed when held up to the light.) Stieglitz experimented with autochromes during his holiday in Europe with Kitty and Emmy. This series produced a poignant portrait of himself and Kitty: Alfred, holding his camera, gazes at his daughter, who rests one hand on the camera and the other on the flowers in her lap. His camera and her bouquet seem emblematic; she poses, reluctantly, as his young muse.

Stieglitz went on making delicate color studies of family and friends, displaying these autochromes along with color prints by other Secessionists in the first show of the 1907–1908 season at 291. That fall, when Paul Strand visited the gallery with his camera class, the young man decided that he, too, would become a photographer—whether or not work of this kind would help him earn a living.

Stieglitz's interest in autochromes waned as other matters became more pressing. In October, the downfall of the Knickerbocker Trust produced a currency crisis. Banks around the country barred their doors against depositors seeking to remove their savings. Market liquidity all but evaporated until J. P. Morgan shored up the financial system with large infusions of cash. Still, thousands lost their investments, among them Alfred's parents. It would have been dispiriting to see them having to move to more modest quarters and to admit that in such a time an art gallery was an extravagance.

On January 2, 1908, when confidence in the commercial system was at a low ebb, Stieglitz opened an exhibition of Rodin's "howlers"—the pencil and watercolor nudes sure to create a stir. Rodin had traced every contour of his models' bodies as they danced around his studio, bent over each other's swooning forms, or baring their private parts. To ensure that viewers got the point, Stieglitz printed an excerpt from Arthur Symons's essay on Rodin's muse in the catalog: "Every movement of her body, violently agitated by the remembrance, or the expectation, of the act of desire, is seen at an expressive moment. She turns upon herself in a hundred attitudes, turning always upon the central pivot of the sex."

The show soon became a scandal. Rodin's nudes were "not the sort of thing to offer to public view," W. B. McCormick declared in the *New York Press,* and Symons's defense was "inspired nonsense." At a time when Anthony Comstock's Society for the Suppression of Vice had resumed its campaign against the dissemination of lewd materials, Rodin's drawings challenged "the prurient prudery of our puritanism," J. N. Laurvik wrote in the *Times.* He continued: "One marvels that this little gallery has not long since been raided by the blind folly that guards our morals."

The Rodin exhibition also provoked similar feelings of outrage in the academy. William Merritt Chase, the well-known American Impressionist, told his classes at the Art Students League that Rodin's nudes were preposterous. Although he himself intended to boycott the gallery, they should see for themselves. One day, the twenty-year-old Georgia O'Keeffe trudged through the snow with her classmates to see what the fuss was about. Rodin's drawings struck her as so many scribbles; she retreated to the back room when Stieglitz and the others began arguing about them. "I had never heard anything like it," O'Keeffe recalled. "There wasn't any place in New York where anything like this was shown."

. . .

"I have another cracker-jack exhibition for you," Steichen told Stieglitz while the Rodins were stirring up controversy. On his return to New York in March 1908, he would bring work by "the most modern of the moderns," the Fauvist Henri Matisse.

Years later, Stieglitz would look back on the Matisse exhibition as "the first blow of 'Modernity' in America." At the time, when Matisse was not well known, Stieglitz was more interested in his radicality than in his artistry. "Here was the work of a new man, with new ideas—a very

anarchist, it seemed, in art," he proclaimed in *Camera Work*. Stieglitz hoped that Matisse would provoke the same outrage in Manhattan as he had in Paris.

He was not disappointed. Most critics took the term *fauve* to mean "wild man." The show, one of them wrote, "brought a recurrence of red wrath." James Huneker called Matisse an outlaw: "Compared to these memoranda of the gutter and brothel, the sketches of Rodin are academic." Edgar Chamberlin sneered, "There are some female figures that . . . seem to condemn this man's brain to the limbo of artistic degeneration." Stieglitz reprinted their reviews in *Camera Work* along with Charles Caffin's thoughts on the artist: "This is not the ocular but the mental impression that he is intent on rendering," Caffin reflected.

That winter, the Camera Club issued Stieglitz with a different kind of challenge. Its membership had declined after he formed the Photo-Secession; the club was almost bankrupt; the trustees blamed him for this situation and asked him to resign. When he refused, they expelled him and told him to remove his belongings. *The New York Times* publicized the case; Stieglitz brought suit against the club, then tendered his resignation when the trustees offered to reinstate him.

Stieglitz told Agnes Ernst, an attractive young journalist who interviewed him at this time, that he was ready to set out on the search for ultimate truth. Theories about art and life were all too narrow, he insisted: They lacked "that perfect freedom which we are looking for." Warming to her presence, he continued: "If only people are taught to appreciate the beautiful side of their daily existence, . . . they must gradually approach this ideal." Some months later, Ernst wrote to Stieglitz from Paris, where she had gone at his urging: "I feel almost like an apostle, and every time a *Camera Work* comes, I wave it like a red flag in the face of my friends."

But some of his usual supporters were losing faith. Once Stieglitz began showing nonphotographic art, several Secessionists resigned. That winter, when the gallery's lease was about to expire, Stieglitz concluded that he could not maintain both 291 and *Camera Work*. Once he decided not to renew the lease, Steichen stripped the walls and packed up the contents. A few days after the close of the Matisse show, a tailor moved into the rooms where thousands of Americans had been introduced to modern art.

Then a "miracle" occurred—in the guise of a patron, the French-born, Harvard-educated Paul Haviland, who represented his family firm in the United States. The young man had made repeated visits to the gallery

during the Rodin show. On learning that it was to close, he signed a three-year lease for the room across the hall and offered it to Stieglitz, who was unsure whether to continue in this reduced space even though Haviland proposed to redecorate to his specifications.

Stieglitz retreated to Lake George to ponder the future. A thought came to him: "Why not continue the 'work' in one room? Why not turn that room virtually into a facsimile of the main older room, so that when people came . . . they would feel at home?" On his return to Manhattan, his friend J. B. Kerfoot discussed the need for support with some photography buffs, including George Dupont Pratt of Standard Oil and Herbert French of Proctor & Gamble, who agreed to cover the rent. Months later, after the death of his father in 1909, Stieglitz began drawing on his inheritance to cover the other costs of running 291 and *Camera Work:* "I could not let the idea of money get in the way of doing work properly."

The gallery would still be known as 291, although it was housed at 293 Fifth Avenue, the common wall having been removed to install the elevator that served both buildings. In the new scheme, visitors stepping into the top-floor hallway encountered one exceptional print or drawing, placed there to whet their appetites for the main room. Stieglitz worked in a small room at the back whenever the occupant, a decorator, was away. When visitors arrived, he rushed into the gallery, where a suspended scrim diffused the sun coming through the skylight. "He was always there, talking, talking, talking, talking in parables, arguing, explaining," Steichen recalled.

Although the talk went on nonstop, Haviland thought of the gallery as "a quiet nook in a city of conflict." In the next phase of 291's existence, the Limoges heir became Stieglitz's collaborator and learned photography under his guidance. Stieglitz published Haviland's essays and images in *Camera Work* and made him an editor in 1910; his portrait of the well-dressed Frenchman shows his appreciation of his sensibility. With Steichen scouting for "howlers" in Paris and Haviland as second in command, Stieglitz had the support he had long desired.

· · ·

The gallery would continue to "champion modern tendencies," Haviland wrote in *Camera Work,* "as an attitude toward life." To those who complained that it no longer served the Photo-Secession, Stieglitz replied that showing other forms of art would stimulate photographers and non-

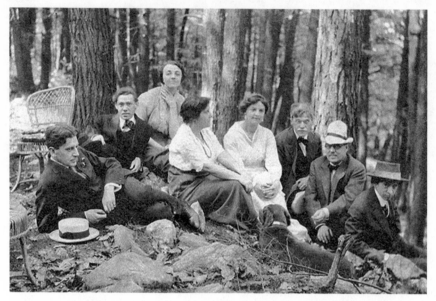

A 291 picnic at Mount Kisco, 1912. Left to right: Paul Haviland,
Abraham Walkowitz, Katharine Rhoades, Emmy Stieglitz,
Agnes Ernst, Alfred Stieglitz, J. B. Kerfoot, and John Marin

photographers alike by stirring up exchanges that transcended the limits
of their training.

That spring, the gallery took the unusual step of showing work by
the Americans Alfred Maurer and John Marin, both of whom belonged
to the expatriate group recently founded by Steichen—the New Soci-
ety of American Artists in Paris. Before sending their oils to New York,
Steichen told Stieglitz that Maurer's landscapes would be this season's
"howlers." Stieglitz contrasted the two artists' temperaments by grouping
the vivid Maurers in rows on one wall and the delicate Marins in a line
on another. "Marin's watercolors sang their quiet song while the Maur-
ers seemed like instruments of music run riot," he recalled; as expected,
the critics denounced Maurer's Fauvist palette and praised Marin's har-
monies. From then on, Stieglitz displayed artworks to encourage dia-
logue among them.

He was also concerned with the timing of new shows. To follow the
Maurer-Marin exhibition Stieglitz decided to feature Steichen in April
and Japanese prints in May. One day, a friend brought the Maine artist
Marsden Hartley to the gallery because he felt that his visionary qual-
ity would intrigue Stieglitz. He decided to squeeze in a ten-day show of

Hartley's intensely rendered mountainscapes, but despite its favorable reception, nothing sold. Still, Hartley was touched by his welcome to 291—"the largest small room of its kind in the world."

Over the next few years, the gallery would introduce art by Americans and Europeans alike. In 1909, Steichen suggested another show of work by the members of the New Society of American Artists. Stieglitz reshaped this idea to present nine "Younger American Painters," including Steichen, Maurer, Marin, Hartley, and two men new to the gallery, Max Weber and Arthur Dove. All were working "toward the realization of a new artistic ideal," Haviland wrote. They shared "a departure from realistic representation, the aim toward color composition, the vitality of their work, and the cheerful key in which their canvases are painted."

When the "Younger Americans" show opened in 1910, the *Times'* critic claimed not to understand their aim—"unless it is to make color and pattern do all the work." Art of this kind upset "all our Western conceptions of a picture." Surprisingly, following James Townsend's quip that some of the nine were "vivisectionists," he told readers of *American Art News* that the exhibit was "weirdly interesting."

About this time, energized by the critics' grudging recognition of 291, Stieglitz returned to photography. Max Weber (who slept on the couch in the gallery's back room) accompanied him on strolls around the city: Weber is the small figure observing the scene in Stieglitz's *Old and New York*, which treats the Vanderbilt Hotel, then under construction, as a geometric grid behind Fifth Avenue's brownstones. Over the summer, Stieglitz photographed the harbor from the deck of a ferryboat. This image, *City of Ambition*, can be seen as a graphic pattern in which the smoke billowing from the smokestacks forms a contrast to the distant buildings, but also as an image of "ruthless materialism . . . a statement about why advanced art found such a cold reception in New York."

For some time, Stieglitz had been choosing prints for the International Exhibition of Pictorial Photography in Buffalo that fall, an event that would publicize 291's defense of photography. Laboring to assemble a history of the art, he planned sections for old masters (including himself), moderns like Steichen, and a few Secessionists. Weber, White, and Haviland accompanied him to Buffalo to hang the show in the Albright Gallery, modernizing its decor with scrims to lower the ceilings and burlap wall coverings in the style of those at 291.

"No show was ever better hung," *American Photography* conceded—although the magazine's critic could not resist calling Stieglitz the "Napoleon of pictorial photography." Such praise only confirmed him in

his views. He told a friend, "Even Mrs. Stieglitz who saw it finally realized that something *has happened*. . . . It does mean one gigantic sacrifice, but everything lasting probably means that."

To some colleagues, the Buffalo exhibition seemed like a betrayal. Over the next few years Käsebier, White, and Weber would all fall out with Stieglitz. In a retrospective account of these years, he wrote serenely, "Just as the Photo-Secession had begun without formality so now, in the same manner, it gradually came to an end." At the time, he was more prickly in a letter to a British friend: "I see none of the photographers . . . I don't miss them. Not because they are not nice fellows but because they have not developed mentally but have stood still during the past six or seven years."

· · ·

On a given morning, a visitor to 291 might encounter the new "fellows"—those who, in Stieglitz's view, were moving forward. The group arrived late, sat around the coal stove to discuss art, poetry, philosophy, and politics, then accompanied him to lunch at the Holland House. Regulars included Steichen, Haviland, Hartley, Marin, the journalists Benjamin De Casseres and Sadakichi Hartmann (who was back in Stieglitz's good graces), Weber (before he fell out of them), Caffin, Kerfoot, and the poet Alfred Kreymborg. Stieglitz had created a space where all were welcome, Kreymborg thought—provided they upheld the group spirit.

Other "experimenters" in the arts found their way to the gallery. In 1909, Stieglitz showed drawings of New Yorkers by the caricaturist Marius de Zayas, a show that, due to its acerbic spirit, failed to impress the critics. In 1910, he introduced Rousseau, and in 1911, Cézanne and Picasso—the season's "red rag," as Steichen foresaw. With Steichen's help and that of Picasso's friend Gertrude Stein, Picasso chose eighty-three of his drawings. Stieglitz bought an abstract nude because he could not, at first, "see" it: He came to think of it as a Bach fugue. Many art lovers dismissed Picasso as a madman. The *Globe* proclaimed, "The display is the most extraordinary combination of extravagance and absurdity that New York has been afflicted with."

Despite (or indeed because of) such responses, the past year had been "the most vital" of his career, Stieglitz told Hartmann, though he had taken few photographs. "I realize," he added, "that in sacrificing my own photography I have gained something I could have never possessed

in any other way"—an understanding of advanced art. Although he was out of step with the country, he did not feel hopeless. The reason for his optimism? Things were about to change: "We stand before the door of a new social era."

By then, some 291 regulars looked to Stieglitz as a kind of prophet, likening his vision of the new era to the liberal sentiments being voiced in response to recent events like the Triangle Shirtwaist fire and the repression of striking unionists. Of this time, Hutchins Hapgood recalled, "Much of the expression of those explosive days was the same, whether in art, literature, labor expansion, or sexual experience." As critics were quick to point out, the 291 group were, in their way, "revolutionists."

Stieglitz believed that his mission was to teach Americans to seek vitality in art as in life. His vehicle in this crusade had been photography, but as the last twenty years had shown, not just any photography—the camera used as a means of liberation from outworn ways of "seeing." Like other proselytizers, he was intolerant of nonbelievers, especially colleagues who failed to embrace the gospel laid out in *Camera Work.*

A century later, it may seem exaggerated to invoke the language of religious zeal in this context. But we have only to think back to the next modernist campaign, the 1913 Armory Show, to grasp how deeply "the new spirit"—the show's motto—disturbed those who preferred the status quo. In 1911, a new group, the Association of American Painters and Sculptors, formed to plan the vast International Exhibition of Modern Art, which has long been known for its site, the 69th Regiment Armory. After Arthur Davies, the group's president, turned to Stieglitz for help, he agreed to lend works from his collection and urge *his* artists, Marin, Maurer, and Hartley, to take part. He also served as an honorary vice president, along with Renoir, Monet, Augustus John, and collectors like Isabella Stewart Gardner and Hapgood's friend Mabel Dodge.

In the meantime, Stieglitz devoted the gallery's 1912 season to Dove's pastels, Matisse's sculpture and drawings, and a show of artwork by children, the first of its kind. Matisse still looked grotesque to most New Yorkers, and the thought that children might paint as well as the so-called moderns gave critics a field day. Yet the tide was beginning to turn. Praising 291—"this celebrated nursery of contemporary art"—the *Times* enthused, "Stieglitz's courage, disinterestedness, and intelligence have placed New York almost abreast of Paris."

To emphasize their independence of mind, the Armory Show's organizers chose as their emblem the pine tree of the American Revolutionary War flag, which appeared on posters, flyers, and campaign badges.

Alfred Stieglitz, photograph of Brancusi exhibition at 291, 1914

In the weeks leading up to the opening, reporters rushed to interview Stieglitz as the only one, until then, to have shown Europe's "wild men." Despite his misgivings about the size of the show, he urged New Yorkers to attend: "You will see there stranger things than you ever dreamed were on land or sea—and you'll hear a battle cry of freedom." He also offered advice to the bewildered: "Don't adopt the enemy's impudent device of plastering these emancipated artists and their work with labels. . . . If a name is necessary in writing about these live ones, call them 'Revitalizers.'"

When the show opened, it was clear that one man's revitalizers could be another's revolutionaries. Making their way through the American sculpture at the entrance, visitors noted the pine trees arranged around the hall. Most strolled along the central promenade, where French art hung in chronological order, as if leading inevitably to the controversial Gallery H, which gave pride of place to Matisse. (The distortions of Matisse's *Blue Nude* often provoked viewers' ire.) Turning left into Gallery I, they joined the mob in front of Duchamp's *Nude Descending a*

Staircase, No. 2—which soon became known as "an explosion in a shingle factory." Since the layout made it impossible to return to the galleries where American paintings were hung, some felt that the Europeans were featured at the expense of artists like Maurer, Marin, Hartley, and Weber, whose work was in the outer rooms.

To many, it seemed as if a bomb had dropped—as if American art had suddenly been made to seem insular. Stuart Davis, whose Ashcan-style watercolors recalled his illustrations for *The Masses,* compared the Big Show to "a masochistic reception whereat the native hosts are trampled and stomped by the European guests." To others, its explosive charge was beneficial. "It set off a blast of dynamite in a cramped space—it blew everything wide open," Kenneth Miller exulted to Rockwell Kent.

Although photography had been excluded, the Big Show was a vindication for Stieglitz. "People are beginning to actually realize that something has happened," he told a friend, "that '291' is not only a 'little exhibition room' where 'friends' meet." He planned several exhibitions to underscore his role in bringing modern art to New York. The first, just before the opening of the Armory Show, featured Marin's watercolors, including recent cityscapes. The critics noted his lively treatment of Manhattan's newest skyscraper, the Woolworth Building, which seemed to cavort in a variety of styles from representational to abstract.

To Stieglitz, the next show, a retrospective of his work, would be a test of the medium's standing as well as a summing up of his achievements. Haviland spoke for his mentor: "The period during . . . the International Exhibition at the Armory was deemed a proper one to show the relative place and value of photography. No better work for this purpose could have been chosen than that of Alfred Stieglitz. His prints represent the straightest kind of straight photography."

While Haviland did not say that some of the images shown were, in a way, self-portraits, he stressed Stieglitz's choice of New York as his subject. Like Marin's, Stieglitz's cityscapes required an adjustment in perspective. *Two Towers, New York* (1911) showed Madison Square Garden and the Metropolitan Life Building (then the tallest in the world) behind the foreground of snow-covered streets where small figures struggle by. Such images read as "modern" through their emphasis on the skyline while playing with the city dweller's sense of scale, which alters as he turns a corner.

Having feared that his work might suffer by comparison with the Big Show, Stieglitz felt vindicated by the critics. His retrospective was "one of the significant events of the art season" (Samuel Swift, the *Sun*); his

prints "unsurpassable" (Edgar Chamberlin, *New York Mail*). His status was secure, Royal Cortissoz wrote in the *Tribune:* "Visitors at the Armory, when they are studying Matisse and the rest, may well recall that it was in the Photo-Secession Gallery that so many of the 'revolutionaries' were first introduced. . . . Mr. Stieglitz has been an exemplary pioneer."

His foreignness having been naturalized, Stieglitz could take his place among the right sort of revolutionaries—those deemed unassailably American.

The Direct Expression of Today

1914–1917

By 1914, Stieglitz was no longer New York's only champion of modern art. After the success of the Armory Show, others opened galleries to show new American artists. But unlike them, he saw art as a spiritual matter rather than as a commodity. It is at about this time that he decided to show those native artists in whom he believed—"because one's own children must come first."

The outbreak of war in Europe that summer further unsettled Stieglitz's thoughts about the links between art and culture. The country's move toward a violently anti-German stance was hard for him to bear. "Colleagues tried to prove to me that Beethoven was no German," he recalled; "that all the cruelty in the world came from Germany and that every Frenchman and Englishman was a saint. I was truly sick at heart."

That year, subscriptions to *Camera Work* declined, and some supporters distanced themselves. To reassure himself that his struggles had been worthwhile, Stieglitz planned a special issue of the magazine on the question "What is '291'?" That fall, he told Caffin that he would seek answers from "twenty or thirty people, men and women, of different walks of life, from different parts of the country, some in Europe."

Steichen returned from France in November, to find the gallery in the doldrums despite a groundbreaking display of African carvings. The wall coverings were dusty, he noted: "There was a dust-covered atmosphere about the whole place." Stieglitz agreed to let him brighten it up with colored papers in abstract shapes as a backdrop for the sculptures. But Steichen was sure that with a war on, there would be little support for the arts. Moreover, he and Stieglitz no longer saw eye-to-eye. Steichen wanted to start a new, forward-looking arts organization, but Stieglitz was focused on the past, as demonstrated by the special issue of *Camera Work*.

Stieglitz published all sixty-eight of the replies he received without

comment in January 1915. The financier Eugene Meyer (who had married Agnes Ernst) repeated what many had said before: 291 was "an oasis of real freedom." Man Ray, a frequent caller, said of the gallery, "A personality lives through it all." To Hodge Kirnon, the elevator man, 291 inspired "those who were daring enough to be intrepid." But not all replies were admiring. One critic said that some exhibitions amounted to "a tearing down of the old faith . . . without substituting anything in its place."

The most challenging response came from Steichen. In his view, the gallery was marking time: The special issue of *Camera Work* was a way of avoiding engagement with the European conflict. Yet if 291, in the person of its "despot," would accept "the necessity of making of itself a vast force instead of a local one," it might still choose to pursue a civilizing mission rather than a local one.

Others close to Stieglitz also believed that 291 was in a rut. Haviland, de Zayas, and Agnes Meyer hoped to revive the spirit of *Camera Work* in a new magazine, to be called—in Alfred's honor—*291*. In its pages they would deploy the latest experiments in design to champion the aesthetic that he had introduced to the world, an approach that would soon be known as New York Dada. De Zayas would run the gallery, Francis Picabia, who was spending the war years in New York, would be an adviser, Agnes Meyer a major supporter, and Katharine Rhoades, the statuesque artist whose work Stieglitz was showing at 291, would help with the layout. He agreed to the plan, though it was not the sort of engagement proposed by Steichen.

After the sinking of the *Lusitania* in 1915, the strain between the two men deepened. Steichen argued for intervention in support of France, while Stieglitz insisted that the United States should stay out of the war. "Close friends seemed to fall by the wayside," he recalled. "I could not turn 291 into a political institution. . . . The work going on at the gallery, I felt, was universal." Steichen did not, but he accepted the truce that allowed 291 to keep going.

· · ·

"What are nations but a series of families," Stieglitz asked a friend at this time. "Is there not this constant war: this desire to destroy: brother and brother, father and son, husband and wife, etc., etc." Rather than "gas[s]ing" about ideals, people should look to themselves. He did not, however, take his own advice. Quarrels with Emmy over the importance

of his pursuits and the triviality of hers, as he saw them, made him feel trapped. For some time, he had been indulging in a flirtation with Rhoades, taking her portrait, writing to her in secret, and publishing her poetry in the July 1914 issue of *Camera Work* (where it suffered by comparison with that of Mina Loy).

In the new year, he grew despondent over what he saw as the defection of his entourage. Haviland's family summoned him to France; a so-called homage to Stieglitz in 291 contained a sharp critique; Agnes Meyer announced plans for an exhibition space ten blocks north of his own, to be called the Modern Gallery. He accepted the fait accompli but brooded about his desertion by his allies. Still, Stieglitz and Steichen continued to work together despite their differences. "Disagreement seemed to enhance rather than diminish their personal regard for each other in those years," Steichen's biographer writes. The strains in their private lives brought them closer when Steichen's wife left him. Both called on Stieglitz as their confessor; the Stieglitz clan offered support. It was a distressing time, Stieglitz told the same friend to whom he had posed his earlier questions: "Tragedies are happening, or about to happen, unpreventable ones."

One of the few bright spots for Stieglitz that year was his meeting with Paul Strand. A sporadic visitor to the gallery, Strand showed Stieglitz his portfolio in the winter of 1915. After looking closely at the young man's prints, Stieglitz gave him what Strand called "the best criticism that I have ever had from anybody." Examining his pictorialist print of a summer house (*Bay Shore, Long Island, New York*), Stieglitz said that the soft-focus lens brought everything together "in a kind of agreeable blur." But it also made each part of the picture look the same: "Grass looks like water; water looks like it has the same quality as the bark of the tree; and you've lost all the elements that distinguish one form . . . from another."

After taking Stieglitz's advice to heart over the next months, Strand was astounded by the older man's reaction on his return to 291 that summer with his latest work, including some sharply focused prints of New York that captured the city's dynamism. "You've done something new for photography," Stieglitz declared. "I'll give you an exhibition and I want to put them in *Camera Work*." He added, " '291' is your place too, you belong here. Come in whenever you want." It would be hard to overestimate the importance of that day for the normally reserved young man: "It was like having the world handed to you on a platter."

It was also a significant day for Stieglitz. For some time he had been despondent about the "lost" members of his entourage and the accusa-

tion by de Zayas and Picabia that he was failing to nourish the next
generation of American artists. Strand was twenty-four and Stieglitz
fifty-one when they met again in the summer of 1915. Sensing the poten-
tial in Strand's work, Stieglitz welcomed him as the man most likely to
follow in his footsteps, the first and most talented of 291's "children."

. . .

Paul Strand was born in 1890 into a middle-class Jewish family that had
lived in New York since the 1840s. His parents, Jacob and Matilda Stran-
sky, had changed their name to Strand when their first and only child
was born; three years later, they settled with Paul's maternal grandpar-
ents and aunt in the brownstone on West Eighty-third Street where he
would live for the next forty years. Strand never forgot that the building

Alfred Stieglitz, *Paul Strand,* 1917

was owned by his uncle, Nathaniel Myers, a wealthy lawyer who paid for their summer vacations and other advantages, such as cameras. The Strands were, he reflected, "not a very well-to-do family" who lived rent-free. "The rest was up to my father and my little aunt who taught kindergarten."

Growing up in a household dominated by women, Paul was especially fond of his father—who supported his artistic leanings, although it was unclear how he would earn a living—but Jacob was often away on business (he sold French clocks and German enamelware). Paul's mother had not wanted a child, he believed; she became an invalid after his birth. He was closer to his aunts, Frances Arnstein, who was active in the reform-era kindergarten movement, and Josie Arnstein Myers, who had no children of her own.

The family gathered on Sundays at the Myerses' house but rarely attended synagogue. They held humanistic views emphasizing social progress, a deethnicized form of Judaism shared by many German-Jewish New Yorkers who saw in the Ethical Culture Movement an alternative to Orthodoxy. Paul attended public school and played with the local boys until his father learned that their pastimes included breaking windows. He was transferred to the Ethical Culture School on Sixty-third Street and Central Park West, where he would, presumably, find a better class of playmate.

ECS, as the school was called, had been founded in 1878 as a society for workingmen. When Paul enrolled in 1904, the student body was mainly middle-class; the curriculum included courses in the crafts (printing, carpentry, and soon, photography) as well as more traditional subjects. The teaching staff included figures from the art world. In his teens, Paul studied with both Charles Caffin and Lewis Hine, who emphasized the use of the camera as a tool of social reform. Hine's camera club became Paul's refuge. His dream of being a photographer crystallized when Hine took its members to 291 and invited Stieglitz to show at the school. (Strand wrote in the ECS alumni bulletin, "The exhibition by Alfred Stieglitz held at the School, and Mr. Hine's class in photography were the start in directing my attention to photography as a profession.")

Despite these auspicious beginnings, Strand believed that his development had been impeded by his family's finances: "I had to, myself, face the problem of being a wage earner as soon as I left high school." After graduating in 1909, he worked for his father and spent his spare hours at the Camera Club, which he joined the year that the trust-

ees moved to expel Stieglitz. Strand espoused the pictorialist aesthetic in vogue there rather than the reform spirit of Hine, who had already begun work as an investigative photographer documenting the abuse of child laborers.

In those years, Strand adopted the soft-focus lens and preindustrial-ist subjects favored by Stieglitz's former colleagues Käsebier and White. Under their tutelage, he became an adept practitioner of the craft, softening his prints by painting them with gum bichromate. His portrait of Matilda Strand was displayed in the club's exhibition in 1910; his *Garden of Dreams,* taken at Versailles during his trip to Europe in 1911, won prizes at the club's annual show. A critic has written, "The picture filled all the unstated requirements for a prizewinner on this circuit: it was handsome and related to great art (Corot, Versailles) and quite empty (while seeming not to be) . . ."

The young man was puzzled by the work he saw at the Armory Show. "I had a feeling that something very important was happening, and I wanted to know more about it," he recalled. Studying Cézanne, Picasso, Picabia, and Duchamp, Strand decided that they had turned their backs on representation in order to experiment, to perform a kind of research. "I like the word research," he said years later. "I think the artist and the scientist are related." What was more, hostility to these progressive artists came from the same source as the art establishment's resistance to photography: "There was a fight going on for the integrity of a new medium and its right to exist, the right of the photographer to be an artist, as well as the right of Picasso and other artists to do the kind of work they were doing." He felt ready to join the cause.

In these years, Strand earned a modest income by taking pictures on college campuses to sell as souvenirs, a practice he continued on his travels around the country in 1915. The scheme was not profitable, but it allowed him to photograph sites like the French Quarter in New Orleans, the Grand Canyon, and the Texas plains. Los Angeles was "provincial," he told his parents: "intensely American, having little distinction and culture." From California, he wrote to Stieglitz: "Everything is extremely American out here—You know what that means." But the trip produced the work that gave him the confidence to return to 291 that summer—when Stieglitz invited him to make the gallery his home.

Strand joined the 291 group at the moment when Stieglitz's relations with Meyer and de Zayas were unraveling. In 1916, Stieglitz turned to those who would replace them—painter and photographer Charles Sheeler, artists Morton Schamberg, Arthur Dove, William Zorach, and

Abraham Walkowitz, who banded together with Steichen, Hartley, and Marin. Stieglitz began a set of portraits of his entourage posed in the gallery, starting with a photograph of Hartley looking out from under his large black hat. This series, which would come to include Marin, Walkowitz, Zorach, and Strand, a regular wrote, revealed "the skyscraper civilization as it lies in the struggling psyche of the male, men caught and held and torn in the fearful psychic conflicts of our day."

In this company, Strand became a defender of the faith that artists could initiate social change by offering new ways to see the world. Despite his habitual reserve, he took part in passionate debates begun at 291 and continued on noontime tramps down Fifth Avenue to Stieglitz's new round table at the Prince George Hotel. Passersby stared at them: "Steichen, lanky and boyish, Walkowitz, diminutive and dignified . . . Marin with his long lean face and roving dark eyes, Hartley, with the aloofness of Hamlet, the stocky mercurial Strand . . . and bringing up the rear, the nervous dynamo Stieglitz." The group became Strand's surrogate family.

Within a short time, the young man also endorsed Stieglitz's idea of photography, as a means to embrace modern life. He may have sensed

Paul Strand, *Fifth Avenue at 42nd Street, New York,* 1915

that Stieglitz was speaking personally when he dismissed pictorial-
ism in favor of the more "masculine" works being produced under his
aegis. The limits of pictorialism, Strand argued the following year in
language echoing his mentor's, resulted from some practitioners' lack of
respect for their craft. Most Americans refused to accept photography
as a native form—one developed "without the outside influence of Paris
art-schools or their dilute offspring." Yet just as their countrymen had
built skyscrapers without foreign precedent, so Stieglitz had created "a
living photographic tradition." (Strand's essay "Photography" was pub-
lished in *Seven Arts* magazine, then in the final issue of *Camera Work*.)

Like Stieglitz, Strand wanted to capture the life of the city in motion.
He took some photographs close to street level, as if immersed in its ebb
and flow: *Fifth Avenue at 42nd Street, New York* illustrates Strand's wish
to depict the formal patterns he saw in the streets in tension with their
chaotic energy. More often, Strand photographed from the upper stories
of tall buildings that offered secure roosts from which to survey the
scene. *City Hall Park, New York,* shot from a courthouse window, caught
people moving through the park below in a composition shaped by the
dark curves repeated in the pathway, trees, and shadows—a bird's-eye
view that subsumes individuals into a swirling pattern.

Similarly, in *Wall Street,* photographed from a high vantage point
across the street from the J. P. Morgan building, people rushing to work
became part of a larger design, their shapes dwarfed by the dark rect-
angles of the site's imposing facade. When he took this picture, Strand
had been absorbed in "watching people walk by those huge . . . rather
sinister windows," he recalled: Rather than using his camera to critique
capitalism, he was attempting to take a picture of movement that was
"abstract and controlled."

Yet *Wall Street*'s original title, *Pedestrians Raked by Morning Light
in a Canyon of Commerce,* blends a concern for abstraction with the
progressive aims of the 291 group. However mixed Strand's motivation
at the time, his photograph stands as a statement about industrial-
ism's power to overshadow human beings. As Stieglitz's latest discov-
ery, Strand was fulfilling his hopes: "In whatever he does," his mentor
wrote, "there is applied intelligence." The two men could not have been
more dissimilar—Stieglitz talked nonstop and dominated any gathering,
while Strand's guardedness caused him to hold back—yet they shared
an unswerving commitment to their chosen medium.

· · ·

Stieglitz again fell prey to depression in the winter of 1916, when anti-German sentiment dominated public opinion. It was some consolation to recognize in Strand someone like himself, though less outgoing and less fortunate in worldly terms. Their German-Jewish backgrounds strengthened the ties between them: The Strands had lived near the Stieglitzes before moving across town; Paul had studied art with Alfred's friend Caffin. Seeing in the young man his hope of continuity, he decided that Strand's would be the first exhibition of photographs at the gallery since his own in 1913. None had been hung there since then, he wrote, "because '291' knew of no work outside of Paul Strand's which was worthy."

Coming less than ten years after his visit to 291 as a schoolboy, Strand's one-man show, "Photographs of New York and Other Places," fulfilled his dream. Stieglitz timed the opening to coincide with the run of the nearby Forum Exhibition of Modern American Painters—the better to promote his protégé as a "modern." On opening night, visitors wondered what to expect. Strand's prints were striking, if not particularly innovative (*Wall Street* may not have been among them), but visitors were struck by the fact that his New York pictures were shown beside scenes from Europe—implying the photographer's wish to treat native subjects with the same respect as foreign ones.

The exhibition featured Strand's early work along with more graphic photographs like *City Hall Park*. His pictorialist print *Maid of the Mist, Niagara Falls* was much admired. A critic called it a "silvery picture of surpassing loveliness"; another said that it had won him "distinction among American pictorial photographers." Caffin praised his former student's skill as a "straight" photographer and called *City Hall Park* "a fragment of the kaleidoscopic variety of appearances and movements that make up our city life." Stieglitz informed a friend that the show was a major event: Strand's prints were "straight all the way through, in vision, in work and in feeling."

Strand spent the summer of 1916 in Connecticut with his family, devoting himself to three months of "research"—his self-directed attempt to adapt Cubist techniques to his craft. Like Braque and Picasso, he selected household items—kitchen supplies and crockery—as his subjects. Turning a group of white porcelain bowls this way and that, he analyzed their depths and surfaces, then photographed them as related shapes. This series, including arrangements of bowls with pieces of fruit, became his equivalents of Cubist still lifes—something that had never before been tried in photography. He then took his experiments

outside. *The White Fence,* a graphic photograph taken in Connecticut, simultaneously directs and blocks our gaze with its alignment of nine fence pickets standing like sentries in the foreground.

Looking back on that summer, Strand said that this group of semi-abstractions marked a turning point: "I learned how you build a picture, what a picture consists of, how shapes are related to each other, how spaces are filled, how the whole must have a kind of unity." He told Stieglitz, "It has been a summer of work, and I think I shall have some things to show you." Stieglitz replied that he would feature some of Strand's shots, including *City Hall Park* and *Wall Street,* in the next *Camera Work:* "It promises to be an unusually lively number." In the introduction, he gave Strand high praise as a "new worker" in photography: "For ten years Strand quietly had been studying, constantly experimenting, keeping in close touch with all that is related to life in its fullest aspect."

That autumn, Strand turned from geometric forms to portraits of people on the streets of New York. Unlike bowls and fence posts, such subjects were not easily controlled, nor could he let them know that he was taking pictures of them. He solved the problem by using a dummy lens and a viewfinder prism that seemed to focus his camera in another direction while he photographed at a right angle: That way, his subjects, unaware of the process, retained their natural expressions. But unlike Hine, he photographed them not so much to document their impoverishment as to capture them as striking subjects.

The best-known of this series, *Blind Woman,* captures a sightless newspaper vendor dressed in black. Many years later, Strand said that the woman, who had a white sign around her neck that said BLIND, was one of those "whom life had battered into some sort of extraordinary interest and, in a way, nobility." At the time, he recalled, he took her portrait not so much in the spirit of social reform but because she was the focus of a composition that filled the frame with energy.

The clarity of Strand's new prints encouraged Stieglitz to sharpen the focus of his own. That fall, he described his work ("just the straight goods") to his friend R. Child Bayley, the editor of *Amateur Photographer & Photography,* in almost the same terms he had used for Strand. He was also taking pictures of his entourage. While Strand achieved his striking pictures by catching his subjects off guard, Stieglitz revealed his sitters' natures by drawing on their trust. Given the older man's self-assurance and the younger one's caution, their differences were largely temperamental. More comfortable at a distance from those he portrayed, Strand

struggled to allow emotion into form; Stieglitz took portraits of friends to express their shared purpose.

By 1917, it was clear to the 291 group that Strand saw Stieglitz as his mentor and Stieglitz looked to Strand as his heir apparent. Less assertive than Steichen and more purely American than Haviland, Strand was the disciple Stieglitz had dreamed of finding; what was more, his technical skills matched—some said surpassed—Stieglitz's own. In time, Strand would see the older man as the figure against whom he would have to define himself, while Stieglitz would insist on taking credit for Strand as "the first photographer of great promise to have received his visual education at the Photo-Secession Galleries." Eventually, the two would become rivals in their work and in their personal lives. But that spring, as Stieglitz prepared to run more of Strand's prints in the last issue of *Camera Work,* he was forthright in his praise: "The eleven photographs in this number represent the real Paul Strand. The man who has actually done something from within. The photographer who has added something to what has gone before. The work is brutally direct. Devoid of all flim-flam; devoid of trickery and of any 'ism.'"

It is challenging, given their different temperaments, to grasp the significance of Strand's presence in Stieglitz's life just then, yet it is clear that in his view the young man's boldness of vision seemed to indicate a new direction in photography—with images that were "brutally direct" rather than soft, hazy, or pictorial. At this point, when Stieglitz tended to see his own work as proceeding from his generative powers, Strand's potent new images would revitalize their art. They were, Stieglitz declared, "the direct expression of today."

A Woman on Paper

1915–1916

Georgia O'Keeffe went to 291 for a last look in June 1915, after a term at Columbia University's Teachers College. That year, she and her classmates often inspected the exhibits—Marin (she was charmed by his Woolworth Building series), Picasso, and Braque (neither said much to her). What she loved about the place, she told her friend Anita Politzer, was the atmosphere.

When O'Keeffe and Stieglitz began corresponding a year later, she wrote that the rooms themselves had inspired her: "I went in a year ago after you had stripped them—and I just thought things on them." By then, the works embodying her thoughts—the charcoal drawings she called *Specials*—had been on display at 291 for six weeks. Stieglitz wanted one for himself. He could have the lot, she replied: "They are all as much yours as mine."

Stieglitz liked to tell the tale of his first meeting with O'Keeffe as a turning point. A century later, his discovery of the artist who became his protégée, muse, and wife has become a legend. The story begins on January 1, 1916, his fifty-second birthday. That evening, when Anita showed up at 291 with a mailing tube containing Georgia's charcoals, she found him in low spirits. "Feeling more dead than alive," he recalled, he looked at a drawing: "I studied the second and the third, exclaiming, 'Finally a woman on paper. A woman gives herself.'"

That night, Anita re-created the scene in a letter to Georgia, who was teaching art at Columbia College, a Methodist women's school in South Carolina. Stieglitz declared, "She's an unusual woman—She's broad minded, She's bigger than most women, but she's got the sensitive emotion—I'd know she was a woman—Look at that line." Anita was to tell Georgia that he said her drawings were "the purest, finest, sincerest things" that had come to 291 for some time.

Women were as capable of creative expression as men, Stieglitz

believed, but he had been waiting to meet one whose "line" pulsed with sensuality. What did he see in O'Keeffe's *Specials* that made him claim them as emblems of "Woman unafraid"? They spoke to him in the black, gray, and silvery tones of photography, but in another medium. Her line embodied the tactility he revered; her swirls gave off a sense of movement. "Do you like my music," Georgia asked Anita when she sent her the drawings. "What I wanted to express was a feeling like wonderful music gives me."

To Stieglitz, O'Keeffe's abstractions conjured up "Music—Voices—Singing—Water" along with tides of erotic feeling. At a time when Freudianism held sway in progressive circles, it was inevitable that her biomorphic shapes would be seen as sexual symbols and her *Specials* as feminine—although they gestured beyond conventional notions of "male" and "female." They came alive, Stieglitz wrote, because he saw her in them. He added, "They are as if I saw a part of myself."

· · ·

O'Keeffe was astounded to receive these words from Stieglitz. A meeting of the minds seemed unlikely for many reasons—the age difference (she was twenty-eight; he was fifty-two), the disparity in reputations (she was unknown; he was the impresario of modern art), their temperaments (she loved the outdoors; he was a city person), their cosmopolitanism or lack thereof (she had never left the United States). But it was O'Keeffe's Americanness that attracted Stieglitz at a time when he was on the lookout for innovative art that was homegrown. Coming upon her work a few months after his embrace of Strand, he thought of her as his protégé's female counterpart.

Born in 1887 on a farm in Wisconsin to second-generation immigrants who would produce seven children (she was the eldest of five girls), Georgia had not always been able to explore her passion for art. As a girl, she learned sewing, cookery, and how to keep a kitchen garden, and for a year she attended a Catholic boarding school where the sister who taught art inspired her to think of herself as an artist. (The nuns' habits also gave her an appreciation of black and white as a neat color scheme for an independent woman.)

After the family's move to Williamsburg, Virginia, they supported Georgia's studies at the Art Institute of Chicago (1905–1906) and the New York Art Students League (1907–1908) despite their straitened circumstances. When their finances became precarious, she worked in

Rufus W. Holsinger, *Miss Georgia O'Keeffe*, 1915

Chicago as a commercial artist—drawing designs for embroidery and illustrations for advertisements. On her return to Virginia, she found her parents living apart, her mother, sisters, and brothers having moved to Charlottesville. For the next two years, she abandoned art and took a series of jobs to help support the family.

In time, O'Keeffe obtained a position teaching art at a school for girls in Chatham, Virginia—an experience that showed her that a school-marm's life might offer a single woman a way to maintain her independence. At the end of the term, she had no alternative but to return to Charlottesville: Her mother, who was making ends meet by running a boardinghouse, had contracted tuberculosis. At twenty-five, Georgia was resigned to a future as a talented spinster working in obscurity.

The following year, she enrolled in the University of Virginia's summer art program, where she was introduced to the ideas of Arthur

Wesley Dow. Her instructor, Alon Bement, explained Dow's belief that harmonious design mattered more than representation—an approach in sympathy with both the lingering Art Nouveau aesthetic and the anti-mimetic stance of modernism. Bement hired her as his assistant for the next four summers and recommended her for a teaching job in Amarillo, Texas—"something I'd wanted to do all my life. The Wild West, you see," she said years later. She taught there until 1914, when she enrolled at Columbia to complete the prerequisites for a teaching certificate.

For the next year, Georgia lived in New York in a four-dollar-a-week room while studying under Dow, the head of the art department. She and Anita supplemented classes with trips to the galleries—the Montross, to see Dow's oils of the Grand Canyon, and 291. "I didn't understand some of the things he showed, but it was a new wave, I knew that. It showed you how you could make up your mind about what to paint."

After leaving New York that fall to take up her teaching job in Columbia, South Carolina, she poured her enthusiasm for the "new wave" into her classes. To keep in touch with progressive ways of thinking, she subscribed to *The Masses, Camera Work,* and *291*—the next best thing to visiting the gallery, she told Anita. "Then I hurried down to 291 and saw our friend Stieglitz. . . . It does me good to breathe his air for a little while," Anita replied. After hearing about Georgia's exile in South Carolina, Stieglitz said, "When she gets her money—she'll do Art with it—& if she'll get anywhere—it's worth going to Hell to get there." His remarks made Georgia laugh: "I believe I would rather have Stieglitz like something—anything I have done—than anyone else I know of."

Reading the women's correspondence over these months, one sees that their reverence for Stieglitz did not keep Georgia from telling Anita what she wanted and Anita from coming forward as her agent. "Little did I dream that one day she would bring to me drawings that would mean so much to 291," Stieglitz told O'Keeffe. "Nor did you dream when you did them that they would—or could—ever mean so much to anyone . . ."

. . .

What the drawings meant to Georgia was another matter. Judging by her letters from Columbia, the time spent working on them unsettled her. "I made a crazy thing last week," she told Anita, "like I was feeling—keenly alive—but not much point to it all—Something wonderful about it all—but it looks lost—I am lost you know."

At other times, she was overcome with a sense of plenitude. "Anita—

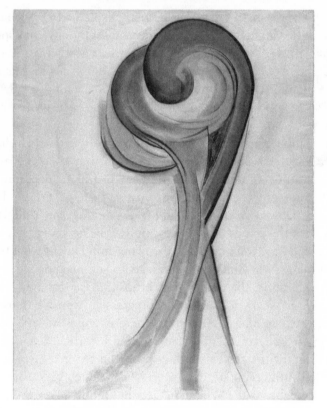

Georgia O'Keeffe, *No. 12 Special*, 1916

do you feel like flowers sometimes?" she asked in a letter describing
the riot of colors in the vases placed around her room. Still, she wor-
ried about how her latest work might be perceived: "I am afraid people
won't understand and . . . afraid they will." Then she turned to the cause
of her concern: Arthur Macmahon, a young political science instructor
from Columbia University whom she had met when both were teach-
ing at the University of Virginia's summer school. They had hiked and
camped in the Smoky Mountains with some like-minded students.
Arthur shared her love of nature and liked to discuss ideas current in
liberal circles.

Since then, Arthur, a man of strict moral principles, had writ-
ten to her often and sent books to stoke her interest in progressive
thought—including Floyd Dell's *Women as World Builders* and *Life and
Youth,* by his friend Randolph Bourne. Sensing the reserve beneath
Arthur's liberalism, Georgia worried that her eagerness might strike him

as forward, even "crazy"—a word that recurs in her letters. Troubled by her emotions, she told Anita that she was closer to being in love than she wanted to be, a state of affairs that muddied her sense of herself. Anita replied that art offered the means to express what one felt: "We're trying to live . . . on paper what we're living in our hearts and heads."

In November, Arthur took a train to South Carolina to spend Thanksgiving with Georgia. They planned more "tramps" in May, when they would share a cabin in the Carolina mountains with his family. The prospect of their reunion moved her to complete the drawings that said on paper what she could not put into words, such as her "crazy" urges. Resisting her wish to spend Christmas with him in New York, she summoned up the capacity for self-control that would often conflict with her emotions: "I want to love as hard as I can and I can't let myself."

But Georgia could not help letting Arthur know that he moved her: "I said something to you in charcoal," she told him in the new year. A few days before, after learning of Stieglitz's response to her *Specials,* Georgia told Anita they were "essentially a woman's feeling." Their surging forms implied strong desires: "There are things we want to say—but saying them is pretty nervy." By then, Georgia could no longer bear her surroundings. "Columbia is a nightmare to me—everything here is deliciously stupid" compared with New York, which held the attractions of 291 and Arthur.

A job offer to be head of the art department at West Texas State Normal College offered a solution. If O'Keeffe would complete the training she had begun at Teachers College, she could start in the fall of 1916 in Canyon, twenty miles south of Amarillo—where, she told Anita, "there is something wonderful about the bigness and the lonelyness and the windyness of it all." But she hesitated because of Arthur. "I want to go—and I don't want to go. . . . Arthur says he will go out soon but the darn fool puts 'soon' a long way off."

In February, after months of restricting her palette to black and white, O'Keeffe began to think in color. Turning to watercolor was like finding her way in the dark. She was cheered by random events—an amusing talk on suffrage by a senator from Colorado, the yellow jonquils, a jazzy "rag" that made her "want to tell all the Methodists to go to Hell." At the end of the month, she quit her job, accepted the Texas offer, and went to New York to complete her certificate.

That spring, she and Arthur were often together. She took him to see new work at the galleries; he introduced her to his mother; their plan to spend May in the mountains may have been revived. Anita's cousin

Aline Pollitzer, with whom she boarded, believed that the young man proposed to Georgia but was rejected. He was, she felt, too straitlaced to share her ardor or her passion for art. Aline admired everything about Georgia—her self-possession, her art, her tailored garments (which she made herself), her lack of interest in other people's opinions. But she could not understand her feelings for Macmahon.

Perhaps still wishing to say things to him, Georgia drew more *Specials*, whose embryonic spirals reveal an awareness of inner landscapes. Over the next few months, working in deep blue watercolors, she created a series of works consisting of pared-down vertical strokes. In one of these, an elegant abstraction called *Blue Lines X,* two strokes stand in the center of the composition, one straight, the other bent like an arm. While many critics (following Stieglitz) would see these lines as emblematic of the sexes, this series can be seen as equivalents of mental states—O'Keeffe's way of "living on paper."

That spring, she also went to 291. It's tempting to think of O'Keeffe gazing at the exhibition of Strand's photographs in March but impossible to know if she saw them. Put off by Hartley's highly charged oils the following month, she was nonetheless drawn to Stieglitz's portrait of the artist in a dark hat and white muffler. Stieglitz hoped to display her work but had not yet decided when to do so. In the crush at the gallery, they were never alone.

Meanwhile, Stieglitz hung the *Specials* in the back room for his own enjoyment. His new finds, Strand and O'Keeffe, had come to 291 just when he was looking for the next generation of kindred spirits. Both embodied in their art an original take on abstraction; at the same time, they seemed to demonstrate ideas about sexual difference to which he subscribed. If Strand's work conveyed a masculine rigor, O'Keeffe's, Sarah Greenough writes, was "expressive not simply of her femininity, but more generally the physical, emotional and even spiritual components of what it meant to be a woman."

In May, Stieglitz decided to exhibit the drawings in which he took such pleasure. On learning that her charcoals were on display at 291, O'Keeffe stormed into the gallery, demanding that he take them down. Stieglitz told her, "You have no more right to withhold those pictures . . . than to withdraw a child from the world." When he asked if she knew where they came from, she retorted, "Do you think I'm a idiot?" He took her to lunch; she consented to leave the drawings where they were.

For the next six weeks, ten of her *Specials* remained at the gallery. No doubt primed by Stieglitz, Henry Tyrrell's review in *The Christian*

Science Monitor introduced the rhetoric that would prevail in future critiques: "Miss O'Keeffe looks within herself and draws with unconscious naïveté what purports to be the innermost unfolding of a girl's being, like the germinating of a flower." Stieglitz developed the theme in his notes for the next *Camera Work*: " '291' had never before seen a woman express herself so frankly on paper." He also ran an appreciation of "the woman pictures" by a writer who had been "startled into admiration of the self-knowledge in them."

O'Keeffe was too distressed to take note of these reviews when they appeared. Her mother died on May 2, and she went to Charlottesville to be with her family. On the train, she poured out her feelings to Arthur: "I wish you would love me very very much for the next few days." Her grief took the form of extreme fatigue: "I have spent most of the time in bed," she told Anita. "I get so tired that I almost feel crazy." Toward the end of June, she told Arthur that she loved him: "Love is great to give—You may give as little in return as you want to—or none at all."

At about the time that Georgia was giving her love to Arthur, she resumed a lively correspondence with her new patron—an exchange that would come to include the twenty-five thousand pages of letters that document the evolution of their relationship: Stieglitz's roles as patron, protector, and confessor; O'Keeffe's shift from protégée to muse to trusted and trusting friend, then lover and wife. Reading this record of their rapport is like listening to a conversation that moves from tactful expressions of sympathy through reassurances of support to a love affair conducted in the language of artistic exchange.

When Stieglitz expressed sympathy for her loss, she thanked him for allowing her to speak freely. Soon she felt able to write to him about Arthur: "Those drawings you have had to grow some way—The man who made me make them—I might better say—that I made them to . . . seems to be part of everything I know." She added, "His life is planned—and he didn't put a woman in the plan—and I have not planned—and need the thing I like— You understand?" Stieglitz did. Wondering if the other man *"saw"* the drawings as he did, he said that men were "just plain stupid." O'Keeffe replied with a defense of men in general ("I think they are all right") and the unnamed one in particular ("I like him because he is rare—feels and thinks too").

From then on, as she recovered her balance, Stieglitz took care to emphasize his detachment. "My only value is that you can talk to me—anytime," he insisted. "I know it's a wonderful comforting restful feeling to feel that there is someone always ready—to understand!" He

hit the right note. "I think letters with such humanness in them have never come to me before," O'Keeffe replied. When the show closed in July, Stieglitz appointed himself the guardian of her drawings. He would have some framed: "I can't bear the thought that they might be soiled—rubbed—for they are not fixed." O'Keeffe replied, "I don't care what you do with them. . . . You are a much better keeper than I am." By then, her health had improved so much that she had gone mountain climbing in the moonlight.

In his role as keeper, Stieglitz sent her his photographs of the newly framed charcoals. "Will the pictures lose any of their freedom?" he asked, teasing Georgia about her own. Her reply blends spirited reports of rock climbing with a playful address to its recipient: "You will probably laugh when I tell you that I like your photographs of my drawings much better than I do the drawings." By then, Georgia had started a set of watercolors—landscapes inspired by the mountains, and abstractions with plumelike shapes in tones recalling the *Blue Lines* series begun in New York.

Before leaving for Texas, she posted a roll of watercolors to Alfred, who teased her by return mail: "You are a careless mother to send your children that way—not even registered!" Then he assured her that her work was "intact," in fact, "safely in my hands," while she made her way west across the country.

· · ·

Canyon was a new town, founded some twenty-five years before O'Keeffe moved there in September 1916. Plunked down in the Panhandle, it took its name from the nearby Palo Duro Canyon. The limitless plains surrounding the town seemed familiar—not disorienting, as in 1912, when O'Keeffe went to teach in Amarillo. But the "educators" who met her on her first day were so narrow-minded that she wanted to "go to you and the Lake," she told Alfred, then added, "but—there is really more exhilaration in the fight here than there could possibly be in leaving it before it's begun."

Georgia won the first round by leaving the room she had been assigned in a colleague's home, where the decor—pink roses—oppressed her. She took refuge in "the only place . . . where the walls wouldn't drive you to drink" before settling in the dormer room of a bungalow owned by the school's registrar. After her request to paint the woodwork black was denied, she placed a length of black cloth in a frame and hung it on the wall.

The new teacher's preference for black mystified the women of Canyon. "Her clothing was all like men's clothing," a student recalled; "she didn't believe in lace, or jabots . . . or ruffles." Black made you look slender, O'Keeffe explained, and floral patterns made you seem large; her low-heeled shoes allowed her to stride with ease across the plains. Despite her queer clothes, the men of Canyon were not immune to the charm of her pale oval face and black waves of hair pinned at the nape of her neck. (Would-be suitors took her for one of those modern women who were said to be easy.) Keeping her opinions to herself, she took comfort in her correspondence and the magazines she received, *The New Republic* (a gift from Arthur) and *The Forerunner,* which called for equality between the sexes and the reform of women's dress.

Georgia's letters abound in comments contrasting the vastness of her surroundings with the small-mindedness of the town. "The Plains sends you greetings," she told Alfred. "It's a great privilege to be given the opportunity to look into a soul like yours," he replied. "I feel it roaming through space." Both looked to nature to express their intimate thoughts. She went outside to read his "sunny letter"; she thanked him for giving her "the quiet dark night."

But Georgia worried that in revealing so much to Alfred, she was betraying her bond with Arthur. She confessed her pique that rather than visit her in September, Arthur had stayed in New York to work on the "stupid" city charter. "I could so easily forget him out here," she told Alfred. Two days later, she wrote that she had been wrong to call his work "stupid"; Alfred replied that while her words had made him smile, he was glad she had changed her mind. As for himself, he said tactfully, "I am not writing as a man to a woman . . . for me you exist primarily as a spirit—as in your work.—And I exist for you as 'Understanding.'"

Meanwhile, invigorated by his time at Lake George, Alfred returned to photography. In September, he took snapshots of himself and Abraham Walkowitz and some frisky views of another guest, Ellen Koeniger, whose wet bathing suit clung to her curves as she dived and swam in the lake. "Photographing always gets my nerves agoing," he told Georgia. "The Lake has been so marvelous," he added. "You have received some of its intensity filtered through me." Hearing about his work moved her to write that she could still "see" his portrait of Hartley: "I remember the shapes in it in such a curious way—and never distinctly enough to be able to put them down." But New York was too distant to see clearly: "There isn't any such place—Anita says there is—but I don't believe it."

What O'Keeffe saw in her mind's eye were the shapes of her surroundings, the plains that came to the edge of town and the striated

canyon that opened up twelve miles to the east. "I wish you could see the landscapes I painted," she told Anita, adding, "My landscapes are always funny and these are not exceptions—Slits in nothingness . . ." That autumn, she returned from descents into the chasm to translate her elation into watercolors, including a set of *Specials* in the fiery hues that made up her new palette. "The plains are very wonderful now—like green gold and yellow gold and red gold—in patches—and the distance blue and pink and lavender strips and spots."

Like the canyon, the boundless land and sky offered new visions. The plains seemed like an ocean, especially at night. "It is absurd the way I love this country . . . and the SKY—Anita you have never seen SKY." It felt blissful to open to the elements, explosions of color at sunset, the radiant night sky. Of the memorable night stroll that inspired the watercolor series entitled *Evening Star,* she recalled, "I had nothing but to walk into nowhere and the wide sunset space with the star." On occasion, she became one with the landscape: "I think all the world has turned into what I'm seeing."

While Georgia yearned to share her new life with Arthur, she sensed that it might be difficult to enter into this contemplative state with the object of her affections present. On her return from a brilliant sunset, she told him that "it would have been nice to be by you . . . but maybe the loneness . . . gave me a chance to see more and know more than I saw." Still, there were times when finding her "loneness" hard to bear, she said things that gave him pause. In October, she told him about her correspondence with Stieglitz and said that the emotions stirred by his letters made her yearn for Arthur.

Increasingly exchanges with Alfred offered the nourishment that Georgia craved. Just as Anita had been her sounding board the year before, Alfred provided emotional sustenance. They wrote to each other of the "humbug" of those around them—Alfred's family, the residents of Canyon. In response to her rapturous letters about the plains, he told her how thrilling it was to immerse himself in the autumn landscape. In October, Alfred sent his favorite book, Goethe's *Faust.* She replied, "It will interest me immensely—because you like it so much." Reading it in the shade of the tumbleweeds, she continued: "I was nearer to you than I have ever been to anyone." A few days later, she received the latest issue of *Camera Work* with his inscription, "To Georgia O'Keeffe this first copy is dedicated by one who loves intensely all that's *genuine.*"

Soon after Alfred's return to Manhattan, he broached a subject that was on his mind—his wish to have more of her "children." To that end

he sent her a check for one hundred dollars: "No one will ever want some of them as badly as I want them—not to own—but to hold & look at." He took it as a mark of their closeness when she wrote him that she could not accept payment—because the drawings had been made for Arthur. Then, admitting that she had imagined having Arthur's child, a subject that she had not yet broached to the prospective father, she wrote, "I can't imagine wanting a little boy that would be mine and anybody else's."

A few days later, Georgia realized that her emotions were in knots. Having revealed so much of herself to Alfred, she yearned for him "in a curious way—it's a mixture of the way I've wanted my mother at times—but not just that—it's the man too." He replied, "I'm glad you feel about me as you do. —And I understand the mother feeling. —You & I—our kind—we really never grow up."

For the rest of the year, Alfred cared for Georgia's work as tenderly as if it were her person. He hung *Blue Lines* at 291 in a show of his favorites and told her where each of the works was placed. "I have to smile at my blue self hanging on the wall beside Marin," Georgia replied, "looking over at Walkowitz and Wright and Hartley." To give her more to smile about, Alfred quoted two distinguished visitors' reactions: Mina Loy liked her work "immensely"; Marcel Duchamp pronounced it "very fine." In the new year, he placed another of her drawings, *Self-Expression* (one of the *Specials*, retitled) at the People's Art Guild, along with work by Marin, Picasso, and Picabia.

While Stieglitz worked to establish O'Keeffe's name in New York, she busied herself with preparations for a talk on Cubism for her colleagues. To this end, he bombarded her with books on modernism (Clive Bell's *Art,* Willard Wright's *Creative Will,* Arthur Eddy's *Cubists and Post-Impressionism*); to share his thoughts on the subject, he sent more copies of *Camera Work.* Stirred by the images in the latest issue, she wrote, "I love the snow and I love Strand's *New York.*" Still, feeling ambivalent about Stieglitz's remarks on her charcoals' "psychoanalytic" value, she struck a devil-may-care pose—"Write a whole book about me if you want to"—before breaking through her defensiveness to confess, "I'm getting to like you so tremendously that it some times scares me."

Their exchanges grew more intimate over the course of the winter. Alfred daydreamed about Georgia in her bed and wrote to her from his own. Georgia kept his letters by her side: "I wanted you when the yellow light came in . . . just to be quiet by you while the sky turned from yellow to cold white moonlight." He described the solace he found at night

in his bath, where he repaired to read her letters: "It's like dope—the heat . . . the sense of water—the nakedness—the aloneness," a means to calm himself but also to rouse his imagination.

Both turned to the language of dreams to express their deepening bond. Alfred dreamed one night that he was sitting beside Georgia while she slept: "I could see your face on the pillow—& I saw your hand moving towards something—in its sleep—it touched my hand." She replied that on that same night she had taken a book to bed, then set it aside: "I put out my hand to touch it—It was something I liked. . . . I thought to tell you—but didn't—probably wouldn't have if you hadn't told me of your dream."

Georgia read and reread Alfred's prose piece "One Hour's Sleep—Three Dreams," in the first issue of *291*. "I'd get it out and read it again tonight," she wrote: "I know it—still I want to read it." (Dream three starts well—"The Woman and I were alone in a room. She told me a Love Story"—but ends badly: She stabs him in the heart.) A few days later, Alfred related a reverie about a man and a woman walking in the mountains: "The snow as bed—the sky as cover!!" He added, "If I could only see you in that room of yours . . . see you falling asleep."

In the same way, their daydreams echoed each other's. Aroused by the memory of Georgia's hands, Alfred longed to touch them. They sometimes "make people say funny things," she replied, mentioning an art student who had studied her long fingers before declaring them the reason that he liked her. She added, "I never think of the looks of them—it's always wanting to use them—touch with them—feel with them." After these provocative words, she concluded by saying, "I've written you enough for one day."

Georgia's tales of flirtations let Alfred know that she appreciated her own powers of attraction. By the end of the year, she was feeling "sixty miles an hour"—a pace not matched by a new suitor, an attorney. It amused her to tell Alfred that she had been "out for contrariness" on a moonlight drive to the canyon, where she rebuffed the man's advances. "He wanted to touch me because I was a woman—I distinctly did not want to be touched because he wasn't a particular man." A few lines later, she imagined Alfred looking at the scene: "You would have had a good time on the back seat."

Georgia took pleasure in sharing Alfred's fantasies but worried that she was not smart enough to understand *Faust*. "No one in the world has succeeded," he replied, then asked teasingly, "Why should a little girl?—You are a great little girl—with a heart big enough to hold the sky

in it." Reading about her escapades, he saw her as "a sort of wild natural woman," or at times, his soul mate. Alfred gave her "a curious kind of balance," Georgia told him in the new year, when she was feeling like "the little girl again after being the wondering woman." The letter ends, "I'd like to be rocked to sleep close to somebody— Goodnight."

Over the months that saw the elaboration of these fantasies, their letters sparked the rush of creative energy that may arise when one is deeply known by another. It is said that O'Keeffe's 1916 watercolor series *Train at Night in the Desert* pays tribute to Stieglitz's *The Hand of Man*, which she had already seen in two issues of *Camera Work*. The shape of the train moving toward the viewer under billows of smoke would have been in her mind on the dawn walk that inspired this series: "A train was coming way off—just a light with a trail of smoke—white—I walked toward it—The sun and the train got to me at the same time," she told him. Then she added, "I thought of you."

By return Alfred expressed his pleasure at her depiction of the scene and her "thinking" it to him: "You saw the big black locomotive coming towards you—the smoke—& the sun broke forth—shooting its rays deep into your being! —And I was with you!!" To continue this charged conversation, he sent another *Camera Work* with his photographs. They were like him, she replied: "You are really here—a lot of you—not all of you—I wouldn't have known you without the letters."

CHAPTER 5

Passion Under Control

1916–1918

An apprehensive note entered Alfred's correspondence toward the
end of 1916, when the stock market began to seesaw. If the coun-
try's precarious neutrality gave way to war, he informed Georgia, the only
positive effect he foresaw was that "some terrible common suffering"
might open Americans' eyes. In the meantime, he worried about plans to
start rationing—including the grain needed to produce beer, the source
of his wife's income. "A wealthy Emmy was bad enough," a biographer
writes; "a poor one was out of the question. . . . Alfred finally began to
think seriously of leaving her."

In the new year, he also began to think of giving up 291. "If there is war
it would be madness to load myself up with a lease—It has been mad
all along but then something was gained by others & myself throughout
that madness." Too low-spirited to pick up his camera, he took comfort
in Georgia's art, although, she, equally unsettled, had not painted for
some time and feared that she would have to leave her job because of
her opinions.

She also doubted the strength of her ties to Arthur. After sending him
a long letter, she wished she could get it back: "It will give his Scotch-
ness an awful jolt. . . . Some things I've been wanting to tell him for a
long time . . ." (These included her realization the previous spring that
she had wanted to have his child.) Did Arthur plan to marry her? Alfred
asked. Did he want her to become "a toned-down free soul?" He under-
stood her wish that he be "less *New Republic*–like," but gave no advice.

Georgia also expressed her concern for the gallery: "Knowing that 291
is—is one of the things that makes life worth living." In February, she
sent him her recent work—more *Specials,* the Palo Duro landscapes,
the *Train at Night* series, and drawings of a friend sleeping, which Alfred
took to be self-portraits. Her daring made him feel cowardly by compari-
son. Still, bucked up by Georgia's "tornado of letting go," he could face

the throngs who came to 291 fearing that it might not survive: "If I have to give up the little place your work will be on the walls when I close it up."

While Alfred contemplated the gallery's demise, Georgia alternated between distress at being called a rebel and pride in her nonconformism. "I've said some scandalous (according to some folks) things in class this week. . . . would the sober ones of the place think me off my track." By then, the sober ones were taking note of her outings with her student Ted Reid, who kept her company on hikes and adopted her ideas about art as an expression of life—which were making him question his engagement to a local girl.

At the same time, Georgia was flirting with other men. She told Alfred of her attraction to Rector Lester, a married attorney, and to Willard Austin, who often drove from Amarillo to see her. In the spring, she kindled such strong emotions in Kindred Watkins, another married man, that he declared his wish to be with her *"right or wrong."* Alfred did not comment on her coquettishness, a tactic that allowed her to express her contradictory urges while feeling understood. As a reader of *The Masses*, Georgia was familiar with its arguments for free love, even though she did not wish to act on them. (All available evidence makes it likely that she remained a virgin.)

Meanwhile, after the sinking of the liner *Housatonic*, President Wilson severed relations with Germany. In March, the government revealed the kaiser's attempt to enlist Mexico's support in the event of war with the United States, in exchange for which Mexico would receive Texas, Arizona, and New Mexico. Congress doubled the size of the army; newspapers denounced the dissemination of enemy propaganda in journals like *The Masses*. Those who did not support the war were deemed subversives.

In this context, the "art game" struck Alfred as so much nonsense, he told Georgia after a trip to Philadelphia to judge the annual photography exhibit at Wanamaker's department store. Combining his pacifism with his artistic credentials, he convinced the jury to give first prize to Paul Strand's *Wall Street*—the picture, to those of a radical bent, that identified the forces behind America's rush to war.

By then, tensions in the country at large were playing out in plans for the next big art event, the Society of Independent Artists' exhibition at New York's Grand Central Palace. In March, Stieglitz took refuge at the home of Walter Arensberg, the society's director, where opposition to the war was taken for granted. The Arensberg salon, which included

artists like Duchamp and Mina Loy, was "very informal," Alfred told
Georgia. Of their plans for the show, he wrote, "It is going to be right.—
Chaos." Each artist could show two pieces; Duchamp insisted that work
be hung in alphabetical order. Alfred submitted two of Georgia's char-
coals, which he renamed *Expressions*—a title that asserted his role as
"co-owner."

At the same time, Stieglitz was readying his next show, "Exhibition of
Recent Work—Oils, Water-colors, Charcoal Drawings, Sculpture—By
Georgia O'Keeffe of Canyon, Texas," to run from April 3 to May 14. After
hanging her work, he took pictures to show her how it looked. "There
is a religious feeling pervading the rooms," he wrote, "an unspeakable
fineness." Her exhibition affirmed the meaning of life on the very day
that Wilson asked Congress to declare war. But by April 6, when Wilson
announced that the United States had joined the Allies, the patriotic
throngs marching up Fifth Avenue took no notice of what was happen-
ing at 291.

In this climate of opinion, Duchamp saw the Independents as a
chance to subvert authority of all kinds. At his urging, the hanging com-
mittee put the letters of the alphabet in a hat and drew to see which
would come first—so as not to give priority to names beginning with *A,
B,* or *C.* (They selected *R.*) To the Arensberg group, such actions merged
their wish to *épater* the bourgeois with their defiance of the country's
hawkishness.

Alfred described the show to Georgia: "The hanging alphabetically
has worked out well, & in some instances has produced some wonderful
results." Yet he had found no new talent among the nearly 2,500 entries.
And while the *O* room was "distinguished" by Georgia's drawings, he
feared they would not receive the attention they deserved.

Alfred also described the "row" that erupted over a late submission—a
porcelain urinal entitled *Fountain.* Signed by one R. Mutt, the piece pro-
voked a split in the board of directors, some of whom found it obscene;
Duchamp and Arensberg resigned in protest. (The urinal had been sub-
mitted by Duchamp to test the society's zeal for artistic freedom.) Alfred
described the object, then enthroned at 291: "Its lines are very fine. I
have made a photograph—suggesting a Buddha form—& there is a large
Hartley as a background." He did not let on that Hartley's canvas, *The
Warriors,* showed helmeted German soldiers: In the current climate, it
was as provocative as Mutt's "sculpture."

The object remained at the gallery while Duchamp's supporters pre-
pared a special issue of their magazine, *The Blind Man,* featuring Stieg-

litz's print and an editorial upholding Mutt's right to show his work. Only "atavistic minds" would be offended, the editors teased: "To any 'innocent' eye how pleasant is its chaste simplicity." But at a time when irony seemed unpatriotic, few judged such art with innocent eyes.

Far from the brouhaha, Georgia felt unsettled in her own way. "What's the use of Art?" she asked Alfred. "It's queer enough to get excited over it when there is no war—But when there is war." She worried about the effect of the conflict on her students, some of whom had gone to the Signal Corps headquarters in El Paso. It pained her to watch them enlist: "What's it all about anyway— I cannot clap and wave a flag."

Georgia distracted herself by dallying with her suitors, then amusing Alfred in letters about them. At a party, she danced with both Rector Lester and Ted Reid. A few days later, Kindred Watkins came to say good-bye before enlisting. Despite her fondness for all three, she felt that no one understood her. Alfred replied, "Waving flags. —Isn't it funny how people are moved by superficial things."

On May 14, the end of the term, Georgia left Canyon abruptly. After learning from Alfred that he was about to close 291, she took her savings out of the bank and boarded the train to New York. "It was him I went to see," she told Anita. "Just had to go . . . There wasn't any way out of it."

. . .

Alfred was holding forth at the gallery when he sensed someone standing behind him. It was Georgia, who had showed up without letting him know that she was coming. He took in her quiet presence. She was not a conventional beauty, but her natural elegance made her all the more remarkable. He rehung her show, which had already come down, so that she could see it. "When she wants something she makes people give it to her," he observed. "They feel she is fine and has something other people have not."

Alfred attempted to capture this something by taking her picture. The first photographs of what would become the extended *Georgia O'Keeffe: A Portrait* show the artist in front of her watercolors, the primness of her tailored black clothes contrasting with the sensuality of her work. During this session, he also photographed her hands in gestures that echo the paintings' swirls. The tapered fingers he had dreamed about were now captured in black and white. But he could not evaluate his efforts: "I'm so full of you that I can't tell you how bad they are—or how good," he said weeks later.

It was just as difficult for those who saw O'Keeffe's work to judge it. Henry Tyrrell equated the artist with her creations: "The interesting but little-known personality of the artist . . . is perhaps the only real key, and even that would not open all the chambers of the haunted palace which is a gifted woman's heart." Praising her skill, he said that it had been employed to create a "veiled symbolism for 'what every woman knows.'" From then on, most critics responded with bafflement, even hostility, to O'Keeffe's work, which seemed alien—outside the norms of mainstream (masculine) art.

One wonders what O'Keeffe made of Tyrrell's account of *Blue Lines* as an allegory of sexual difference: "a man's and a woman's [lives] distinct yet indivisibly joined together by mutual attraction." Perhaps she was having too much fun flirting with members of Alfred's circle to notice. "I had a wonderful time," she told Anita, before asking if she knew Strand. Georgia was thunderstruck when he showed her his new prints. A charged look passed between them; she "fell for him." Soon she was "making Strand photographs for myself in my head." One afternoon, they strolled up Fifth Avenue with Stieglitz, who sensed the attraction between his protégés.

Georgia also warmed to Alfred's friend Henry Gaisman, the inventor of the Autographic camera, for which Eastman Kodak had recently paid the sum of $300,000. On Decoration Day, when Gaisman drove Stieglitz, O'Keeffe, and Strand to Coney Island, the three men vied for her attention. Having told Stieglitz that he was looking for a wife, Gaisman put Georgia beside him in the front. Alfred wrapped her in his cape when the wind came up, while Paul, one may suppose, directed her gaze to the shapes and angles of the amusement park.

Arthur was not forgotten amid her social whirl. After looking Macmahon over when he came to Georgia's show, Alfred declared him a fine fellow but incapable of grasping her art. One afternoon, Paul met Arthur when he came to 291 to take Georgia to dinner; she did not let on that she wanted Paul to join them. When Arthur kissed her good-bye at the station, she seemed to have "frozen" toward him, she told Alfred after boarding the train: "Maybe the warmness of all you folks down there made Arthur seem farther away than ever." Confessing her attraction to both Strand and Gaisman, she asked for the inventor's address. By then, she felt so "mixed up" that she wished that Alfred could take her in his arms.

Georgia's visit had given Alfred a sense of completion just as he was preparing to give up the gallery. Friends were helping take everything

down—chief among them Strand, whom he photographed as his part-ner in destruction. After tearing the burlap off the walls, Alfred took the photograph that conveys his sense of loss, a statue of a woman warrior amid the debris, entitled *The Last Days of 291.*

It was the end of an era in many ways. In June, as temperance groups lobbied for a ban on alcohol, Wilson declared his support of the "drys"—a stance sure to lead to prohibition. Having already left the marital bedroom to sleep in his study, Alfred informed Emmy that their dwindling finances would require a move to a smaller apartment. "The wife and I had words," he told Georgia. Emmy was possessed of "great self-will"; he was "no husband for her."

Friends came to mourn with Stieglitz when he settled in a tiny room, which he nicknamed "the Vault," in the same building. Guido Bruno's essay "The Passing of '291'" eulogized Stieglitz's previous "cubby-hole": The birthplace of modern art in America, its influence was felt "in every art gallery, in every museum, in every studio, and, perhaps, in every artist's life." Strand drafted an homage to his mentor entitled "Photog-raphy." He asked, "Where in any medium has the tremendous energy and potential power of New York been more fully realized than in the purely direct photographs of Stieglitz?" Strand's essay appeared that summer in *Seven Arts,* one of the few publications that still voiced anti-war sentiments. But in the aftermath of 291's glory days, he told Alfred, "Something—somehow—seems missing—the salt is out of things."

· · ·

The two men corresponded sporadically over the summer. "It seems impossible to get away from the war," Paul wrote from Connecticut. "It touches everybody now and everywhere one finds the same resent-ment and lack of enthusiasm." Despite Alfred's pleasure in the vistas at Lake George, he felt too numb to pick up his camera. Alluding to his marriage, he wrote, "Of course the War as a background emphasizes all the weaknesses which I tried to overcome all these years—in which I failed."

In this state of mind, Alfred told Georgia that he lived for her let-ters, the green stamps she habitually used, her looping, spiraling prose. For the time being, his dreams of her made up for what he lacked. He was dwelling in his imagination, where what mattered most—art and "livingness"—converged in thoughts of her.

In the meantime, Georgia resumed life in Canyon in a state of per-

plexity about her week in New York. "I felt as I left that I meant a lot to many," she told Alfred. That day, she began painting the figures lodged in her imagination—vibrant watercolors with the curve-topped vertical shape that first appeared in the charcoals prompted by her feelings for Macmahon. "I guess they are Strand," she continued; "it's something I got from him."

O'Keeffe continued to work with forms associated with particular people: "Some folks make me see shapes that I have to make—other folks don't." After resuming her friendship with Ted Reid, she wondered why its shape did not move her to paint. "There is something so fine—so beautiful—just a very slender streak of it . . . And it terrifies me . . . that I may unwittingly break it." Alfred refrained from observing that he was not one of those who made her see shapes.

Georgia also began an intimate correspondence with Paul. His prints had astonished her, she told him: "The work—Yes I loved it—and I loved you—I wanted to put my arms round you and kiss you hard—There you were beside me really and the same thing in front of me on paper." The excitement she felt in his presence had encouraged her. But it was not enough to make Strand photographs in her head. She wanted him with her in Canyon, where she was now seen as downright peculiar.

"I am the most talked of woman on the faculty," Georgia told Alfred, then reflected, "if I were different from what I am I'd be artificial." While Alfred and Paul both reinforced her sense of self, it was Paul's photographs that inspired new ideas for paintings. Their flattened geometry and tight close-ups began to inform her compositions; she wanted more of his work. In one of four letters to Paul posted that day, she wrote, "I sang you three songs in paint"—adding that it might not be wise to write to him care of 291.

About the same time, a parcel arrived with Alfred's portraits of Georgia. She told him, "I love myself as you make me. Maybe it's you and me that I like." The next day, she showed his photographs to her students: "They were surprised and astonished too." Alfred enthused, "I could do thousands of things of you—a life work to express you."

While Alfred and Paul vied unwittingly to stir Georgia's imagination, the final issue of *Camera Work,* with a review comparing her art to music, let her see that some people understood what she had to say. Georgia thanked Alfred for her copy and for his support: "You—believing in me—that making me believe in myself—has made it possible to be myself."

By summer, Georgia was feeling so much herself that she sent Alfred

two sets of abstract portraits, the first of Strand, the second of Kindred Watkins. They were like her, Alfred wrote, "Passion under control." He showed them to Paul without explanation; a few days later, Alfred told Paul that the ones that the young man liked best were, in fact, portraits of himself. Paul blushed, then let on that Georgia had written about sending him something. For the rest of the year, Georgia wrote passionately to both men.

In July, she was moved to fashion her own likeness. After pondering Alfred's photographs of her, she began a set of self-portraits, red-toned washes that she painted in the nude from her reflection in a mirror. "I couldn't get what I wanted any other way," she told him. Alfred was thrilled by her frank allusions to her body. "I'd like to kiss it from top to bottom," he wrote. Her words made him wish for "a long, long sleep—entwined."

At about the same time, he asked if she could imagine having his child. She replied, "All of me has been yours many times. . . . I'd have no choice if I were near you." Throughout the summer, they shared sexual fantasies. Georgia confessed that painting in the nude was so exciting that it was hard to sleep. She continued: "I'd like to put my arm round your neck—both arms and feel close to you—my breasts close to you—and feel that you like them." Alfred's dreams echoed her own: "A woman lay in my arms. . . . I whispered into her ear: 'The drawings are for me only—aren't they.' "

Alfred did not know that Georgia was writing to Paul with a similar sense of excitement. One night in bed, she told Paul that she wanted to go to him, and failing that, to crawl inside the life of Nietzsche he had given her. She liked his essay in *Seven Arts*, but even more his sharing it with her. Seeing his latest prints in *Camera Work* had stirred her: "Your songs—that I see here—are sad—very wonderful music." While they made her aware of his "strengths" and her "weakness," their gifts were complementary: "I give you something that makes it possible for you to use your strengths."

After a night walk in the canyon, Georgia sent Paul a verbal snapshot of her room—the white woodwork, the wallpaper's silver stripes, the black cloth framed in black—an appeal to his imagination to bring him close to her. But his reluctance to respond in kind was vexing. Although Strand's letters have not survived, it is clear from her own that she wanted him to make a move. Yet given their status as Alfred's protégés it would have been treacherous to be more forthcoming. Paul could not pledge his heart to Georgia without jeopardizing his fealty to Alfred.

In some ways, Georgia's rapport with Paul replayed her relations with Arthur—to whom she wrote after her return to Canyon: "This spring I've been too much loved by many different people." She told Arthur about her new work, including the nude self-portraits: "You probably wouldn't like it. . . . It is too much like me—says things that would make you speechless . . ." It was clear that Arthur's morality kept him from embracing her art and its deep source in the life of the senses.

By then, Georgia had resumed her tramps with Ted Reid, whose clean-cut looks may have reminded her of Arthur. (Ted was eight or nine years her junior.) They explored the canyon and watched the moon come up over the plains. Ted made her laugh, she told Alfred: "Living with him would be lots of fun. . . . He is the only person I ever knew who would take me to the tail end of the earth where folks wouldn't bother me . . ." In New York, she had put Ted out of her mind, but now, in the landscape they both loved, she admitted, "I seem to like him like I like myself."

While Georgia's responses to the men in her life perplexed her, these erotic stirrings nourished her desire to paint. Her *Evening Star* series, a group of bold watercolor abstractions, celebrates the heat radiating from the star in fiery circles. Another series, *Light Coming on the Plains*, reverberates with the shimmer of light glimpsed at dawn. These visions of nature pulse with energy—enacting O'Keeffe's determination to go on being herself.

She posted her watercolors to Alfred, who was still in New York. In July, writing from the Vault while soldiers paraded up Fifth Avenue, he told Georgia that Steichen had gone to Washington to work with the Signal Corps. He added, "I must find something to do or I'll go mad." When Georgia's package arrived, he wrote, "I'm glad you followed *your* own feeling—You always do, that's what makes you such a wonder."

Having her with him in this way had an immediate effect. After months of feeling unequal to the task, he began taking pictures. "Photographing excited me terribly," he wrote, but it was also tiring. The letter, which includes his reply to one of hers about Ted's role in her life, continues, "Age makes no difference—yet it does." What Alfred had to offer was "a greater consciousness," which perhaps made up for reduced physical stamina. But seeing her like a flower about to bloom, he gave her his blessing.

For the rest of the year, Alfred's affirmation of Georgia's fluctuating emotions created an ease between them that allowed her to write freely. Taking the high ground, he kept their intimacy alive while taking plea-

sure in her passing fancies. In this way, he could preside sagely over her enthusiasms while telling himself that she would soon lose interest in men whose lives were unsettled—especially now that the war made everyone's future more uncertain.

. . .

When Georgia's classes ended, she went on vacation with her sister Claudie, who had joined her in Canyon and would enroll at the college that fall. In August, they took the train through New Mexico—"where the nothingness is several sizes larger than in Texas"—to Colorado. Georgia wished that Alfred could join her.

While she hiked in the mountains and painted watercolors, Paul worried that she had broken off their correspondence. He sought Alfred's advice, wondering if he had irked her. It was not Paul's fault, Alfred replied: "She has gone through a very perfect experience—still is in it—& she seems to be very tired from all the work—So letter-writing of all kinds—to anyone—would have been forced—& as you know Canyon does not force. . . . rather an honest silence than a mechanical line."

The two men continued to compare notes about "Canyon." Each kept to himself the upheavals in her emotions, including the confessions she made to both of her feelings for Ted. "I wonder why I don't marry him today," she told Alfred. A few days later, she wrote to Paul about the unnamed man who was "like this country." With this man she walked across the plains to see "big stretches of nothing"; their relationship was impossible, but "that doesn't phase [*sic*] him at all." She added, in an implied contrast to Paul's caution, "I have never seen anyone with such damnable nerve."

What Georgia wanted was a wholehearted companion to share her joy in what she saw on the vast plains or in the high mountains. Yet she valued Paul's work. One artist to another, she described the colors of the peak that she had painted and teased him about which of her beaux she wanted at her side. She said that she liked his new prints, especially *Geometric Backyards,* a New York scene whose lofty vantage point enhanced the diagonals of the clotheslines; she wondered what he would find to do in Colorado.

Toward the end of her holiday, Georgia told Paul that having dismissed her suitors from her thoughts, she now felt "gloriously free." Though some might call her fickle, "with me it's more a feeling of master of myself." In the same letter, she included a fable about a chestnut

tree whose inherent strength caused it to tower above its companions, thereby producing "fuller, richer fruit." True to its nature, it kept on growing, "immovable, straight up into the light"—rather like herself.

Paul then told Alfred that he had finally heard from Georgia—"one of the finer parts in this delicate thread of what has been for me a perfect relationship." (It may have seemed perfect because it was conducted long-distance, Georgia's scrawls stretching like fine wires across the distance between them.) He said that he had been writing poems but didn't let on that they were for her. Paul hoped to see her new work but had little else to look forward to in his alienation from "all the sentiments and feelings upon which the mind of the country is centered."

Both men returned to New York, to find that few in progressive circles felt able to contest the growing pro-war sentiment. Stieglitz went daily to the Vault, where Strand, Marin, Hartley, and Walkowitz gathered, along with some like-minded artists and writers—Charles Sheeler, Arthur Dove, Herbert Seligmann, Paul Rosenfeld, and Waldo Frank. Yet even there, Alfred felt "devoid of ideas—devoid of dreams."

It was obvious that the 291 spirit could not survive. That month, *Seven Arts* ceased publication after its backer withdrew support because of its antiwar stand. Alfred's home life was in shreds. After a row with Emmy, he decamped to his niece Elizabeth's studio on East Fifty-ninth Street, which he had been using as a darkroom, and encouraged Elizabeth to correspond with Georgia. Strand kept him company there until late at night, he wrote on October 23, in a letter that reads like a declaration of independence from marriage. (Stieglitz went home after a few nights in the studio.)

About this time, Paul was composing a tribute to the gallery. "What was 291?" he began, echoing the 1914 contributions to *Camera Work*. "Was it a spiritual idea? Was it a Man? Or was it a place? . . . 291 was none of these things because it was all of them." But it was no longer possible to imagine an artists' collective unsullied by commercialism. Although Stieglitz had devoted himself to "guarding the idea from the twisting power of money. . . . It was the people themselves who killed 291," Strand claimed. "With that rupture, one of the most vital and significant experiments, not only in American life, but in the world life of today, came to an end."

Paul sent Georgia a copy of his essay along with his latest poems. She replied warmly, "I love you like I did the day you showed me your work—Love you both armsful—Or is it what you say that I love." But she ended on an ironic note: "Isn't our little mutual admiration tendency

amusing." Paul's tribute, she told Alfred, "made me feel just like his work made me feel. . . . But what is the war going to do to him." With no like-minded companions nearby, she felt "as alone as though I were the only person in Texas."

Moreover, she had stopped painting. On her return to Canyon, she found the atmosphere changed. The town was intensely patriotic; her students, including Ted, were all enlisting. Her ambivalence about her role deepened. "I've been wondering what living is for," she told Alfred. "Painting seems such a sickly part of the world—Outdoors is wonderful—I want to take hold of all of it with my hand."

But the man with whom she had embraced the plains was being pressured to stop seeing her. Surprised to meet Ted with his former fiancée, she supposed that he had gone back to her because their own relationship was hopeless—not realizing that Ted had been told by school authorities that he would not graduate if he didn't stop seeing Georgia. (It is likely that Ted was also trying to protect what was left of her reputation.)

Georgia expressed her dismay to Paul. She could not paint "because everything seems so mixed up." On November 15 (her thirtieth birthday), she wrote that after seeing Ted off at the station she understood her feelings for him: "We meet equally—on equal ground." But she had to let him go. Then she added, "you pull me in spite of myself." When Paul made it clear that he could not join her, she became impatient; "he seems to be getting too old too soon," she complained to Alfred.

In December, Georgia turned her mind to the vexations of Canyon. Asked to report to the art faculty on a recent trip to the army camp at Waco, where she had talked with the soldiers (including her brother and Ted Reid), she erupted into "an explosion I've been growing to all my life." Art as taught at the college "was rotten because it has no relation to life."

Putting her thoughts into practice, she had protested against the sale of anti-German Christmas cards. She also planned to voice her opposition to the pro-war hysteria in a watercolor of a starless American flag in a dark sky. What she had in mind, she told Alfred, "wasn't the flag at all—it just happened to take flag shape." Despite "the futility of everything," she felt more sure of herself. Pondering what Alfred meant to her, she continued: "It's like father, mother, brother, sister, best man and woman friend, all mixed up in one." He replied, "I'm glad to know that I am all the things you say I am to you—quite a family in one person!"

Georgia's health worsened after a cold became an infection, while

Georgia O'Keeffe letter to Alfred Stieglitz, December 3, 1917

Alfred's paternal role was uppermost in his mind. On December 28—
four days before turning fifty-four—he contemplated the age difference
between himself and the "children," Paul and Georgia: "I know what
you are to him—what he feels—better than he knows it." Might she
not think of Paul as the man to give her a child? But by then, Georgia
was sure that she and Paul were "cut out of altogether different kinds
of stuff."

During this exchange of letters, Georgia consulted doctors in Ama-
rillo, who prescribed extended rest in a warm climate. Alfred feared that
she had one of the strains of influenza that were racing across the coun-
try. "I'd like to be buried way out on the plains," she wrote. "Did you ever

see an old gray rag . . . flapping in the wind on a wire clothesline"—like her American flag. She took medical leave in February, and with her friend Leah Harris, who was recovering from tuberculosis, she went to San Antonio to recuperate.

Over the next months, Alfred and Paul shared their concern for her. After Paul showed his mentor a letter from Georgia that scolded him for not enlisting, Alfred wrote, "He sat there like a little boy. . . . I had to laugh when he said: 'How much you & she are alike.'" Alfred became distraught when Georgia told him that another doctor despaired for her: He begged to know the details of her treatment. In March, telegrams flew back and forth from New York to San Antonio as Alfred and his niece proposed different scenarios for Georgia's care, including bringing her to Manhattan to live in Elizabeth's studio.

Georgia's spirits improved when she and Leah moved to a farm in Waring, fifty miles from San Antonio. She wrote infrequently to Paul

Alfred Stieglitz letter to Georgia O'Keeffe, June 13, 1918

Flower of my Soul's Yearning of all these many years — that's what You are. Yes, You are. —

Here I am ready to steal some more moments to be with you — It is a glorious feeling to know what I know — What you have told me — what I have seen —— What you Express every moment —— in just being ——

—— I still have one thought above all —— To Want You Strong — There is so much for You to Give the World ——

Always the Flower —
The Flower that has to Wither —

June Days —
five so far —
each so full. ——

but continued her correspondence with Alfred, recounting her pleasure in rural life and her sense that Alfred mattered more to her than anyone. But after she told him that the man who lived down the road had banged on their door one night (he left when Leah brandished a gun), Alfred determined to protect his "little girl" from danger and, if possible, persuade her to come to New York.

The obvious person for that job was Paul. His loyalty to Alfred and his eagerness where Georgia was concerned were well known, and he had his own reasons to want a change of scene. That spring, he developed a crush on Elizabeth, Alfred's niece and confidante. But Elizabeth was in love with Donald Davidson, an art student whom she installed in the bosom of the family by persuading Alfred to hire him as the Stieglitzes' gardener. Strand embarked in early May to meet Georgia in San Antonio, the trip funded by Stieglitz.

After he settled in a rooming house near Georgia's, they strolled around town together. She painted Mexican women in their shawls; he took their portraits along with hers. She was "just like a child," Paul told Alfred, "very beautiful . . . very much mixed up." He sent his assessment two days later: Georgia needed an income, not for its own sake, but for "stability of living." If Paul had money of his own, he would support her. "But I haven't," he continued. "You and she ought to have the chance of finding out what can be done." He added, "I love her very much—You know my feelings for you."

Georgia's feelings for Paul turned to exasperation after their return to Waring, when he expected her and Leah to look after him. He was "the most helpless, slow, unseeing creature I ever saw," she told Alfred. "You have spoiled him," she added, "his mother has spoiled him and I guess above all he has spoiled himself." Moreover, his veneration for Alfred annoyed her: "You are such a perfect god to him." She, Paul, and Leah made a shaky trio, their relations complicatedly "three cornered."

This unstable situation became more confused after Georgia allowed Paul to touch her. He had put his arms around her, but there had been "no passion," he informed Alfred, then promised, "It won't happen again." By then, Georgia had received Alfred's cable urging her to come to New York and a letter explaining that he had sent Paul to free her of any illusions about his suitability as a partner: "I can write now all this—a couple of weeks ago it would have been absurd." Two days later, he told Paul that he would provide the resources for her "if she wants to come—really wants to—feels the necessity—and feels that she can stand the trip physically—all else would arrange itself."

At the end of May, the three-cornered arrangement in Waring stabilized enough for Paul to describe it in terms that must have stirred his mentor. "I am in a state—photographing Leah—nude—body wet, shining in the sunlight. . . . Georgia painting Leah. . . . All of us happy." A few days later, they drove to see the stone houses in a nearby town: "The most extraordinary simplicity of structure . . . Georgia wanted to live there." Still vacillating about the future, she asked Paul to stay with her in the West; he offered to support her "without expecting anything in return." After relating this exchange, he mused, "I could do it—if it were to be—But it isn't—which I knew long ago."

By then, Georgia knew that she could neither return to Canyon nor take Paul seriously, although she would allow him to escort her to New York. On June 3, she telegraphed Alfred to say that they would leave that night: "If I had let anybody or anything get in my way I wouldn't be going. It has to be this way. I don't know why. I don't know anything."

Squaring the Circle
1918–1920

Georgia was feverish when Alfred met their train at Grand Central Station, and he and Paul rushed her to Elizabeth's studio. She spent the next weeks in bed in the smaller of the two rooms, until she could move to a spot beneath the main room's skylight. The pale yellow walls and orange floor made it hard to think about painting there. "But it was exciting," she recalled. "It made me feel good and I liked it."

Alfred devoted himself to her. His brother Leopold, a doctor, examined her and prescribed bed rest. Alfred spent each day at the studio, thrilled to be the guardian of his dream woman, whose frail health made her dependent on him. For two years, their courtship had been epistolary. Now they could resume their communion face-to-face. "We have talked over practically everything," he told Elizabeth. "Into one week we have compressed years."

Although Alfred had never gone near a stove, he learned to cook eggs, and he made sure that Georgia had every comfort, including art by Rodin and Marin on the walls. He wrote to her every night from his apartment. Their closeness, he thought, had its source in the purity of her nature: "I have nothing to do with it except reflect yourself back to yourself." Georgia replied, "I've been lying here listening for you in the dark—My face feels so hot—Aching for you way down to my fingers' ends. . . . The woman you are making seems to have gone far beyond me."

It was a great relief to accept his protection after months of uncertainty. Soon, despite the heat, Georgia felt well enough to start painting, once again in the nude. Awed by her ease in moving from dress to undress, Alfred told Elizabeth that their rapport was "intensely beautiful—at times nearly unbearably so." To Dove, he exulted, "These last 10 days have been very full ones—possibly the fullest I have had in my life."

Their rapport was charged with tension once Georgia felt well enough to pose for him. Given the ardor of these early photographs, many

assume that they became lovers soon after her arrival. While it is difficult to imagine them not yielding to their passion, newly released correspondence shows that this was not the case; the excitement palpable in these portraits of O'Keeffe owes as much to the frustration of their desires. Taking into account Alfred's status as a married man, his fears for her health and possible pregnancy, and his sense that he should wait until she "gave" herself, one can understand that even such ardent souls might agree to the deferral of their desires.

During this time, Stieglitz took possession of his beloved with his camera. In one group of portraits, O'Keeffe (clothed) poses in front of *No. 15 Special,* a drawing that held an almost spiritual meaning for Stieglitz. Her white collar, dark jacket, and hat form a prim disguise, one that enhances the gravity of her expression. In a related group, the same dark hat contrasts comically with her nightdress while echoing the Art Nouveau swirls of *No. 12 Special* behind her, positing a likeness between the woman and her art.

Writing to Georgia late one night, Alfred touched on his wish to photograph her in the nude. The subject had come up in conversation with Paul, he explained, when the young man mentioned that she had declined to do so for *him*: "He said: I think she'd pose nude for you—& I said: Perhaps she would." He was gleeful on learning that "no man on earth has ever been given such gifts—so consciously—so willingly—naturally."

Portrait sessions continued until the end of June. In a series of poses that illustrate Alfred's wish for Georgia to see herself as he did, she let down her hair and loosened her kimono to reveal her breasts. Standing before *No. 15 Special,* she gazes at the camera unabashedly or takes her breasts in her hands as if weighing their contours (perhaps a gesture derived from Rodin's drawings). "I'll make you fall in love with yourself," Alfred wrote, then added that he could hear her "telling me what I must not do" until she was ready.

Their impassioned discovery of each other was interrupted in July when Alfred took Kitty to summer camp in New Hampshire. After his return, he brought Georgia to his apartment to continue portrait sessions in his dressing room. Emmy walked in on them unexpectedly and ordered him to stop seeing the self-possessed young woman. He refused, packed his bags, and joined her at Elizabeth's studio. While it was the opportunity he had been waiting for, it was painful to admit that after twenty-five years of marriage he and Emmy shared little except their love of their daughter.

For a time, Alfred and Georgia slept side by side, with a blanket over a

clothesline between them, an arrangement that intensified the charged atmosphere. He kept his camera on a rickety tripod with the black cloth under which he disappeared when the time was right. It was understood that they would be in the studio whenever the light was best for picture taking.

Much has been written about these sessions over the next two years, when most of the extended *Portrait* was taken. Was Stieglitz in control, or was O'Keeffe an equal partner in the portrayal of "the woman [he] was making"? Do these deeply felt images belong among O'Keeffe's works as well as Stieglitz's? Should we see in them an "ongoing exchange of observation and solicitation (hers as well as his), provocation and response (his as well as hers)"? Or as a biographer puts it, as the evidence of a subtle collaboration—"an intricate psychological pas de deux"?

As Georgia gained the confidence to respond to Alfred's suggestions, she invented poses that drew on her experience as an artist. Yet to claim her as the *Portrait*'s coauthor is to ignore her account, decades later, of Stieglitz's staging the scene. "He wanted head and hands and arms on a pillow—in many different positions. I was asked to move my hands in many different ways—also my head—and I had to turn this way and that. There were nudes that might have been of several different people—sitting—standing—even standing upon the radiator against the window. . . . In a way [I] wondered what it was all about."

Still, since O'Keeffe had painted nudes of herself and friends, "wondering what it was all about" sounds less than candid: Her remarks reflect the stance of the austere figure she cut in later years. In 1918, when Stieglitz was the best-known photographer in America, it was not surprising that she yielded to his suggestions or that he cajoled her into enacting his fantasies. There was also a certain playfulness in their rapport. O'Keeffe teased Stieglitz about using the radiator as a prop. It amused her that this rudimentary pedestal allowed him to photograph her against the curtain in the nude sequence that turns her into a classical torso or an Isadoraesque dancer—pictures marked by the fin de siècle aesthetic shared by both.

After describing these sessions in her introduction to *Georgia O'Keeffe: A Portrait by Alfred Stieglitz* (1978), O'Keeffe turned to the question of her uncertain future at that time, when she was under contract to return to Canyon. "[Stieglitz] asked me if I could do anything I wanted to do for a year, what would it be. I promptly said I would like to have a year to paint. . . . He thought for a while and then remarked that he thought he could arrange that," she recalled, understating the enormity of the decision to embrace her new life.

In the meantime, Alfred informed Paul of Georgia's progress. The young man now felt "somewhat lost," Alfred told her. Their absorption in each other excluded him; he was also subject to the draft. Perhaps feeling remorse for having made Paul their go-between, Alfred helped him obtain conscientious objector status after he began work as a laborer on Elizabeth's new project, a farm on her father's Westchester estate. But in August, when Paul understood that his feelings for Elizabeth would not be reciprocated with Davidson on the scene, he abandoned farm life, even though it meant having to enlist.

About this time, Stieglitz took O'Keeffe to Lake George. His mother, who never cared for Emmy, made Georgia feel at home. The family welcomed her, although their noisy self-absorption and the clutter of life at Oaklawn made a painful contrast to their quiet studio. When dinner conversation became too boisterous, Georgia ate on the porch or persuaded Alfred to go rowing. "The days here are the most perfect of my life," he told Strand. Their happiness was interrupted when Alfred rushed to Kitty's camp after receiving a letter begging him to explain the situation. He returned to Lake George believing that his talks with Kitty (and Emmy, who was staying nearby) had settled things, that Kitty would accept Georgia after spending September at Oaklawn.

Before going into the army, Strand wrote Stieglitz to say that he understood the need for readjustments in relationships. Those he cared for were all "moving out and away on their own determined roads—roads that mine will no longer parallel." He hoped that Alfred and Georgia were now "in the best of health and the oneness of living."

Paul's letter arrived shortly after Alfred's return to Oaklawn on August 9, a date that became sacred to him as the day when Georgia "gave" him her virginity. For some time, the weather had mirrored his turmoil. The thunder and lightning that day heightened the rapture of his reunion with his beloved, who told him what he already knew: that she was his. "It's a wonder I didn't give you a child!" he recalled years later. "You are my woman for all time—You are not like other women—and I am your man for all time. . . . Your virginity is in my trust."

The family indulged the couple's delight in each other, watching them giggle as they bolted up the stairs after lunch to take a nap—their euphemism for lovemaking. Alfred rejoiced to Dove: "Since I saw you I have been living as I never lived before. . . . O'Keeffe is a constant source of wonder." They were now "one in a real sense."

Understandably, they did not share the intimate details of their happiness. Reading their correspondence, one is touched to find the names that they invented for each other's privates. Georgia's was "Miss Fluffy"

or "Fluffy"; by extension, lovemaking was "fluffing," a less risqué ver-
sion of the common term. Alfred's was the "Little Man" or "The Little
Fella," often abbreviated as "T.L.F." (While one is tempted to take liter-
ally his emphasis on size, his bed partners considered him a highly sat-
isfactory lover.) The sort of erotic playfulness that occurs at the start of
love affairs, these endearments would give way to other names—though
Alfred would often ask after Fluffy's welfare. That autumn, their glee
kept them entranced with each other.

Although their passion did not abate, this period of undisturbed hap-
piness was short-lived. In September, when Kitty threw a tantrum about
Georgia's presence at Oaklawn, Georgia and Alfred fled to New York.
He returned a few days later to try to make Kitty see his position, but
neither was willing to compromise. From then on their relations would
be strained. Alfred told Paul that he could not describe the "mess" at
Oaklawn except to say that everyone was suffering. But he was grateful
to Paul for his help in recent months and thought that Georgia's "queer
feeling" about Paul had dissipated: "Perhaps we'll meet soon after all the
three of us—with no tensions." Paul replied to this backhanded apology:
"Grateful—it seems funny that you should feel that way about me—It's
been all your doing."

After Kitty's departure at the end of September, the couple spent
the next month painting, photographing, and making love. Alfred pho-
tographed Georgia out-of-doors, her long fingers stroking the bark of a
tree, seated matter-of-factly on the ground to paint, or staring at him
while wrapped in his black loden cape. Indoors, she posed for a set of
nudes that crop her torso from the swell of the breasts to the thighs,
accentuating the dark mat of her pubic hair. (O'Keeffe reproduced the
most explicit of these in *Portrait*.) He also photographed her gracefully
gesturing hands as emblems of the woman whose novel ways of express-
ing the natural world amazed him.

Georgia's return to oils that fall adapted the poetics of photography
into several innovative compositions. In *Music, Pink and Blue, No. 1*,
an apparently pure abstraction based on a segment of a shell, waves of
color ripple out from their source in the large blue shape at the center
to suggest corporeal forms. The more representational portraits of red
canna lilies also begun at this time adapt the use of the close-up to bring
the viewer into the flower's folds. While Georgia was having difficulty
in mastering oils, Alfred told Paul, her best paintings were displays of
"Loveliness—Savage Force—Frankness—The Woman."

Over the next months, as Strand sought Stieglitz's help in his attempt

to be transferred to the Signal Corps' School of Photography, his letters became conciliatory. It pained him to read of the "hell" that Alfred and Georgia had gone through: "I am . . . sharing this thing with you as far as that is possible." With this letter, which asks Alfred to intervene on his behalf, Paul included a copy of his Signal Corps application, which lists "Alfred Stieglitz, Photographer" as the first of the well-known citizens who would recommend him. Before Alfred got around to complying with this request, Paul was sent to the Mayo Clinic in Minnesota for a course of studies leading to accreditation as an X-ray technician.

Alfred encouraged Paul's engagement in his new life. "I hope you'll be kept away from N.Y. for a while yet for your own good," he wrote in November. Manhattan had gone mad when news of an armistice produced wild celebrations before proving to be a hoax. "I knew that the people had no conception what 'Peace' would actually bring. . . . That 'Victory' meant a probable Breadline . . . It made one shudder to think of what's probably coming to so many blind ones & to many of us who see." Georgia's health was much improved, he added. "Some day I hope you & she will be at ease again with each other."

A week after the actual armistice, Alfred began printing the scores of portraits he had taken since Georgia's arrival in New York. He had to be satisfied with palladium paper but hoped that the end of the war would mean that platinum, which he preferred, would again be available. The alternative, gelatin silver, he told Paul, "would not do at all for the things I have done. My negatives are 'queer.'" (He did not explain that he was experimenting with processes to evoke the luminosity of flesh tones.) But he had made "a few prints which, when finished, will sing the high C." Alfred continued: "G. whenever she looks at the proofs falls in love with herself. Or rather her Selves." The letter ends, "Demobilization has begun in earnest—I wonder what is to happen to you."

· · ·

Alfred's fears about demobilization proved to be prescient. That winter, the economy slid into recession as factories that had worked overtime to make war matériel closed, and countless veterans were unable to find jobs. In these circumstances, Strand's work as an X-ray technician gave him stability while exposing him to a different kind of photography. Medical service convinced him that art and science were "closely related when they are both creative and impersonal." The impersonality of the operating room appealed to him: "I could more easily be a surgeon

than a nurse because ideas interest me more than the routines of bring-
ing people back to health."

Ironically, Strand found himself in need of nursing when he was
hospitalized at the end of the year. What had seemed like a case of
the influenza sweeping through U.S. military installations that winter
proved to be pneumonia. From his sickbed, he expressed the hope of
seeing Stieglitz and New York again: "I need the livingness and stimu-
lus. . . . I'm hungry for something that might be called beautiful." A few
weeks later, when the Strands came to Minnesota to be with him, his
mother contracted pneumonia and died in the same hospital. Paul felt
"almost like a murderer." Following her death, he took a month's leave to
join Alfred and Georgia.

The many visitors who had flocked to their Fifty-ninth Street studio to
see Alfred's prints and Georgia's oils agreed that their work was "unlike
anything they [had] ever seen." While one can imagine the awkward-
ness of his reunion with the couple, Paul was stunned by the boldness
of their art, and Alfred was glad to have him on the spot to help with
the selection of some of his *Portrait* prints for an exhibition at the Young
Women's Hebrew Association in March, their first public showing.

"Your photographs and her work are part of me," Strand wrote to Stieg-
litz when he returned to duty. "I don't have to close my eyes to see the
ones that hit me hard. I am seeing the grey painting and the very pale
portrait—they seem somehow related." (While he did not say how, he
no doubt sensed the intimacy that had inspired them.) After a month in
New York, Paul could barely tolerate his "stupid life" in Minnesota. Dis-
tractions like burlesque shows and "dope" were unrewarding: "I haven't
met a soul that I want to see twice, or a woman I want to touch."

That spring, as fears of a conspiracy or even a Bolshevist-style revo-
lution were trumpeted in the press, Alfred was perturbed by art-world
politics—in particular, the efforts of his former friend Clarence White,
who still practiced the kind of pictorialism that he had once pursued.
And the recent construction of a neoclassical Arch of Triumph in
front of the Flatiron Building for a victory parade disgusted him. "It all
reminds me of Nero fiddling while Rome was burning. The arch is the
limit—The poor Flatiron."

Paul's letters allude to the concerns of the day, including the anar-
chist plot uncovered in April when the authorities learned of threats to
such figures as J. P. Morgan, John D. Rockefeller, Justice Oliver Wendell
Holmes, and Attorney General A. Mitchell Palmer (who hired J. Edgar
Hoover to investigate). On June 2, 1919, the day that eight large bombs

went off in as many cities, Paul informed Alfred that the Minnesota summer put him in mind of the year before with Georgia and Leah: "Made me think of them often and all that has happened between." While photography seemed "pretty far away," he wanted to believe that "something exists in the world besides Bolshevism and the League of Nations."

Alfred and Georgia were taking refuge in art, a friend wrote to Paul a few days after the bombings. "They have found a little island of safety in their work—The rest of the world goes chasing soap bubbles, reading newspapers and other fiction, making love and finding it is an illusion, cursing Wilson, Republicans and Bolshevists." Yet Alfred fretted about the future: "Is it a madness to produce as we are producing—& living as we are living—in the centre [sic] of the maddest city—that ever happened." He and Georgia decamped to Lake George for their last summer at Oaklawn: The old house would be sold that year, leaving the Stieglitz family farm on the hill and a stretch of lakefront, where they would remain until November.

"As I print you come to my mind frequently," Alfred told Paul after his return to Manhattan. They corresponded about the fine points of papers, whether the texture of palladium could be improved by waxing the surface, the technique that Strand favored. Stieglitz experimented with different versions of each image until he was satisfied; his perfectionism had an influence on O'Keeffe's way of working. Their relationship was "of mutual benefit all the time." He added, "It would be great if it could be arranged to have you here later in the season."

In the meantime, Strand resumed his role as defender of the faith. After receiving an offer to join White's group, the Pictorial Photographers of America, he composed a scathing letter of rejection, which he copied and sent to Alfred. Strand was not in sympathy with the group's aims: Photography had to be "an embodiment of a life movement or it is nothing to me. This quality I find only in the work of . . . Charles Sheeler . . . and Alfred Stieglitz." Pleased with Strand's critique, Stieglitz told him that he had begun to think of reclaiming his leadership role—for photography's sake.

To escape the heat Strand repaired to a lakeside camp in Quebec, where he thought of Georgia and Alfred. He could picture her at the nightly dances, and he looked forward to seeing Alfred's new prints. After a cordial exchange of letters, Alfred invited Paul to stop at Oaklawn on his way home. It would have taken considerable aplomb not to feel like a third wheel, given the couple's mutual absorption, especially

since the "relatedness" of their work that Paul sensed in the spring had become even more pronounced.

Alfred praised Georgia's new oils, including *Inside Red Canna,* the large close-up that offered a "bee's-eye view" of its subject, and *Red and Orange Streak,* a semiabstract rainbow arcing across the night sky. Alfred's aesthetic—close cropping, shallow depth of field, using the edge of the picture as a framing device—had begun to influence her compositions, and his portraits of her inspired some of her paintings, most notably an untitled self-portrait that reclaims his image of her breasts and torso. Both were finding sources of refreshment in their happiness. When Paul went back to New York, Alfred wrote, "I'm glad we had you with us."

. . .

Since Paul's induction into the army, he had often told Alfred of his lone-liness. His letters describe the few people of his own age whom he met, especially the "girls." At the camp in Quebec, he spent time with some Ethical Culture graduates and three young women, a librarian, a social worker, and an orthopedic therapist, none of whom inspired a wish for continued closeness. In October, a few weeks after his return to New York, he was surprised to find an attentive listener in the "very pretty girl" he met at a party given by Alfred's collector friend Jacob Dewald. That evening, they chatted, played tunes on the pianola, and looked at the paintings on the walls. "The good looking young lady liked the Marin and 'hated' the Benton—it was funny—and funny being there."

We may assume that the "good looking young lady" was Rebecca Sals-bury. She would have been invited to the party because of the Dewald family's ties to ECS, from which the vivacious young woman had gradu-ated three years after Strand. They may already have seen each other at alumni events, in which Rebecca took an active part. A leader during her school years, she had opinions about many things, including art and politics. What was more, her long dark hair, oval face, and lithe form gave her a resemblance to Georgia.

Though it was unclear in which branch of the arts Rebecca might excel, she, too, had artistic ambitions. At ECS, she had enjoyed gym-nastics while also writing theatricals, plays, and poems; in recent years, she had composed songs with her brother, resulting in the publication of their *Book of Children's Songs.* In the spirit of ECS's emphasis on civic-mindedness, she also wrote a pro-Wilson play, *At the World Peace*

Table, and collaborated with William Allen of the Institute for Public Service on *Liberty the Giant Killer,* a book that drew the lessons of the war for children. Rebecca illustrated these moralizing tales with stick figures meant to inspire readers to paint their own pictures or enact their favorite story.

After graduation, Rebecca had trained as a kindergarten teacher at the ECS Normal School, taking courses in art, nature study, and educational theory. In her address as valedictorian, she recalled the day that she heard two waifs singing her songs in a tenement courtyard and her dream of "little children . . . singing all over the world." But her first teaching experience, at a charity kindergarten, did not live up to this vision. Disillusioned, she resigned from her job, learned to type, and became a medical secretary—a career that proved no more stimulating. When she and Paul met, Rebecca was at loose ends, she later told him, "swinging crazily along, perhaps missing the important things."

On meeting her, new acquaintances learned that her ideas had been shaped by her reverence for her father and her glamorous upbringing in the days of his successful business venture, Buffalo Bill's Wild West Show. Though short in stature, Nate Salsbury loomed larger in Rebecca's imagination than his flamboyant partner, William F. Cody, at the time one of the best-known Americans in the world. Salsbury always claimed that as manager of the show for twenty years it was *he,* not Cody, who had molded its enactment of the country's westward expansion. Over time, Salsbury acquired a great many shares in the show; his death in 1902 burnished his family's image of him as the mastermind behind one of the best-known cultural phenomena of the day.

While a recent history of the Wild West Show calls Salsbury's claims "self-aggrandizing," it is true that during his partnership with Cody, what had been a ragtag rodeo became the polished production that toured European capitals and attracted patrons like Pope Leo XIII and Queen Victoria. Rebecca grew up listening to Nate's stories about taking the cast of cowboys, Indians, horses, and cattle to England and staging both public presentations and private performances for Victoria's Golden Jubilee. On the show's return to London in 1891, when Rebecca and her fraternal twin, Rachel, were born, Salsbury told journalists that the pageant illustrated the actual making of the West. Thousands of Europeans embraced the spectacle; Nate's children saw him as a statesman without portfolio.

They also loved to hear of Nate's youthful exploits. Rebecca's brothers, Nate Junior and Milton, encouraged their father to retell the story

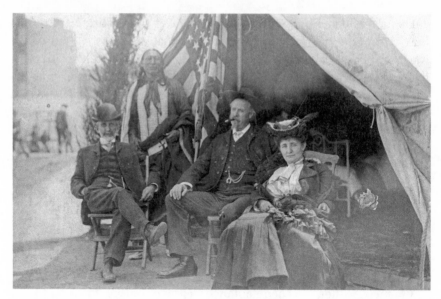

Nate and Rachel Salsbury with Buffalo Bill (center) and Chief Iron Tail

of his running away from home at fifteen to serve as a drummer boy in the Civil War and his time in Andersonville Prison. Rebecca was stirred by Nate's derring-do. Taking him as her model, she became something of a daredevil, enjoying swimming, horseback riding, and rough-and-tumble games—unlike her sister Rachel, who was named for their mother.

Mrs. Salsbury, a trained opera singer, had been the lead soprano in the Troubadours, Nate's first theatrical company, when this popular group toured the country in the 1880s. After they married, she left the stage and did her best to erase the taint of the theater by maintaining bourgeois standards. Over time, Nate's management of the Wild West Show made him wealthy and allowed the children to grow up in comfortable circumstances.

Reading between the lines, one wonders what the Salsbury children made of their parents' mixed marriage. Born Rachel Samuels in Newburgh, New York, Mrs. Salsbury was the daughter of a Jewish merchant. Little is known of her musical career except that, chaperoned by her mother, she toured with an English opera company before joining Nate's Troubadours. Although Judaism held that offspring of a non-Jewish father and a Jewish mother should be brought up in the mother's faith, the Salsburys' religious training was minimal, like that of many children

at ECS. Rebecca, who was named for Nate's mother, internalized her heritage as a conflict between her maternal line and her father's "American blood."

Early photographs of the twins show how little they resembled each other. Becky, her family nickname, was thought to favor Nate, and Rachel, known as Ray, their mother; Becky was the pretty one and the more high-spirited. (At two, judging by portraits in which a favorite toy, a sock monkey, is clutched first by one, then by the other, the twins were already rather competitive.) Dressed in 1890s finery with their smartly suited brothers, they are the image of the affluent middle-class life for which they were being groomed. Even in snapshots outside their Upper West Side apartment building, the twins are dressed to the nines. Portraits of Rebecca in her early twenties present her as a latter-day Gibson Girl, her dark waves swept on top of her head in a knot, but with a quizzical look in her eyes.

Knowing that their father was part owner of a Montana cattle ranch, the Salsbury children had a sense of themselves as landed gentry. (The ranch had legendary status for the family because Nate claimed to have invented the Wild West Show there.) While Becky thought of her father and herself as westerners, the family spent holidays in Long Branch, the fashionable resort in New Jersey where Nate bought a "cottage" (a large house with servants' quarters) in 1895, when he retired from the Wild West Show.

Family photos show the girls in the care of a lifeguard; Becky became an avid swimmer even in frigid ocean water. Since the resort's golden era, when celebrities like Diamond Jim Brady spent holidays there, Long Branch had been a destination for influential New Yorkers, and more recently, their Jewish counterparts. The children would have known that Long Branch was called "the Jewish Newport" because of the well-to-do families—Lehmans, Guggenheims, Bambergers, and Bloomingdales—who summered there.

By 1900, Nate dressed in a three-piece suit and bowler hat, a style suited to his standing after he bought land in Long Branch to build a "select cottage colony." The local papers hailed him as a public benefactor, and he hoped that the development would ensure his family's future, given his loss of income from the Wild West Show under the new management. Nate's wish to secure his legacy is apparent in his names for the colony, known as the Reservation, and its cottages (among them, Shoshone, Cherokee, Iroquois, and Navajo). That these three-story mansionettes each had ten bedrooms, modern plumbing, and butler's

pantries gave them the cachet to justify their status as rentals for those who hoped to live like Diamond Jim.

While the Reservation increased the family's resources by creating their own East Coast domain, Nate's retirement was poisoned, he believed, by worsening relations with Cody, who kept asking for loans to maintain the Wild West Show. In his last years, as his children watched him write the memoir he meant to call "Sixteen Years in Hell with Buffalo Bill," they absorbed his resentment of Cody and his belief that the show had ruined his health. Salsbury died on Christmas Eve, four days after the twins' eleventh birthday. His body was taken to New York in a special car, the memorial service conducted by his fellow Masons. *The New York Times* noted Salsbury's career "as boy soldier, comedian, and manager of amusement enterprises"; Buffalo Bill's Wild West Show opened with its flag at half-mast.

· · ·

In 1903, when the Wild West Show began to deteriorate, Rachel Salsbury sold her husband's shares to safeguard his investment. The family continued to live in their Upper West Side apartment (at 30 West Ninety-sixth Street), the children attending private schools while their mother dealt with the lawsuits that plagued the show's shareholders. With her siblings, Rebecca pored over their father's scrapbooks, which detailed his theatrical ventures (including the first troupe of black performers in the United States) and reread his letters, written in the joshing style that reinforced their family feeling. She and Milton planned to publish Nate's account of the events that had brought them prosperity but shortened his life. In 1920, about the time that Rebecca met Paul Strand, Mrs. Salsbury sold the Reservation. The family fortunes continued to prosper; after Ray and Nate Junior both married, Rebecca continued to live with her mother, who kept close watch on the purse strings and discouraged her daughter's wishes for a less conventional way of life.

Dressed in a ruched and pleated high button blouse with a bow in her hair, Rebecca looks back at us from a contemporary portrait that marks a contrast to her accomplishments as gymnast, creator of theatricals, and author. She seems suspended in the atmosphere of her mother's household—the overstuffed parlor that symbolized all that she yearned to escape. When she and Paul met, he would have been struck by the dissonance between her background and her potential. Like him, she had absorbed the ECS ethos; like his aunt, she had put this into practice

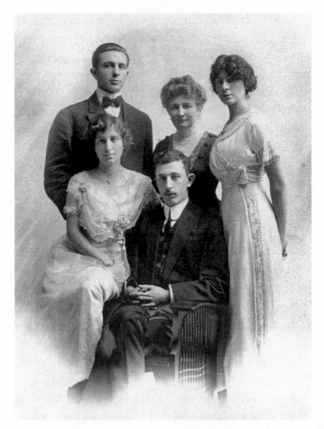

The Salsburys. Seated: Rachel, Nate Junior;
standing: Milton, Mrs. Salsbury, Rebecca

in the kindergarten movement. Despite bouts of low spirits, she revived in like-minded company. That the Salsburys were wealthy would not have gone unnoticed; more important, Rebecca's supple form made her a promising subject.

Their courtship began in the winter of 1919, when Paul, at twenty-nine, was struggling to find work as a commercial photographer, and Rebecca, who had just turned twenty-eight, was living at home. He took her to concerts and art exhibitions, among them a Marin retrospective (his Woolworth Building series made her feel "half-drunk"). During the day, when Paul's house was empty, they found privacy in his room, whose sparse furnishings struck Rebecca as the antidote to her mother's decor. They exchanged books (Conrad, Nietzsche, volumes of verse) and read each other's manuscripts. Paul told her to keep writing. He spoke of his

admiration for Stieglitz but did not introduce them until later, a brief meeting in which his mentor joked about the ennui of travel in the grand style—as practiced by his wife and her mother.

At this time, when Paul was photographing advertisements for such things as ball bearings and pharmaceutical products, he began a project with his friend Charles Sheeler. They hoped to capture the spirit of the city with Sheeler's 35mm movie camera. In practice, this meant gaining access to the upper floors and rooftops of the skyscrapers from which they photographed. Over the next six months, they took shots of the crowds disembarking from ferries or rushing to work in Wall Street's canyons, along with semiabstract views of Manhattan punctuated by smoke rising from locomotives and steamships. Strand called their portrait of the city in motion "the scenic."

Inspired by Alfred's portraits of Georgia, he also began what would become an extended portrait of Rebecca, for whom the walk from West Ninety-sixth Street to his home on West Eighty-third was a trip to another world. He photographed her with her hair down, her face showing the strain of trying to relax, and her dark hat shading her eyes. Although Paul's prints moved her to want "to see more deeply," she was concerned that they caught the "shadows and frets" that she kept hidden—the "neurosis" caused by being told repeatedly that her youth was slipping away. Paul was helping her "to get that notion by the throat."

Alone in Paul's room, he and Rebecca became intimate, and in time, lovers. She teased him about their lovemaking, his knotting her garters on a trip to Coney Island, their availing themselves of a remote park bench that left horizontal stripes on her winter coat. Although she was not used to housekeeping (the Salsburys had servants), she joked that she would learn the skills needed as a poor man's wife—in her view, an act of defiance that would meet with her mother's disapproval.

In the happiness of their new relationship, they wrote songs and poems for each other. (Like Paul's letters to her, his poems have not survived.) One of Rebecca's depicts the couple in Paul's room: "How tenderly / The breeze parts our snowy curtains / Eager to wake,— / Yet fearful / Lest it intrude." Each object testifies to their rapport: "Your open book / Touches my gloves / In rapt communion /. . . . There is no need / For us to speak." Rebecca called the poem "My Photography."

This free-verse declaration of love was included in a letter posted after Rebecca went to Niagara Falls with her mother at the end of May, the start of a long trip to Chicago, Montana, Canada, and Maine. Obliged to serve as Mrs. Salsbury's traveling companion, she already had "men-

tal indigestion." For the next three months, Rebecca would cling to the idea of communion with Paul as the remedy for the rage she felt in such circumstances. On occasion, even thoughts of him did not suffice: "I wanted to write to you yesterday, but was not able to—I could not seem to push my surrounding and people far enough away to give me space enough to find you."

Still, she clung to the thought of his "camera magic." And she looked forward to her two-week break from "Mummer" at her father's ranch. Once in Montana, Rebecca asked for more portraits of herself and sent Paul a poem that imagines their love "consummated / First in pregnancy—Then—In rapt maternity." In the same missive, she wrote, "It is curious to read your letters way out here. They are so full of contacts with other people, while here—there is only the language of the hills." Then she pleaded, "Come out and loaf and laugh and lounge with me." Her request (which echoes Georgia's letters to Paul three years earlier) would become a motif in the couple's relations and shape Rebecca's sense of what was possible for herself.

A Fine Companionship

1920–1921

The Red Menace preoccupied many Americans in the months lead-
ing up to the presidential election. The Socialists' nomination of
Eugene Debs, still in prison for his antiwar activities, along with the
fear that an economic downturn could foment revolution, created major
unease. The Republican candidate, Warren G. Harding, argued that the
situation required a "return to normalcy"—the old ways of living for-
saken in recent years.

To progressives who deplored Harding's stance (along with his neolo-
gism, *normalcy*), the thought of a return to prewar days meant the rejec-
tion of all that they had worked for. From Lake George, Stieglitz wrote
to Dove, "With the quiet of the morning it is hard to believe that there
is greater Hell in the world than during the War—& that sooner or later
something must 'happen.'" That summer, while he and Georgia stayed
at the lake and Rebecca traveled with her mother, Paul continued to
work on the "scenic," which had, in a way, developed from his photo-
graph of Wall Street's canyons. He left for a vacation in Canada just
before something happened that would persuade a majority of the elec-
torate to vote for Harding.

On September 16, a bomb filled with metal and dynamite went off
across the street from the Morgan Trust building, killing thirty-eight
people and injuring hundreds. (The timing, soon after the indictment of
the anarchists Sacco and Vanzetti, made it seem like a protest against
their imprisonment; the case was never solved.) Official reaction was
swift. Palmer stepped up the surveillance of radicals; the New York
police formed a unit to monitor suspicious elements.

Under the circumstances—the sense of postwar dislocation, growing
antiradicalism, and the rise of xenophobic nationalism—groups like the
United Americans called for a new order based on the Ten Command-
ments. Writing in *The New Republic,* a banker worried that America

was entering "a maelstrom of bad times"; a businessman opposed to both unions and immigrants claimed that the United States was "in the hands of labor agitators, politicians and fruit peddlers"—by which he meant Italians, like Sacco and Vanzetti.

Members of the Stieglitz circle would Americanize in their own way—as "workers" who would save America's soul by portraying it in terms attuned to its own shapes and colors. The younger men who had recently joined Strand to gather around Stieglitz—Paul Rosenfeld, Waldo Frank, and Herbert Seligmann—shared his messianic view of the arts, a secular version, some said, of their middle-class Jewish outlook. Theirs was "the first generation of Americans consciously engaged in spiritual pioneering," Frank wrote in *Our America,* a kind of group manifesto. 291 had shown the way toward America as "a promise and a dream." Now writers like Sherwood Anderson and Van Wyck Brooks, artists like Stieglitz and Charlie Chaplin, and poets like Robert Frost and Carl Sandburg were making art that would reinvigorate the country: "We all go forth all to seek America. And in the seeking we create her."

Reading Frank's *Our America* during her travels that summer, Rebecca was stirred by the author's zeal (and perhaps pleased to know that he came from Long Branch). "Strando" having recommended the book, it struck her as the last word on "this business of being oneself." At her father's ranch in Montana, she indulged in behaviors she thought of as "hell-raising"—wearing pants to go horseback riding, peppering her speech with the ranchers' "god damns," and "building up a lot of badly needed character." Photos taken there show her attempts to Americanize, western-style: Seated squarely on her saddle, she is the partner of her new idol, Bill Sullivan, the ranch manager. Meeting up with her brother Milton, who had been working in the mines, she listened to his tales of the Wobblies and was awestruck to meet the populist hero William Jennings Bryant.

Paul sent books to assist in her project of self-discovery. Writing from her Lake Banff hotel, where Rebecca spent the rest of July with her mother, she said that she had just "met" Paul's idol Sherwood Anderson in the pages of *Our America* and saw him, Dreiser, and Stieglitz as models of the kind of free thinking she admired: "It seems as if no outward circumstance or pressure can dominate this force of self and its expression." She tried to keep this thought in mind even in dark moments (as when taking tea with her mother in her Sabbath garb, a white satin dress trimmed with lace).

Correspondence with Paul provided Rebecca with a weapon against

Bill Sullivan and Rebecca on horseback, Square Butte, Montana, 1921

self-doubt. "No one can help as you do," she wrote after imagining him by her side on a walk. Considering herself "a person of more than medio-cre artistic ability," she felt that she needed "some force or call it person [to] stimulate the ability into a flash of something fine." Paul was that person. To demonstrate her talent, she sent him drawings, love poems, and verbal snapshots; to show her faith in him, she asked if he was not "absorbing too much of Stieglitz." She added, "No man's life parallels another's exactly and you have enough personality of your own not to envy anybody."

Meanwhile, Rebecca tried not to think about what she would do after fulfilling her obligations. Paul offered to put her in touch with Waldo Frank's wife, Margaret Naumberg, who had studied with Maria Mon-tessori before founding the Walden School in Manhattan to promote the development of young children through artistic self-expression. But Rebecca was reluctant to go back to teaching. Above all she looked to her relationship with Paul. She sent him a poem that began "Some-

times / You are so much in me / That I am you," then received one from him that read "And you are far away— / Yet—very close— / No / Right inside of me." Their accord gave her "a feeling of oneness—of perfect communion.

By then, Rebecca's sense of spiritual pioneering had deepened her scorn for formal religion as practiced by her mother. Absorbing Paul's values (and by extension, Alfred's), she echoed their talk about the importance of "seeing": Paul's photographs revealed the essence of his subjects—whether people, bowls, or landscapes. Just when she was on the verge of giving in to the plush life she was leading, a letter from him had the effect of "justif[ying] the other self and strengthen[ing] it." But by August, when Rebecca returned to New York with bronchitis, she feared that she was "dying—spiritually." To strengthen her commitment to "seeing," she went to the Metropolitan Museum to revisit the paintings they had looked at together.

"The circle is complete again," Rebecca wrote from the Long Branch hotel where she had gone to convalesce—though it was odd to find a "kosher" family residing in the house her father had built for them. Old friends welcomed her; she joined a reading group of "well-fed ladies in irreproachable summer frocks" while continuing to devour works on Paul's reading list, Anderson's *Winesburg, Ohio* and a volume of Nietzsche, both in favor in the 291 circle.

By then, an emotional shorthand had developed between the couple based on their being Ethical Culture graduates and secular Jews. Rebecca's allusions to her coreligionists assume that Paul shared her view of the people at the hotel where she and her mother spent September. It was "filled with F.F.P.'s (First Families Palestine)," she wrote. On Yom Kippur, she went swimming, "to the consternation of the ladies of the house, who consider me slightly deranged." She added, "I'd rather swim in the ocean than atone all day in a synagogue!" She asked Paul to send her his recent portraits of her—"I truly feel that they will be a source of health, strength and beauty."

It was at about this time, when Rebecca saw Paul's portrait series as a kind of mirror, that she began using his nickname—"Beck," a snappier version of her given name—and decided to try painting. Since the spring, she had daydreamed that she, too, might explore new fields of expression. Her rapport with Paul helped her form an idea of herself as someone who not only posed for the up-and-coming photographer but might, with his support, become an artist. That this view of their relations echoed the rapport of Alfred and Georgia was not lost on her. Soon

she was experimenting with graphic black-and-white compositions that looked distinctly modern. "I owe you so much for having started me," she told Paul, "whether I do anything or not."

Strand stopped at Lake George that fall to show Stieglitz his new work, including the portraits of Beck. After a summer in the family farmhouse, now known as "the Hill," Alfred and Georgia did not miss Oaklawn. For the past two years, she and Davidson had been cultivating the wizened apple trees that abounded on their land. To Alfred, the orchard's rebirth symbolized his vision of a homegrown modernism: His portrait of Georgia holding a branch laden with fruit all but proclaimed her artistic fecundity as a native product. With the help of the Davidsons and other guests, Waldo Frank and Margaret Naumberg, she renovated a shed to use as a studio—an undertaking Alfred found so impressive that he photographed the women nailing shingles on the roof in their bloomers. He took few photographs of Georgia, despite her radiant health; two portraits of Naumberg suggest that he may have preferred Margaret's reflective mien and soulful eyes.

Alfred spent much of his time printing recent work while Georgia put the finishing touches on the shed. It distressed him to learn that the "shanty" (Georgia's name for it) was *her* studio and not the shared space he had imagined. When the heat became unbearable, she painted there in the nude. These hours of solitude allowed her to start a new

Alfred Stieglitz, *Elizabeth Davidson and Georgia O'Keeffe.*
On the roof of O'Keeffe's shanty, Lake George

series—oil paintings of apples, which took on lives of their own. While Alfred liked to compare his artists to apple trees (the soil gave their art its zest), O'Keeffe's paintings hint that she saw the fruit as a way to depict human relationships. It is not far-fetched to see her need for privacy in *(Untitled) Apple and White Dish,* in which a solitary apple sits alone on its china pedestal. Similarly, the two rounded forms in *Apples—No. 1* may stand for Alfred and herself, and the grouped shapes in three related compositions called *Apple Family* for the dynamics in the crowded household from which she retreated to paint these placid models.

During Paul's visit to the Hill, he let Alfred know that Beck was not only keen to work with him as his model but had herself begun to paint. "When we return she ought to see more of Georgia's work," Alfred wrote after Paul's visit. "It may be helpful—a clarifier. —I wonder what she will finally decide to do—that is what course she will feel she must follow." Glad to learn that Beck was also a typist, Alfred asked if she took shorthand. (She did.)

Alfred did not let on that Paul's portraits of Beck had caused him some unease. Several of his own prints, the "nearlys," were not quite right, he confessed to Seligmann: "I am getting to hate 'nearlys' more & more. —And the more nearly to the IT—the more I hate that nearly.—It's like an incomplete erection." He worried that a lack of virility was apparent in his prints, especially now that he was preparing for his first exhibition since 1913, at the Anderson Galleries. (The equation of formal rigor with the artist's potency was a recurrent trope in the Stieglitz group's discourse. Sherwood Anderson would write, "I have quite definitely come to the conclusion that there is in the world a thing one thinks of as maleness that is represented by such men as Alfred Stieglitz. It has something to do with the craftsman's love of his tools [*sic*] and his materials.")

By October, Alfred had overcome his concern about the "nearlys." He had been thinking about Paul, he wrote: "The girl—your work. . . . I hope life in N.Y. with you is more agreeable than you anticipated made so by your friend. —There is nothing more stimulating than a *fine* interchange between male & female." He could see that some of his own prints were "corkers." His recent portraits of Rosenfeld and Frank sought to honor their commitment to American art: He photographed Rosenfeld with a typewriter and four books chosen to emphasize their significance (among them, *Our America*), and Frank on the porch, peeling apples onto a manuscript, as if infusing it with sap. When Paul expressed his admiration for Frank's likeness, Alfred promised to take

one of him, since Paul's technical advice had been crucial to his success with this new kind of portraiture.

On November 2, as a fierce gale blew across the lake, Alfred reacted to the news of Harding's landslide victory by stoking the fire and waiting out the storm. Finding the embers still glowing the next day made him feel "Master of the situation," he told Paul, though he added, "Let's hope it wasn't an accident." Whatever happened in the larger world, the important thing was finding the energy to start a new project, "pitching in & making a beginning."

In the meantime, Paul took over the room that had been his father's, since it had the right kind of light to use as a studio. When he and Beck continued their portrait sessions out-of-doors, she found it hard to stay still during the long exposures. "Movement is everywhere," Paul wrote to Alfred, "but I learned something—in fact there has been more of that I think than actual results." Beck tried to defuse the situation with humor, teasing Paul about the need for "asbestos underwear." They had made a start, he told Alfred, "a fine companionship . . . a chance to work together."

Judging by Beck's letters from Long Branch, where she went to practice painting in December, their companionship meant even more to her. After buying a worker's flannel shirt, she felt dressed for the part, although due to the weather, she had to wear her fur coat over this outfit. Paul would laugh at her efforts, she thought, yet her usual tensions had vanished after a few days on her own. It was exciting to layer paint in broad strokes on the canvas; she had hoped to do a nude self-portrait, but it was too cold.

Beck wanted Paul to know that, following his lead, she was trying to see things in their own right. "I have been thinking about what you said about your need for sharpness—acidity," she wrote. "I love that hardness in you—for it means no beating around the bush and no assuming of other people's values." She ascribed the change in herself to their rapport: "Strength seems to flow from you to me, from me to you and back again, like fine music. I realize it so much more when I get away and find myself dissociated from everybody but myself and you."

· · ·

Georgia and Alfred returned to New York at the end of the year to take up residence in his brother Leopold's brownstone on East Sixty-fifth Street, where they would have separate studios and a salon in which

to receive friends. In the new year, members of the group went into high gear to publicize his upcoming retrospective. Rosenfeld let him know that he would return the favor Stieglitz had shown him by taking his portrait for an article about the exhibition for Scofield Thayer's new magazine, *The Dial;* Henry McBride, who thought that the show would attract the old 291 crowd, said that he would join them at the opening. Strand had recently written an essay entitled "Alfred Stieglitz and a Machine" but had not found a taker. It was privately printed for distribution at the show, which opened on February 7.

The gallery filled up quickly, despite the driving rain. McBride noted, "There is such a thing as loyalty in America, Alfred Stieglitz is now thinking, or ought to be thinking, for all of his old friends and disciples and many new ones turned out on Sunday and Monday afternoons to see his life work . . . and tell him how much they had missed him." Alfred's favorites—Marin, de Zayas, Hartley, Walkowitz, Rosenfeld, and Strand—watched admiringly as he held forth nonstop. To those who asked if he planned to start a new gallery, he replied, "Why should I? . . . I have my own work to do." Of his work as a whole, he said, "These are moments consciously recorded by me. There is a specific way of approaching life and letting life be life."

At the time, Georgia did not comment on the 145 "moments" comprising Alfred's retrospective. His photographs were all "spiritually significant," she wrote the following year: "I can return to them day after day . . . with always a feeling of wonder and excitement akin to that aroused in me by the Chinese, the Egyptians, Negro Art, Picasso, Henri Rousseau, Seurat, etcetera." They should be taken for what they were—proof of his artistic vision and "spiritual faith in human beings." When crowds at the gallery gathered in front of a particular nude, O'Keeffe may have thought that they shared her belief in its spiritual significance. While she was perhaps naïve about the awed response to the nude pictures of herself, she could not have anticipated the rhetoric of those critics who had been primed by Stieglitz to discuss these pictures in his own language.

The photographer was one of "the great affirmers of life," Rosenfeld wrote. "He has felt the life in every portion of the body of women," he continued, "the navel, the *mons veneris,* the armpits, the bones underneath the skin." Cataloging the body parts on the walls, Rosenfeld praised Stieglitz's ability to "pour out his energy with gusto" into each of them, his camera's enactment of a "grand double movement" of "penetration" and "release." Similarly, Lewis Mumford declared, "It was his

manly sense of the realities of sex, developing out of his own renewed
ecstasy in love, that resulted in some of Stieglitz's best photographs. In a
part by part revelation of a woman's body . . . Stieglitz achieved the exact
visual equivalent of the report of the hand or the face as it travels over
the body of the beloved."

It was one thing to regard photographs of oneself as art objects and
quite another to learn that the revelation of one's body would be taken
as evidence of the photographer's "love of the world." Coming from
months of solitude at the lake, where she had reflected on relationships
in her *Apple Family* series, O'Keeffe felt exposed once this kind of lan-
guage began appearing in print. Becoming a newspaper personality (as
McBride would write) not for her own work but because of the scandal
ignited by Alfred's was not the kind of attention she desired. And she
must have felt doubly betrayed once she understood that Alfred had
orchestrated publicity for the show in terms guaranteed to kindle the
prurient interest of the public.

When visitors picked up copies of Strand's essay as they strolled
around the gallery, O'Keeffe may have hoped that his focus on the
nature of photography would deflect attention from herself. "Stieglitz
had accepted the machine, found in it something that was part of him-
self," Strand wrote, with greater feeling for his mentor's kinship with the
camera than Rosenfeld or Mumford. Yet the familiar rhetoric surfaced
in Strand's account of the masculine as objective and the feminine as its
opposite, as in his praise for the way that Stieglitz's portraits, "whether
they objectify faces or hands, the torso of a woman, or the torso of a tree
suggest the beginning of a penetration of the scientific spirit into plastic
media."

One wonders if Beck, a modern woman in the making and a careful
reader of literary texts, detected the echoes of this rhetoric in Paul's
essay. Early in their acquaintance, she warned him against following too
closely in Alfred's footsteps, yet she took pleasure in her role as his muse
in a project inspired by Alfred's ongoing portrait of Georgia. Meeting
Georgia on the walls as she walked around the gallery was a revelation
of the kind of woman Beck hoped to become: one whose lack of inhibi-
tions had made possible new ways of affirming the "reality" of which
Paul spoke, through the use of the camera.

At this point, unaware of Paul's ties to Georgia, Beck's admiration for
her was undimmed. She would have agreed with McBride's look back
at this volatile time, just before the new administration's embrace of
normalcy: "O'Keeffe is what they probably will be calling in a few years

a B.F., since all of her inhibitions seem to have been removed before the Freudian recommendations were preached upon this side of the ocean." If the Stieglitz retrospective proved how much his circle missed him, it also launched O'Keeffe's reputation as the woman who "became free without the aid of Freud."

. . .

Despite Beck's wish to shed her inhibitions (to be Beck rather than Rebecca), it was impossible to do so while living with her mother. While attempting to balance the roles of modernist muse and dutiful daughter, she had a great deal to hide. Mrs. Salsbury would have been outraged to learn that she was having an affair with an irregularly employed photographer and taking as her model an artist who lived with her married impresario. On holiday with her mother in the spring, Beck told Paul that she had torn up her latest painting, and that she had devoured Sinclair Lewis's *Main Street* (another group favorite) but regretted its heroine's abandonment of her dreams. What kept her going, she told him, was the memory of "your beautiful loving, our beautiful loving, so quiet and turbulent."

But it was disappointing to learn that her own turbulence had spoiled the results of their last portrait session. "I raged when you wrote that I had <u>moved</u> again—that <u>must</u> be conquered," she wrote, telling Paul not to be "too patient" with her. She offered her services in a different role, as sounding board and typist once he could start writing a book on photography based on his articles—an offer meant to enhance his reliance on her while propping up his self-esteem. "It will be different even from whatever Stieglitz might write," she noted.

It would not have been obvious to readers of Strand's criticism that he lacked self-confidence. Like Rosenfeld, Frank, and Seligmann, he contributed essays to periodicals that, in their view, paid insufficient attention to the kind of art they favored. He argued that the camera, though a machine, could convey the texture of modern life, and in the hands of a man like Stieglitz, photography was anything but mechanical. "Alfred Stieglitz and a Machine" was scheduled to appear in France and Germany; his review of a watercolor exhibit that omitted O'Keeffe ran in *The Arts*; his defense of Marin's Americanness appeared in *Art Review*. Beck thought that Paul's way with words could result in a book that confirmed both his expertise and his acuity.

To maintain some degree of independence, she went on typing

records for two New York doctors, an occupation that got her out of the house and left her mind free for other pursuits. But Beck's salary was insufficient to cover items like fine clothes or holidays, for which her mother provided funds when it suited her. Nor were Paul's prospects encouraging. He felt like a monkey jumping from one perch to another, he told Alfred that summer, when he was looking for work in the new field of advertising. He had met with an agency to discuss the use of the slow-motion camera to analyze athletic form. But lacking the funds for the specialized camera, he felt blocked: "When you need other folks before you can do a thing you must expect to be blocked, I suppose."

Strand was also trying to find an outlet for the scenic filmed the year before with Sheeler. Entitled *New York the Magnificent,* it ran for a week in July at the Rialto Theatre. The program began with a newsreel; the scenic, sandwiched between an Oriental dance and an aria from *Aïda,* came before *The Mystery Road,* a feature film about an English earl's affair with a French peasant. Their movie earned positive reviews, including one that deemed it "more interesting than the feature," but Paul despaired of finding a distributor, especially after learning that local newsreel companies were documenting the city in a naturalistic style more apt to meet with success than their film's distanced approach. (While some called their scenic groundbreaking in its alternation between modernism and romanticism, its depiction of faceless crowds was at odds with the tender intertitles from Walt Whitman's "Manna-hatta," for which it was later named.)

Paul and Beck were enjoying the summer even though they were not often together. Anxious to cultivate Alfred's approval of them as a couple, Paul told him that she swam as well as he did, described their culinary efforts (Paul offered to make Welsh rarebit for Alfred and Georgia), and praised a painting of Beck's that hung on his wall opposite work by Marin and Dove: "It . . . lives very well for me with the other things despite its limitations." Alfred gave them his blessing. Recalling their last time together, he wrote, "You and Beck both looked very fit that evening, Beck particularly. She seemed much 'improved,' in many ways. Freed." He invited Beck to spend her holiday at the lake, but he worried about Georgia's eyes—the strong summer light had made it impossible for her to paint.

At the end of the summer, Paul informed Alfred of the death of his uncle Nathaniel Myers, the family benefactor, and mentioned the bequest he intended for Paul despite his belief that men should look after themselves. Alfred replied, "I dare not express the hope that you

might be given the chance to marry." Paul replied that nothing had changed, as it would take time for the will to go through probate. "I am heir to what is known as a 'nest egg' and in that I was lucky," he added, in that Myers's other nephews received nothing.

In the meantime, Paul felt blocked. His slow-motion-study project had come to nothing, and while de Zayas planned to take the scenic to Paris, their hopes for a commercial run had not met with success. What made him happy was Alfred's willingness to include Beck in their circle. "I showed her your letter," he wrote. "She has been fine—strong and yet amazingly naive in some things. . . . But we are working it out together so far and what more can we ask."

Paul arranged for Beck to spend September with friends who took in boarders at Twin Lakes, Connecticut, where his family often stayed. While he worked on prints in the city, she could devote herself to water-colors; he would join her on weekends. At first, finding it too difficult to combine color and volume, she told Paul that she would not use her paints until she felt she was not wasting them. More ambitious for his success than for her own, she encouraged him to write in the morning and print in the afternoon. But what mattered most was their love: "You . . . seem to be in my hands, my feet, my breasts, stirring in my womb—and outside me too in everything that is beautiful."

Beck picked up her paints to try working *en plein air,* but she was again frustrated by her inability to translate the landscape into form. After noting "a hot red star" in the night sky (an evocation of O'Keeffe's night star paintings?), she composed word pictures to show Paul that she, too, had the gift of "seeing." But without a strong calling as an art-ist, she reverted to the role of helpmeet: "If only I could do more—give myself more and more to you—and your work."

Still, Paul's insistence that she pose for hours each weekend felt like an added pressure. After a trip to a pine forest where she painted and he photographed, she told him that the place now spoke to her of him, and in almost the same breath, voiced her independence: "You seemed to want to identify me with a tree and I wasn't feeling that." Recalling his remark about her needing to relax, she chided, "It isn't a matter of not being relaxed. It's a matter of position." Moreover, she was cross with him for photographing her when she was sleeping: "Do you think it's nice to take ladies off their guard like that . . . ?"

Paul continued to fret about Beck's inability to relax but did not see that his single-mindedness made it hard for her to let go. Unlike Stieg-litz, he lacked the playfulness that put sitters at ease. Besides, Beck

was unlikely to feel carefree in front of the camera with so much at stake, including their future as a couple. Yet despite her reservations, she longed for his return.

To thank Stieglitz for inviting her to Lake George and explain her decision not to accept, Beck composed a letter on October 1. "I have not been unmindful of your generous hospitality," she began: she had simply felt too "fagged" to make another journey. Since coming to Twin Lakes, she had gained some ease with "that very elusive medium," watercolor, and spent each weekend with Paul. She added, "It's fine to be together," but she said no more about their relations except that they looked forward to seeing Alfred and Georgia in New York.

"I had a very fine note from Beck," Alfred told Paul some days later. "I hope the relationship is developing naturally & this to your mutual development." He did not let Paul know of his reservations about his work, although at about this time he expressed his doubts to Seligmann: "I do hope that Strand finally finds some means of getting cash so he can get the full experience of the experiment—if it's in him to get a full experience." Seligmann replied that Strand's prints were "all dressed up with technical mastery and no place to go."

At this point, Paul was unaware that his position as Alfred's favorite was being called into doubt. He praised his mentor's recent comments on the "Paintings by Modern French Masters" exhibition at the Brooklyn Museum as "more alive—more truly criticism than all the 'literature' of the professionals," and said that he hoped for lively writing from Rosenfeld and Seligmann. Still, he was disturbed by what he called Rosenfeld's "mystic streak, which tends to become somewhat saccharine"; the same was true, he thought, of Frank's *Our America*.

Strand was himself trying to write criticism that avoided the saccharine. His current piece, "Photography and the New God," was to appear in *Broom*, a magazine of the arts recently founded by Alfred Kreymborg and Harold Loeb. Given that the country as a whole was obsessed with science, photographers were well placed to articulate this philosophy. "The deeper significance of a machine, the camera, has emerged here in America, the supreme altar of the new God," he argued. But this deity had to be humanized "lest it in turn dehumanize us," he wrote in an aside, before ending with a high-minded question about "the relation between science and expression . . . whose coming together might integrate a new religious impulse."

Shortly after taking possession of his modest nest egg, Paul and Beck were married at the Society for Ethical Culture on January 21, 1922. In

a gesture of reassurance for their families, they chose as their officiant David S. Muzzey, an ECS leader and a Columbia professor; Beck's sister Ray was her witness. Following their honeymoon in the Pocono Mountains, the Strands would take up residence in his family home and turn his room into an up-to-date photographic studio with minimal furniture and photofloods in lieu of lamps. That their sanctuary was a shrine to Paul's ambitions did not seem odd to them, nor did the thought of starting marriage without a home of their own. For Beck, the move from her mother's household to her husband's provided the entry into the kind of life she had always longed for.

Twentieth-Century Seeing

1922

Stieglitz embraced the young couple wholeheartedly. It seemed likely that their marriage would end any awkwardness between Paul and Georgia and establish the two couples' relations on a new basis. Paul wrote from the Poconos that he wished Alfred and Georgia could join them there.

On their return, the Strands began turning Paul's room into a space for "20th century seeing." Like a miniature 291, it displayed their art collection, including work by Dove, Marin, and O'Keeffe (a group of apples) in plain wooden frames. Georgia's apples made a strong statement, Paul told Alfred; they were there "in the same sense that some photographs are there." At that time, the couple also possessed one of Brancusi's casts of *Mlle. Pogany,* the semiabstract head of a woman that had mystified viewers at the Armory Show. Paul's photograph of the head suggests a portrait of a woman who knew how to stay still; Beck amused herself by covering the sculpture's pate with her hat.

While Beck could be irreverent about Paul's icons, he remained in thrall to the Stieglitz ethos. That winter, he gave his support to Alfred's latest plan, a magazine for the promotion of the American vernacular in art to be called *Manuscripts,* or *MSS.* Seligmann and Rosenfeld would serve as editors; O'Keeffe would design the logo; Strand would oversee an issue on the question "Can a photograph have the significance of art?" The first number set the tone: "*MSS.* is published by the authors of the writing which appears in it. Send them ten cents a copy if you like it, or Subscribe One Dollar for Ten Numbers to be issued in Ten Days—Ten Weeks—Ten Months—or Ten Years."

The magazine's cheeky attitude accorded with Beck's disinclination to follow the rules. She wrote to Alfred, offering her typing skills in the service of "something <u>really</u> alive," unlike the treatises on medical disorders that occupied her during the day. Happy to use her free time in sup-

port of the group's house organ, she took on what became a second job: transcribing essays for the *MSS.* photography issue, working as Paul's coeditor, and critiquing the piece that he was writing for *Broom.* In time, she hoped, he could start his book on the aesthetics of photography.

The newlyweds sought out like-minded friends, including the photographer Kurt Baasch and his wife, Isabel. Strand had met Baasch at the Camera Club, where he'd had a solo show in 1913. But unlike Strand, Baasch was not ambitious, preferring to take pictures on weekends at his house on Long Island. The Strands enjoyed trips there to visit the couple and their daughter, Olga, who loved to tease her shy "*tio*." Paul relaxed with them: "He was warm with us, one of the warmest people I knew," Olga Baasch recalled. Beck's high spirits made a strong impression: "There was often a cigarette dangling from her mouth. She was the only woman I knew who smoked, even in the flapper era."

The marriage of Waldo Frank and Margaret Naumberg offered a different kind of model—theirs was a union of free spirits. They had wed to satisfy the need for respectability, but they supported each other's quest for self-expression. Margaret introduced Waldo to the ideas of Freud, which seemed to justify sexual freedom, and in his mind, his affairs: "We had wanted to live openly together because we loved each other. . . . It was understood between us that we were not really married." But reporting one's infidelities to one's spouse was not Beck's way of being modern, nor did she feel at ease with Margaret, whose status as an educator reminded her of her own lack of direction.

Beck was thrilled to be included when Alfred and Georgia invited the clan to their salon. Her acceptance by people whom Paul admired—Rosenfeld, Seligmann, and, above all, O'Keeffe—made her feel that they were kindred spirits. Still dressed in the stylish clothes paid for with her clothing allowance, Beck began modeling herself on Georgia, who ignored current fashion—shorter skirts, low waists, and bold colors—in favor of loose black dresses or tunics and long white smocks. But Georgia was slow to warm to the newcomer.

In the meantime, Beck sympathized with Georgia's consternation at the growing number of critiques explaining her work by virtue of her sex. Rosenfeld rhapsodized in *The Dial:* "Her great painful and ecstatic climaxes make us at last to know something the man has always wanted to know. . . . The organs that differentiate the sex speak." The normally sympathetic Hartley declared, "The pictures of O'Keeffe . . . are probably as living and shameless private documents as exist." Reading Hartley's essay, Georgia had been tempted to lose the manuscript to keep it

from appearing in Hartley's *Adventures in the Arts*—a book dedicated to Stieglitz, whose "Freudian" views were constantly replayed in their circle. Hutchins Hapgood told her not to mind: "They were only writing their own autobiography . . . it really wasn't about me at all."

In May, Georgia went by herself to stay with friends in York Beach, Maine. She took long walks, watched the waves crashing on the rocks, and painted the sweeping landscape. She hoped that Alfred could understand her exhilaration: "I am getting to something of myself here that I couldn't get when I was with you." Still, the separation only enhanced their intimacy: "We seem to be one if we're miles apart." While she was glad to be getting back to herself, she missed him, especially in bed. (Her letters inform him of Fluffy's alertness and her desire for the Little Man.) After describing the "green glass" of the sea, she confessed, "I am on my back—wanting to be spread wide apart—waiting for you to die with the sense of you—the pleasure of you—the sensousness of you touching the sensousness of me."

While Georgia recovered her joie de vivre, Beck delighted in her budding friendship with Alfred. She, Paul, and others in the group spent an enjoyable evening together after a concert; Beck made them laugh by describing Paul in his lavender pajamas. "It was all so humorous & very nice," Alfred told Georgia. He appreciated Beck's breezy manner as much as her secretarial skills. In July, she wrote to him at Lake George, saying that Paul would provide the "serious, critical, analytical bon mots" in his letters, and she would "be silly" in hers. Over the next few months Beck would play the role of flirtatious "kid" to Alfred's "Old Man."

Before leaving New York, Alfred asked Beck to pose for him. One picture from this session was "astonishing," he told Paul, "exactly the thing I was after." In the first of Alfred's many portraits of Beck, her hands clasp a gleaming black ball, suggesting a glimpse into the future. Beck was glad to learn that she had stayed still. "Good old Stieglitz," she wrote, "to get me moveless the first shot out of your Eastman box. I have gurgled and crowed over poor Paul until I am sure he wishes neither of us had ever been born. . . . Shoot along a proof to show him how superior we are as a working team."

Their exchanges became more complicitous over the summer. Beck asked if "St.," Alfred's habitual signature, meant "saint" and teased him about being a martyr. She continued: "I miss seeing your hundred thousand year old eyes looking across at us 'kids' and . . . loving us—Well, we all love you." Alfred replied that "St." meant "Stewed" and addressed her as "R.S.S." He chortled at the thought of her hat on *Mlle. Pogany's* head.

"You are a thoroughly live wire," he continued. Paul was fortunate "even if you occasionally have to bat each other into shape so as to bring about a more complete fit."

While Beck let Alfred know that she enjoyed a good fight, Paul restricted remarks about their life together except to note their happiness. She was "a great kid—fine and staunch," he wrote after letting on that he, too, had photographed Beck's hands. At the start of another three-cornered relationship, each read letters from the others out loud to their spouses as demonstrations of their trust.

Only Georgia kept her distance. Hoping to help in Georgia's efforts to regain the weight she had lost, Beck told Alfred to have her drink cocoa. She pictured Georgia slaving over the piece she was writing for the *MSS.* photography issue and her reactions when letters from Paul and herself were read aloud. Beck could not help seeing "Georginka" as the antidote to her own sister. While she was unsure how offers of friendship would be received, Alfred wrote that *he* was "more than well pleased" with her and Paul. He appreciated Beck's devotion to *MSS.*: "You would have been a great asset at '291.'" Even more, he enjoyed her remarks on married life: "So you and Paul had a real tussle & he has made a photograph after it which you think is an addition. I don't doubt he is growing. And naturally I'm curious to see what he has done." (By then, she surely sensed that Alfred was more than a little jealous of Paul.)

After printing his recent negatives Alfred told Paul that he would keep only a few—chief among them the print of Beck's hands. He continued: "I have come very close to the Centre of the Bull's Eye. . . . It's that darned Centre that is the only satisfying thing. It's like the Centre of Woman that man tries in vain to reach." Paul was more guarded about his problem with hitting the mark in portraits of her. By then, he was pursuing work in motion pictures, and through Beck's connections, he found work as a freelance cinematographer with a company specializing in surgical films.

To this end, Paul bought an ultramodern motion-picture camera on the installment plan—the gleaming Akeley that became one of his favorite subjects. That summer, he alternated between close-ups of the Akeley and of Beck's face and hands, including some in which she held *Mlle. Pogany.* Sensing Alfred's interest in their rapport, she said that Paul's refusal to credit her with the staging of these pictures had resulted in another tussle. But she did not state the obvious: that her hands served each day to earn the wages on which they relied and at night to type submissions to *MSS.*

At this time, the Strands tried out a device called an "Iron Virgin," the head clamp that Paul asked Alfred to get for him to help Beck stay still. Alfred wrote, "Wait until Paul puts you into the Iron Virgin & says: 'Smile—be natural.'—If Stieglitz made you do these things you'd look natural enough." When Beck complained that the clamp was gouging holes under her ears, Alfred pictured Paul's reaction: "He'll be shouting to you soon: 'For Heaven's sake breathe. . . . Sit still—don't move—let there be life.' " The experiment was not a success.

By the end of the summer, Beck was ready to leave town. Alfred welcomed the thought of her spending time at Lake George: "You poor lonely more than tired Soul—with Paul working so hard. . . . I'd like you to have a great vue [sic]—A real healthy rest. —Out of doors. —We'll do all to help you get it." If she read between the lines, his signature hinted at fantasies about what might take place there: "Here's to you & Paul—from us both—Your old St. (Sinner)."

<center>. . .</center>

Alfred and Georgia met Beck at the station and took her to the Pines, a nearby guesthouse. Despite the full house at the Hill, they both looked more relaxed than in New York. Georgia had gained ten pounds; Alfred had recovered from his exhaustion. They were preoccupied by his mother's health (she was attended by two nurses), his estrangement from Kitty (he had not been invited to her wedding to Milton Stearns, a childhood friend), and his divorce proceedings. Still, they took Beck to tea with their guests and for rows on the lake, a favorite pastime.

Despite their kindness, Beck felt unsure of her role there. She had brought painting supplies, but her palette, made of glass, had broken during the trip. While the one undamaged piece allowed her to make do, it was a bad omen. After seeing Georgia's oils, a series of Lake George landscapes, Beck felt worse than inadequate. She had the finest paper, brushes, watercolors, and oils, she told Paul, "everything but ideas." Moreover, despite its obvious beauty, the site did not enchant her. She doubted that she would stay for the month.

Beck's spirits lifted when Alfred repeated his praise of her as a model. His shot of her "paws" was a success; he looked forward to more sessions. She admired his new work, portraits of Donald Davidson, Claudia O'Keeffe (then an art student at Teachers College), and his niece Georgia Engelhard, known as "Georgia Minor," as well as his photographs of barns, trees, and clouds; Beck urged Paul to add to his portfolio even

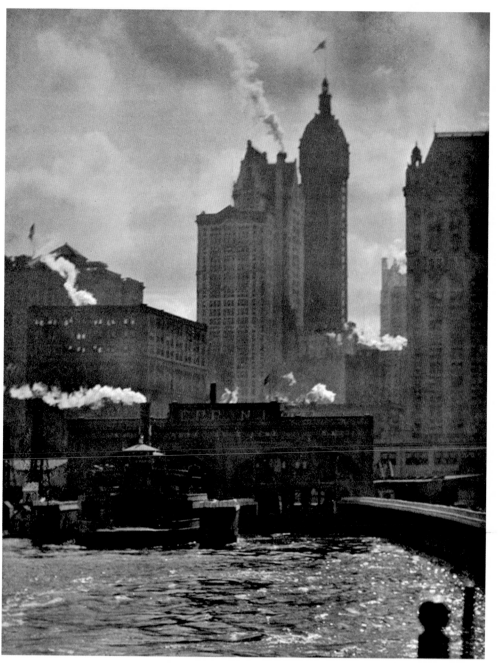

Alfred Stieglitz, *The City of Ambition*, 1910

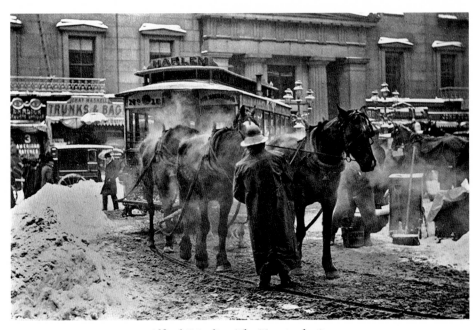

Alfred Stieglitz, *The Terminal*, 1893

Alfred Stieglitz, *The Hand of Man*, 1902

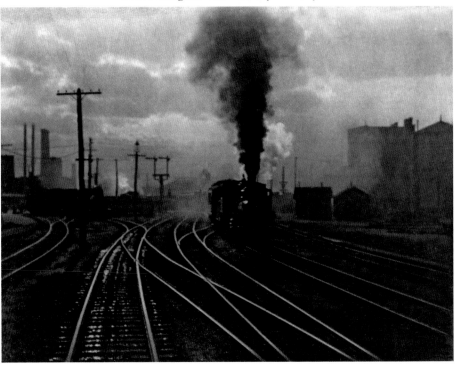

Alfred Stieglitz, *Waldo Frank*, 1920

Alfred Stieglitz, *Marsden Hartley*, 1916

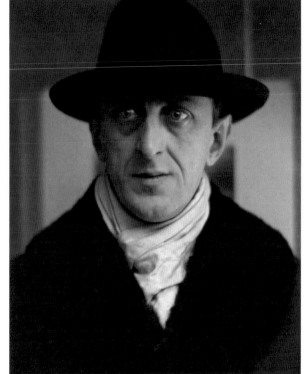

Alfred Stieglitz, *Music: A Sequence of Ten Cloud Photographs, No. 1,* 1922

Alfred Stieglitz, *The Glow of Night—New York,* 1897

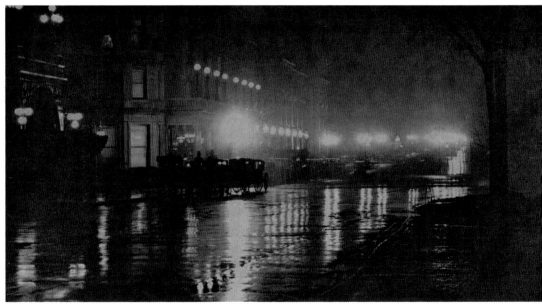

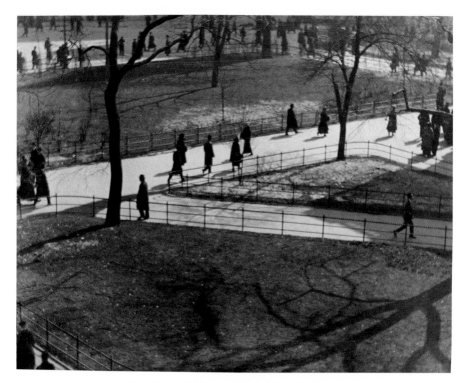

Paul Strand, *Central Park, New York*, 1915

Paul Strand, *Backyard, Winter, New York*, 1917

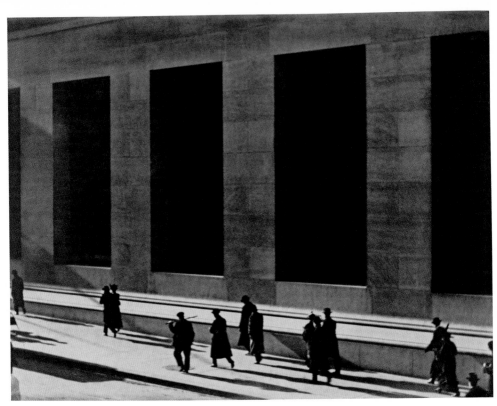

Paul Strand, *Wall Street*, 1915

Paul Strand, *The White Fence*, 1916

Paul Strand, *Rock, Port Lorne, Nova Scotia*, 1919

Paul Strand, *Akeley Camera with Butterfly Nut, New York*, 1922–23

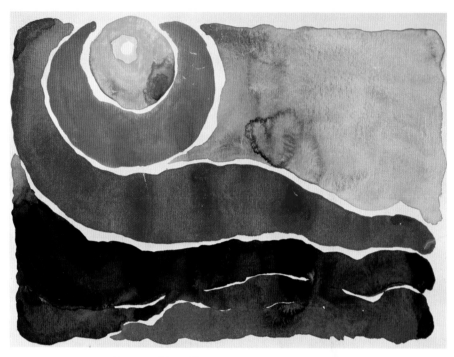

Georgia O'Keeffe, *Evening Star No. IV*, 1917

Georgia O'Keeffe, *Starlight Night*, 1917

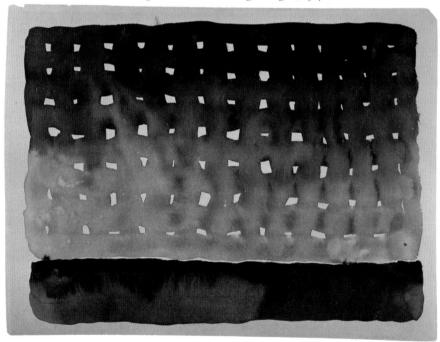

though he was focusing on cinematography. "We must accomplish more this winter," she wrote, and to that end, she sent him a check for his birthday to pay off the amount due on the Akeley. "The camera really belongs to both of us," she added. "Everything we have is ours together."

Beck was elated by the critique of the recent Camera Club show in *The New York Times,* which applauded Paul's "quiet challenge" to those who refused to see photography as art. Of his picture of a car engine, the critic wrote, "Mr. Strand, working with a machine, chooses a machine for his subject, and deliberately, intelligently, turns it into a work of art." His approach to the subject received high praise: "The kind of tactile stimulus Picasso attempted to give by pasting bits of sandpaper and cloth on the surface of his canvases, Mr. Strand succeeds in giving more naturally." The critic praised Nikolas Muray's prints of dancing girls, which hung next to Strand's "disciplined arrangements," but found Muray's dancers less striking than Strand's well-ordered machines.

The next day, Alfred photographed Beck cavorting in the lake with Georgia Minor. Given her namesake's reluctance to take time away from painting to pose, he had made few pictures of her over the summer. A few days later, Alfred and Georgia invited Beck to join them in another favored pastime, swimming in the nude, which was new to her. Alfred would take advantage of Beck's fondness for the practice to photograph her voluptuous form, but for the time being he confined himself to head shots, including two of her posed against a pile of hay, which offered a bristly contrast to her smooth cheeks and profile.

Over the next weeks, Beck found ways to hold her own. When oil and watercolor proved too difficult, she turned to another medium, words. After typing the bulk of the contributions to the *MSS.* photography issue, including Georgia's, she made suggestions, which were adopted; at Alfred's prompting, she began jotting down thoughts on her own life in photography. She also took notes on Alfred's reminiscences. Envisioning herself as his Boswell, she asked Paul to bring steno pads when he came to the lake for the weekend. She added, "We could try some nudes out-of-doors—if you want to—we would be free around here." But his visit was too brief for picture taking.

After Paul went home, Beck accepted Alfred's invitation to move to the farmhouse and agreed to daily photo shoots during her swims: "A lovely relationship has developed between us and we have lots of fun gamboling about," she told Paul. She did not mention their deepening intimacy, such as Alfred's awareness of her pain during her menstrual cycle, of which she spoke openly in her new life as a free spirit. Bath-

ing naked most mornings, she enjoyed herself as much as Alfred during these sessions: "another grandie swim—& Stieglitz made some more snaps, of me in the nudelet."

Stieglitz's snapshots of Beck in the nude tell a story that is open to more than one interpretation. In some, she grins up at him from the water as if they are in cahoots; in others, her curvaceous form emerges from the lake mottled with droplets—evocations of the cold water on her skin. Judging by the shots of Beck cradling her ample breasts, she understood his desire for women to seem complicitous in the "taking" of their likeness. Stieglitz would always appreciate how easily she gave herself to his camera and to his fantasies. Years later, he said that he had taken these shots "to prove to Paul that in Becky . . . he had a much more pliant and vital model than the . . . rather fragile O'Keeffe."

Whatever his motives at the time, sheer enjoyment of their rapport suffuses these photographs. In one, Beck's breasts seem to float on the lake like water lilies, Alfred thought; another depicts her legs and buttocks as if her derriere were offering itself to the gaze. Beck wrote enthusiastically to Paul: "Some of them—a nude of me in the water, is a beauty and some of the others fine too. He takes quite a different slant at me from you." Perhaps she hoped that Paul would be moved to take a more vigorous "slant" once he had seen his mentor's work.

Alfred Stieglitz, *Rebecca and Paul Strand, c. 1922*

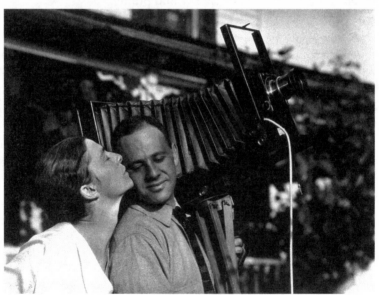

Paul joined Beck at the Hill in October after the Stieglitz family's departure. Relations between the two couples were cordial. After a neighbor who had watched Alfred's sessions at the lake with Beck made a complaint, a plainclothes policeman began staking out the site. Ironically, the Strands were nabbed when they went skinny-dipping at Alfred's urging and Paul photographed Beck in the nude. Alfred paid the fine—ten dollars each—in acknowledgment of his responsibility. After Paul's return to New York, Beck asked him not to mention the incident, "because it can be made unpleasant or a charming story, depending on how it is done. . . . You aren't always as gay about things as I am."

Paul had angered Alfred by photographing on the Hill, which was *his* turf, and doing so "like one possessed—shooting right & left—forward & backward—upward & downward & in directions not yet named." What Paul felt about Alfred's pictures of Beck went unrecorded, although he did photograph the two of them as they swam together, clothed. Nor did it help matters when Alfred asked Georgia to read aloud her essay for Paul's issue of *MSS.* just before his departure. She acknowledged Paul's contribution to photography "in that he has bewildered the observer into considering shapes, in an obvious manner, for their own inherent value" but reserved her praise for Sheeler, whose photographs, she thought, were "of equal importance" to his paintings.

In the exchange that followed, Paul let them know that his feelings were hurt. Beck took his part out of "irritation," she told him, "intensified by G's tenacity in not listening to you." Alfred hoped that the experience had caused only temporary heartache. Their taking time to listen to Georgia, he wrote, had been "important for all of us—including Beck if she feels she is part of your work." (Alfred claimed that criticism could be constructive even when it caused distress.) But the incident cast a shadow on their relations. For the rest of the year, Paul concentrated on *his* subjects, chief among them the elegantly configured Akeley.

Beck tried to smooth things over by assuring Paul that Alfred held his work in high esteem, and, in the same letter, sending him a check drawn from her dress allowance. Although motion-picture jobs were now coming his way, his still photography should not suffer, she thought. What was needed was a step in the direction she outlined, portraits of influential men like Alfred. Meanwhile, Paul must take care to avoid trouble by developing his latest portraits of her, including a shot of her thighs and groin emphasizing the dark triangle of her pubic hair, at his home studio rather than at the club.

Beck's last weeks at the lake were idyllic. By then a valued mem-

ber of the household, she spent her time transcribing Alfred's reminiscences and typing contributions to *MSS.* while working on her own. She read and commented on Rosenfeld's essay about Georgia for *Vanity Fair,* which was to serve as advance notice for O'Keeffe's January show. After praising her technique, it rehearsed the rhetoric about her work as outpourings of her womb, implying that its force derived from her conjoining of male and female energies: "She is one of those persons of the hour who, like [D. H.] Lawrence, show an insight into the facts of life of an order well-nigh intenser than we have known." When Alfred informed Rosenfeld of Beck's fear that readers would take his words as evidence of his feelings, the critic replied, "I am sorry for Georgia's sake, for it will keep people from seeing why I really wrote my piece. People are all so foolishly personal."

Alfred took more portraits of Beck, including one that revealed some

Alfred Stieglitz, *Georgia O'Keeffe and Rebecca Strand,* 1922

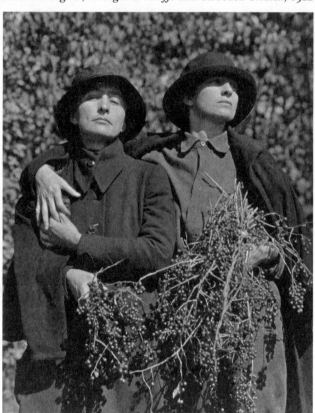

habitual distress, before turning to his new obsession—pictures of clouds that to his mind were equivalents of the emotional states evoked by music. (He would first call them *Songs of the Sky* and then later *Equivalents.*)

Georgia completed her apple series and painted more autumnal landscapes. Looking at her studio one day, she decided to portray it in "one of those dismal-colored paintings like the men"—the result, *My Shanty*, recalls Hartley's dark-toned palette. Beck understood the joke implicit in depicting the shack in hues sure to make "the men" pay attention. But when Georgia hung her oils on the farmhouse walls, they made such an impression that Beck wondered why *she* kept trying to paint. "I really can't do it," she confessed to Paul; "I am not an artist."

Her medium, it appeared, was friendship. Beck and Georgia went rowing together and walked around the lake to pick branches of bittersweet (once dried, the orange berries would brighten the New York winter). She did domestic chores, such as making flannel slippers for Georgia, who appreciated her skills as a seamstress—and took every opportunity to go on outings with "Jink" or "Jinkie" ("Georginka" shortened to its diminutives). Impishly augmenting Beck's place in their trio, Alfred took to calling her "Beckalina." But Georgia, whose self-containment Beck admired, did not indulge in pet names. Georgia was "a great gal to be with," Beck told Alfred after leaving the lake. "It was fine to wander & romp with you, for a brief interval, along the clear deep stream of your kind of living."

· · ·

But it was difficult to maintain this kind of living in New York. Beck went back to work preparing reports on topics like childhood narcolepsy and encephalitis for Walter Kraus, a prominent neurologist, whose office was on West Seventy-fifth Street. (His interest in Jewish genealogy established a kinship between Beck's mother's family and his own.) In her spare time, she typed the remaining contributions to the *MSS.* photography issue. Using the Akeley, Paul pursued the varied opportunities that came his way: a one-reel slapstick comedy, a tonsillectomy, more medical films, commencement exercises at Princeton, polo matches, and horse races—the latter a subject he described with enthusiasm to Alfred.

It was satisfying to receive the November issue of *Broom* with Paul's "Photography and the New God" and five reproductions of his work.

His essay, a defense of the art, argued that the true significance of the camera had arisen in America, where the machine had become god. Photographers should humanize this mechanical deity by using it to capture the profound sense of passing moments. Seen in this light, the concept of portraiture became "that of a record of innumerable elusive and constantly changing states of being." He added, "This is as true of all objects as of the human object."

At about this time, Alfred told Beck that he had printed some "howling" good portraits of her. "Georgia says several are additions & says: 'Aren't they beautiful?' . . . Perhaps the prints will tell you a few things not so clear to you now." Repeating his praise in a letter to Paul, he said that these prints, which he would eventually count among his favorites, would surprise both of them. With Beck he had been "able to complete the circle." In another letter to Beck, Alfred hinted that Paul was less able than he to capture her emotions. "How you'll like them as 'Portraits' I don't know. —As prints, as photographs, everyone will have to like them. . . . They are entirely different from [Paul's] things of you."

Alfred's glee put Beck in an awkward position. She was glad to know that along with Georgia she was one of his "Immovables"—the muses he praised as "a new order of beings brought into the world by photography." At the same time, she wanted to support Paul's wish to make an extended portrait of her. They tried a new approach, with Beck in bed, resting her head on a pillow. Judging by the prints, which suggest that she was naked, she felt more receptive to Paul's latest attempts, having absorbed Alfred's praise of their way of working. At this point, she could relax into a rapport that had so far eluded her as Paul's "human object." Yet despite the intimacy of their mise-en-scène, his portraits of Beck seem posed.

Alfred wrote that he missed her: "It does seem as if you ought to be coming downstairs in those trousers of yours and get busy on dish washing." Georgia had finally hit her stride. She was going flat out to be ready for her January opening at the Anderson Galleries; Alfred was putting in long days in preparation for his show in April. He told Beck that she had been a "corking" helper and asked if she had finished her piece for the *MSS.* special issue. By November, after typing the last contributions, she was ready to concentrate on her own. She would be one of the few female contributors, along with Alfred's niece Elizabeth, the novelist Evelyn Scott, and Georgia.

Unlike Georgia's piece, which set out her artistic credentials, Beck's presented a woman whose life in photography had been shaped by men.

First came her father, identified as "Owner of Buffalo Bill's Wild West." Since childhood she had been surrounded by images: "Indians, cowboys, buffaloes, arenas, Bill Cody on horseback, Bill Cody on foot, Bill Cody in his tent"—authentic records of American history. Then, as a secretary, she had kept records with a different kind of imagery—"hemiplegics, diplegics, paraplegics, hysterics, neurotics . . . fear, pain, destruction, death." Her marriage to Strand came next. She listed his subjects and equipment ("crockery, machines, pipes, carburetors . . . oil ball bearings, cameras, tripods"), then his words to her as his model ("Oh hell! you MOVED AGAIN! The best portrait I've made. DAMN!"). His photographs, she concluded, were "not things just looked at, but SEEN."

Alfred replied that he liked parts one and two of her piece but found part three "not quite clear" despite its echoes of his preoccupation with "seeing." While it was disheartening to read his response, it was worse to be told that her work would not be included in the special issue because she was not among the "Elect," the group of artists whose contributions she had typed: To make an exception for the editor's wife would do a disservice to Paul. With a characteristic lack of empathy, Alfred added, "You don't mind my stating exactly as I feel."

His letter left no room for Beck to say that she did mind being left out of the project to which she had devoted herself. "It is difficult for me to say anything about MSS and the thing I sent you," she replied. "You once said that you felt I would have something to say about photography as I was so much mixed up with it. . . . Perhaps I misunderstood." Moreover, she had written about Paul objectively rather than to "puff" his work. Feeling shut out by the very person who urged her to express her feelings, she felt "embarrassed at saying anything."

A week later, Hedwig Stieglitz suffered a massive stroke. Alfred and Georgia rushed to New York a few days before her death. He dealt with his grief by busying himself with the *MSS.* special issue, which would include some thirty statements by personalities as diverse as Sherwood Anderson, Charlie Chaplin, Hutchins Hapgood, Waldo Frank, Marcel Duchamp, John Marin, Carl Sandburg, and O'Keeffe. "Thanks for the Giving," Alfred wrote awkwardly in a note to Beck. "I hope the Strands Paul & Beck enjoyed MSS. —It's attracting attention." He looked forward to seeing them again and expressed the hope that Beck's "mean week" (her period) had come to an end, as if partly aware of the pain he had caused her.

Beck tried to repair the breach by revising her essay. The new draft closed with a section about what she had learned from Alfred—including

his remarks on his cloud pictures ("I watched the sky for 9000 years to get that particular sky") and, more generally, the goals of photography. "Life, its direction faced, seen, insisted upon" was what he hoped to portray—"a way of looking at things, at people, at the world . . . with no prejudice against life, no resentment, freeness, a fine freeness, making the heart beat wildly."

Alfred allowed that the new version was an improvement, but he did not comment on Beck's identification with his battles on behalf of "seeing." He closed with a wish for the new year: "May the kindly stars lead you into all the good things." Then, stepping back from their usual intimacy, he signed, "As ever '291.'" The circle of friendship was unbroken, but it had to be maintained on his terms.

Kinds of Living

1923

That winter, crowds flocked to the Anderson Galleries to see the new show, whose catalog was entitled *Alfred Stieglitz Presents One Hundred Pictures, Oils, Water-colors, Pastels, Drawings, by Georgia O'Keeffe, American.* Friends noted that Stieglitz's title emphasized his role. McBride wrote waggishly, "He is responsible for the O'Keeffe exhibition . . . Miss O'Keeffe says so herself, and it is reasonably sure that he is responsible for Miss O'Keeffe, the artist."

Georgia took the opportunity to explain herself to a sympathetic woman journalist. After recounting the outlines of her art training, she

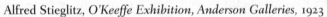

Alfred Stieglitz, *O'Keeffe Exhibition, Anderson Galleries*, 1923

said boldly, "I made up my mind to forget all that I had been taught, and to paint exactly as I felt." This approach did not preclude a mastery of technique, the journalist noted: "She paints apples, and the texture of their skins is reproduced so perfectly that one is almost tempted to take a bite." Yet O'Keeffe could also be introspective, she continued, quoting Rosenfeld on her work's "feminine" nature. O'Keeffe was no doubt displeased to see Rosenfeld's thoughts about her in an interview intended to highlight her craft. Yet the piece was timed to give maximal exposure.

Starting on January 29, some five hundred people showed up each day of the exhibition; numerous publications sent reviewers. To those who had first seen O'Keeffe's work at 291, the change of venue was striking: It was now being shown in the grand manner. But the gallery's red plush walls reminded some of her appearance there two years before in Stieglitz's portraits of her, which seemed to hover like palimpsests beneath the surface of her paintings.

One day, studying O'Keeffe's oils, Marcel Duchamp asked why she had not included a self-portrait. O'Keeffe laughed, perhaps reflecting that for those who knew how to see, her still lifes served this purpose. Also, the sale of *My Shanty* to the collector Duncan Phillips confirmed her hunch that using the dismal hues favored by "the men" would pay off. Twenty of her paintings sold—to Stieglitz family members, Sherwood Anderson, and others, including the Strands, who bought a view across Lake George painted when Beck was in residence, a show of support and an avowal of her insider status.

While it is likely that Beck supplied the funds for this purchase, Paul did his part by writing to Henry Tyrrell about O'Keeffe's importance in American art. Recalling Beck's remarks on Georgia's dislike of the innuendos purveyed in reviews, Paul asserted that her work's place was among "things of the mind and the spirit." He continued: "Here in America . . . the finest and most subtle perceptions of women have crystallized for the first time in plastic terms, not only through line and form, but through color used with an expressiveness which it never had before." O'Keeffe's show demonstrated that she had "the power and precision of genius."

Although Tyrrell reproduced Strand's letter in his column, this attempt to displace the trope of O'Keeffe as a sexual being came too late to influence other critics, some of whom also quoted Rosenfeld to claim that she painted from, or with, her body. Disappointingly, Helen Appleton Reed cited Hartley's account of O'Keeffe's oils as "shameless private documents," then opined, "To me they seem a clear case of Freudian suppressed desires."

The commonly held view that O'Keeffe's work should be seen in psychoanalytic terms also appeared in McBride's review, which played with the idea: "In definitely unbosoming her soul she not only finds her own release but advances the cause of art in her country." He continued: "She will be besieged by all her sisters for advice—which will be a supreme danger for her. She is, after all, an artist, and owes more to art than morality." Georgia wrote to thank him. His tongue-in-cheek advice, that she get herself to a nunnery, had made her smile.

Despite McBride's wry remarks and the Strands' supportive gestures, Georgia succumbed to the depression that often accompanied showings of her work; she took to her bed with a cold. Meanwhile, Alfred went to the gallery every day to lecture visitors about her Americanness. Those who picked up the brochure he had prepared found contradictory views expressed, in the Hartley piece and in her personal statement—which presented her as someone with a mind of her own: "I found that I could say things with color and shapes that I couldn't say in any other way. . . . Some of the wise men say it is not painting, some of them say it is. Art or not Art—they disagree. Some do not care."

"You have had reports about the excitements at the Anderson! More are to come I'm sure," Alfred crowed to Beck: "The Old Man & Little Fellow are on the job, a tough combination to beat." When the show closed, his efforts on Georgia's behalf had earned her about three thousand dollars ($41,000 today), which made her think that she could earn her living as an artist. "One must sell to live—so one must be written about and talked about whether one likes it or not," she told a friend. She had to accept her reliance on Stieglitz and his spokesmen in a world where artists' reputations were constructed and maintained by men.

In February, Alfred turned to his next task, an exhibition of his recent work to open at the Anderson in April. Meanwhile, he had to vacate the gallery's spare room, where he had been storing his archive and the complete inventory of *Camera Work*. In despair, he tore up hundreds of prints and copies of the magazine—at a time when Beck had begun collecting the full run of *Camera Work* as an act of homage. When Paul told Alfred that he had forbidden her to read copies in the bathtub, Alfred replied that he would give her waterproof ones: "Beck has her own kind of pleasures & delights. —I think I know some of them."

Alfred's new show consisted mainly of portraits, the majority of them women. He selected twenty-two of Georgia, though not the more daring nudes: "New York is still not ready for some of the most significant portraits I have made," he wrote in the catalog. From his portraits of Beck, he chose four of the most striking and the one of her hands.

We can imagine her delight on learning that *The New York Times* had singled them out: "In a portrait of Rebecca Salsbury Strand the head is against straw in such a way as to emphasize texture. The firm round flesh against the prickly straw. Especially in the photographs of hands, texture is strikingly managed." Yet one wonders if she enjoyed being seen as texture and whether the reference to her "firm round flesh" caused concern, in that her mother was sure to object to such terms.

Both Strands would have noted the omission of Paul's likeness in the section devoted to men, which featured some of Stieglitz's favorites. The presence of Marin, Duchamp, Seligmann, Rosenfeld, and Anderson on the walls would have underscored his disciple's absence. Nonetheless, Paul showed unwavering support for Alfred in a talk he gave about this time at the Clarence H. White School of Photography. (In 1916, after falling out with Stieglitz, White had formed the Pictorial Photographers of America, where he taught pictorialist technique to photographers hoping to work as illustrators.)

Photographers needed to show respect for their craft, Strand argued, looking not to the history of painting but to their tradition, to the work of David Octavius Hill and Alfred Stieglitz: "From the beginning Stieglitz has accepted the camera machine, instinctively found in it something which was part of himself and loved it. And that is the pre-requisite for any living photographic expression." Alfred thought so highly of the talk that he told Paul to send it to the *British Journal of Photography*. He added, "White is really too unspeakably stupid not to have the paper printed."

Still, it had been galling to read Sheeler's critique of Stieglitz in *The Arts*, which charged him with "preciousness"—the use of palladium prints rather than those made with "a less aristocratic element, such as silver." Strand dashed off a rejoinder: Photographers used palladium not because it was precious but because it gave the most permanent results. Sheeler retorted, "Any exception that Stieglitz may have taken, through you . . . is quite alright"; Strand replied that he wrote not as Alfred's mouthpiece but from a "love of truth." This tart exchange ended relations between Sheeler and his former friends.

By contrast, Rosenfeld's wholehearted embrace of the Stieglitz line was evident in his plans for a book on American artists whose work kept the spirit of 291 alive. Having recently written a book about modern composers, he told Stieglitz that the new one might include figures like Gertrude Stein and Marianne Moore but would feature Marin, Hartley, Dove, Anderson, O'Keeffe, and himself—as the one who created the family feeling in the arts that Rosenfeld meant to celebrate. He would

send him drafts of each chapter and take advice on the illustrations. Rosenfeld's homage to their mentor became a project in which both Strands played their part over the next few months.

In June, Alfred and Georgia asked Beck to accompany them to Lake George. She accepted with glee, as Paul was again traveling in his efforts to succeed in cinematography. She told him not to fret about finances: "I know things are hard for you—this struggle to get some sort of a foot-hold. . . . We'll pull along for a while & see what happens. Remember that I do not expect <u>anything</u>—only want you to be a little freer in your mind." From the lake, she wrote that she missed him: "You are a lovely lover and my happiness lies deeply in you."

Beck was delighted to be with Alfred and Georgia again, and by their compatibility as a threesome. The women did domestic chores while Alfred rested. Wearing their bathing suits because of the heat, they made ice cream with wild strawberries from the woods; they painted the kitchen floor "a sweet and girlish grey." Alfred urged Beck to stay longer; he was too tired to pick up his camera but hoped she would return to pose for him and resume her role as scribe, to transcribe more of his stories. "It is heavenly quiet with just the three of us," she told Paul. Still, she warned him to inform her mother that she was staying at the guesthouse rather than with the unmarried couple: "I'm not going to give this up just for a question of propriety."

Beck went back to New York, with an invitation to return to the Hill in September. She and Paul were apart much of the summer, when he traveled in search of employment. "I want you so to be free and yet we are caught in the net of necessity," she wrote during one of their sepa-rations. About this time, she told Alfred, with whom she could speak freely, "I must earn my daily roast beef and potatoes here (and, inciden-tally, the good Paul's)." She was glad when he went to Saratoga to film the races. The town's proximity to Lake George meant that he could spend time at the Hill: "You deserve a little holiday & I know what being with Stieglitz means."

At this point, Stieglitz, too, was in low spirits. In recent months, there had been a rapprochement between him and Kitty after she became pregnant. When Alfred visited her after the birth of her son, he learned that she had succumbed to depression, which then developed into post-partum psychosis. He blamed himself for having neglected her: "I cer-tainly failed in so many ways in spite of all my endeavour to protect and help her prepare herself for life. I realize with every new day what a child I have been & still am." Worse, when his visits provoked Kitty to rage, the doctors told him not to return.

He and Georgia had often discussed her wish to have a child. At thirty-five, she felt some urgency but deferred to Alfred when he argued that she could not paint and look after a baby; moreover, at fifty-nine he was too old to be a father. Given Kitty's condition, he insisted that Georgia must not risk pregnancy—even though his niece Elizabeth, who had two little girls, promised to help if they were to have a child. At the same time, Georgia had to tolerate the presence on the Hill of Alfred's secretary, Marie Boursault, who was pregnant, and her two-year-old daughter.

Alfred described the situation to Beck, who had let him know that she, too, was ambivalent about children. "Marie's kid is cute but she cries much more than the contract calls for. . . . A baby does make a huge difference." Beck's reply made her position clear: "I think the business of raising a kid is horrible. They all smell, spit, sleep, slobber, snort. Then when you have lived thru this S period you go into F period—Fight, fuss, fall, feed, fresh and so on." To end any doubts, Beck told Paul that during a friend's visit with his children, their unruliness had spoiled the day. She added, "I know I would be evil to my kids!"

Paul's freelance work allowed him little time for still photography, and he was dissatisfied with the few images he printed that summer, except for those of the Akeley. Alfred said that he understood Paul's frustration about not being able to earn a living and Beck's feelings on the subject. Yet, he reflected, Paul had "my kind of 'touch' in some things. A genius." If necessary, he joked, the two couples could "build a straw bed big enough for all of us & go asleep & dream that Life is full of Beauty & Art & Kind People." When Paul returned to the lake for a few days, the men photographed each other and Paul amused Georgia by helping in the kitchen. Their meals, Alfred told Beck, resembled a dance with Paul and Georgia "in a pas de deux."

Marooned in the city for August, Beck decided to redecorate the Strands' kitchen. She painted the walls gray, black, and brown, put down a complementary rug, shellacked the floor, and painted the fireplace. When the cook hooted at the *moderne* color scheme, Beck ranted, "She'll keep that kitchen clean while I'm in it or there'll be a Yankee-Jewish War." (In her view, her "Yankee" persona—Nate's legacy—distinguished her from most Jewish New Yorkers.) After this altercation, Beck withdrew to their room, which soothed her, "as though only loveliness could find its way in to share the loveliness we have had together in it."

Over the summer, Alfred's letters to Beck became more flirtatious, his joie de vivre having revived as he printed some images of her from the year before. "Beckalina Mina Carissima," one began. "For an hour

or more I have been tickling up your rear into most perfect condition of delight." Moreover, her "most strongly alive . . . emerging from water in the sunglare rear" had delighted those guests who had seen it (one wonders if Paul was among them). When Paul allowed that he missed Beck, Georgia quipped that she was probably glad to have him out of the house. Alfred wished that Beck were with them: "You are liked by us up here on the Hill & not the least of all by the T.L.F."

To prove the point, Alfred invited Beck to occupy "her" attic room on her return. Anticipating the renewal of closeness, Beck wrote that when Paul told her about Alfred's insomnia, she wanted "to take you in my arms against my broad bosom . . . make you rest against—well, what is it—all that is gentle and tender in Woman." The thought of her bosom helped, Alfred replied, but he also valued her as a muse. After two months at the lake, he was "fit for the gods—& several goddesses." In the meantime, Beck told Paul how much she longed for him: "I'm like a ship without a rudder."

Beck arrived at Lake George, to find the Hill full of people. In addition to Marie and Yvonne Boursault, the guests included Katharine Rhoades, Anita Pollitzer, the Seligmanns, and Elizabeth and Donald Davidson; more family members were expected. Katherine Herzig, Hedwig's nurse, was running the household with Georgia. After Paul's departure, Beck helped Alfred paint the kitchen floor pistachio green before resuming her duties as his typist. "Will I never stop?" she asked Paul in a letter detailing the Hill's division into two camps—"the racketing in the kitchen and then somewhere else in the house Stieglitz or Georgia quietly doing something."

Beck's dream of a perfect union with Paul took a jolt one afternoon when she and Georgia went rowing. "She told me the story of the time you were in Texas," Beck informed him. "She has forgotten much that happened—but was amused by recalling it." Making light of what transpired between herself and Paul allowed Georgia to downplay the meaning of this revelation, just as Beck's reference to her in her letter to Paul emphasized the women's closeness rather than the history of his relations with Georgia. On hearing Beck's professions of love for Paul, Georgia gave her a poem cut from a newspaper, which, she said wryly, voiced her wish to hear him respond in kind.

It came as a surprise when Georgia announced that she would soon go to Maine for a month with the friends who had invited her the year before, knowing that she could entrust the household to Beck. From then on, Beck sent bulletins assuring her that Alfred was in good form

and life on the Hill was going smoothly. His letters to Georgia told a different story. Tensions developed between Beck, who was sometimes willful, and Katherine Herzig, who let Beck know that she preferred working with Georgia. After soothing Beck's feelings, Alfred joked, "There is peace amongst the women folks." A few days later, he wrote, "Beck as nice as she is—& certainly developing—does lack creative seeing—It's a pity. But I suppose that can't be 'given' one." Meanwhile, he relied on her as typist and model—activities that, in his view, did not require creative seeing.

Beck was also enlisted in the effort to get Rosenfeld's work in progress into shape. Its importance to the group was obvious. Stieglitz promised Rosenfeld that he would do all he could to help him meet his deadline, since the book would give an account of "America without that damned French flavor!" In recent years, he continued, he had been involved in fighting to have Georgia's work recognized as American in his sense of the term: "Of course by American I mean something much more comprehensive than is usually understood." At this stage in the country's cultural life, it was imperative to challenge the idea that America was "only a marked down bargain day remnant of Europe."

Rosenfeld was pleased that "Rebecca Countess of Salisbury" would insert Alfred's comments in his chapter on Georgia: He admired her secretarial skills and high spirits. Beck no doubt kept her thoughts to herself as she retyped his effusions, including these remarks on Georgia's art: "It leads us, this painting, further and ever further into the verity of woman's life. . . . She gives the world as it is known to woman." Beck enjoyed the work because it brought her deeper into Alfred's charmed circle, but at the same time, she told Paul, she thought that Rosenfeld's understanding of Georgia "derives from [Alfred's] photographs rather than directly from her paintings."

Rosenfeld admired Beck and Georgia as women who knew their own minds. (Georgia reminded him of Wagner's Brünnhilde.) In September, he went to Lake George to work on his manuscript with Beck. They took breaks to go rowing and discussed the idea of a fund to help support Alfred, an easygoing entente developing between them. Still, one wonders what Beck thought when he read the end of his O'Keeffe chapter to Alfred. "The American failure has been primarily a failure between men and women," it began. In his view, the American female was like "a dwelling uninhabited, grey and chill like the houses where the furniture stands year-long in twilight." O'Keeffe was an exception: "A woman . . . going toward the fulfillment of a destiny." (Rosenfeld devoted a chapter

to Margaret Naumberg but omitted Waldo Frank, with whom he and Stieglitz had been feuding.)

These stirring words may have prompted Beck to ask whether less exceptional women could follow in Georgia's footsteps. She sympathized with her friend's need to work in peace but feared that her own talents might not extend beyond painting the kitchen floor. And her position at the Hill enhanced her self-doubt. "I am the only one who seems to create nothing," she wrote to Paul. "I am always conscious of it & regret it. The only real thing I can do is in my relationship with you."

At that time, Alfred, still suffering from insomnia, turned increasingly to Beck. He came into her room at night, she told Paul, "like a haunted man pursued by his daemon." While there is no question that Beck was devoted to him, it is unlikely that she took him into her bed—as some have assumed—given her devotion to Georgia and the value she gave the sexual aspect of her relations with Paul. Even so, somewhat ingenuously Beck repeated her wish to "take [Alfred] to my broad bosom and comfort him," assuming that Paul would understand.

While Alfred continued to rely on Beck, she was unaware that he was also complaining to Georgia about her. Annoyed when Beck continually found fault with the old Corona she was using, he compared her to a piano with some stuck notes. Her obstinacy was harming both her attempts at art and her marriage, he thought, and she was inclined to behavior unsuited to her sex. (In a feisty moment, she challenged Davidson to wrestle, then ended the fight by biting him, to show Alfred that she could.)

Alfred told Georgia that Paul looked weary when he came to the Hill for the weekend: "I fear Beck worries him a great deal even more than he worries her." But he was also annoyed with Paul, who had again tried to capture his likeness: "If Strand doesn't understand what a portrait is—he is deficient in all his work, deficient of the creative quality which gives life." Equally critical of Beck, he wrote, "It's amazing how sensitive she is at moments & how something gets in the way then & turns a fine material into something much less fine." Alfred complained that when he needed her, she seemed "a million miles" away. He added, "She's all right—but there is a messiness somewhere which will ever remain messy."

Complaints about "messiness" in others were often projections of his own distress. For some time, the Stieglitzes had been thinking about selling the Hill. Alfred lived there with Georgia for long periods each year but contributed little toward the cost of upkeep (he claimed that

their improvements to the outbuildings increased the property's value). Already concerned that this might be their last stay, he became apprehensive when his brother Leopold told him that he did plan to sell the house on East Sixty-fifth Street, where Alfred and Georgia had lived for the last three years. The thought of approaching homelessness sent him into a panic. He ranted at Beck and Rosenfeld, telling them that he felt guilty about Kitty's illness, that no one understood him, that his life was a disaster. Worse, he feared that Georgia was leaving him.

Beck sympathized with Alfred's determination to keep the farmhouse, but being with him through this prolonged crisis took its toll, she told Paul. "Stieglitz wants his own way of living and his passion for trying to make other people see it in the face of their own inherent qualities really gets things into such a state of pressure that you . . . feel as though you were suffocating." Rosenfeld, finding it impossible to work, "said he had never been in such hell." Now, despite her love for Alfred, Beck looked forward to leaving soon after Georgia's return. "I shall be glad . . . to come to you again for our own kind of living."

Concerned about Alfred's state of mind, Georgia telegraphed that she would return home sooner than planned, even though he protested that she must stay in Maine to paint. He would need to be careful, Beck told Paul, in order not to overwhelm her: "This house is queer—so many ghosts of old experiences drifting around and so much suffering." When Georgia returned in good form, Alfred calmed down, and Beck told Paul that she would stay a few more days, until she could face Manhattan.

Alfred decided that in the future he would do less on behalf of all those who relied upon his support. "I feel the more the people he has fought for begin to be responsible for themselves the better he will like it," Beck explained. Rosenfeld agreed: He was "ready to fly with his own wings." But she could not see that such a change would also touch her and Paul, that their relations with Alfred and Georgia would change. Beck was proud of having stood her ground when Georgia criticized her for wearing trousers (they had not yet been adopted in progressive circles). Describing their "row" to Paul, she declared, "No harm done. She capitulated."

Some years later, Alfred was still smarting about this quarrel. He recalled Georgia's resentment of Beck for taking her place that summer, Beck's attempts at intimacy with both of them, and her self-importance—all symbolized by her riding pants. Yet Beck had come to see that making Georgia capitulate was not good for their friendship, nor was the continuation of their threesome conducive to good relations

between the couples. She caught the train to New York soon after Georgia's return, leaving her and Alfred to themselves.

. . .

Beck had no trouble finding another job. Ten days after her return, she was hired by the Neurological Institute of New York, on East Sixty-seventh Street. The institute, the first in the country, was a palace, she told Alfred, and her work with the directors, Drs. Frederick Tilney and Henry Riley, more challenging than at her previous post. She was learning to use up-to-date devices, a silent typewriter that was a pleasure to operate and a dictaphone with amplifiers. She would stick with this job "until I can't anymore—spiritually," she continued. At the same time, she was retyping parts of Rosenfeld's manuscript, including the chapter on Georgia. Paul was again traveling to film horse races: "I don't care about the money he makes as money—but I do know he is released from a tremendous burden of a fixed idea."

Unexpectedly, Alfred's woes resurfaced in Beck's New York life. Soon after her return, she noticed a young couple at the institute, bound to each other by some deep sorrow. Seeing this woman and her husband brought to mind her last days at the Hill, where the shared suffering, she wrote, "seemed to envelope me like a clinging, heavy vapor. I tried to struggle free of it and found myself weighted down by a sense of double suffering." The woman, she learned, was Kitty, who was a patient there. "Your family does run into my life," she wrote in November, when Leopold Stieglitz came to consult with the doctors. After checking Kitty's records, Beck told Alfred that they were optimistic about her, provided there was no interference from Emmy—an interpretation that endorsed his view of the matter.

Beck had witnessed what no one else had seen, Alfred told her after she left Lake George. She was very much part of the Hill—the distress of those days had deepened their intimacy. Beck agreed: "There was infinite pleasure and real suffering." As she sat at her typewriter, memories of their time together overwhelmed her: "I can see you, Stieglitz, Davidson & Elizabeth at the side of your shack, the day after Englehard spoke of selling the farm—and the hurt I felt & the rage." She agreed that he must let his "children" go it alone. "Your light is too intense for most & burns with an almost unbelievable purity!"

Judging by the Strands' correspondence with Stieglitz for the rest of the year, neither felt that they had been burned. Alfred made a point

of encouraging Paul by introducing him to acquaintances in the racing world. "You will come into your own," he told him, after inquiring about Paul's photographs at the lake, including his portraits of Alfred. "My whole being is far beyond portraiture," he added. In Alfred's mind, the Hill had replaced 291: He and Georgia were so productive there that he was toying with the idea of it as a permanent home. Just the same, they would return to New York for the winter and looked forward to seeing the Strands. Beck replied, "You two are still the finest thing we have besides our being together, and our deepest satisfaction, when regarding the rest of the world, is in the thought that you just are."

Alfred and Georgia enjoyed their last weeks at the lake, when, despite the intense cold, her sister Ida came to stay. He took snapshots of Ida (she declined to pose in the nude) but was reserving his energy for his cloud pictures. Photographing clouds, he explained, let him evoke thoughts and feelings different from those he captured in portraits, including the images of Georgia and other women that had often expressed his vision of life. Alfred would later name this series *Equivalents,* a title suggesting its origins in the Symbolist theories of his youth. In 1923, he called his cloud pictures *Songs of the Sky,* visual harmonies that conveyed psychic states in the manner of music.

By then, Georgia was painting full-time. While Alfred devoted himself to the skies, she turned to the fruits of the earth, although apples no longer claimed her attention. That fall, she painted magnified close-ups of oak leaves in clusters of red or green, filling the compositions with pulsing energy. On the same compressed scale, she did paintings of fruit that accentuate their fullness of form and may also stand in for relationships. In *Red Pear with Fig,* for example, a purple fig reclines in front of its shapely red companion. Similarly, in the series *Alligator Pears* (a term for avocados), the fruit is arranged alone or in twos on cloths to set off these rounded shapes and brilliant surfaces (their greens, browns, and blacks suggest that she painted them until they were ripe for consumption).

While Alfred imagined the Hill as their home, Georgia was more ambivalent. "There is something so perfect about the mountains and the lake and the trees—Sometimes I just want to tear it all to pieces," she told Sherwood Anderson. Yet it was also true that when the household ran smoothly, she could paint. After hiring a housekeeper, the couple worked all day: "We all spend most of our time alone—each tending to his own particular job—and get on wonderfully." They returned to New York in November after a blizzard that delighted Georgia, who dragged

Alfred outside to take pictures. Looking back at their time at the lake, he
told Beck, "I know all your Life you'll remember it—Heartaches & all."

In the meantime, Beck had been helping Rosenfeld revise his manu-
script while he rewrote the penultimate chapter—about Stieglitz as one
of "the great affirmers of life." Alfred proposed revisions to an earlier
draft, which called him America's greatest artist: "I know my own worth.
But I'm not sure about being as much an artist as one of the leading spir-
itual forces in this country." Both were satisfied when Rosenfeld submit-
ted the manuscript but disappointed to learn that the publisher would
limit the number of illustrations to reduce costs. Of the nine included,
five were Stieglitz portraits, of Marin, Hartley, Dove, Anderson, and
O'Keeffe (a severe 1922 shot chosen with her approval, in contrast to
earlier ones). Stieglitz selected a Strand portrait of himself taken that
fall as the book's final image: Staring at the camera, he seems to chal-

Alfred Stieglitz and Georgia O'Keeffe kissing, Lake George

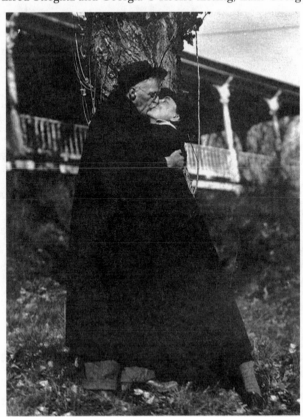

lenge his disciple to take a picture as expressive as his own. The result, prominently placed in the volume, made both Strands feel that Paul had taken a step forward.

In advance of publication, Stieglitz told Rosenfeld that his collection of essays was "a hummer." He continued: "My name can be used to advertise the book & help sell it. —But perhaps my name has very little selling value." Surprised to learn that it mattered in some quarters, he informed Paul that a journalist from *The American Hebrew* was writing about him as "a Jew who has arrived." He added ironically, "I arrived. At Nowhere—a marvellous place so much finer than Somewhere." He and Georgia had to leave their apartment by the following June. What was more, he would turn sixty on January 1, a date that always caused him to reflect. If he was, as the journalist claimed, a genius of the camera, he was far from a success in worldly terms.

"I have learnt an awful lot this summer & this autumn—about myself & my dreams," Alfred told Paul, "the dream that under 'free' conditions people will cooperate because of common sense if for no other reason." Now, in his disillusionment, he could see that in groups like the Camera Club, the Photo-Secession, and 291, it had been his guiding hand that held things together. Rosenfeld gave these sentiments another twist: "At the root of the man's dream of a group of people, working together, each one preserving his own identity, there must lie some strong unconscious family feeling; perhaps the strong Jewish family feeling; extended in this case not to individuals related in blood, but related in work and spirit. All his life [Stieglitz] has been hoping for the realization of this dream."

Rosenfeld's book, which would be published in 1924 as *Port of New York,* was like a birthday present—one that gave Stieglitz satisfaction in its praise of the individual artists and the group spirit that he had struggled to create. The book concludes with a paean to his *Songs of the Sky* as the artistic expression of this dream, an affirmation of the soul as "something thrust fuller than the skyscrapers." Ironically, Rosenfeld may not yet have seen the sardonic photograph from that series called *Spiritual America*—a gelded, harnessed stallion meant as a comment on the state of contemporary American culture.

Sensitive Plants

1924

I don't worry but I am not growing younger," Stieglitz told a friend toward the end of the year. Brooding about his age and impending homelessness, he felt like a cross between "the Flying Dutchman & Wandering Jew."

Still, at sixty his artistic stature was undiminished. In January, the Royal Photographic Society of Great Britain conferred its Progress Medal on him for "services rendered in founding and fostering Pictorial Photography in America" and for *Camera Work,* "the most artistic record of Photography ever attempted." But this accolade, linking his name to pictorialism despite his objections to the contrary, failed to assuage him. And when he forwarded Strand's and Rosenfeld's essays on his new work to the society, its director called Strand a "pretentious duffer" and said that Rosenfeld's prose gave him a headache.

Stieglitz took comfort in his budding friendship with a newcomer to the New York art scene, the racially mixed writer Jean Toomer. Since the publication of *Cane,* Toomer's novel about American blacks in Georgia, writers close to Stieglitz praised the author's take on the subject. Rosenfeld called the book something new in American letters. Waldo Frank, Toomer's friend and literary sponsor, claimed that Toomer wrote "not as a Southerner, not as a rebel against Southerners, not as a Negro, not as an apologist or priest or critic but as a poet."

Overnight, it seemed, Toomer had arrived. Looking back at this time, he mused, "If you were doing anything worthwhile in any of the arts, and in the modern idiom, to arrive meant that you were welcomed . . . into the most remarkable up-swing yet to occur in our national culture." That Toomer was strikingly handsome, with copper-colored skin and silky black hair, only enhanced his appeal. His background (he claimed French, Dutch, Welsh, Cherokee, African-American, and Jewish forebears) made him exotic; his bearing gave him the air of a well-educated

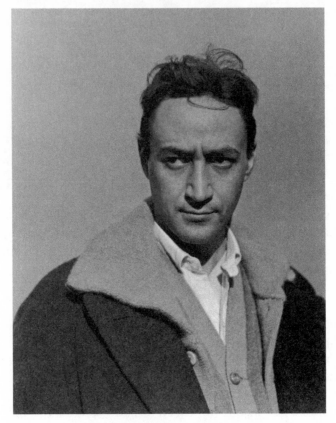

Alfred Stieglitz, *Jean Toomer,* 1925

Indian. While many looked to Toomer as a type of the "New Negro," he saw himself as someone who transcended racial categories.

Toomer called on Stieglitz and O'Keeffe a few days after Alfred's sixtieth birthday. Following a rapt contemplation of his cloud photographs, the young man sought Alfred's advice about the unease that he was experiencing since his bewildering success. Toomer's Whitmanian notion of the self had helped him formulate the idea of a new American race that would reconcile differences. Crucial to this process was the need to "see" into the essence of things, a term that few others than Stieglitz understood.

After their evening together, Toomer thought that he had been recognized by a visionary. He awoke with "a vivid sense of your pure black," he told Alfred, "a beauty as intense and clear as I've ever known." He was equally effusive in his thanks to Georgia. The couple had grasped *Cane*'s spirituality, though most did not. "When I say 'white,' they see a certain

white man, when I say 'black,' they see a certain Negro. Just as they miss Stieglitz's intentions . . . because they see 'clouds,'" Toomer wrote. He looked forward to the next opportunity to discuss with Alfred the unity of seer, camera, and subject matter as revealed in his skyward-gazing photographs.

What was more, meeting Alfred had stirred up questions for him about the relations of art and life. Chief among them was the triangle formed by Toomer, Naumberg, and Frank, who had used his influence to launch *Cane*. Despite the Franks' open marriage, their union began to unravel when Naumberg and Toomer fell in love. Frank may not have suspected the affair at this stage, but his relations with his friend had deteriorated. Jean told Alfred that since their evening together, he had been seeking a way to attune body, mind, and spirit.

The young writer thought that he had found his way when he and Naumberg attended "demonstrations" by the Greek-Armenian guru George Gurdjieff. Gurdjieff's vision of wholeness, Toomer wrote, offered "a life and a way to which I felt I could dedicate my whole mind and heart and body and strength." That evening, the harmony of self and world glimpsed in Alfred's images came to life in Gurdjieff's "Fourth Way," especially in the sacred dances intended to awaken disciples—the next "up-swing" to which Toomer would devote himself.

Gurdjieff returned to his headquarters in France about the time that Naumberg went to Reno to seek a divorce; Toomer's plan to join her had to be kept secret so that Frank would not hold up the proceedings. In February, Toomer wrote to Stieglitz of the "inward re-buildings" taking place: "I am broken glass, shifting, now here, now there to a new design." He came to see Alfred when he was immersed in preparations for a show of Marin's watercolors and told him of his hope that like-minded souls would "*directly* see you and O'Keeffe" in the joint exhibitions of their work scheduled for March at the Anderson Galleries.

One would like to know what others in the group thought of Alfred's new protégé and of the awkward triangle he formed with Frank and Naumberg. Given Alfred's estrangement from Waldo and the circle's tendency to adopt his views, some of its members would have sympathized with Toomer. Rosenfeld, with whom Frank had been feuding, said that if Toomer's prose was rather exalted, this was because he was experimenting. He concluded sympathetically, "Toomer comes to unlimber a soul."

During this period, Beck was putting the turmoil of her stay at Lake George behind her. She hoped to help Alfred finish the book they had begun there and told him that if support was needed (there was talk of

a fund to buy his prints for the Metropolitan Museum), she could con-
tribute a thousand dollars. But after falling ill in February, she went to
recuperate at the Briarcliff Manor Lodge, a Westchester resort known
for famous guests like Thomas Edison and J. P. Morgan. Soon she felt
well enough to try sledding—a pastime, she teased in a note to Georgia,
that had already resulted in her ripping the breeches that nearly caused
a rift between them. Georgia, ill with a preexhibition cold, did not reply.

Gossip about their friends' affairs abated when Naumberg took up
residence in Reno and Toomer, who was already living with her in secret,
wrote to Stieglitz and O'Keeffe, giving as his address the Toomer home
in Washington. Alfred and Georgia busied themselves with arrange-
ments for their exhibitions, in particular their effort to shape critical
reception with carefully worded personal statements.

· · ·

Alfred's account began cheekily: "Stieglitz once more. There seems no
escape." In using the third person, he may have hoped to deflect feelings
in those who thought, as he claimed to do, that exhibitions were passé.
Yet New Yorkers were "hungry for wisdom," he continued, compliment-
ing potential viewers in advance. For this reason, he had agreed to show
his *Songs of the Sky,* images in which they might find revelations, "per-
haps even a philosophy."

By contrast, O'Keeffe believed that her work was "very much on the
ground." Writing to Sherwood Anderson to ask him for a foreword to her
catalog, she noted, "There will be only two abstract things—or three at
the most—all the rest is objective." With his help, she hoped to coun-
ter eroticizing reviews with her "objective" studies of fruit, flowers, and
landscapes. Disappointed by his refusal, she chose three reviews from
the year before, including the notice by McBride advising her to get her-
self to a nunnery. "I have kept my pictures small because space in New
York necessitated that," she said in a short statement, voicing her hope
that "someone will buy something."

Visitors encountered O'Keeffe's fifty-one drawings, oils, pastels, and
watercolors in the larger of the Anderson's two rooms. Her colors were
dazzling, especially the varied greens of the pears and avocados; the
white calla lilies seen in photographic close-ups showed the extent to
which this flower had captured her imagination. Some puzzled over her
nonrepresentational oils, such as *Dark Abstraction*—a composition sug-
gesting a landscape traced with folds of red and blue. But given the lilies'

phallic pistils and the slits at the center of the abstractions, most viewers found it hard to see her work as objective.

McBride spoke for those who had doubts about the artist's apparent naïveté. O'Keeffe found in the calla lily "the secrets of the universe," he wrote tongue in cheek. "The crux, so to speak, of the calla is the yellow rod at the base of which the real flowers occur, and it is this yellow that sounds Miss O'Keefe's [*sic*] new note. The best of her new pictures, to me, was a flaming arrangement of yellows, very spirited, very pure." His insight into O'Keeffe's blend of spirit and purity was echoed by Helen Read, who declared, "This is O'Keeffe's show." Yet Read equated her work with her person: "Each picture is in a way a portrait of herself."

Whether the same was true of Stieglitz's photographs was another matter. His placement of *Spiritual America*, the image of a gelded stallion, at the entrance to his room, all but dared viewers to question his intentions. With his images of clouds, McBride wrote, the photographer had gone "about as far in finish and subtlety and richness as the camera can go." (McBride ended by quoting the critic who found "something spooky in them.")

Elizabeth Cary confessed that having found *Songs of the Sky* "emotionally torturous," she felt their spiritual import once Stieglitz explained them. She added, "Pictures must speak for themselves, however." Cary's comparison of their shows concluded with a statement of preference: "Even though each plate of Stieglitz is a solved mathematical problem, there is a curious suggestion of other problems to come. In every composition of Georgia O'Keeffe, with a greater simplicity and a more direct power, there is something more satisfying and complete."

With their work in adjoining rooms and their relations a matter of common knowledge, it was inevitable that some chose to compare the two artists. The majority of critics praised Stieglitz for his role as photography's pathfinder even when they did not grasp his intentions. A second review by Read was devoted to O'Keeffe but again linked her art to her sexuality: "Psychoanalysts tell us that fruit and flowers when painted by women are an unconscious expression of [their] desire for children." Despite Georgia's best efforts, her work was still being defined according to ideas of femininity that reduced artistic expression to sublimation.

Beck went to the Anderson Galleries soon after her return to New York. In a letter to Paul, she had less to say about their friends' shows than about the gallerygoers. They were "a funny mob . . . old spinster gals—flappers—hawk nosed student boys" gathered around Alfred as he "roared" at them. Jacob Strand joined her (Alfred was fond of Paul's

father, who gave him financial advice); Beck suggested that she, Paul, and Jacob purchase one of Georgia's paintings. Before the end of the show, they bought the semiabstract *Alligator Pear No. 11,* with the fruit seen against a green triangle set in white drapery. Alfred, Beck, and Georgia repaired to a nearby restaurant, where he added a note to Beck's letter to say that she was in fine form: "We're glad to have had her with us for the evening."

The next day, Beck bought a copy of *Port of New York,* which had just been published. She had little to say about her role in the preparation of the manuscript. After inspecting the illustrations, she pronounced Paul's portrait of Alfred a success but could not say the same of Alfred's portrait of Georgia, who looked "rotten." Above all, she wanted to reassure Paul of her love: "You have released a lot in me & I wish I could do as much for you."

Following the closing of their joint show and purchases of O'Keeffe's paintings by the couple's friends, their difficulties seemed to have been resolved. Alfred expected to clear several thousand dollars, and he looked forward to opening a new gallery. But despite her sales, Georgia had doubts about the viability of art. She told her sister Catherine that commercial art of the sort she had practiced in the past allowed one to earn a living but was "prostitution," and went on, "few real artists make money enough to live. . . . You are not mixed in with the hash of the world like I am."

That spring, Paul took on the task of answering Georgia's critics. Her art was that of a woman, he argued, but did not result from her sexuality. One can imagine his conversations with Beck, and her role as typist, as he wrote and rewrote this essay. It began, "Here in this American land, something rare and unforeseen, something precise and significant in the realm of the spirit, has unfolded and flowered in the work of Georgia O'Keeffe." Women had not, until recently, distinguished themselves in art because they had been "limited to the home and to the lesser crafts," such as weaving and lace making. In these domains, their "imaginative resourcefulness and . . . savage intensity" could not attain the level of art, in his view "a philosophic projection" onto the material world. By the time Paul's essay reached final form, these passages had been edited out, presumably at Beck's suggestion.

The final draft argued for O'Keeffe's importance in artistic terms. Using color and form, she had created "a communicable aesthetic symbology expressive of the social significance of her world"—a portrayal of reality on a par with those of Matisse and Picasso. Like the feminists Christabel Pankhurst and Emma Goldman, O'Keeffe was a pioneer, and

her work, grown from the native soil, deserved comparison "with the best work of men." Strand's accolade would meet with approval from the group—although not from its subject—when it appeared in print.

Georgia turned her mind to more urgent concerns, such as putting their belongings in storage before moving out of Leopold's house. "It seems we have been moving all winter—Stieglitz has to do everything in his mind so many times before he does it in reality," she told Sherwood Anderson. They went to Lake George in June, aware that they would have to find lodgings on their return to Manhattan. Meanwhile, she was glad to be there alone: "I don't know why people disturb me so much. . . . It is the first time I have come here that I have really liked it."

. . .

Alfred set about disrupting their solitude almost immediately. He photographed the chestnut tree on the hill, which struck him as an heroic figure—holding on despite its waning powers, like himself. "Even the old chestnut tree on the upper Hill is singing his swansong," he informed Beck, letting her know that he looked forward to having her there: "You know what I feel about you." In his next letter, he compared Georgia's recent oils to Beck's work from the year before and said to give herself time to paint.

Beck replied that Alfred's departure had left a hole in her life. She also missed Georgia, "although that crabbed wench probably won't believe it." After a visit to Long Branch, where the neighbors welcomed her as "the same old Rebecky . . . wild as a hyena," she was dreaming of "rolling in the buttercups, sans negligee" at the Hill. If Alfred and Georgia agreed, the Strands would go there for the aptly named Independence Day.

Alfred wrote that they would be pleased to have them. Meanwhile, he was taking pictures of a naked Beck in his mind: "I thought of you frequently as I saw the high grasses here—& full of white daisies—& it was hot—& I felt wouldn't Beck like to plank herself down here—sans." Paul was once again in his good books, having supplied his portraits of Alfred to the British Royal Society for an article in his honor and to *Vanity Fair* for the magazine's "Hall of Fame." He was glad that Paul's career was taking off: "You have achieved your aim of last summer. And have really gone way beyond what you then dared hope for."

The Strands arrived at the Hill for the Fourth of July. Beck tried to make a place for herself by doing household chores, but Georgia, annoyed at having to set aside her oils, became frustrated. In the weeks

following the Strands' departure, when a stream of friends and family, including the Davidsons, started showing up, she lost her appetite and took to her bed. Alfred tried to protect her from intrusions into her solitude but also let her know that he felt threatened by it. She protested to Sherwood Anderson, "I have to keep some of myself or I wouldn't have anything left to give."

Their relations were further complicated by the news that Emmy had finally granted Alfred a divorce, to be finalized in September. He would then be free to marry, a step that in his view would defuse the tension in their lives by formalizing their personal and financial arrangements. Georgia, who was less than pleased by the prospect, would try, unsuccessfully, to resist marriage. Looking back on her fight to preserve her independence, she observed, "I like getting what I've got on my own."

Vanity Fair had just named Georgia to their "Hall of Fame" a month after Alfred's appearance there in June. The July issue, which celebrated America's independence, sported a cover that she could have designed. It showed two young women throwing fruit at a fleeing male oppressor in Colonial garb from their perch high in an apple tree. In her "Hall of Fame" portrait, one of Alfred's from the year before, Georgia glares at the camera as if confirming the caption: "She is rapidly coming into her own as an American painter of the first magnitude." Paul joked to Alfred, "Georgia looked at home in the H of F—the lightweight champ of the ladies, ready and capable of knocking them all dead."

Paul could not have anticipated that his return to the Hill at the end of July was poorly timed. Thinking that he had done the cause another good turn, he brought the proofs of his essay on Georgia, which was scheduled to appear in *Playboy*—then an avant-garde magazine of letters run by Egmont Arens. (The issue would include Arens's praise of Alfred and Georgia as leading lights of the art world.) Although the Davidsons did their best to comfort Georgia, she blew up at Paul after reading his piece. Rather than seeing it as a vindication, she took out her resentment at all those who explained her art in terms of her sexuality—though Paul had taken pains not to do so. They argued, and he left feeling baffled and rejected; Beck became indignant on his behalf.

Under the circumstances, Beck did not feel welcome to spend August at the Hill as planned, especially on hearing from Alfred that she should take one meal a day elsewhere because he did not want Georgia in the kitchen: "There'll be no trouble at all unless the lady folks can't live without." He continued ineptly: "I wouldn't say 'Come' unless it were 'right' all around. Of course you may have new plans." Realizing that

Georgia did not want her at the Hill after the blowup with Paul, Beck decided to board at the Pines.

"This thing with G.O.K. has had a curiously liberating effect," she wrote Paul from the train. "Before there was always excitement & now I'm indifferent." Alfred met Beck at the station, looking downhearted, but "said nothing about your contretemps. . . . I told him exactly what we felt—& he agreed that there was no other way to feel." In Beck's resolve to maintain her composure, she turned down Georgia's invitations and claimed to enjoy meals at the Pines, where there were no dishes to wash, "no fuss of any kind."

Alfred was disconcerted by the tension that had flared up among the four of them. Unable to admit his role in their disagreements, he thought of it as a falling-out among the "lady folks." And given his reliance on advice from Paul's father, he no doubt sensed that friction between himself and the Strands might have unfortunate consequences in the future.

Beck decided to make the best of things. She spent her days riding the horse she had rented, swimming, resting, doing crossword puzzles, and writing to Paul. "Don't fret for a minute about any disharmony here. . . . Georgia goes about her business, I about mine." Beck and Alfred resumed their afternoon swims; he photographed her making faces at him; Georgia offered to let her stable her horse at the farm. But she had no idea what Georgia was thinking. When the July *Playboy* arrived, Beck told Paul, "It's much nicer than the lady it is about."

Still ailing, Georgia said nothing about their estrangement until the day when she suddenly opened up. "She is very unhappy," Beck explained, "and what happened here has nothing to do with you." Georgia was beside herself with worries—the pressure to marry, the conflict she felt between her love for Alfred and the demands he made on her, his need to have his way, combined with his frailty and increased dependence. "So much suffering between two people who really care so much for one another that they hurt one another," Beck lamented. She spoke with both of them after Georgia broke down: "She has been pushed pretty far & is pretty ragged—spiritually." But while the three of them were again at peace, Beck could not forgive Georgia for hurting Paul.

The rest of the month went smoothly except for the prolonged stay of Leopold and Lizzie Stieglitz, who talked of building their own cottage on the property. When she could, Georgia slipped away to her shanty, where she was painting specimens from her garden: corn plants with their dark green leaves unfurling in opposite directions and close-ups

of flowers, more calla lilies, red canna, and pink petunias painted larger than life. Beck's emotions clouded her judgment: "I don't like the things she has done this summer."

Paul did his best to remain on good terms with Alfred, trying in vain to find the papers that Alfred wanted for printing and sending him his Graflex when Alfred's own camera suffered mechanical failures. Paul also confided in Alfred about the declining health of his aunt Josie, who owned the house on Eighty-third Street where the Strands had lived for decades. Until the terms of her will were known, it seemed likely that he and Beck would also have to find new lodgings. Paul thanked Alfred for voicing his concern about the couple's future.

On her return to New York, Beck received a note from Alfred. He had been printing his images of her, which gave him a heartache: "I do see all I missed doing I would so liked to have done with La Beckalina das Beckchen! A G[od] D[amn] Shame . . . no one to blame but yours truly." He continued: "I don't think the summer was lost for you in spite of all the 'unnecessary unpleasantness'—I wish I were just a bit 'wiser'—or whatever you call it."

· · ·

Life at the Hill smoothed out after the departure of summer guests. Ida O'Keeffe arrived in the middle of September and took to brightening the rooms with floral bouquets, while also relieving Georgia of chores. Rosenfeld, who joined them for a few days, flirted with Ida, to Alfred's dismay. A biographer writes, "With Rosenfeld, as with Strand, Alfred felt an intense sexual rivalry. It was as though he could assuage his fears about losing Georgia . . . if he could defeat his 'sons' on the field of love." When Ida refused to pose in the nude, he took pictures of her long underwear flapping on the line—a sly riposte to her so-called reserve.

Glad to have Ida as her ally, Georgia went back to painting the world outside her door. Autumn leaves that had fallen on the ground inspired new arrangements of shape and color. In her bold, large-scale *Pattern of Leaves,* a torn burgundy maple leaf overlies its companions in a confined picture space; similarly, *Leaf Motif No. 1* approaches abstraction through O'Keeffe's handling of the leaf's inner and outer edges. Other studies from this time imply that, like apples and flowers, leaves offered a way to evoke the intricacies of human relations.

O'Keeffe once declared that she would enjoy people more if they were like trees, and she and Stieglitz looked to the trees at the farm as familial presences. In 1919, engrossed in his composite portrait of

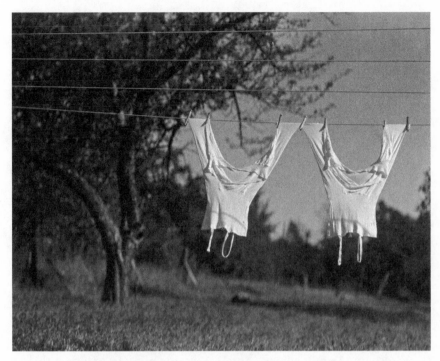

Alfred Stieglitz, *Long Underwear, Lake George*

Georgia, Alfred had told a friend that he had also been photographing trees—"human trees," like the venerable chestnut with which he identified (*The Dying Chestnut*). On their return to the lake in 1924, he wrote of his regard for this upright specimen. One can see in O'Keeffe's *The Chestnut Gray*, painted that year, an allusion to Alfred's esteem for his arboreal counterpart. Like his 1919 photograph, her frontal composition addresses the tree head-on, as a being facing mortality. When not turning his camera skyward, Alfred photographed other favorite trees on the farm.

All was harmonious, Alfred told Beck, now that Georgia could devote herself to painting. Beck answered tartly, "I am glad that it is at last peaceful—and sorry that Das Beckchen is *apparently* not one of the people that is 'complementary' to others." Relationships were "sensitive plants," Alfred replied, and human beings "queer bits of mechanisms" that sometimes broke down. Looking back on the summer, he tried to console her: "You really had nothing to do with the, let's call it unrest—inner of G.—as I see it. But we won't go into that. You have too much sense."

Beck did not hold the unpleasantness against him, especially once

Alfred sent her two prints of herself taken at lighter moments. "They show there's life in the old girl yet & who knows, I may yet be a music hall queen, started on a histrionic career by little A.S." Alfred had been kind to write during "this jangly time," she added, when Paul's aunt Josie lay dying. "I sit and wonder what its all about, this death thing—that's lurking for us all." It was reassuring to learn the terms of Paul's aunt's will: She had left the house to her sister, whom the Strands regarded as the head of the household. Alfred told Beck that he held her in his thoughts.

During the fall, Paul put in long hours on an assignment to film operations at the Jersey City hospital. Having negotiated better terms at her job, Beck wrote to Alfred, "I've learned to make myself independent—with not much of a training to start with—except an antagonistic family and a passion for independence." Now that the housing situation had been resolved and both she and Paul were contributing to their upkeep, "the idea of a child becomes active—but not yet." She added, "Perhaps some day—if the doctors give me a clean bill of health and I'm not too old." (She was nearly thirty-three.) Beck looked forward to her next adventure: "Someday I'm going off. Break tracks and get into trouble."

Alfred, on the other hand, was turning his mind to practical things, like finding a home for himself and Georgia. They returned to New York in November and, with the proceeds of their sales and the promise of a thousand dollars a year from Leopold, rented the top floor of a brownstone on East Fifty-eighth Street. Unconcerned with the election of Coolidge to the presidency, Alfred took pleasure in Sherwood Anderson's dedication for his newly released memoir, *A Story Teller's Story*: "To Alfred Stieglitz, who has been more than father to so many puzzled, wistful children of the arts in this big, noisy, growing and groping America."

Alfred heard from another of his "puzzled" children, Jean Toomer, when the young man returned to New York to teach the Gurdjieff method. That spring, Toomer had told Alfred about his efforts to square his spiritual quest with his private entanglements. Although some friends had declined when pressured to take sides regarding the Toomer-Naumberg-Frank triangle, Jean told Alfred, "We've again made conduits to each other. I believe that this time (we are worse than lovers!) things will hold." He hoped that Alfred would help him with finances when he began teaching Gurdjieff's method. Alfred and Georgia attended his classes but did not pursue the matter, no doubt because they had other things on their minds.

When Alfred's divorce became final, he redoubled efforts to persuade Georgia to marry him. The entwining of their personal and professional lives would be ratified by their union, which would also simplify issues like taxes and inheritance. It was urgent to regularize their relations now that Kitty had been institutionalized following a relapse: Her doctors believed that their marriage would force Kitty to accept reality.*

Georgia acceded to Alfred's arguments, on certain conditions. She was thirty-seven. She had made a name for herself and earned an income from the sale of her art. She did not want to be known as his wife, which would imply that her achievements were the result of his sponsorship. (It was surely hard to accept that his sensational portraits and marketing of her as "Georgia O'Keeffe, American" had played a big part in establishing her reputation.) O'Keeffe remarked years later of her desire to keep her name: "I wasn't going to give it up. Why should I take on someone else's famous name?" She agreed to marry but not to become a Stieglitz.

The couple had to go to New Jersey to obtain a license because of Alfred's status as a divorced man, which prevented him from remarrying in New York. The plan was that Marin, who lived across the Hudson, would meet them at the ferry landing and drive them to a justice of the peace in Cliffside Park. This official would then issue the license and perform the ceremony three days later. On the way, Marin turned to joke with Georgia, hit a grocery wagon, and careered into a lamppost. They emerged from the car unhurt but badly shaken. It was not a good start.

On December 11, the couple went back to New Jersey, where they were married without incident by the justice of the peace, with Marin and George Engelhard, Alfred's brother-in-law, as their witnesses. The ceremony was unusual only in that Georgia insisted on omitting the pledge to love, honor, and obey. There were no guests, no exchange of rings, no celebratory dinner, no announcement in the papers. Only a few friends were told that they had married. Years later, asked how she felt at the time, O'Keeffe replied, "What does it matter? I just know I didn't want to."

* The theory advanced by Kitty's doctors proved to be wrong. Her emotional state remained that of a child; she would be institutionalized for the rest of her life. Alfred, barred from visits because of her rages when she saw him, sent gifts but had little to do with her husband or their son. He harbored the idea that a genetic fault in his makeup was to blame for Kitty's condition.

The Treeness of a Tree

1925

In the new year, Stieglitz began organizing a large-scale exhibition to commemorate the twentieth anniversary of 291. Rather than show O'Keeffe's work, he would promote the idea of a group of artists whose vision was both homegrown and aesthetically advanced. To prove the point—that the group shared a visual language attuned to native culture—he announced the show with a Barnumesque flair: "Alfred Stieglitz Presents Seven Americans: 159 Paintings, Photographs & Things, Recent & Never Before Publicly Shown, by Arthur G. Dove, Marsden Hartley, John Marin, Charles Demuth, Paul Strand, Georgia O'Keeffe, Alfred Stieglitz." The show would be at the Anderson Galleries from March 9 to 28, 1925.

Stieglitz outdid himself as a pitchman. In advance of the opening, he produced a sixteen-page catalog with essays by Sherwood Anderson and the sculptor Arnold Rönnebeck, a poem by Arthur Dove, and a roll call of the exhibitions mounted at 291—as if they had led, inevitably, to his new show. McBride thought that Stieglitz would fill the gallery with the aid of the pro-American rhetoric with which he characterized these artists. Strand, unconcerned with the ballyhoo, felt vindicated that Stieglitz would be showing his prints for the first time since 1916. It would be the ideal venue, Alfred told Beck: "I am very glad that there is to be the chance to see them publicly under such perfect conditions."

To underscore the idea of a group vision, he devised an installation featuring Demuth's portrait posters of Dove, Duncan, and O'Keeffe at the entrance and examples of work by each of the artists in the hall. The preopening publicity worked as expected. On opening day, "there was an immense buzz of talk of people who were as much interested in each other as in the new pictures."

In the main room, visitors encountered each of the seven artists on the walls devoted to their work. "O'Keeffe outblazes the other painters in the exhibition," Edmund Wilson declared in *The New Republic*.

Her giant petunias, calla lilies, and landscapes (three abstractions, each titled *From the Lake*) affected him viscerally, unlike Marin's seascapes and Hartley's "sullen" still lifes. On the next wall, Strand's prints were grouped by subject matter—cityscapes, studies of leaves, and close-ups of machinery. While it may have surprised members of the group that his portraits of Beck were not included, some were glad to find her present in Dove's assemblage portrait of the Strands. Entitled *Painted Forms, Friends,* it employed metal rods, wires, nails, and a coiled spring to depict their rapport in rounded shapes that recalled her own as well as Paul's focus on his Akeley.

In the weeks before the opening, Beck was keeping her mother company in Atlantic City, where Paul sent her a copy of the exhibition catalog. One can picture her smiling at Rönnebeck's listing of "Jack Dempsey, the Five-and-Ten-Cent Store, Buffalo Bill, baseball, Henry Ford, and perhaps even Wall Street" as the symbols from which the seven in the group constructed their reality. The catalog was beautiful, she told Paul, and the show likely to be "a whopper."

While positive responses were to be expected from those in the inner circle, some of the uninitiated were put off by the hoopla. The catalog surrounded the art "in a halo of words," a critic wrote: "Americanism and emotionalism are self-consciously and unduly emphasized." Others said that the show was meant for a coterie. Professing herself an outsider, one critic praised Strand's *Leaves*: "exquisite in texture and color, as indeed are his photographs of buildings and machines."

One can imagine Beck skimming the reviews for mentions of Paul. Elizabeth Cary, writing in *The New York Times,* allowed that Stieglitz's *Equivalents* were beautiful, but Strand's images of machines seemed "more obvious in their truth." The comparison between their bodies of work reappeared in *The Arts.* Stieglitz's pictures of clouds were "expert," but Strand's diverse images formed a "conscious arrangement of material in which the attractiveness of his subject matter plays no small part."

It was awkward to have the two men's work compared in print, but even more disconcerting to read McBride's tribute to Strand's images penned in the belief that they had been made by Stieglitz. The photographer was the "Bellini" of the machine age, McBride wrote: "What used to be expended upon madonnas is here lavished upon pistons and revolving steel wheels." Stieglitz made light of the matter by suggesting that McBride might be senile, even though he also praised O'Keeffe. (McBride reserved his scorn for Hartley's "awfully fatigued" paintings, the result of his decision to live in Paris rather than in the United States.)

Georgia, bedridden with the flu, took pleasure in McBride's review.

"You are good! and I laughed at what you did to me—We are going to send it to Hartley—so that he sees what you say about those who live abroad." Despite her mental fog, she was thinking of a new subject—the urban landscape. If she could accomplish what she had in mind, she wrote, "my New Yorks would turn the world over." And, not coincidentally, prove the rightness of Stieglitz's promotion of her as an exemplar of native modernism.

Despite his efforts to publicize the "Georgia O'Keeffe, American" label, some critics reverted to Freudian-inspired notions. A "peculiarly feminine intensity . . . galvanized all her work," Edmund Wilson believed. Unlike male artists, whose creations stood at a distance from themselves, women artists had a way of "appearing to wear their most brilliant productions . . . like those other artistic expressions, their clothes." Thus, a woman's art was a projection of herself: O'Keeffe's dark green cornstalks were "charged by her personal current and fused by her personal heat."

Georgia did not write to thank Wilson or comment on his clothes analogy, although it would have been easy to mark the contrast between her sober garb and her vivid canvases. On the one hand, she believed in the idea of differences between male and female experience and felt that her art conveyed them. On the other, she did not want it seen through a Freudian lens. "I have always been very annoyed at being referred to as a woman artist rather than an artist," she said years later. But in the 1920s, cross with the male critics, she hoped that another woman would know how to express the distinctions that she saw in her painting.

At about this time, Georgia contacted Alfred's friend Mabel Dodge Luhan, who had been trying to lure him to Taos since settling there. After meeting Mabel on one of her visits to New York and reading her essay on the actress Katharine Cornell, Georgia asked whether Mabel might want to write about her: "A woman who has lived many things and who sees lines and colors as an expression of living—might say something that a man can't—I feel there is something unexplored about woman that only a woman can explore." Mabel would accept the invitation, but not in the way that Georgia anticipated.

Given her strained relations with Beck, it is not surprising that Georgia did not turn to her for this purpose. Since the previous summer, there had been no overt rift, yet each remained detached in her dealings with the other. Due to the lack of correspondence between them at this time, it is impossible to know the details of their relations, but it seems that a certain *froideur* prevailed.

By then, Alfred and Georgia had become friendly with Florine and Ettie Stettheimer, whom they met at Paul Rosenfeld's soirées. Florine had invited Georgia to tea after the 1921 show at the Anderson Galleries. "I was pleased to see her whole, as so far I only knew her in sections," she informed her sister. (Her insightful poem about the couple begins, "He photographs / She is naked / he proclaims / She has no clothes / other than his words.") Georgia and Alfred attended the Stettheimers' evenings in their well-appointed home on Seventy-sixth Street, Florine celebrating her circle's gatherings in faux naif paintings that depict their guests (including Duchamp, Hartley, McBride, and Stieglitz), but she did not show her own work. Georgia enjoyed the sisters' sly sense of humor.

Alfred continued his risqué correspondence with Beck. After she told him that she had frayed her buttock skin when riding in Atlantic City, he said that he dreamed of photographing the "roundness & texture & line" of her posterior. From Lake George, he reported an actual dream about her, one that was "satisfactory for all concerned." He continued in terms that she was bound to understand: "The Hill seems not quite complete without Splashing Waters—Yodelling greetings to the morning."

Beck refrained from comments on Alfred's dream but described her new job with Dr. Dudley Roberts and mentioned the photographs that Paul had recently taken for Gaston Lachaise, who gave the Strands two of his drawings. They hoped to spend August in Maine, where Lachaise was building a summer home. But she would miss Lake George: "The three months in three years—are still alive to me—my quiet attic room & the other little room—the lake, the clouds, the hills—the pain—the caring—G's struggle—You—well, perhaps some day again—you will let me come."

In the meantime, she and Paul swam often in the Olympic-size pool at the Shelton, a luxurious new hotel on the East Side, and strolled nightly in the park along Riverside Drive. By the end of June, tired of being alone when Paul was out of town (that year he filmed two movies, several sports events, and varied hospital procedures), Beck confessed to Alfred that she was "ready for trouble." She added, "It's good I am not coming to the Lake."

· · ·

More than trouble, Beck needed a change of scene. Since the last century, many New Yorkers had "rusticated" in Maine; recently members of the Stieglitz group escaped the scorching city summers by decamp-

ing there as well. Hartley, with whom Beck corresponded regularly at this time, painted his brooding mountain landscapes in the western part of the state, and Rosenfeld and Toomer planned to work on their current projects near York Beach in August. Others in the group spoke of the peace they found along the rocky coastline, whose primeval forests, granite rocks, and churning seas offered subject matter for painters and photographers alike.

Even before the war, several pictorialists had found their way to the pristine coastal area called Seguinland and had settled on Georgetown Island, at the mouth of the Kennebec River. In the 1900s, the photographer F. Holland Day invited Gertrude Käsebier and Clarence White to his retreat there. The trio formed a summer school of photography held at the Seguinland Hotel. Marin came to the area in 1914 and, with Stieglitz's help, earned enough from the sale of his seascapes to buy the small island where he painted during the 1910s. Other modernists who summered there included Max Weber and the Zorachs, along with Gaston and Isabel Lachaise.

Still, the decision to summer in Georgetown may have felt like an abandonment of Lake George. While Stieglitz encouraged "his" artists to seek refreshment in Maine, he did not go himself, having suffered through O'Keeffe's trips to York Beach. Nor had he wanted to see Lachaise's sculptures when the Frenchman tried to interest him in showing them at 291. Since then, McBride had compared Lachaise to Michelangelo, and the new cultural arbiter, *The Dial*, featured essays on the sculptor by others, including Rosenfeld. By 1925, Stieglitz was warming to Lachaise, particularly after he and O'Keeffe accepted his offer to portray them (he had already done busts of E. E. Cummings and Marianne Moore). Alfred voiced his approval of Beck's plan to go to Georgetown: "You'll enjoy it there much more than you could possibly the Hill this year."

The Strands moved into the Seguinland Hotel at the end of July, the management accommodating Paul's needs by giving him a space for a darkroom. The Lachaises showed them around and took them on bracing swims, "au naturel all of us and no constable about to worry us," Beck told Alfred; Isabel joined them at the hotel while their house was being completed. Once rested, the Strands took vigorous hikes and climbed the ocean-weathered rocks on the shoreline. "You and G. would love this place," Beck wrote. "It is wild and free—I wish you could be here with us." In lieu of going there, Alfred sent her a print of the lake to remind her of their summers together.

It surprised Beck to find out how deeply she and Paul responded to the landscape: "At first the country seems very austere and almost melancholy—but after a time as it reveals itself it becomes more & more lovely and in places almost tender." One day the couple rowed to a remote beach, where they enjoyed themselves "sans vêtements." That the landscape seemed "almost tender" suggests that relations between the couple softened as Paul began finding new subject matter in nature—though he did not avail himself of the opportunity to resume his portrait of Beck.

It was impossible not to marvel at Lachaise's devotion to Isabel—his muse since they had met nearly twenty years before in Paris. Ten years younger than Isabel, Gaston had moved to Boston to be near her (she was married at the time) and waited a decade until they could marry. In her mid-fifties, Isabel continued to pose for the voluptuous sculptures inspired by his vision of her. Writing about his 1918 exhibition, McBride called Lachaise "ardent," and his nudes, "energy incarnate." Another critic observed, "The breasts, the abdomen, the thighs, the buttocks—upon each of these elements the sculptor lavishes a powerful and incisive massiveness . . . that answers not to the descriptions of nature but to an ideal prescribed by his own emotions."

Beck grew fond of Isabel over the course of the month. "You should see Mme L. move through the icy water with as much grandiose calm as though she were serving afternoon coffee," Beck told Alfred. The women were already on intimate terms when Beck took on her role of helper during Isabel's preparations for her new home. She admired the older woman's way of leading an unconventional life but may have wondered about Gaston's devotion to her as muse in the flapper age, when charms like hers were out of fashion. (Beck was drawn to a small Lachaise torso that resembled her own curvaceous frame—a piece that she later bought for her art collection.)

Their husbands were also supportive of each other. Lachaise had written of Strand's work that it expressed his personality "in a clear forceful simpli[fi]cation." That summer Strand began a set of studies of rocks, plants, and driftwood meant to show the thing itself, rather than (as Stieglitz claimed to do in his *Equivalents*) as counterparts to emotional states. One such image, *Rocks, Georgetown, Maine*, exhibits great delicacy in its treatment of geological pattern: the layered stone resembles feathers or wings. Simplifications of this kind, Lachaise maintained, revealed "the spirituality of matter." Strand would return the compliment in his essay on the Frenchman turned American. Inspired by

the young country's vitality Lachaise had created "a synthesis in which human growth approximates the rich variety and growth of nature."

For the rest of the month, Paul trained his focus on the natural world. Beck missed their photographic sessions, the intimacy he'd once brought to his portraits of her—which had been shelved while he concentrated on his career as a cameraman. She could not have helped comparing their relationship to the older couple's, given that Gaston's sculptures relied on Isabel for inspiration. Reflecting on her own position—reliable wage earner and occasional muse—Beck may have seen herself in a negative light. She was neither a traditional woman like Isabel nor an accomplished painter like Georgia, her chief examples of women married to artists.

Beck came up with a plan to bring her closer to Paul while taking her in a new direction. After persuading him to teach her to use his Graflex,

Paul Strand, *Mme. Lachaise and Rebecca, Georgetown, Maine*

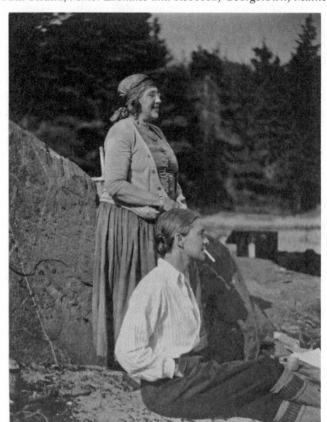

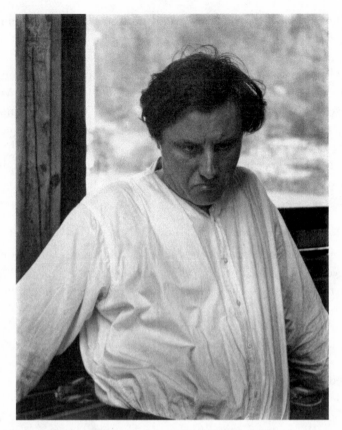

Paul Strand, *Gaston Lachaise, Georgetown, Maine,* 1927

she took a series of photographs, printed them in his darkroom, and sent one of the best, "Blue Sky Without a Cloud," to Alfred, followed a few days later by a portrait of the hotel dog and "a head of Mr Strand looking very alert!" Alfred thanked her for her amusing tribute to his sky images and seemed glad that she and Paul were "snapping & sporting."

By the end of August Paul had "ten fine prints," he told Alfred, despite dropping his camera into the water (he and Beck saved several films and developed them in his darkroom). He found time to take snapshots at the beach, one of a formally dressed Gaston kneeling before Isabel to tie her shoelace and another of a swimsuit-clad Beck. His most striking photograph shows Isabel, portly in her full-skirted dress, gazing into the distance while Beck, in modish trousers and with a cigarette dangling from her mouth, sits below her on the sand—two generations of artistic women. While one cannot date Strand's Georgetown images with cer-

tainty, he may also have taken several portraits of Lachaise glowering in his peasant's shirt—an image full of feeling for his friend's struggles.

After the Strands' return to New York, Paul gave Alfred an account of their time in Georgetown: "The weeks in Maine were so fine, really perfect days of work and play . . . we enjoyed Lachaise and Madame Lachaise whose attentiveness and acquaintance with the island made our own enjoyment of it keener." What he did not say was that they were thinking of buying a house there, to re-create something of the ambience of the Hill in a more carefree style—like that of the warmhearted Lachaises.

· · ·

For Alfred, a summer without the Strands proved peaceful but uninspiring. Severe eye pain kept him from reading or printing, and Georgia was having difficulty walking after her legs became swollen following a smallpox vaccination. The treatment prescribed by Leopold Stieglitz—a month's bed rest with her legs wrapped in bandages—did not help her disposition. At Alfred's invitation, Rosenfeld and the Kreymborgs were staying at the Hill to work on their new manuscripts, and Toomer was expected.

Uncharacteristically, Georgia turned over the use of her shanty to the Kreymborgs, since she could not even hobble there to paint. Various family members—Leopold and Lizzie, Alfred's sister Selma—were also in residence. When Elizabeth Davidson's girls arrived for the summer, three-year-old Sue curtsied and said, "How do you do, Aunt Georgia?" to which she responded by slapping the child and growling, "Don't ever call me 'Aunt.'"

Having agreed to forgo children of her own, Georgia had little time for those of others. She set herself apart from the group; rather than eat meals prepared by Lizzie's cook, she made salads of watercress and onions to enjoy on the porch while the others indulged in Stieglitz family jousting. "We had two yowling brats here for six weeks who carefully kept anyone from tasting their food or having anything resembling peace," she complained to Ettie Stettheimer. Once her legs recovered, she often rose at dawn to row across the lake, where she studied the trees, which inspired a series of paintings once the guests departed.

"The Hill would have been nothing for you this year," Alfred told Beck. Missing her high spirits, he relished every chance to tease her in allusions to times past. "Don't let a whale swallow you up when you

are sporting in the Maine waters," he cautioned, and in a postscript, he asked whether the whales liked her "Waterlilies" (his name for her breasts). When she wrote that she had been pronounced "gynecologi-cally PERFECT" (she was still unsure about having a child), he replied, "I thought surely you were on the way to triplets." In the same letter, he embraced her as "one of us photographers" and offered to "boom" her. That she was pondering what she saw as the choice between having "triplets" and finding her way as an artist did not occur to him.

In the same letter, Alfred enclosed a print of the Strands taken on one of their stays at the lake. In the foreground, Beck, in profile, bends her head back to kiss Paul, who turns to her with his eyes closed. She thanked Alfred, then chided, "You did do rather badly by little Strand. I look like a giantess beside him." She enclosed her print of the Lachaises' place in Maine and said that mutual friends had spoken of Georgia's improved health: "She means so much—& is so rare in these hurried days." Beck confessed that she missed Alfred, especially after "meeting" his bust in Lachaise's studio. "I couldn't help patting your cheek! it was fine to have your lovely presence in the room even in that form & I real-ized how very much you have always meant & still mean to me."

Alfred was flattered that Beck missed him and wished that she were there to help him repaint the kitchen floor, but also, he wrote, "to take you in hand & make a real photographer of you." He hoped that Georgia would soon start "her autumn fling"—the weeks of nonstop painting possible after the departure of guests. By mid-October, only Rosenfeld and Toomer remained, the latter working on an account of his spiri-tual evolution. Since his return from France the year before, interest in Gurdjieff had grown among the intellectuals who met at the homes of influential figures like Muriel Draper and Jane Heap. Toomer had also set up a study group in Harlem, which drew Zora Neale Hurston and Langston Hughes.

In Toomer's view, Stieglitz was as much a spiritual guide as Gurd-jieff. His photographs revealed the essence of things—"the *treeness* of a tree . . . what bark is . . . what a leaf is . . . the *woodness* of wood." One day, as Jean, Paul, Alfred, and Georgia were having breakfast while a snowfall blanketed the hillside, it seemed that they were cut off from the world. At that moment, a great warmth suffused the kitchen—"a most amazing sense that life was coming into us, that the wide world was immediate out there, that we were in the midst of happenings in America, that Stieglitz had an interior connectedness with life."

Stieglitz, in turn, felt a strong connection with the young writer.

Toomer believed that Alfred was one of those rare people who helped others to find their way. This ability, he thought, explained to his generation "why we value him, we who are younger than he but old enough to realize that thought and action are nothing unless they issue from and return to being." Perhaps intending to reveal the young man to himself, Alfred asked him to pose out-of-doors in his rumpled cardigan and overcoat—a session resulting in fifteen portraits that capture his moody charm.

Meanwhile, Georgia was hitting her stride. Making up for lost time, she painted seven portraits of trees—the kind that she preferred, at times, to people. The vitality of nature is implied in the swaying limbs of the birch trees with which she had communed over the summer. In two oils entitled *Birch and Pine Trees,* the branches of a dark green pine enlace the birches' silvery trunks; another in this series, *Birch and Pine Trees—Pink,* was, she later told Toomer, "a painting I made from something of you the first time you were here." While she was too discreet to say more, the embrace of the rose-toned birch limbs by the darker pine hints that Toomer was one of those who made her see shapes that "passed into the world as abstractions—no one seeing what they are."

By November, Alfred had printed nearly 350 images. "I have a few that will tickle 'das Beckchen' all over," he wrote, "& make her feel particularly glad she has a photographer as a husband & a photographer as a very good friend." He and Georgia were in a frenzy of production but had no definite housing prospects for the winter. They had applied for rooms at the Shelton, perhaps at Beck's suggestion, but since its completion the year before, the residential "club hotel" had been fully occupied. He continued drolly, "I hope New York will have some tiny corner with a bed in it to receive two such distinguished American citizens."

· · ·

At the last minute, the Shelton's managers found that they could offer the couple a two-room suite on the eleventh floor. The hotel was situated at Lexington Avenue and Forty-ninth Street, and the expressive use of its setback construction let light and air into the streets below. Its thirty-four stories made it the tallest hotel in the world; it offered such amenities as a cafeteria that served breakfast and dinner, housekeeping services, a pool, a gymnasium, and a billiard room, as well as comfortable lounges and reading rooms. It was an ideal solution for Georgia.

While their bedroom was just big enough for twin beds and a chest

of drawers, the sitting room windows gave a sense of spaciousness, and its sleek decor—off-white furniture, pale gray walls, and curtain-less windows—created an atmosphere that encouraged her to focus on painting. Visitors were surprised to note the absence of canvases on the walls. When Anita Pollitzer paid a call, Georgia explained, "I like an empty wall because I can imagine what I like on it." She claimed the dramatic exterior views for herself in a series of sketches of the sky-line and St. Patrick's Cathedral—shapes that would soon appear in her paintings.

Although the pace of life in New York was more hectic than Alfred remembered, he and Georgia no longer felt that they had to be part of it. To Alfred, their sparsely decorated suite seemed like an ocean liner high above the busy streets. "We feel as if we were out at midocean," he told Sherwood Anderson. "All is so quiet except the wind—& the trembling shaking hulk of steel in which we live—It's a wonderful place."

By contrast, the Strands had gone back to "the old grind." Each day Beck made her way from West Eighty-third Street to her job with Dr. Roberts, whose practice as a gastroenterologist, while not enthralling, offered good working conditions and a Park Avenue location just blocks from the Shelton. Paul used his inheritance to add to their growing art collection (through Alfred, he purchased a Hartley) and promised to help underwrite Alfred's next venture, the exhibition space he planned to rent at the Anderson Galleries. But film assignments required his absence from the city for weeks at a time, and Beck no longer felt inspired by photography, which she had taken up to share his passion rather than as her calling.

"Every time you go away there is the same old lost feeling," she told him. "I really am having a little inward struggle—with still the same old urge for something to develop—an affirmation of something." She con-tinued pensively: "I guess I miss being photographed a lot."

Turning the Page

1926

Beck dealt with her feeling of loss by giving her support to Alfred's latest scheme. His plan to open an exhibition space in a large, high-ceilinged room in the Anderson building—to be called the Intimate Gallery—was the affirmation she had been waiting for. Along with Stieglitz family members, wealthy patrons, and Paul Rosenfeld, the Strands committed themselves to underwriting the costs of renting room 303. While helping to prepare the space, Beck also bought art by Alfred's favorites to add to the Strands' collection. Despite the cooling of relations with Georgia, Beck's embrace of the gallery, known to friends as "the Room," seemed to assure her place in the inner circle.

Stieglitz informed prospective visitors that the Intimate Gallery would serve not as a commercial space but as "a Direct Point of Contact between Public and Artist." (Just the same, he set prices according to his ideas of what buyers could afford and whether they cared deeply for the work.) Building on the theme of his 1925 Seven Americans show, he planned to devote the Room to Marin, O'Keeffe, Dove, Hartley, Strand, himself, and the unnamed number seven—a designation that would allow him to vary the list as he saw fit. Only at the Intimate Gallery, he maintained, could art lovers reflect upon "the complete evolution and the more important examples of these American workers."

For their first exhibition, Georgia covered the walls with unbleached muslin, and every morning Alfred swept the black rug to remove smudges. The tall windows took up so much space that there was room on the walls for only a few paintings; the rest were placed on the floor or on the furniture. The newly brightened gallery, Stieglitz told Anderson, encouraged the paintings to be themselves: "There is no artiness—just a throbbing pulsating being."

Stieglitz's nativist approach functioned as an implicit critique of the many Americans—artists, writers, and intellectuals—who had flocked

to Paris or Berlin, where they could live well due to the exchange rate. O'Keeffe went along with his pro-American rhetoric while noting that it should not limit one to a particular style, such as representation. "One can't . . . be an American by going about saying that one is an American," she declared. "It is necessary to feel America, live America, love America and then work." Much later, she recalled the effect of this credo on the men in the group: "They would all sit around and talk about the great American novel and the great American poetry, but they all would have stepped right across the ocean and stayed in Paris if they could have." She added, "Not me, I had things to do in my own country."

· · ·

One of the things Georgia meant to do was to paint her "New Yorks." After several years of good sales, she was ready to tackle the scenes from her windows. Strand and Stieglitz had already photographed the cityscape in a variety of moods; Sheeler and Demuth, who occasionally filled the number seven slot, were painting urban landscapes with simplified forms and industrial subject matter, the style that became known as Precisionist. But these approaches were overtly masculine. It seemed inappropriate for a woman to tackle the subject—an objection that only intensified O'Keeffe's desire to persevere: "When I wanted to paint New York, the men thought I'd lost my mind. But I did it anyway." Her first cityscape, *New York Street with Moon,* was completed in 1925 but was omitted from that year's Seven Americans show due to Alfred's uncertainty about showing something so unlike her previous work.

In February 1926, he invited the Strands to join Seligmann, Georgia, and himself to hang her new show, "Fifty Recent Paintings, by Georgia O'Keeffe." They placed *New York Street with Moon* between two of the big windows, as if its jutting forms fit easily into the skyline on either side. The first thing one saw on entering the gallery, this canvas made a striking contrast to her petunias, maple leaves, and birch trees—a gamble on the part of the hanging committee that paid off on opening day, when it was sold. "No one ever objected to my painting New York after that," O'Keeffe noted.

Her exhibition was a success. Until April, when it came down, the Room was often so crowded that it was difficult to get inside, let alone see the paintings. Georgia absented herself to attend the National Woman's Party convention in Washington at the request of Anita Pollitzer, the group's executive secretary. A member in good standing since

1913, Georgia delivered a speech that was, Anita thought, the best of the evening. A journalist in attendance wrote that if O'Keeffe cared for anything other than her work, "it is her interest and faith in her own sex. . . . She believes ardently in woman as an individual—an individual not merely with the rights and privileges of man, but, what is to her more important, with the same responsibilities. And chief among these is the responsibility of self-realization."

In March, an interview with O'Keeffe in *The Chicago Evening Post* quoted her on a woman's right to fulfill her potential. The interviewer, Blanche Matthias, linked O'Keeffe's sense of autonomy to her "profoundly feminine" art, answering her call for a critic who shared her vision. "Many men here in New York think women can't be artists, but we can see and feel and work as they can," O'Keeffe declared. In response to complaints about obstacles in the way of a woman's career, she snapped, "Too much complaining and too little work." Matthias concluded ironically, "Women like O'Keeffe are dangerous. . . . Look sharp, you worlds, who see in flag-waving an excuse for murder, and in power, your privilege to abuse. The O'Keeffes are coming!"

But few apart from Georgia's intimates understood the cost involved in her calls for self-realization. The day after her talk to the convention, she returned to New York and collapsed from stomach pain, followed by dramatic weight loss over the next few weeks. One can imagine her reading her reviews in bed, perhaps smiling at *The New Yorker*'s words on her success: "Psychiatrists have been sending their patients up to see O'Keeffe's canvases. . . . They limp to the shrine of Saint Georgia and they fly away on the wings of the libido." McBride began by saying that he would note the opinions of her female fans before giving his own: "I like her stuff . . . but I do not feel the occult element in them that all the ladies insist is there. There were more feminine shrieks and screams in the vicinity of O'Keefe's [*sic*] works this year than ever before."

Beck learned that Georgia was ailing in March, when she was again keeping her mother company on the New Jersey shore, and wrote to Dudley Roberts, whose expertise in gastroenterology made it likely that he could help. When Georgia consulted him, Beck asked Roberts to keep her informed, "for I really feel responsible for whatever happens to her."

Beck was adding Georgia to her list of concerns at a time when the Salsburys were going through a difficult patch. Mrs. Salsbury's sale of the family home and the distribution of the proceeds among her children allowed Beck to give up her job as a medical secretary, but with financial independence came the need to take responsibility for their

mother, who had recently settled in an apartment close to her son Milton, her primary support. When Milton needed surgery, Beck took their mother to New Jersey during his convalescence, which was slower than expected, and then the two women extended their stay while Milton's wife looked after him.

On Beck's return to New York, she took on the additional task of sorting through their father's papers to relieve Milton of the work he had begun with Richard Walsh, the literary editor who contacted him because he was writing a book on Buffalo Bill to show "the processes by which a semi-legendary figure was created." Beck was happy that Nate's story would at last be told from his perspective, and Walsh expressed his gratitude to her for her hard work, but by late spring, after a series of colds, she felt too weak to keep going—though she had, she told Alfred, avoided "la gripette." She did not mention her fear that she might have tuberculosis, which ran in the family.

She had already begun to imagine a long vacation and was thinking of spending the summer in Europe with Paul before they settled down and had children (she felt that at almost thirty-five, this might be her last chance). But like Georgia, Beck believed that she had things to do in her own country—in her case, Square Butte, Montana, where her father's ranch continued in operation. "I have been thinking about the ranch," she told Paul. "It will eventually be sold—and when I think that perhaps you will never see it if you don't go now it makes me quite ill." She would ask the manager if they might stay; if not, they could go to Europe. But, she added, "my first love is the butte."

Beck was articulating what had always been the case. While she embraced the Stieglitz circle's staunch nativism, she also wanted to share the Salsbury legacy with Paul. (She may have reflected that except for his weeks in New Mexico as Alfred's envoy, she, Georgia, and Hartley were the only ones in their circle who had spent time west of the Mississippi.) Between colds, Beck planned an itinerary to accommodate her need for a restorative holiday and Paul's for new sources of inspiration. When she told Alfred of their plan to spend three months in the West, he gave them his blessing. "Stay away as long as you possibly can," he wrote. "It's your chance."

· · ·

When Beck learned that she and Paul would not be able to stay at her father's ranch, she settled on Estes Park, Colorado. (She may have been influenced by Isabella Bird's popular account of her travels there, *A*

Lady's Life in the Rocky Mountains.) Soon after their arrival, she sent Alfred a postcard showing their cabin: surrounded by wildflowers, it had a fine view of the snow-topped peaks.

From this vantage point, New York seemed like "a distant and disagreeable ant heap," Paul told Alfred. Marin should join them: far from seeming aloof, the Rockies were "closer somehow to human experience." No doubt thinking of his correspondence with O'Keeffe during her time in Colorado, he went on to say, "Georgia knows this country and I think she will agree with what I am rather vaguely trying to say about it." After consulting a doctor, Beck learned that she was anemic but not tubercular, but she was still feeling unsteady. "After what has happened in the family," Paul added, "I only wish we could be here in the West a year at least."

Paul Strand, *Blasted Tree, Colorado,* 1926

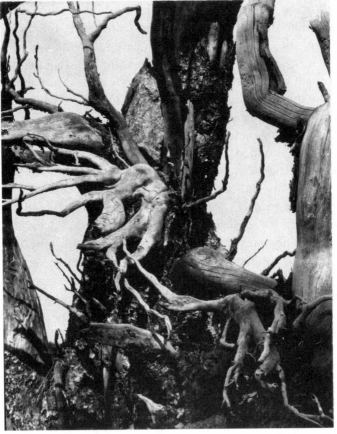

While he was glad to report that Beck was having "a good-bad time with her watercolors," Paul was circumspect about his own work—nature studies rather like his photographs from the previous summer in Maine and a new series, images of twisted tree stumps, suggesting some uneasiness about the "human experience" that seems to echo in their forms. In one, *Blasted Tree, Colorado,* branches jut out from the trunk like misshapen limbs; in another, *Tree Root, Colorado,* the root's angle resembles a bent, or broken, leg—as if nature were in sympathy with human suffering.

Paul's portrait of Beck posed against a tree trunk may be related to his tree series from this time, when she could not decide whether she wanted children, or whether being true to herself meant finding her way as an artist. "Paul made the tree prints when I was so ill in Estes Park," Beck told Alfred. "I was frantic and he [was] trying to bring me to the point where I could decide for myself what to do for myself."

In August, the Strands moved to Mesa Verde, Colorado, the site of

Paul Strand, *Rebecca, Taos, New Mexico,* 1932

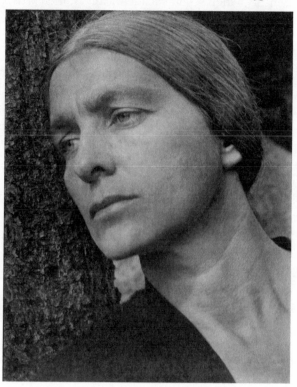

ancient cliff dwellings. Paul photographed the well-preserved alcove houses as nearly pure geometric form and developed his work each night in the hotel cellar—in one instance, printing the image of a rock shelter upside down to enhance its balance. They went on to Santa Fe to find Rosenfeld and the Kreymborgs, who been spending the summer there to complete writing projects. "Your babies haven't been loafing," Paul assured Alfred.

But judging by the paintings that he and Beck saw in the Santa Fe museum, the local artists had been wasting their time. "I have never seen more trashy, utterly commonplace picture making. It is almost unbeliev-able that this amazing country can be seen in such a dead way." The only one who showed a sense of place was Hartley, though his work was not on view: Paul had to talk the attendant into retrieving the museum's one Hartley from storage. He hoped that Marin and O'Keeffe would one day do the Southwest justice.

The Strands' next stop was Taos, where Hartley had lived and painted ten years earlier. Taos, a stop on the popular Indian Detours trips hosted by Harvey Girls in Navajo-style outfits, had been an art colony since the nineteenth century, when several academically trained artists (including Ernest Blumenschein, Frederic Remington, and Walter Ufer) came to paint the landscape and the Pueblo people's timeless dwellings. Locals had taken to calling Taos "Mabeltown" after Alfred's friend Mabel Dodge bought an extensive property near the Pueblo, married Tony Luhan, a Pueblo Indian, and began her reign over the town's social life. When Mabel learned that Paul and Beck were staying in a bed bug–ridden hotel, she offered them la Casita Rosa (the Pink House), a small adobe on her property. It had a separate studio and the cachet of having housed D. H. Lawrence, whom Mabel lured to Taos in 1922 with the promise of time to write.

The main house, where they took their meals, was called Los Gallos, after the array of ceramic roosters perched along the roof. Filled with Mabel's unconventional guests, Los Gallos was impossible to describe. It was "casual, amusing, a scream, a playhouse, a theatre, a church, a harem, a studio, a nursery, a yacht, a boudoir," Beck told Alfred. She added, "Why she has been so kind to us we do not know except that she probably is to everybody." Beck felt so relaxed there that she painted a number of cheerful watercolors of the scenes around her.

One wonders whether Mabel told the Strands about Jean Toomer's visit earlier that year. On meeting Toomer in New York, she had urged him to go to Taos to establish a Gurdjieff center at her home, and once

there, he understood that Mabel not only planned to take the center under her wing but meant to lay claim to him, as well. Declining to be a kept man, he returned to New York after sending most of the funds she had donated to Gurdjieff. What began as a "magnificent gift to consciousness" ended in mistrust, recriminations, and, in time, the end of Mabel's infatuation.

Through Beck, Mabel also extended an invitation to Alfred and Georgia to come to Taos. "It's really very beautiful," Beck assured him, "& she would do some great things." The idea would take several years to germinate. Having learned from Rosenfeld that Georgia had recently fled from Lake George to her sanctuary in Maine, Beck expressed the hope that she and Alfred were now in better health. She ended with a question: "And are you content? Best to Georgia—I want her to be happy too."

A few weeks later, Beck let on that she had come to understand something about herself in recent months: "My taste for adventure has developed into an appetite!"

.　.　.

Their summer at Lake George had been dismal, Alfred replied, "a sort of hash & and not good hash at that." It began with an attack of kidney stones that landed him in New York's Mount Sinai Hospital. Georgia and her sister Ida looked after him during his convalescence at the lake; there were no guests except for one of Georgia's painting students. Lee and Lizzie Stieglitz sent their cook to prepare meals for the household while they were in Europe: They planned to go to the Hill on their return with the Davidson girls. Far worse, from Georgia's perspective, Alfred's sister Selma kept announcing her imminent arrival. Georgia grew more than usually anxious and started losing weight again after Ethel Tyrrell and Eva Herrmann, the daughters of Alfred's friends, came to stay and Alfred photographed them in the nude—which no doubt brought to mind his sessions with Beck.

In August, Eva told Georgia that she had seen Alfred kissing the cook. Georgia then decamped to York Beach, where she spent most of her time walking by the ocean. "I was like a mad woman," she told Alfred. "All the world seemed gone from me—everything that I had ever been able to touch and to build my life on seemed shattered." But solitude agreed with her: "I will be all right—I knew it out there tonight—It is something that goes thru my blood." She took solace in the shells she

picked up from the sand and in the serene hues of the sky and water. "It seems to be the first firm feeling I have had under my feet in months."

Alarmed, Alfred took the unusual step of going to York Beach at the end of August. Their passion revived, and Georgia agreed to return to the lake, for she could not imagine living without him. A few days before her scheduled return, she felt ready to paint: "I have been letting the ocean and the rocks and the sand get into me," she wrote. By then the outer world had permeated her vision. In *Blue Wave Maine,* a sense of boundlessness suffuses her depiction of the sea, tossed by a stylized wave and lit by the glow along the horizon—a scene from nature approaching the sublime.

She was also sorting through the shells that she planned to treat as subjects. It is tempting to see in this new series of oils reflections of her state of mind—her need for solitude and her concern that in her isolation, she was cutting herself off from life. Three oils from this time show silver-and-white clamshells standing upright in a confined space; small in scale, they evoke twin motifs of opening and closing. Suggestively, *Open Clam Shell* allows a view into the bivalve's interior but blocks access into the small opening within; *Closed Clam Shell* shuts itself up tight, offering its line of closure to the (too inquisitive?) gaze. O'Keeffe's apple series had depicted changing patterns of relationship; her enigmatic shell series meditate on the integrity of the self.

In a magnanimous moment, Alfred wired Georgia to say that she should stay in Maine as long as she liked. She put off her departure for another week while he went to New York to choose work for an international art exhibition being organized by Man Ray, Katherine Dreier, and Marcel Duchamp, the founders of the dadaesque Société Anonyme. From the lake, Georgia wrote to him that this phase in their relations "mark[ed] the turning of a page" although she did not know "what is on the other side." This sentiment, which recurred the next day, conveys a nascent sense of poise in the face of his demands: "It must be that I am turning a page in my life—and I must see as clearly as I can what is—not what I want to see—but what is."

They spent the next month together at the lake. In addition to the clamshell series, Georgia painted a number of floral pictures, a poignant study of the maple tree with which Alfred identified, and six oils, each called *Shell and Old Shingle.* Placing a shell from Maine next to a shingle from the roof of an outbuilding, she looked at them from all sides until they became "shapes together—singing shapes." While this series contrasts the shell's smooth curves with the shingle's flinty texture, these

shapes also evoke O'Keeffe's turning over in her mind the contradictions between her thirst for solitude and her responsiveness to the pull of life with Alfred. Moreover, the landscape entitled *Lake George Blue* (whose handling of sky and water contrasts with the openness of *Blue Wave Maine*) feels dark, heavy, and foreclosed.

Surprisingly, Stieglitz did not send any of O'Keeffe's recent paintings to the Société Anonyme exhibition to be held that fall at the Brooklyn Museum. Instead, he chose her *Abstraction II* and *Maple Tree* (also called *Grey Tree, Lake George*), compositions that were undeniably modern but predated her "turning of a page." (He also sent works by Dove, Hartley, and Marin, along with eight of his photographs, although none by Strand, after giving the thought some consideration.)

Alfred and Georgia returned to New York in November to take possession of suite 3003 on the twenty-eighth floor of the Shelton—a good omen in his opinion, since it echoed the number of the Intimate Gallery, 303. Georgia made the main room, which was also her studio, into a minimalist space that anticipated what would become her unvarnished lifestyle. A visitor recalled, "I entered a room as bleak as the North Pole. It might have been a cloister or the reception room of an orphanage, so austere was it, with its cold gray walls, and its white covers over dull upholstery. There was no frivolous pillow, no 'hangings.' The only spot of color was a red flower on an easel. There was not an inch of cretonne or a dab of chintz. . . . All the charm of life is out there beyond the windows."

Living together in this austere space for the next ten years, Alfred and Georgia, despite their love for each other, would disagree more often than in the past. At thirty-nine, tied to a man in his sixties who was set in his ways, Georgia longed for greater freedom, while Alfred wanted a partner who would devote herself to him as artistic impresario as well as to their private life. By the new year, when they were preparing her annual exhibit at the Room, Georgia sensed that change was inevitable.

Alfred, too, was mulling over their rapport. "Any true relationship is tragic," he was heard to say. "Marriage, if it is real, must be based on a wish that each person attain his potentiality, be the thing he might be, as a tree bears its fruit—at the same time realizing responsibility to the other party. . . . At least trees can only be themselves." It may not have occurred to him that Georgia was already wondering how to be herself under the circumstances—since it was clear that despite Alfred's desire to recognize his responsibility to her, his own needs would always come first.

The End of Something

1927–1928

Once again, the new year began with O'Keeffe's exhibition at the Room. "Much is happening—but it doesn't take shape," she told Waldo Frank, whose essay on her in his new book, *Time Exposures,* had "more of a warm kindly feeling—and less of the knife for me than for most of the others." The effects of Georgia's page turning would not be evident in her show: "It is too beautiful. . . . I would like the next one to be so magnificently vulgar that all the people who have liked what I have been doing would stop talking to me." She had mixed feelings about the event: "I have come to the end of something."

By all accounts "Georgia O'Keeffe: Paintings, 1926" *was* beautiful. The elegant neutrals of her cityscapes—four Sheltons, three East Rivers, two street scenes—created a subtle background for her cannas, calla lilies, and the showstoppers, the purple petunias and black iris, which inevitably evoked erotic feelings. The brochure included statements by fellow artists. Oscar Bluemner's may have given her pause: "In this our period of woman's ascendancy we behold O'Keeffe's work flowering forth like a manifestation of that feminine causative principle, a painter's vision new, fascinating, virgin American." Still, Demuth praised her as a colorist: "In her canvases each colour almost regains the fun it must have felt within itself, on forming the first rain-bow [*sic*]."

Few critics mentioned the shell paintings. Exceptionally, Helen Read's interest in O'Keeffe's handling of form led her to applaud her treatment of the clamshells' pearly interiors and their textured outsides. Read concluded, "There are few conceivable subjects which so put to test her ability to paint . . . and yet relate it to all of life." A well-dressed woman in the early stages of pregnancy was seen gazing at two of the small paintings, a white flower and a white shell. The visitor, who introduced herself as Dorothy Norman, had been coming to the gallery for some time but lacked the funds to make a purchase.

McBride wrote that he looked forward to an account of "ladies' day" at the exhibition. "This priestess of mystery known as Miss O'Keeffe almost had me in her power," he wrote tongue in cheek, but he thought it best to leave the subject to the ladies, some of whom said that "gazing into Miss O'Keeffe's petunias gave them the strangest imaginable sensations." Her new work was "intellectual rather than emotional," indeed "rather French." O'Keeffe told him that she was glad "to have the emotional faucet turned off," and went on to say, "The ladies who like my things will think they are becoming intellectual . . . the men will think them much safer if my method is French." The exhibition was a success. The six canvases sold brought in seventeen thousand dollars (equivalent to over $200,000 today)—O'Keeffe's highest earnings to date.

Strand was pleased that the Room's last show of the season would be of Lachaise's voluptuous females, among them the walking woman in bronze that the sculptor had given the Strands as a gift. Paul also purchased a portfolio of Marin's work and an O'Keeffe, which he paid for in installments. (That year, he had a number of film assignments—including *Betty, Behave,* Columbia University's Varsity Show, which was screened at the Waldorf-Astoria.) Paul brought his best prints from Maine and Colorado to show Alfred in hopes that he, too, would have his turn at the gallery, and although Alfred approved of his new direction, he did not offer to hang them.

Beck took the matter in hand. Relying on their mutual fondness, she wrote to Alfred: "Ever since Paul told me that you had seen his recent work and affirmed it I have been wanting to tell you how happy this has made me. . . . I felt sure that you would see in some of his prints what I felt sure was there." After commenting on the portraits of her taken in Colorado, she gushed, "Do you know how lovely you are? And that for all this and everything else that you inherently are and always will be I am ever-increasingly grateful."

Alfred's reply was affectionate toward Beck but cautious in regard to Paul. "Yes, several of those photographs of Paul's are very fine—He told me how they happened—after I had remarked that these were truly alive." But that was all he said. It would take him two years to decide that the rest of Paul's work was sufficiently alive to warrant being shown at the Room—despite his protégé's support of its activities and his status as one of the seven whose creativity it was meant to celebrate.

The Lachaise exhibition, a critical success, closed on April 14. Stieglitz bought three small sculptures for himself but not the alabaster bust of O'Keeffe—perhaps because it betrayed a lack of feeling for her as

a woman. (She would later acquire it for herself.) That same day, he and Georgia quarreled, and she fled to Connecticut to be with friends. While they were still passionate about each other, both acknowledged that their desires were often at cross-purposes. She said that she felt misunderstood; he sent assurances of his love, along with a well-worn excuse: He had been preoccupied by the gallery. "You charge me with neglect," he chided. "I hold you have no actual ground for feeling what you do—or maybe *how* you feel it." In a more detached mood, he allowed that their conflicts might be due to other things, like age: "Maybe the 23 years difference . . . brings its own individual inevitability."

· · ·

Beck's worries multiplied that spring as her brother's condition worsened. In June, she helped Milton's wife by looking after their baby and made plans to take her mother on vacation after his next operation. In a letter to Alfred, she asked ironically whom she would have to care for next. "Myself? No—because I really feel I'm not *alive* to take care of—Just existing and ready to live somebody else's life so *they* can live. . . . What the hell!" Was this "the good life," she wondered. Alfred's reply may not have brought much comfort. "Yes, you are there . . . to help others live. It's a hellish life all right when one has two sides to one's makeup."

Hoping that Milton's convalescence would go well, Beck took their mother to New Jersey. But dealing with her mother's criticism of her unconventional ways (like her preference for scanty underwear) made her feel once again the impossibility of finding her way. To Paul, who was filming in Princeton, she wrote that she was furious at having to stay put "when I would like to go to Alaska—make love to a handsome chauffeur—get drunk—paint my facia [sic] low & common as a release from all this deadly atmosphere." (Like his other letters, his reply to this cry of rage is not extant.)

Although rumors of an impending stock market drop had Beck concerned about the future, her brother's recovery lifted her spirits. Still, time spent at their hotel—the other guests were "fat—prosperous—& not a single suggestion of any *fire*"—made her fear for herself. "What, oh my darling," she asked Paul, "shall I be at 50? 60? 70?"

Their life together was on hold. Paul was unsure about future assignments, and it was too soon to act on their plans to return to Maine. In August, when Milton seemed much improved, they traveled to Georgetown, but returned to New York when they learned that he was dying. He

did not know her at first, but then, she told Alfred, "smiled with ineffable tenderness, said 'hello darling'—then slipped off." Beck had written to Georgia about his death but thought her letters so inadequate that she destroyed them. She could, however, open her heart to Alfred: "When I see how easily life flows into death I can only beg you not to get involved in all the things that harass you. . . . Life is precious—especially yours."

Summer at Lake George took its familiar shape that year—peace and quiet before the arrival of family members and guests, followed by the hubbub that pushed Georgia to thoughts of escape. At first, following a bout of rheumatism in her hand, she did little painting, and Alfred declared himself to be empty of all thoughts or ambitions. When Georgia discovered a lump in her breast, he took her to Mount Sinai Hospital for surgery, and after the tumor was found to be benign, she spent eleven days in bed. By September, she was painting again, but without much enthusiasm; nor did he feel excited about his new prints.

All in all, the summer was disappointing, except for visits by Georgia's favorites, Donald Davidson and Georgia Minor (Englehard), who repaired with her to the shanty for cocktails. It rained so much, Georgia told Anita Pollitzer, that when it stopped, "one has a mania to spend all ones time turning the house hold goods such as mattresses and pillows and blankets in the little sun that stingily shows its face." One day she tore down part of the porch roof to let in more light. "It caused an uproar."

She expressed her discontent in several stunning landscapes that imply the wish for a sunny locale. Blazing with the heat and light lacking at the lake, *Red Hills with Sun* seems to tap into the energy of the West as reimagined in her private vision. Similarly, in *Black Abstraction*, the most dramatic canvas from this time, O'Keeffe conveyed what she had seen on the operating table as she succumbed to the anesthetic—the bright overhead light shrinking down to the white dot at the dark center of consciousness, and of the composition.

In September, Alfred told Beck, who had gone back to Maine, that he and Georgia were enjoying the autumn. Yet, he added, "there seems to be little spirit to anyone." Beck was delighted to hear from him. "The wires of mutual thought must have been vibrating across the distance," she mused before telling him of her sorrow. "The past three years were such a nightmare . . . that I have really needed this much time to make up for the damage." Under the care of Isabel Lachaise, she had her own room, which she filled with flowers. After Milton's death, Paul had stayed in New York to shoot a film and for that reason had been unable

to continue his nature photography. "Deep down," she added, "he would give a lot to go on without interruption."

Beck had also been thinking about the future. She was still uncertain about her artistic vocation and continued to doubt her suitability for motherhood. It was at about this time that she and Paul reached the decision to forgo parenthood. In September, she told Alfred that she would never have children: "I have missed the moment. . . . I shall try to find an equivalent." Some of her women friends had found their "equivalents": Georgia was fulfilled by her art, Isabel by being Gaston's muse and by the creation of their home. This decision, she wrote, "leaves me freer to move along a different direction"—although she could not say what it would be.

For the rest of the month, Beck went antiquing with Isabel, reembroidered a vintage rug, and made ornaments with seashells, activities pursued between bursts of house hunting. The naively painted decorations on the glass panes of antique clocks and mirrors caught her eye, especially their use of floral themes. In letters to Paul, she described the houses for sale in Georgetown but refrained from taking the next step while he was in New York. ("Why can't we take the real estate leap with more confidence when all our friends dash so gaily off?" she asked.) Lacking Paul's replies to her letters, which beg him to join her, we cannot know whether their closeness had diminished, or whether he was simply focused on his career. Meanwhile, Beck put his equipment in storage so that he could resume work if he returned.

In October, to her surprise, Paul allowed himself two weeks in Maine. "We are well—gay—busy," she exulted to Alfred, especially once Lachaise had also returned from New York. The two couples were enjoying local festivities like the county fair. "I got the most thrill out of it," she wrote. "Anything touching on showmanship always moves me tremendously." Beck sent her greetings to Georgia, as well: "Tell her for me, specially, that I hope she is gay—and that all the loveliness of which she is so truly capable has had a chance to exist." Beck had been loath to express her feelings more openly, given her sense that "she is interested only in adequate things."

The Strands returned to Manhattan that month after a trip to Boston to see the prints that Alfred had donated to the Museum of Fine Arts in 1923. Beck was delighted to see two of the images that Alfred had given her. "They sang and vibrated with enormous vitality," she wrote: "How lucky I am to have them—and others through your generosity." While Paul was keen to return to photography, it was rewarding to learn that

Manhatta would be screened at the London Flim Society that fall. The first feature-length talkie, *The Jazz Singer,* had just opened in New York, signaling the end of the silent era in motion pictures. The Strands' financial investments were performing as expected, and like many Americans, they were optimistic about their value continuing to rise.

Beck considered the idea of taking a painting class with Charles Martin, a modernist artist recommended by Georgia—perhaps a worthwhile move if she were to become an "adequate" painter. But after starting another secretarial job, she decided to experiment on her own. She completed several compositions based on arrangements of fruit—unavoidably suggesting Georgia's treatments of this theme.

That winter, Georgia took on a new role at the recently opened Opportunity Gallery, located on East Fifty-sixth Street. When Alon Bement, the gallery director and Georgia's former teacher, asked her to curate the December exhibition, she chose mainly work by women, including that of her sister Ida Ten Eyck, Georgia Englehard, Frances O'Brien, and Helen Torr Dove. For Beck, it would have been heartening to think that her work might one day be included—provided that Georgia decided to take it seriously.

In the meantime, Paul was having difficulty persuading Alfred to do the same with his work. His mentor often sought his advice about photographic papers and printing techniques, but he was in no hurry to schedule a show of Paul's photographs. Instead, he urged him to turn his mind to helping publicize Georgia's next exhibition by writing about her for *Creative Art.* Paul declined Alfred's request; he had just begun a piece on Lachaise for the new annual of art and letters, *American Caravan.*

By the end of the year, relations between the two men had cooled. "You know that my interest in you is as great as it is in Marin or Georgia," Stieglitz wrote, before undercutting this profession of interest by dismissing Paul's concerns as personal. He continued: "I say many things in an abstract way which are taken personally when not so intended. I am rarely personal. You must know that after all these years."

Stieglitz had a lot on his mind as 1927 drew to a close. Despite O'Keeffe's wish to stay at the lake, he insisted on returning to New York in November to supervise activities at the Room. There would be seven exhibitions that season, starting later that month with one of Marin. Georgia's would inaugurate the new year, preceded by some advance publicity—an article about her in *Creative Art* by the critic Louis Kalonyme (the opportunity that Strand had turned down).

From then on, Stieglitz also indulged his "personal" side in talks with Dorothy Norman, the well-to-do young woman who had visited the Room the previous spring. At twenty-two, Norman had taken part in several causes of the sort disdained by her wealthy parents-in-law, among them the American Civil Liberties Union. In her view, the Normans' "reactionary political attitudes" corresponded to their preference for conventional works of art, while she and Edward, her husband, "gravitate[d] to art that is breaking new ground." Dorothy was exhilarated by what she saw at the gallery.

Not long after giving birth to her first child, she found Stieglitz alone there. He asked if her marriage was emotionally satisfying, and she said that it was—even though, as she would write in her memoir, marital pleasure had eluded her. Stieglitz continued:

Alfred Stieglitz, *Dorothy Norman,* 1930

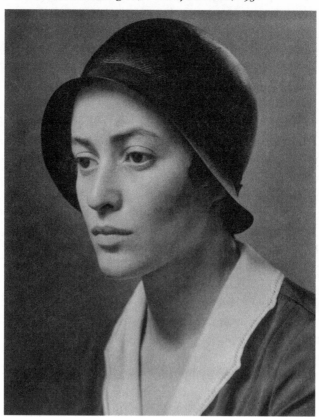

"Is your sexual relationship good?" Talking about such matters is of vital importance, in spite of my inability to be totally honest. Stieglitz inquires, "Do you have enough milk to nurse your child?" Gently, impersonally, he barely brushes my coat with the tip of a finger over one of my breasts, and as swiftly removes it. "No." Our eyes do not meet.

Dorothy was electrified. From then on, she went to the Room almost daily.

Stirred by Dorothy's devotion as well as by her flapperish air, Alfred let her do whatever she wished. Members of the group noted that the two seemed to dote on each other. At this point, Dorothy was perhaps too naïve to suspect that Alfred consistently took pleasure in flirting with pretty women. Claiming to be inspired by the Room and its presiding spirit, she told him: "If you do want any help—I'm just aching to give it. I love what you're doing." To show her commitment, she took on the secretarial work (formerly Beck's domain) and used her father-in-law's birthday check to buy a Lachaise sculpture. Soon Dorothy began jotting down Alfred's pronouncements, with the idea of writing a book about him.

During the time when Dorothy was becoming a fixture at the Room, Georgia discovered another lump in her breast. On December 30, she underwent a second surgery at Mount Sinai, where she remained for the next ten days. The cyst proved to be benign, but her recovery was long and painful. It was a dismal start to the new year.

. . .

Her exhibition opened without her being present on January 9, 1928. By then, the critics recognized O'Keeffe as a mature artist. McBride praised the boldness of her Shelton Hotel paintings, the visionary *Red Hills with Sun,* and the brooding *Dark Iris.* Annual exhibitions tested an artist's staying power, he noted, yet O'Keeffe seemed "to pursue her way in calmness toward the idea she clearly indicated for herself at the beginning of her career." Despite his initial doubts about the secrets in her flowers, he could say with conviction that paintings like the swirling *Abstraction—White Rose* "content those who respond to the painter's touch and to her clarity of color—and mean just what the spectator is able to get from them." He concluded, "To overload them with Freudian implications is not particularly necessary."

O'Keeffe was so pleased with McBride's review that she wrote to thank him: "What you have done has helped make a place in the world for what I do." Still weak from her surgeries and increasingly annoyed by Dorothy's presence in her life, she took solace in friends like McBride, on whom she knew she could rely.

When Alfred introduced Dorothy to Georgia at the gallery, the young woman's first impression was that she was "striking" despite her unfashionable clothes. On hearing of Dorothy's work with the ACLU, Georgia told her that she should drop all such "nonsense" and help the Women's Party. Dorothy replied coolly, "Other causes interest me more." Still, while she did not fathom Georgia's refusal to call herself Mrs. Stieglitz, she respected her opinions. Georgia did not reciprocate: "I never did like her. . . . She was one of those people who adored Stieglitz, and I am sorry to say he was very foolish about her."

Although Dorothy did not buy anything that day, she donated a hundred dollars (the equivalent of over a thousand dollars today) in support of the gallery. Soon she befriended members of his entourage, starting with Paul and Beck. When the Normans met the Strands at a mutual friend's, Dorothy sensed Paul's reserve. Later she studied his prints and asked what kind of camera he used. "He glared at me," she recalled, "and replied haughtily, 'It is *not* the camera.'" When Dorothy related her faux pas to Alfred, he showed her some of his *Equivalents*. "Now, instead of being saddened and humiliated, as I was at Strand's, I exult at having seen something extraordinary." (Did she also sense his pleasure in impressing her at the expense of his disciple?)

Beck continued to do whatever she could to maintain close relations with Alfred. After Georgia's show closed, she organized all the documents at the gallery—correspondence, reviews, sales records—that had not yet been filed. Alfred appreciated her "neatifying." In addition to Beck's organizational skills, he told her, she had talent: "All it needs is a chance to develop."

By then, Beck's pastels were on display in the Opportunity Gallery's April show, curated by Georgia. It is of interest that Beck exhibited under her maiden name, avoiding any association with Paul and asserting her status as a Salsbury. The *New York Tribune* singled out her "rather individual fruit decorations done in pastels"; when the best work of the year was shown at the gallery in December, a critic was glad to rediscover Beck's *Autumn*, "a flower painting of bold and decorative rhythms."

Having her work shown for the first time would have been rewarding, and that it appeared under the auspices of O'Keeffe made it even

more so. Georgia's decision to give Beck the chance was a way of making amends; she may have sympathized with her decision not to have children. From then on, the two were on warmer terms. Georgia introduced Beck to Madame Geo, her French dressmaker, whose designs suited Georgia's preference for understatement. Madame Geo had recently given a series of radio talks about style, and a journalist observed, "This designer, who has counted among her patrons Queen Marie [of Romania] and much more significantly for this discussion Georgia O'Keeffe, makes dresses which are interesting to architects, sculptors, and engineers for their clean structural lines." Both Beck and Georgia appreciated their exceptional workmanship.

In the meantime, a minor sensation erupted in the press about the prices Stieglitz had obtained for O'Keeffe's recent work. After negotiating the sum of $25,000 for six calla lily paintings, he made much of the

Covarrubias, *Our Lady of the Lily* (*The New Yorker,* July 6, 1929)

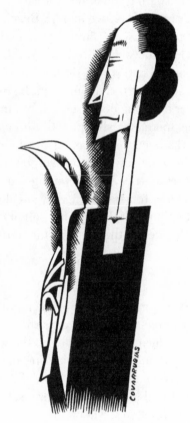

secrecy surrounding the sale to an anonymous buyer (Mitchell Ken-nerley and his fiancée). "Artist Who Paints for Love Gets $25,000 for 6 Panels," *The New York Times* announced. "Not a rouged, cigarette smoking, bob-haired, orange-smocked Bohemian, but a prim ex-country schoolmistress who actually does her hair up in a knot is the art sensa-tion of 1928!" declared the *Evening Graphic*. Once again Georgia was in the news. Although the deal fell through that spring, along with the pro-spective buyers' engagement, she was still smarting from the unwanted attention.

During the last exhibition of the season, of the notorious calla lil-ies, Stieglitz made up his mind to offer Strand a show. Beck was over-joyed. It was what she had been working for, relying on her closeness to Alfred while pointing out the merits of Paul's work. "You must know how much this means to both of us," she wrote. "It is an affirmation of him as a worker—and for me the affirmation of what I believed him to be the first time I saw his photographs. That has been my greatest happiness—that—and sharing you and Georgia—as friends."

In May, Georgia again took refuge at York Beach. "I am quite a nor-mal being here," she told her sister: "wonderful food—busy people who leave me alone—and the ocean." Alfred was making do with her like-ness, Lachaise's alabaster bust, which sat in front of him as he wrote to tell her that the next season at the Room might be his last: "I don't want to waste any time over anything not essential. You understand."

She did. What was more, she shared with him a vision that came to her as she watched the ocean: "It is as terrifically male and female as ever—the same terrific male power in the overpowering breakers as they move toward you—slowly—but surely coming—and the same marvel-ous loveliness that seems female when they break—I love it—I wish you were watching it with me." (Perhaps her solitary enjoyment of these tremors heightened the idea of their complementarity.)

· · ·

Georgia returned to New York at the end of the month in time to accom-pany Alfred to Lake George. After a few days there, when he wrenched his back and then tore a ligament in his finger, she was in a daze, telling McBride, "I look around and wonder what one might paint—Nothing but green—mountains—lake—green. . . . And Stieglitz sick." In July, with his blessing, she hired a housekeeper and set off on a monthlong journey through the Midwest to see her family and "her America." Alfred

hoped that she would regain her lightheartedness. "I have robbed you of much of it without acquiring any," he wrote. Yet it was their closeness that made him "a bit worth-while. . . . Heavens knows I have been taught much by you."

During Georgia's absence he mused on the impediments to their relations, starting with the age difference. At forty, she could not grasp how he felt at sixty-two. "The beginning of our togetherness was much simpler. . . . But the question of practical daily living is not as simple as it was—or as we thought it was." Even so, they had both "grown greatly—one thro' the other." And their sexual rapport was still strong.

Alfred found his thoughts on intimacy confirmed in the book he was reading that summer, *Lady Chatterley's Lover,* which he saw as "a sort of Bible." Lawrence, who had been corresponding with Stieglitz for some time, sent him one of the thousand copies privately printed in Florence (the book would be banned in the United States and the United Kingdom). Alfred could not put it down. "It's a powerful book," he told Georgia. "There is a deep relationship between his writing & my photographs & feeling about life. —And between your work & his too. . . . He understands the forces."

At the same time, Alfred was also writing daily to Dorothy, who was vacationing on Cape Cod. Unaware of their correspondence, Georgia returned from the Midwest feeling refreshed. She enjoyed August at the lake until Alfred suffered an attack of angina and was ordered to bed, where he remained for most of September; she looked after him with the aid of a nurse and her sister Ida. Writing to Florine Stettheimer, she said that she had "not a thought in my head—unless strained spinach, peas, beans, squash—ground lamb and beef—strained this—five drops of that—a teaspoon in a third of a glass of water—or is it a half—pulse this—heart of that." There was little relief, except when the women "got hysterical laughing" as they rubbed meat through a sieve for the fourth time.

Stieglitz's letters to Strand from this time barely allude to his condition. Earlier in the summer, he had thanked Paul for sending him supplies and asked what he thought of the dip in stock prices after the boom in the first half of the year (five million shares were traded on June 12 in what looked like a random drop in value). Paul had passed on his broker's appraisal of the market, along with his sense that although it was ailing, there was no reason to worry.

Relations between them warmed still further with Strand's defense of the group credo. That year, *The New Republic*'s serialization of Waldo

Frank's *Re-Discovery of America* stirred up controversy about Frank's critique of Marin, whose art he called a retreat from modernity into a romanticized Maine landscape. Having found his own sources of inspiration in Maine, Strand leaped to the defense in a letter to the magazine: Far from being an escapist, Marin was a patriot. He went on to say, "Perhaps more than anyone in painting, Marin is related to the American pioneer." A native consciousness infused his work, moving toward "an apocalyptic penetration of the spirit of place." Alfred congratulated Paul on his letter's publication: "Am glad it's in print. Important."

Strand carried forward his defense of the group's Americanism in an essay on Lachaise in the 1928 *American Caravan*. (Rosenfeld and Kreymborg had founded the annual to showcase work by writers of whom they approved: It would publish Robert Frost, Wallace Stevens, William Carlos Williams, Marsden Hartley, and Jean Toomer.) Lachaise's statues were "projections of an elemental vision," Strand wrote. The Frenchman had abandoned Europe to channel the energy of the New World into shapes "in which human growth approximates the rich variety and growth of nature"—especially the female form, his "epic symbol." Paul's essay, Alfred told him, "reads splendidly. —As for your Show in the Room it will come off."

The Strands took up residence at their Georgetown hotel in July. Paul needed time off from freelancing to produce a body of work for his upcoming exhibition, which would, in its own way, emphasize the "rich variety and growth of nature" that he admired in Lachaise. He and Beck spent three months in Maine, photographing, painting, antiquing, and seeing friends. Visits with members of the circle absorbed much of their time. They inspected Marin's island, which was splendid but useless as a place to live, and drove to York Beach to see Rosenfeld and Toomer, who returned their visit in August. Hartley was expected around then to stay with the Lachaises. When their friends converged on Georgetown, Beck wrote to Alfred, "I felt you must walk in at any moment."

Hartley, who was often ill at ease with the more prosperous members of the group, felt at home with the Lachaises and, soon, with Beck, whose fondness for their hosts and for Georgetown was infectious. They began to correspond after Hartley's return to Paris—an exchange that comforted him: "It is just that nice to be hearing so directly and so intimately from you and the special circle. I am so thoroughly pleased that you are one of those Americans who can write." Beck sent him things he needed from New York and carefully chosen presents—an antique vase, a handmade valentine, a quilt—along with occasional checks for small

amounts of money. Hartley called her his "good angel." She typed the manuscript of his poems and sought his advice about painting on glass, which he considered an "almost selfless" practice—an ideal that ran counter to the self-aggrandizing art of most modernists.

At about this time, Paul confessed to Alfred that he was having trouble getting started: "Something in me I suppose plus a more critical attitude," along with faulty equipment—a tripod that quivered in the breeze and a camera that demonstrated "its essential junkiness." Still, in August he judged some prints to be satisfactory. Following Rosenfeld's inspection, Paul relayed his comments to Alfred: "He felt for the first time no 'sense of unrelieved strain,' that they had a 'vigorous life of their own.' "

While it is hard to give exact dates to Strand's nature studies, several images from that summer bear witness to the change he sensed in himself. The tracery of a spider's web shimmers with drops caught in the mesh of *Cobweb in Rain;* the shoreline's textures are felt in the accidents of line and pattern in *Rock by the Sea;* ferns peering through swordlike leaves in *Wild Iris* form part of a larger whole. With these close-ups of plants, rocks, and driftwood, the natural world approaches the human. A critic would write of them, "The artist, by a sort of sensuous sympathy with the body of his material has somehow become one with it."

Beck found it hard to bear Paul's exclusive focus on his work. One day when he went to the beach to photograph, she sat down for "a little talk" with Alfred. She had to let Paul go "his solitary way," she wrote, and wondered whether Alfred was content "tinkering" by himself. Because he had asked about her painting, she said that some of her pastels showed promise, then admitted, "It is slow, this learning by oneself." But it was comforting to know that she was in his thoughts. Nostalgic about summers at Lake George, she thought of "the little room you came into, the photographs at the lake, in the hay," then said wistfully, "Perhaps it will happen again sometime, some different way."

Beck was hoping that she could limit her work hours that winter in order to take art classes. "I really feel I could develop something of my own with a little instruction. I sometimes feel I have very little of that [my own] what with the demands of my family, Paul's problem, his family, my own physical limitations—life is horribly short—and if there is to be no 'home'—no child, I want something that is truly mine." Her recognition of how things stood ends poignantly: "Take care of your rare little self—and again, love me always as I love you."

It is intriguing to learn that Beck and Alfred shared a sense of Paul's "problem" (his cautious temperament? his self-absorption?). In his com-

ments to Alfred about Beck's pastels, Paul remained his analytical self: "The average I think shows a great development over the past—even those she did this Spring—She certainly has ability—and something her own which is trying to break through." Given the disappearance of his letters to her, we cannot know to what extent he nourished her creativity or hindered it by being overly critical.

Still, a trace of reserve is implied in Paul's response to Alfred's admiration of D. H. Lawrence. Quoting Rosenberg, Paul wrote that their friend "felt Lawrence had become fixed on sex and was trying to make that all of life." For Strand, as for some other highly focused people, sex was not at the heart of life, perhaps not even an important part of it. And because his "sensuous sympathy" informed his rapport with photography, it was less likely to be shared with his wife when nature took her place as an (undemanding, unwavering) source of inspiration.

. . .

Following Alfred's recovery, he and Georgia returned to the Shelton. Paul was taking time between jobs to prepare prints for his show at the Room; Beck was pleased by the publication of Walsh's book, *The Making of Buffalo Bill,* with its tribute to Milton and thanks to her as adviser. Pirated copies of *Lady Chatterley's Lover* were already for sale in New York. Paul informed Alfred that he had bought one and sent a check to Lawrence in the hope that the writer would one day see the best of America—the work of O'Keeffe, Marin, and Stieglitz—to compensate for "the America that was pirating his book."

In the next few months, the two couples heard another Lawrence enthusiast, Mabel Luhan, extoll the merits of the novel and of its author. Six years earlier, she had lured Lawrence to Taos with the promise of an utopian community, or at least a home, for himself and his wife, Frieda. The only person capable of interpreting native culture, she believed, Lawrence would promote a way of life uniting body and soul attuned to the spirit of the place. Although he found much to admire in Pueblo life, he came to see Mabel as someone who not only appropriated Indian culture but was power-mad in ways that undermined her professed spirituality.

During the winter of 1928 Mabel was in residence in New York with the English artist Dorothy Brett, who had gone to Taos with the Lawrences but had stayed on after they'd returned to Europe. For some time, Stieglitz had hoped to exhibit Lawrence's paintings—"to chal-

lenge the entire country on the book and what is being done to it." But that fall, when *Lady Chatterley* was condemned as obscene, Lawrence had abandoned the idea. At Mabel's urging, Brett took her paintings of Pueblo ceremonial dances for a possible exhibition at the Room, but after seeing them, Stieglitz declined. Following one of their frequent quarrels, Mabel told Brett that she was no longer welcome at her apartment. Brett moved to the Shelton, where a friendship with Alfred and Georgia began over the breakfast table.

Just the same, both remained on good terms with Mabel. Their cordial relations suggest that neither had read Mabel's response to Georgia's request to write about her art from a woman's perspective. Mabel rose to the occasion, but what she wrote seemed envious and cold. She had felt "indelicate" when gazing at O'Keeffe's flowers. The artist, she continued, had externalized "her true being out onto canvases which, receiving her outpouring of sexual juices . . . permit her to walk this earth with the cleansed, purgated look of fulfilled life." Stieglitz did not fare any better: She called him a showman whose only motive was to sell his wife's work. Mabel's essay remained unpublished.

What disturbed Georgia that winter was Dorothy's presence at the Room and Alfred's attachment to her. One day when they were alone, Dorothy said that she loved him. Alfred kissed her, she recalled, "as I have never dreamed a kiss could be." From then on, they were obsessed with each other: "We must be in touch in person, by letter, by phone at every possible moment." Alfred's declaration of his feelings reads in kind. "We are *one*. —Every day proves it *more and more to be true*." In time, convinced that their relationship concerned only themselves, they became as intimate as circumstances allowed.

Others in their circle saw Dorothy as a socialite who was devoted to modern art, or so she thought. The more observant, watching her with Alfred, sensed their closeness. Georgia could not help letting her know how she felt. "She always looks at me as if I were some queer species of animal who had strayed in," Dorothy told Alfred, "and wouldn't I please remove my superfluous presence far enough away so as to be out of her sight."

How Closely We 4 Have Grown Together

1929

While insinuating herself into activities at the Room, Dorothy did little to assuage Georgia's resentment, and Georgia preferred not to look too closely: "That I haven't thought much of how I feel is the way I like it. I am not talking much to Stieglitz," she told a friend.

Georgia *was* talking to Beck that winter, as their friendship strengthened. It is pleasant to picture them at Madame Geo's boutique on East Fifty-seventh Street. One wonders which designs Beck would have chosen. Both admired the way the designer's silhouettes followed the lines of the body while allowing for freedom of movement. Georgia ordered a pin-tucked tunic and underdress in white silk georgette, a pleated tunic of black silk to wear over the white one, and a matching black wool coat and skirt. To the art world's surprise, she turned up at exhibitions that winter in a scarlet cape.

Beck and Georgia prepared the Room for the first show of the season—work by Hartley, who was still in France. When Beck wrote to him about the fir tree they trimmed on his behalf, he replied that it was surely "the gayest note in what . . . cannot help but be a solemn event." In the same letter, he described the challenges of the medium that she was trying to learn: reverse oil painting on glass. This traditional form, in which the artist applies paint from the surface to the background, demanded patience. In Hartley's view, the only ones to master it were sign painters, yet recently Arthur Dove, Rockwell Kent, and Joseph Stella had explored this demanding form.

Shortly before the opening of Georgia's exhibition in February, she described some of her canvases to Mitchell Kennerley. *Yellow Hickory Leaves with Daisy* brought to mind autumns at the lake: "The thing I enjoy of the autumn is there no matter what is happening to me—no matter how gloomy I may be feeling—so I came up with my hickory leaf and daisy. . . . It is a particular triumph because everybody and every-

thing about me seemed to be particularly in the way of my doing any-thing." She also liked *Red Barn, Wisconsin:* "The barn is a very healthy part of me . . . my childhood." Looking at her show, she saw the world of her imagination: "I never get over being surprised that it means anything to anyone else."

The remarks of some critics still held surprises. Twelve years after her first exhibition, O'Keeffe was such an institution, one wrote, that it was hard to know what to say. Another surmised that she would one day be seen as an old master. Meanwhile, her new work represented a transi-tion: Oils like *Red Barn, Wisconsin* and her East River views seemed less original than her flowers and abstractions. Still, McBride marveled at her latest calla lilies, "fully a yard wide." They put him in mind of Walt Whitman, who, like Georgia, had "grand ideas for America."

Few mentioned O'Keeffe's leaf paintings, a theme that she would continue to develop. *Faded and Black Leaves,* a composition painted parallel with the picture frame, positions the large central leaf and its smaller companions against one another. It is tempting to see in the cen-tral leaf's torn edges a note of fragility and to read the leaf-against-leaf placement as an equivalent for human relationships. But it is just as likely that the play of shapes and colors appealed to her as a source of solace no matter how gloomy she might have been feeling.

When the show came down, Georgia decided to forgo the ordeal of annual exhibitions. She and Alfred were quarreling, he anguishing over the possibility that Kennerley's finances might mean the end of his sup-port for the Room. Alfred dictated the rhythm of their days to suit him-self; the exchanges that had nourished their rapport seemed to have ended. Worse, Georgia had done no painting that winter. "I must get back to some of my own ways or quit," she told Ettie Stettheimer.

About this time, McBride wrote a critique of American expatriates. These "truant artists" should come home. Hartley, named among those "jeopardizing their careers for the dubious consommations of the Café de la Rotonde," was both enraged and stirred by McBride's words, con-fessing to Beck, "I want to get into some really wild places in the U.S." He would "strike West" if it became financially possible.

Georgia had not forgotten their friends' accounts of the Southwest as a mecca for artists. Hartley had praised the Pueblo Indians' rapport with their landscape, Rosenfeld considered them a deeply soulful people, and the Strands agreed that their stay in New Mexico had revived them. Throughout the winter of 1929, Georgia tried to convince Alfred that a stay of some months there might take her work in new directions, but

he panicked at the thought of her going away—his usual anxiety having become more acute because of his liaison with Dorothy.

Georgia turned to Beck, who was also keen to strike west. If they traveled together, a plan that Alfred would find hard to refuse, they could immerse themselves in the shapes and colors of their native land while pondering the future. As Alfred tried to argue Georgia out of going, she fought back with her own weapons: silence and strength of feeling. "If I can keep my courage and leave Stieglitz I plan to go West," she told a friend. "It is always such a struggle for me to leave him."

In the meantime, Alfred's decision to show Paul's work at the Room galvanized the Strands. One wonders what Beck thought of Paul's decision to show only his nature photographs. While his choice of prints presented a unity of theme and treatment, it would have been hard not to reflect on the omission of his portraits of her. Of the thirty-two prints in the show, four were taken during their 1926 trip to the Southwest and the rest in Maine—when Beck had organized their stays to let Paul focus on his art. Leaving her out of the show made sense aesthetically, but it was a way of holding her at arm's length.

It would also have been disappointing to learn that Alfred would not write the foreword for Paul's catalog. At the last minute, Lachaise contributed an homage to his friend's "precise, clear, fundamental" work. In the language of the Stieglitz circle's nativism, Lachaise concluded, "Strand's photographs are powerful, personal, spiritual, decisively American contributions."

While Lachaise hailed Strand as an American master, the critics emphasized his feel for composition. Noting that a show of his work was overdue, the *Times* regretted that it was restricted "to the vegetable kingdom" but praised his close-ups of rocks, grasses, ferns, and driftwood. *The New Yorker* was less forthcoming. Strand's art was marked by selectivity—"arrangements of matter, composed by nature, and bounded by the horizons of his camera." The review concludes, "Mr. Strand remains to us a superb connoisseur of forms and delicate arrangements."

Stieglitz continued his practice of holding forth throughout the run of the show. The photographer Berenice Abbott went to the gallery one day and listened to Stieglitz's discourse. Praising some of Strand's prints and critiquing others, he seemed less than enthusiastic about the work as a whole. Abbott was taken aback by Stieglitz's tone when he showed her his *Equivalents,* hinting that their vision of life was larger than Paul's.

It came to Strand's attention that Stieglitz did not always place his

work in a good light. When he voiced his concern, Stieglitz replied, "I'm afraid you have misunderstood many things I have said during your show." Still, three prints sold, among them *Garden Iris,* bought by Stieglitz for O'Keeffe. Its tight focus resembles her close-ups of the flower and suggests that while relations with Strand were strained, their artistic affinities still held. Stieglitz sent Strand a check for $187.50, explaining that he had deducted 25 percent of the cost ($250) for overhead.

By then, both men were adjusting to their wives' departures, and Beck and Georgia boarded the Twentieth Century Limited to Chicago on April 27. Although Beck's plan to absent herself from New York had not provoked opposition, she blamed herself for a recent "row" with Paul. Of her decision to leave, she wrote, "I can't help it. It's like trying to keep a thoroughbred horse in a strange stall—or else a jackass! and whichever I am, I am a failure at any adjustment—I hope there will be more peace from now on." She hoped that the separation might bring them closer.

On leaving Grand Central Station the two friends settled into their comfortable seats and wept. Then, as the train rolled north along the Hudson, Beck declared, "Well we did it ourselves." She meant, Georgia told Alfred, "that we left of our own accord—nobody sent us." Recalling that day years later, Georgia reflected, "The difficulty in getting out here was enormous, but I came."

· · ·

Given the volume of correspondence among the foursome that summer, one might think that they did little but write to one another. This was not the case, but the women's decision to go west marked a turning point for all of them. Judging by the exuberance of their letters, Beck and Georgia thrived on doing as they pleased—drinking in the grandeur of New Mexico while opening themselves to the unconventional way of life they found there.

They stopped in Chicago to see Georgia's brother Alexis and his family—a visit that let Beck see Georgia in her native element. The next leg of the trip, to Santa Fe, began with high expectations. The California Limited's accommodations were famous. It had dining cars, a lounge car, an observation car, and sleeping quarters. Beck wrote to Paul on the Limited's stationery, with its dream-inducing logo, "en route," as they watched the country unfold—the Kansas plains, the rugged Colorado vistas, the mountains of New Mexico. "All my American or Western

blood sings in me," she exulted. (One wonders how he took her next sentence: "All the Jewish blood dries up like a vapor under a sun so strong it cannot survive.")

"We are here—and we are both much pleased," Georgia informed Alfred. The next night they ran into Mabel—who "began working on us," Beck told Paul, "and has . . . offered us the same studio you and I had." Despite the drawbacks of Mabel's, such as being under her thumb, Los Gallos had its charms—the location, Lawrence's studio, and the staff, who prepared three meals a day. And once Mabel set her mind on something, it was hard to resist. Going to Taos for the Pueblo Indians' dances, they set off in Mabel's Cadillac along the dirt road that wound its way through the river canyon before rising to the high-desert country, backed by the Sangre de Cristo Mountains.

They inspected the Pink House, although it was not yet ready for them. At a slight distance from the main house, it still had Lawrence's frescoes and massive vigas—Spanish-style rafters made of tree trunks whose ends projected beyond the adobe walls. Seeing the little house gave Beck "a terrible yearning," she told Paul. She added, "Much as I want you here I feel that this separation will be good for us." He should tell Alfred, who believed Georgia to be fragile, that she had not had

Mabel and Tony Luhan, Taos

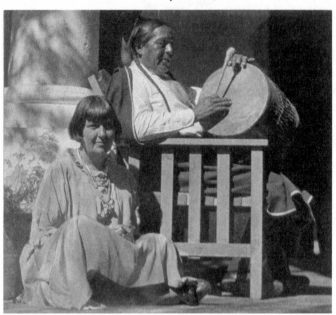

"a single ache or pain . . . in spite of new food and exciting vistas constantly opening up."

Beck's sentiments are echoed in Georgia's letters. "This really isn't like anything you ever saw," she told Alfred. She felt about the Southwest as she had in the past, "only maybe I enjoy it even more because I think I understand it." A few days later she wrote, "I wish I could tell you how alive I feel—I really never felt better in my life—Beck is amazed."

Clearly, Georgia had bounced back from her depression of recent months. The air was intoxicating, the adobes' massed shapes offered themselves as subjects, and the local attractions, like the Pueblo dances, were so inspiring that everything felt like a dream. After a few days, when an ailing Mabel retired to her bed, Georgia and Beck began going on jaunts with Tony Luhan. When Georgia asked him if he admired Taos's Sacred Mountain, he replied simply, "That's why I'm here."

Beck and Georgia stayed at the main house for some weeks with Mabel's other guests—Una Fairweather, a mystic, and Ella Young, an Irish poet who spoke eloquently of elves, fairies, and the benefits of talking to trees. Ella's unearthliness intrigued Beck, and her talk of "astral bodies, reincarnations, vibrations, ghosts, spooks, mediums" was a lingo that she wished to learn. Within a short time she began to think that it would be easy to believe that "the whole landscape has a religious feeling."

The two friends established a routine of vigorous hikes alternating with painting sessions. At first, Georgia was put off by the mountain range: "It is as though I fall into something from which there is no return." To find her way into this landscape, she did a large oil of cottonwood trees and showed it to Beck, who approved. Then, sensing that it had more in common with her Lake George paintings, Georgia concluded, "It isn't really of this country." One evening they took a walk into the hills, where a large black cross stood flanked by smaller ones. Abstracting its shape, Georgia painted the cross against the dark sky. Soon she would tell Alfred, "I just feel so like expanding here—way out to the horizon—and up into the sunshine."

Beck found herself in the position of living at close quarters with the woman she most admired while trying to forge her own path. When Georgia worked in her studio, Beck looked for subjects that, unlike the mountains, were not intimidating, choosing themes that suited her current medium, pastels, like floral bouquets and an abstraction inspired by what she felt when Tony played his drum—"a resonance that banged through me from head down the spine and into the toes!" A few days

later, she rejoiced to Paul, "Georgia looked at my pastels tonight and I feel ever so much better as she liked them very much."

As Mabel's health worsened, Beck took on the management of the household and continued in this role when Mabel went to Buffalo in June for a hysterectomy. Of Beck's new role, Georgia told Alfred, "She makes a fierce face over it but I think she likes it." Georgia did not say that she, too, relied on Beck's practical side. They took the bold step of buying a car together, which they then named "Hello." Paul was not to tell Alfred that Beck was teaching Georgia to drive. Georgia's slow mastery of the wheel exasperated her friend, as did remarks about Beck's domesticity: "Georgia is extremely self-centered—thinks mostly of herself."

In a photograph taken soon after their arrival, the two women form an arresting pair. Side by side in front of the Pink House, they complement each other, Beck's prematurely gray hair tied in a chignon, as are Georgia's dark tresses. Visitors remarked on a certain resemblance. They dressed alike in minimalist blacks and whites, and both were resolute about what they hoped to accomplish. Hutchins Hapgood's daughter Miriam, who was staying at Mabel's, saw them as striking examples of female emancipation. Surprised to find O'Keeffe sewing shirts for

Rebecca Strand and Georgia O'Keeffe, Taos, New Mexico, 1929

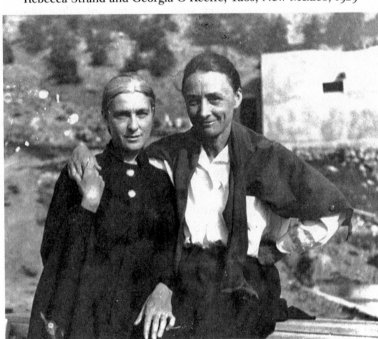

Stieglitz, Miriam compared her stitches to her brushstrokes and saw in Beck's fondness for western garb an embrace of her role as Nate Salsbury's daughter. Georgia could have been speaking for Beck when she told Alfred, "This seems to be my world—and I can't help it."

Which did not mean that their husbands were forgotten. Beck kept a picture of Paul by her bed and dreamed of holding him close: "I wish you could come to me with your plunge & swiftness and that I could receive the blessing of it." To remind Georgia of what she was missing, Alfred sent love to "Lady Fluffy." Georgia posted him a nocturnal kiss: "My night is so different from your night. . . . It touches something in me that I so like to have touched." Alfred sent more love to Fluffy. "She must be looking quite a wild one," he wrote, unsure whether he could take "a real picture of her. —Of you?"

One wonders if the women shared these fantasies when reading their letters aloud at night. "We both say we are not lonesome," Beck told Paul, "still I am sure we both feel that the only thing lacking is our respective beaux, for there are times when love would be most welcome." She asked him to join her in Taos: Georgia would give them the Pink House and sleep in her studio.

Still, they did not lack male companionship. John Collier, the commissioner of Indian Affairs, and his son Charles were Mabel's guests that summer. The composer and photographer Ansel Adams was also staying at Los Gallos; Adams, who was photographing the Pueblo, would collaborate with Mary Austin on *Taos Pueblo,* the book published the following year with his images and her text. Marin arrived a few weeks later. "He doesn't know where he is," Georgia told Alfred, "but he is pleased." One morning, Marin told Beck that he could not paint the landscape: "He feels he has no right to make the country what he 'sees' it but it should be done as what it is." Soon Marin would feel sufficiently grounded to evoke it in a series of watercolors.

Surrounded by artists, each with a particular genre, Beck adopted one that had not been claimed, reverse oil painting on glass. Her subjects, flowers on their own or in vases, were traditional, but her technique was not. After painting the foreground on the underside of the glass, she worked backward, a painstaking exercise but one that suited her desire to be in control. Georgia encouraged her. Having herself painted a great many botanical portraits, she could appreciate Beck's adaptation of the genre to this medium, as in *Portrait of Miriam—1929,* which showed Miriam Hapgood as a sunflower. To Miriam, Beck's portrait captured "the transformation . . . taking place in me that summer."

Beck's paintings also reflected changes in herself. Although she

felt she had to explain her choice of another motif—artificial white roses from a department store—she told Paul that they were placed in churches in tribute to the Madonna, which gave them an aura: "I know that artificial flowers sound horrible to you, but they really are quite beautiful." On seeing the roses' potential, Georgia, too, began painting them. Teaching Georgia to drive required forbearance; helping her to find new themes allowed Beck to see herself as a peer.

The two women behaved like best friends, giggling over private jokes, escaping the other guests to go on jaunts, and, after Mabel's departure, spending most of their time together. (They took care not to be seen sunbathing nude: "G & I get into our skins & out of our clothes right after breakfast—put down a blanket and lie in the warm, healing sun," Beck told Paul.) Beck set aside her city shoes in favor of moccasins, but although she wore pants when riding, she went along with Georgia's request for her to dress in a feminine way. When Beck made herself a

Rebecca Strand and Georgia
O'Keeffe, Taos, 1929 tintype

red flannel skirt, Georgia contributed silver buttons for the belt and gave her a necklace of silver beads. They shopped for earrings for Madame Geo, whose pared-down styles were set off by these western touches.

Sometime later, they had another picture taken in their finery. Beck is the dominant figure in a black "sateen" workman's shirt with a necklace of silver beads and bear's teeth; her arm is around Georgia, the smaller figure, whose pose and garb echo her own (Georgia wears four strings of white wampum to contrast with the dark fabric). Beck placed this image in a decorative frame—a gesture acknowledging their embrace of their new lives. In letters to Paul, she took pride in their partnership: "The miracle of Georgia's and my 'getting on' together continues—happily & naturally—& will to the end—She says she is satisfied with it—& that's convincing."

· · ·

Alfred and Paul weathered their wives' absences well enough at first. Closing the Room once he knew that the lease would not be renewed and arranging to store hundreds of works kept Alfred busy through June. Paul helped when he could, but it was disconcerting to watch Alfred's orgy of destruction when he began destroying negatives and copies of *Camera Work*. Alfred told Georgia about an evening at the Normans': He enjoyed their hospitality and was pleased to see paintings there by members of his circle, but afterward he felt "a million years old." Still, he assured her, he would not be too sad at the lake because he had already imagined how it would be without her.

But that would not happen. Once settled at the Hill, Alfred began burning still more books and papers, as well as many of the prints and negatives he had sent there only weeks before. A few days later, he outlined his last wishes: to settle a small income on Georgia, donate his best work to the Metropolitan Museum, and return many of his paintings to their makers. He asked only one thing of her—to bury him with her 1916 *Blue Lines*.

The apocalyptic clouds in his *Equivalents* taken that summer suggest Alfred's anguished state of mind. Of such images, he told Dorothy, "My photographs are a picture of the chaos in the world, and of my relationship to that chaos. My prints show the world's constant upsetting of man's equilibrium, and his eternal battle to reestablish it." Georgia's absence had disturbed his sense of balance; he would become frantic in his efforts to reestablish it.

But Georgia was unaware of this turn in Alfred's thinking. She, Beck,

and Tony had set out on a trip to see the Mesa Verde cliff dwellings, and from there traveled to Gallup, Albuquerque, and back to Taos. The trio were delighted with their adventures and with one another. Georgia and Beck loved sleeping under the stars, with nothing to eat but oranges and whiskey. The trip was cleansing, Georgia told Alfred: "The best thing all this is doing for me is that many of those old things are sliding away. . . . Put all that heartache in your pocket—and just let down—these things aren't so bad." She could now look to the future—her paintings, a new exhibition space, and their reunion.

During this time, a storm blew up when Mabel, still awaiting her hysterectomy, wrote to Georgia of her fear that Tony no longer loved her. Georgia replied that in her view Mabel and Tony were "welded together," and that his relations with his Indian wife did not threaten their union. Mabel, however, misreading between the lines, fixed on Georgia's call for acceptance: "Next to my Stieglitz I have found nothing finer than your Tony—but I feel you have got to let him live and *be* his way however much it might hurt you." Georgia added, "If he does go out and sleeps with someone else it is a little thing." She ended with a declaration: "I'm having a grand time just being ME—I think I would never have minded Stieglitz being anything he happened to be if he hadn't kept me so persistently off *my* track."

This did not sit well with Mabel. She chided Georgia for not caring whom Tony slept with, and made matters worse by informing Alfred of her fear that Georgia and Tony were having an affair. Mabel's alarm threw Alfred into an agitated state: He lay awake at night, imagining the worst.

He remained in limbo while Georgia and Beck took a second trip with Tony and four Indians to Santa Fe and Las Vegas, where they drank too much whiskey. Georgia told Mabel that she came through this time "much more clear than usual—with a fine neutral feeling." She could now tell Alfred that she and Beck had bought a car, which she was learning to drive. "I made up my mind to it last year and now I have done it. . . . I have told you about the worst thing I have done since I was away." She ended on a conciliatory note: "I wouldn't mind being fluffed—I wonder if it is the altitude or not being fluffed—We are both certainly keyed up to a pitch to tear the roof off."

These sentiments excited Alfred but failed to console him. He wrote her a twenty-five-page letter that begins with his dream of their lovemaking. "I had a terrific erection—Fluffy looked like the big *Black Iris* which next to the *Blue Lines* is closest to my heart—& as I took hold of

you—& rammed my Little Man into you, you said with sighs—sighs so deep so heartbreaking—you must leave him no matter what happens." The dream mounts in intensity until he withdraws the Little Man and moans, "I & mine are accursed." (Alfred feared that he had a genetic defect that had caused Kitty's schizophrenia.) He went on to rehearse self-serving explanations of recent squabbles (including Georgia's distrust of Dorothy), old grievances, and new complaints, chief of which was his realization that Georgia no longer needed him.

It was in this condition that Paul and his friend Harold Clurman found Stieglitz when they stopped to visit on their way to New England. Alfred treated them to "a long discourse on life, part lament, part harangue" that lasted for eighteen hours, stopping only to read aloud his letters to O'Keeffe. "As we retired for the night—Strand said that in view of Stieglitz's excited state we ought not to leave—Stieglitz came to our room with us and stood over our beds, continuing his monologue." The cause of his distress, Clurman thought, was jealousy. Alfred claimed that Georgia had taken up with "an Indian" because of "the physical thrill she felt in the Indian's presence."

Letters and telegrams flew back and forth between Lake George and Taos over the next few days. Paul wired Georgia, "Never have I seen such suffering. Your letter this morning telling him you loved him actually saved him." He added, "The future is still a blank for him and so far for all of us." Paul felt especially close to Alfred because of his shaky rapport with Beck, who wired him *not* to come to Taos, since she would go east at the end of July to take her mother to New Jersey.

A few days later, Paul told Georgia that he thought Beck was wasting her time in Taos—"letting it become just a plain drinking bout of excitements." He hoped that Georgia could help Beck get over her resentment about leaving, but he did not see that this resentment resulted from her having to abandon her new life just as it was getting started. What Beck wanted was a relationship that supported her yearning for a creative outlet. She admitted to Alfred some time later, "For seven years I've shut out things believing that they would stand in the way of what Paul was trying to do."

The two couples became more entangled in their efforts to cope with Alfred's mania. By mid-July, he felt so weak that he dictated two letters to Paul in which he proposed taking the train to Albuquerque to meet Georgia. One can imagine Paul's feelings as he took down Alfred's words: "I must see you & hear you—what you have to say about your decisions—new attitude—new feelings." The next day, Alfred decided

instead to go to Chicago, then to forgo the trip altogether. He wired Beck, who was fielding his telegrams while Georgia was traveling: "I have been thinking entirely in terms of Georgia and have decided it would be criminal on my part to disturb in any way her original plans."

The friendship between the women seems to have exacerbated the tensions among the foursome. They were protective of each other and determined to ignore other people's expectations; at the same time, they were behaving like the free spirits they intended to be—enjoying the kind of closeness that can thrive between women and indulging in a certain giddiness for the fun of it. But to Paul, such playfulness was unrelated to the creative imagination as he conceived of it.

Beck and Georgia celebrated their friendship with glee—driving into the desert at night, washing "Hello," then turning the hose on each other, wearing fancy clothes to dinner, dancing with their male companions. One night, Georgia went up on the roof to watch the sunrise: "We do such things here without being thought crazy," she told a friend. For Beck, Georgia was the high-spirited sister she had always wanted.

By July, however, Beck was distressed about returning to a life where the things they did *would* be thought crazy. She could not check her sense of loss on leaving Georgia:

> We have had a beautiful relationship together and feel the need of nobody else. . . . I think she is fond of me and I know I am of her. Nobody can ever take this experience and mutual sharing away from us, no matter what happens—even if the relationship itself changes. I think she is perfectly happy with me for she speaks all the time of getting a large car next Spring and our going off together again in it. We also have in mind trying to find a little house somewhere near New York that we can retire to when we feel like it.

Beck's sense that Paul understood how much this meant is implied in the next sentence: "I am entirely myself in her company."

On the basis of such passages, some have argued that their happiness developed into an affair. If one takes into account their passionate ties to their husbands, however unsteady on occasion, this interpretation seems tendentious, relying as it does on excerpts taken out of context from letters like the one quoted above. Other than these documents, evidence is lacking to support such a reading, which contradicts the strong heterosexual attractions expressed by both women. If anything,

Beck may have hoped that accounts of her "beautiful relationship" with Georgia would bring her renewed respect from both Paul and Alfred.

"How closely we 4 have grown together," Beck wrote to Alfred in a moment of wishful thinking. She could not have suspected that in her role as go-between she would unleash another round of manic behavior, this time directed at her. After she wired to say that Georgia was still incommunicado, Lee Stieglitz (who had gone to the lake) wrote that Alfred was "going to pieces."

Rather than blame Georgia, Alfred excoriated Beck: "You are absolutely unseeing," he wrote on July 21. Her well-meaning accounts of Georgia's emancipation had enraged him. It was "diabolically unfair" of Beck to imply that he had kept Georgia from doing such things (she hadn't). In his anguish, he harked back to times when Georgia resented Beck's presence at the lake. "I have learned one great thing," he continued, "not to waste my time on people who have no vision. . . . You don't know what friendship is any more than you see Love when it is before you." Worse still, he wrote, Beck had made "tremendous mischief without wishing to not because of your feeling for Georgia but because of your feeling for self."

This attack was his way of blaming the messenger. "You have lived very close to Georgia for 3 months," he scolded; "how about my 11 years & 3 years correspondence before." Again, one wonders what Paul made of Alfred's rants and how he coped with his divided loyalties once his mentor began to castigate his spouse. In these weeks, during which Paul acted as Alfred's minder, the men learned to lean on each other. "I don't know what would have happened hadn't Strand been here," Alfred told Georgia. He added, "He has his own problem."

By then, Beck was on her way east. She wrote to Georgia from the Limited's observation car: "One night gone—and with it the mountains and clear air—You—Tony—all of Los Gallos." It was a shock to find herself there: "I'm still in the Casita Rosa with you." She hoped to return in the fall and asked Georgia to wait for her. Of their times together, she wrote, "How right they were—how necessary." Paul would meet her at Albany to take her to Alfred. She could not believe that he had meant the things he had said. She added, "I will be glad to see Paul & know his tenderness once more—I need it—badly."

During their time at the lake, Beck told Alfred how much he had hurt her. While he continued to cast doubt on her ability to "see," they tried to settle their differences. "I took a lot of pretty awful punishment, but in the end it was all for the best." Beck reassured Georgia that Alfred's

love for her burned "with an incredible flame," and that her own feelings for Paul had reignited: "He certainly missed me," she wrote discreetly. Yet Beck found herself in "a trance of readjustment."

Paul's attitude may not have helped. After leaving the lake, he voiced his relief that Alfred was at peace with Georgia: "The suffering not in vain—but bringing what must be a greater oneness." Yet he fretted about Beck's role: "As I see all that has happened—nothing is changed—yet I feel to a certain extent Beck's weakness was lost sight of by me— And that did something perhaps to you—and that in turn again to me—She really [is] the weakest of us all—without direction—at the root no faith in herself."

Unaware that they were discussing her, Beck wrote to Alfred about the need for change: "Now that some other 'action' seems necessary, it will be hard to act—Paul's leaving me for spending all his money, or having a child in a home won't do it . . . it is going to be slow & painful."

By August, Beck was considering various plans for the future. Hoping that Georgia would drive "Hello" cross-country, Beck again asked her to await her return so they could travel together. When Georgia wired that she would take the train to Albany, then go to the lake, Beck decided to spend September with Paul, in hopes of patching things up. Paul, his mind on Alfred's woes, rejoiced at the news of Georgia's return: "The cataclysm comes—innocent things are beaten down—the mountain remains." He added, "Beauty must come out of all this pain—that I feel deeply—for all of us." Thanking Alfred for his advice about Beck (this letter is lost), Paul mused, "It will be slow but we will work it out together—the oneness—I know how deep she is in me."

· · ·

Georgia was delighted to find Alfred in good spirits. Their reunion, she told Mabel (they had made peace on Mabel's return to Taos) was "the most perfect thing that has ever happened to me." The weather was balmy, their surroundings an incitement to work. She was painting trees, leaves, and abstractions based on natural forms—her "equivalents" for states of feeling. Some canvases begun in Taos now seemed odd; she was working on them slowly. (One wonders if *Pine Tree with Stars at Brett's* was among them. Its perspective, gazing up through the tree into the night sky, linked the artist's location to the cosmos through its radical changes of scale.) Georgia's sense that it would take time to absorb the influence of New Mexico is also felt in *Farmhouse Window and Door,*

which treats the entrance to their Lake George home as a threshold that blocks the view—an inward-turned look at the place she came back to in full knowledge of its constraints.

At this point, Georgia was still unaware of Alfred's intimacy with Dorothy, with whom he had been corresponding all summer. Referring to each in code—Georgia was "S.W.," or Southwest, and Dorothy, "Y.L.," or Young Lady—he told Dorothy that it was thanks to her that he had survived Georgia's neglect. He accepted her criticisms of "S.W." and their entourage. Since the spring, Paul and Dorothy had been discussing the idea of a new gallery to continue the work of the Room. Dorothy would be an essential part of it, Alfred insisted, with the Strands—on whom he relied despite his reservations. When he expressed doubt about the idea, Dorothy told him not to abandon his dream: "The Room is an admission not of failure but of truth. . . . I really do love you—like nothing on earth. It is bigger than you can ever know."

Unaware how things stood, Paul spoke to Alfred of his high regard for "Mrs. Norman," to whom he had sent a portrait of Alfred taken at the height of his misery: "In spite of its pathos she felt it the finest thing of you she had seen." Paul may not have understood that Dorothy's support for the new gallery had a great deal to do with her wish to replace Georgia as its presiding spirit. In his mind, Dorothy was "a rare and beautiful person all alive and really articulate as few I know are."

By then, Paul was again photographing Beck. While both of them thought well of these portraits, this opportunity for rapprochement was abandoned when they went to Canada so that Paul could photograph in the Gaspé Peninsula, a region of rugged sea cliffs and mountains along the Saint Lawrence River. It was as if they had gone to another world.

For the next six weeks, Paul worked to capture what he called the place's essential character by relating the elements of each composition—houses, headlands, fishing boats, clouds—in a unified perspective. Concentrating on this approach, he chose not to photograph the region's residents. Strand's engagement with the Gaspé would lead to his idea of creating a sense of place wherever he went—a turning point made possible in a setting without prior associations and far from the influence of Stieglitz. But despite Beck's hopes for change, she slid back into the role of helpmeet. She missed Taos, she told Tony Luhan; meaning to speak French, she found herself speaking Spanish instead. With this letter, she sent a snapshot of herself, as if trying to post herself back to New Mexico.

The Strands returned to New York in October to devote their efforts

to Alfred's next gallery. Now that an upstart venue, the Museum of Modern Art, was to open on Fifth Avenue, it became urgent to identify donors who could help Alfred continue in his role as reigning impresario and accept his terms. Paul, Beck, and Dorothy were to sign the lease, but only Alfred would decide what was to be shown; investors must not expect to make a profit. The Strands drafted a letter to prospective backers, and Dorothy lobbied her husband, who promised three thousand dollars in support of the venture. Over the course of the fall, the donor list came to include Jacob Dewald, Paul Rosenfeld, Lee Stieglitz and family, Beck and Paul, and Paul's father, who had done well on Wall Street. A total of more than sixteen thousand dollars in pledges accrued over the next three years.

Alfred told Beck that he appreciated the Strands' efforts. He did not apologize for the way he had treated her, but he hoped that she had forgiven him. When stock prices plummeted on Black Thursday, October 24, he wrote, "To start anything pertaining to Art in days like these seems like challenging the Devil himself." Beck's letter posted that day reassured him that there was nothing to forgive. She was again working as a typist and again wondering if she should take drawing lessons—perhaps with Alfred's former friend Thomas Hart Benton, who was teaching at the Art Students League. Paul had found gallery space on the seventeenth floor of a new building at 509 Madison Avenue and was negotiating the lease, pending Alfred's approval.

Meanwhile, Alfred and Georgia were enjoying a second honeymoon. Reflecting on her time in Taos, Georgia told Mabel, "The summer had brought me to a state of mind where I felt as grateful for my largest hurts as I did for my largest happiness—in spite of all my tearing about, many things that had been accumulating inside of me for years were arranging themselves—and rearranging themselves. The same thing has been happening to Stieglitz." Their delight in each other is palpable in the portraits he took to commemorate their reunion. In some, the twinkle in her eye transmits her glee in these "rearrangements"; in others, his acceptance is implied in images of Georgia standing beside her car.

The stock market collapse did not disturb their happiness, even though Alfred's income would be reduced. What worried him were the implications for the future: "With the smash up in Wall Street, I wonder how many people will be interested in 'painting' and 'photography' and in what I stand for." Paul wrote, with remarkable understatement, "This has been a trying two weeks." Although his father had suffered losses, Paul's response was calm: He might manage to negotiate a lower rent

for the gallery. Stieglitz offered to release his donors from their commitments, but none found it necessary to accept. He and Georgia returned to New York to attend the opening of the Museum of Modern Art, an occasion it would have been unwise to boycott.

"It seems to me that we never went to town in better condition," Georgia wrote Beck before they left. "Good idea that going West! And when I spread out my work last night before packing it—I patted myself on the back and said to myself—Not so bad—Guess you've won again—It looked so good I called him in to look at it. . . . He curled over in a chair—and looked as pleased and surprised as I felt. . . . Of course I can pick holes in it—but what of that—one can pick holes in anything."

New York in New Mexico

1930–1931

Stieglitz was delighted with the new gallery. Its name, An American Place, was apt, a visitor noted: "American it is, from door mat to uncamouflaged steam piping; American in the best sense, with none of the intruding furbishings and fixings so often . . . deemed essential." The high ceilings, the large central room, and the four smaller ones made the Place feel like the Intimate Gallery on a loftier scale. From this perspective, Alfred began photographing the skyscrapers going up in midtown—the start of a series to depict the city in transition.

Alfred's circle called these rooms the Place or 509, in the spirit of 291. The first season was to start with Marin and O'Keeffe, followed by a group show of five members from the usual roster. Georgia worked with the Strands to ready the gallery. They painted the walls white and the floor a glossy gray and set up floodlights with blue bulbs to simulate natural illumination. To inaugurate the central space, the women trimmed a fir tree with presents for their friends, including the Luhans—a kind gesture after Mabel had tried to upset Beck by suggesting that she must be "miserable" in New York. She replied, "I am very chipper & lively—having nothing to be miserable for."

"Georgia O'Keeffe: 27 New Paintings, New Mexico, New York, Lake George, Etc." opened on February 7, 1930. Of the twenty-seven paintings, nineteen had been done the summer before—among them images of a ceramic rooster at Los Gallos and *After a Walk Back of Mabel's*, a vertical rock shape seen against the colors of the American flag. Visitors did not, as Georgia feared, poke holes in her reputation on the basis of this new departure, but some were surprised by the subject matter—the Taos Pueblo, the Ranchos de Taos church, and the dark Penitente crosses against skies painted in glowing reds or blues.

"I saw the crosses so often—and often in unexpected places—like a thin dark veil of the Catholic Church spread over the New Mexico

landscape," O'Keeffe observed of *Black Cross, New Mexico,* a canvas painted after a walk in the hills with Beck. Her crosses provoked varied responses in the critics, who pondered their reference to the Church. McBride addressed the issue in his usual manner: "Georgia O'Keeffe went to Taos, New Mexico, to visit Mabel Dodge. . . . Naturally something would come from such a contact as that. But not what you think. . . . Georgia O'Keeffe got religion." He quoted Georgia's tart reply: "Anyone who doesn't feel the crosses . . . simply doesn't get that country."

Edward Jewell went further. The new O'Keeffe show was the most exciting so far: "The pictures look perfectly beautiful. . . . Perfectly hung and in a perfect light, [they] can never hope to appear to better advantage." A note of "monumental vigor" had emerged in some. *Pine Tree with Stars at Brett's* (now known as *The Lawrence Tree*) was

Alfred Stieglitz, *Georgia O'Keeffe,* 1930

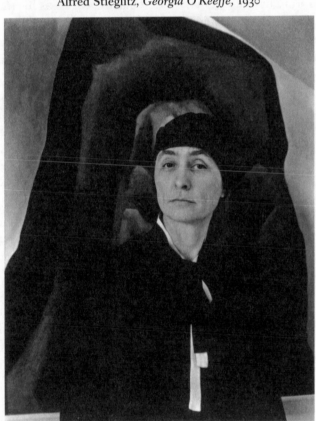

astounding, its vision of solitude "pierc[ing] through to sheer spiritual experience."

Stieglitz documented the show with nine installation photographs, but only one of the artist. Posed in front of her most forceful composition, *After a Walk Back of Mabel's,* O'Keeffe seems as upright as the boulder that dominates the painting. Part of her white collar peeks out from her black garment like a cross, enhancing her air of detachment; her wry expression hints at her awareness of Alfred's preoccupation with Dorothy, who photographed her looking at the camera with an odd half smile.

Stieglitz began taking photographs of Dorothy at this time, the start of an extended portrait consisting of some 150 images with similarities to his portrait of Georgia. In his early photographs, Dorothy is the Young Lady of his reveries—shy, reflective, a bit withdrawn. As a group, they dwell on her dark eyes and full lips, except for a study of her hands joined as if in prayer. Dorothy's bold side was not on display, nor did Alfred's camera capture her determination to replace Georgia as his muse.

Although the repercussions of Wall Street's collapse were not immediately felt in the group, some voiced a concern about the direction art would take in the future. Hoover claimed that the economy was sound, and indeed, five months after the market crash, the Cleveland Museum of Art paid O'Keeffe four thousand dollars for her *White Flower.* Stieglitz depended on her to pay the rent at the Shelton and prop up finances at the Place. From these lofty perches he continued to photograph buildings under construction: the Waldorf-Astoria Hotel, the RCA Victor Building, and the RKO Building at Rockefeller Center. Increasingly, these images reflected his sense of isolation. "My little capital is shrinking fast," he told a friend. "And I didn't speculate!! As if living today wasn't the worst kind of speculation."

Stieglitz would come to feel that he was being singled out by the progressives, who dismissed his cause as individualistic or, worse, blind to the country's ongoing crisis. Muralists like Thomas Hart Benton and John Steuart Curry were engaging with social problems by painting scenes that glorified family and labor as core American values. In March, *New Masses,* the reinvigorated leftist periodical, denounced O'Keeffe's new show as an example of bourgeois individualism. Stung by this attack, she agreed to debate Mike Gold, the magazine's pugnacious editor, in defense of her work and the Stieglitz group's aesthetic.

One can imagine the Strands trekking to Greenwich Village in her support. The debate, held at the Hotel Brevoort in March, was deemed important enough for the *New York World* to send a reporter, who

described O'Keeffe as the more sympathetic of the debators: "Her face, unadorned by cosmetics, with its flash of intelligent arched eyebrows, her severely simple silk dress, her tapered, sensitive, ivory-colored hands, merged quietly into a whole, utterly simple, utterly poised."

Gold, who seemed ill at ease, began by arguing that art needed to engage with the issue of the day—the plight of the oppressed. When O'Keeffe asked if women were included in this group, he said that only working-class women qualified. She replied that women were oppressed regardless of class; moreover, artists could allude to their woes without resorting to the "glorified cartoons" favored by *New Masses*: "The subject matter of a painting should never obscure its form and color, which are its real thematic contents. So I have no difficulty in contending that my paintings of a flower may be just as much a product of this age as a cartoon about the freedom of women—or the working class—or anything else."

But in Gold's view, form and color were "artified evasions" of reality. "You're a nice boy all mixed up by a lot of prejudices," O'Keeffe concluded. "I'll take you to see my show, and then bring you home to Stieglitz and dinner!" (There is no record of her having done so.)

The terms of their argument, which would shape alliances in the years to come, were too dissimilar to be reconciled. Those who, like Strand, had begun to think that art should relate more directly to society would have felt uncomfortable to see the two points of view dramatized in this way. By fall, Strand found himself drawn to cultural work that acknowledged the conditions in which it existed; he and Clurman were discussing the possibility of another kind of artistic community, a "Group Idea" rather than a coterie of "seers."

One wonders what Beck thought of the debate. After asking Gold whether he disliked flowers because they were not useful, Georgia scolded, "You may be seeking the freedom of humanity, but you want to make art a tool . . . your mass artists will inevitably become bad artists." To Beck, who was still struggling to be seen as an artist, Georgia's defense would have been persuasive. "I have made three paintings on glass and done a lot of chores for 509," Beck told Mabel, emphasizing her loyalty to the Place and her status as an insider.

· · ·

For the next three years, the Strands would summer in New Mexico while Paul labored to compose images blending social awareness with aesthetic effects and Beck mastered the discipline of reverse oil paint-

ing on glass. Both found satisfaction there as members of a group of East Coast and foreign transplants seeking to immerse themselves in what they called "the authentic America." While trying to forge a renewed sense of connection to each other, they were also seeking a social relatedness of a kind that was rapidly becoming less likely at the Place.

Mabel invited Georgia and Beck to stay with her again in 1930, but both felt that they should make separate travel plans in accord with their husbands' wishes. Georgia again had difficulty making up her mind about leaving: "I couldn't decide until Stieglitz decided—it came quietly—naturally. . . . It is almost as tho Stieglitz makes me a present of myself in the way he feels about it." Arriving in June, to find Mabel still suspicious of her rapport with Tony, Georgia ate her meals in town, often with the Marins, and later with the Strands.

Beck agreed to stay with her mother in New Jersey while Paul drove their car south, put it on a boat to Texas, then drove to New Mexico—a holiday, to Beck's way of thinking. They would meet in July to take up residence at the Pink House. Hartley wrote to Beck to encourage her: "You must paint your glass pictures. I am jealous of you that you should know that style of painting." Alfred gave her his blessing: "May the summer intensify your passion for the Wilds of the West. . . . I don't see why passion shouldn't be intensified when passion is really passion." He added, "Georgia is leading a relatively quieter life. . . . It's all very different this year."

What Alfred did not say was that he was obsessed with Dorothy, who was spending the last months of her second pregnancy with her family. His letters to Georgia that summer lack the passion of the previous year, owing to the fact that he was writing daily to Dorothy and making frequent calls as her due date approached. He took few photographs—shots of the "little house" that served as his studio and some *Equivalents*, all less tortured than those done the summer before, during his breakdown. He told Georgia that her absence did not disturb him: "You must not set yourself a date to come back. Your work must come first."

While Georgia found that she could work best by avoiding the kerfuffles at Los Gallos, it was difficult to ignore the struggles being waged by Mabel, Brett, and Frieda Lawrence over Lawrence's ashes once Frieda had brought them there after his death that spring. Mabel let guests know that Georgia was no longer her favorite: She had recently lured the poet Robinson Jeffers to replace Lawrence as resident scribe. Georgia moved into the hotel, where she took her meals. Taos was "so

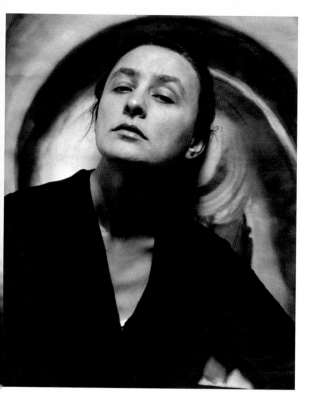

Alfred Stieglitz, *Georgia O'Keeffe*, 1918

Alfred Stieglitz, *Georgia O'Keeffe*, 1918

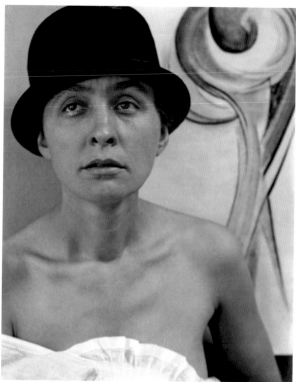

Georgia O'Keeffe, *Nude No. VI*, 1917

Alfred Stieglitz, *Georgia O'Keeffe*, 1918

Paul Strand, *Bowls*, 1916

Georgia O'Keeffe, *Abstraction
White Rose*, 1927

Alfred Stieglitz, *The Dancing Trees*, 1922

Georgia O'Keeffe, *Birch and Pine Tree No. 1*, 1925

Georgia O'Keeffe, *Radiator Building—
Night, New York*, 1927

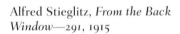

Alfred Stieglitz, *From the Back
Window—291*, 1915

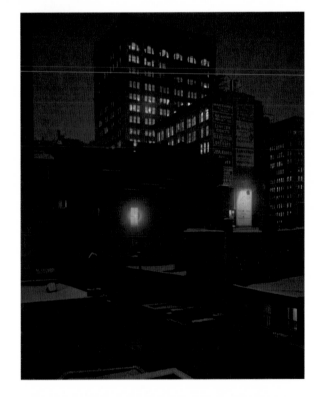

Paul Strand, *Rebecca, Twin Lakes, Connecticut*, 1921

Paul Strand, *Rebecca, New York*, c. 1923

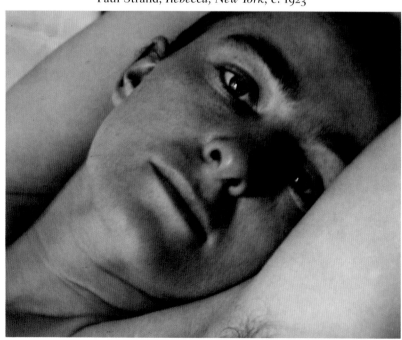

Alfred Stieglitz, *Rebecca Salsbury Strand*, 1922

Alfred Stieglitz, *Rebecca Salsbury Strand*, 1922

Georgia O'Keeffe, *Oriental Poppies,* 1927

Georgia O'Keeffe, *Blue Wave Maine,* 1926

beautiful—and so poisonous—that the only way to live in it is to strictly mind your own business," she wrote; "as one chooses between the country and the human being the country becomes much more wonderful."

After some preliminary drawings Georgia began to translate the landscape onto canvases that reflect its solitary splendor. She would complete twenty-two landscapes that summer, including brilliantly colored studies of the mountains in Alcalde, where she stayed for some time with her friend Marie Garland. O'Keeffe's studies of the flowers outside her Taos studio, in turn, inspired bold close-ups like *Black Flower and Blue Larkspur*. ("Strand likes it much," she told Alfred. "No one else has seen it.") She painted the Ranchos church, which Strand was also depicting, but their views of the building were quite different: "I hate the back of my Ranchos church. . . . It is heavy—that is why Strand likes it I suppose—I want it to be light and lovely and singing."

While O'Keeffe respected Strand's aesthetic, she rejected his "heaviness"—his fixation on the idea of the landscape as a problem. The solution to this problem, he would claim, lay "in the quick seizure of those moments when formal relationships do exist between the moving shapes of sky and the sea or land"—as in his *Badlands,* near Santa Fe, New Mexico, where the cloud patterns complement the jagged line of mountains and the irregular shapes in the foreground. Strand's 1930s images of relationships between sky and land form an initial response to Stieglitz's emotive use of clouds in *Equivalents,* and mark the start of his effort to avoid imposing his personality on nature.

"The only thing that is intensely living for me here is the country itself," Paul told Alfred. Yet he could not grasp the spirit of the Pueblo. "I must admit that the Indians are not very much a part of the summer for me. I know I can't do anything for them nor can I live with them and possibly in time get to know something about them—to penetrate that barrier that Lawrence so quickly sensed." That summer, he would take several images of Indian rituals that treat the dancers not as individuals but as swirling patterns of light and dark.

Strand set aside his formalist concerns on occasion—in photographs of Marin painting outdoors and the Mexican composer Carlos Chávez gazing at the landscape, and in several portraits of Beck that reflect the return of closeness between them that summer and his respect for her as a "worker." Acknowledging the many shades of emotion in their rapport, Beck sat for him in poses recalling their sessions from the 1920s, and at least once, in the nude—a torso that brings to mind both Paul's and Alfred's earlier portraits. This set of images suggests a rapproche-

ment between photographer and muse, which is not to say that their relations were without strain.

In the heady atmosphere of Taos, where Beck felt more at ease than Paul did, she could relax in front of his camera. She gave herself unstintingly to the enterprise, changing her clothes and poses to suit the occasion. Her prematurely white hair is fastened in a bun for one image in which her heart-shaped silver brooch marks a contrast to her dark garments and severe expression. She poses in profile, with her hair down, or with her back turned in the same cloaklike garment, seemingly detached from the demands of the session. In another, she is seen in profile against a sky full of clouds; apart from shots of her naked bust in front of a rough wooden door or on a bench, there are few indications that these portraits were taken in a particular landscape.

Unlike Paul, Beck strove to incorporate the Southwest in her art. Her painting of the Ranchos church differs from his studies of its massive forms as well as from Georgia's semiabstract renderings. In Beck's version, residents in native costume traverse the foreground and the church looms in the distance—there to serve the people, rather than as an inspiration for artists. Still, while it is difficult to date her reverse oil paintings, two completed in 1930 suggest that when painting flowers, Beck felt Georgia's influence. In *Echo of New England,* two calla lilies stand in a blue vase against a screen of red and white curtains; *Austerity,* its companion piece, shows a single calla in a black vase. Yet Beck's lilies are unlike Georgia's voluptuous specimens even when they suggest stand-ins for the female form. Their glassy surfaces avoid the imprint of the artist's persona and hold at bay the potential viewer's engagement.

Paul was proud that Beck and he worked diligently all summer. He told the Baasches, "Beck has done some ten nice glass paintings and I, God knows how many photographs. Never worked so much before—almost every day—like a job." Still, toward the end of August he took part in a community effort dreamed up by Beck in support of Mabel's fund drive to remove tin cans from the roads. Beck's tour de force, a tin can tea dance, was adopted by the local artists, who made posters while Beck and Miriam Hapgood decorated the hall with tomato cans. The town united in the effort, including an auction and men's and women's beauty contests—the sort of thing that brought out Beck's high spirits.

"I hope you are as much in love with the life down there as ever—And that you are painting some & well," Alfred wrote encouragingly. After years of uncertainty about her right to count herself among the chosen, Beck could finally do so. The Taoseños not only accepted her as one of

them but adopted her view of herself as Nate Salsbury's daughter—a "character" in her own right. The circle of those who admired her work widened, including the artists Nicolai Fechin and John Young-Hunter, Spud Johnson, Ansel Adams, and Georgia, though she and Beck saw each other less frequently than the year before.

In August, the two women took a car trip to Santa Fe to visit the nearby Puye cliff dwellings, the ancestral home of the Santa Clara Pueblo. Driving across the Rio Grande and into the sweltering canyon backed by rows of blue volcanic mountains, they wore "as little as possible," Georgia wrote Alfred, "and that is very little." Their slow progress along the parched track to this ancient site felt like a voyage to "the heart of something. . . . But only God knows what." Traveling together into the past, they could not help wondering what lay ahead.

. . .

The Strands stayed in Taos for several weeks after Georgia's departure for Lake George. Soon after her arrival there, Georgia told Beck that she was content: "Whenever I come back to Stieglitz, I always marvel to see how nice he is. There is something about being with Stieglitz that makes up for the landscape." But she quickly realized that his toleration of her absence that summer owed a great deal to his infatuation with Dorothy. He became more than usually anxious as Dorothy's due date approached, to the point of developing abdominal pains, which abated after Edward Norman wired that his wife and newborn son were fine.

Georgia's thoughts about this situation may be gleaned from the advice she sent Brett that fall, when her friend was trying to write about her years with Lawrence. In Georgia's view, one had to face the shadows in order to carry on: "The vision ahead may seem a bit bleak but my feeling about life is a curious kind of triumphant feeling about—seeing it black—knowing it is so and walking into it fearlessly because one has no choice." By then, she had no choice but to cope, as consciously as possible, with the love affair that was changing the terms of her marriage.

In October, a new financial panic began, with numerous bank failures followed by a decline in the money supply. Paul worried about the declining value of his and Beck's stocks: "I cannot resist buying a paper every day to see how much more our 'fortunes' have shrunk," he told Alfred. After their return to New York, Beck took charge of the Place, typing correspondence, reminding donors that their pledges were due, and working on the budget. She informed Alfred that the 1930–1931 sea-

son's totals would be lower than the year before, some "guarantors" having ended their support. She was thrilled to receive an unexpected gift from him, three prints, including one of her hands holding a glass ball from her first session as his model. "I can not tell you how beautiful they look," she wrote, "the hands hold that shining crystal forever." Alfred replied that he would see her soon, as he was "itching to be on the job."

Unlike previous years, when he was loath to leave the lake, Alfred was actually "itching" to see Dorothy, who had just returned to New York. Georgia may have hoped that she would stay home with her children, but this was not what happened. Dorothy took on what had been Beck's duties at the Place. One can only wonder whether Beck continued in her role as Georgia's confidante at this time, when Georgia kept her feelings to herself. Just the same, by going to the gallery only to hang shows (her own would open in January), Georgia let it be known that she was keeping her distance.

The title of O'Keeffe's 1931 exhibition—"Recent Paintings, New Mexico, New York, Etc., Etc."—hinted at her new life apart from Stieglitz. "Back from her second (or is it third?) visit to New Mexico, Miss O'Keeffe says she is ready to go again," Edwin Jewell wrote in the *Times*. Her last trip had resulted in new themes unified by the "mysterious quality" common to her work: landscapes, "with their hills that, in rhythmic, vital waves, both reveal and retreat . . . flowers and shells that live an inward life of their own, or that mirror in fugitive flashes the inward life of the artist." O'Keeffe clearly meant "to stun rather than to confide."

It would have surprised O'Keeffe to see Jewell's perceptive review on the same page as his critiques of two socially conscious muralists, José Orozco and Thomas Hart Benton. Orozco's *A Call to Revolution,* at the New School for Social Research, was disappointing, Jewell wrote, despite its lively portraits of Lenin, Gandhi, and other figures because its diverse elements were not interrelated. By contrast, Benton's murals at the Art Students League depicted scenes from American history "with a fervor that makes the work essentially original." Jewell ended by alluding to the debate between those who claimed that art must be politically engaged and those who decried this stance: "You will probably like these pages of history either very much or not at all."

By then, Strand was working with Clurman on ideas for socially engaged cultural events. Clurman's talks to drama groups about the need for a New York company on the model of the Moscow Art Theatre had already attracted people like Lee Strasberg and Cheryl Crawford, with whom he would form the Group Theatre. He argued that

rather than distract audiences from social problems, the theater should address them. When Strand took Norman to meet this group, she rallied to the cause. Seeing no contradiction between the Stieglitz ethos and the Group Idea, she joined the Group Theatre's executive council.

In February, when Georgia's show was still at the Place, she received an extraordinary letter from Dorothy. Of Georgia's dislike of her relations with Alfred, Dorothy wrote grandly, "You are preoccupied with the relationship of any two living forces which feel the necessity of merging with one another in order that they may attain fulfillment." Then, in her newfound role as critic, Dorothy said that she admired Georgia's work but found it sad: "so sad that one cannot stand it, and so beautiful in its greatness beyond desire that one stands and bows down before it. . . . You are an artist—you are beautiful and so I love you." While Dorothy's tender of affection expressed her wish for closeness between them, her efforts would have the opposite effect.

Clurman remarked on Dorothy's air of guilelessness to Stieglitz: "One is easy with her because she *receives* so effortlessly that one feels no check on one's own personality. . . . One can be with her and at the same time alone with oneself." Clurman's letter is reprinted in Norman's memoirs, perhaps as a tribute to her effect on people other than Georgia. Alfred kept singing Dorothy's praises to friends—extolling her talents, intelligence, and many accomplishments at so early an age. He was forty years her senior, but Dorothy's adoration made him feel young again.

What was more, despite the age difference, or perhaps because of the excitement it generated, their lovemaking (which probably began at about this time) was highly fulfilling to the young woman, whose rapport with her husband left much to be desired. "To have a complete erotic experience again and again is breathtaking," Norman would boast in her memoirs. Years later, she declared, "Any young woman would have been fortunate to have Stieglitz as a lover."

Still, Dorothy lacked one key element: She was not an artist. With Alfred's encouragement, she took the next step. "Strand's and Stieglitz's prints have opened my eyes to the power of photography," she wrote of this time, when Alfred lent her his Graflex, then bought her a smaller one and, despite his refusal to take students, taught her to use it. For Alfred, these sessions, which stirred him, were more important than anything else. For Dorothy, they were occasions to explore their love: "While I remain beautifully still for him, he makes comical faces, sticks out his tongue, at times smiles broadly—anything to make me laugh—before he

settles down into being whichever self takes over." Alfred paid homage to Dorothy's new self with a portrait of the Young Lady as photographer. Wearing a dark cloche hat, she steadies her Graflex to take his picture in recognition of their passion for camerawork, and for each other.

. . .

Georgia left for New Mexico in April 1931, a month earlier than the year before, with the intention of returning in July. Alfred planned to stay in Manhattan until mid-June (when Dorothy went to Woods Hole), after which he would repair to the lake. Meanwhile, he prepared Marin's next exhibition, including his New Mexico watercolors, and worked with Dorothy on an edition of Marin's letters. His mentions of her in letters to Georgia read as attempts to play down their intimacy: "Mrs. Norman" looked unwell while going over page proofs for the book; "the Normans" took Alfred to dinner with Clurman, Strand, and their friend Gerald Sykes. Alfred did not mention Dorothy when he urged Georgia to stay in New Mexico longer than planned: "You owe it to your work—which is really yourself—to utilize this great opportunity."

Rather than stay in "Mabeltown," Georgia rented a cottage at the H & M Ranch in Alcalde, forty miles southwest of Taos. The owners, Marie Garland and Henwar Rodakiewicz, had gone with her to the Grand Canyon in 1929, and she had visited their ranch several times in previous summers. Her hosts formed a striking couple. Marie was a Bostonian in her sixties who had published three books of poetry and two tomes on Hindu spirituality; at twenty-eight, Henwar, her fourth husband, was completing his first movie, *Portrait of a Young Man in Three Movements.* Marie's excellent meals and tolerant attitude suited Georgia perfectly.

In the summer of 1930, the blue Jemez Mountains and dark mesas near the ranch inspired her to paint such oils as *Out Back of Marie's II,* now known as *Black Mesa Landscape, New Mexico.* A year later, Georgia would depict these landmasses with broad, flat brushstrokes to evoke the sensuousness of their adamantine forms, the way they echo the shapes of the female body. "There is something about all of it that makes me feel so close to the earth," she told Alfred after her arrival. "I like being on the ground so much I just feel like jumping up and down."

In New York, there was little cause for elation. By June, as Alfred prepared to close the Place, the mood reflected the widespread fears following the latest bank panic. Centered in Chicago, it further harmed the economy by creating deflationary conditions (restricted credit, high

unemployment, reduced consumption). Watching the stock market's gyrations, Alfred worried about the future. "Wall Street is frightful," he wrote. "I have gone through pretty tough times but none like this." Still, Georgia was not to fret about him or the current malaise.

Under the circumstances Paul took on more work as a cameraman. In June, he filmed the graduation ceremonies at Princeton, earning an extra one hundred dollars (the equivalent of about fifteen hundred today) for shooting in the rain. Beck kept her mother company in Atlantic City for a month, counting the days until she and Paul could go back to Taos. That winter, when she'd given Alfred one of her reverse oil paintings on glass, he had said that he would keep it at the Place "so Paul & all others can enjoy that little thing in the corner as much as I do." As if that were not enough to gladden her heart, he had offered the Strands a joint exhibition the following year. Amazed that Alfred thought so well of her work, Beck had taken care to praise Paul's: "You will find in it the grandeur and isolation of the New Mexican country—something he feels not only about that country—but about living itself."

As the Strands prepared to leave for the summer, Paul confided in Alfred, "If nothing comes out of it (the opportunity to work certainly is being given us, barring sickness), we will deserve no more such opportunities." His loyalty to Alfred remained unshaken. He told the critic Samuel Kootz that he would not take part in Kootz's book on photography unless Stieglitz was featured (when Stieglitz declined to send prints, Strand withdrew). But as he spent more time with Clurman, Paul became receptive to the notion of another kind of artistic community. In June, he met Clurman's friend Clifford Odets, a cofounder of the Group Theatre; he would join the group in the fall as an artistic adviser—along with Aaron Copland, Waldo Frank, and, surprisingly, Stieglitz.

Clurman had already noted Stieglitz's competitive streak. After Clurman's highly positive review of Strand's 1929 show appeared, Stieglitz told him, "You would not have written about Strand as you did if you had seen my work first." Clurman was also struck by a confession Strand had made to him: "I remember you . . . saying . . . 'the difference between my photographs and Stieglitz's is that he has life and I have none.'" But Clurman saw no point in comparisons. When the two men took his portrait at Lake George, he wrote, "Stieglitz's photograph shows me receptive, smiling, kindly, and soft. Strand's photo has me stern, ready for battle, indomitably prepared for every terrible eventuality. . . . Each of these two artists had done his self-portrait."

The Strands arrived in Taos toward the end of June, having rented

Mabel's Pink House and arranged for Paul's darkroom above the movie theater. A woman from the Pueblo saw to their needs. "I think I am on my way now," Paul told Seligmann, "much more sensitized to the Mexican spirit, which lives here darkly under the bright light." He was intrigued by the interweaving of cultures: the Indian, the Mexican, and the traces of the white settlers whose dwellings he photographed in old mining towns. They stood there "with a kind of courage and an undeniable dignity"—words that suggest how he wished to present himself.

That summer, Paul sensed that he was succumbing to the Southwest. "The days slip by within this magical repetition of sun and storm and cold scarlet nights," he told Alfred. "So much so that if one had not made a few photographs & paintings standing on the mantel—they might well be a kind of dreamlike mirage." He and Beck did little but work; her paintings showed promise: "Some of them very handsome indeed—all of them good workmanship." As for himself, he had "gotten more into the spirit of the country and so the photographs are simpler—more direct." They hoped to stay in Taos as long as possible, perhaps until October.

Though Beck rarely dated her paintings from this time, we can watch her progress, starting with *Red Geranium,* a 1931 still life that makes one think of Georgia. "I seem to be hunting for something of myself out there," Georgia wrote during their first summer in Taos, when she sought inspiration in flowers, shells, and stones. Two years later, Beck kept to the theme in which Georgia excelled—blossoms treated like self-portraits. But rather than paint wildflowers, as Georgia had, Beck portrayed a well-behaved geranium in its yellow pot. Given the geranium's frontality, one may infer the lingering influence of O'Keeffe, whose flowers had confronted viewers in this way for a decade. However, painting backward, Beck created a flat, almost two-dimensional flower quite unlike her friend's. In time, she would use highlights and shadows to model her subjects' contours—techniques that were taught at art schools but that she had to learn on her own.

What mattered most to Beck, one suspects, was that Paul admired her discipline at a time when he, too, was focused on his art. Leaving each morning at the same time, he drove into the countryside in search of promising sites. The photographer Dorothea Lange, then living in Taos, recalled him as "this very sober, serious man . . . he was so methodical and so intent that he looked neither to the right nor to the left." She reflected much later, "All the photographers I'd known always were with lots of other people, but somehow this was a lone man, a solitary." (Paul never spoke to Lange but went on photo shoots with Ansel Adams and Carlos Chávez, who were Mabel's guests that summer.)

Paul went on photographing the ghost towns and stark landscapes that lent themselves to unified pictures of land, sky, and the occasional building—as in *Dark Mountain* (1931), where the formal details of an adobe are balanced by the distant mountains. Formalist concerns are also paramount in images like *Ghost Town, Red River, New Mexico,* a close-up of a ruined dwelling's clapboards; similarly, images of the Ranchos de Taos church treat it like an abstraction, bringing its masses to the frontal plane to enhance its monumentality. A revealing story is told about Strand's pique when he found a basketball backboard affixed to the church's rear wall. After complaining to the priest, he paid the boy who had put it there to remove the backboard because it spoiled the picture in his mind.

Strand hoped to create an extended portrait of New Mexico in the same way that he had approached the Gaspé Peninsula. Yet as the backboard episode suggests, his attitude was that of an outsider. In discussions with Chávez and Elizabeth McCausland, who was also in Taos, he kept returning to the role of the artist in society. Increasingly, Strand would use his camera in the attempt to document ways of life different from

Paul Strand, *Ranchos de Taos Church, New Mexico,* 1931

his own. Yet, as he said years later, he took few portraits of "the people who lived there . . . the people indigenous to New Mexico"—perhaps because the growing sense of dislocation that he and others experienced in the 1930s only deepened his habitual reserve.

That summer, while Strand worked from his stance as an outsider, O'Keeffe immersed herself in the landscape that would shape her art for the rest of her life. Visitors were surprised to find bleached animal skulls arranged around her studio, where a ram's head with a curly horn had pride of place. On drives into the country, she picked up bones and other treasures—an eagle feather, a kachina doll with "a curious kind of live stillness," a pink shell that was a gift from a Tewa Indian. "When I leave the landscape it seems I am going to work with these funny things that I now think feel so much like it," she told Henry McBride. She would go east in July: "I don't seem to remember what its like there but I'll be finding out. Cant leave that man alone too long."

Georgia's ruminations may have been prompted by reading Mabel's article in *Creative Arts,* "Georgia O'Keeffe in Taos." With the superior knowledge of one who had lived there for years, Mabel described Georgia's awe when she and Beck first arrived: " 'Wonderful' was a word that was always on her lips." Much of the piece was devoted to Georgia's driving: "Beck Strand had the dubious joy of teaching her and we all watched her lovely silver hair grow more silvery day by day. . . . Driving the Ford stimulated Georgia in exact proportion to Beck's nervous apprehension. . . . Beck—whose noble friendship never wavered—would come in haggard and distraught and sinking into a chair, exclaim: 'Well, I don't know what Stieglitz would say!' " Mabel ended by taking credit for Georgia's exalted state: "It did her what is called good and thus we share somewhat in her fate."

After the Strands' arrival in June, when Paul and Georgia drove their cars across the Rio Grande, his got stuck in a sandbank: She and two Mexicans labored to get it out. "It hurt Strand mightily to have to pay the Mexicans the four dollars," she reported to Alfred, adding, "I really had to laugh at him." She found Paul annoying—especially when he critiqued the painterliness of her recent canvases. Later, when she went to Taos to see Beck, they rode to visit Frieda Lawrence at her ranch. "They sat there in their saddles, handsome and straight as Indians, turning their horses around and around so as to see the view," Frieda recalled. "I never had seen such women, so unconcerned about everything except the beauty around them." She would always think of Georgia as she appeared that day with Beck, "beautiful and unmuddled."

. . .

Picturing the Strands in Taos, Alfred wrote to Georgia: "Beck is reveling in her heaven—And Strand will add to his trophies of photography. What a chance he has. He ought to do some great work this year after the criticism I gave him." Alfred added that he had been printing some "large New Yorks"—a theme that would reestablish his preeminence. His relations with Paul underwent further strain due to Dorothy's dislike of both Strands; that summer, when Alfred took few photographs except for some somber *Equivalents,* the idea of Paul's recent accolades may have revived his competitive streak. Georgia was surely struck by Alfred's insistence that she stay away longer: "I'm really in better shape in every way than in ages. Except perhaps the Little Man doesn't show as much interest in life as at one time."

Alfred did not let on that his thoughts were focused on the hope of a tryst with Dorothy, whose ardent missives begged him to join her before Georgia's return. In one, she recounted a dream about a woman's desire to be "utterly one" with "God"—Dorothy's pet name for Alfred. In others, she plotted ways for them to be together provided Georgia stayed in New Mexico until August. Earlier that year, Beck had told Paul that she hoped not to be drawn into "the problem between G & S," adding, "That has long since gotten beyond what anybody can do about it."

Georgia decided to return to the lake in July after Alfred told her that he was going to Boston to see his son-in-law and grandson, then stay with the Normans. During his visit, he and Dorothy took pictures of each other, including shots of her nude, in a field of flowers. In a carefully worded letter to Georgia, he described the Normans as "a good combination even if not perfect" and praised Dorothy's domestic skills, which he compared to Georgia's: "So different from what you'd have & do." But the seashore was not the best place for Dorothy to practice photography; he hoped to arrange for her to visit him at Lake George.

One can only imagine Georgia's reunion with Alfred on July 16, a few days after his tryst with Dorothy. (Apparently, Georgia ignored the extent of their intimacy. Judging by Dorothy's fear weeks later that she might be carrying Alfred's child, his stay at Woods Hole included the enactment of her dream.) Soon, Georgia confided in her friend Vernon Hunter, "I am feeling a bit disgruntled that I thought I had to come East and came the middle of July. Everything is so soft here. I do not work. . . . I walk much and endure the green."

By then, Alfred and Dorothy were writing to each other several times

a day and holding long phone calls in front of their spouses, as if their spiritual accord made them immune to the mundane claims of marriage. Alfred went to Boston on August 26 to meet Dorothy at a hotel, where (he told Georgia) they had separate rooms, then took her to Woods Hole. Rehashing recent arguments with Georgia about a possible separation, he wrote, "In spite of our 'failures' respectively I feel that I still have something to give you if you will let me—& I know you have very much to give me." The idea of separate quarters at the Shelton seemed "ridiculous," but he would accept her decision. He closed with a peace offering: "I'm going to photograph you as soon as I get back."

Georgia made up her mind to face the situation. "I sometimes wonder where I am—what time of year is it—and what is it all about," she told Beck. "I have been working on the trash I brought along—my bones cause much comment." Alfred's family was annoying, but she enjoyed walks in the hills with the other guests. "So all put together—it seems a pretty good life," she continued after thanking Beck for her gifts—a shirt, a cactus, and a sage plant—souvenirs of the Southwest to help her endure the green. She was sending Beck funds for a corduroy skirt and jacket: If she couldn't feel at home where she was, she could at least dress as if she did. The letter ends plaintively: "My greetings to Paul—also specially to Tony—and anyone else who may think of me."

Beck, who could appreciate Georgia's dilemma, sent her the corduroy skirt and jacket, along with a black-and-white handkerchief, which inspired Georgia to dye her new garments black. "I feel perfect," she told Beck, "almost as good as an animal with fur on it." Then she confessed, "It seems quite impossible that the summer is over—It has been a bit fantastic to say the least." Although Georgia did not mention Dorothy, her rival's influence is implied in her uncertainty about the future: "I may stay up here after Stieglitz goes to town—haven't decided—but probably will—I don't feel a bit ready for town. If the others all go to town I'll stay—if they stay I will not."

Divided Selves

1931–1932

While Georgia pondered her options, Beck grew ever more loath to leave Taos. Her summer had been "the best ever," she told Alfred. In addition to completing fifteen reverse oil paintings, she was having a grand time, especially riding "like hell" on her "wild little horse." She continued: "We've gone miles over the sagebrush—through the arroyos, by moonlight or in the burning sun—there have been dances, parties—mucho whiskey. . . . New friends—some of them swell."

One new friend who probably kept Beck company on these rides was mentioned only in the next sentence—the kind of allusion that makes sense if one reads between the lines. Paul had gone to Colorado with some of his friends while Beck remained in Taos to let her oils dry before their departure. Like a woman who declines to give her lover's name but can't help mentioning him obliquely, she gave Leadville as the group's destination: This Rocky Mountain mining town was the family home of Bill James, the most prominent of her "swell" new friends. Now the owner of the Kit Carson Trading Post (where tourists on Indian Detours trips bought souvenirs) and a member of the town's hard-drinking circle, Bill had noticed her strolling through Taos. While the outlines of their love affair can be pieced together from photographs and correspondence, we do not know its exact chronology. It's clear, though, judging by her actions in the months to come, that Bill James's presence in Taos was one of the main reasons for her reluctance to leave and her decision to return, by herself, the following winter.

· · ·

Georgia's attempts to bring New Mexico to New York were making changes at the Hill. Claiming the farmhouse as her domain, she took down a closet wall to make her room larger, painted the floor dark

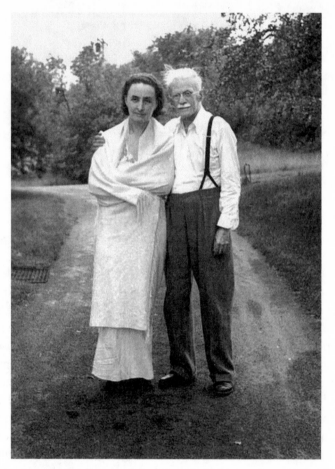

Josephine B. Marks, *Georgia O'Keeffe and Alfred Stieglitz at Lake George*

green, and laid a Navajo rug. "The house is full of bones & skeleton heads—Mexican flowers, etc," Alfred told Beck about these alterations to the decor, and to relations between himself and Georgia.

As promised, he took new portraits of her. Three prints entitled *Georgia O'Keeffe—Hands and Horse Skull* contrast the skeletal head with her suntanned hands. These prints were remarkable, he told her, "but they do not actually express my feeling about you underlying all temporary feelings." Georgia also posed in an Indian blanket, holding the skull she was about to depict in several oils, and in the nude—her torso seen frontally and from the rear in shots that emphasize overt views of "Fluffy." Alfred added, "My real feeling for you is in only a couple of the very fine nudes." He was taking stock, accepting Georgia's independence while

laying claim to her physicality. ("I have been photographing like mad for the last 10 days, nudes chiefly," he told a friend: "Large old fashioned fever heat.") That fall and winter, the couple made love often—while Alfred continued relations with Dorothy.

Georgia and Alfred went to New York together in October to ready the Place for the first exhibition of the season. "It'll be funny (!) to hang the Marins without your & Paul's help," Alfred wrote Beck, still in Taos, "but it would have been very foolish to cut short your stay down there. I hope we'll manage." When they were done, Georgia returned to the lake, leaving Alfred to do as he pleased while she prepared for her exhibition at the end of the year. Paul and Beck went to see Alfred soon after their return and discovered that he had indeed managed without them. Feeling remiss, Paul reinserted himself into Alfred's good graces by working with Dorothy on funding and other issues at the Place.

Paul had recently heard from Duchamp's friend Julien Levy, who hoped to inaugurate his Madison Avenue gallery that fall with a retrospective of American photography. Levy asked him to lend work but, downhearted about his prospects, Paul agreed to do so only if Levy bought three prints at a hundred dollars each—this on the advice of Stieglitz, whose cooperation Levy hoped to obtain. Stieglitz persuaded Levy to enlist his father as a backer and, rather than lend his originals, made him buy an old *Camera Work* to cut out Alfred's prints and hang them at the show. Levy remained fond of Stieglitz, but in his memoirs, still "appalled by the force of [Strand's] bitterness," he wrote that Paul "seemed to have been born with a black cloth over his head."

During this period, Georgia began a painting of the cow's skull that appeared in Alfred's recent portrait of her. It would never sell, she thought, but it amused her. As she painted the blue background with red stripes on each side of the skull, the canvas made her think "many funny things about painting—Art—Myself—and maybe America." O'Keeffe's account of her process is worth quoting at length:

> I thought of the city men I had been seeing in the East. They talked so often of writing the Great American Novel—the Great American Play—the Great American Poetry. I am not sure that they aspired to the Great American Painting. . . . I knew that at that time almost any one of those great minds would have been living in Europe if it had been possible for them. They didn't even want to live in New York—how was the Great American Thing going to happen? So as I painted along on my cow's skull on blue I

thought to myself, "I'll make it an American painting. They will not think it great with the red stripes down the sides—Red, White and Blue—but they will notice it."

With the creation of this defiantly "American Thing," O'Keeffe affirmed her right to evoke the native scene in her own way, as Edward Hopper and Thomas Hart Benton were doing, yet as something of a joke, although one that would make the great minds take notice.

Pleased with her new theme, O'Keeffe painted more skulls, sometimes adding artificial flowers to their heads. A composition featuring a horse's skull with a pink rose placed jauntily over one eye "makes me laugh every time I look at it," she told Alfred. She also liked her depiction of a jawbone backed by a black fungus: "Sounds diseased but it isn't." Other horse's skulls, with and without artificial white roses of the kind that Beck had found on their first summer in Taos, were also diverting: "I really don't know why I laugh because it really isn't funny—only seems funny to me." To some, these paintings' symbolism is more apparent than their humor. One of her biographers notes, "As well as death, they represent an interior strength, tranquil, remote, and enduring."

Georgia drove to New York in November for the opening of Julien Levy's gallery. She talked to him about "her country"—the canyons near Santa Fe "where she thought she would like to live, perhaps for the rest of her life." The colors were constantly changing, she explained: "Browns, oranges, red, and then violet and deep into purple." In contrast to the gallery's white walls the vista in her mind's eye seemed "most unreal while all the time it is very real." Paul's views of New Mexico, each turned away from the next on the curved walls, seemed out of place beneath their glass frames. Of Levy's retrospective (which included Käsebier, Haviland, Steichen, and Weston), Edwin Jewell wrote, "This is probably the first really successful attempt to give a synthetic picture of photography's development in America."

Georgia made several trips to New York that fall, sometimes without giving advance notice. One day, she arrived at the Shelton, to find Alfred with Dorothy: He had brought her to their rooms to continue their portrait sessions. In what reads like a repeat of Emmy's finding Alfred with Georgia years before, some biographers say that Dorothy was naked (this cannot be confirmed). Whatever took place, Georgia went back to the lake the next day. She told Alfred, "Talking in this way cannot go on—neither of us can afford to be spent that way. . . . I kiss you very quietly—and very sadly." Alfred wrote the same day that he

regretted having hurt her; still, they had "fluffed beautifully." Echoing Oscar Wilde, he mused, "It is said that people kill what they love."

Over the next weeks, the Strands inventoried the works they had brought back from Taos for their joint exhibition in the spring. Paul would show his landscapes from the Gaspé, New Mexico, and Colorado but none of his portraits; Beck hoped to enhance her paintings' allure by placing them in old Mexican frames made of punched tin. She would finally be seen as an artist with her own aesthetic rather than as a muse, yet given Alfred's distraction, the prospect of their show was unsettling.

In December, when Georgia returned to New York to hang her show, Alfred was beset by money problems, including a shortfall in the gallery's general fund. Despite his reluctance to deal with finances, he covered some costs and paid the rent for the darkroom. He had hoped to reimburse himself from the fund, he told Paul, who was acting as treasurer. But given the depressed art market, this was unthinkable, nor could he repay investors. Georgia would donate several thousand dollars to the fund in the form of paintings; he would contribute twenty-five prints "at the average value of $150—or maybe only $100 apiece." In this way, "the dignity of the experiment called An American Place will be upheld." Alfred thanked Paul for his efforts on their behalf: "I know the strain you are under—must be under with everything as it is."

Alfred then took Paul into his confidence about plans "to breathe a bit of life" into the Place. When Georgia's exhibition closed, he would display his own work: "For photography's sake, for The Place's sake, & for my own impersonal sake." The time was right, he thought, to show his new series, the "New Yorks," taken from his windows at the Place and the Shelton to document the city's transformation. While Paul admired these increasingly remote images of the skyline, Alfred admitted in a moment of doubt, "Everything is so far from my own ideal that I oftentimes don't quite know whether I see a reality or not."

The timing of their shows was less than ideal. Georgia's opening received a brief mention at the bottom of a full-page spread in the *Times* devoted to the Diego Rivera retrospective at the Museum of Modern Art, which was causing a flurry in the press. Rivera had worked feverishly to create the portable murals depicting heroes like the revolutionary Emilano Zapata as well as scenes of striking workers being suppressed by soldiers. Closer to home, his *Frozen Assets,* a composition set against the New York skyline showing a homeless shelter on top of a bank vault, provoked observations about the work's immediacy at a time of long breadlines.

In December, Edward Jewell devoted three articles to the Mexican art-

ist. Under the circumstances, when all New York appeared to be debating the merits of politically charged art, it seemed likely that O'Keeffe's new paintings would be overlooked. On a different but equally vexing note, after hanging her canvases she had to submit to the trial of having them documented by Dorothy in her role as gallery photographer. (By then, Dorothy was all but running the Place.)

In the new year, as Beck prepared to return to Taos, Paul visited the Rivera show with Elizabeth McCausland; Georgia also took the time to see what everyone was talking about. To her surprise, Rivera turned up at the Place with his wife, Frida Kahlo. "I think his show very uneven but he himself is a person," Georgia told a friend. "He came to my show—stood in front of every painting—looking and carefully considering it—a fullsized—deliberating person—and I thought to myself—If one person like that came every year and looked that way I would paint much better."

Soon the critics began responding, some in shock, to O'Keeffe's juxtapositions of bones. "I imagine that she saw these ghostly relics merely as elegant shapes," McBride wrote. "Like the plant forms and shells . . . that she so inordinately admires, these bones to her are part of nature's marvelous handiwork." O'Keeffe explained to an artist friend that these oils were "a new way of trying to define my feeling about that country." That the critics deemed them newsworthy due to their subject matter made her feel "like crawling far far into a dark—dark hole."

In a letter to Brett, she allowed that she had not worked on this theme long enough to move through the "objective" phase and into the "memory or dream thing that I do that for me comes nearer reality." Looking at her last year's work made it hard to start again: "I try to make out a direction for myself for at least a year and as that involves my personal living as well as my working it becomes a bit difficult." Then, picturing Brett's shack and Frieda's ranch in the hills above Taos, she mused, "[I] wish I could be walking along . . . without my clothes on—or sitting up among the trees in a sunny spot—alone—just me and the sun and the trees and the pine needles."

One wonders what Beck thought of Georgia's new work and Rivera's ideas about native culture as a source for art. A few weeks after her fortieth birthday, one of those moments that may spur one to action, she took the train to New Mexico by herself. Alfred wrote her a few weeks later, "I hope Taos is giving you your heart's desire. . . . If I could bring you a bit of Peace—don't you think I would? But it seems beyond my powers to bring anyone any peace—maybe because I'm too often eagerly looking for a bit myself."

. . .

Beck was already in Taos when Alfred's retrospective, comprised of photographs from the last forty years, opened on February 15, 1932. With Dorothy's help, he grouped his work in series—the *Equivalents*, studies of New York, and portraits. His cloud pictures, Edwin Jewell wrote, were "visualizations, as Mr. Stieglitz phrases it, of his philosophy of life"; his recent views of Manhattan were cool and rational, especially when compared to his earlier cityscapes. While many saw the recent prints as more objective, their allusions to the transformation of New York over time implied another aspect of his "philosophy," that of an Olympian observer pondering the nature of change.

The exhibition also included a set of portraits that composed a mini-retrospective within the larger show. Images of Georgia, identified both by name and as "Torso," illustrated shifts in feeling between the couple over the years; two from 1923 entitled *Nude in the Lake*—most likely Beck—offered a different vision of the feminine. Three portraits of O'Keeffe stood out in the group of Stieglitz stalwarts, including Rosenfeld, Frank, Hartley, and Anderson (but not Strand). What struck members of the group was the addition to their number of Dorothy Norman: The prominence of her portraits reflected her sway over Alfred's imagination. "If speculations about Alfred and his new, much-younger-than-Georgia model did not reach the press," a family member recalled, "they were carried in thundering whispers by those who crowded the gallery."

Georgia informed Brett, "The place is the most beautiful now that it has been—The rooms as a whole are more severe—more clear in feeling—and each print as you walk down the length of each wall and look closely . . . it is as though a breath is caught." But the next sentence reveals the strain beneath her apparent serenity: "I am glad he is showing them but there is something about it all that makes me very sad."

In this state of mind, Georgia also told Brett, who was disheartened by Alfred's lack of interest in her work, not to worry about the Strands' show that spring. While Beck may have boasted to friends in Taos, her paintings would be shown on sufferance now that Dorothy had the upper hand. (In Dorothy's view, Beck was common, and Paul slavish in his devotion to Alfred.) Georgia told Brett drily, "Showing or not showing any ones work doesn't make it any better or worse—so let it go at that."

When not at work on her oils, Beck presumably took more moonlight rides, drank "mucho" whiskey, and spent evenings pondering her heart's desire. In a 1932 photo of her with Bill James, they are a couple dressed for a fiesta: her long white lace dress, elbow-length gloves, and dark

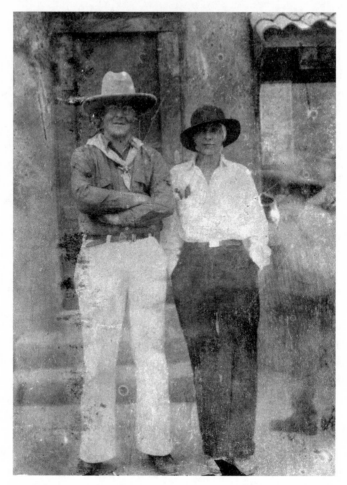

Bill James and Rebecca Strand, Taos, 1932 tintype

shawl set off the black sash, headband, and hat of his Spanish colonial costume. In another, they stand side by side in complementary riding outfits. By then, Beck was hitting her stride in her chosen medium. She returned to New York with some twenty southwestern scenes—paintings of the Mexican devotional images called *santos,* women in black crossing the empty mesa, the Ranchos de Taos church, flowers, cactus, and sagebrush.

In her account of this time, Beck implied that her acquaintance with Bill began in 1930, when the economic crisis reduced the number of Indian Detours groups coming to Taos and left him "saddled with a large stock of bad accounts and good Indian wares." Her allusion to

the sign on his door—"gone to Mike's"—hints that they frequented this establishment, where bootleg booze flowed freely. She said little about herself but stressed Bill's resourcefulness: He brewed his own beer and imported Scotch whiskey, in violation of the laws in force under Prohibition. She did not mention that he was separated from his wife, who lived in Denver, or that he was almost nine years younger than she was.

Beck's pride in Bill's western background is also apparent in her account of his earlier life in Denver. He told her about his sister, Edna, who had restored the derelict Central City Opera House, and of his efforts on her behalf—which included scouring Denver for props and playing the part of a croupier when Edna, who married into one of Denver's wealthiest families, the Chappells, staged a production of Dumas's *Camille* with Lillian Gish. It pleased Beck that the Jameses not only came from "hardy pioneer ancestors" but cared about the arts. What was more, Edna's in-laws had recently given their twenty-two-room mansion to the Denver Art Association, where one could see the work of Matisse and Picasso as well as that of artists from Taos and Santa Fe.

It was with mixed emotions that Beck went back to New York in time for her show with Paul and to see how things stood between them. Alfred had made it clear that the Strands would have to do everything themselves; there would be no advance publicity, no catalog, no help with the decor. Brought closer in their dismay at his attitude, Beck and Paul hung their work to feature his photographs. Elizabeth McCausland praised their "unflinching integrity," especially the images from the Southwest that showed "the whole wreck and ruin of a frontier civilization." *The New Yorker* was less enthusiastic: "One of the early pupils of Master Stieglitz, [Strand] has old-fashioned notions about a camera." Beck's medium was "more or less a lost art," the critic continued. Then, praising her "modest endeavors," he paid her a compliment: "Now and then one of them achieves a high point of beauty." McCausland allowed that this medium made possible "a suave sense of finish in the completed painting" with no obvious limitations when practiced by "an honest and sincere artist like Rebecca Strand."

Still, it was hard for the Strands to take much satisfaction in their notices, given the way they had been treated. Realizing that Alfred disapproved of his "pupil's" turn to social engagement, Paul went to the Place when their show closed and turned in his key. His fealty to Alfred ended just as his marriage was coming under greater pressure because of Beck's feelings for Bill James. Writing to her years later, he recalled that day, a turning point in his relations with Alfred, and, in a sense,

with her: "The day I walked into the Photo-Secession in 1907 was a great moment in my life . . . but the day I walked out of An American Place in 1932 was not less good. It was fresh air and personal liberation from something that had become, for me at least, second-rate, corrupt, meaningless."

For Beck, who was just coming into her own, the situation was less straightforward. "Isn't there something we all can do to go back to the warmth and understanding of the 'old days'?" she would ask Alfred. "Won't you write to Paul some day and tell him of the Place and all the things that have always meant so much to him and always will?"

. . .

At this time, Georgia was also coping with the increased tensions in the group by resigning herself to Alfred's infatuation with Dorothy. It was a fait accompli, something that she had to live with despite her distress. However, that spring, as she took steps to assert her autonomy, Georgia's actions only worsened the strained relations between herself and Alfred.

To show that Americans were as capable as Rivera at depicting contemporary life, the Museum of Modern Art organized an exhibition of murals by local artists for the opening of its new home on West Fifty-third Street. The curators, Julien Levy and Lincoln Kirstein, invited O'Keeffe, along with Stuart Davis, Sheeler, and Steichen, to submit designs on "some aspect of 'The Post-War World.'" Not surprisingly, most entries were concerned with social issues. *Manhattan,* O'Keeffe's seven-foot-high panel (the central one in a triptych called *Skyscrapers*) was the exception. Over its jazzy cityscape painted in red, white, pink, and mauve floated three artificial flowers, a witty composition that evoked her sense of humor.

On the strength of this entry, Donald Deskey, who was in charge of decor at Radio City Music Hall, asked O'Keeffe to paint the murals for the ladies' powder room (the Radio City building, part of Rockefeller Center, was to be completed by the end of the year). She accepted his terms, fifteen hundred dollars, even though she often earned twice as much for one canvas, because she had long wanted "to paint something for a particular space—and paint it *big*." When Stieglitz learned the terms of the contract, he berated her for disregarding his role as her agent, gallerist, and spouse. She held her ground but fretted about the pain that she was causing him—at a time when he felt free to continue his betrayal of her with Dorothy.

Georgia's unease is expressed, guardedly, in a letter to her Texas friend Russell Vernon Hunter. Without explaining the predicament in which she found herself, she wrote, "You are wise—so wise—in staying in your own country that you know and love—I am divided between my man and a life with him—and some thing of the outdoors—of your world—that is in my blood—and that I know I will never get rid of—I have to get along with my divided self the best way I can." Over the next months, torn between her desire to return to the Southwest and her fear of the consequences, she would attempt to live as a "divided self."

In mid-May, when Georgia went to the lake with her photographer friend Marjorie Content to prepare the house, she was unsure whether she would stay there over the summer. In June, having all but decided to return to New Mexico, she wrote to Alfred, who was still in New York, "It is very difficult to go through the motions of starting—and get myself off when I have really no desire to go—I go because I think I'll be able to work." He urged her to decide for herself. But when she chose to stay at the lake, he worried that she would not manage to work there after all—without pointing out that her presence would keep him from seeing Dorothy. Georgia decided to stay where she was; her decision, rather than bringing them closer, widened the gulf between them.

Over the next months, Alfred wrote constantly to Dorothy and sneaked into the village for phone calls. In August, after spending a few days in New York, Georgia told him, "I haven't felt that I was with you at all these weeks there—You seemed to be somewhere else." Alfred informed Dorothy that he had lost any desire for Georgia; they lacked "spiritual togetherness." In another letter, he recounted a dream in which Georgia divorced him to marry her "friend," Gustav Eckstein, and said he could not make love to her because "that would be adultery."

Divorce was on everyone's mind that summer when Alfred's brother Lee divorced his wife to marry his mistress of many years. Reflecting on this turn of events, Georgia wrote to Beck, who was again in Taos, "Makes me feel that my grandfather that I never saw will rise out of his grave and start flirting with my daughter that I never had." She added, "I sit in the sun in the boat on the lake . . . and let it go at that."

In the attempt to find some pleasure, Georgia went to Canada with Georgia Engelhard, by then a budding artist. On their trip to the Gaspé (inspired by Paul's photographs?), Georgia painted tightly cropped studies of the peninsula's long white barns and large-scale images of its decorated crosses, including a seven-foot-tall one with a bloodred heart, which amused her: "On the Gaspé, the cross was Catholicism as the

French saw it—gay, witty." The two Georgias returned to Canada several times to bring back contraband liquor; on one foray, they were relieved of their booty and made to pay charges—an incident that caused a row when Alfred opened the letter containing the receipt for Georgia's fine.

About this time, Alfred enlisted friends to help him talk Georgia out of the mural project. "Everyone dislikes the Idea of Radio City," she told Brett, "but I feel that has nothing to do with my wanting to paint a room—so there we are all in a squabble." What was worse, work on the powder room had to be postponed because construction was weeks behind schedule. Georgia went to New York in September to gauge the delay and signed a contract stipulating November 1 as the date of completion. A week later, Alfred tried to have the contract voided, arguing that he was the one to set the terms of her engagement. Over the next weeks, Stieglitz badgered Deskey with proposals. O'Keeffe's fee should be five thousand dollars, or she could work for free except for materials; in either case, the deadline should be changed. (The final contract is no longer extant.)

Georgia stayed by herself at the lake to work on her designs. In her anxiety about the project, she turned to her confidantes in the Southwest, who were closer to her in spirit than those around her. "I can't paint a room that isn't built," she grumbled to Brett, "and if the time between the building and the opening isn't long enough I can't do it either." The situation was "precarious." After another visit to the site, Georgia told Beck of her sympathy for the workers "who have to struggle with every one from Mr. Rockefeller . . . to the stone mason." She added, "I am a bit worn. . . . My Gawd won't I get hell if I cant make a go of it."

Georgia returned in October, only to find Radio City in chaos. Her canvas would not stay on the walls because the plaster was still wet. "So I've told them I am not going to do it," she announced to Beck: "I am in a sulk because I want to do it but I can't." Thanking Beck for the dried sage she had sent from Taos, Georgia wished her well in the land they both loved. Accounts of Georgia's relinquishment of the project vary, some describing her in tears and others insisting that she remained calm. Stieglitz called Deskey the next day to say that she was having a nervous breakdown. A few days later, Georgia told Russell Vernon Hunter that she no longer wanted to paint at Radio City but still had "a fever to do a room." She added wryly, "Our kitchen has the best plaster so I thought I'd start on that." (Deskey replaced her and extended the deadline.)

In November, Georgia had some weeks of peace alone at the lake,

when she may or may not have painted the kitchen. She took walks, puttered about the house, and readied her canvases in case she felt like painting. After finding no satisfaction, she told Alfred that she had stopped trying. He sympathized: "I know how difficult it is to get ago-ing feeling as you do. . . . But one dare not give in. That would mean complete paralysis. —That's what's threatening the whole country." He wondered if she took an interest in the election, which Franklin Roose-velt had won by a landslide after promising a New Deal for the belea-guered country. Georgia replied, "There isn't an idea in my head so I get out and use my legs. . . . My body is first rate—The rest of me is quite empty."

Just the same, during these weeks her mind was not at rest. Georgia knew that Alfred was working with Dorothy on a book of her poems; he would publish it in the new year under the title *Dualities*. Having accepted his ultimatum about the Radio City murals, Georgia hoped that she would avoid further alienating his affections. But she had given way against her better judgment. By mid-November, she was at such an impasse that the only solution seemed to be living apart from Alfred. Three days after her forty-fifth birthday, he apologized lamely for his part in her depression: "I did feel miserable knowing you so down & much because of 'me'—Yes, 'me' in quotation marks."

Soon after her return to New York to prepare her next exhibi-tion, Georgia's distress manifested itself in headaches, chest pains, weeping fits, and an irregular heartbeat. She followed Lee Stieglitz's prescription—bed rest and a bland diet—for several weeks, until her condition grew worse, aggravated by Alfred's tendency to hover while plaguing her with questions. Just before Christmas, she moved to her sister Anita's Park Avenue apartment. Lee thought that she was suffering from early menopause (this was not the case); Alfred's visits were kept to once a week for thirty minutes. Her depression deepened.

On February 1, Georgia checked herself into the well-regarded upper East Side Doctors Hospital, a decision with which Alfred did not inter-fere. That day he wrote:

<u>You must not worry about anything & above all not about me. I want you to get well. That's the one thing I want above all things. And you will get well.</u> I am relying absolutely on you to be good—to give yourself a full chance. —I know the changes must disturb you some. —All changes disturb even sensitive well people.

Over the next weeks, as she underwent treatment for psychoneurosis, Georgia tried "by inches and minutes" to resume normal life. Being ill was "funny," she told a friend; "it always seems it isn't intended for me."

The staff encouraged Georgia to see one person each day. Beck, who was in New York that winter, went to see Georgia's show and visited her at the hospital. The women discussed their equally uncertain plans for the future, and Beck sent gifts that she hoped would give Georgia pleasure, white silk handkerchiefs and one of her reverse oil paintings. Gradually, Alfred was allowed to visit more often. His belief that Georgia had a heart condition was, in a sense, correct: Her heart had broken in the attempt to win him back. But she had not lost her sense of humor. "Getting over whatever I have is a very strange performance," she told Beck: "I'll not go into it—but you would certainly laugh."

In March, Georgia made a quick trip to see her exhibition, which had been hung by Alfred with Dorothy's help. She would have been struck by the placement of the tall Gaspé cross with a red heart and the delicate *Bleeding Heart,* a pastel of two pendant blossoms, each on their separate walls. O'Keeffe's images, McBride wrote, formed a "soul reflection" that seemed to have been "wished" onto the canvas. In a letter to Beck, who had joined Paul on his travels, Georgia wrote that she had returned to the Place briefly: "Couldn't stay but a few moments—but I got there."

Soon, Georgia felt well enough to think of sailing to Bermuda with Marjorie Content and her daughter, Sue Loeb, who would keep her company at a hotel on the western end of the island. Reassuring Beck about her plan to spend the spring there, she wrote, "I like Margery [sic] very much and a place where the sun shines and it is warm—where no one will ask me how I feel and no one I know will be around seems very good to think of. . . . It is time to get out of here even if the view is good."

Don't Look Ahead or Behind

1933

I did pick myself up and get away," Georgia reassured Beck in April, when she was convalescing in Bermuda. But it was too difficult for her to describe this "strange little island." By then, Beck had joined Paul in Mexico, a place that offered the couple the hope of a reconciliation, or at the least time to assess their differences. In June, Georgia was still unsure about returning to New Mexico. "The doctor is insistent that I should not go west till the end of July at the earliest. . . . I am glad Paul is finding something down there that he likes—and that interests him. Give him my greetings and tell him I wish him luck."

. . .

Both O'Keeffe and the Strands had left the country just when it seemed that the hope engendered by Roosevelt's election might have been justified. Checking out of the hospital a few weeks after his inauguration, Georgia was in no condition to attend to the great changes he would make over the next months—the start of measures that would constitute the New Deal. Nor could she have paid much attention to conditions at the end of the year, when the country's economic woes were at their worst. By then, stocks had lost most of their value, some ten thousand banks had failed, and more than thirteen million Americans were out of work. In the winter of 1932–1933, the low point of what some were calling the Great Depression, the social crisis deepened fissures in professional and personal ties alike.

After Paul's break from Alfred the previous spring, the Strands decided to go back to Taos. This stay would be critical for Paul, whose desire to refocus his art had intensified in recent months through his involvement with the Group Theatre. Already imagining a trip to Mexico, where art was part of the revolution, he applied for a Guggenheim

Fellowship to spend the following year there, but he was turned down. When he decided to go anyway, Paul wrote to his friend Carlos Chávez (the composer was then head of the Fine Arts Department in the Ministry of Public Education) for help in getting his equipment across the border; Chávez invited him to show his work in Mexico City.

Paul's decision to leave Taos by November left Beck in a quandary. Loath to abandon the site that fostered her sense of herself as an artist, she was also unsure about putting her relationship with Bill James on hold in order to follow Paul. Bill admired Beck as a woman and an artist, but he, too, was married. Both would have to be divorced if they were to be together. In the meantime, there was the risk of scandal getting back to her family—above all, her mother. And it was painful to consider the effects of divorce even in free-spirited Taos. One of Paul's portraits of Beck taken before he left for Mexico shows her in black, with a big black hat partly shielding her tense visage from the camera, and from him. The distance between them is palpable.

Beck returned to New York in November while Paul prepared to drive to Mexico. One evening, she confided in Harold Clurman, who informed Paul that she seemed unable to imagine the future. "Perhaps she will find some resolution of her problem," he continued, "and perhaps that is why she had the impulse to return." Clurman also commented on Paul's break from Alfred, whom he just seen: "The main burden of his talk was that you had misunderstood his criticisms. That because you were so superb a photographer—your prints better than his in many respects—he felt it is his duty to counteract glib praise from unqualified people by testing your work by the severest standards." Clurman applauded Paul's decision to go to Mexico: The country seemed to hold "something which will answer some need in you."

In February, Clurman told Paul that he and Beck had spent much of the night drinking while she poured out her distress:

> Beck "broke down" and confessed her pain and despair. I don't mean she became maudlin: on the contrary, she became very real, spoke more truly than in her more "self-possessed" moments. She spoke what was on her heart. . . . In her pain, I recognized all the pain and doubt that seems to dwell in everybody nowadays and fills the atmosphere like the very air we breathe. What she expressed was simply that inability to hope, to believe, to trust and enjoy life, which makes life such a pointless martyrdom to so many of the people we know and love.

By then, Paul had made the grueling drive south to Mexico City with Susan Ramsdell, a friend from Taos, taking with him an assortment of prints, including work shown at the Place the previous spring.

Chávez had arranged for his work to be shown at the Ministry of Education's Sala de Arte. The "Exposición de la Obra del Artista Norteamericano Paul Strand" included landscapes from Maine, the Gaspé, Colorado, and New Mexico, as well as three portraits of Ella Young and seven of Beck—presumably the images taken in Taos a few months earlier. Hartley, who was in Mexico, helped Strand hang his show in the light-flooded *sala.* Although his prints were up for less than two weeks, Paul was touched that some three thousand people came to see them. "With the show at street level, people would go in one door, go through the room, and out the other door. It became part of the street. All sorts of people came: policemen, soldiers, Indian women with their babies. . . . I've never had such an audience anywhere else."

Strand then wrote a proud but conciliatory letter to Stieglitz about the show, a striking contrast to his last exhibition at the Place yet one that drew on what he had learned there.

> I put myself in Chavez' hands completely and the show is the result of his engineering. . . . Everything I asked for was given . . . the spirit not unlike the Place—and I feel you would not be ashamed of the show. Probably you could easily improve it—but it is the best job I could do, and I know no one but you or Georgia who could have done it better.

Having just learned of Georgia's illness, he continued, "Too cruel—to be struck down that way—and she must get better—I want to believe she will." He concluded, "Mexico is another world—on the surface almost too picturesque—Beneath—something very extraordinary."

In February, when Beck made up her mind to join Paul in Mexico, she booked passage on the *Orizaba,* a Ward Line cruiser that serviced the New York–Cuba–Mexico run. The ship called at Nassau, Havana, Progresso, and Veracruz; passengers on the five-day voyage south took advantage of the fact that once at sea, they were not subject to Prohibition. (Ward Line cruises were known as "alcohol-enriched vacations"; the previous April, the poet Hart Crane, who had been drinking after a fight, had jumped to his death from the *Orizaba's* deck.)

Paul would have met Beck in Veracruz, then taken her to Mexico City on the train, which ascended from the steaming, gardenia-scented

plains through orange groves and coffee plantations into the mountain range topped by the volcanic Pico de Orizaba, the highest peak in the country. One can picture her gazing at the changing scenes from the observation car while she listened to Paul's tales of his adventures. By the time they descended into the Valley of Mexico, she would have been filled with the sense of how "very extraordinary" the country was, and what it meant to Paul as the place where he could practice his art in the context of the social experiment taking place there. They took in Hartley's exhibition of his landscapes, including an O'Keeffe-like *Popocatépetl, Spirited Morning—Mexico;* when the trio traveled to nearby villages together, Hartley told Beck that he would be glad to leave.

The Strands joined friends from Taos, Miriam Hapgood and Edward Bright, in Oaxaca City. Although the town had recently suffered an earthquake, there was much to delight the senses—vibrant textiles and gaily decorated pottery, along with heaps of bright-colored vegetables in the markets, Baroque churches, and ongoing fiestas. ("These people have an exuberant creativity and natural taste," Miriam wrote unselfconsciously.) The two couples stayed in Oaxaca for the month, leading up to the Good Friday Penitente ritual, when a Christlike figure crawled into town on his knees, "his back torn and bleeding from the thorns of an organ cactus strapped across his shoulders as in the arms of a cross." While the peasants' religiosity struck some foreigners as excessive, Beck and Paul came to feel that its expression in art and ritual embodied a form of belief in keeping with their lives.

During this time, Paul took many of the photographs that would comprise his *Mexican Portfolio,* including sculptures (*bultos*) by anonymous artists found in local churches. Assuming that Beck resumed her role as his assistant, she would have sat for hours in semidarkness during the long exposures required to capture these richly textured devotional figures. For the eerily beautiful *Virgin, San Felipe,* Strand intensified the statue's rapt concentration by slowing his shutter speed to photograph close-up; his *Cristos,* crowned with real thorns or marked by bleeding wounds, treat the figures' heightened realism as allusions to the exaltation of spirit. The Strands undoubtedly sensed that these figures were ideal subjects. Although hard to make out, they were always available and never moved.

By then, Paul had worked out a way to deal with this issue in his portraits of ordinary people by taking candids with a prism attached to his lens—a modern version of the device he had used for street shots in the 1910s. In his view, this technique was justifiable because it allowed him

to capture people's natural expressions—since the prism made it seem that his camera was pointed elsewhere. In this way, his *Woman, Pátzcuaro,* embodies "Mexicanidad": Wrapped in her shawl, the woman is archetypally Mexican. Similarly *Man, Tenancingo* accords its subject, a fiercely mustachioed peasant in a white overblouse, a distanced respect, as if the photographer did not wish to intrude on this man's solitude.

Strand was perhaps unaware that to some, especially those on the Left, virtues of the kind emphasized by his prints were seen as attributes that persisted at the expense of a more up-to-date vision of the country. From his perspective as a well-intentioned gringo, these images mattered because they tapped sources of belief lacking in countries like his own. Writing to Marin about his trips to places where "the Indians live very much as always," he mused, "they amazingly keep a certain innocence." He would have discussed these questions with Beck, whose fluent Spanish allowed her to immerse herself in the culture.

Paul explained his new focus to a colleague, the photographer Irving Browning:

I made a series of photographs in the churches, of the Christs and Madonnas, carved out of wood by the Indians. They are among the most extraordinary sculptures I have seen anywhere, and have apparently gone relatively unnoticed. These figures [are] so alive with the intensity of the faith of those who made them. That is what interested me, the faith, even though it is not mine; a form of faith that is passing, that has to go. But the world needs a faith equally intense in something else.

Given this approach, it isn't surprising that Strand framed street scenes to eliminate contemporary references: There are no electric lights, no telephone poles, nothing to mar the sense of "timelessness" that he found appealing. Nor did he focus on deprivation, preferring instead to work from a detached, yet empathetic, idea of noble poverty.

Still, the problems of daily life were never far from his mind. From Oaxaca, Strand informed Chávez that he and Beck could not stay in Mexico unless he found a job. She and Miriam took the train to Mexico City while Paul drove his beaten-up Ford along the nearly impassible roads. He accepted Chávez's offer of a teaching post at an elementary school. It paid a wage but left him free to travel to Michoacán with Augustín Chávez, his patron's nephew, to arrange an exhibition of children's art. Touring this impoverished region with the young man, who

became his translator, he took more of the images that would compose his visual record of Mexico—again choosing to omit things like railway lines that might detract from his version of rural life.

While Paul visited other parts of the country, Beck explored the arts and crafts of Mexico City. At this time, she began what would become a rich collection of brilliantly colored miniature sculptures. Inspired by these folk creations, she completed several reverse paintings on glass—a pale magnolia nestled in green leaves, a pink rose in an ebony vase, a bloodred sacred heart aflame against its black background, and a white lamb with flowers, entitled *Painting for a Little Girl.* In these months, she may also have bought the wooden sculpture of the Christ Child as a pilgrim depicted in her "serious and poignant" reverse oil *Santo Niño de Atocha.* (He was "a very fine little gentleman, a little *consentido*—spoiled—in his satin bloomers and ruffles," she told friends.) Beck's growing command of the medium encouraged her to portray the human figure overtly or implicitly: In *Mexican Gourd Pitcher and Tulip Bud,* the subject's armlike handle suggests a female form, with the head, a tulip bud, protruding from the vase against the luminous blue background. For her as for Paul, Mexico offered fresh spurs to creativity.

Alfred sent Beck his ironic congratulations: "So you are a real Mexican now—Well I hope you like it." (He noted Georgia's progress but seemed more interested in making sure that Beck received a copy of Dorothy's *Dualities.*) Georgia wrote Beck from Bermuda, "It is warm and slow and the sea such a lovely clear greenish blue I have done little but sit—However the sitting is good—Am glad I came."

Far from New York, it would have been touching to be reminded of the fault lines in relations between the pair who had been Beck's idols. It was easy to see in Alfred's obsession with Dorothy the seeds of Georgia's breakdown. By herself much of the time as Paul traveled to remote parts of Mexico, Beck pondered her own dilemma—her uncertainty about the future and the steps they would have to take if Paul decided to stay in Mexico. At the same time, returning to Taos to wait for Bill's situation to be resolved meant a leap into the unknown. There was the matter of his divorce, under what conditions he might acquire one, and the matter of her finances when it became known that she was no longer with Paul.

In August, after Paul's return from his travels, the Strands sought and obtained a preliminary divorce. A few days later, Beck boarded the train that would take her home to the United States. While people believed that it was she who had initiated the divorce proceedings, a letter from

Paul to Kurt Baasch states that he had made the decision: "It was I who crystallized the situation after three years of constant pain and struggle to resolve what finally became inevitable. . . . We actually did it without bitterness, ugliness or resentment—but as you must know, knowing us, at the cost of the most tearing, wrenching & suffering for both." Their decision was, he believed, "an act of faith in each other—in life itself."

Writing to Paul on the voyage north, Beck said that she still thought of him as her husband. Alone, she felt "exposed, vulnerable, rather frightened." But knowing of his faith in her, she would try to have confidence in "this obscure and rather menacing step I have taken." Toward the end of the three-day trip, after examining the divorce papers, she polished off the bottle of whiskey she had brought with her—"a godsend," she told him, in her current state of blankness.

· · ·

When Georgia returned to New York in May, she told Alfred that despite the improvement in her health she had no wish to resume life there while he wound up the season at the Place. The next day, he took her to the lake, where she spent the summer under the care of Margaret Prosser, the housekeeper, and later Georgia Engelhard. Alfred refrained from inviting guests because of her nervous state. Georgia's condition was "pathetic," he told Dove. "At times I feel like a murderer. There is Kitty. Now there is Georgia."

It was just as well that Georgia had been in Bermuda when Dorothy's book of verse was launched, since her rival's effusions on love, jealousy, and the divine impressed some in their circle. Rosenfeld wrote that her poems possessed "a great deal of knowledge and a deal of innocence"; Brett gushed that they turned "Religious Ecstasy . . . into an utterance that is incorruptible." Had Georgia glanced at the contents, she would have been mortified by the poem entitled "The Purity of Alfred Stieglitz" and enraged by its companion piece, "Georgia O'Keeffe, Neo-Primitive Iconographer." (Dorothy called this poem an homage to her rival's art: "With a sadness beyond sadness / She creates an Affirmation—Reharmonizing Dissonance.") While it is likely that their affair ended at about this time, Alfred and Dorothy wrote to each other daily—while he bemoaned the emptiness of life without her.

Alfred sought solace in nature—the lake, grasses, trees, and skyscapes—which he captured in images that seemed to offer refuge from his anxiety about Georgia's collapse. He also took some striking por-

Alfred Stieglitz, *Georgia O'Keeffe,* 1932

traits of her. In one group, she leans against her new Ford convertible—a form of support, literal and metaphorical, betokening her wish for independence. In *Georgia O'Keeffe—Hand and Wheel,* her fingers caress the lustrous cover of the spare wheel—an image that calls to mind his studies of her hands from a happier time. In others, she leans pensively against her convertible, perhaps waiting for the day when she can take the wheel. (O'Keeffe included six images of herself and her Ford in her 1978 version of Stieglitz's *Portrait*—as if they said something important about her at that time.)

She found the strength to pose for Alfred but did not attempt to paint. "I have done nothing all summer but wait for myself to be myself again," she told Russell Vernon Hunter. "I seem to have nothing to say. . . . I read and sew and fuss about at much of nothing—walk a little—drive a little and the day is gone—sleep only a very little—eat a great deal—Not much of a life." The only thing that stirred her was the thought of going west: "I must go back to it. . . . The pull is so strong."

Georgia kept in touch with Beck, envisioning her in the land that meant so much to both of them. She wrote about things that Beck would appreciate—her convertible, the goldenrod in bloom, her pride in

her ability to bear the strain of daily life once Alfred's family came to the lake. By the end of summer, she confessed that she would have to put off the idea of going west: "I just sit in my effortless soup and wait. . . . The worst of my fatigue is a suffering in my nerves that is much worse than physical pain." Georgia would stay at the lake for most of the year with their housemates, a white cat and her rambunctious kittens.

From Taos, Beck sent Georgia a series of thoughtful gifts—more handkerchiefs, a blouse, a pair of Mexican sandals, and an artificial flower of the kind that both women liked to paint—and wrote of doings there without saying much about her life. In November, when Georgia heard rumors about the Strands' divorce, she asked how she should present Beck's version of the story to refute what was being said by "the garbage carriers" (chief among them, Mabel). Georgia did not need details, "but if you wish me to pass any news I'll pass it—otherwise I am quite pleased to say . . . that I know nothing about it."

When Beck replied that the rumors were true, Georgia offered her the advice that she was herself trying to adopt:

> Try not to take it too seriously—or maybe I mean take it more seriously—imagine that it is two years from now—and in the meantime don't do anything foolish. Only time will make you feel better—and don't talk about it to people if you don't want to. . . . Why should you be expected to explain your personal life to anyone—It is rather difficult to even explain it to oneself. . . . Don't look ahead or behind and maybe you can enjoy the "now."

Rather than fret about the future, Georgia suggested that Beck should think of joining her for a long stay on a warm, restorative island.

By the time Beck received Georgia's counsel, she was already immersed in her new life. Often at Los Gallos, she was teaching Mabel's friend Muriel Draper to drive and typing volume two of Mabel's memoirs, but she was living in town and socializing with artists who were not in Mabel's thrall—such as John Young-Hunter and Nicolai Fechin, whose vivid portrait of Beck at that time accentuates her silvery locks and bright red lipstick. Acutely sensitive to the controversies unleashed when marriages end, Beck tried not to take sides when the Fechins divorced. And while she could not always rely on Bill, who was traveling between Taos and Denver, his plan to start a wholesale liquor business seemed likely to succeed after the repeal of Prohibition. Meanwhile,

she told Paul (they maintained a correspondence), she planned to join Bill on a hunting trip: "I am supposed to try shooting but I really don't believe I can!"

Beck had many reasons to stay in Taos that winter—among the most compelling, a one-woman show at the Denver Art Museum's Chappell House. The exhibition, no doubt arranged by Bill's sister, ran for the last two weeks of December, while Bill's family entertained her and the local gossips speculated about their relationship. In the Chappell mansion's opulent setting—it had a grand staircase leading to a ballroom, a conservatory, and a marble fountain—Beck's paintings struck a curious note. "Unique Exhibition of Paintings on Glass," a Denver paper announced. Donald Bear, the museum's curator, mused, "If one were tempted to place these pictures in a category, one would be forced to conclude that they are of themselves so much a part of the personality of the artist who painted them that they belong only to themselves." He ended with remarks on the oil entitled *Portrait of Bill*: "an amusing, ingenious arrangement of attributes and habits which contribute the picture of a personality, without the necessity of actual portraiture."

From Denver, where Beck spent some weeks while her show was up, she sent Bear's review to Alfred along with a letter downplaying her pride in her exhibition. "I do manage to hobble ahead, in spite of this and that," she wrote. Denver was "a crazy place—the world's champion booze-fighters roll around in it." Her new life was "swell . . . but tough at times." She continued: "Part of the toughest part has been concerned with the suffering caused by what seems to be a difference in feeling between the three of us—you, Paul and myself. I know there really is no difference and hope you feel the same." Moreover, Beck's heart ached when she thought of Georgia's long convalescence; it was hard to admit that the four of them were no longer close.

By return mail, Alfred expressed his regret for the misunderstandings that had arisen among them. "I see very clearly how they came. I am much alone & have had much chance to see straight . . . above all without any theories about life." He hoped that the breach with Paul would one day be mended and thought fondly of him working with Beck and Georgia to hang so many shows: "It was all very fine. And remains so . . . an integral part of the Place's spirit." As he contemplated the new year (when he would turn seventy), Alfred still believed in "something beyond all of us . . . The Idea. —And The Idea is as alive as ever."

. . .

The idea paramount in Georgia's mind was to see if she could bear the pace of life in New York. "I feel as if I'm waking up from a long queer sleep," she told Beck in November. After eight months spent in restful settings, she was ready to test the waters. Alfred had made several trips to Lake George, including a surprise visit for her birthday. At the end of the month, she went to New York, where she saw Marin's retrospective at the Place and spent time with Duchamp, Toomer, and the Stettheimers. When people asked about the Strands, she reassured Beck, "I said nothing. . . . One has to be very strong to stand ones friends and enemies." She wished her luck for her Denver show and asked her to visit if she came east. Georgia's foray into town had rekindled her spirits: "I feel more free to take myself any place I want to go."

Georgia also kept in touch with Paul. Of her exploratory trip to New York, she wrote, "The principal things about it all for me were that I could again walk the street a little without fear of losing my mind." By then, she was back at the Hill with Toomer, who needed a calm place to complete the essay he was writing about Alfred. Georgia thought well of Jean: "an unusually beautiful—clear person—with an amusing streak." They were comfortable together without needing to converse: "The not talking seems to give a real quiet that seems to make the whole house feel good. . . . The world here is very lovely white it is all white." Alfred looked ill when he arrived for Christmas but recovered by the time he left four days later, bucked up by Jean's reading aloud of his paean to him. "I really wish you could have been here for everything," Georgia concluded.

"The greatest Christmas I could have received was your being virtually your old self," Alfred told Georgia once he was back in New York. One wonders whether he saw Georgia's transformation as the result of time spent "not talking" with Jean, who was not only an attractive man but had a soulful way about him. In the last days of December, their rapport deepened into an emotional intimacy compounded by the erotic charge felt by both. Jean left on the last day of the year, after a stirring exchange the night before, during which Georgia made it clear that she would not act on her feelings for him despite their intensity. After his departure, Georgia teased him about her cat's need for a tom now that she was in heat: "I never saw such a performance before—and right at this moment I don't need it—troubles enough with myself—I do have to laugh when I think of your possible remarks if it had happened when you were here." She confessed, "I like you much. I like knowing the feel of your maleness and your laugh."

Other letters between them imply that they decided not to consummate their relationship because of Georgia's sense that her "troubles" needed to be resolved before she could risk intimacy. After Toomer left, she recognized his effect on her: "I seem to have come out of my daze into another world today—feeling very good—as tho there is nothing the matter with me any more." While the rapport that had developed between them could not be sustained, she had come to life "in such a quiet surprising fashion. . . . Everything in me begins to move."

Another Way of Living

1934

Alfred greeted the new year by himself. Writing to Georgia from his bed while listening to the street noise below, he was amazed that they had come this far. At midnight he sighed pensively, "Oh Georgia . . . I am seventy finally. —I never expected to see that age—Yes seventy. —And you on the road to full recovery." He would spend January 1 at the Place: "Whether anyone comes or not is immaterial."

In the coming year, each of the four would spend more time apart from the others. The two couples would disentangle themselves from their familiar ways of being together; their bonds would loosen yet survive, variously, the near dissolution of relations. "I hope 1934 will be a year of relative peace for all of us," Alfred wrote wistfully to Beck. It would be the year in which his intimates recognized that he was a man of the previous generation—for whom seventy meant the start of extreme old age rather than the prospect of the new beginning he dreamed of for himself and Georgia.

. . .

A few weeks after putting Beck on the train back to the United States, Paul began work on his next project—a government-sponsored film about the fishermen of Alvarado, a coastal village forty miles south of Veracruz. Henwar Rodakiewicz, who had been borrowing his Akeley, joined him in Mexico City with the camera. At the end of October, the two men traveled to Alvarado with Augustín Chávez to scout locations. In the new year, Paul was named director of Photography and Cinema at the Ministry of Public Education (SEP), with a contract to produce a series of forward-looking films over the next five years.

His first project was a tale of collective action, he told the Baasches: "solidarity—something I believe in—and a criticism of capitalism, a system I detest." He continued:

My interest in the social forces of to-day has grown considerably in this year. . . . I don't see how anyone, the artist particularly, can stand aside. . . . I don't know whether I can be labeled a Communist but I find the ideas of Marx which I have been reading very true to me—an ideal to be sure far distant even in Russia—but the only one left, that has any hope in it for a decent human life.

He urged the like-minded to join him. When Ansel Adams wrote that Stieglitz was encouraging him to find his own way in photography, Strand replied, "These are critical years for anyone who is alive—aware—has not insulated himself in some 'esthetic' rut."

Strand returned to Alvarado in January 1934, full of hope that his film experience would allow him to engage with the world around him. His contract specified that he was to collaborate with his Mexican colleagues to practice in production the same values the film would depict. But the combination of this high-minded approach and the shoestring budget proved challenging. The film, initially called *Pescadores,* was to culminate in the fishermen's strike against the profiteer who kept them impoverished; its realism would be enhanced by hiring locals—a tactic that would also hold down costs. It did not escape Strand that as the man who paid the wages, he was in the position of the film's bad guy: "In a world in which human exploitation is so general it seems to me a further exploitation of people, however picturesque, different and interesting to us they may appear, to merely make use of them as *material.*"

Not surprisingly, he soon found himself in conflicts occasioned by his employment of the very people he wanted to represent as converts to the cause. Having promised to pay the minimum wage, he had to bargain to buy the boats, nets, and fish needed in filming at the same time that he was laboring to portray the value of solidarity. The film's scenes of the fishermen working to toss out their nets or haul in their lines are choreographed set pieces focused on male camaraderie: They share an idyllic (homoerotic?) spirit that is at odds with the film's political goals. At the same time, the fishermen, all amateurs, are often more believable than the actors who play the profiteer and the handsome rabble-rouser whose death deepens the men's determination to strike.

In addition to Strand's problems with his crew (compounded by his poor Spanish), some found him difficult to work with. Strand was "always a little on the slow side," Rodakiewicz recalled. A still photographer more than a cinematographer, he thought in terms of single frames rather than of action shots, which gives the film a static quality. Augustín Chávez left because of differences of opinion with Strand, whose insis-

Ned Scott, Paul Strand filming *Redes,* Mexico, 1934

tence on his way of doing things may have seemed to him like yanqui imperialism. Others complained of his rigidity. To Fred Zinnemann, the film director who took Rodakiewicz's place after he, too, left, Strand was "the most doctrinaire Marxist I had ever met."

Despite Paul's embrace of socialism, his Mexican partners' objections to his painstaking ways threatened to undermine the project. After Augustín Chávez's departure, one of his colleagues from Mexico City arrived to replace him; he, too, left in a matter of months. In September Augustín claimed full credit for the production and, with the support of the SEP's new director, took control of all material aspects, including the music. Strand was informed that he had to complete the film in a month, after which he must leave Mexico. In November, he wired Carlos Chávez, whose film score was to be replaced by that of another composer, "There is plenty of Trickiness and Dishonesty Around As I now see but please Believe that I have Never Been Deliberately or Consciously Disloyal to you." The film, still in postproduction in Mexico City, would be released in 1936 under the title *Redes* ("Nets").

. . .

During these months, Paul kept in touch with Beck. She offered support when he mentioned Henwar's lack of enthusiasm for his politics:

"If H[enwar] is not interested in the social aspect of the scenario . . . don't let him deflect you." She also helped in practical ways, ordering the agar-agar Paul used in the sizing of platinotype prints and sending boxes of his work to Kurt Baasch for safekeeping.

Later that year, Paul let her know that Barbara ("Bobby") Hawk, a friend from Taos, had come to work as his assistant, and, in the process, become his companion. Beck hoped that they would take the film to Hollywood. Although Augustín had taken control, Paul should stay in Mexico for the premiere:

> By that time perhaps all will be straightened out and the dept. de Ed. persuaded that it's the film, its import & not who made it. . . . If all of you, as Americans, had the insight & ability to put the message into form, they should be glad to give you credit. The US have been generous & kind to Mexico's representatives in the arts—Rivera, Orozco, Tamayo—and Mexico can well afford to return the compliment—!

She closed this missive with the hope that Paul and Bobby would then come back to Taos: "If my being here would stand in the way of that, I can easily be elsewhere—Though why all 4 of us, as mature people, could not meet, I don't see."

Beck could now present herself as a mature person (she was nearly forty-three). Bill's divorce was about to be finalized despite his wife's "double-crossing" (she kept the funds he gave her to go to Reno and bought a mail-order divorce of the kind that had just been ruled invalid). Beck confessed to Paul, "Truly I don't want to marry. It's all right this way." In a note to Bobby on that letter, she said how glad she was that Paul had a new partner. Bobby could help him deal with the machinations of people like Augustín: "I never could teach him that myself because I was so often muddled & resentful." But now, in her new guise as a maverick, she declared herself ready to take on the "bastards."

It is of interest that at this time Beck was also taking on Mabel, whose dominance made Taoseños think twice about crossing her. For some time, Beck had been helping Mabel organize her correspondence. When she came across a letter that referred dismissively to "the Strands," she took issue with her: "There is a decided balking on my part at wishing to continue working for you," she wrote. "I do not now and never have been a person to you that meant much, apart from being 'useful' and therefore, feeling this way, it would be painful and dishonest for me to continue." Leaving Mabel to her own devices, Beck also took

her to task for gossiping about the Strands' divorce after promising to keep it a secret: "Yours is a repulsive spirit and I am glad to be through with it." From then on, she referred to her former friend as "Dodge Mabel Luhan."

Beck's defiant attitude had become an important part of her "western" self. With no one to object to her pecadilloes, she smoked constantly and outdrank most of the customers at Mike Cunico's rough-and-tumble nightclub, where she and Bill joined in the poker games. The regulars' enthusiasm for hard living spurred her to act like a latter-day Annie Oakley, the sort of woman her father might have admired. She soon became notable among the town's more picturesque residents. "She had begun to act tougher and wilder that it was her true nature to be, simply out of delight in finding herself 'free,'" Spud Johnson recalled.

In this spirit, Beck let it be known that she answered to "Becky"—her devil-may-care nickname from girlhood—but continued to show her work as Rebecca Strand—the surname she had once avoided so as to be judged on her own merit. By summer, she had completed ten more reverse paintings to complement the twenty-one shown in Denver for a solo show at the Museum of New Mexico, in Santa Fe. The catalog included tributes by Augustín Chávez (written before his break with Paul), Elizabeth McCausland, and Paul. Chávez paid her a backhanded compliment: "The innocence of her feeling has not been touched by preconceived or sophisticated ideas." Her paintings, McCausland wrote, were the result of "spiritual honesty." Paul defended them against the charge of being decorative—that is, feminine and of minor import: "There is much room in this world for songs as well as symphonies. There are few enough of both that have life and give life. This having and giving exists for me in these unpretentious and lovely paintings of Rebecca Strand."

Beck, a.k.a. Becky, may have been amused by the conjunction of her different personas as well as by her reputation as "the most striking" person in Taos—as in the account of a journalist who compared her to a film star:

During dinner at the tavern on the plaza, I saw Becky Strand. . . . There she stood, just outside the door on the narrow sidewalk. She wore black cowboy boots, blue denim breeches and a black and grey checked shirt. On her head was a black slouch felt hat. Her hair is silver but her face is young. From a corner of her mouth a cigarette dangled. . . . A picture from the Parisian Apache quarter, yet one of the more sophisticated of the Taos women.

Rebecca Salsbury James in fiesta garb

Beck thought well enough of this notice to paste it into the scrapbook of her exploits.

Motivated by her recent success, she tried a variation on her chosen medium, using as her support antique mirrors with punched-tin frames. Bill's mother ordered one to send to a friend in London, and Beck thought so well of them that she planned to offer the rest for sale to Elizabeth Arden. She was also painting a reverse oil based on a cross in a nearby graveyard. It is tempting to imagine Beck showing this piece to Georgia when the latter made her way to New Mexico in July, and to envision Georgia at her solo show in Santa Fe.

Whatever Georgia thought of her work, Beck's recognition by the local art world was encouraging. She accepted the Museum of New Mexico's invitation to show her new pieces in their annual exhibition

"Painters and Sculptors of the Southwest." Four of her reverse oils were selected, outnumbering the work of other artists; *Paul,* another of her small "object portraits," was probably among them. Like Beck's recent *Portrait of Bill,* this composition evoked its subject through a witty arrangement of carefully chosen items, in this case alluding to photography in its central figure, a black circle that resembles a camera lens. Inscribed "Paul/Taos/1934," it served as an affectionate farewell to their marriage.

. . .

In the first months of 1934, as Georgia retrieved her self-possession, she continued to draw sustenance from her rapport with Toomer. "I started to paint," she told him soon after his departure. "It will undoubtedly take quite a period of fumbling before I start on a new path—but I'm started." By the end of January she felt up to a trip to Manhattan to see her retrospective, "Georgia O'Keeffe at 'An American Place,' 44 Selected Paintings, 1915–1927." Alfred had chosen some of her most eloquent work—two *Specials* from 1915, clamshells, jack-in-the-pulpits, and abstractions. *The New Yorker* compared O'Keeffe favorably to Matisse but added, "These pictures are not derivations; they are sources." Her canvases conveyed "almost every phase of the erotic experience" yet gave off a "fierce virginal candor."

Georgia was still finding it difficult to be in Manhattan. "I do not particularly enjoy thinking of [it]," she told Toomer. To have him with her in spirit at the Place, she added to Alfred's selections the painting that crystallized her sense of him at the lake in 1925 (*Birch and Pine Trees—Pink*). "I never told you—or anyone else—but there is a painting I made from something of you the first time you were here," she wrote. "It is rather disturbing to take the best of the work you have done from the people you have loved and hang it that way and go away and leave it." Still, it was useful to see that with each trip to the city, she felt more equal to its challenges.

When it became too cold to stay at the lake, Georgia went back to New York to be with Alfred. During this time, she realized that she still felt close to him: "There were talks that seemed to kill me," she told Toomer, "and surprisingly strong sweet beautiful things seemed to come from them." Just the same, she had to plan her future on her own terms. Two weeks later, she boarded a boat to Bermuda. From the ship, Georgia wrote that she was about to begin "another way of living," and went

on to say, "I feel more or less like a reed blown about by the winds of my habits—my affections—the things that I am—moving it seems—more and more toward a kind of aloneness."

From the island, where Georgia stayed at a house owned by Marie Garland, she wrote to ask Paul if he planned to stay in Mexico and told him that the Museum of Modern Art had bought her *Black Hollyhock, Blue Larkspur* (from her first summer in Taos with Beck)—which meant that with the funds from other sales she could pay her bills for the year. She had found new subjects—glossy green banyans and the voluptuous flowers of the banana tree. Writing to Beck, she was able to imagine the future: "I begin to think of New Mexico with a vague kind of interest." But she would settle neither in Taos nor at the H & M Ranch because she did not want to see people. The only way not to be "run ragged" was to live on her own. She would have to go to New York before traveling west, "but if the doctor says I can go—I think I'll make it."

On her return to New York, she saw Toomer, who had fallen in love with Marjorie Content. Although taken aback by the news, Georgia wrote warmly, "I like it very much that you and Margery [sic] have started what I feel you have—I like it for both of you." Of herself, she said that she now understood many things that had disturbed her before her breakdown: "They seem to come clear in such a strangely quiet way—something seems to take form in me without my knowing why or how." Alfred accepted Georgia's need to return to the Southwest but planned to keep the Hill free of guests that summer in case she changed her mind.

"I really have to move myself mostly with my head," Georgia confessed to Beck. She justified the outlay of energy needed to travel as "the easiest way for me to get to work—and that I must do." In June, Georgia met Marjorie in Chicago to drive her friend's Packard to Alcalde, where they stopped at the H & M Ranch in spite of Georgia's misgivings. Given her mixed feelings about Jean's plan to join them there, she must have found it unsettling to learn that Marie and Henwar had divorced at about the time that he joined Strand in Mexico. Still, Marjorie and Georgia enjoyed the kind of companionable rapport that recalls her summers in Taos with Beck, when they pursued their interests by day and shared their intimate thoughts at night. When Mabel tried to lure Georgia to Taos, she wrote candidly, "I like you Mabel but some times you just seem so funny. . . . I think the reason you seem funny to me when you behave badly is that I always feel you are mistaken."

Alfred was still worried about Georgia's equilibrium. Shortly after her

arrival in Alcalde he wrote, "I don't know what state you're in but I dare not let it affect me. That doesn't mean I don't feel it deeply." Georgia's reply is worth quoting at length:

> The last year I was in the city with you—from the fall of 1931 to the fall of 1932—our relationship was certainly not very pretty. . . . During that time you did things . . . that you had no right to do without speaking to me about it if I was really any part of what the Place meant to you . . . every time I went there you made me feel you didn't want me there—You will say you didn't want me there because I didn't want someone else there—and all I have to say about that is that I do not for one moment accept the idea of your going about publicly making love to someone else. . . . It was you who wanted me and insisted on marriage and I am inclined to feel that I had a right to expect you to respect that relation.

In the clear light of her new surroundings, Georgia understood that she could no longer accept the patterns of their life together. Her love for him, she wrote, "tears me to bits because I feel you have chosen a road without me."

Meanwhile Georgia was feeling her way toward something new as she explored the landscape on foot or in the Packard. In August, she went to Taos to see Beck but was unimpressed by her transformation. Writing to Ettie Stettheimer, Georgia said that Beck was "the same in spite of her boots and her pants—both I think are very warm in the summer—or any other time—and her whiskey." She added, "I am not quite sure whether it is all just funny or very pathetic."

That summer, she found the place that would allow her to move toward her kind of aloneness. Charles Collier drove her to see the landscape around Ghost Ranch, a dude resort at the eastern end of the Jemez Mountains that was composed of bungalows grouped around a ranch house at the end of a dirt road. Some forty miles southwest of Taos, it was another world. Beyond the ranch, quartz cliffs gleamed red and yellow in the sunlight; the nearby escarpments formed a geological layer cake; the Pedernal, a striated peak on the mountains' north flank, dominated the view. Unfazed by the local belief that the ranch was haunted, O'Keeffe fell in love on the spot. After returning the next day and learning that there was a vacancy, she packed her bags, leaving Jean and Marjorie to themselves. She would see them again when she went to Taos in September to witness their marriage.

Once she had settled in her spartan lodgings, Georgia set aside her prejudice against dude resorts. Ghost Ranch, which catered to people with means (it cost eighty dollars a week), offered good meals, privacy, an austere glamour (guests were given kerosene lamps), and the astounding scenery that she would paint for the rest of her life. At first, she hiked all day, stopping to bathe in irrigation ditches, or drove into the canyons, gathering rocks, bones, and branches as she went. At night, she often walked to the high mesa to watch the sunset flame across the sky—regaining the sense of freedom she had known in the Palo Duro Canyon.

Soon she began painting the nearby hills, whose curves and hollows

Ansel Adams, *O'Keeffe and Carcass, Ghost Ranch, New Mexico,* 1937

suggested bodily contours modeled in flesh tones. Of these sun-baked land-forms, where she imagined herself lying naked, she admitted, "A red hill doesn't touch everyone's heart as it touches mine." But at this point, recovered from her collapse of the past eighteen months, it was pleasing to know that this was her landscape, and to claim it as her own.

. . .

Alfred was in a reflective mood when Georgia returned to the Hill that fall. He had spent the summer photographing trees, grasses, and out-buildings while supervising plans for a volume in honor of his seventieth birthday—a project undertaken that year by Paul Rosenfeld, Waldo Frank, and Dorothy, who had chosen the contributors and were seeing the book into its final stage. One day, Alfred discovered some of his old glass plates in the attic, "in imperfect condition, scratched and battered." When he made new prints of these early pictures (among them *Sun Rays—Paula*), he felt "startled to see how intimately related their spirit is to my latest work." His youthful images looked as fresh as his recent landscapes.

Still, he could not help noting the elegiac mood of the contributions to his birthday volume—to be entitled *America & Alfred Stieglitz: A Collective Portrait*. The editors, assisted by Lewis Mumford and the educational reformer Harold Rugg, had asked many of Stieglitz's associates to write essays, among them Anderson, McCausland, Seligmann, Clurman, Toomer, and William Carlos Williams. Tributes by artists like Brett, Demuth, Hartley, and Marin were also included, though neither Georgia nor Beck wrote for the volume. The most surprising tribute came from Gertrude Stein, whose *Autobiography of Alice B. Toklas* had recently become a best seller: Stein thanked Stieglitz for publishing her for the first time in *Camera Work*.

Among the more substantial pieces were those Williams and Mumford wrote about Alfred's social and cultural backgrounds. Rosenfeld described his youth, Seligmann retold the saga of 291. Norman waxed rhapsodic about the Place. Stieglitz's artistic achievements were examined in an historical essay by his friend R. Child Bayley and in Strand's revised 1921 essay, "Alfred Stieglitz and a Machine." It fell to Toomer to evoke Alfred on the Hill—the essay he had been writing while keeping Georgia company there the previous winter. As a whole, the volume was marked by a messianic tone, set out by the biblical epigraphs alluding to its subject as a latter-day prophet—a "seer."

Unexpectedly, when the publisher saw the completed manuscript and its many photographs (Stieglitz prints and work by artists shown at his galleries), he rejected it as too costly. Through Dorothy's social connections, she learned that Carl Van Doren of the Literary Guild wanted an art book for the Christmas trade; delighted with the volume, he pulled off a coup by publishing thirty thousand copies in the midst of the Depression. "The book at once clarifies and elevates the whole issue of art in America," Van Doren opined. To Stieglitz, who had despaired of its seeing the light of day, it was "a Wonder."

It was also the occasion for him to break his vow not to show his work by starting the season with a retrospective, "Alfred Stieglitz: Exhibition of Photographs (1884–1934)," which opened on December 11, to coincide with the publication of the volume. This display of Stieglitz's work—several *Equivalents,* selected images from New York and Lake George, and a *Dead Tree* series—also featured six portraits of Georgia, including two at the wheel of her car that seemed to testify to her need for independence.

Historians who say that Stieglitz chose not to include portraits of Dorothy in this retrospective appear to have overlooked the double exposure entitled *Dualities,* which stood out among the small number of portraits shown due to its odd treatment of her face (she seems to grimace) and its echo of her book title, which Stieglitz had been preparing for publication when he took this portrait. In Edward Jewell's tempered critique of the show, he acknowledged that Stieglitz had told him of this photograph's "profound significance"—which escaped Jewell, despite the photographer's remarks about its relation to "his philosophy of life." Perhaps by then, Stieglitz had accepted the changes in his rapport with Dorothy and understood its effect on his marriage.

Jewell's less than effusive tone turned positively acerbic in his review of the commemorative volume a week later. Stieglitz's philosophy, he wrote, had produced in his entourage "a sort of half-idolatrous worship, an atmosphere of incantation and pseudo-mystical brooding upon the thisness and thatness of life and the human soul." Jewell quoted Norman's comparison of the Place to a cathedral and its guiding spirit to a priest, and came down hard on Frank's placing Stieglitz in the company of such figures as Plato, Socrates, and Confucius. While these "instances of emotional agitation" were mitigated by the more substantial contributions, he concluded, "a sometimes almost trancelike panegyric . . . constitute[s] the book's essential message."

To make matters worse, *Time* magazine appeared on December 24 with Thomas Hart Benton on its cover. The arts review identified Stieg-

litz's former friend as the most outstanding of the regionalists as well as "the most virile of U.S. painters," as demonstrated in Benton's canvases of farmers, field workers, hillbillies, and burlesque queens. Hostility between the Stieglitz group's embrace of modernism, seen as a foreign import, and the stance of the more American-than-thou regionalists had been simmering for years; it erupted that fall when the conservative critic Thomas Craven denounced Stieglitz as "a Hoboken Jew without knowledge of, or interest in, the historical American background." Benton pursued this line of attack in his review of the commemorative volume. Stieglitz suffered from "a mania for self-aggrandizement," Benton wrote: With the changes wrought by the Depression, his influence had evaporated. Looking back, Benton wondered "how a small group of New York cultists can arrogate to themselves and a simple photographer a position of supreme eminence in American culture."

What O'Keeffe thought of this controversy went unrecorded, except for her disparagement of the regionalists, who, in her view, saw the American scene as "a dilapidated house with a broken-down buckboard out front"—the kind of dust bowl images painted by those who saw art as a vehicle for social commentary. It was Norman who enabled Stieglitz to have the last word in the row with Benton. Engaging him in an imaginary dialogue (their words noted by her) for *The Art of Today*, Stieglitz denounced Benton's diatribe as an example of "the increasing gangsterism in what is called the art world." Far from being passé, he was still the presiding spirit at the gallery: "The real joke of the matter is, that these people who are so cock-sure that I am dead, don't even come up here to see what is actually taking place."

But there were others who, like Benton, insisted that Stieglitz's credo did not suit the circumstances in which the country found itself. *America & Alfred Stieglitz* was "a portentous and heavy document," book critic John Chamberlain wrote in an end-of-the-year review that ran in the *Times* the day before Alfred's seventy-first birthday. Art critic E. M. Benson, who published a biography of Marin that year, spoke for many outside the Stieglitz circle in his summation of their leader's significance: "What one took for wisdom in 1905 sounded pretty flat in 1925, and sounds flatter still in 1935. It wasn't Stieglitz who had changed, but his audience. . . . In short, Stieglitz didn't keep up with the parade."

· · ·

Writing to Beck at the end of December, Georgia mentioned neither the reviews of *America & Alfred Stieglitz* nor the omission of both women's

thoughts about its subject. Instead, she sent New Year's greetings and expressed regret that she had been unable to find the kind of pajamas Beck had asked for. Georgia was taking things out of storage in hopes of going back to work.

In Taos, Beck was sorting through Paul's prints still in her possession and taking his part against Augustín Chávez. Still angry about their friend's "perfidious" conduct, she urged Paul to "fight him with lethal weapons" to keep him from taking credit for their film. She added, "If you let A. steal it, I'll have my first disappointment in you—ever."

Paul returned to the Southwest with Bobby Hawk in December, then traveled around the region while deciding whether to go back to New York. We can only imagine his reunion with Beck, and his reaction to the flamboyant figure she cut in Taos. It is not known whether he saw Alfred and Georgia in New York before leaving for Moscow to meet Soviet cultural leaders, including film director Sergei Eisenstein. About that time, Strand told a friend, "I have come to the point where I believe that any young artist who is not aware of the human struggle—economic and political—which overshadows . . . every part of the world today—is strangely outside the main currents of life."

Georgia was already planning to return to Ghost Ranch in June, before spending the winter with Alfred—the pattern she would maintain for the next decade. Once he accepted her need to live according to her desires, they established a new equilibrium and missed each other during separations, when Georgia worried about the effects of his aging. Sometime later, she told McBride, "Aside from my fondness for him personally I feel that he has been very important to something that has made my world for me."

By then, the foursome had dispersed both geographically and psychically, yet for the most part they thought fondly of one another. Beck's yearning for "the old days" gave way to her wholehearted embrace of life in Taos. Paul remarried and immersed himself in the task of aligning his art with his politics—which would, in time, mean leaving the country. Georgia devoted her creative energies to her new homeland while remaining attentive to Alfred. She and Beck visited each other and sent gifts, but as Georgia became the iconic figure of her later years, their closeness diminished somewhat. It was the end of an era—one in which their influence on one another flowed in all directions, and the interweaving of their lives in support of Alfred's "Idea" established the foursome's bonds as friends, protégés, mentors, and lovers.

AFTERMATH

Alfred

Weegee (Arthur Fellig), *Alfred Stieglitz*, 1944

One gray day toward the end of 1934, Imogen Cunningham went to the Place. Stieglitz had just taken down the exhibition of his work timed to complement the publication of *America & Alfred Stieglitz*. Cunningham had just come from San Francisco to do portrait work for *Vanity Fair*. Having admired Stieglitz since the 1910s, she decided to start her portrait series with him.

The likenesses Cunningham took that day, she told him, confirmed her memory of Stieglitz "as the father of us all." In one, dressed in a dark overcoat, he pored over papers at his desk while Cunningham watched him "like a hawk." In another he posed in front of O'Keeffe's *Black Iris*

with a guarded look in his eye, as if daring Cunningham to think any less of him because of his age. Still the impresario of the Place, she recalled, "he stood rock-steady for every shot."

Alfred told Imogen that he and Georgia were delighted with her work. Her "rock-steady" likeness would run in the March 1935 *Vanity Fair,* he added with obvious satisfaction. The magazine devoted a double-page spread to his work—two portraits of Georgia, an early landscape, and an *Equivalent*—to underscore his fame as "the camera's almost legendary saint." Following this encomium, the editors proposed a sly summation of Stieglitz's life: "Fifty-one Years in the Dark Room."

The New Yorker's Lewis Mumford suggested an equally lonely parallel for Stieglitz's struggle on behalf of "seeing." He was the Captain Ahab of American art; his recent exhibition had been even more "climactic" than the memorable one at the Anderson Galleries in 1921, with its "incomparable studies of the nude." Still, if Mumford's review made up for criticisms of *America & Alfred Stieglitz,* Stieglitz lacked the means of response he had had in *Camera Work.* "That's the one thing I do miss," he complained to Arthur Dove. "A weapon in the form of one's own printing press."

Stieglitz also missed the support of younger people acting on his behalf, as the Strands had done. That spring, he looked to the artist William Einstein, a distant cousin of his who had recently returned to New York from Paris. While he did not think much of Einstein's painting, he enlisted his enthusiastic relative to help with the tasks needed to keep order at the Place.

The other candidate for the job, in Alfred's mind, was Ansel Adams, whom he had first met in 1933, when Adams came to show him his portfolio. At the time, Adams watched Stieglitz scrutinize his prints, shut the portfolio, and announce that while they were some of the best he had seen, he could not give him a show. After that visit, inspired by Stieglitz's dual roles as gallerist and photographer, Adams opened a gallery in San Francisco and began the correspondence that demonstrates his reverence for the older man. ("I would not have believed before I met him that a man could be so psychically and emotionally powerful," Adams wrote to Strand.) But Adams was unlikely to leave California, having made common cause with Cunningham, Edward Weston, and others committed to a "straight photography" approach to natural form.

O'Keeffe, who had befriended Adams on her first trip to Taos, invited him to the Shelton when he returned to New York in 1936. The young man showed her and Alfred his recent prints, taken under the sway of

Alfred's belief that images of nature could be equivalents of psychic states, and was thrilled when Stieglitz offered him a show. "I have done one good photograph since my return," Adams told Stieglitz. "My visit with you provoked a sort of revolution in my point of view." It also gave Stieglitz a disciple of the kind he had had in Strand, albeit at a distance.

He decided to open the Place on a "western" note. When Georgia returned from Ghost Ranch and showed him Beck's latest oils, he saw that her imagery offered another approach to native art, one that could enhance the East-West connection that promised to bring new life to the gallery. "I open 1936–1937 with you & Adams," he informed Beck. Adams's work would hang in the big room and hers in the small one. Beck's reply is missing, as is her response to his note the next day saying that he had changed his mind but would show her work later that year.

One wonders to what extent Georgia influenced the decision to accord Beck the status she coveted—to be shown at the Place in her own right. In another letter to Beck, Alfred remarked on his "queer" way of doing things. He added, "Truly beautiful moments can never be killed. And we have certainly enjoyed aplenty." As for their misunderstandings, he mused, "They are part of the growing pains I suppose if there is any growth at all. . . . Am not as spry as I was not so very long ago."

Alfred's sense of vulnerability had intensified in response to shifts in his rapport with Georgia. Earlier that year, she had accepted a commission to paint a six-by-seven-foot mural at the Elizabeth Arden Beauty Salon for the unprecedented sum of ten thousand dollars. Because the couple's rooms at the Shelton were too small for such a project, Georgia rented an airy duplex on East Fifty-fourth Street overlooking the East River and asked Alfred to join her there. "She has a penthouse studio," he told Adams half in shock; the studio was "so grandly spacious and light that I feel queer."

Georgia decorated in her usual manner—white walls, dark brown floors, black furniture relieved by Navajo rugs and arrangements of flowers, shells, bones, and skulls. Alfred resisted the move (the duplex was drafty and so far from the Place that he had to take taxis) but then gave in to her wishes. When friends came to dinner, the housekeeper Georgia hired for such occasions saw to everything. Along with the knowledge that her life in the Southwest awaited her, her income reinforced the sense of self-command that came with these arrangements.

Despite their affection for each other, Alfred was slow to adjust. "I haven't been well," he complained to Adams after Georgia's departure for Ghost Ranch in 1936: "Heart. Damn it." He added, "My memory isn't what it was. It's like the heart. A bit on the blink." What he did not

mention was his fear that what he stood for no longer mattered. After Adams's first meeting with Stieglitz, the younger man had asked him to consider the idea that he presented "an all-enfolding armor to the world which keeps both the good and bad from you, which protects and prohibits at the same time." In 1936, he wrote to reassure Alfred of his enduring significance: "The Place, and all that goes on within it is like coming across a deep pool of clear water in the desert."

By then, Stieglitz had chosen the group show to follow Adams's work, in a sense prolonging its western theme. Hartley and O'Keeffe were represented by canvases inspired by the earth forms of New Mexico—O'Keeffe's "brawnier and at the same time subtler," according to the *Times*. The reviewer seemed bemused by the pieces in the smaller room: "recent decorative paintings on glass by Rebecca Strand, wife of Paul Strand, photographer . . . chiefly floral and design subjects with a hint of O'Keeffe." While only one of Beck's pieces sold, they were "much admired," Alfred wrote when her show closed. He added, "It's ever the old story here[.] I refuse to become a 'Salesman.'"

Although the country was still suffering under the weight of the Depression, Alfred's disdain for salesmanship had not abated, nor had he changed his mind about socially relevant art. Still, he departed from his practice of showing the usual roster of artists in order to display the satiric watercolors of George Grosz, who had fled to New York from Germany, and he sent funds to László Moholy-Nagy so that he, too, could escape to the United States. Stieglitz had been slow to recognize the Nazis' threat to Europe as a whole, but once Hitler annexed Austria, conversation at the Place was interrupted when members of the group turned on the radio for the news. Dorothy proposed the idea of publishing a magazine to oppose all forms of repression; Alfred offered her the Place as her headquarters.

By the spring of 1938, alarmed by the prospect of an European war and mourning the death of his brother Julius, Alfred was depressed. In April, he suffered a heart attack, the first of a series of coronary episodes; two weeks later, he came down with pneumonia. In a note to Edward Weston, he mused, "Will you and I ever meet again. —I doubt my ability to come West or really to go anywhere 'far' from the source." After Georgia took him to the lake, he recovered slowly, while doing his best to undermine her plans to return to Ghost Ranch. In July, exhausted by the demands of caring for him, Georgia told a friend that she dreamed of "a dry open space all by myself." Once Alfred's health was stable, she left for New Mexico, where she stayed until November—the pattern she would follow in the years to come. Dorothy went regularly to the Place

to supervise the gallery's finances and produce her magazine. (Ironically, it may have been a relief to Georgia to know that Dorothy was looking after Alfred during her absences.)

For some time, Dorothy had also been taking down Alfred's reminiscences. From 1938 on, they would appear in her magazine, *Twice a Year: A Semi-Annual Journal of Literature, the Arts and Civil Liberties*, which reproduced his signature scrawl on the cover and four of his prints in each issue. As *Twice a Year*'s presiding spirit, he welcomed the stream of contributors who visited the gallery—poets, novelists, and intellectuals, like his old friend Dreiser, and new ones, like Henry Miller (who wished he had known Stieglitz at 291: "If I had met him then," Miller wrote, "the whole course of my life would probably have been altered.") Interchanges with newcomers revived his spirits, and Alfred took pride in Dorothy's credo that the arts sustained the spirit of freedom.

While this manner of addressing the situation in Europe had a heartening effect, Alfred's hostility to the institution he saw as the competitor to his life's work—the Museum of Modern Art—did not abate. He grumbled that at MoMA, "politics & the social set-up come before all else." His suspicions had deepened in 1935, when Alfred Barr, the director, asked Beaumont Newhall, who ran the library, to plan an exhibition on the history of photography. Stieglitz turned down Newhall's request to have him chair the advisory board and refused to lend work. Nor did he attend the show's opening in April 1937, which included images by Adams, Berenice Abbott, Weston, and Walker Evans, along with thirteen prints by Strand. The following year, still recovering from his heart attack, Stieglitz relented. Receiving Adams and Newhall at his bedside, he give Newhall permission to use an image of Lake George as the frontispiece of his forthcoming book, *Photography: A Short Critical History*, and to dedicate it to him. The men nearly broke down when Stieglitz asked them to take his place as photography's champions.

By then, Stieglitz had ceased taking pictures, bringing to a close the most passionate years of his life. In a letter to Weston, who had recently won the first Guggenheim Fellowship given to a photographer, he tried not to sound envious of Weston's good fortune. The letter also reveals his disdain for contemporary work ("So little vision. So little true *seeing*") and his bittersweet sense of the present:

Here I am the first time in 55 years without a camera. Yes there seems to be millions on millions of photographers & billions of photographs made annually but how rare a really fine photograph. . . .

I'm an old man. May be have been an "old man" for many years. . . . Waldo Frank some years ago said to me: "Stieglitz when you are dead I'll write your biography." I wondered how much he knew about me & why wait till I'm dead. But all I said was: Frank my biography will be a simple affair. If you can imagine photography in the guise of a woman & you'd ask her what she thought of Stieglitz, she'd say: He always treated me as a gentleman.

If he had failed to teach Americans to embrace "seeing," he remained, at least in his own eyes, his medium's favorite suitor.

Dorothy's portraits of Alfred in these years also bear witness to his sense of himself as photography's lover. In some, he entrusts himself to her as his confidante; in others, the twinkle in his eye suggests that he is savoring their past intimacies; in still others, he rests his head on the back of a chair to gaze at the woman who continued to inspire him. But these portraits also hint that Dorothy had begun to distance herself. Her studies of Alfred's gnarled hands bring to mind both his portraits of her youthful ones holding her camera and of Georgia's elegant fingers taken in the years when she gave herself unstintingly to the role of muse.

Over time, Alfred came to accept Georgia's annual displacements. They spent winters together in New York; in the spring, before going to New Mexico, she went to Lake George to prepare the house; then, depending on Alfred's health, she returned to the lake in the fall. When apart, they sent each other deeply thoughtful letters that still conveyed their affection. Writing of the war from Ghost Ranch, Georgia observed, "All seems so peaceful off in the country like this"; in the last line she teased, "You are a lunatic and I love you." Missing her but secure in the knowledge that she would return, Alfred conceded, "You would have gone to the southwest sooner or later. . . . I realize full well, and have for years realized it, that all this set up [Lake George] is not for you, that you couldn't stand what I am forced to stand. . . . It's all in my photographs—It's all in your paintings."

Despite occasional complaints about what he had to endure, Alfred enjoyed being coddled by the female members of his family. Sue Lowe recalls conversations with him at the lake on subjects ranging from Hitler's madness to her budding sexual feelings, a topic to which he returned with each grand-niece (Georgia thought that his infatuation with fifteen-year-old Ann Straus had much to do with her resemblance to Dorothy). He continued to rise early, read his correspondence, and prepare envelopes for his replies, occasionally putting a note for Doro-

thy in an envelope meant for Georgia. Lowe gives a tender account of his routines: "Correspondence dispensed with, he either set off for the post office, his round of miniature golf, and his chocolate ice-cream cone or for his wicker chair on the porch—to read, catnap, to talk with guests, or to photograph with his eyes the grasses, trees, barns and sky." As he grew weaker, he renounced activities except for his daily walks, and when Ann Straus introduced her fiancé to him, his infatuation loosened its grip.

A certain remoteness from his coreligionists' fate may be attributed to the Stieglitzes' view of themselves as assimilated members of modern society. Initially Alfred did not seem too concerned with the fate of the Jews, but once the Germans began bombing England, he abandoned his efforts to persuade listeners that the German people, misled by the Nazis, were not responsible for the war.

One wonders whether Alfred was shown Strand's striking response to Nazism. A photograph of a skeleton crucified on a swastika, this overtly political image appeared in 1939 on the cover of *TAC*, the Theatre Arts Committee magazine, under the title *Swastika (a.k.a. Hitlerism)*. Alfred and Paul were reconciled when Paul came to see his mentor in 1940 after his second angina attack of the year. Dorothy, who had taken over Alfred's correspondence, wrote to Paul, "It was really beautiful to see how much your note and the visit meant to him."

But Stieglitz was still not ready to set aside his suspicions about MoMA's plans for a Department of Photography, the first of its kind, under Beaumont Newhall. When Newhall, again working with Adams, sought to enlist Stieglitz as its eminence grise, Stieglitz made it clear that "he could not accept a subsidiary or ancillary position in an arena he felt he had created." Some months later, following failed attempts to mount a Stieglitz retrospective as the department's first show, the two men were astounded when he agreed to let them display some of his prints at their inaugural exhibition, "Sixty Photographs: A Survey of Camera Esthetics."

Stieglitz and O'Keeffe went to the museum on opening day, December 31, 1940. It was surely gratifying to see a reproduction of his iconic *Night—New York* on the catalog cover and to read MoMA's tribute to "his courageous pioneering and experimentation, untiring struggle to have [photography] recognized as a medium of artistic expression . . . his impact on more than a generation of workers and his uncompromising demands on them to achieve the finest quality of craftsmanship and perception." The exhibition was a grand survey of the art, includ-

ing work by Abbott, Atget, Mathew Brady, Cartier-Bresson, Dorothea Lange, Moholy-Nagy, Eliot Porter, Man Ray, Sheeler, Steichen, and Weston.

It was also a reunion of sorts. Aligned across the wall in their simple frames, the eight Stieglitz prints appeared to introduce the three Strands: Given the sequencing, some saw Strand's *Photograph—New York* as an homage to his mentor. Displayed in this way, Stieglitz's prints (including *The Hand of Man, The Steerage,* and *Georgia O'Keeffe—Hands and Thimble*) seemed to have made peace with the occasion. And while the inclusion of Norman's 1934 portrait of Stieglitz may have struck an incongruous note, it was not remarked upon except by *The New York Times,* which praised her use of shadows.

To his entourage, it seemed that "Sixty Photographs" had been planned to usher in Alfred's seventy-seventh birthday, on January 1. Georgia wrote to McBride, "I see Alfred as an old man that I am very fond of, growing older—so that sometimes it shocks and startles me when he looks particularly pale. . . . I like it that I can make him feel that I have hold of his hand to steady him as he goes on." That spring, her attempts to "steady" Alfred included helping him organize thirty-six boxes of his photographs while sorting through her own work. When she was with him in New York, Georgia saw to his comforts, such as buying him the unfashionable clothes he favored and ordering a loden cape from Germany when his old one wore out. Every year, before going to the Southwest, she hired companionable housekeepers to care for him and arranged for friends to keep an eye on him.

Even so, Alfred was downcast for much of the spring. It lifted his spirits somewhat to read a *Vanity Fair* article entitled "The Fighting Photo-Secession," by Steichen, whom he hadn't seen in twenty years. In the current context, Steichen wrote, "the heritage stemming from this Photo-Secession movement stands out in bold relief as a great tree against the sky, and the trunk of that tree is Alfred Stieglitz." Alfred let his old friend know that he was "bowled over" by his words: "If you were here I'd grasp your hand." A meeting was arranged; the two were reconciled despite their differences—which were largely of Alfred's making once Steichen went into commercial photography, Alfred's bête noire.

But Alfred's dejection, exacerbated by chronic health problems (painfully itching skin, sinusitis, angina), returned to plague him that summer. "I'm managing to scrape through one day after another," he confessed to Arthur Dove. "Do absolutely nothing but lie about. . . . Not a thought in my head or elsewhere." Worse, he feared that the war would force

him to close the Place just as the first war had brought the end of 291. "If I have the misfortune to live a year or two longer, I shall find myself where I was in 1917," he told Nancy Newhall (Beaumont's wife), who was taking down Alfred's remarks with an eye to writing his biography. She noted sympathetically, "He feels alone, although surrounded by friends . . . that the place of photography in the average mind is rather worse than when he began."

Over the next years, as fewer people went to the Place, Stieglitz became convinced that it was dying. "The beautiful living things no longer mean anything real to people," he told Nancy. Fearing that Georgia would do away with his intimate portraits of her after his death, he was tempted to destroy them. Shocked to hear him say that he should have died after his first angina attack, Nancy replied, "Then I and so many others would never have known him. It meant a great deal to us; no doubt we were selfish. He said it was not selfish. Still, for the first time he was envious—of the dead." In 1943, when Hartley died at sixty-six after exhibitions at several prominent galleries, Stieglitz mused, "What a lucky man . . . to have passed out in his zenith."

By then, Georgia had taken the precaution of moving to a smaller but warmer apartment a block from the Place. That way, Alfred could walk to the gallery (taxis were scarce due to gasoline rationing), and he no longer complained of the draft. But that winter, as he recovered from further angina attacks, visitors to the Place found him much reduced, mulling over his failings or dozing on the cot that Dorothy had installed for him, wrapped in his cape.

But he rose to the occasion when people came to see him as he was about to turn eighty. To Nelson Morris, who interviewed him for *Popular Photography,* he was the one "whom the younger generation of serious camera workers had come to regard as the[ir] patron saint." While Stieglitz disapproved of what he saw as current misuses of their medium, he admired Morris's Rolleiflex and said that he would have liked such a camera. His early work, Morris thought, was the precursor of the reportage practiced in *Life*: "His photograph of a steamship steerage . . . will long rank as an example of the high type of work we present-day journalistic photographers seek to emulate." Morris took a compassionate picture of "the great old man"—his second in color, Stieglitz mused, harking back to the autochrome one by Steichen.

It was surely with mixed feelings that Stieglitz consented to talk to Thomas Craven, who ten years earlier had dismissed him as a "Hoboken Jew" lacking a sense of the American background. Craven found him on

his cot, "suffering from a heart attack, and from an aching heart, too . . . but his ego was unimpaired." Craven could not resist the occasional jibe: Stieglitz had become "the center of a cult of frustrated artists and the dilettantes who spoke of him—and still do—in terms reserved by less obsequious persons for the Lord Almighty." Yet Craven delivered an almost unbiased account of Stieglitz's importance as a photographer and gallerist while praising his refusal to enrich himself. Their interview appeared in *The Saturday Evening Post* with reproductions of *The Steerage,* portraits of O'Keeffe, and a likeness, by Norman, of Stieglitz looking his age.

On January 1, 1944, a group of well-wishers went to the Place to celebrate Alfred's eightieth birthday. He expatiated on the absurdity of the commemorative pieces appearing in the press, like Craven's tribute to him as an "old master of the camera." Still, the new year brightened his mood, and recognition by mainstream periodicals drew people to the Place in greater numbers. That winter, he worked with the Philadelphia Museum of Art to choose thirty-five of his prints, along with three hundred drawings, paintings, and photographs (including six by Strand and four by Norman) from his own collection, for an exhibition entitled "History of an American: Alfred Stieglitz, '291' and After"—an implicit response to those who contested his right to speak for American art.

By the spring, however, Stieglitz was often too tired to do anything but rest. One day, a man in a rumpled suit walked up to him in the street and asked brusquely, "You Stieglitz?" He introduced himself as Weegee, the crime photographer; although Alfred had never heard of him, he asked him up to the Place. "Weegee the Famous," as he liked to style himself, recounted his visit as a cautionary tale about the nature of fame:

He started to talk, the most famous photographer in the world, the man who sponsored unknown painters and sculptors who are famous today. Stieglitz pointed to a phone near his cot. *It never rings,* he said. *I have been deserted. The paintings on the wall are orphans. No one comes up to see them!* He was a failure, he told me . . . others were successful because they had wanted money, because they were politicians, showmen.

Weegee photographed Stieglitz on his cot, a portrait that is less than complimentary. Suddenly, he slumped over in pain and whispered, *My heart. It's bad.* When he had recovered, Weegee left, murmuring to him-

self, "It doesn't seem right that such a great artist should have such a little reward." His account of their meeting in *PM,* a New York daily, did not so much pay homage to Stieglitz as depict him as a great man humbled.

Judging by their poses, a double portrait of Stieglitz and O'Keeffe taken at this time by Arnold Newman (who photographed famous figures) was meant to support Alfred's stature as the grand old man of photography. The dominant figure, he stands erect and stares at the camera, while a diminutive O'Keeffe seated behind him looks to one side. Yet, according to Sue Lowe, this image belied the state of their rapport: "Over the past several years, the prevailing ingredient in the relationship between Alfred and Georgia—a mutual generosity that many failed to perceive—had grown. In some ways, they had exchanged roles." Although Alfred had been "steeling" himself for Georgia's departure that year, he wrote, "Your going is very right—For you. So it must be right for me." He added, "It's all a difficult lesson—living if one is truly conscious of the significance of the moment."

By 1945, Alfred had weakened considerably, while remaining mentally vigorous. His spirits lifted with the end of the war. Despite his opposition to MoMA's plan to give Georgia a retrospective the following year, he agreed, when she insisted that a one-woman show would not only benefit her career but underscore his role in bringing it to this point. After completing his biographical sessions with Nancy Newhall, Alfred spent the summer at Lake George. Georgia joined him in the fall, and together they chose the paintings for her new show at the Place and MoMA's retrospective the following spring, the first devoted to a woman artist.

Stieglitz attended the opening of O'Keeffe's retrospective on May 14, 1946, despite his reservations. To his surprise, he approved of MoMA's installation: "It is a glorious exposition. In a sense a miracle . . . I am glad to live to see this day." He and Georgia went to a party at the Newhalls' with friends and colleagues, including Abbott, Sheeler, André Kertész, Strand, and Norman, whose presence there caused Georgia to turn around and walk out. Georgia read only two of her reviews, a laudatory piece by McBride and an essay by James Thrall Soby, MoMA's curator of paintings, which acclaimed her as "perhaps the greatest of living women painters." (Soby continued: "She created this world; it was not there before; and there is nothing like it anywhere.")

Alfred was delighted by Soby's review, since the curator had not thought much of her work at first, and deeply moved by what they had accomplished together: "How beautiful your pictures are at the Mod-

ern . . . we are a team." The next day, as she was preparing to leave for the Southwest, he wrote, "You need what 'Your Place' will give you. Yes you need that sorely. And I'll be with you, Cape and all. And you'll be with me here." Enchanted to find the love notes that she had left for him in the apartment, he responded, "Ever surprised. And ever delighted."

Alfred stayed in New York while the housekeeper began packing for his trip to the lake. On July 6, he went to the Place to meet the Newhalls. They found him on his cot, barely able to whisper that he had had a heart attack. He was taken home and put to bed, where he was seen by his doctor. There was nothing to worry about, Alfred told Georgia on July 8 (the doctor implored her to come back). As he was dressing to go to the Place the next day, he suffered a massive stroke and was taken to Doctors Hospital. He never regained consciousness. The telegram informing Georgia of his condition reached her on July 11. She rushed to the Albuquerque airport in her cotton dress and work shoes, arriving in New York in time to get to the hospital before he died in the early-morning hours of July 13.

The next day, twenty of Alfred's friends and family, including Sue Lowe, Anita Pollitzer, Steichen, and Strand gathered at Frank Campbell's funeral home on Madison Avenue. Georgia had torn the satin lining out of the plain pine coffin she had selected and, overnight, sewn into it a new one of white linen. The casket, draped in black, reminded some mourners of the black cloth–covered camera of Stieglitz's early days in photography. Following his wishes, there were no speeches or music, only some flowers. According to Lowe, "Georgia accepted condolences in calm dignity, her self-containment making the extravagant tears and sobbing embraces of some around her [including Dorothy] seem grotesque." Then, after the ceremony, "Georgia, with a majesty I shall never forget, eluded the hands of sympathizers and entered the limousine that would carry her behind the hearse to the crematorium."

Later that month, Georgia took Alfred's ashes to Lake George and buried them at the base of an ancient tree at the water's edge. She could not imagine going back there, she would write to one of his Stieglitz relations, "unless—maybe to stand just for a moment where I put that little bit that was left of Alfred . . . but I think not even for that. I put him where he could hear the Lake." She noted cryptically, "That is finished."

· · ·

In the days after Alfred's memorial, Georgia tended to unfinished business. She had been "strained but under control" at the funeral, Strand

told the Newhalls, while Dorothy, "utterly shattered," wept. Nancy Newhall informed Ansel Adams that Dorothy was shocked when Georgia told her to remove her things from the Place by the fall and to cede control to her—moreover, that she considered Dorothy's relationship with her husband to have been "absolutely disgusting." Dorothy managed "a few heartbroken responses"; Georgia consulted a lawyer, which brought "a new note of dignity" into the situation.

In time, Dorothy devised her own monument to Alfred, in the form of the *Stieglitz Memorial Portfolio,* published in 1947, with scores of tributes by prominent artists, writers, critics, and friends, including Paul and Rebecca—but nothing at all by Georgia.

Rebecca

Rebecca Salsbury James, Taos, 1937

O f the scores of tributes in the *Stieglitz Memorial Portfolio,* the most
personal was signed "Rebecca Salsbury James." No doubt sur-
prised to be asked for a contribution, Beck described her first meeting
with Alfred:

I first knew Stieglitz in 1921—taken to him 25 years ago by Paul Strand, straight from a gold and brocade parlor at 39 West 96th Street, N.Y.C., to a tiny storage room in the old Anderson Galleries. The first time I heard him talk was at the Chinese restaurant in Columbus Circle—he talked from seven to midnight. After that first talk I went back to and finally left the gold and brocade parlor, never again to be quite the same person.

By then, she could measure the distances she had traveled from her mother's parlor to her *moderne* quarters at the Strands' and finally to the spacious adobe in Taos where she lived with Bill James. In her view, Alfred had set her on the path to becoming the person she was meant to be.

Beck was fifty-five when she wrote this tribute. She and Bill had lived in the house they called Casa Feliz since 1937, when they married. She would spend the rest of her life there. The dry mud walls and undulating lines of Spanish-Pueblo Revival houses like Casa Feliz reference both the Pueblo's adobe structures and the town's colonial past—the perfect place to confirm her life as a westerner. Casa Feliz was also the first home that Rebecca chose for herself, having spent several years with Bill at El Pueblito, a cross between an artists' commune and an art center (now the Harwood Museum). After a honeymoon in Mexico, they began restoring their adobe to suit her idea of life in harmony with the local culture.

It seemed fitting when five men from the Buffalo Bill show turned up in Taos and joined their work crew, as if her father's world had come to put the seal of approval on her own. Over time, she and Bill added exterior walls, patios, and a studio above the garage. Her art had gone "more or less to hell," she told the Baasches, but Casa Feliz was living up to its name: "I love it so I scarcely leave."

When Rebecca went to New York after her mother's death in 1937, she was glad to see Paul and meet his wife, the actress Virginia Stevens (they married in 1936). But she felt uneasy about his politics: "I'd much rather see him put all his energies and interest in his work." She also called at the Place and recalled this visit on her return to Taos:

I expected to find Stieglitz older & frailer—but he looks just the same. He started a great harangue but I just laughed & told him he was a bad old man—then he laughed too. It all seems very far away from this secluded, rough, easy-going life here—but I know there

was much of value in it all for me—and painful as much of it was, I am glad it all existed.

She still cared for Alfred but could not forgive his behavior toward Paul.

From their base at Casa Feliz, Beck and Bill made forays into Taos's nightlife. The town's frontier atmosphere attracted cowpokes, horse dealers, and gamblers with names like Doughbelly Price and Curly Murray. The Jameses played poker at Mike Cunico's place and downed the hooch known as Taos Lightning. Lined up at the bar, Beck recalled, "artists, writers, truck drivers, cowmen, business men, farmers, traveling salesmen, celebrities, quenched their thirst, swapped stories, laughed and hollered." Mike gave the regulars nicknames ("Shotgun," "The Buffalo," "The Kangaroo Kid"); one of them noted, "Becky shunned the rest of the town, allying herself with the sporting clique"—an observation that measures her resolve to present herself as her father's daughter. Her style set her apart: She wore soigné western garb that showed off her figure, and smoked cigarettes in a long silver holder.

In time, Bill became a director of the Denver bank founded by his grandfather and was comfortable enough to serve as a village councilman. Beck became irate when *The Taos Review* announced that she had inherited $85,000 from her mother (the equivalent of two million dollars today). "This is decidedly not the case and I wish you would so inform your readers," she protested. (The details of her inheritance are not known, since Mrs. Salsbury's estate, worth more than six million dollars at today's rates, was divided among her nine heirs.) Beck preferred the account of herself in *The Houston Chronicle* ("noted artist of Taos, N.M., and daughter of the late Nate Salsbury"), published when she lent her Wild West memorabilia to an exhibit about Buffalo Bill.

Becoming a westerner heightened Beck's sense of herself as a Salsbury. She kept in touch with Ethel Salsbury, Milton's widow, who was raising their son, Nate Salsbury III, in New York. Starting in 1937, when Nate was twelve, he spent summers with "Auntie." She was "a tremendous character," he recalled. "She lived through the whole development of the Taos artists' colony, the drinking, the fighting, the competitions. People looked up to her. I loved her dearly; Bill adored her." Nate was, in a way, the child the couple would never have.

At a time when eccentricity flourished, "Becky linked two Taos worlds, that of the artist and that of the roistering frontier," the local bookseller thought. Toward the end of 1938, Beck retreated to her stu-

dio to prepare a solo show for the Colorado Springs Fine Arts Center, a multicultural space opened in 1936 to house indigenous art, though recently mounting shows of the French moderns. Displayed in the center's blend of Native American and classical design, Beck's paintings stood out; judging by the checklist for a show of Taos artists that same year, they probably included flower paintings and still lifes, such as her juxtaposition of a macaw's feather and a camellia—perhaps suggested by O'Keeffe's similar choice of subject matter.

Beck and Georgia saw each other infrequently but sent notes and cards, especially at Christmastime; Beck included gifts of the sort that Georgia appreciated. Once the road from Taos was improved, they visited more often. It was important to Beck to think that she was maintaining the shared values of their life together. When Paul sent her a copy of his portfolio of Mexican photographs in 1940 (many taken when they had toured Mexico together), she reflected, "I am glad I have worked—in the sense of keeping faith with what you encouraged me to start so long ago."

In her own way, Beck was turning to a situated sense of art—cultural forms embodied in the experiences of daily life. By 1940, she was taking an active part in celebrations like the annual fiestas in the plaza, where Indians, Hispanics, shopkeepers, artists, and villa dwellers like Mabel all showed up in costume. There were parades, a string orchestra, dancers of all kinds, stagecoach rides, penny pitching, and the coronation of a queen. One year, Beck oversaw the local artists' attempts to devise costumes for their float; she and several friends would commemorate the fiesta in a set of murals à clef. By the 1950s, she was a regular in the annual stagecoach ride through town.

Soon after the Japanese attack on Pearl Harbor, the Jameses enrolled in the war effort. Bill volunteered with the U.S. Army Air Corps and was stationed in Maryland, where Beck joined him—too brief a visit, in her opinion, although they had time for a reunion with Paul, Virginia, and the Baasches. When Bill went to Albuquerque to teach chemical warfare, she began work as director of the Taos Red Cross Knitting Group. Like a sewing circle whose members gossip and socialize, the group was an alternative to her studio. On Bill's return to Taos, she threw herself into his latest plans, his cattle ranch and the New Mexico Angus-Aberdeen Cattlemen's Association.

Their friends included the poet Spud Johnson, who came to Taos to work for Mabel while publishing his gadfly review, *Laughing Horse,* and running a bookstall near the plaza. Beck was closest to the painter Cady

Wells, who was often her guest. Their circle filled out when they were joined by Tom and Dorothy Benrimo, an artist couple from New York, and Kay and Richard Dicus. Having studied at the Art Students League, Dicus adapted to life in Taos by turning his hacienda, La Finca, into a bohemian B and B. Once Dick began raising cattle, he and Bill found that they had much in common, including the care of ailing cows.

From New York, Georgia sent occasional news of old friends, like Paul. *Native Land,* his 1942 movie on the trade unions' struggles against the corporations, was beautifully photographed but "cruel," in her opinion. Georgia had been uncomfortable with him when he came to lunch: "I was glad to see him but when he left I felt it had not been pleasant." He was still dreaming of a world "where the ideals of the Soviet Republic prevail." To some extent, Rebecca shared Georgia's assessment. "I feel you get too preachy," she told Paul in reply to his insistence on socialism as a bulwark against fascism. While Bill was a staunch Republican, he had offered his services to Truman following Roosevelt's death. "So you see, we are not blindly partisan."

In the same letter, she wrote, "I . . . have philosophically made up my mind that for the moment I cannot paint much." Still, over the next years, she produced a number of reverse paintings on glass, whose titles suggest her preoccupations. The garden at Casa Feliz inspired some intensely felt floral studies, *White Roses at Twilight* and *Hollyhocks and Polar Ice Gladiolas;* in both of these, the glass surface holds the viewer at a distance while the refinement of the facture draws one to the flowers themselves. Another series evokes the elements in poetic juxtapositions. *Earth and Water* pairs a dying tree with a huge white shell; *Fire and Air* sets a blackbird soaring in the night sky against the dark mountains.

Two landscapes from this time, *Walking Woman* and *Mourning Woman in Campo Santo,* use their flattened perspectives to depict female figures traversing the landscape in quest of the solace figured in the distance. Commenting on this series, Beck compared her terrain to that of Constable, who said of his sites, "These scenes made me a painter and I am grateful." Rebecca continued: "Paraphrasing this for myself I say, 'A walking woman, a waiting woman, a watching woman, a mourning woman, a devout woman, adobe, cedar posts, old dry wood, the fields of alfalfa, the churches—I love these things. They have made me paint, and I am grateful.'" In this spirit, she turned her subjects' limitations to her advantage.

Beck also completed a sequence on the seasons—*Summer in Taos, Autumn in Taos, Winter in Taos,* and two versions of the intriguingly

titled *Despair in Taos. Winter in Taos,* which foregrounds a branch of thorns and a bear's tooth against a backdrop of mountains, may have been her reply to Mabel's memoir of the same title. While Mabel's book related a day in her life with Tony, Rebecca's painting envisioned a world larger than the self. (She completed this enigmatic scene in 1948, more than a decade after the publication of Mabel's *Winter in Taos* [1935].)

While some Taos artists went on enjoying Mabel's patronage, others kept their distance. For her own reasons, among them a desire to set the record straight, Rebecca overcame her hostility when Mabel began writing a book entitled *Taos and Its Artists,* which was to include her. To help Mabel with this project, she verified the details of her fellow artists' careers, corresponded with the publisher, and advised him on her own entry, to be illustrated with one of Paul's portraits of her. (When published, it was credited to Bill James.)

Beck may have found some satisfaction in reading Mabel's account of her career. It began, "The paintings on glass by Rebecca James . . . are perhaps the most exquisite productions of any Taos artist"; they touched one "through . . . their inconspicuous delicacy." Mabel continued: "Trying to analyze this knockout influence of theirs, I have wondered whether the artist actually transfers an unconscious high vibration of her own directly to the surface before her." As for the resemblance of her floral portraits to Georgia's, they painted in distinctly different manners. Georgia's flowers demanded one's attention; Beck's were modest. (When praising friends who were currently in favor, Mabel could not resist slighting those no longer on her list.)

In Mabel's view, Taos had already replaced New York as "the best-known and most significant art center of America." The growing prestige of New Mexico's artists, enhanced by the increasing number of exhibitions and books like Mabel's, brought Beck's work to the attention of those who understood the linkages between southwestern tradition and art steeped in its values. Even allowing for a certain amount of self-promotion, Mabel's conclusion echoed the sentiments of its subjects: "Taos is going forward. . . . The *genius loci* is still exerting its age-long influence."

Although equally entranced by the landscape, Beck did not admire Mabel's rapturous self-expression, nor did their rapprochement extend to her taking part in Mabel's salons. Beck socialized instead with people who took an interest in the town. At that time, she was writing a counternarrative to celebrate Taoseños who had contributed to its character "but not with brush or pen." She began with eight biographies of

"oldtimers," including Gerson Gusdorf, a German immigrant who had learned English, Spanish, and Tiwa after coming to Taos in 1884; Gusdorf had founded a dry-goods store and the Don Fernando Hotel, where artists who lacked indoor plumbing rented rooms to luxuriate in its bathtubs, until it burned down in 1933. Beck's evocation of the hotel reads like a lament for the years when she and Bill were deciding how to be together: "Paintings by Taos artists covered the walls, draped over the balconies were brilliant Mexican and Indian blankets. . . . A mighty pine log blazed in the fireplace around which Taoseños gathered to thaw out."

Beck would add ten more biographies of Taos notables and publish them under the title *Allow Me to Present 18 Ladies and Gentlemen and Taos, N.M. 1885–1939*. She saw herself as an impresario, like her father. Featured among the "gentlemen" was her husband, described as a Denver aristocrat turned rancher, councilman, and bank director. Like Bill, these hardy western types—including the Gusdorfs, Doughbelly Price, and Mike Cunico—stayed in Taos "because they felt something different, enchanting, 'foreign' and free was going on as in no other place they had known before."

In 1948, Beck and three friends collaborated on a set of murals to celebrate the fiesta. Working with her in her garage, the Benrimos and Barbara Latham, a book illustrator, devised a lighthearted re-creation of the event. They painted dancers and canoodlers on the rooftops, a rollicking stagecoach in the plaza, and a variety of locals—Pueblo dwellers, cowpokes, ladies in suits, children, and artists—along with caricatures of notables like Mabel, Frieda Lawrence, the art collector Millicent Rogers, and, for good measure, themselves. Beck, in her black riding hat, shirt, and trousers is shown from behind, while Bill, looking like a western squire, surveys the scene.

The murals paid tribute to their friendships but also to the plaza itself—the camera shop, the art gallery, the Emporium, and Ilfeld's Hardware, the successor to Gusdorf's dry-goods store. Max and Bertha Ilfeld, a well-educated couple from the Boston area, had settled in Taos at about the same time as Beck, and they became good friends. Max, a civil engineer, played poker with Bill; he and Bertha, an open-minded woman who had studied at Radcliffe, supported local culture. At Beck's urging, they backed the Artists Association's plan to ensure that new buildings echoed vernacular styles to keep Taos "authentic."

Bertha often took Florence, her daughter, to Casa Feliz. The house was "dark and cool with lots of art on the walls . . . informal, comfortable," Florence recalled. Once the war broke out, Beck's nephew Nate

stopped coming, but in 1940 Florence met a young teenager who was staying with the Jameses, introduced to her as Vera, Bill's adopted daughter. Beck confided to Paul, "I have to smile when I think of my bringing up a kid at my advanced years!" (She was nearly fifty.) Noting Beck's strained relations with Vera, Florence wondered whether she was Bill's daughter from his first marriage. After Vera went to boarding school, she became "wild," and at eighteen, she died in a car crash. "There was always some mystery about her," Florence mused. We know only that Vera's ashes were interred in the Jameses' plot in Denver, at a slight distance from the rest of the family.

Beck said little to friends about her own family, except to regale them with her father's exploits. The Ilfelds, who were Jewish, had no idea that she had been brought up in her mother's faith. Although there were several Jewish families in town, Florence observed, "one didn't talk about being Jewish. We celebrated Christmas and Easter, not the High Holy Days. The Gusdorf sisters held seders in their restaurant on the plaza, but I had no idea that this was part of Jewish tradition." Beck never mentioned a religious affiliation. Like many Anglos who settled in the Southwest, she came under the spell of its rich blend of Indian spirituality and Hispanic religious fervor, the sources that infused the region's hybrid culture and, increasingly, her art.

Beck would describe her discovery of the colcha stitch, a form of embroidery practiced by Hispanic women, as an epiphany. For some time, she had been taking Spanish lessons from her neighbor Jesusita Perrault—a former state senator and labor organizer who still danced at the fiestas. After one lesson, Jesusita showed Beck her embroidery of floral patterns. Beck later described her reaction:

This, I thought with excitement, this is for me. . . . I was on my way. On my way to where? To what? As in any high adventure, the end, or the where, was shrouded. . . . The embroideries give the answer. The "what" that has gone into them is respect for tradition, the awareness and love of things and places about me that I could not see any other where. The embroideries express the *ambiente* in which I live.

Her reflections likened stitchery to meditation: "It has taken time to find out where I was going because I was not going. I was staying in the room where I now sit and letting the things I have loved . . . say with a clear voice, 'Please make me.'"

Beck's discovery of this type of needlework was all the more surprising because the colcha stitch had nearly died out. After decades of use in domestic embroideries and ecclesiastical textiles, colcha survived only in the practice of Jesusita Perrault and a few others in the northern part of the state. During this time, when Beck was learning this exacting technique (colcha uses long, overlapping stitches anchored from the back by cross-stitches), she was also learning to tame her impatience. Colcha embroidery demands great concentration, yet it became, for Beck, "the most free-wheeling stitch I know."

By the 1950s, Beck was holding colcha sessions at Casa Feliz, where she taught Bertha Ilfeld the art. These "colcha clubs" satisfied her desire for an art form imbued with a sense of place. As for the debate about whether such crafts counted as art in the same way that painting did, this no longer mattered: "Both the painter and the hand-stitcher start with equally simple, ordinary tools—and for both the responsibility is the same—to create something that lives." It pleased her that colcha could be humorous, as in the coat of arms she stitched for Bill depicting the animals on his ranch—a bull, a stallion, and a pig set in a trefoil (the threefold shape familiar from Christian symbolism).

Increasingly, Beck adapted Spanish Colonial imagery to her own ends. These motifs became her visual vocabulary, a blend of geometric forms and flowers, hallowed landscapes, and religious icons like the Sacred Heart, the Lamb of God, and the Holy Child of Atoche—images that were familiar to the people she lived among. Her 1950 *Agnus Dei* centers its lamb on an oval field below a golden crown and above a sacred heart, with angels in the corners. Similarly, *The Queen of Heaven* surrounds the figure robed in the Virgin's traditional blue with angels, lambs, wreaths, and garlands (the Queen is placed against a cross, part of which is replaced by her own person).

In Beck's effort to renew the practice of colcha, she had the help of two women who shared her love of this distinctive art: Nellie Dunton, whose 1935 *Spanish Colonial Ornament* was published under the auspices of the Federal Art Project, and Elizabeth Boyd (known as "E."), whose studies of the region's art became Beck's source books. E. Boyd would, in turn, pay her respects to Rebecca: "Mrs. James demonstrates the range of imaginative composition, color and texture which can be achieved with stitches. It may be noted that the intangibles of patience, skill and faultless taste are her ingredients for picture-making."

While immersed in efforts to revive this tradition, Beck also completed some of her most accomplished reverse paintings on glass. Geor-

gia wrote to propose that they travel together to New York. She hoped to show Beck's oils in the last exhibition at the Place. Beck agreed but warned that she might cancel. "New York seems forbidding after 15 years away—and I with hay sticking out of my ears!" After declining Georgia's invitation at the last minute, she told Paul, "The end of an era has come. In spite of all the heartache I owe Stieglitz and you much and my only way to prove it is to keep on working."

In 1951, Beck and Bill drove to California to present her oils at welcoming venues. That year, she had a show at San Francisco's Palace of the Legion of Honor; it traveled to the Santa Barbara Museum, where Donald Bear was then the director. Her paintings were admired in both venues, and some sold. The *San Francisco Chronicle* remarked on the "hushed" settings beneath their glossy surfaces—"bleak mountains, snowy foregrounds, and . . . adobe churches dwarfing a few shrouded figures" portrayed naïvely yet "with infinite pathos, sympathy and love." *El Crepusculo,* a Taos paper, declared, "The Painter on Glass Comes into Her Own."

By the 1950s, Beck's mastery of both reverse oil painting and colcha had given her the confidence to practice these arts unapologetically. Having overcome her sense of internal division, she had come to see herself as Bill and their friends saw her. Paradoxically, in this flamboyant village she found the serenity she had previously sought in vain, the spiritual poise behind her turn to depictions of women praying, burial grounds (*camposantos*), and homemade miniatures inspired by the figures in her collection of folk art. In these years, she honed her gift "for seeing and leaving alone."

To Frieda Lawrence, who spent a day with "Rebequita" as she prepared for an exhibition in Santa Fe in the summer of 1952, her embroideries were a mirror of herself. After explaining how she devised motifs inspired by traditional themes, Beck demonstrated the meticulous work required to prepare the threads used for her creations. A few days later, she told Frieda that their conversation had made her think about her materials: "a stiff little piece of steel and a thin thread. Certainly all small tools, but what an enormous expression they can make if the eye is true, the hands diligent, the mind disciplined, the spirit aware."

The Old Palace of the Governors in Santa Fe, the venue for her next show, complemented this approach. This historic building seemed to confer its endorsement on her work, which was displayed in antique cabinets and on the main room's whitewashed walls. The show gave a full picture of what could be done with colcha—including fiesta skirts

and a bedspread stitched with flowers. Some of the colchas were placed next to the designs that had inspired them, and others were paired with reverse paintings on glass using the same motif. (Bill's coat of arms was also on display.) Beck posed for *New Mexico Magazine* in front of the cabinet that held her miniatures. The magazine's critic described her favorite: "A tiny cluster of three roses, each petal perfectly formed, yet not larger in size than a dime." She concluded, "To revive a craft long since discarded . . . and to do this quietly without fanfare or shouting from the housetops to attract attention, is an accomplishment worthy of note."

Beck's exhibitions in 1954—in Roswell, New Mexico, and New York—could not have been more dissimilar. In the spring, she showed embroideries with spiritual themes at the Roswell Museum, where work by O'Keeffe, Hartley, and Marin had been on display. In a change of emphasis from these modernist icons, the Roswell exhibition honored Catholic archbishop Lamy (the model for Willa Cather's *Death Comes to the Archbishop*) with a display of liturgical art. One wonders how Beck felt seeing her work among the richly embroidered velvets, silks, and brocade at the museum—whether she felt at home there.

In September, she and Bill traveled to New York with her paintings on glass for a one-woman show at the Martha Jackson Gallery, which featured up-and-coming artists. The paintings were grouped by subject: flowers, paired shells entitled *Peace*, figures, including her walking women, and landscapes, among them *Fire and Air* and *Imagined Landscape*. Her world was "intimate," Elizabeth McCausland wrote in the catalog: "There is no room for panoramas in the grand manner; but a leaf of a shell may be of vast import." Her oils transmitted their maker's sense "that she is bound in the unity of human beings which none can expect to escape if he is to fulfil himself as a human being and as an artist."

The New York Times was less generous in its appraisal. While James's oils came from "the Far West," the reviewer wrote, they were not "without extra-local appeal." Her feel for "the lonely drama of the high mesa-lands" was palpable, but the mood was somber—with "hints of menace in the . . . solitary black-clad figures who move through the landscape with such a stricken Martha Graham air." Still, her flower pictures were "attractive," and her "mildly surrrealist subjects . . . neatly painted." That her work was owned by such people as Leopold Stokowski, Frieda Lawrence, Millicent Rogers, and the late Alfred Stieglitz (among the collectors listed) failed to impress him.

Just the same, the gallery sold nine paintings, and Beck left ten of
her best ones in New York for future shows. From Taos, she wrote to
Paul about the gallery in Palm Beach, Florida, that wanted to show her
work. She had agreed but changed her mind when she considered the
venue: "The things—which are austere, most of them, and of this coun-
try, might not go well in that plush place." It gave her greater pleasure to
be asked to contribute a painting to the Lawrence memorial chapel in
the hills above Taos. Impressed with Paul's latest book of photographs,
which had just arrived, she said, marveling, "It's amazing how hard you
continue to work. I am afraid I do not have the same drive although I
keep going."

While Beck felt the need to justify herself as a "worker," her forties
and fifties were the most productive years of her life. An inveterate
scrapbook maker, she began to document these years in a photo album,
which presents a carefully curated picture of the couple's life together.
Looking through its pages is like watching a slide show. We see Beck
as snappy dresser Taos-style—in riding pants and boots, blue jeans and
checkered shirt, or formal garb, a black satin blouse with a silver brooch.
There are photos of the couple smooching and Beck swigging from a
bottle of gin, as well as a tribute to her father in front of Casa Feliz:
Beck, in work clothes, poses with the men from the Wild West Show. A
portrait of the Jameses with Bill in a suit and tie, western version, and
Beck in a denim shirt transmits their ease with each other.

The album also includes shots of Beck in fiesta garb (at fifty, she is
as lean as when she first came to town) and at a cattle sale, as secretary
of the Angus-Aberdeen Cattlemen's Association. In many images she
is smiling; in a few, she stands solemnly in front of her artwork. At her
fifty-second birthday party, the marks of age on her face are softened by
her happiness; Bill beams in the background. In others, at a costume
party, he peeks out from under an impromptu headdress while brandish-
ing Beck's Lachaise torso, kept in the hallway, she explained, to give "a
rich and warm reception to everyone who enters our front door."

Beck painted and embroidered for her own pleasure but also to make
gifts for friends. For a couple newly settled in Taos, she painted a still life
entitled *Bowl of Vegetables*. It shows a dish full of produce rather than
the traditional flowers; the back reads "For Jane and Rick, Happy Many
Things But Mostly a Happy Home." In the same spirit, she painted
Shell on the Sand, a small oil that hints at vast spaces, and inscribed
it "To Celebrate a/Friendship/To Cady Wells from/Rebecca James/Sep-
tember 25, 1937." (Wells returned the favor by giving her his abstraction

embroidered in the region's colors, with "Rebecca S. James" and the date, 1950, at the center.) Later, when Beck realized that she had given away over half of her creations as presents, she understood more fully how her art was woven into the mesh of her friendships.

She made every effort to keep in touch with Georgia. Once Georgia was living in New Mexico year-round, she went to Taos on occasion; Beck continued to give her gifts of foodstuffs, flowering plants, and blouses in the styles they both favored. After one visit, Beck wrote a mock obituary for "a slightly known citizeness who had lived there for the past 15 years, Rebecca Salsbury James"; she had died, the spoof asserts, by trying to help "the extremely well-known lady artist, Miss Georgia O'Keeffe," who had been unable to zip up a pair of pants (Georgia had recently adopted jeans). After "a succession of rage-strokes," Mrs. James sends a message to say that "everything is very pleasant in Heaven, though she would almost rather be in Hell which she missed only because of her noble act of friendship for Miss O'Keeffe." There is no reply to this odd missive.

Georgia invited the Jameses to spend Christmas with her that year, but Beck turned down the chance for them to trim the tree together, given the need to look after Bill's "critters." After one visit to Taos, Georgia wrote, "I wish you would both come over and look at my world here—it is really very good—more for what is around out doors." Following a visit to Georgia's new home in Abiquiu, Beck wrote to Paul, "She looks well and still gets that 'witchy' look—but it's always fun to see her and talk over 'old times.'" (The next sentence describes Beck's sixty-first birthday party in an implied comparison to Georgia's solitude.) Sometime later, Beck complained, "She is a notoriously bad correspondent."

The somewhat barbed quality of these letters suggests that while Beck's rapport with Georgia eased over time, she could not help comparing herself with the "extremely well-known lady artist." After telling Georgia about her shows in California, Beck mentioned that she had seen Georgia's work in San Francisco. From then on, she sent Georgia reviews of each of her shows. "Here we are after 40 years on the same piece of *pink* paper!" she exulted when both their names appeared in a gallery brochure. Georgia's example was still with her, when Beck sold ten embroideries: "As you used to say about a show when you sold something—'I am not a failure.'"

By then, Beck and Bill had grown very close to the Benrimos. Beck admired Tom's Surrealist-tinged landscapes and saw in Dorothy a kin-

dred spirit. Their rapport, based on their cosmopolitan backgrounds, respect for one another as artists, and shared delight in the absurd, was apparent. They reveled in events like the Casa Feliz poker soirées, with the players in costume and under the influence of Bill's liberally administered booze. One year, the Benrimos made paper miniatures of the Jameses in fiesta garb—a tiny Bill in red trousers and checked jacket with a cigar, and a larger Beck in her signature outfit, toting a gun. Beck's *For Dorothy,* a colcha with gold and silver threads stitched into the wreaths around a gleaming heart, conveys its maker's affections. Dorothy was one of those rare people, Beck wrote, who "carry over into maturity what is most special and pure in childhood."

By the late 1950s, Beck rarely left Casa Feliz. She had begun suffering from joint pain a few years before. When her condition was diagnosed as rheumatoid arthritis, she underwent a variety of treatments. Her let-ters to Paul include details of her prescriptions and injections, including gold salts, then thought to slow the progression of the disease. In 1960, she wrote:

> I am still plagued with arthritis & never pain free—My doctor says it took a long time to get it & will take a long time to get better—but sometimes I wonder if it is worth the effort. . . . I can't get up the studio steps to paint & my hands are not very good for embroidery—besides when one feels so ruddy uncomfortable it's hard to do anything "creative"—Maybe I just don't have the fortitude—but at my age [sixty-eight] it is difficult to summon it.

She spent her days reading, listening to music, and sewing. In spite of her gnarled fingers, she had made a set of embroideries on the theme of the seasons. "I know you would like them—they 'say something.' "

Paul's opinion still mattered to her; their rapport strengthened with the distance between them. "I cannot realize I am 70," she wrote when he sent her another book of his photos as a birthday gift. It gave her pleasure to think of her oils in his house. Recalling the years when Paul photographed her repeatedly, she added, "I once asked you if you plan to publish the group of portraits you made—Or have you given it up?" Her letters do not return to the subject.

The following year, when Paul sent his latest book, Beck thanked him. "What a <u>worker</u> you are—for one who is no longer young. Keep it up as long as you can lest disaster strike you." She had some good news: The Museum of International Folk Art in Santa Fe planned to show her

embroideries. She calculated that she had made some two hundred col-chas and an equal number of paintings, of which seventy-five had sold. "So you see in my 32 years here I have not been lazy!" She added, "If it were not for Bill I don't believe I would want to go on."

That winter, when Beck sought treatment in Carmel, California, for a bronchial complaint, she and Georgia corresponded frequently. Beck thanked Georgia for her gift—a chic wrap dress that was easy to put on because it had "no buttons, zippers, snaps, or fussies." When Beck learned that she was to undergo lung surgery she told Georgia that she would wear the dress to the hospital: "If I leave the hospital in 2 weeks I shall wear my black dress out again. But whatever happens know it will be the last garment I shall wear on this earth whenever the last moment does come along." The operation was a success, and Beck returned to Taos, but there was little improvement in her arthritis: she limped about "like a lady convict with a ball and chain!"

Even so, Beck's handicaps did not keep her from speaking her mind. To a graduate student seeking to learn the conceptual bases of Paul's photography, she wrote, "My experience with every artist I have ever known is that no one of them works with a pre-cerebro-psycholigico-philosophico-psychico concept in mind. Artists put down what they do because primarily they must affirm the things they care for most—people, landscape, seascape, or still life—something they are moved by or that 'begs' to be captured in permanent form." She sent Paul a copy of this letter, which spoke for him but also for herself.

Exercised by what she saw as misleading criticism, Beck wrote to Van Deren Coke, who had cultivated a rapport with her as director of the University of New Mexico Art Museum and enlisted her help on his book, *Taos and Santa Fe: The Artist's Environment*. Coke's account of Beck's career made her so angry that she wrote to protest his "irre-sponsible guesswork." Her choice of subjects had nothing to do with Georgia's: "Yes, I painted flowers—what artist has not—but I have also painted landscapes, adobe houses, the campo santo, birds, the native people." To his claim that her use of sharp edges was inspired by Paul's images, she replied that she favored them because she disliked "fuzzy" ones. Similarly, the idea that she had learned about reverse oils from Hartley was wrong. "Everyone is influenced at one time or another . . . the important thing is whether he or she outgrew that influence." (Beck tried to make up with Coke by inviting him to her next exhibition.)

On May 19, 1963, Bill drove Beck to Santa Fe in time for the opening of her show at the Museum of International Folk Art. Some two hun-

dred people showed up; the one who gave her the greatest pleasure was Georgia. Writing to Paul, Beck rejoiced: "Georgia came from Abiquiu! She thought the show very beautiful and said 'Rebecca, you have certainly sewed your heart into these things.'" Beck sent Paul a copy of the catalog, with color photographs of her embroideries and texts by E. Boyd and Frieda Lawrence. The museum had done a fine job. Just the same, she continued, "pain is my constant companion . . . a rather bitter 'swap' for what we thought would be some wonderful last years together—they have been blasted and we must face whatever lies ahead. But if I am to eventually become bed-ridden I don't want to live."

Paul's concern about Beck's health may have motivated him to go to Taos that summer, when he and Hazel Kingsbury, his third wife, were in the United States. Knowing that they would stop in Santa Fe to see her show, she told Paul to compare a reverse oil and colcha, each called *Devout Woman,* since they were based on the same motif, a church he had photographed. Despite her eagerness for him to grasp the connections between their work, she asked him to book a hotel in Taos: "I'm not 'up' to very much in the way of entertaining—and Bill has enough in taking care of all my needs." She was, however, glad to see Paul and meet Hazel, "to know, in spite of distance and the years that have flown by so fast, that there is still the old friendship." Paul gave the Jameses a print of the Ranchos de Taos church; Beck gave the Strands a colcha entitled *A Quiet Place,* to complement those he had bought. "I am still overcome," she wrote after their departure, "not only by your wanting the things, but your so generous purchase."

That fall, she had some pleasant surprises. Her Santa Fe show was held over; at Paul's suggestion, the Currier Museum, in Manchester, New Hampshire, asked to show her embroideries; Georgia came to see her and talked of sending her exhibition to New York, perhaps to the Museum of Modern Art. "I am pleased she thinks the things good enough," Beck told Paul. "It's hard for me to think of them as 'important' because they were made over the years with no intention of public showing." Some months later, an editor from *Women's Day* magazine who had seen her colchas in Santa Fe commissioned Beck to write an article on the tradition. She was to be paid handsomely; there would be other assignments in the future.

By then, Beck understood that she could take on only a few projects, things she could handle while sitting in a chair. Her embroideries were shown at the Currier Museum the following summer, but there were no reviews; her only satisfaction was seeing her name with Georgia's in

the brochure. After her most recent visit, Beck told Paul that Georgia was "a very true person according to her own lights." She reflected, "40 years have not diminished our friendship & liking for one another—because, I think, we have never 'invaded' one another—or become 'intimate'—although we experienced a great many things together."

Over the next two years, Beck worked diligently to organize her papers in order to give them to archives that would make them available to the public. She began with her father's reminiscences. Her friend Otto Pitcher, an actor in local productions, transcribed the papers concerning Nate's theatrical career to send to the New York Public Library. After a long correspondence with Donald Gallup of the Yale Collection of American Literature, where Stieglitz's papers were held, Beck donated her own, including letters from Stieglitz, O'Keeffe, Hartley, and Mabel Luhan; the album she made to display Stieglitz's photographs of her; her father's books and memorabilia, along with curiosities like Buffalo Bill's moccasins. She advised Paul to think of doing the same. Gallup had come to see her. He was "neat and 'scholarly' without being pedantic."

About this time, the Jameses decided to leave their art collection to the University of New Mexico Art Museum in Albuquerque, which gave them a show. In the catalog, Beck explained that theirs was not a collection "in the strict sense of the word." It included works by "the artists Stieglitz believed in—Dove, Hartley, Marin, O'Keeffe and Strand"—who were, in those days, "in a process of continuous development toward the great stature they would later achieve." Later, she added paintings by Fechin, Benrimo, and Cady Wells, thus putting together "this modest cross-section of work by American artists." Beck sent Georgia the catalog, with the image she included of her "from the Pink House Days"—an allusion to their summer at Mabel's, since Georgia would know that it had been cropped from one taken of them in 1929. Beck did not go to the opening.

By then, her main project had become the restaging of her life. She organized her personal archives to give to the local history museum—scrapbooks from her childhood and school days, with the texts of her poems, songs, and other writings, assorted memorabilia, and binders of photographs of her life in Taos, carefully annotated for the scholars who would one day read them.

The album entitled "Rebecca William," which remained at Casa Feliz, is the most curious of these endeavors. It begins with images of the house, the stage set on which the play of the Jameses' life took place. Next she arranged portraits of the Salsburys in a kind of flashback to her

childhood, with images of her mother, herself, and Rachel, their brothers, and nannies, all formally attired. But just as with the cropped image of Georgia, she repurposed these portraits. Cutting large brown paper frames to place over each image, she covered up her twin and their frilly dresses in a photo of the two girls together to present herself as unique. To "read" this version of her life pre-Bill, one must gently lift the frames that keep one from seeing the whole picture, the family ambience from which she had removed herself. The many joyful shots of her life with Bill are followed by photographs of him before they met; it ends with a set of portraits of him looking fondly at the photographer, most likely his wife.

"I am getting into fields I never knew I would," Beck mused about her collaboration with Dorothy Benrimo. One hundred of Dorothy's images of crosses from local cemeteries, taken with Bill's camera, were to be exhibited at the Amon Carter Museum, in Fort Worth; Beck, who had introduced Dorothy to the director, wrote an essay for the catalog, which was entitled *Camposantos*. Sitting in her chair, she studied these black-and-white images. Benrimo's hope, she thought, was "to capture in some permanent form the illusive quality these simple grave markers evoked. How make real such inner abstract feelings as humility, simplicity, solitude, faith? How communicate outwardly the mystery of death?" Beck hoped that Paul would like the images and her essay, which concludes, "This is a lovely . . . contribution to the esthetic archives of Spanish-American mores as recorded through the perceptive eye and receptive heart of Dorothy Benrimo."

About this time, the Jameses drew up their wills. Each made bequests—to relatives, Taoseños in their employ, and the Arthritis and Rheumatism Foundation, but chiefly to each other. Should both die as a result of an accident, they wished to be cremated and have their ashes scattered on the mesa west of their pastureland. Their wills testify to the care with which they planned the end of their lives. At the same time, Beck set up accounts for Nate Salsbury's children and instructions about the works of art to go to him, along with their house. And she sent Nate the few remaining items that had belonged to her father: canes, cuff links, swords, and suspender buckles.

Given that Bill was younger than Beck, they took it for granted that he would outlive her. His death of a heart attack in 1967 came as a terrible shock. "I do not know if I shall be able . . . to carry this massive burden of grief," she wrote to Paul. "His heart broke long ago—12 years, over what happened to me, and mine broke seeing his break—yet we

could have gone on facing this together." Her greatest comfort had come from Georgia, who took Bill's body to Albuquerque for cremation, then brought the ashes to Taos to be strewn on the mesa: "6+ hours of being in the car—getting home at 9 at night—and she is 80—nobody else has come anywhere near that unforgettable act of friendship."

Rebecca was fortunate in finding two caregivers in town, Raycita Cordoba, a woman from the Pueblo, and Winifred Legge, who had studied art in Paris and conversed with her in French. They were "more than satisfactory," she told Paul, but her life felt "vacant." Still putting her affairs in order, she donated one of the five properties she had bought over the years to the Kit Carson Foundation. The plaque read "In Memory and in Honor of her Husband, Bill James who once lived here."

Georgia visited when she could, bringing vegetables from her garden; Paul sent loving support. "We were much moved by your own account of all that you have been doing in placing and giving away your own precious things to the repositories where they will be seen and appreciated," he wrote. Hers was "a wrenching task and a valiant one." Paul's letter came too late. "I can no longer live without Bill," Beck wrote to Nate earlier that month. "I died the day he did and each day since has been a marking time until I could do all the things I had to do the way I wanted. . . . I am at last free and want release—I want to go in quietude to him." On July 8, 1968, she ended her life with an overdose of medication.

The *Taos News* ran her obituary on page one. Spud Johnson wrote the next day that he was struck by Rebecca's contradictions. "She was tough, and yet she was gentle . . . stubborn and uncompromising, but extremely vulnerable. She was gay and witty—and then sometimes curiously humorless. She was a sensitive, perceptive artist and a lady, yet her language could, on occasion, be as rough as a stevedore's."

In accordance with her wishes, there was no service. Like Bill's, Rebecca's ashes were scattered on the mesa to the west of her pasture. In lieu of an epitaph, her thoughts on the *camposantos* may suffice: "There are hundreds of these blessed fields scattered throughout New Mexico. Commonplace or unusual, crude or refined, these grave markers rise in uncounted numbers as mute, yet eloquent testimonials."

Paul

Paolo Gasparini, *Paul Strand, Orgeval, France,* 1957

Contributors to the Stieglitz memorial had been asked to ponder the question "What has gone out of our lives now that Stieglitz is no longer here." Seeking to evoke "the principles for which he stood, and the spirit in which he worked," Norman placed Strand's tribute after the posthumous appreciations by Demuth, Hartley, and Lachaise and before Seligmann's praise of Stieglitz as the guiding spirit for all who "devote themselves to the quest of revelation."

Unexpectedly, Strand recast his mentor's legacy in the language of

revolution. Adapting Stalin's description of the writer's role under social-
ism, he wrote that Stieglitz would be mourned by "men everywhere who
believe that 'the artist is the engineer of the soul' "; while Stieglitz didn't
use such terms, "they describe the very foundation stone of his faith."
After praising his struggles on behalf of modernism, Strand exhorted the
next generation to carry on the fight: "We realize as perhaps he did not
that the freedom of the artist to create and to give the fruits of his work
to people is indissolubly bound up with the fight for the political and
economic freedom of society as a whole."

By 1947, when the portfolio appeared, Strand's tribute would have
disturbed many who hoped to put such debates behind them. His con-
victions had strengthened over the last decade, when he played a leader-
ship role among cultural "workers" for whom art's purpose was to drive
social change. While the rhetoric of struggle against reactive forces was
still current in *New Masses,* where this tribute first appeared, the maga-
zine would cease publication the following year, when the House Com-
mittee on Un-American Activities began its harassment of left-wing
organizations. Saying more about Strand's beliefs than about his men-
tor's, his homage discomfited those who wanted to remember Stieglitz
in the messianic prose that echoed throughout the portfolio.

· · ·

Soon after Strand's return from Mexico in 1935, he traveled to Mos-
cow with his Akeley camera to join Group Theatre founders Harold
Clurman and Cheryl Crawford. Well received because of their politics,
the trio were invited to the Moscow Art Theatre and to see the latest
Russian films. Strand met the leading film directors, including Eisen-
stein, Pudovkin, and Dovzhenko. Eisenstein, who thought that Strand
was essentially a still photographer, offered him a job even so, but visa
problems kept him from staying on. Still, the creative ferment of these
months in Russia moved him to seek out Americans who shared his
views. He joined the American Labor Party in 1937 and remained a
member for the next decade.

After his return to the United States, Strand joined the film group
Nykino, whose progressive stance inspired its members to make docu-
mentaries illustrating the struggles of ordinary people. At the invitation
of his friend Ralph Steiner, Strand traveled to Texas to make a film on
the dust bowl; Leo Hurwitz, a member of Nykino, joined them. "It was
just fantastic to see that reddish earth blowing," Strand recalled. "We got

to some places where you were right down to the crust of the earth." But Pare Lorentz, the director, showed no interest in the script that Strand and Hurwitz wrote to indict the ranchers whose exhaustion of the soil had brought about the catastrophe. The final version, entitled *The Plow That Broke the Plains,* was "a pretty picture," Strand thought, "but . . . the guts had been taken out of it."

In 1937, Nykino evolved into Frontier Films, the company founded by Strand and Hurwitz to make documentaries that would serve as warnings to their countrymen. "We were very concerned about what was going on in the world," Strand explained. "I suppose other people might have described us as radicals." They were particularly concerned about the Spanish Civil War. Of Frontier's six documentaries, *Heart of Spain,* edited by Strand and Hurwitz from footage shot in Madrid, and *Return to Life,* filmed in Spain by Cartier-Bresson, were shown in support of the Committee to Aid Spanish Democracy.

Frontier Films also obtained a print of Strand's *Redes,* released in the United States as *The Wave;* a local critic called it "an interesting photographic album, but a dull motion picture." Together, Strand and Hurwitz developed an editing style blending Soviet and American techniques. They based their most ambitious film, *Native Land,* on recent Senate testimony about civil rights violations—attacks by corporations on labor unions and atrocities by the Ku Klux Klan—and enlisted the well-known singer/activist Paul Robeson as their narrator. *Native Land* took four years to make and was not released until 1942, just months after the Japanese assault on Pearl Harbor—a time when civil rights issues were lost in the groundswell of pro-war opinion.

Hurwitz, who was almost twenty years younger than Strand, looked to him as a professional artist. "He had the feeling . . . that once you took an idea, you put your teeth in it, you worked with it, you took responsibility for all its corners," Hurwitz recalled. But Strand was hard to know: cranky at times, ungenerous at others. In these years he also acted as a mentor to the young photographers at the Photo League, a progressive group that overlapped with Frontier Films. As an honorary member of the board, he took part in discussions about the degree to which one could create images combining social meaning with artistic merit: "Strand was a kind of patron saint . . . admired by everybody at the League." But he took few photographs, with the exception of his much-reprinted image of a skeleton crucified on a swastika.

Strand made a brief return to nature photography in 1936, during his honeymoon with Virginia Stevens on the Gaspé Peninsula. They

had met at the Group Theatre, where she acted in a variety of plays under the direction of Cheryl Crawford and Lee Strasberg. Virginia was twenty-three and Paul forty-six when they married. She looked up to him. On daily photo shoots in the Gaspé, he taught her to see the material world as he saw it. "I was made aware of things I had never been aware of before," she recalled. Still, "as a human being wanting somebody close," she found Paul's idea of a honeymoon different from her own. "He could not touch you and caress you. . . . I entered the dark wood when I married him." One cannot help thinking that Paul's memories of his time there with Rebecca cast a shadow.

Virginia resumed acting after their return to New York. Over the course of her career, she performed in *Macbeth, The Merchant of Venice,* contemporary plays, including the intriguingly titled *Weep for the Virgins,* and Gilbert and Sullivan operettas. While pursuing her career, she also played a major part in Paul's next project, his portfolio of Mexican photographs. Lee Strasberg suggested the idea of staging the images like a play. Starting with shots taken when Strand first went to Mexico, moving on to architectural facades, then church interiors and worshippers, the sequence would move back and forth to give a sense of place. Virginia took on the role of publisher, including responsibility for reproductions to approximate Paul's originals. Of this project, Strand observed obliquely, "Craftsmanship is built upon years of work—years of experience with and feeling for the materials of the craft."

Paul's feeling for his materials was more acute than his sense of how to nurture a rapport with his wife. Over time, Virginia was increasingly disturbed by his "volcanic angers" and his inability to relate to her except through his art. "Nothing turns him aside or weakens his drive," she remarked years later. "He was never in any doubt about his talent." He agreed to see her therapist but reported after a session that he spent his time talking about photography. Some people could not be analyzed, the therapist explained; Strand was one of them. Perhaps he felt that Virginia's engagement with his work was in itself rewarding: She played a grieving widow in *Native Land.* Strand's photography was "his best effort to render the emotional significance of the object," Hurwitz wrote at this time. His images seemed impersonal, yet they recorded the emotions locked away below their surfaces: They were his "autobiography."

In the mid-1940s, Strand expanded on an autobiographical project of sorts with Nancy Newhall, who was replacing her husband (then on military duty) at the Museum of Modern Art. Newhall asked Strand to help mount an exhibition of his work, the first retrospective accorded

to a photographer and his first in New York since the unsatisfying show at An American Place in 1932. As they looked at his images together, Paul told Nancy about his break from Stieglitz. He had fallen under the spell of Stieglitz's vision of O'Keeffe, but his marriage to Rebecca had not achieved anything like their rapport. Worse, his extended portrait of her had been "forced"; it irritated both Stieglitz and O'Keeffe (he did not mention its effect on Beck). "The message was still too painful to accept," Newhall noted. Strand's vision struck her as somber—unlike that of Stieglitz, who once told her "that Paul had no sense of humor, especially about himself."

Newhall struck a more positive note in her essay for Strand's MoMA catalog. "The work of Paul Strand has become a legend," she began. "Rarely exhibited, its influence has nevertheless spread through the last thirty years of photography." Then, echoing Stieglitz, she called Strand "a discoverer of photographic forms and concepts for our time." Newhall praised his sense of place: "His search for fundamentals that shape the character of all that rises from a land and its people." Noting that his images had been called, variously, "brutal, cruel, tender, selfless, precious, static, timeless, tumultuous, [and] wonderfully alive," she left the final verdict to viewers of the future.

Edward Jewell wrote a cool appraisal of Strand's retrospective in *The New York Times*. His development over the last thirty years was "well illustrated" and his "diversified material" fittingly arranged by groups, of which the abstractions were among the most striking. Jewell admired Strand's close-ups of rocks and driftwood from Maine and the "narrative" of his time in Mexico. But he had little else to say. Like Newhall, he quoted Stieglitz's remarks about his protégé to give "the great dean of American photographers" the last word (Jewell mentioned that lenders to the exhibition included Stieglitz and "Miss Rebecca James"). Beck wrote Paul distractedly that she wished that she could see the show.

Strand's collaboration with Newhall took a more personal turn after his return to still photography. Over time, they found a way of working together on a book in which his images would be complemented by her selection of writings by representative New Englanders. He began with portraits of self-contained individuals encountered on visits to Maine and Vermont. His subjects, who had led hard-scrabble lives, inspired Strand's respect. Their book, *Time in New England*, became an evocation of an American past based on moral integrity—a tacit response to the present.

In 1944, after a trip west for documentary film work that included

stops to see the Jameses in Taos and Ansel Adams in Yosemite, Strand's attitude toward the country changed. He agreed to chair the photography section of the Independent Voters Committee of the Arts and Sciences for Roosevelt, which soon merged with Progressive Citizens of America, a group calling for negotiations with the USSR and an end to war. That year, Strand also did film work for the government and took part in a project with Hurwitz and Newhall, an eighty-foot-long photomontage chronicling the Roosevelt years. In 1945, he was invited by the Roosevelts to the inaugural ceremonies and lunch at the White House, along with some 250 American artists and scientists.

When the war came to an end, Strand returned to the project with Newhall. While he traveled around New England to photograph, she wrote to suggest images that would illustrate the ideas emerging in her choice of texts, such as interiors comprised of domestic objects, to reflect a simple life, or natural prospects, to evoke spaciousness of thought. "The problem was to marry the photographs I had and would take over the next few years to that text," Strand recalled. The marriage of image to text became "a major turning point in my whole development."

It was also a return to the past—to summers when Beck had accompanied him on photo shoots, and times in the apple orchard at Lake George. Strand found himself going back to subjects he had first attempted in Maine—trees standing like sentinels in a sere landscape, the sea's ebb and flow, a shy jack-in-the-pulpit (quite unlike O'Keeffe's bold studies of the plant), along with portraits of New Englanders and the architecture of churches and meeting halls. His most buoyant print, *Apple Tree in Full Bloom,* almost bursts out of its frame. At a time when McCarthyism was casting a pall on cultural life, this symbol of a vibrant national heritage expressed hope for a renewal of the consensus begun in New England, including the "freedom of the individual to think."

By this time, Strand was associated with more than twenty organizations that would be deemed subversive by the U.S. attorney general, starting with the Photo League, which was formally charged in 1947; Strand gave the opening speech at a protest meeting. The FBI had had him in their sights since the release of *Native Land,* along with Robeson and Hurwitz, who would be blacklisted in the 1950s despite his film work for the Office of War Information. Convinced that Strand was a Communist, the FBI took an interest in his sponsorship of Progressive Party leader Henry Wallace's presidential campaign in 1948 and his activities as cochair of the Progressive Citizens of America's arts division.

Strand's marriage came under increasing strain at this time. In 1949,

the year he met the photographer Hazel Kingsbury, he and Virginia were divorced. In the 1930s, Kingsbury had worked for Louise Dahl-Wolfe, a photographer for *Harper's Bazaar,* and during the war she enlisted with the Red Cross to photograph in Europe and the Far East. Hazel's good humor and professional outlook appealed to Strand, and she became his collaborator, the rare person who could accept his exclusive focus on his work while ensuring the conditions in which it took place.

In 1949, Strand's activism came to a head, culminating in protests against the reactionary turn in U.S. politics. That spring, with Aaron Copland and Clurman, he spoke on the "Effects of the Cold War on the Artist in the United States" at the National Council of the Arts, Sciences and Professions Congress for World Peace and joined a call by Ben Shahn and Clifford Odets for a Bill of Rights conference to "speak up against the police state methods of certain Army and FBI officials." The Photo League threw him a farewell party before he sailed to Europe to show *Native Land* at a film festival in Czechoslovakia, where it won an award. In his acceptance speech, Strand defended the Hollywood Ten, the producers, directors, and screenwriters who refused to answer HUAC's questions about their Communist sympathies.

Strand also took part in a conference on cinema in Perugia, Italy, on the question "Do today's films reflect the problems of modern man?" There he met Cesare Zavattini, the scriptwriter for De Sica's 1948 neo-realist classic, *The Bicycle Thief,* which addressed the question. Strand stayed on in Paris, where he worked on an application for a Fulbright Fellowship to make a photographic study of a French village—a project that would further his work on the sense of place. (His application was denied.) He flew back to New York on December 25, 1949, the day after he learned of his father's death.

Over the years, Jacob Strand had become a successful businessman. His company marketed metal casters called "Domes of Silence," to be placed under furniture legs. His bequest made it possible for Paul to live as he wished—free of the need to earn a living and far from the increasingly anti-Communist atmosphere.

Since his time in Taos with Beck, he had dreamed of depicting the life of a village in all its particularities, an idea inspired by his admiration for Anderson's *Winesburg, Ohio.* With this in mind, Paul sailed to France with Hazel in February 1950, and they spent the next two years traveling in search of the ideal village; they never found it. Meanwhile, he took hundreds of photographs of provincial France and a way of life that would soon disappear. He and Hazel were married in Paris in 1951 and

would remain there until 1955, when they bought a house in Orgeval, a small commune to the northwest of the capital. There, Paul arranged for the construction of the darkroom he had always wanted and Hazel turned her attention to the large overgrown garden.

The idea of another photo book took shape when the Strands met Claude Roy, the young French poet and Communist Party member who became his collaborator. Over the next two years, Roy would write texts to complement Strand's images, plan the layout, and arrange for publication. Roy invited the Strands to his family home, where his rapport with the villagers made them feel that they had entered "la France profonde"—the culture of rural France as distinct from that of Paris. Strand was unusual, Roy thought: "He did not insinuate himself into French life like someone coming from the outside. . . . He let himself drop into the taciturn depths of the French nation with the submissiveness of a pebble that falls to the bottom of a well, making all kinds of everyday discoveries on his way."

These discoveries included melancholy landscapes, cemeteries, storefronts, and village walls, their facades unchanged apart from the marks of time. For one, *In Botmeur, Finistère, France*—where two buildings frame a pollarded tree that seeks to break out of its confinement—Roy composed a Verlainesque poem in imitation of its forms: "The house would like to become a tree nourished by the soil / . . . the tree ends up with a past that knows better than it does. . . ."

Strand also took a number of portraits, relying on Hazel to establish a rapport with potential subjects (she spoke French; he did not). In Douarnez, a Breton fishing town, he photographed four elderly fishermen as if they were monuments to an older way of life; for *Young Boy, Gondeville, France,* he had his nineteen-year-old subject hold the pose while he set up his equipment. The portrait captures the youth's annoyance at having to stay still. Known in France as *Le Jeune homme en Colère,* the photo seems to allude to the country's postwar mood. For Strand, such portraits transcended their moment to reveal the core of each person. He sent a copy of the book to Rebecca for her birthday. His images, she replied, "tell me you are still the same 'you'—that there has been no 'falling off' in intensity and feeling."

La France de Profil was published in 1952. Critical response to its side-on profile was muted: "The stubborn preoccupation of Paul Strand appears to be the achieving of pictures beyond the reach of time. . . . He aims his camera at eternity." Strand's portrait of the country was too static, some thought, given the contemporary taste for images plucked

from life—the poetry of the streets depicted by Cartier-Bresson or in albums like Izis's *Paris des Rêves*.

Knowing that his approach was best suited to a rural locale, Strand met Zavattini in Rome to discuss their working on a portrait of an Italian village. After scouting several communes near Naples (which he rejected as too poor to serve as his ideal), Strand settled on Luzzara, Zavattini's hometown, in the Po River valley. It was not picturesque, but "the plainness was a challenge—it meant that you had to look closer." To do so, he relied on the services of Valentino Lusetti, a sharecropper who had learned English as an American POW. Lusetti helped allay the villagers' suspicions of Strand, took him to the local factories (where straw hats and Parmesan cheese were made by hand). He also introduced him to his family—the widowed matriarch and five brothers grouped before their home in what has become Strand's best-known image of Italy.

Meanwhile, Hazel chronicled Paul's activities with pictures of him at work—photographing hats, the cheese factory, or the café, while taking care to exclude signs of modernity like cars or mopeds. One day, he approached a little girl on her way to the grape harvest, an encounter she recalled decades later. "Scared of this very serious man who never smiled," she was puzzled by his bulky camera, never having seen one, and his request to take her picture. She returned in her best dress; Paul asked her to change into something old, then placed her in front of a weathered wall and put a straw hat on her head for a portrait entitled *Farmer's Daughter,* which treats her more as a type than as an individual.

For his portrait of the Lusettis, Strand posed the five brothers around their mother, an erect figure in the doorway of their home. As matriarch, she epitomizes the strength needed to endure decades of hardship on sharecroppers' earnings. (She took Valentino's place in the fields while he worked with Strand.) Zavattini's text would speak in her voice to explain their past: Four of her children died in infancy, her husband died after years of politically motivated beatings, her surviving sons' military service distanced them from one another, yet each was bound to her and to the land. Juxtaposed to Strand's portrait of the family, the text underlines the lingering effects of the Fascist regime and World War II.

The Lusetti family portrait appeared on the cover of the book published in 1955 as *Un Paese*—a felicitous title in Strand's view, in that *paese* means both a country and a land or village. Strand's "lesson in humanity" came out at a propitious moment, an Italian historian notes, "when the realistic lessons of his pictures struck the right note both culturally and politically." (In these years, artists, writers, and intellec-

tuals like Zavattini were counting on the new postwar regionalism as a means to unify the country.) But the fine paper and beautifully printed images made the book too costly for most readers. Moreover, another critic writes, *Un Paese*'s "reconciliation of Strand's solemnity with Zavattini's popularism" made Luzzara look like "any village."

Over the next twenty years, Strand would strive to portray village life as "the common denominator of all humanity." Whether in the Outer Hebrides, Egypt, Ghana, Morocco, or Romania, he chose his subjects to emphasize the dignity of ordinary people—"the plain people of the world, in whose hands lie the destiny of civilization's present and future well-being." In these years, Steichen's 1955 "Family of Man" exhibition, which portrayed the common aspects of diverse cultures, toured the world (Strand was not among the 168 American photographers included). But unlike the best-selling book that complemented Steichen's exhibition, Strand's books were rarely available in the United States, making him feel even more cut off from his own country.

The Strands adapted to the rhythms of life in Orgeval with the help of the Letutours, a local couple who were devoted to them. Hélène, the housekeeper, took on the task of spotting of Paul's prints when Hazel retired to her workroom, where she made quilts. Raymond carried out Hazel's plans to enlarge the garden. She surprised the couple by planting vegetables suited to American tastes—corn, squash, and cucumbers for dill pickles. Hazel, who was a good cook, made pies and cookies, jam from the homegrown pears, and Sunday roasts for their friends, which were followed by sessions in the living room, where they admired Paul's latest prints. Everyone sat quietly while Hazel removed their tissue paper wrappings. He rarely spoke about his work, a friend recalled: "Talking about it shattered the illusion." If people saw what he knew was there, he would open up; if not, he remained aloof.

At Claude Roy's suggestion, Strand went to Paris and the provinces for another project, portraits of a variety of French people, including artists and intellectuals. It was not necessary to talk to his subjects, Strand believed. "Whether I like a person or not is not really pertinent." Still, he was moved to meet Picasso, who expressed his gratitude to Stieglitz for bringing his work to America. Malraux was "not very warm," but Marcel Marceau was "affable" and his wife "a real Botticelli." His favorites were Marcel Cachin, a founder of the French Communist Party, and the Nobel laureate Frédéric Joliot-Curie, also a Communist. The book was never published because the publisher felt that too many prominent people had been left out.

By the mid-1950s, Strand was focusing his attention on Scotland's Outer Hebrides. He was attracted to this rugged Gaelic-speaking locale after hearing its music on the radio. He and Hazel spent three months on South Uist and nearby islands, photographing this windswept land—starting with the grassy fields that give the islands their local name, Tir a'Mhurain. Once again, he took portraits of people who had endured under harsh conditions: "Here are fine people born of a rich culture hundreds of years old, tenacious in the face of all hardships." He worried about their future: "Can they make this island and their own lives part of the world as it develops?" Hoping that these questions would emerge in collaboration with the writer Basil Davidson, Paul and Hazel studied his images after their trip to see how different pairings spoke to one another, and to Davidson's prose. Composing the book they called *Tir a'Mhurain* was like making a movie, Strand thought: "a montage problem, in which a movement must be created, of variety and meaning." It was not published until 1962, when its outlook seemed dated (a missile range had just been established on the island).

By then, the Strands were taking it upon themselves to depict ancient lands in the process of transformation. Over the next decade, as industrialization brought radical change to many societies, they spent extended periods in Egypt, Morocco, Ghana, and Romania. In 1959, they went to Egypt at the suggestion of James Aldrich, an Australian writer, who told them about the changes under Gamal Abdel Nasser and suggested the idea of a book. They chose to concentrate "on the human material the Egyptian revolution is working with," Aldridge wrote in the introduction, "to show that in fact Egypt is still incredibly old, even at the moment when it is exhilaratingly young." This double perspective is born out in Strand's images. He photographed engineering feats like the Aswan Dam, a steel mill at Helwan, and the young people whose lives were being changed by the new order, along with iconic figures: a cordial sheikh, and the villagers who invited the Strands home for cups of strong coffee. A local writer praised their efforts when *Living Egypt* was published: "The sentiment is not of the condescending Westerner, but of the man who understands the Egyptians for what they are and what they will become."

In the 1960s, when the promises of modernization held sway in developing countries, Strand would continue to juxtapose images of industrial facilities with portraits of the people whom they were meant to serve. Through Basil Davidson, who had written books about modern Africa, Strand received an invitation from Kwame Nkrumah, the presi-

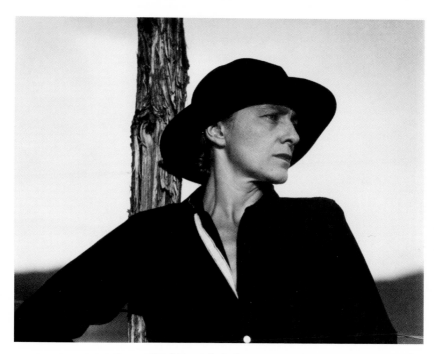

Paul Strand, *Rebecca*, 1930

Paul Strand, *Campo Santo, New Mexico*, 1932

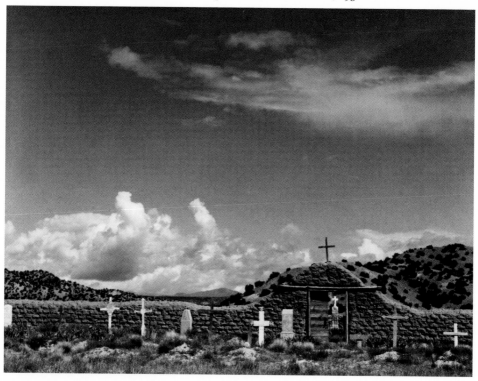

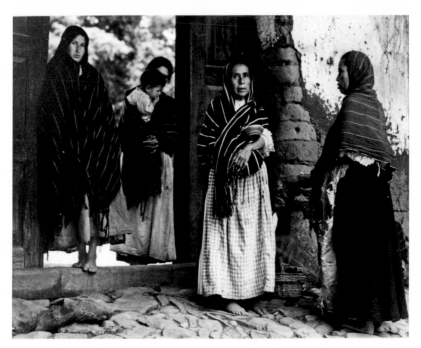

Paul Strand, *Women of Santa Anna, Michoacán, Mexico,* 1933

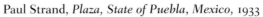

Paul Strand, *Plaza, State of Puebla, Mexico,* 1933

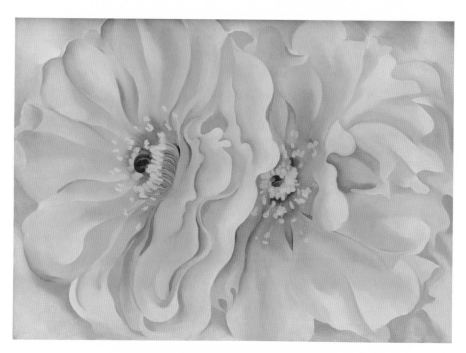

Georgia O'Keeffe, *Yellow Cactus*, 1929

Georgia O'Keeffe, *The Lawrence Tree*, 1929

Georgia O'Keeffe, *Black Cross, New Mexico*, 1929

Georgia O'Keeffe, *Rust Red Hills*, 1930

Georgia O'Keeffe, *Sky Above Clouds III*, 1963

Rebecca Salsbury James, *Walking Woman*, 1946

Rebecca Salsbury James,
*Edge of the Campo
Santo, Taos, N.M.*, 1953

Rebecca Salsbury James,
Fire and Air, c. 1950

Rebecca Salsbury James,
Earth and Water, 1950

Rebecca Salsbury James, *Winter in Taos*, 1948

Rebecca Salsbury James, *Paul*, 1934

dent of Ghana, to portray his country's transformation since independence. Strand again photographed gleaming structures (the turbines at the Volta Dam, the oil refinery at Tema), along with the workers at these sites, in an implicit statement of faith that modernization would benefit ordinary people. It is interesting that his images of Ghanaians are often less tightly composed than his earlier work, more attentive to changing realities. *Ghana: An African Portrait* did not appear until 1976, after Nkrumah had been deposed. Still, this portrait of Ghana under his rule, Davidson wrote, held "a wider meaning, with [the] underlying sense that is valid for the whole of independent Africa."

As one studies the photographic record of Strand's travels in these years, it is not always obvious that they were made possible by his partnership with Hazel. In 1971, he would write, "Over the past twenty years she has shared and helped to resolve the technical, esthetic, and above all human problems which our explorations together raised"—a fair account of her role, yet something of an understatement. Over the years, Hazel developed his negatives, spotted his prints, and handled his correspondence with museums and publishers. She also made extensive preparations for each of their trips, compiling maps and equipment, and seeing to matters like visas. On location, she sketched sites to be photographed, took notes on technical issues, and documented Paul at work, while conversing with onlookers, often in sign language. Her own photographs comprise a diary of their collaboration, which allowed him to work without distractions. "Once Paul gets under the dark cloth, he's completely oblivious of everything," she told a friend.

When Davidson first met the Strands, Hazel was suffering what she called "wear and tear." (Davidson noted, "Nothing Paul and I did together was without her creative interest and support.") At sixty-five, Paul was "heavily built, slow of movement . . . measured rather than slow of speech, picking words in his own style." The couple's rapport, Davidson thought, was based on "a long mutual trust given lively edge by the affectionate abrasions of companionship." He sympathized with Strand as a victim of the Cold War. The FBI had tracked his movements for years; his passport was revoked from 1955 to 1958, which meant that he could not leave France. When difficulties arose about the French edition of their Hebrides book, Davidson also witnessed Strand's intransigence when it came to defending his work. His insistence on technical excellence, he wrote, "functioned as a kind of justice towards his subject, his medium, and himself."

In 1965, Strand received a letter from Michael Hoffman, the pub-

lisher of *Aperture,* a photography magazine that sought to emulate *Camera Work.* His introduction to Strand by the Newhalls, who were among *Aperture*'s founders, gave the young man a kind of pedigree. Hoffman had just published a book by Weston; now he agreed to republish Strand's *Photographs of Mexico* in a new edition entitled *Mexican Portfolio.* When Strand returned to New York in 1967, Hoffman struggled to meet his standards. He found the one photogravure press with vintage machinery that allowed the printer to work by hand, as well as handmade paper from France and a lacquer that would give Strand's prints the desired luminosity. With this edition of the *Mexican Portfolio,* limited to one thousand copies, Strand began a collaboration with Hoffman that would lead to his again becoming known in the United States.

That year, exhibitions of his photographs were held at the Worcester (Massachusetts) Art Museum, the San Francisco Museum of Modern Art, and the Sunset Center in Carmel, California. The following year, Dorothy Norman established the Stieglitz Center at the Philadelphia Museum of Art, with Michael Hoffman as adviser—at which point Hoffman began working with Strand on plans for a full-scale retrospective. More exhibitions followed, in Belgium, the Netherlands, and the United States. The Strands decided to rent an apartment in New York from Paul's friend Jim Aronson, the founder of the left-leaning *National Guardian.*

In these years, Paul kept in touch with Beck and sent her copies of all his books, including the 1967 *Mexican Portfolio.* Writing to console her after Bill's death, he asked her to leave the portfolio to the New Mexico Museum of Fine Arts. By return, she sent two of her photographs of him and gave a third to the Beinecke. "I seem to move in a dream in some darkened landscape," she wrote, "going through motions of duty and responsibility." Yet she was glad to know of Paul's successes. His reply months later said how busy he had been and applauded her efforts to set things in order. The letter arrived after her death. Otto Pitcher wrote to say that Beck had wanted Paul to have a small white shell that he had given her years before. Paul agreed that this keepsake be sent to New York and asked Pitcher to make certain that her copy of the *Mexican Portfolio* made its way to the museum, a matter that preoccupied him until he learned that it had reached its destination.

By this time, Strand and Hoffman were engaged in plans for the two-volume catalog that would accompany his retrospective. Walter and Naomi Rosenblum, friends from progressive photography circles in New York, suggested ways to structure his work; Catherine Duncan,

an Australian writer living in France, took on some of what had been Hazel's job by editing the text and keeping track of its multiple versions. The first section, "Camera Work, Early Personalities," was a backward glance within the book's overall review. It included one portrait each of Stieglitz, Marin, and Lachaise (but none of O'Keeffe) and two of Paul's over one hundred portraits of Rebecca: *Rebecca Salsbury,* a head shot from 1921, and *Rebecca's Hands,* taken two years later.

The vast retrospective, with nearly five hundred photographs, toured the United States for two years, traveling to St. Louis, Boston, New York, Los Angeles, and San Francisco. Strand approved of the way it was hung, with sculpture by Picasso, Brancusi, and Lachaise in dialogue with the images, and he felt vindicated by the response. "Paul Strand is one of the legendary names in the history of American photography," the *Times* declared. "Mr. Strand remains to this day a vital photographic artist." Strand's art exhibited "the beauty of soberness," another critic mused. He continued, "The effect of seeing so much Strand is to feel yourself elevated to a level of noble and pure sensations. His language—his plain, documentary-like, straightforward style—has a modern feeling to it, but the story he wishes to tell is a 19th-century one, or at least one that is far from us in time. Like other members of the group that periodically clustered around Alfred Stieglitz."

In interviews, Strand credited Stieglitz with launching his career but took care to distinguish his starting point from that of his mentor. On the importance of emotional content in photography, he said that understanding mattered more than feeling—to his mind, "a very easy way to escape reality." Strand thought that he had grown as an artist by meeting reality on its own terms. His satisfaction is evident in his remarks on photography as an art that offers "something new through which the human spirit and mind can express themselves." While some still saw it as a mechanical medium, this attitude was waning now that museums were starting to collect photographs.

During this time, the Strands often stayed in New York. Michael Hoffman introduced the photographer Richard Benson to Strand, with the idea that Benson might print for him, though Paul had never allowed anyone except Hazel in his darkroom. John Walker, a young Canadian who showed Strand his own photographs, asked if he could make a film about him. To his surprise, Strand agreed. When Walker asked which images he should look at, he said, "It's what *you* see that's important."

In 1973, Strand was named a fellow of the American Academy of Arts and Sciences; the following year, he gave extensive interviews to Calvin

Tomkins, whose *New Yorker* profile evokes Strand's pleasure at his long overdue recognition. He also enjoyed speaking with the young photographers who sought him out. Asked if his retrospective had broken the barrier to seeing photography as art, he replied, "I don't want to give the impression that I brought this about single-handedly. All I would say is that this exhibition was such a force, and the response was so strong, that the opposition has become less and less."

During these years, as Strand's eyesight weakened, he continued to make prints, with Hazel serving as his eyes in the darkroom. His vision was restored after cataract surgery in 1973, but he was often irritable about technical matters and became even more dependent on Hazel. Yet he never stopped working. A friend observed, "He has a one-track mind, and nothing gets in the way of what he wants to do."

In 1974, the Strands learned that tests for Paul's chronic shoulder pain revealed that he had bone cancer. He went back to New York for treatment, which did little to alleviate the pain. By 1975, his life was restricted to Orgeval. Their walled garden had become a world of its own, edged with flowers, herbs, and wisteria climbing up the walls. Paul photographed it in all seasons from his bedroom window and close-up, peering into layers of leaves and branches with an elegiac sense of natural cycles. (At his request, part of the garden was left untouched.) He gave these images titles that suggest his state of mind: *The Apple That Fell, Iris Facing the Winter, Great Vine in Death*. By this time, he was working with Catherine Duncan on the project he called *The Garden Book*. "As we worked, the photographs of flowers grew more and more evanescent," she recalled, giving way to "grave, almost austere" images with titles like *Revelations*.

Although Paul was often ill, he also agreed to work on two portfolios for Aperture with Richard Benson, who came to live with the Strands in 1975. Paul hobbled downstairs to check each step of the process; as he grew weaker, Benson took the prints up to his bedroom for him to inspect. The first portfolio, called *On My Doorstep,* would contain eleven photographs from different periods of his life, chosen from the yellow boxes of negatives kept by his bedside and under the bed.

One day, Paul opened one of these boxes and found portraits of Rebecca that he had not seen for years and had never printed. Benson sensed that it upset him to sort through these negatives. For the portfolio, Strand chose the headless image he called *Torso, Taos, New Mexico, 1930,* which shows Rebecca's voluptuous body, cut off above the breasts and below the pubic hair. "We couldn't get the print to look right," Ben-

son recalled. Paul asked Hazel to bring them one of her silk scarves to tie on the lens: "The exposure was ruined by the passage of the light through the silk, but the print looked terrific." The young man had the impression that Rebecca had been "a live wire." Others remembered the episode differently: "Rebecca's torso in its strange and shocking nudity gave us the ghostly shiver of voyeurs."

Paul was still not satisfied. He told Richard to use vintage paper for some additional prints of *Torso*. "Spurred on by my wish to be rid of that damn picture we had already worked so hard on," Richard said, he did as he was told. The new prints pleased Paul but had to be destroyed because they exceeded the limit set for the portfolio. It is likely that seeing them revived Paul's complicated feelings about his rivalry with Stieglitz. Getting the nude image of Rebecca to match the idea in his mind would have brought some comfort.

Strand found the strength to keep working with Benson. During this time, he told a visitor, "When you come to the end of seeing—when seeing is only looking—then you've reached the end of your road. I don't know, but it seems to me that if I could go on for another fifty years, I'd have no hesitation in saying that I would be very busy." (He was eighty-five.)

Strand made his definitive choice of images for the second portfolio, which he entrusted to Benson for decisions about printing. Soon thereafter, he became bedridden and refused to eat or drink; Benson kept watch at night while Paul remained in a semicoma. Strand died on March 31, 1976, after suddenly sitting up and exclaiming, "*All my books!*"

· · ·

That year, the Strand retrospective that had begun in Philadelphia started its European tour, over the next two years traveling to London, Stockholm, Paris, Amsterdam, and Berlin. Not long after his death, the Paul Strand Collection, composed of his papers, correspondence (including letters from Alfred, Georgia, and Rebecca), work prints, and master prints, was set up at the Center for Creative Photography in Tucson, and the Paul Strand Foundation (later part of the Aperture Foundation) was established by Hazel Strand and Michael Hoffman.

During these years, John Walker began the interviews and patient reconstruction of Strand's life that would result in his prizewinning film, *Strand: Under the Dark Cloth*. Thinking about his subject in relation to himself, Walker observed, "It turns out his photography was detaching

him from his world. . . . He was somewhat detached from the human-
ity that he was trying to capture." Fred Zinnemann agreed with this
assessment: "He didn't have much deep contact with people. He loved
humanity in the abstract rather than in the specific."

Walker also interviewed Hazel, who returned to the United States a
few years after Paul's death. By then, she had lost the enthusiasm that
she had once had for photography. Thinking back on her years with Paul
and what mattered to him, she said of his immaculate prints, "They
were his women, they were his children, they were the love of his life."

Georgia

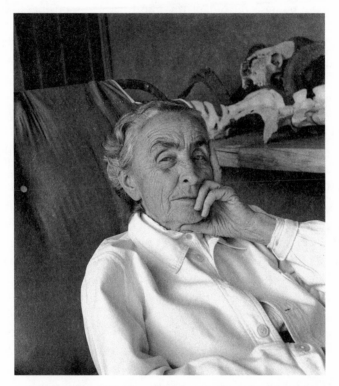

Todd Webb, *O'Keeffe on the Portal, Ghost Ranch,* 1963

Georgia did not contribute to the *Stieglitz Memorial Portfolio.* She would spend the years after Alfred's death paying homage in her way—settling his estate, donating his collections to institutions, organizing his archives, and choosing the repository where they would be housed.

Settling Alfred's affairs touched her deeply. She coped with her mixed emotions while working with James Johnson Sweeney at MoMA to plan two Stieglitz exhibitions—one of his photographs, the other of his art collection. The press release announced that both would be held "at the express request of Georgia O'Keeffe, executrix of the Alfred Stieg-

litz Estate." O'Keeffe's resolve is not surprising given Norman's push to assert herself as his memorialist. (Norman believed that Stieglitz had made *her* his executrix but had changed his will at O'Keeffe's insistence.)

In preparation for the MoMA shows, Georgia made small prints of Alfred's photographs. That spring, she sent Beck fourteen prints of his portraits of her, for which Beck made a small hand-stitched album as a showcase. Some of these portraits would be in the exhibition, Georgia wrote: "I am going a bit out of my mind with this business. . . . I am ready to be finished with it and be a painter again."

After the two shows opened on June 10, 1947, the *Times* ran Jewell's review under the headline HAIL AND FAREWELL. Several portraits of O'Keeffe, among them her hands holding a thimble and, ten years later, a skull, were included, but there were none of Norman. (Upset that she had been left out, Norman photographed the sign outside the museum in a shot recalling Stieglitz's photo of the Flatiron Building.) But the *Times* gave Norman the last word: Jewell ended by announcing the publication of her portfolio, with relevant details for buyers.

Still, Georgia would have ample opportunity to shape Alfred's legacy over the next three years with the help of Doris Bry, the Wellesley graduate she hired to manage the sorting process. Bry, who had been working with Norman, felt that she could not cope with both women; she devoted her time to O'Keeffe, whose no-nonsense manner she preferred to Norman's "slushiness." Bry would recall, "Working on this material with O'Keeffe was my graduate school. Later I realized that she had been training me to look after her own estate."

From the more than 2,500 Stieglitz originals, O'Keeffe chose what she called the "Key Set"—sixteen hundred master prints for the National Gallery of Art, the most important part of his estate. In each case selecting the best examples, she included the 331 photographs he had made of her between 1917 and 1937, and from his more than 150 photographs of Norman, she chose 19 of the more modest portraits.

To disperse his art collection, some 850 pieces, including work by Rodin, Matisse, Brancusi, and Picasso, African sculpture, and prints by pioneer photographers as well as by friends like Strand and Steichen, O'Keeffe sought the advice of trusted associates—the curator Daniel Catton Rich, the Stettheimers' friend Carl Van Vechten, and her financial adviser, William Howard Schubart, who was Alfred's nephew. The bulk of the collection went to the Metropolitan Museum; the remaining works were divided among the Philadelphia Museum of Art, the Art Institute of Chicago, the Library of Congress, and Fisk University.

Once her plans were finalized, O'Keeffe wrote a statement for the *Times*. "Stieglitz often said that he didn't collect pictures, that the pictures collected him. I think he had no particular feeling of ownership . . . he left it for me to decide." Still, she recoiled at the editor's insertion of her status as his widow: "Kindly print the article as I wrote it or do not print it at all. I would prefer not to mention the fact that I was married to Stieglitz."

Bry was given the task of organizing Stieglitz's archives—over fifty thousand pages of correspondence, files, scrapbooks, family documents, and photographs. Impressed by Donald Gallup, whom O'Keeffe met through Van Vechten, she decided to entrust Stieglitz's papers to Yale. The papers would be shipped to New Haven over the next few years, but she restricted access to his correspondence with Emmy, Kitty, and Katharine Rhoades and stipulated that their own should be sealed until twenty years after her death. When financial support for the archive did not materialize, she donated the funds herself.

O'Keeffe had been financially independent since the 1930s. With her inheritance (the equivalent of over $150 million today), she was wealthy. Moreover, she owned two houses in New Mexico—her base at Ghost Ranch, where she lived in the 1940s when not in New York, and an old adobe in Abiquiu being restored by Maria Chabot, the young woman who had, since 1941, been seeing to O'Keeffe's needs there. Chabot completed renovations in 1949. That year, after concluding her affairs in New York, O'Keeffe returned to New Mexico for good.

Moving had long been her way of escaping to a sense of greater freedom. Even so, O'Keeffe's farewell to the city where she had lived for nearly thirty years stirred up the complex emotions implied in her 1949 painting of the Brooklyn Bridge. Unlike recent depictions of this epic symbol, O'Keeffe's is deeply personal—perhaps "an abstract double portrait of herself and Stieglitz." Their rapport, figured in the heart shape formed by the network of cables below the bridge's neo-Gothic ogives, is also implied in the gradation of blacks, whites, and browns—the hues of Stieglitz's medium. Yet the composition leads one's eye beyond the bridge to the blue sky "calling—as the distance that has always been calling to me" (as O'Keeffe wrote of another blue horizon).

Georgia wrote to Anita Pollitzer that she had not yet put the past behind her: "I still have so many tag ends of Alfred's affairs to attend to. . . . I will never be finished." There was the matter of the Place. With the help of Bry, who came to Abiquiu that winter, Georgia turned Alfred's haphazard accounts of her work into a consistent inventory, then put her

mind to closing the gallery. She asked Beck to mark the occasion with a joint show of her reverse paintings on glass and Georgia's canvases. When Beck bowed out due to apprehensions about New York, Georgia replied, "You make me feel very tough that I can still start out for that horrid old town."

"Georgia O'Keeffe, Paintings 1946–1950" failed to excite much interest in the art world, where the loose, disruptive canvases of the Abstract Expressionists held sway. The exhibition, including eight canvases entitled *In the Patio,* nine of cottonwood trees, and assorted landscapes and flowers, emphasized her southwestern sources, a lexicon by then at odds with the trend toward subjectless art. O'Keeffe's *Brooklyn Bridge,* her only canvas from the Stieglitz era, hung next to the somber *Black Place Green,* a juxtaposition that dramatized her turn to the majestic paintings for which she would increasingly be known.

O'Keeffe's new show received faint praise. The *Times* called her "an enigmatic and solitary figure in American art"; the critic's somewhat tepid review began, "Admirers of the decorative art of Georgia O'Keeffe may well encounter surprise"—the surprise being her choice of trees rather than bones or flowers, and the fact that they were "suggested rather than realized." McBride noted her pared-down technique, "an increased urge to dispense with all fripperies."

Georgia maintained her composure despite the lack of enthusiasm. "I have always been willing to bet on myself," she told Schubart. "I dont even care much about the approbation of the Art world." Once in New Mexico, she rejoiced, "I can not tell you how pleased I am to be back in this world again. . . . I feel about my friends in N.Y. that I have left them all shut up in an odd pen that they cant get out of."

O'Keeffe's world offered her more than the chance to dispense with "fripperies." Since her discovery of Ghost Ranch a decade earlier, she had been working to remake her life in that landscape: "All my association with it is a kind of freedom," she observed. In 1937, after three summers at the dude ranch, she moved to an adobe on the property, two miles from the main house—in direct communion with the landscape. O'Keeffe striped pinkish reds and yellows across her canvases to depict the cliffs looming beyond the ranch (*Red and Yellow Cliffs*) and limned the distant Pedernal mesa in glowing blues (*Red Hills with Pedernal*). The Pedernal, her "private mountain," would recur in numerous compositions, paired with a totemic deer's skull or framed by a shape suggesting a pelvic bone. O'Keeffe bought this adobe in 1940, despite its lack of heat or running water, because she loved the solitude.

But it was a difficult place to inhabit by herself. In 1940, she met Maria Chabot, a young woman whose local knowledge and independent mind appealed to her so much that she invited her to Ghost Ranch. Chabot had left school at fifteen. A Spanish speaker and an aspiring writer, she had lived in Mexico, studied Spanish colonial artifacts, and created the craft markets in Santa Fe as part of her work with the Association of Indian Affairs; when they met, she was running the ranch of O'Keeffe's friend Mary Wheelwright, who collected Navajo art. Chabot offered to manage O'Keeffe's encampment so she could devote herself to painting. Each summer, Chabot laid in supplies, kept house, and organized expeditions to O'Keeffe's favorite spots, including the other-worldly rock formations she called "the White Place," which she painted after nights camping amid its towering cliffs and spires.

Maria's spirit of adventure complemented Georgia's in other ways. During the war years, when food was rationed, they worked to be self-sufficient. Meals were often made with canned goods enhanced with spices. Georgia told the Stettheimers about scouring the mesa for a plant called *chimaja:* "I loved walking in the low sun—evening light through the red and purple earth—bending or kneeling often to pick the small fragrant leaves. . . . It entertains me too—to find something to eat—growing wild out in that bare place." After Maria planted fifteen acres of beans, Georgia boasted, "We manage very well—canning and drying and preserving. . . . Those beans mean steady contact with the Spanish people of the valley."

Her interest in local ways grew once Chabot began supervising the restoration of O'Keeffe's Abiquiu house, which would take four years. Chabot laid out the rooms, chose the cedar logs for the ceiling, turned the stable into a studio, set tiles at the door to the enclosed patio, all while adapting vernacular designs. Bricks were made from earth on the site, then finished by the village women: "It was a bright clear day and is quite wonderful—women on scaffolds against the sky . . . men mixing a vast pile of mud for the women to plaster with. It is really beautiful to see and the mud surface made with the hand makes one want to touch with the hand—and there it is soft against the sky."

O'Keeffe's response to her new home reflected her ties to Chabot, which were not, however, without disagreements. "I don't want to know about the private lives of people who work for me," she declared. Their rapport was muddied by the fact that Chabot worshipped her employer. "You told me honestly that I was not the type you would have as a friend," Maria wrote after a quarrel. "What I've been to you amounts to utility,

and what you have been to me was and is enlightenment." Years later, after O'Keeffe had dismissed Chabot, the young woman admitted that their relationship had been unbalanced. But their bond was not sexual, as some have thought it was: "I would not say in any sense of the word was Georgia a lesbian. Her life was about work, not sex. She was not interested in human relationships."

What did interest Georgia were her surroundings. She described her Abiquiu vista to Arthur Dove as one painter to another: "I wish you could see what I see out the window—the earth pink and yellow cliffs to the north—the full pale moon about to go down in an early morning lavender sky . . . pink and purple hills in front and the scrubby fine dull green cedars—and a feeling of much space."

The sense of being both inside and outside was equally pronounced on the patio. "The wall with the door in it was something I had to have. It took me ten years to get it—three more years to fix up the house so I could live in it—and after that the wall with a door was painted many times." Her fascination with this site would produce the increasingly abstract patio paintings that meditate on her home's embeddedness in the earth from which it was made.

When the Abiquiu house was completed, Georgia turned her attention to the garden. Describing it like a canvas, she told McBride, "lots of startling poppies along beside the lettuce—all different every morning—so delicate—and gay—My onion patch is round and about 15 feet across—a rose in the middle. . . . I dont know how I ever got anything so good." Georgia took charge of ordering seeds, planting, weeding, composting, and watering the garden. She told a friend, "It has surprised me to feel what a warming difference a garden can make in ones life."

Visits by friends brought other satisfactions. In 1949, Georgia invited Beck to spend Christmas with her. If Beck had small candles and holders, they could trim the tree outside. "If you haven't," she said, "we will fix up something anyway—We always have." The next year, Spud Johnson and Brett drove from Taos for Thanksgiving. It was "stimulating and satisfying to be with her," Spud wrote; Brett was inspired to pick up her paints on their return. Other guests included Georgia's sisters Catherine and Claudia; Doris Bry, who was acting as her agent in New York; and Anita Pollitzer, who was writing an article about Georgia. Anita was surprised to find life in Abiquiu "as comfortable as on 54th Street." Still, Georgia emphasized that she was not a social being: "There are so many wonderful people whom *I can't take the time to know.*"

Not all visits turned out well. After Henwar Rodakiewicz's divorce

from Marie Garland, he went to see Georgia with his new wife, Peggy Bok, who became her close friend; soon they, too, divorced and Peggy remarried. In 1947, Henwar persuaded Georgia to take part in a film about New Mexico for a State Department series on artists. The short black-and-white film presented a stern-faced O'Keeffe hauling in bones from the desert: It was not a flattering portrait. She and Henwar quarreled; their friendship came to an end. The release of *Land of Enchantment* in 1948 launched O'Keeffe as icon, the reclusive artist attuned to her austere landscape.

Pollitzer's article for *The Saturday Review,* "That's Georgia," developed the legend of her friend as desert dweller. She compared her to the Chinese sage Sou Tsen-tsan, whose verses—"I think of neither life nor death/I honor painting"—introduce the article: "A solitary person, with terrific powers of concentration, she is so in love with the thing she does that she subordinates all else in order to win time and freedom to paint." On reading the piece, Georgia told Anita of her "odd feeling of there being something religious in your way of doing it." Rereading it, she noted, "You seem to be on the way to becoming an authority on me," and agreed to Anita's plan to write a full-length biography of her.

O'Keeffe liked to say that she had given away everything that tied her to the past. But it kept catching up with her, she informed Schubart, when a truck came from New York with crates of her belongings. Alfred was still with her, she told Peggy (Bok) Kiskadden, who helped her sort his remaining letters: "I wrote to him from this table so many times—so he is always here—and when you were in Abiquiu he seemed vaguely present—as you drove out of the gate—it was as if that thing he had been in my life for so long was going again—driving off into the dawn."

With the departure of this part of her life, O'Keeffe's return to painting took a less passionate course—one in which a sense of detachment reigns. "The painting is like a thread that runs through all the reasons for the other things that make one's life," she told an interviewer in 1962, when her well-appointed home and garden, relations with the staff and villagers, and then her beloved chow dogs brought calmer satisfactions. In these years, she painted the cottonwoods along the riverbanks, large-scale flowers, and twisted tree stumps; few are handled with the intimacy of her earlier work.

At the same time, she depicted her patio wall and door in all colors and weathers, as if they defined the terms of her removal to an enclosure of her own. Two large abstractions, *From the Plains, I* and *II* (1955), hark back to the Texas oils of the same title with swaths of orange and yellow

flashing across their skies; *Ladder to the Moon* (1958), in which a luminous ladder in the night sky suggests a passage to an elsewhere, recalls O'Keeffe's ability to infuse some works with an otherworldly glow.

Since the closing of the Place, O'Keeffe had shown her work at Edith Halpert's Downtown Gallery, one of the few New York venues that Alfred had favored. Over the next decade, Halpert would do well by O'Keeffe, selling nearly two hundred works at prices that often outdid those obtained by Stieglitz. But O'Keeffe had doubts about Halpert's taste as well as the prices she set for her work. "I'm conceited enough to know what pictures I paint will sell," she told a journalist. "The success I've had has come from a strange combination of luck and my rather odd ability to paint pictures people would buy."

Along with the proceeds from her inheritance, O'Keeffe's earnings from sales allowed her to do as she saw fit both at home and on the trips she took, starting in the 1950s. With Spud Johnson, the photographer Eliot Porter, and his wife, Aline, an artist, she went to Mexico in 1951 to inspect "the murals the boys [Rivera, Orozco, Siqueiros, and Covarrubias] have been doing." Of these four, she preferred Orozco, whose art had "a feeling of violence and revolution," but despite her admiration for him as a colorist, the trip did not inspire her to paint.

She went to Paris for the first time at sixty-five, in 1953. The Sainte-Chapelle astonished her, as did Chartres Cathedral; the French countryside was enchanting; but Cézanne's Mont Sainte-Victoire failed to impress her, and she turned down the chance to meet Picasso on the grounds that they could not talk to each other. In Madrid, she found much to enjoy at the Prado, particularly the Goyas. Recalling her return trip there a year later, O'Keeffe reflected, "I was very excited by the Prado, which made me think there must have been something the matter with me."

O'Keeffe was much more excited by her trip to Peru in 1956. The colors there were "unbelievable . . . marvelous purples, violent colors. And the Andes are sparkling—they freeze at night, and in the morning they glitter." Driving along narrow mountain roads, she made sketches, which she drew on later to depict Machu Picchu washed with brilliant blues and greens, and the purple-hued Misti volcano. These mountains compared favorably with the Pedernal. But she was glad to get home: "Most of what I see travelling are people unsatisfied—hunting the unknown that they will never find. Maybe I am queer that I am so singularly pleased with the life I have in N.M."

In many ways, O'Keeffe preferred her small world to the larger one.

"I have been working," she told Anita, "trying to work my garden into a kind of permanent shape—so that if I live for twenty-five years it will be pleasant to walk about in by the time I am too old to do anything else." Soon the garden yielded more than enough produce for her use and that of her friends. "It looked like a Persian miniature," one of them thought. Inside the adobe walls "it was cool and shady, dappled with sun and hot spots, and full of a vivid mix of flowers and vegetables."

Another of the pleasures afforded by O'Keeffe's "world" was that of eating well, something she began taking seriously in her sixties. Like her friend Adelle Davis, she believed in eating right to keep fit; moreover, she thought that good food enhanced creative work. A forerunner of the organic movement, O'Keeffe made yogurt, ground whole grains for bread, and drank smoothies. At Georgia's request, her sister Claudia sent her nuts, dates, and brewer's yeast from Los Angeles, where she ran a Montessori school. Georgia perfected recipes to please the eye as well as the palate, including brightly colored soups: purple borscht, carrot soup with herbs, spinach soup in black bowls to reflect the colors of the earth. Mainly vegetarian, she enjoyed homegrown potatoes cooked with Indian spices but also local recipes like chile verde. She required her housekeepers to adopt her beliefs and befriended those whose cooking met her standards.

In the mid-fifties, Georgia was reconciled with Maria Chabot, who was again working for Mary Wheelright. After Maria and some acquaintances came to Abiquiu for lunch, Georgia wrote to a friend, "They just stopped and looked in a odd way that made me feel they were very surprised." The house that Chabot had labored to restore for her was now "something that feels like my shell to live in." With her organized daily life and respectful staff, O'Keeffe ventured out on occasion—balancing the satisfactions of home and the lure of the "faraway."

In these years, Doris Bry also worked part-time for her, a job that required trips to Abiquiu and, in New York, overseeing sales of her paintings. Like Chabot, whose jealousy of Bry on one of her visits to Abiquiu had provoked Chabot's dismissal, Bry felt protective of O'Keeffe—to the extent of controlling access to her as well as to her work. Such was Georgia's reliance on Bry that she asked her to critique Pollitzer's draft of her biography in progress—a project encouraged by its subject, who gave her friend permission to quote from the embargoed Stieglitz-O'Keeffe letters at the Beinecke. Bry told Pollitzer that her research was commendable but her prose less so.

While Anita's sense of Georgia tended to be worshipful, her ideas

about her friend's approach to art were well founded. "We probably all derive from something," Georgia noted in a letter. This recognition encouraged Anita to adapt the words of a philosopher who wrote of the meeting of East and West in O'Keeffe's art: "You not only speak your *inner* self—but you let the Mountain speak for the Mountain, the flower for the flower." Since O'Keeffe's student days, when she absorbed Arthur Dow's theories, she had pored over studies of Buddhism, Asian art, and classics like Hokusai's *One Hundred Views of Mount Fuji*. In 1959, she embarked on a three-month trip around the world, with extended stays in India, Japan, Southeast Asia, and the Middle East. Along the way, she made many small drawings, which were redone on a larger scale and then as oil paintings after her return.

O'Keeffe felt a sense of recognition in Japan. Seeing Mount Fuji first-hand inspired her to paint this icon as a white triangle backed by a fading pink sky. Close in feeling to Japanese *notan*—an arrangement of shapes defined through the play of light and dark—this was her way of letting the mountain speak in its own language. Having long been familiar with another iconic item of Japanese culture, the kimono, she collected these robes in many styles, from formal black to gauzy summer silks, even an underkimono painted with an image of Mount Fuji. (She wore them as negligees, in the fashion of her youth.)

She returned from Japan with souvenirs—silk and woolen suits, a silk coat, shoes, pashminas, and lengths of material; on a return trip the following year, she bought wooden sandals and a "Happi coat" to add to her highly personalized wardrobe, itself an unusual meeting of East and West. In the 1960s, she started wearing an American equivalent of the kimono, the wraparound—a dress without buttons or zippers that made its wearer look well turned out. The wrap dress, often in black, would become O'Keeffe's uniform. (In 1962, she sent one to Beck to lift her spirits, a gift that moved Beck to write, "How good it has been to have a friendship with a woman that has been strong and warm and true.")

O'Keeffe's round-the-world plane trips also gave her a new perspective—that of gazing out the window at the clouds below. In the early 1960s, she painted the *Sky Above Clouds* series, four canvases, each with a serene pink sky above the horizon, and below it, a sea of cottony clouds. Moving from a realistic treatment of the motif in the first painting, she completed the series with a monumental version twenty-four feet wide and eight feet high. "Such a size is of course ridiculous," she wrote, "but I had it in my head as something I wanted to do."

As O'Keeffe's trips deepened her sense of the interwoven patterns of

art and life, they confirmed her belief that New Mexico was perfect for her. To Yousuf Karsh, who asked when he came to photograph her why she lived in such a remote place, she answered cheekily, "What other place is there?" In the same spirit, on the occasion of her retrospective at the Worcester Art Museum in 1960, she called Abiquiu "the most wonderful place in the world"—a statement that reflected her convictions but also her canny sense of how to present herself.

When she went to New York in 1961 to install her Worcester show at the Downtown Gallery, Halpert is reported to have said, "Oh, Georgia, is that *another* flower?" By then, each found the other unyielding; it would be O'Keeffe's last exhibition with Halpert. The critics were guarded in their praise. Robert Coates wrote in *The New Yorker* that O'Keeffe's move to simplified forms "implies some casting about in search of inspiration": He saw traces of Miró in *Ladder to the Moon* and hints of Albers in *White Patio with Red Door.* The *Times* remarked on her refinement of forms "from which she pared away all adventitious dross, to leave an image as lucid as the deserts she admires."

In 1963, Bry became O'Keeffe's sole agent, an arrangement that paid a commission of 25 percent. Bry had recently published well received scholarly work about both Stieglitz and O'Keeffe. As Georgia's agent, she began limiting how much of her work came on the market and, on O'Keeffe's instructions, buying back undervalued examples. Soon Bry was known for being protective of her employer. Like Chabot, she was also possessive, discouraging would-be clients unless they seemed worthy and telling those who sought to contact the artist not to bother.

Meanwhile, curiosity about O'Keeffe was heightened by pieces in magazines like *House Beautiful, House & Garden,* and *Vogue.* Laura Gilpin, known for her images of the Southwest, had been taking O'Keeffe's portrait since the 1950s. Shots of her interiors, collections of stones and bones, and the artist in front of her panoramic studio window appeared in "The Austerity of the Desert Pervades Her Home and Work," Gilpin's 1963 piece for *House Beautiful,* which treated her adobe as an artistic creation in its own right.

Gilpin's attention to detail set a precedent for those who followed, including *Life* photographer John Loengard. On his first visit to Abiquiu, in 1966, when he wanted to talk about Stieglitz, O'Keeffe refused to oblige. Immaculate in a black wrap dress, she posed for him in the garden, her studio, sitting on her bed with her eyes closed, and holding a favorite rock, which, she said with a grin, she had stolen from Eliot Porter. Loengard went back to New York with scores of black-and-white

pictures, including one of O'Keeffe laughing, but the project was set aside due to doubts about its importance.

That same year, *Vogue* sent Cecil Beaton to photograph the artist. In contrast to her diffident pose in Beaton's 1946 portrait of her with Stieglitz, twenty years later she stands like a heraldic figure in a black coat with kimono-like sleeves in her adobe's entryway, with its massive antlers on the wall. O'Keeffe was "a phenomenon," the art critic E. C. Goossen wrote in the accompanying article, "not only because she is an extraordinary artist but also because she has survived the prejudice against her sex in art." He added, "She is almost totally unsentimental and barely tolerates sentimentality in others."

Not to be outdone, *Life* sent Loengard back to Abiquiu for what would become a thirteen-page spread in the March 1968 issue—"Georgia O'Keeffe in New Mexico: Stark Visions of a Pioneer Painter." Hoping for a striking cover shot, Loengard went with her to Ghost Ranch. She took him on walks, explained how to kill rattlesnakes, and climbed halfway up the ladder to the roof, where he photographed her in profile. Loengard later remarked, "She looks like she's at rest, but she isn't really. She is sort of coiled." This introduction of O'Keeffe as the exemplar of a self-disciplined lifestyle came at the right moment. To a public seeking role models, her homes and her art were all of a piece, embodying an ideal in which the diverse elements of a life were congruent with one another.

In these years, Anita Pollitzer worked on her biography, with Georgia's approval. When she sent her the manuscript in 1968, as *Life* was preparing its feature on the artist, it was clear that their projects were at odds. O'Keeffe reread the manuscript before sending her friend a letter of rejection, copied to her publisher. "It is a very sentimental way you like to imagine me—and I am not that way at all. . . . To call this my biography when it has so little to do with me is impossible—and I cannot have my name exploited to further it." To make matters worse, Georgia offered to pay for her time. Anita never recovered from the shock; she died in 1975, after lapsing into senility.

O'Keeffe refused to sanction her friend's account for several reasons. Its tone was too intimate, and it did not support the legend that O'Keeffe had been honing about herself as someone whose achievements were due to hard work. She disdained Pollitzer's view of her as happy: "I do not like the idea of happyness—it is too momentary—I would say that I was always busy and interested in something—interest has more meaning to me than the idea of happyness." And she objected to Anita's account of Stieglitz's role in her life, coming just when she hoped to replace his myth of her with one of her own.

The myth of O'Keeffe as self-sufficient recluse was in place when her retrospective opened at the Whitney Museum in 1970. She had just received the Gold Medal for Painting by the National Institute of Arts and Letters. For some time, writers had been promoting her as the sage of Abiquiu. (O'Keeffe "appropriated the 19th century image of the Pioneer Woman," Robert Hughes wrote, "and, against all odds made it work.") The retrospective included 121 works selected by Bry and Daniel Rich, a choice that conveyed "a clear, cool essence of acutely personal sensitivities distilled through tactful self-discipline," John Canaday wrote in the first of three articles accorded the nearly eighty-four-year-old artist by the *Times*.

O'Keeffe told Grace Glueck, who interviewed her for the occasion, that people who saw erotic symbols in her work were "really talking about their own affairs." Her flowers, deserts, and mountains were "just what's in my head." In the same way, *Sky Above Clouds IV* came to her after she saw some large paintings and thought, "I could do a better one." On the subject of her experience as a female artist, O'Keeffe said that the men she knew "made it very plain that as a woman I couldn't hope to make it." Then, with a "liberated smile," she added, "Women have always been treated like Negroes in this country."

At this time, with the feminists of the 1970s looking to her as an icon, O'Keeffe must have seen that many women not only understood their second-class status but meant to do something about it. Yet although she was a lifelong feminist and a member of the Woman's Party, she rejected the younger women's calls for solidarity. She had achieved success through her own hard work; others should do the same. On occasion, she contradicted herself. To a writer who asked her about women artists, she bristled: "Write about women. Or write about artists. I don't see how they're connected. Personally, the only people who ever helped me were men."

By this time, O'Keeffe was a celebrity, with a new generation of enthusiasts for whom her art and legend converged. The Whitney retrospective, which traveled to Chicago's Art Institute and the San Francisco Museum of Modern Art, was featured in the national news; a procession of photographers traveled to Abiquiu for stories about her. Arnold Newman photographed O'Keeffe in her beloved Ghost Ranch landscape; Dan Budnik captured her with her hair down; Bruce Weber depicted her with her eyes closed, a nunlike figure in her black dress; Ansel Adams paid homage with a portrait of her wizened face resting on her still-elegant hands. At each session, she presented herself with the same composure.

Jeronima ("Jerrie") Newsom, her cook, housekeeper, and companion from 1966 to 1974, made sure that O'Keeffe's households ran according to her standards. Hired because she made a good sponge cake, Newsom learned to bake bread the O'Keeffe way, accompanied her employer to Ghost Ranch each summer, received guests, and drove her to Santa Fe for hair appointments. As Georgia's eyesight started to waver, Jerrie began to serve as her eyes.

O'Keeffe first noticed a visual blur in 1971. The specialists agreed: She was suffering the loss of central vision due to macular degeneration. Soon she had difficulty seeing both color and line. Of this time, O'Keeffe reflected, "When you get so old that you can't see, you come to it gradually. And if you didn't come to it gradually, I guess you'd just kill yourself." Over the next year, she managed to complete three studies of a polished black rock lit by a mysterious light emanating from within. Her last unassisted painting, *The Beyond*, depicts the horizon as a long white streak with a blue sky above and a black plain below. These late works appear to signal O'Keeffe's sense of her situation.

Her remarks about the aid given her by men notwithstanding, O'Keeffe relied on the female employees and friends who helped her maintain her independence. Jerrie Newsom saw to her domestic life and walked her around the courtyard when she could no longer go out in the desert. Maria Chabot visited her at Ghost Ranch and placed her facing her beloved Pedernal, which, O'Keeffe said, she could feel, though not see. Starting in 1971, Virginia Robertson spent weekdays at Abiquiu as her secretary and companion. When Robertson found a scrap of prose by O'Keeffe, she urged her to write about her paintings, and Georgia began the lengthy process of dictating to Robertson, who transcribed her remarks, read them to her, and helped her revise. O'Keeffe announced her plan to set up a foundation for her art, with Robertson in charge, and to include her in her will, but the young woman demurred, having foreseen the problems that might result, and told O'Keeffe that she would have to leave her employ. Visibly upset, O'Keeffe told her, "No one is ever going to leave me again."

By then, according to Carol Merrill, who spent weekends at Abiquiu to organize the library, O'Keeffe's retinue resembled a medieval court full of intrigue. Before Robertson left in 1973, she told Merrill that if she was to stay on, she "must maintain the mystique." By then O'Keeffe's celebrity status was attracting young artists of all sorts as well as people at loose ends, who went to Abiquiu in search of inspiration. When Gloria Steinem arrived at her door with a bouquet of roses, O'Keeffe

refused to see her. Some supplicants were turned away, others invited to spend the night.

Curiously, the day after Robertson announced her decision to leave, a lanky young man came to Ghost Ranch looking for work. His initial attempt failed; on his return, O'Keeffe tested him with practical tasks, such as building shipping crates and trimming hedges. One day, he cleaned O'Keeffe's shoes, which were too scuffed for a woman of her standing, he thought; soon he became part of the household.

John Bruce Hamilton, known as Juan, was twenty-seven and down on his luck when he entered O'Keeffe's employ. Raised by missionaries in South America, he spoke fluent Spanish. Hamilton had found work in the Ghost Ranch compound's kitchen (it had become a conference center) in hopes of one day meeting the artist, whose image he first encountered in the 1968 *Life* feature. Having trained as a potter, he was eager to reconnect with his art but unsure how to do so. O'Keeffe gave him more exacting tasks, like handling her correspondence. Merrill, who was already doing this work, had to accept his new role as O'Keeffe's helper. The young man had the advantage of an artist's sensibility and his dark good looks; moreover, he amused O'Keeffe, who was bored with the worshipful attitude of most young people.

As it happened, Calvin Tomkins came to interview the artist for *The New Yorker* three weeks after Hamilton arrived. Tomkins saw that the young man O'Keeffe called her "boy" meant to get on well with her. She voiced her concern about Juan's future and her hope to build a kiln at Ghost Ranch so that he could return to pottery and she could stay there with him year-round. Tomkins encouraged her to work up the notes she had been jotting down about her art, and she asked him to return to Abiquiu to advise her on their publishability. She also "flirted imperiously" with him. When Juan brought out a poster showing a feminist version of Leonardo's *Last Supper* with O'Keeffe as Christ, she teased, "I never deny anything anybody says about me."

Hamilton soon became indispensable. In 1974, when friends asked O'Keeffe to join them on a trip to Morocco, she announced that he would go with her. (Over the next few years, Hamilton would accompany her on trips around the country and to Antigua, Costa Rica, Guatemala, and Hawaii.) Given her age and failing eyesight, he gave O'Keeffe the support she needed, assuring her well-being and keeping her spirits up by not kowtowing. Juan occupied a room in her house until, with her help, he bought his own. He came early each day to take O'Keeffe on walks, made appointments and took her to them, ate with her, even cut-

ting morsels that she could not manage to do herself. Some of her staff were not taken with him. Newsom resigned that winter, after telling O'Keeffe, "I am not going to look after your help."

When O'Keeffe bought Hamilton a kiln, he taught her to make small pots from clay coils. While his larger ones were "near to sculpture," she thought, the clay had a mind of its own: "I finally have several pots that are not too bad, but I cannot yet make the clay speak." Hamilton also helped her with the book that she was writing about her art. She arranged to have this memoir published in 1976 to her specifications—unpaginated, oversize, with high-quality illustrations and telling images of herself, like the final one, which shows her in Hamilton's studio, stroking one of his pots. Hamilton is not named as the artist who made the clay speak, but he is prominently thanked in the acknowledgments.

Georgia O'Keeffe was notable for "how much O'Keeffe left out," Sanford Schwartz wrote in *The New Yorker*. Stieglitz was mentioned in passing; family members were not identified. She seemed to have "no contemporaries, close friends, or critics, nor does she mention artists and writers from the past who might have influenced her." Yet O'Keeffe's remoteness expressed her way of life: "Her painting, with its images of romantic isolated purity, became an embodiment of an individual who was strong enough to live out her life exactly as she wanted. . . . For many Americans, especially in the twenties, thirties, and forties, O'Keeffe was a living symbol of self-assertion." Recalling Stieglitz's portraits, Schwartz concluded that she was a great actress. In her book as in his photographs, "she isn't mugging or impersonating, she's entrancing herself."

Acclaim for the artist came at the highest level when she was awarded the Medal of Freedom by Gerald Ford in 1977. By then (O'Keeffe was almost ninety), Hamilton had become indispensable as her confidant, travel companion, and facilitator in the larger world—including sales of her paintings, two of which were sold that year without Bry's knowledge. Ironically, Bry believed that in 1973, the year of Hamilton's arrival in Abiquiu, she and O'Keeffe had finalized an agreement naming her exclusive agent and executrix, with an annuity for Bry in her will. When news of the recent sales reached Bry, she protested—to no avail. Hamilton had for some time been aggravating O'Keeffe's discontent with her as agent. Now, given his centrality in her life, Georgia informed Bry that their arrangement had come to an end: Bry was to return all works in her possession by herself and by Stieglitz.

When Bry did not respond, O'Keeffe went on the warpath. She sued Bry for the return of her property, and Bry countersued for breach of

contract, charging Hamilton for damages caused by "malicious inter-ference." Their suits were not settled until the 1980s, when most of Bry's claims were rejected. O'Keeffe had not, in fact, established the protections that Bry understood to be in force. Both Bry and O'Keeffe declined to discuss the case, but Hamilton felt that he had nothing to hide. "There is prejudice against us because she is an older woman and I'm young and somewhat handsome," he told *People*. Denying rumors that he and O'Keeffe had married, he added, "That's not to say the rela-tionship isn't as meaningful as a marriage."

By then, people seeking access to O'Keeffe understood that they must go through Hamilton. With his encouragement, the filmmaker Perry Miller Adato succeeded in persuading the artist to let her make a documentary about O'Keeffe, in which Hamilton appears. Adato's pro-posal, to have O'Keeffe present her work on her own terms, helped her to come across as relaxed. ("Just don't cross her," Adato noted. "She's a tough cookie.") The film complemented her memoir's emphasis on her integrity as an artist: O'Keeffe made it clear that she had struggled to maintain her stability after being promoted as a highly charged sexual being. The film, released on public television for her ninetieth birthday, exposed neither her frailty nor her blindness.

By 1978, having effectively presented herself as an uncompromising loner who cared only for art, O'Keeffe concluded that she had set the record straight concerning Stieglitz's role in her success. Weston Naef, of the Metropolitan Museum, approached her that year about plans to hold an exhibition entitled "Georgia O'Keeffe: A Portrait by Alfred Stieg-litz," and O'Keeffe and Hamilton worked with him to select fifty-one prints, which were then reproduced in an elegant publication with the same name (from negatives made by Richard Benson from the origi-nal prints). The sequence, Hamilton explained, formed "a photographic diary of their relationship, from beginning aloofness through its evolve-ment into a passionate intimacy and then the later phase when O'Keeffe got more into her life." This account also publicized the concurrent show of Hamilton's "sensuously sculptural pots" and ran a photograph of him holding a Stieglitz image of O'Keeffe, as if he were now in charge of the narrative.

The art critic Hilton Kramer took a different view. Despite its impor-tance in the history of American art, the Stieglitz exhibition was "the story of a love affair . . . the most beautiful and moving photographic show in recent memory." Kramer noted that it was also "Miss O'Keeffe's and Mr. Hamilton's version of the 'story.'" Once again, there was no

mention of her marriage, a detail that underlined the portrait's poignancy. It was remarkable, he thought, that O'Keeffe had managed to preserve her privacy "while at the same time giving us an unforgettable account of one of the central experiences in her life." Although few nudes were included, there was "a heat in these pictures we do not feel in the others."

That year, O'Keeffe gave Hamilton a broad power of attorney, and in 1980 she changed her will to name him her executor, the heir to Ghost Ranch and a number of artworks, and the person to choose all additional works to give to the institutions she had named. His marriage to a younger woman halted rumors about his relations with O'Keeffe but did not end the concerns among some of her friends and family (including her sister Claudia) that he was exercising undue influence over her affairs.

Since 1979, O'Keeffe had been working with Sarah Greenough, a young historian of photography who was cataloging the Stieglitz bequest at the National Gallery of Art with the intention of holding an exhibition of his photographs there in 1983. During these years, Greenough went to Abiquiu to work with O'Keeffe and Hamilton, her cocurator and editor of the catalog; they also collaborated on plans for an O'Keeffe centennial. Greenough noticed O'Keeffe's increasing frailty; by 1982, she was deaf as well as nearly blind.

She was going over memories of those who had been close to her when John Walker interviewed her in 1981 for his film on Paul Strand. Stieglitz had been "a kind of idol to Paul," she reflected, yet he sometimes refused to share work with him, perhaps because he was jealous. As for the Strands' marriage, it had been unwise for them to live with Paul's family. No doubt thinking of herself with the Stieglitzes, she remarked, "[Rebecca] had a hard time standing it." She noted what she saw as their incompatibility: "Rebecca was a very lively, lean young woman and Strand was thick and slow. They were . . . not built to live together." Georgia let on that she had been "amused" when Paul went to see Rebecca in Taos after their divorce but did not call on her. She did not mention Rebecca's late blooming as an artist.

O'Keeffe was relieved when *Bry vs. Hamilton* concluded in 1982 (the settlement paid for Bry's legal bills; Hamilton remained in charge of O'Keeffe's affairs). The following year, Hamilton and O'Keeffe went to Washington for the National Gallery's Stieglitz retrospective and then to New York for its installation at the Metropolitan Museum. During their stay, Hamilton arranged to have Andy Warhol speak with them for *Inter-*

view magazine. Their exchange began with O'Keeffe's complaint that she felt lost without her cane, to which Hamilton replied, "You can use me." Juan had, she observed, "moved into my world and little by little he got into things. He knows more about my affairs than I do." Warhol compared the artist at nearly ninety-six to another national monument, the Brooklyn Bridge, which had just turned one hundred. Reminded that she had painted the bridge, her thoughts turned to Stieglitz—until Hamilton prompted her to talk to Warhol about the Pedernal.

After their return to New Mexico, O'Keeffe's strength declined; a few months later, she had a heart attack. When the Hamiltons took her to live in Santa Fe, the doctor who looked after her found her lucid at times and confused at others. In 1984, Hamilton purchased a large property in her name, with ground-floor rooms for her and the staff, and the rest of the house for his family. One day when Christine Patten, her weekend nurse, was dressing her, O'Keeffe cried out, "I don't know how I can get through another day and I don't know why I have to!"

During this time, two codicils were added to O'Keeffe's will. The first gave Hamilton the power to sell her Abiquiu house or otherwise dispose of it and compensated him for his services. The second, which undid the original will's provision for the bulk of her estate to go to museums, left O'Keeffe's paintings and properties—a sizable fortune—to Hamilton. Under the impression that they were to be married, O'Keeffe wore a white kimono on the day of the signing. She held on to the arm of the judge who was to have witnessed the document but, on reading it, declined to do so. Other witnesses were found; O'Keeffe signed in a quavery hand.

When President Reagan awarded her the National Medal of Arts in 1985, O'Keeffe was too weak to attend the ceremony. By then, she spent days in her room, facing the light that filtered through the window. As she gradually lost her sense of time, memories of Stieglitz came back to her. Hamilton visited every day but spent weekends with his family. She often asked him to drive her to Ghost Ranch; when he refused, she became petulant. The stress of taking care of her under these circumstances took a toll on Hamilton, and he kept threatening to leave.

In March 1986, Hamilton went to Acapulco for a vacation with his family. The housekeeper called to let him know that O'Keeffe was fading. Hamilton said to tell him if her condition worsened. That night, when her breathing became labored, O'Keeffe was taken to the hospital. She died at noon on March 6, while the Hamiltons were in transit from Mexico. She was ninety-eight.

In accordance with her wishes, Georgia was cremated and her ashes returned to Hamilton. He drove to Ghost Ranch, climbed to the top of the Pedernal, and scattered the ashes in the direction of her home there, over the high-desert land that she loved more than any other.

· · ·

But this was not the end of the story. O'Keeffe's family opposed probate by charging Hamilton with undue influence over her and challenging the codicils that radically enhanced his inheritance. During the ensuing case, Hamilton's background was investigated, O'Keeffe's domestic and medical personnel were brought in to testify, Doris Bry was subpoenaed, and some fifty people were interviewed. In 1987, an out-of-court settlement was reached, in which Hamilton accepted the family's position: The codicils to her will were voided and its original terms accepted, including the distribution of the bulk of her work to museums. Hamilton kept Ghost Ranch, her letters to him, and a number of paintings and copyrights.

Although the parties to the suit agreed not to discuss the settlement, the National Gallery's O'Keeffe retrospective became the occasion for Hamilton to tell his side of the story. It was not true that he had exercised undue influence: "Her health wasn't what it had been but she knew what she was doing." The retrospective opened in November 1987, when O'Keeffe would have been one hundred. Greenough, Hamilton, and Jack Cowart served as the editors of the catalog, which let O'Keeffe speak in her own voice through a selection of letters to Alfred, Paul, Rebecca, and others. Greenough notes, "The letters poignantly reveal her great love for Stieglitz and the landscape of New Mexico, and they speak of her struggle to construct a way of life that would accommodate both."

Twenty-five years later, Greenough would publish *My Faraway One*, the edited O'Keeffe-Stieglitz correspondence, which invites one to follow the twists and turns of their relationship—for which these passionate spirits had no models. A few years before her death, O'Keeffe asked Greenough to take on this project, telling her only to "make it beautiful and make it honest." Reading the record of their attempts to reconcile artistic, emotional, and spiritual fulfillment, readers may be moved by their wish to "touch the center" of each other, and by the story of their engagement with their fluctuating worlds.

ENVOI

Looking back at this quartet of strong-willed egos nearly one hundred years later, we can ponder the affinities chronicled in their vast correspondence—in this way, as O'Keeffe wrote to Stieglitz, "peeping over the rim into our world." Their liaisons can also be traced when considering the artworks made by them for one another. For just as poets write sonnets, odes, or even limericks, so artists devise gifts for friends and lovers in the language of their shared pursuits.

For decades, Stieglitz's intimates orbited around him like the planets of their own solar system. The idea of their circle as a distinct universe was understood by the recipients of affectionate gifts such as Dove's 1925 abstract portrait of the Strands, *Painted Forms, Friends*. Displayed at Stieglitz's "Seven Americans" exhibition that year, this assemblage paid homage to two of the circle's most faithful members, whose labors, personal and artistic, supported the group's commitment to "seeing."

Dove's portrait was surely in Rebecca's mind when she devised a gift for Paul to express her sense of their marriage. In 1934, just months after their divorce, she painted an "object portrait" entitled *Paul*, which alludes to his metier in its shapes, especially the black circle suggesting a camera lens, and its dimensions (eight by ten inches, those of his photoplates). Perhaps the most eloquent items in this playful composition are the green twig of life and the red heart crowned with the letter *P*, symbolizing the bonds between them. At some point, she revised the inscription on the back to read "Paul/Taos/1934/Rebecca Salsbury James"—a farewell that became an au revoir in later years, when she found in Bill James the loving support that allowed her to flourish as an artist.

Although Paul and Rebecca maintained a strong connection, his gifts to her were ambiguous. He sent her each of his photo books, but none of them mentioned her. The magnum opus of his later years, these volumes would have brought to mind her role in the trips to the Gaspé, the Southwest, and Mexico that helped him develop his ideas about the sense of place. Yet his portrait of her, including more than one hundred images, was never shown; to the end of his life, he kept most of these negatives under his bed. The problem, he confessed to a friend, began when he came under the spell of Alfred's portrait of Georgia: "He could not help reflecting something of that experience when

he photographed Becky. But Becky was not Georgia, and he was not Stieglitz."

More detached observers have found in these portraits a moving study of Rebecca's subjectivity, her intensely focused search for a way of being in the world. The National Gallery's 1990 exhibition of Strand's work included several of these portraits, and a likeness of her graces the catalog's cover. In 1996, an exhibition entitled "Rebecca" assembled fourteen portraits of her, which were published without comment except for enigmatic quotations from Strand, such as "All good art is abstract in its structure." This indirect acknowledgment has served as her memorial until recently, when shows of her work began to afford her recognition.

It is not surprising that Paul and Rebecca sought to model themselves after Alfred and Georgia. Then as now, there were few examples of marriages that enhance the creativity of both partners, in which the claims of both head and heart are the bases for intimacy. Seen another way, shifts in the nature of connections among self-involved people, particularly artists, are inevitable. Yet the testament to these bonds, the exchanges that arose from the interlacing of their lives, still touch us.

In her eighties, Georgia reflected that her relationship with Alfred had been "really very good, because it was based on something more than just emotional needs." She added, "Both of us were very interested in what the other was doing. . . . Of course, you do your best to destroy each other without knowing it." A few years later, she gave another account of his impact, one that speaks to his sway over the Strands and the rapport between the couples: "He gave a flight to the spirit and faith in their own way to more people—particularly young people—than anyone I have known. . . . If they crossed him in any way, his power to destroy was as destructive as his power to build—the extremes went together." She added, "I put up with what seemed to me a good deal of contradictory nonsense because of what seemed clear and bright and wonderful."

We can see in some of O'Keeffe's tributes to Stieglitz—the illuminated *Radiator Building*, a 1927 cityscape with his name emblazoned in neon, and the 1949 farewell to the Brooklyn Bridge—her acknowledgment of what had been "clear and bright and wonderful" in their rapport. Still, recalling their long partnership as she chose Stieglitz's portraits of herself for the Metropolitan Museum's 1978 exhibition, she wrote with some ambivalence about his role as a source of light: "His eye was in him, and he used it on anything that was nearby. Maybe that way he was always photographing himself."

One could, of course, say the same of the foursome's portrayals of their mercurial ties through their attempts to evoke the Zen-like closeness of artist and subject. Might such representations of the wish to perpetuate intimacy express at once the confines and the yearnings of the singular self?

Acknowledgments

I began this tale of a close-knit foursome with little sense of how intricate it would prove to be. What I first thought of as a story about creative affinities came to resemble a constantly changing choreography, one that figured the partners' relations not in twos but multiplied four by four.

I started with Rebecca Salsbury's letters at the Center for Creative Photography. The CCP staff guided my research in the Paul Strand Archive, which also holds Strand's correspondence from Alfred Stieglitz, Georgia O'Keeffe, and others that allowed me to reconstruct the chronologies of their friendships. David Benjamin, Katie Sweeney, James Uhrig, and Shandi Wagner provided help of many kinds; Leslie Squyres gave generously of her time and attention over the course of the project.

With the assistance of Amanda Bock of the Philadelphia Museum of Art's Department of Photography, I was able to study Strand's portraits of Rebecca at a time when the PMA's exceptional collection of his prints was still being cataloged, an invaluable resource for this project.

Sarah Greenough, Senior Curator and Head of the Department of Photography at the National Gallery of Art, arranged for me to examine original prints held there by Stieglitz and Strand, shared hard-to-obtain documents, and steered me in the right direction on numerous occasions.

This book would not have been possible without the aid of the staff at Yale University's Beinecke Rare Book and Manuscript Library, where the bulk of the documents consulted are held. Nancy Kuhl, Curator for Poetry, Yale Collection of American Literature, gave generously of her time; I also received assistance from Moira Fitzgerald, Anne Marie Menta, John Monihan, Matthew Rowe, Natalia Sciarini, and Adrienne Sharpe.

The staff of the Georgia O'Keeffe Museum were unfailingly helpful. I would like to thank Tori Duggan, Elizabeth Ehrnst, and Kira Randolph, as well as Cody Hartley, Senior Director of Collections and Interpretation.

At the University of California, Santa Cruz, the staff of McHenry Library found whatever I needed; Dean Tyler Stovall and Irena Polić of the Department of Humanities gave invaluable support; Jennifer Chu offered help in the final stages; Jay Olson kept me digitally fit.

For access to material in the following private collections and for their insights, I am grateful to Alan B. Macmahon and Gail Macmahon Cornaro; Ellen Lowe and Sue Davidson Lowe; and the late Nate Salsbury III, Ellen Salsbury, and Peter Salsbury, without whose warm collaboration the story of Rebecca could not have been written.

For their gifts of time, materials, and advice I would like to thank the following institutions and people: Ansel Adams Publishing Rights Trust, Claudia Rice; Currier Museum of Art, Meghan L. Petersen; Harwood Museum of Art, Jina Brenneman and Debi Vincent; Lachaise Foundation, Paula Hornbostel; Monmouth County Historical Association, Laura M. Poll; Museum of International Folk Art, Laura Addison, Caroline Dechert, and Carrie Hertz; Museum of Modern Art Library, Lori Salmon; New York Public Library, Billy Rose Theater Division, Michael Messina; Roswell Museum and Art Center, Candace Jordan-Russell; Southwest Research Center, Nita Murphy; University of Delaware Library, Rebecca Johnson Melvin; University of New Mexico Art Museum, Bonnie Verardo; Wharton Esherick Museum, Katie Wynne.

Several people who knew my subjects personally or through their work helped me form my own picture of them. While Strand remains an enigmatic figure, the late Richard Benson illuminated his later years, as did John Walker, whose documentary *Under the Dark Cloth* is the best portrait of the photographer. Olga Vrana recalled moments with Strand when she was a child; Rebecca Busselle told me about her time with Hazel Kingsbury after his death. Calvin Tomkins, who interviewed both Strand and O'Keeffe for *The New Yorker,* encouraged me to see the group as a whole. The late Doris Bry shared recollections, including O'Keeffe's high-handed treatment of her; Tony Berlant described O'Keeffe at Ghost Ranch. I gained insight into life in Taos from Susan Dicus Chittim, Florence Ilfeld Beier, and Rena Rosequist; Kevin Cannon invited me to the Casita Rosa when I was staying at Los Gallos, now a guesthouse and cultural center that still evokes the reign of Mabel Dodge Luhan.

I relied on Katherine Hoffman and Richard Whelan for their authoritative work on Stieglitz and Suzan Campbell for her pioneering thesis on Rebecca Salsbury James. Of the extensive scholarship on O'Keeffe, several studies were indispensable, including the biographies by Laurie Lisle, Roxanna Robinson, and Hunter Drohojowska-Philp, volumes by Barbara Buhler Lynes, and studies by Charles Eldredge, Sarah Greenough, Sarah Whitaker Peters, Elizabeth Hutton Turner, and Sharon R. Udall. *My Faraway One,* volume 1 of Greenough's magisterial edition of the Stieglitz/O'Keeffe correspondence, came out as I was starting this project, making it possible to correct past misunderstandings and offer new interpretations. (While I am indebted to books by these and other scholars of the period, any factual or interpretive errors are my own.)

Many people provided responsive listening, material or moral support, and encouragement. They include Tenshin Reb Anderson, Kristina Baer, Janeen Balderston, Mary Blume, Scott Bongiorno, Jesszell Boyer-Marie, Cherie Burns, Karen Butts, Candace Calsoyas, Clark Carabelas, Warwick Clarke, Wanda Corn, Roland Cortadellas, Françoise Develay-Cortadellas, Sue Dirksen, Jean Englade, Michael Englade, Jack Eschen, Pamela Hall Evans, Michael Fenisey, Christa Fraser, Denis Gallagher, Peter Gessner, Helen Greenwood, Kokyo Henkel, Patricia Hewitt, Tom Honig, Tom Hurwitz, Michèle Jolé, R. R. Jones, Jerry Kay, Stephen Kessler, Rosie King, James Krippner, Cecily Langdale, Richard Menschel, Drew Miller, Nita Murphy, Mary Nelson, Sarah-Hope Parmeter,

Jory Post, Flo Queen-Stover, Nanette Schuster, Liz Sheehan, Bernabe Struck, Terese Svoboda, the Tuesday group, Angela Thalls, Andres Vargas, Melissa West, Michael Wolfe, and Susan Wyndham. Valda Hertzberg, my beloved mother, urged me to keep writing as her life was coming to a close; Alexandra Kennedy saw me through the later phases of the book and into the next; my family provided moral support despite my immersion in other people's lives.

Special thanks for reading portions of the manuscript go to Anne Bast Davis, Sarah Greenough, and Annie Bishai, whose invaluable suggestions and perspectives have enriched it. This book could not have come to completion without the spirited assistance of Chessa Adsit-Morris, whose meticulous research and organizational talents ushered the project through months of manuscript preparation and image research.

I also wish to thank the following for their help with the challenges of securing image rights: Sean Campbell, Buffalo Bill Center of the West; Charlotte Chudy, Aperture Foundation; Anita Duquette, Whitney Museum; Ellen Grier, Condé Nast; Peter Huestis, National Gallery; Nigel Harrison, Blake Hotel Collection; Betsy Evans Hunt, Todd Webb Archive; Fernanda Meza, Artists Rights Society; Diana Reeve, Art Resource; Claudia Rice, Ansel Adams Publishing Rights Trust; Michelle Roberts, New Mexico Museum of Art; David Rozelle, San Francisco Museum of Modern Art; Whitney Scullawi, Crystal Bridges Museum; Richard Sieber, Philadelphia Museum of Art; Norm Scott, Ned Scott Archive; Laura West, Sotheby's; the owners of work by O'Keeffe in private collections; and Paolo Gasparini, who graciously allowed me to reproduce his portrait of Paul Strand.

As always, I am grateful to my agents, Georges, Anne, and Valerie Borchardt. I have been fortunate to work once again with the exceptional people at Knopf. Thanks to Carol Edwards, for bringing consistency to the manuscript; Iris Weinstein for her care with the layout; Carol Carson for her imaginative cover designs; Marc Jaffee, for shepherding the book calmly and carefully through the many stages of production; and Bob Gottlieb, my perspicacious editor. I would not have attempted this tale of interwoven lives without his support; he is the best listener and reader one could hope to have.

Endnotes

The bulk of the Alfred Stieglitz, Georgia O'Keeffe, and Rebecca Salsbury Strand James archives—including correspondence, manuscripts, and other personal papers—consulted for this book are in the Collection of American Literature, Beinecke Rare Book and Manuscript Library, at Yale University. The bulk of the Paul Strand papers, including Rebecca Salsbury's letters to him, are held at the Paul Strand Collection, Center for Creative Photography, at the University of Arizona.

I have also made extensive use of *My Faraway One: Selected Letters of Georgia O'Keeffe and Alfred Stieglitz, Volume 1, 1915–1933*, edited and annotated by Sarah Greenough (New Haven: Yale University Press in association with the Beinecke Rare Book and Manuscript Library, 2011). This volume is referred to in the notes as *MFO*; unless otherwise specified all correspondence so referenced is held in the Alfred Stieglitz/Georgia O'Keeffe Archive at the Beinecke.

Other published works for which full references appear in the bibliography are referred to by the author's name or, for frequently cited sources, initials. When more than one work by an author has been cited, the short title is given. Correspondence is referred to by the author's name, or initials in the case of frequent citations.

Names are abbreviated as follows:

AA	Ansel Adams
AS	Alfred Stieglitz
PS	Paul Strand
GOK	Georgia O'Keeffe
RS	Rebecca Salsbury
RSS	Rebecca Salsbury Strand
RSJ	Rebecca Salsbury James
AP	Anita Pollitzer

Archives and private collections are abbreviated as follows:

AAA	Harwood Foundation Archives, Archives of American Art, Smithsonian Institution, Washington, D.C.
ASA/YCAL	Alfred Stieglitz Archive, Yale University Collection of American Literature, Beinecke Rare Book and Manuscript Library, New Haven, Connecticut
CCP	Paul Strand Collection, Center for Creative Photography, University of Arizona, Tucson, Arizona

GOKMRC Georgia O'Keeffe Museum Research Center, Santa Fe,
 New Mexico
MDL Mabel Dodge Luhan Papers, Yale Collection of American
 Literature, Beinecke Rare Book and Manuscript
 Library, New Haven, Connecticut
MFC Macmahon Family Collection, Austin, Texas
MOMA Calvin Tomkins Papers, Museum of Modern Art Archives,
 New York, New York
NGA National Gallery of Art, Washington, D.C.
NYPL Billy Rose Theater Division, New York Public Library,
 New York, New York
RSJ/YCAL Rebecca Salsbury James Papers, Yale Collection of
 American Literature, Beinecke Rare Book and
 Manuscript Library, New Haven, Connecticut
SFC Salsbury Family Collection

OPENING

3 "Never was there such": John Tennant, "The Stieglitz Exhibition," *The Photo-Miniature* 16, no. 183 (July 1921): 138. My account of this exhibition is based on the contemporary reviews and recollections noted in the following notes, as well as other sources, including Guido Bruno, "Stieglitz: Photographer," *Bruno's Review*, June 1921, pp. 185–86; Walter Pach, "Art," *The Freeman*, February 23, 1921, pp. 565–66; and F.C.T., "Alfred Stieglitz," *British Journal of Photography*, March 4, 1921, p. 126.

3 "Stieglitz has not divorced": Hamilton Easter Field, "At the Anderson Galleries," *Brooklyn Daily Eagle*, February 13, 1921.

3 "His resurrection": F.C.T., "Alfred Stieglitz."

4 "They make me want to forget": Tennant, p. 139.

5 "showed us the life": Paul Rosenfeld, "Stieglitz," *The Dial* 70 (April 1921): 398.

5 one man, who ranted: Letter from an anonymous "lover of art" to Mitchell Kennerley, February 9, 1921, forwarded to ASA/YCAL.

5 "psychological revelations": "Photographs by Alfred Stieglitz," *New York Times*, February 13, 1921.

5 "The spirit of sex": Rosenfeld, "Stieglitz," *Port of New York*, p. 273.

6 "He loves her so": Hapgood, p. 339.

6 "He spends an immense": Henry McBride, "Modern Art," *The Dial* 70 (April 1921): 481.

6 "Mona Lisa got": Henry McBride, "O'Keeffe at the Museum," *New York Sun*, May 18, 1946.

6 "universality in the shape": AS, quoted in "Studio and Gallery," *New York Sun*, February 19, 1921.

7 "laid bare the raw material": Herbert Seligmann, "A Photographer Challenges," *The Nation,* February 16, 1921, p. 268.

7 "Stieglitz . . . accepted" to "destroys": PS, "Alfred Stieglitz and a Machine," unpaginated.

7 "affirmation, life kindled": RSS, "My life, like all Gaul . . . ," unpublished ms., YCAL.

7 "a tightly integrated foursome": Belinda Rathbone, "Portrait of a Marriage," *The J. Paul Getty Museum Journal,* vol. 17 (1989): p. 90.

7 "There was a constant grinding": GOK, quoted in AS, *Georgia O'Keeffe: A Portrait,* unpaginated.

CHAPTER 1: BORN IN HOBOKEN

11 "[He] would spend": Whelan, *Alfred Stieglitz,* p. 15.

11 "musicians, artists, and literary folk": AS, quoted in Norman, *Alfred Stieglitz,* p. 15.

12 "in the pure and virtuous": Whelan, *Alfred Stieglitz,* p. 49.

14 Stieglitz later said: On Stieglitz's illegitimate daughter and his support of her, see Greenough, ed., *MFO,* p. 164, n. 347.

14 "It was, after all": AS, quoted in Norman, *Alfred Stieglitz,* p. 34.

14 "the spiritual emptiness": ibid.

14 "You push the button": AS, *Twice a Year* 1 (1938): 95–96.

14 "a fish out of water": AS, *Twice a Year* 8/9 (1942): 106–7.

16 "Every stitch in the mending": AS, "My Favorite Picture," *Photographic Life,* 1899, pp. 11–12; reprinted in Whelan, ed., *Stieglitz on Photography,* p. 61.

16 "He felt that the driver": Whelan, *Alfred Stieglitz,* p. 118.

16 "so-called 'American Photography'": AS inscription on verso of *Winter—Fifth Avenue,* AS, *Alfred Stieglitz: The Key Set,* vol. 1, p. 51.

16 "A driver I saw": AS, quoted in Norman, "Stieglitz's Experiments in Life," *New York Times Magazine,* December 29, 1963, p. 12.

17 "the key to all art": AS, "A Plea for Art Photography in America," *Photographic Mosaics,* 1892; reprinted in Whelan, ed., *Stieglitz on Photography,* p. 30.

17 "technically perfect": AS, quoted in Norman, *Alfred Stieglitz,* p. 42.

17 "I would rather be": AS, quoted in Paul Rosenfeld, "The Boy in the Dark Room," in *America & Alfred Stieglitz,* ed. Frank et al., p. 75.

17 "the development of an organic idea": Publication Committee letter, *Camera Notes,* July 1897; cited in Whelan, *Alfred Stieglitz,* p. 145.

17 "I had a mad idea": AS, quoted in Norman, *Alfred Stieglitz,* p. 43.

18 "To demand the portrait": AS, quoted in the wall text for *Georgia O'Keeffe* (1921), Metropolitan Museum of Art 2002 exhibition "Twentieth Century Photographs," as cited in Hoffman, *Stieglitz,* p. 331, n. 127.

18 "all parts of a woman's body": Seligmann, *Alfred Stieglitz Talking,* pp. 138–39.

18 The halation (the blur or halo): AS, "Night Photography with the Introduc-

tion of Life," *American Annual of Photography and Photographic Times Almanac for 1898;* reprinted in Whelan, ed., *Stieglitz on Photography,* pp. 81–86.

18 "His attitude toward the club": Theodore Dreiser, "The Camera Club of New York," *Ainslee's* 4 (October 1899): 324–25.

19 "no longer any dispute": Theodore Dreiser, "A Master of Photography," *Success* 2 (June 10, 1899): 471.

19 "Not only during my first visit": Sadakichi Hartmann, "The New York Camera Club," *Photographic Times,* February 1900, p. 59.

19 "a full share of knocks": Caffin, pp. 33, 49.

20 "I shall use the camera": Niven, p. 75.

20 "I think I've found my man": AS, quoted in Newhall, p. 119.

21 "*Camera Notes* was a lie": AS, quoted in John Francis Strauss, "The Club and Its Official Organ," *Camera Notes* (January 1901): 153–61; Whelan, *Alfred Stieglitz,* p. 174.

21 "Yours truly": AS, quoted in Norman, *Alfred Stieglitz,* p. 48; on the Secession, see Whelan, *Alfred Stieglitz,* p. 179.

21 "Those of a similar mind": AS, "The Photo-Secession," *American Annual of Photography and Photographic Times Almanac for 1904,* p. 42; cited in Homer, p. 28.

22 "no one but Stieglitz": Steichen, unpaginated.

22 "rather helter-skelter": ibid.

22 "too ostentatious": ibid.

22 "To advance photography": *Camera Work* (July 1903), unpaginated supplement.

22 "battling . . .": AS, quoted in Norman, *Alfred Stieglitz,* p. 66.

23 "he was not for a moment": Niven, p. 163.

23 *Camera Work* was itself a work of art: Rosenfeld, "The Boy in the Dark Room," *America & Alfred Stieglitz,* p. 82.

23 "to the special necessities": Sidney Allen, "A Visit to Steichen's Studio," *Camera Work* 2 (April 1903): 25–28.

24 Kerfoot combined inked silhouettes: J. B. Kerfoot, "The ABC of Photography," *Camera Work* 8 (October 1904): 40.

24 "It is to America": AS, "Six Happenings 1: Photographing the Flat-Iron Building," *Twice a Year* 14/15 (1946–1947): 188–90.

24 "familial dysfunction": Whelan, *Alfred Stieglitz,* p. 200.

24 "During that period": AS, "Some Impressions of Foreign Exhibitions," *Camera Work* 8 (October 1904): 34.

25 "routinely exaggerated": Whelan, *Alfred Stieglitz,* p. 201.

25 "pictorialists throughout the land": Sadakichi Hartmann, "Little Tin Gods on Wheels," *The Photo-Beacon,* September 1904, pp. 282–86; cited in Whelan, *Alfred Stieglitz,* p. 205.

25 "with which the walls": AS, "The 'First American Salon' at New York," *Camera Work* 9 (January 1905): 50.

26 "Eventually, '291' came to be": Whelan, ed., *Stieglitz on Photography,* p. 177.

CHAPTER 2: PORTRAIT OF 291

27 "without the stereotyped": AS, "Editorial," *Camera Work* 14 (April 1906): 17.

27 "The vanity of these people": Charles FitzGerald, *Evening Sun*, December 9, 1905; reprinted in *Camera Work* 14 (April 1906): 35.

28 "in impulse and form": Hapgood, pp. 336–37.

28 "You forgot all about New York": Paul Haviland, "The Home of the Golden Disk," *Camera Work* 25 (January 1909): 21.

29 "You can give up": AS, "Four Happenings," *Twice a Year* 8/9 (1942): 122.

29 "Steichen had become": Niven, p. 212.

29 "The real battle": Joseph Keiley, "The Photo-Secession Exhibition at the Pennsylania Academy of Fine Arts," *Camera Work* 16 (October 1906): 51.

29 "Smith is a young woman": James Huneker, reprinted in AS, "The Editor's Page," *Camera Work* (April 1907): 37–38.

29 "thoughts loosened": Smith, cited in Hoffman, *Alfred Stieglitz: A Beginning Light,* p. 228.

29 "the pliability": AS, "Our Illustrations," *Camera Work* 27 (July 1909): 47.

30 During the 1907–1908 season: Sarah Greenough makes this point in *Modern Art and America,* p. 31.

31 "Every movement of her body": Arthur Symons, quoted in "The Rodin Drawings at the Photo-Secession Galleries," *Camera Work* 22 (April 1908): 35.

31 "not the sort of thing": W. B. McCormick, *New York Press;* reprinted in *Camera Work* 22 (April 1908): 40.

31 "the prurient prudery": J. N. Laurvick, *New York Times;* reprinted in *Camera Work* 22 (April 1908): 35.

31 "I had never heard": GOK, "Stieglitz: His Pictures Collected Him," *New York Times Magazine,* December 11, 1949, p. 26.

31 "I have another cracker-jack": Steichen to AS, 1908, quoted in Alfred H. Barr, Jr., *Matisse,* p. 113.

31 "the first blow": AS, *Twice a Year* 1 (1938): 100.

31 "Here was the work": Unsigned (AS), *Camera Work* 23 (July 1908): 10.

32 "brought a recurrence": Bulliet, *Apples and Madonnas,* p. 55.

32 "Compared to these memoranda": Charles FitzGerald, reprinted in *Camera Work* 23 (July 1908): 10.

32 "There are some female figures": Edgar Chamberlin, reprinted in *Camera Work* 23 (July 1908): 10.

32 "This is not the ocular": Charles Caffin, "Henri Matisse and Isadora Duncan," *Camera Work* 25 (January 1909): 18.

32 "that perfect freedom": Unsigned [Agnes Ernst], "The New School of the Camera," *New York Morning Sun,* April 26, 1908; cited in Whelan, *Alfred Stieglitz,* p. 234.

32 "I feel almost like an apostle": Ernst to AS, quoted in ibid., p. 234.

33 "Why not": AS, *Twice a Year* 8/9 (1942): 124–26.

33 "He was always there": Steichen, unpaginated.

33 "a quiet nook": Paul Haviland, "The Home of the Golden Disk," *Camera Work* 25 (January 1909): 21.

33 "champion modern tendencies": ibid.

34 "Marin's watercolors sang": AS, quoted in Norman, *Alfred Stieglitz*, p. 97.

35 "the largest small room": Hartley, p. 61.

35 "toward the realization": Paul Haviland, "Photo-Secession Notes," *Camera Work* 30 (April 1910): 54.

35 "unless it is to make color": Elizabeth Carey, "News and Notes of the Art World," *New York Times*, March 20, 1910.

35 "vivisectionists": James Townsend, in *American Art News*; reprinted in *Camera Work* 30 (April 1910): 47.

35 "ruthless materialism": Whelan, *Alfred Stieglitz*, p. 279.

35 "No show was ever": F. Austin Lidbury, "Some Impressions of the Buffalo Exhibition," *American Photography* (December 1910): 676; cited in ibid., p. 284.

36 "Even Mrs. Stieglitz": AS to George Seeley, November 21, 1910, ASA/YCAL; cited in ibid., pp. 283–84.

36 "Just as the Photo-Secession": AS, quoted in Norman, *Alfred Stieglitz*, p. 79.

36 "I see none": AS to Ward Muir, January 30, 1913, ASA/YCAL; cited in Whelan, *Alfred Stieglitz*, p. 292.

36 "red rag": Steichen to AS, undated [Summer 1910], cited in Whelan, *Alfred Stieglitz*, p. 294.

36 "The display is": Arthur Hoeber, *New York Globe*; reprinted in *Camera Work* 36 (October 1911): 29.

36 "the most vital": AS to Sadakichi Hartmann, December 22, 1911; cited in Norman, *Alfred Stieglitz*, pp. 109–10.

37 "We stand before the door": AS to Heinrich Kuehn, October 14, 1912; cited in Whelan, *Alfred Stieglitz*, p. 299.

37 "Much of the expression": Hapgood, pp. 339, 341.

37 "this celebrated nursery": Felix Grendon, "What Is Post-Impressionism?" *New York Times*, May 12, 1912.

38 "You will see there": "The First Great 'Clinic' to Revitalize Art," *New York American*, January 26, 1913; quoted in Norman, *Alfred Stieglitz*, p. 118.

39 "explosion in a shingle factory": On this phrase, see Francis N. Naumann, "An Explosion in a Shingle Factory," in *The Armory Show at 100*, ed. Marilyn Satin Kushner, Kimberly Orcott, and Casey Blake, pp. 203–9.

39 "a masochistic reception": Stuart Davis, quoted in Barbara Haskell, "The Legacy of the Armory Show," in *The Armory Show at 100*, pp. 399–400.

39 "It set off a blast": Kenneth H. Miller, quoted in ibid., p. 410.

39 "People are beginning": AS to Ward Muir, January 7, 1913; quoted in Anne McCauley, "The 'Big Show' and the Little Galleries," in ibid., p. 145.

39 "The period during": Paul Haviland. "Photographs by Alfred Stieglitz," *Camera Work* 42/43 (April–July 1913): 46.

39 "one of the significant": Swift, quoted in Whelan, *Alfred Stieglitz*, p. 317.

40 "unsurpassable": Edgar Chamberlin, quoted in ibid., p. 317.

40 "Visitors at the Armory": Royal Corissoz, quoted in ibid., pp. 316–17.

CHAPTER 3: THE DIRECT EXPRESSION OF TODAY

41 "because one's own children": AS, quoted in Norman, *Alfred Stieglitz,* p. 119.

41 "Colleagues tried to prove": ibid., p. 124.

41 "twenty or thirty people": AS to Charles Caffin, November 17, 1914, ASA/YCAL; quoted in Whelan, *Alfred Stieglitz,* p. 330.

41 "There was a dust-covered": Steichen, unpaginated.

41 all sixty-eight of the replies: Quotations in this and the following paragraph are from *Camera Work* 47 (July 1914): passim.

42 "Close friends seemed": AS, quoted in Norman, *Alfred Stieglitz,* p. 124.

42 "What are nations": AS to Anne Brigman, September 28, 1914, ASA/YCAL; quoted in Niven, p. 405.

43 "Disagreement seemed": Niven, p. 443.

43 "Tragedies are happening": AS to Anne Brigman, April 16, 1915; quoted in Niven, p. 418.

43 "the best criticism": PS, interview, December 28, 1971, Homer, pp. 4–5.

43 "You've done something new": PS interview in Hill and Cooper, eds., p. 3.

43 "It was like having": PS, quoted in Tomkins, *Paul Strand,* p. 20.

45 "not a very well-to-do": PS, interview, June 25, 1974, Homer, p. 2.

45 "The exhibition by Alfred Stieglitz": PS, unsigned and identified as "Photographer; 1904—graduated 1909," *Ethical Culture School Record* (New York: Society for Ethical Culture, 1916), p. 94.

45 "I had to, myself": PS, interview, 1974, Homer, p. 2.

46 "The picture filled": Hambourg, p. 15.

46 "I had a feeling": PS, quoted in Tomkins, *Paul Strand,* p. 19.

46 "I like the word": PS to Calvin Tomkins, July 7, 1973, Tomkins notes, MOMA.

46 "There was a fight": PS interview, quoted in Hill and Cooper, eds., p. 4.

46 "provincial": PS to parents, quoted in Hambourg, p. 25.

46 "Everything is extremely American": PS to AS, May 16, 1915, ASA/YCAL.

47 "the skyscraper civilization": Rosenfeld, *Port of New York,* p. 272.

47 "Steichen, lanky and boyish": Alfred Kreymborg, *Troubadour,* p. 127.

48 "without the outside influence": PS, "Photography," *Camera Work* 49/50 (June 1917): 780–81.

48 "watching people walk": PS, quoted in Tomkins, *Paul Strand,* p. 19.

48 "In whatever he does": AS, "Photographs by Paul Strand," *Camera Work* 48 (October 1916): 11–12.

49 "because '291' knew": ibid.

49 "silvery picture": Royal Cortissoz, "Random Impressions," *New York Tribune;* "Notes and News," *American Photography* 10 (May 1916): 281; both cited in Greenough, ed., *Modern Art and America,* p. 247.

49 a "straight" photographer: Charles Caffin, "Paul Strand in 'Straight' Photographs," *New York American,* March 20, 1916.

49 "straight all the way": AS to R. C. Bayley, April 17, 1916, ASA/YCAL.

50 "I learned how you build": PS, quoted in Tomkins, *Paul Strand,* p. 19.

50 "It has been a summer": PS to AS, August 28, 1916, ASA/YCAL.

50 "It promises": AS to PS, August 31, 1916, CCP.
50 "For ten years": AS, "Photographs by Paul Strand," *Camera Work* 48 (October 1916): pp. 11–12.
50 "whom life had battered": PS, interview, June 25, 1974, Homer, p. 11.
50 "just the straight goods": AS to R. C. Bayley, November 1, 1916, ASA/YCAL.
51 "the first photographer": AS, quoted in Naef, unpaginated (on #48).
51 "The eleven photographs": unsigned [AS], "Our Illustrations," *Camera Work* 49/50 (June 1917): 36.
51 "brutally direct": ibid.

CHAPTER 4: A WOMAN ON PAPER

52 "I went in a year ago": GOK to AS, July 25, 1916, *MFO*, pp. 15–16.
52 "Feeling more dead": AS, quoted in Norman, *Alfred Stieglitz*, p. 130.
52 "She's an unusual woman": AS, quoted in AP to GOK, January 1, 1916, Giboire, ed., pp. 115, 116.
53 "Woman unafraid": AS, October 9, 1919, "Woman in Art," Norman, p. 137.
53 "Do you like my music": GOK to AP, June 1915, Giboire, ed., p. 5.
53 "Music—Voices—Singing—Water": AS to GOK, July 10, 1916, *MFO*, p. 13.
53 "They are as if": AS to GOK, June 1916, Pollitzer, pp. 139–40.
53 Coming upon her work: Sarah Greenough writes, "What Stieglitz saw in both Strand's and O'Keeffe's work were possibilities, the scattered germs of thoughts that he believed . . . held the potential to merge modernist vision with an expression of the American experience"; Greenough, ed., *Modern Art and America,* p. 249.
55 "something I'd wanted": Tomkins, GOK notes, MOMA.
55 "I didn't understand": GOK, quoted in Lisle, pp. 72–73.
55 "Then I hurried down": AP to GOK, October 1915, Giboire, ed., pp. 38–39.
55 "I believe I would rather": GOK to AP, October 1915, ibid., p. 40.
55 "Little did I dream": AS to GOK, July 10, 1916, *MFO*, p. 13.
55 "I made a crazy thing": GOK to AP, October 1915, Giboire, ed. p. 66.
55 "Anita—do you feel": GOK to AP, October 1915, ibid., p. 46.
57 "We're trying to live": AP to GOK, October 26, 1915, Pollitzer, p. 35.
57 "I want to love": GOK to AP, January 14, 1916, Giboire, ed., p. 123.
57 "I said something": GOK to AWM, Jan. 6, 1916, MFC.
57 "Columbia is a nightmare": GOK to AP, January 4, 1916, Giboire, ed., p. 118.
57 "there is something wonderful": GOK to AP, January 14, 1916, ibid., p. 123.
57 "I want to go": GOK to AP, January 1916, ibid., p. 124.
57 "want to tell all the Methodists": GOK to AP, January 28, 1916, ibid., p. 127.
58 "expressive not simply": Greenough, ed., *Modern Art and America,* p. 250.
58 "You have no more": AS, quoted in Norman, *Alfred Stieglitz,* p. 131.
59 "Miss O'Keeffe looks": Henry Tyrrell, "New York Art Exhibition and Gallery Notes," *Christian Science Monitor,* June 2, 1916, reprinted in Lynes, *O'Keeffe, Stieglitz, and the Critics,* p. 166.

59 "'291' had never": AS, *Camera Work* 48 (October 1916): 12–13; reprinted in Lynes, *O'Keeffe, Stieglitz, and the Critics*, p. 166.

59 "I wish you would": GOK to AWM, May 3, 1916, MFC.

59 "I have spent most of the time": GOK to AP, June 1916, Giboire, ed., p. 159.

59 "Love is great to give": GOK to AWM, June 20, 1916, MFC.

59 "Those drawings": GOK to AS, June 22, 1916, *MFO*, p. 9.

59 "just plain stupid": AS to GOK, June 26, 1916, *MFO*, p. 11.

59 "I think they are": GOK to AS, July 3, 1916, *MFO*, p. 11.

59 "My only value": AS to GOK, July 10, 1916, *MFO*, p. 12.

60 "I think letters": GOK to AS, July 11, 1916, *MFO*, p. 13.

60 "I can't bear": AS to GOK, July 16, 1916, *MFO*, p. 15.

60 "I don't care": GOK to AS, July 25, 1916, *MFO*, p. 15.

60 "Will the pictures": AS to GOK, July 31, 1916, *MFO*, p. 17.

60 "You will probably laugh": GOK to AS, August 6, 1916, *MFO*, pp. 18–19.

60 "You are a careless mother": AS to GOK, August 16, 1916, *MFO*, pp. 20, 22.

60 "go to you and the Lake": GOK to AS, September 3, 1916, *MFO*, p. 27.

60 "the only place": GOK to AP, October 1916, Giboire, ed., p. 206.

61 "Her clothing": Ruby Cole Archer, quoted in Robinson, p. 159.

61 "The Plains sends": GOK to AS, September 3, 1916, *MFO*, p. 27.

61 "It's a great privilege": AS to GOK, September 20, 1916, *MFO*, p. 29.

61 "sunny letter": GOK to AS, September 24, 1916; "the quiet dark night," GOK to AS, September 26, 1916; both *MFO*, p. 34.

61 "I could so easily": GOK to AS, September 26, 1916, *MFO*, p. 35.

61 "I am not writing as": AS to GOK, September 30, 1916, *MFO*, p. 38.

61 "Photographing always": AS to GOK, September 28, 1916, *MFO*, p. 37.

61 "The Lake": AS to GOK, September 30, 1916, *MFO*, p. 38.

61 "I remember the shapes": GOK to AS, October 1, 1916, *MFO*, pp. 39–40.

62 "I wish you could see": GOK to AP, October 1916, Giboire, ed., p. 207.

62 "The plains": GOK to AP, October 1916, ibid., p. 209.

62 "It is absurd": GOK to AP, September 11, 1916, ibid., p. 184.

62 "I had nothing but": GOK, *Georgia O'Keeffe*, unpaginated.

62 "I think all the world": GOK to AP, October 3, 1916, quoted in Udall, p. 26.

62 "it would have been nice": GOK to AWM, September 25, 1916, MFC.

62 "It will interest me": GOK to AS, October 26, 1916, *MFO*, pp. 49–50.

62 "To Georgia O'Keeffe": AS dedication, October 28, 1916, cited in *MFO*, p. 51. After prolonged labor pains, he teased, he had given birth: "Father healthy. —Child a book."

63 "No one will ever": AS to GOK, October 26, 1916, *MFO*, p. 48.

63 "I can't imagine": GOK to AS, October 31, 1916, *MFO*, p. 57. GOK wrote to Macmahon on December 28, 1916, of her wish for a child with him: "There had never been anyone else that I would want—or would have for the father of my child" (MFC).

63 "in a curious way": GOK to AS, November 4, 1916, *MFO*, p. 60.

63 "I'm glad you feel": AS to GOK, November 9, 1916, *MFO*, p. 60, n. 134.

63 "I have to smile": GOK to AS, November 22, 1916, *MFO*, p. 79.

63 "immensely": AS to GOK, November 27, 1916, *MFO*, p. 81.

63 "very fine": AS to GOK, December 15, 1916, *MFO*, p. 89.

63 "I love the snow": GOK to AS, November 4, 1916, *MFO*, p. 59.

63 "I wanted you": GOK to AS, February 4, 1917, *MFO*, p. 103.

64 "It's like dope": AS to GOK, December 21, 1916, *MFO*, p. 90.

64 "I could see your face": AS to GOK, November 10, 1916, *MFO*, p. 64.

64 "I put out my hand": GOK to AS, November 13, 1916, *MFO*, p. 73.

64 "I'd get it out": GOK to AS, November 27, 1916, *MFO*, p. 83.

64 "The snow as bed": AS to GOK, December 21, 1916, *MFO*, p. 91.

64 "make people say": GOK to AS, November 13, 1916, *MFO*, pp. 72–73.

64 "He wanted to touch me": GOK to AS, January 2, 1917, *MFO*, p. 98.

64 "No one": AS to GOK, December 26, 1916, *MFO*, p. 95.

65 "a sort of wild": AS to GOK, November 16, 1916, *MFO*, p. 74.

65 "a curious kind of balance": GOK to AS, January 3, 1917, *MFO*, p. 99.

65 "A train was coming": GOK to AS, November 30, 1916, *MFO*, p. 84.

65 "You saw the big black locomotive": AS to GOK, December 4, 1916, *MFO*, p. 86.

65 "You are really here": GOK to AS, December 23, 1916, *MFO*, pp. 93–94.

CHAPTER 5: PASSION UNDER CONTROL

66 "some terrible common suffering": AS to GOK, December 21, 1916, *MFO*, pp. 91–92.

66 "A wealthy Emmy": Whelan, *Alfred Stieglitz*, pp. 384–85.

66 "If there is war": AS to GOK, February 6, 1917, *MFO*, p. 106.

66 "It will give his Scotchness": GOK to AS, December 29, 1916, *MFO*, p. 97, n. 211.

66 "a toned-down": AS to GOK, January 16, 1917, *MFO*, p. 102.

66 "Knowing that 291": GOK to AS, March 15, 1917, *MFO*, p. 124.

66 "tornado of letting go": AS to GOK, February 11, 1917, *MFO*, pp. 110–11.

67 "I've said some scandalous": GOK to AS, February 16, 1917, *MFO*, p. 113.

67 *"right or wrong"*: Kindred Watkins to GOK, May 6, 1917, *MFO*, p. 136, n. 294.

67 "art game": AS to GOK, February 22, 1917, *MFO*, p. 115.

68 "very informal": AS to GOK, March 26, 1917, *MFO*, p. 124.

68 "There is a religious": AS to GOK, April 2, 1917, *MFO*, p. 132.

68 "The hanging alphabetically": AS to GOK, April 10, 1917, *MFO*, pp. 132–33.

68 "Its lines are very fine": AS to GOK, April 19, 1917, *MFO*, p. 135.

69 "atavistic minds": editorial, *The Blind Man* 2 (May 1917): 4–5. Stieglitz also contributed a letter saying that the Independents' purpose would have been better served by withholding the exhibitors' names.

69 "What's the use": GOK to AS, April 24, 1917, *MFO*, pp. 139–40.

69 "Waving flags": AS to GOK, May 1, 1917, *MFO*, p. 142.

69 "It was him": GOK to AP, June 20, 1917, Giboire, ed., p. 255.

69 "When she wants something": AS, quoted in Seligmann, *Alfred Stieglitz Talking*, p. 13.

69 "I'm so full of you": AS to GOK, June 3, 1917, *MFO*, p. 154.

70 "The interesting but little-known": Henry Tyrrell, "New York Art Exhibition and Gallery Notes: Esoteric Art at '291,'" *Christian Science Monitor*, May 4, 1917; reprinted in Lynes, *O'Keeffe, Stieglitz, and the Critics*, pp. 167–68.

70 "a man's and a woman's": ibid.

70 "I had a wonderful time": GOK to AP, June 20, 1917, Giboire, ed., p. 256.

70 "making Strand photographs": GOK to PS, June 3, 1917, CCP.

70 "frozen": GOK to AS, June 1, 1917, *MFO*, pp. 152–53.

71 "The wife and I": AS to GOK, July 2, 1917, *MFO*, p. 173.

71 "cubby-hole": Bruno, "The Passing of '291,'" *Pearson's* 38 (March 1918): 402.

71 "Where in any medium": PS, "Photography," *Seven Arts* 2 (August 1912): 524–25.

71 "Something—somehow": PS to AS, July 3, 1917, ASA/YCAL.

71 "It seems impossible": PS to AS, July 31, 1917, ASA/YCAL.

71 "Of course the War": AS to PS, August 18, 1917, CCP.

72 "I felt as I left": GOK to AS, June 5, 1917, *MFO*, p. 155.

72 "Some folks": GOK to AS, June 28, 1917, *MFO*, p. 165.

72 "The work—Yes": GOK to PS, June 12, 1917, CCP.

72 "I am the most talked of woman": GOK to AS, June 11, 1917, partially quoted in *MFO*, p. 154.

72 "I sang you three songs": GOK to PS, June 12, 1917, CCP.

72 "I love myself": GOK to AS, June 16, 1917, *MFO*, p. 161.

72 "They were surprised": AS, *Georgia O'Keeffe: A Portrait*, unpaginated.

72 "I could do thousands": AS to GOK, June 8, 1917, *MFO*, p. 161, n. 338.

72 "You—believing in me": GOK to AS, June 29, 1917, *MFO*, p. 167.

73 "Passion under control": AS to GOK, June 23, 1917, *MFO*, p. 163.

73 "I couldn't get": GOK to AS, July 1, 1917, *MFO*, p. 169.

73 "I'd like to kiss it": AS to GOK, July 2, 1917, *MFO*, pp. 173–74.

73 "All of me has been yours": GOK to AS, July 2, 1917, *MFO*, pp. 171–72.

73 "I'd like to put my arm": GOK to AS, July 13, 1917, *MFO*, p. 177.

73 "A woman lay in my arms": AS to GOK, July 28, 1917, *MFO*, pp. 177–78.

73 "Your songs": GOK to PS, June 26, 1917, CCP.

74 "This spring I've been": GOK to AWM, received June 20, 1917, Robinson, p. 186.

74 "You probably wouldn't": GOK to AWM, July 1917, Robinson, pp. 186–87.

74 "Living with him": GOK to AS, August 6, 1917, *MFO*, p. 180.

74 "I must find something": AS to GOK, July 28, 1917, *MFO*, p. 178.

74 "I'm glad you followed": AS to GOK, August 27, 1917, *MFO*, p. 186.

74 "Photographing excited me": ibid.

75 "where the nothingness": GOK to PS, August 15, 1917, CCP.

75 "She has gone through": AS to PS, August 18, 1917, CCP.

75 "I wonder why": GOK to AS, August 6, 1917, *MFO*, p. 180.

75 "like this country": GOK to PS, August 10, 1917, CCP.

75 "gloriously free": GOK to PS, September 12, 1917, CCP.

76 "one of the finer parts": PS to AS, September 15, 1917, YCAL. Strand's poems have not survived.

76 "devoid of ideas": AS to GOK, September 30, 1917, *MFO,* p. 193.

76 "What was 291?": PS, "What Was 291?," October 1917, unpublished type-script, CCP.

76 "I love you": GOK to PS, October 24, 1917, CCP.

77 "made me feel just like": GOK to AS, October 29, 1917, *MFO,* p. 203.

77 "I've been wondering": GOK to AS, September 20, 1917, *MFO,* p. 191.

77 "because everything seems": GOK to PS, October 30, 1917, CCP.

77 "We meet equally": GOK to AS, October 1, 1917, *MFO,* p. 193.

77 "an explosion": GOK to AS, December 7, 1917, *MFO,* pp. 217–18.

77 "wasn't the flag": GOK to AS, December 14, 1917, *MFO,* p. 222.

77 "It's like father": GOK to AS, December 17, 1917, *MFO,* p. 223.

77 "I'm glad to know": AS to GOK, December 28, 1917, *MFO,* p. 219.

78 "I know what you are": AS to GOK, January 2, 1918, *MFO,* p. 240, n. 476.

78 "cut out of altogether different": GOK to AS, January 18, 1918, *MFO,* p. 235.

78 "I'd like to be buried": GOK to AS, January 31, 1918, *MFO,* p. 246.

79 "He sat there like": AS to GOK, January 22, 1918, *MFO,* p. 243.

80 "just like a child": PS to AS, May 15, 1918, ASA/YCAL.

80 "stability of living": PS to AS, May 17, 1918 (letter X), ASA/YCAL.

80 "the most helpless": GOK to AS, May 21, 1918, *MFO,* p. 290.

80 "You are such a perfect god": GOK to AS, May 25, 1918, *MFO,* p. 292.

80 "no passion": PS to AS, May 29, 1918, ASA/YCAL.

80 "I can write now": AS to GOK, May 26, 1918, *MFO,* p. 296.

80 "if she wants to come": AS to PS, May 25 [?—postmark fuzzy], 1918, CCP.

81 "I am in a state": PS to AS, May 30, 1918, ASA/YCAL.

81 "The most extraordinary": PS to AS, June 1, 1918, ASA/YCAL.

81 "If I had let anybody": GOK to AS, June 3, 1918, *MFO,* p. 298.

CHAPTER 6: SQUARING THE CIRCLE

82 "But it was exciting": GOK, *Georgia O'Keeffe,* unpaginated.

82 "We have talked over": AS to ESD, June 16, 1918, ASA/YCAL.

82 "I have nothing to do with it": AS to GOK, c. June 10, 1918, *MFO,* p. 300.

82 "I've been lying here": GOK to AS, June 14, 1918, *MFO,* p. 302.

82 "intensely beautiful": AS to ESD, July 2, 1918, ASA/YCAL.

82 "These last 10 days": AS to AD, June 18, 1918, ASA/YCAL.

83 newly released correspondence: See *MFO,* p. 299.

83 "He said: I think": AS to GOK, mid-June 1918, *MFO,* p. 303.

83 "I'll make you fall in love": AS to GOK, July 2, 1918, *MFO,* pp. 306–7.

84 belong among O'Keeffe's works: Janet Malcolm takes this view in *Diana & Nikon,* p. 122.

84 "ongoing exchange of observation": Anne Wagner, *Three Artists (Three Women),* p. 92.

84 "an intricate psychological pas de deux": Whelan, *Alfred Stieglitz,* p. 406.

84 "He wanted head and hands": AS, *Georgia O'Keeffe: A Portrait,* unpaginated.

84 "[Stieglitz] asked me": ibid.

85 "somewhat lost": AS to GOK, mid-June 1918, *MFO,* p. 303.

85 "The days here": AS to PS, August 4, 1918, CCP.

85 "moving out and away": PS to AS, August 10, 1918, ASA/YCAL.

85 "It's a wonder": AS to GOK, August 5, 1929, *MFO*, pp. 506–7. Greenough identifies August 9 as "virginity day," thus establishing that it came after the taking of AS's most erotic portraits of GOK. See *MFO*, pp. 299, 311.

85 "Since I saw you": AS to AD, August 15, 1918, quoted in AS, *The Key Set*, p. 322.

86 "mess": AS to PS, September 15, 1918, CCP.

86 "Grateful—it seems funny": PS to AS, September 20, 1918, ASA/YCAL.

86 "Loveliness—Savage Force": AS to PS, November 17, 1918, CCP.

87 "hell": PS to AS, October 11, 1918, ASA/YCAL.

87 "I hope you'll be kept away": AS to PS, c. November 8, 1918, CCP.

87 "would not do at all": AS to PS, November 17, 1918, CCP.

87 "closely related": PS to Strands, October 25, 1918, CCP.

88 "I need the livingness": PS to AS, January 10, 1919, ASA/YCAL.

88 "almost like a murderer": PS to AS, February 6, 1919, ASA/YCAL.

88 "unlike anything": AS to PS, January 28, 1919, CCP.

88 "Your photographs and her work": PS to AS, April 15, 1919, ASA/YCAL.

88 "It all reminds me of Nero": AS to PS, March 28, 1919, CCP.

89 "Made me think of them": PS to AS, June 2, 1919, ASA/YCAL.

89 "They have found a little island": Herbert Seligmann to PS, n.d. [June 1919], CCP.

89 "Is it a madness": AS to PS, June 8, 1919, CCP.

89 "As I print": AS to PS, August 11, 1919, CCP.

89 "an embodiment of a life": A copy of this letter is included in PS to AS, August 9, 1919, ASA/YCAL.

90 "bee's-eye view": Sarah Whittaker Peters, *Becoming O'Keeffe*, p. 228.

90 "I'm glad we had you": AS to PS, October 6, 1910, CCP.

90 "very pretty girl": PS to AS, October 13, 1919, ASA/YCAL.

91 "little children": RSS, May 27, 1916, SFC.

91 "swinging crazily along": RS to PS, August 8, 1920, CCP.

91 "self-aggrandizing": Louis S. Warren, *Buffalo Bill's America*, p. 238.

93 "American blood": RSS to PS, Monday [April 30, 1929], CCP.

94 "as boy soldier": *New York Times*, December 25, 1902.

95 "half-drunk": RS to PS, June 27, 1920, CCP.

96 "to see more deeply": RS to PS, July 7, 1920, CCP.

96 "How tenderly / The breeze": RS to PS, May 3, 1920, CCP.

96 "mental indigestion": RS to PS, c. May 28, 1920, CCP.

97 "camera magic": RS to PS, June 15, 1920, CCP.

97 "consummated / First in pregnancy": RS to PS, June 11, 1920, CCP.

CHAPTER 7: A FINE COMPANIONSHIP

98 "return to normalcy": Warren G. Harding, "Back to Normal: Address Before Home Market Club," Boston, May 14, 1920.

98 "With the quiet of the morning": AS to AD, August 28, 1920, ASA/YCAL.

99 "a maelstrom": Charles Merz, "The Temper of the Country," *The New Republic,* November 10, 1920, pp. 259–60.

99 "the first generation": Waldo Frank, *Our America,* pp. 9, 184, 10. Frank's book went through three printings in six months.

99 "this business of being oneself": RS to PS, July 8, 1920, CCP.

99 "hell-raising": RS to PS, June 11, 1920, CCP.

99 "It seems as if": RS to PS, July 11, 1920, CCP.

100 "No one can help": RS to PS, August 20, 1920, CCP.

100 "absorbing too much": RS to PS, June 8, 1920, CCP.

100 "Sometimes/You are so much": RS to PS, July 5, 1920, CCP.

101 "justif[ying] the other self": RS to PS, July 11, 1920, CCP.

101 "dying—spiritually": RS to PS, August 5, 1920, CCP.

101 "The circle is complete": RS to PS, August 28, 1920, CCP.

101 "filled with *F.F.P.'s*": RS to PS, September 8, 1920, CCP.

101 "to the consternation": RS to PS, September 8, 1920, CCP.

102 "I owe you so much": RS to PS, Tuesday [December 1920], CCP.

103 "When we return": AS to PS, September 21, 1920, CCP.

103 "I am getting to hate 'nearlys'": AS to Herbert Seligmann, September 15, 1920, ASA/YCAL. See also AS to GOK, January 17, 1918, *MFO,* p. 237, on virility and art.

103 "I have quite definitely come": Sherwood Anderson, "Alfred Stieglitz," *The New Republic,* October 25, 1922, p. 215.

103 "The girl—your work": AS to PS, October 22, 1920, CCP.

103 "corkers": AS to PS, October 27, 1920, CCP.

104 "Master of the situation": AS to PS, November 2, 1920, CCP.

104 "Movement is everywhere": PS to AS, November 16, 1920, ASA/YCAL.

104 "I have been thinking about": RS to PS, Sunday evening [December 1920], CCP.

104 "Strength seems to flow": RS to PS, Tuesday [December 1920], CCP.

105 "There is such a thing as loyalty": Henry McBride, "Photographs by Stieglitz," *New York Herald,* February 13, 1921; reprinted in McBride, *The Flow of Art,* p. 160.

105 "Why should I": AS, quoted in "Stieglitz, the Pioneer Who Has Developed Photography as an Art," *New York Evening Post,* February 12, 1921.

105 "These are moments consciously recorded": AS, quoted in David Lloyd, "Studio and Gallery," *New York Sun,* February 19, 1921.

105 "spiritually significant": GOK, "To MSS. and Its 33 Subscribers and Others Who Read and Don't Subscribe," *MSS.* 4 (December 1922); reprinted in Lynes, *O'Keeffe, Stieglitz, and the Critics,* p. 183.

105 "the great affirmers of life": Paul Rosenfeld, "Stieglitz," *The Dial* 70 (April 1921): 397, 398.

105 "It was his manly sense": Lewis Mumford, "The Metropolitan Milieu," in Frank et al., eds., *America & Alfred Stieglitz,* p. 57.

106 "love of the world": Herbert Seligmann, "A Photographer Challenges," *The Nation,* February 16, 1921, p. 268.

106 "Stieglitz had accepted the machine": PS, "Alfred Stieglitz and a Machine," unpaginated, ASA/YCAL.

106 "O'Keeffe is what they probably will be calling": Henry McBride, "Art News and Reviews," *New York Herald,* February 4, 1923; quoted in Lynes, *O'Keeffe, Stieglitz, and the Critics,* p. 187.

107 "your beautiful loving": RS to PS, Tuesday [c. March 22, 1921], CCP.

107 "I raged when you wrote": ibid.

108 "When you need other folks": PS to AS, August 3, 1921, ASA/YCAL.

108 "more interesting than the feature": ibid. Robert Allerton Parker called the film a "glorious adventure," one that "emphasizes anew the art of the camera"; see "The Art of the Camera," *Arts and Decoration,* October 1921, p. 369.

108 groundbreaking: Jan-Christopher Horak calls *Manhatta* the first avant-garde film made in the United States; see "Modernist Perspectives and Romantic Impulses," in *Paul Strand,* ed. Stange, p. 55.

108 "It . . . lives very well": PS to AS, August 3, 1921, ASA/YCAL.

108 "You and Beck both": AS to PS, September 2, 1921, CCP.

108 "I dare not express the hope": AS to PS, September 3, 1921, CCP.

109 "I am heir": PS to AS, September 5, 1921, ASA/YCAL.

109 "I showed her your letter": PS to AS, September 5, 1921, ASA/YCAL.

109 "You . . . seem to be": RS to PS, Wed. 4:30 [September 1921], CCP.

109 "a hot red star": RS to PS, Tuesday eve. [September 1921], CCP.

109 "You seemed to want": RS to PS, Wednesday [September 1921], CCP.

110 "I have not been unmindful": RS to AS, Wed. [c. October 1921], ASA/YCAL.

110 "I had a very fine note": AS to PS, October 4, 1921, CCP.

110 "I do hope that Strand": AS to Herbert Seligmann, August 20, 1921, ASA/YCAL.

110 "all dressed up": Herbert Seligmann to AS, September 28, 1921, YCAL.

110 "more alive": PS to AS, August 3, 1921, ASA/YCAL.

110 "The deeper significance": PS, "Photography and the New God," *Broom* 3 (November 1922): 257–58.

CHAPTER 8: TWENTIETH-CENTURY SEEING

112 "20th century seeing": PS to AS, July 2, 1922, ASA/YCAL.

112 "*MSS.* is published": *MSS.* 1 (February 1922): unpaginated.

112 "something really alive": RSS to AS, February 15, 1922, ASA/YCAL.

113 "He was warm with us": Olga (Baasch) Vrana interview with the author, April 4, 2012.

113 "We had wanted to live openly": Frank, *Memoirs of Waldo Frank,* p. 206.

113 "Her great painful and ecstatic climaxes": Paul Rosenfeld, "American Painting: Women, One," *The Dial* 71 (December 1921): 666–70.

113 "The pictures of O'Keeffe": Marsden Hartley, "Some Women Artists," in *Adventures in the Arts,* p. 116.

114 "They were only writing": GOK to Mitchell Kennerley, fall 1922, Cowart and Hamilton, p. 170.

114 "I am getting to something": GOK to AS, May 6, 1922, *MFO,* p. 327.

114 "I am on my back": GOK to AS, May 16, 1922, *MFO,* pp. 333–34.

114 "It was all so humorous": AS to GOK, May 5, 1922, *MFO,* p. 325.

114 "serious, critical, analytical": RSS to AS, July 10, 1922, ASA/YCAL.

114 "astonishing": AS to PS, July 15, 1922, CCP.

114 "Good old Stieglitz": RSS to AS, July 14, 1922, ASA/YCAL.

114 "I miss seeing": RSS to AS, July 10, 1922, ASA/YCAL.

115 "You are a thoroughly live wire": AS to RSS, July 13, 1922, ASA/YCAL.

115 "a great kid": PS to AS, August 14, 1922, CCP.

115 "more than well pleased": AS to RSS, May 1922 [*sic*], ASA/YCAL.

115 "You would have been a great asset": AS to RSS, August 23, 1922, ASA/YCAL.

115 "I have come very close": AS to PS, August 16, 1922, CCP.

116 "Wait until Paul": AS to RSS, July 15, 1922, ASA/YCAL.

116 "He'll be shouting": AS to RSS, August 7, 1922, ASA/YCAL.

116 "You poor lonely": AS to RSS, August 28, 1922, ASA/YCAL.

116 "everything but ideas": RSS to PS, Saturday morning [September 9, 1922], CCP.

117 "We must accomplish more": RSS to PS, September 9, 1922, CCP.

117 "quiet challenge" to "well-ordered machines": "Recent Pictorial Photography at the Camera Club Exhibition," *New York Times,* September 10, 1922.

117 "We could try some nudes": RSS to PS, Friday, September 16, 1922 [?], CCP.

117 "A lovely relationship": RSS to PS, Thursday, September 29, 1922, CCP.

118 "another grandie swim": RSS to PS, Saturday night, September 20, 1922, CCP.

118 "to prove to Paul": AS to Nancy Newhall, quoted in Whelan, *Alfred Stieglitz,* p. 433.

118 "Some of them—a nude of me": RSS to PS, Saturday night [September 1923?], CCP.

119 "because it can be made unpleasant": RSS to PS, Friday a.m. [October 6,] 1922, CCP.

119 "like one possessed": AS to Paul Rosenfeld, October 4, 1922, ASA/YCAL.

119 "in that he has bewildered": GOK, "To MSS. and its 33 subscribers and others who read and don't subscribe!," letter to the editor, *MSS.* no. 4 (December 1922): 17.

119 "irritation": RSS to PS, Wednesday night, October 5, 1922, CCP.

119 "important for all of us": AS to PS, October 5, 1922, CCP.

120 "She is one of those persons": Paul Rosenfeld, "The Paintings of Georgia O'Keeffe: The Work of the Young American Artist Whose Canvases Are to Be Exhibited in Bulk for the First Time This Winter," *Vanity Fair,* October 1922, p. 114.

120 "I am sorry for Georgia's sake": Rosenfeld to AS, September 23, 1922, ASA/YCAL.

121 "one of those dismal-colored paintings": GOK, *Georgia O'Keeffe,* unpaginated.

121 "I really can't do it": RSS to PS, October 12, 1922, CCP.

121 "a great gal to be with": RSS to AS, September 20, 1922, ASA/YCAL.

122 "that of a record": PS, "Photography and the New God," *Broom* 3, no. 4 (November 1922): 256.

122 "howling": AS to RSS, October 28, 1922, ASA/YCAL.

122 "able to complete the circle": AS to PS, October 28, 1922, CCP.

122 "How you'll like them": AS to RSS, November 1, 1922, ASA/YCAL.

122 "a new order of beings": AS to RSS, November 3, 1922, ASA/YCAL.

122 "It does seem as if": AS to RSS, October 24, 1922, ASA/YCAL.

123 "Owner of Buffalo Bill's": RSSJ, "My life, like all Gaul . . . ," unpublished ms, ASA/YCAL, unpaginated.

123 "not quite clear": AS to RSS, November 3, 1922, ASA/YCAL.

123 "It is difficult for me": RSS to AS, November 6, 1922, ASA/YCAL.

123 "Thanks for the Giving": AS to RSS, November 29, 1922, ASA/YCAL.

124 "I watched the sky": RSSJ, "My life, like all Gaul . . . ," unpaginated.

124 "May the kindly stars": AS to RSS, December 29, 1922, ASA/YCAL.

CHAPTER 9: KINDS OF LIVING

125 "He is responsible": Henry McBride, "Art News and Reviews—Woman as Exponent of the Abstract: Curious Responses to Work of Miss O'Keefe [*sic*] on Others; Free Without Aid of Freud, She Now Says Anything She Wants to Say—Much 'Color Music' in Her Pictures," *New York Herald*, February 4, 1923; reprinted in Lynes, *O'Keeffe, Stieglitz, and the Critics*, p. 187.

126 "I made up my mind": "I Can't Sing, So I Paint! Says Ultra Realistic Artist; Art Is Not Photography—It Is Expression of Inner Life!: Miss Georgia O'Keeffe Explains Subjective Aspect of Her Work," *New York Sun*, December 5, 1922; reprinted in Lynes, *O'Keeffe, Stieglitz, and the Critics*, pp. 180–82.

126 "things of the mind": PS, quoted in Tyrrell, "Art Observatory: Exhibitions and Other Things," *The World*, February 11, 1923; quoted in Lynes, *O'Keeffe, Stieglitz, and the Critics*, p. 194.

126 "To me they seem": Helen Appleton Read, "Georgia O'Keeffe's Show an Emotional Escape," *Brooklyn Daily Eagle*, February 11, 1923; reprinted in Lynes, *O'Keeffe, Stieglitz, and the Critics*, p. 192.

127 "In definitely unbosoming": Henry McBride, "Art News and Reviews," reprinted in Lynes, *O'Keeffe, Stieglitz, and the Critics*, pp. 189–90.

127 "I found that I could say": GOK, statement in *Alfred Stieglitz Presents One Hundred Pictures, Oils, Water-colors, Pastels, Drawings, by Georgia O'Keeffe, American* (New York: Anderson Galleries, 1923); reprinted in Lynes, *O'Keeffe, Stieglitz, and the Critics*, p. 184.

127 "You have had reports": AS to RSS, February 3, 1923, ASA/YCAL.

127 "One must sell to live": GOK to Doris McMurdo, July 1, 1922, ASA/YCAL; reprinted in Cowart and Hamilton, p. 170.

127 "Beck has her own": AS to PS, January 2, 1923, CCP.

127 "New York is still": AS, *An Exhibition of Photography by Alfred Stieglitz: 145*

prints, Over 128 of Which Have Never Been Publicly Shown, Dating from 1886–1921 (New York: Anderson Galleries, 1921), unpaginated.

128 "In a portrait of Rebecca Salsbury": "Art Week Marked by Events of Wide Interest—Foreign Notes," *New York Times,* April 8, 1923.

128 "From the beginning": PS, "The Art Motive in Photography," *British Journal of Photography* 70 (October 1923): 612–15.

128 "White is really so unspeakably stupid": AS to PS, July 16, 1923, CCP.

128 "preciousness": Charles Sheeler, cited in Whelan, *Alfred Stieglitz,* p. 445.

128 "Any exception": Copies of Sheeler and Strand letters were included in PS to AS, June 26, 1923, ASA/YCAL.

129 "I know things are hard": RSS to PS, Tuesday [June 19, 1923], CCP.

129 "You are a lovely lover": RSS to PS, Wednesday evening [June 20, 1923], CCP.

129 "a sweet and girlish grey": RSS to PS, Friday p.m. [June 22, 1923], CCP.

129 "I want you so to be free": RSS to PS, Friday night [August 27, 1923], CCP.

129 "I must earn my daily": RSS to AS, June 29, 1923, ASA/YCAL.

129 "You deserve a little holiday": RSS to PS, Sunday a.m. [July 27, 1923], CCP.

129 "I certainly failed": AS to Elizabeth Stieglitz Davidson, October 11, 1923, ASA/YCAL.

130 "Marie's kid is cute": AS to RSS, July 1, 1923, ASA/YCAL.

130 "I think the business": RSS to AS, July 2, 1923, ASA/YCAL.

130 "I know I would be evil": RSS to PS, August 6, 1923, CCP.

130 "my kind of 'touch'": AS to RSS, July 1, 1923, ASA/YCAL.

130 "in a pas de deux": AS to RSS, July 20, 1923, ASA/YCAL.

130 "She'll keep that kitchen": RSS to PS, August 20, 1923, CCP.

130 "Beckalina Mina Carissima": AS to RSS, August 6, 1923, ASA/YCAL.

131 "to take you in my arms": RSS to AS, August 7, 1923, ASA/YCAL.

131 "fit for the gods": AS to RSS, August 9, 1923, ASA/YCAL.

131 "I'm like a ship": RSS to PS, August 22, 1923, CCP.

131 "Will I never stop": RSS to PS, Sunday a.m., September 2, 1923, CCP.

131 "She told me the story": RSS to PS, Thursday [September 6, 1923], CCP.

132 "There is peace": AS to GOK [September 10, 1923], *MFO,* p. 341.

132 "Beck as nice": AS to GOK [September 13, 1923], *MFO,* p. 343.

132 "America without": AS to PR, September 5, 1923, ASA/YCAL.

132 "It leads us": Rosenfeld, *Port of New York,* pp. 204–5.

132 "derives from [Alfred's] photographs": RSS to PS, Friday a.m. [September 21(?) 1923], CCP.

132 "The American failure": Rosenfeld, *Port of New York,* pp. 209–10.

133 "I am the only one": RSS to PS, Wednesday a.m. [September 19, 1923], CCP.

133 "like a haunted man": RSS to PS, September 4, 1923, CCP.

133 "I fear Beck": AS to GOK, September 23, 1923, *MFO,* pp. 352–53.

133 "If Strand doesn't understand": AS to GOK, September 25, 1923, *MFO,* p. 356.

133 "a million miles away": AS to Elizabeth Stieglitz Davidson, September 24, 1923, ASA/YCAL.

134 "Stieglitz wants": RSS to PS, September 28, 1923, CCP.

134 "This house is queer": RSS to PS, September 28, 1923, CCP.

134 "I feel the more": RSS to PS [Sunday, September 30], CCP.

134 He recalled Georgia's resentment: See AS to RSS, July 21, 1929, YCAL.

135 "until I can't anymore": RSS to AS, October 29, 1923, ASA/YCAL.

135 "seemed to envelope": RSS to AS, October 15, 1923, ASA/YCAL.

135 "Your family does run into my life": RSS to AS, November 15, 1923, ASA/YCAL.

135 "There was infinite pleasure": RSS to AS, October 8, 1923, ASA/YCAL.

135 "I can see you": RSS to AS, October 29, 1923, ASA/YCAL.

136 "You will come into your own": AS to PS, October 15, 1923, no. 2, CCP.

136 "You two are still": RSS to AS, November 25, 1923, ASA/YCAL.

136 "There is something so perfect": GOK to SA [November 1923], cited in Whelan, *Alfred Stieglitz*, pp. 454–55.

137 "I know all your Life": AS to RSS, November 17, 1923, ASA/YCAL.

137 "I know my own worth": AS to PR, November 14, 1923, ASA/YCAL.

138 "a hummer": AS to PR, November 20, 1923, ASA/YCAL.

138 "a Jew who has arrived": AS to PS, November 15, 1923, CCP. See Clarence I. Freed, "Alfred Stieglitz: Genius of the Camera," *The American Hebrew*, January 18, 1924.

138 "I have learnt an awful lot": AS to PS, November 15, 1923, CCP.

138 "At the root of the man's dream": Rosenfeld, *Port of New York*, p. 264.

138 "something thrust fuller": ibid., p. 279.

CHAPTER 10: SENSITIVE PLANTS

139 "I don't worry": AS to Marie Boursault, November 28, 1923, ASA/YCAL.

139 "services rendered": Whelan, *Alfred Stieglitz*, pp. 456–57.

139 "not as a Southerner": Waldo Frank, "Foreword," in Toomer, pp. 138–40.

139 "If you were doing": Toomer, quoted in Kerman and Eldridge, p. 107.

140 "a vivid sense": Toomer to AS, January 10, 1924, Whalan, ed., p. 189.

140 "When I say 'white' ": Toomer to GOK, January 13, 1924, ibid., p. 191.

141 "a life and a way": Toomer, quoted in Whalan, ed., p. xxxv. Toomer saw Gurdjieff's system as "the idea that man is composed of body, emotions, and mind, and that normal living should provide means for the adequate constructive functioning of these three parts" (ibid.).

141 "inward re-buildings": Toomer to AS, February 20, 1924, Whalan, ed., p. 195.

141 "Toomer comes to unlimber": Rosenfeld, *Men Seen*, p. 233.

142 "Stieglitz once more": AS, *Catalog of Third Exhibition of Photography by Alfred Stieglitz* (New York: Anderson Galleries, 1924).

142 "very much on the ground": GOK to Sherwood Anderson, February 11, 1924, Cowart and Hamilton, p. 176.

142 "I have kept my pictures": GOK, quoted in *Alfred Stieglitz Presents Fifty-One Recent Pictures: Oils, Water-colors, Pastels, Drawings by Georgia O'Keeffe, American* (New York: Anderson Galleries, 1924).

143 "the secrets of the universe": Henry McBride, "Stieglitz, Teacher, Artist; Pamela Bianco's New Work: Stieglitz-O'Keefe [*sic*] Show at Anderson Gal-

leries," *New York Herald,* March 9, 1924; reprinted in Lynes, *O'Keeffe, Stieglitz, and the Critics,* p. 200.

143 "This is O'Keeffe's show": Helen Appleton Read, "News and Views on Current Art: Georgia O'Keeffe Again Introduced by Stieglitz at the Anderson Galleries," *Brooklyn Daily Eagle,* March 9, 1924; reprinted in Lynes, *O'Keeffe, Stieglitz, and the Critics,* p. 201.

143 "about as far in finish": McBride, *New York Herald,* March 9, 1924.

143 "emotionally torturous": Elizabeth Luther Cary, "Art: Exhibitions of the Week: 'Spiritual America' Print," *New York Times,* March 9, 1924; reprinted in Lynes, *O'Keeffe, Stieglitz, and the Critics,* p. 198.

143 "Psychoanalysts tell us": Helen Appleton Read, "Georgia O'Keeffe—Woman Artist Whose Art Is Sincerely Feminine," *Brooklyn Sunday Eagle Magazine,* April 6, 1924; quoted in Lynes, *O'Keeffe, Stieglitz, and the Critics,* p. 211.

143 "a funny mob": RSS to PS, March 13, 1924, no. 2, CCP.

144 "rotten": RSS to PS, March 14, 1924, CCP.

144 "prostitution": GOK to Catherine O'Keeffe, February 8, 1924, Robinson, pp. 265–66.

144 "Here in this American land": PS, "Georgia O'Keeffe," unpublished manuscript, CCP.

144 "a communicable aesthetic": PS, "Georgia O'Keeffe," *Playboy: A Portfolio of Art and Satire* 9 (July 1924): 16–20; reprinted in Lynes, *O'Keeffe, Stieglitz, and the Critics,* pp. 216–20.

145 "It seems we have been moving": GOK to Sherwood Anderson, June 11, 1924, Cowart and Hamilton, pp. 177–78.

145 "Even the old chestnut tree": AS to RSS, June 11, 1924, ASA/YCAL.

145 "although that crabbed wench": RSS to AS, June 19, 1924, ASA/YCAL.

145 "I thought of you frequently": AS to RSS, June 26, 1924, ASA/YCAL.

145 "You have achieved": AS to PS, June 28, 1924, CCP.

146 "I have to keep": GOK to Sherwood Anderson, June 11, 1924, Cowart and Hamilton, p. 178.

146 "I like getting what I've got": GOK, quoted in Carol Taylor, "Lady Dynamo," *New York World-Telegram,* March 31, 1945; quoted in Drohojowska-Philp, p. 239.

146 "She is rapidly coming into her own": "We Nominate for the Hall of Fame," *Vanity Fair,* July 22, 1924, p. 49.

146 "Georgia looked at home": PS to AS, June 25, 1924, ASA/YCAL.

146 "There'll be no trouble": AS to RSS, July 28, 1924, ASA/YCAL.

147 "This thing with G.O.K.": RSS to PS, August 2, 1924, CCP.

147 "no fuss of any kind": RSS to PS, August 4, 1924, CCP.

147 "Don't fret for a minute": RSS to PS, August 5, 1924, CCP.

147 "It's much nicer": RSS to PS, August 7, 1924, CCP.

147 "She is very unhappy" to "hurt one another": RSS to PS, August 8, 1924, CCP.

147 "She has been pushed": RSS to PS, August 10, 1924, CCP.

148 "I don't like the things": RSS to PS, August 4, 1924, CCP.

148 "I do see all": AS to RSS, September 5, 1924, ASA/YCAL.

148 "With Rosenfeld": Whelan, *Alfred Stieglitz*, p. 463.

148 O'Keeffe once declared: Hartley, "Some Women Artists in Modern Painting," *Adventures in the Arts*, p. 116.

149 "human trees": AS to Anne Brigman, December 24, 1949, ASA/YCAL.

149 "I am glad": RSS to AS, September 9, 1924, ASA/YCAL.

149 "sensitive plants": AS to RSS, September 16, 1924, ASA/YCAL

149 "You really had nothing": AS to RSS, October 3, 1924, ASA/YCAL.

150 "They show there's life": RSS to AS, September 9, 1924, ASA/YCAL.

150 "this jangly time": RSS to AS, September 21, 1924, ASA/YCAL.

150 "I've learned to make myself": RSS to AS, October 8, 1924, ASA/YCAL.

150 "Someday I'm going off": RSS to AS, October 24, 1924, ASA/YCAL.

150 "To Alfred Stieglitz": Sherwood Anderson, *A Story Teller's Story* (New York: B. W. Huebsch, 1924).

150 "We've again made conduits": Jean Toomer to AS, June 30 1924, Whalan, p. 203.

151 "I wasn't going to": GOK, quoted in Sieberling, "Horizons," *Life,* March 1, 1968, p. 40.

151 "What does it matter": GOK, quoted in Tomkins GOK notes, MOMA.

CHAPTER 11: THE TREENESS OF A TREE

152 "I am very glad": AS to RSS, February 11, 1925, ASA/YCAL.

152 "there was an immense buzz": Henry McBride, "The Stieglitz Group at Anderson's," *New York Sun,* March 14, 1925; reprinted in Lynes, *O'Keeffe, Stieglitz, and the Critics,* pp. 225–27.

152 "O'Keeffe outblazes": Edmund Wilson, "The Stieglitz Exhibition," *The New Republic,* March 18, 1925, pp. 97–98; reprinted in Lynes, *O'Keeffe, Stieglitz, and the Critics,* pp. 227–29.

153 "a whopper": RSS to PS, March 3, 1925, CCP.

153 "in a halo of words": Helen Appleton Read, "News and Views on Current Art: Alfred Stieglitz Presents Seven Americans," *Brooklyn Daily Eagle,* March 15, 1925; reprinted in Lynes, *O'Keeffe, Stieglitz, and the Critics,* p. 233.

153 "exquisite in texture and color": Margaret Breuning, "Seven Americans," *New York Evening Post,* March 14, 1924; reprinted in Lynes, *O'Keeffe, Stieglitz, and the Critics,* p. 225.

153 "more obvious in their truth": Elizabeth Luther Cary, "Art: Exhibitions of the Week; Seven Americans," *New York Times,* March 15, 1925; reprinted in Lynes, *O'Keeffe, Stieglitz, and the Critics,* p. 230.

153 "expert": Helen Appleton Read, "New York: Seven Americans," *The Arts* 7 (April 1925): 229–31; reprinted in Lynes, *O'Keeffe, Stieglitz, and the Critics,* pp. 237–38.

153 "Bellini": Henry McBride, "The Stieglitz Group at Anderson's," *New York Sun,* March 14, 1925; reprinted in Lynes, *O'Keeffe, Stieglitz, and the Critics,* pp. 225–27.

154 "You are good!": GOK to Henry McBride [March 1925], Cowart and Hamilton, p. 179.

154 "peculiarly feminine": Edmund Wilson, "The Stieglitz Exhibition," *The New Republic,* March 18, 1925, pp. 97–98; reprinted in Lynes, *O'Keeffe, Stieglitz, and the Critics,* pp. 227–29.

154 "I have always been very annoyed": GOK in Mary Lynn Kotz, "O'Keeffe at 90," *Artnews,* December 1977, p. 44.

154 "A woman who has lived": GOK to MDL [1925?], Cowart and Hamilton, p. 180.

155 "I was pleased to see her": FS to ES, December 9, 1922, Stettheimer Papers, YCAL.

155 "He photographs/She is naked": Ettie Stettheimer, *Crystal Flowers* (New York: Banyon Press, 1949), p. 53.

155 "roundness & texture & line": AS to RSS, March 4, 1925, ASA/YCAL.

155 "satisfactory for all concerned": AS to RSS, June 14, 1925, ASA/YCAL.

155 "The three months": RSS to AS, June 16, 1925, ASA/YCAL.

155 "ready for trouble": RSS to AS, June 29, 1925, ASA/YCAL.

156 "You'll enjoy it there": AS to RSS, July 11, 1925, ASA/YCAL.

156 "au naturel": RSS to AS, August 1, 1925, ASA/YCAL.

157 "At first the country": RSS to AS, August 14, 1925, ASA/YCAL.

157 "ardent": Henry McBride, "Gaston Lachaise," *Sun,* February 17, 1918; reprinted in McBride, *The Flow of Art,* pp. 150–51.

157 "The breasts, the abdomen": Hilton Kramer, *The Sculpture of Gaston Lachaise* (New York: Eakins Press, 1967), p. 13.

157 "You should see Mme L.": RSS to AS, August 1, 1925, ASA/YCAL.

157 "in a clear forceful": Lachaise, in *MSS.* 4 (December 1922): 9.

158 "a synthesis": PS, "Lachaise," in Kreymborg, Mumford, and Rosenfeld, eds., *The Second American Caravan* (New York: Macaulay, 1928), pp. 651–52.

159 "a head of Mr Strand": RSS to AS, August 24, 1925, ASA/YCAL.

159 "snapping & sporting": AS to RSS, August 26, 1925, ASA/YCAL.

159 "ten fine prints": PS to AS, September 28, 1925, ASA/YCAL.

160 "The weeks in Maine": PS to AS, September 4, 1925, ASA/YCAL.

160 "How do you do": Lowe, p. 225.

160 "We had two yowling brats": GOK to Ettie Stettheimer, August 6–25, Stettheimer Papers, YCAL; quoted in Cowart and Hamilton, p. 181.

160 "The Hill would have been": AS to RSS, July 22 and July 30, 1925, ASA/YCAL.

161 "gynecologically PERFECT": RSS to AS, September 12, 1925, ASA/YCAL.

161 "I thought surely": AS to RSS, September 14, 1925, ASA/YCAL.

161 "You did do rather": RSS to AS, September 23, 1925, ASA/YCAL.

161 "to take you in hand": AS to RSS, October 13, 1925, ASA/YCAL.

161 "the *treeness* of a tree": Toomer, "The Hill," in *America & Alfred Stieglitz,* ed. Frank et al., p. 298.

162 "why we value him": ibid.

162 "a painting I made": GOK to Toomer, February 8, 1934, Cowart and Hamilton, p. 218.

162 "passed into the world": GOK, *Georgia O'Keeffe,* unpaginated. Sarah Green-
ough discusses these works in "'Slipping into the World as Abstractions':
Georgia O'Keeffe's Abstract Portraits," at https://www.nga.gov/content/
ngaweb/audio-video/audio/greenough-okeeffe.html.

162 "I have a few": AS to RSS, November 9, 1925, ASA/YCAL.

163 "I like an empty wall": GOK to AP, Giboire, ed., p. 294.

163 "We feel as if": AS to Sherwood Anderson, December 9, 1925, Greenough
and Hamilton, p. 214.

163 "the old grind": RSS to AS, September 12, 1925, ASA/YCAL.

163 "Every time you go away": RSS to PS, November 3, 1925, CCP.

CHAPTER 12: TURNING THE PAGE

164 "a Direct Point of Contact": AS, "The Intimate Gallery" announcement,
Arthur Dove exhibition, January 11 to February 6, 1926.

164 "There is no artiness": AS to SA, December 9, 1925, Greenough and Hamil-
ton, p. 214.

165 "One can't": GOK, Blanche C. Matthias, "GOK and the Intimate Gallery,"
Chicago Evening Post, March 2, 1926; reprinted in Lynes, *O'Keeffe, Stieglitz,
and the Critics,* p. 249.

165 "They would all sit": GOK, quoted in Edith Evans Asbury, "Silent Desert
Still Charms Georgia O'Keeffe, Near 81," *New York Times,* November 2, 1968.

165 "When I wanted to paint": GOK, quoted in Mary Lynn Kotz, "Georgia
O'Keeffe at 90," *Artnews,* December 1977; Robinson, p. 293.

165 "No one ever objected": GOK, *Georgia O'Keeffe,* unpaginated.

166 "it is her interest": Frances O'Brien, "Americans We Like: Georgia O'Keeffe,"
The Nation (October 12, 1927), pp. 361–62; reprinted in Lynes, *O'Keeffe,
Stieglitz, and the Critics,* p. 272.

166 "profoundly feminine": Matthias, "Georgia O'Keeffe and the Intimate Gal-
lery"; reprinted in Lynes, *O'Keeffe, Stieglitz, and the Critics,* pp. 246–50.

166 "Psychiatrists have been sending": Murdock Pemberton, "The Art Galleries:
The Great Wall of Manhatta; or, New York for Live New Yorkers," *The New
Yorker,* March 13, 1926, pp. 36–37; reprinted in Lynes, *O'Keeffe, Stieglitz, and
the Critics,* p. 251.

166 "I like her stuff": Henry McBride, "Modern Art," *The Dial,* May 1926, pp.
436–37; reprinted in Lynes, *O'Keeffe, Stieglitz, and the Critics,* p. 253.

166 "for I really feel": RSS to PS, March 18, 1926, CCP.

167 "the processes by which": Richard Walsh, *The Making of Buffalo Bill* (India-
napolis: Bobbs-Merrill, 1928), p. v.

167 "la gripette": RSS to AS, April 2, 1926, ASA/YCAL.

167 "I have been thinking": ibid.

167 "Stay away as long": AS to RSS, July 13, 1926, ASA/YCAL.

168 "a distant and disagreeable": PS to AS, July 13, 1926, ASA/YCAL.

169 "a good-bad time": PS to AS, September 20, 1926, ASA/YCAL.

169 "Paul made the tree prints": RSS to AS, May 25, 1927, ASA/YCAL. The por-
trait of Beck against the tree is dated 1932 at CCP and 1933 at the Philadel-

phia Museum of Art but may have been taken earlier. In it, her hair has not yet turned white, which it would by 1929.

170 "Your babies haven't been loafing": PS to AS, September 20, 1926, ASA/YCAL.

170 "I have never seen more": ibid.

170 "casual, amusing": RSS to AS, September 15, 1926, ASA/YCAL.

171 "magnificent gift": Toomer, quoted in Kernan and Eldridge, p. 147.

171 "It's really very beautiful": RSS to AS, September 15, 1926, ASA/YCAL

171 "My taste for adventure": RSS to AS, October 3, 1926, ASA/YCAL.

171 "a sort of hash": AS to RSS, September 27, 1926, ASA/YCAL.

171 "I was like a mad woman": GOK to AS, August 22, 1926, *MFO,* p. 364.

172 "I have been letting": GOK to AS, September 11, 1926, *MFO,* p. 372.

172 this new series of oils: On this series, see Robinson's eloquent discussion, pp. 297–98.

172 "mark[ed] the turning": GOK to AS, September 21, 1926, *MFO,* p. 375.

172 "It must be that": GOK to AS, September 22, 1926, *MFO,* p. 377.

172 "shapes together": GOK, *Georgia O'Keeffe,* unpaginated.

173 "I entered a room": Frances O'Brien, "Americans We Like: Georgia O'Keeffe," *The Nation,* October 12, 1927; Drohojowska-Philp, p. 259.

173 "Any true relationship": AS, quoted in Seligmann, p. 84.

CHAPTER 13: THE END OF SOMETHING

174 "Much is happening": GOK to Waldo Frank, January 10, 1927, Cowart and Hamilton, p. 185.

174 "In this our period" and "In her canvases": *Georgia O'Keeffe: Paintings, 1926* (New York: Intimate Gallery, 1927); reprinted in Lynes, *O'Keeffe, Stieglitz, and the Critics,* pp. 257–58.

174 "There are few": Helen Appleton Read, "Georgia O'Keefe [sic]," *Brooklyn Daily Eagle,* January 16, 1927; reprinted in Lynes, *O'Keeffe, Stieglitz, and the Critics,* p. 261.

175 "ladies' day": Henry McBride, "Modern Art," *The Dial,* March 1927, pp. 262–63; reprinted in Lynes, *O'Keeffe, Stieglitz, and the Critics,* p. 267.

175 "to have the emotional faucet": GOK to McBride, 1927, Drohojowska-Philp, p. 274.

175 "Ever since Paul": RSS to AS, May 25, 1927, ASA/YCAL.

175 "Yes, several of those": AS to RSS, May 30, 1927, ASA/YCAL.

176 "You charge me": AS to GOK, April 15, 1927, *MFO,* p. 379.

176 "Maybe the 23 years": AS to GOK, April 15, 1927, ASA/YCAL.

176 "Myself? No": RSS to AS, June 21, 1927, ASA/YCAL.

176 "Yes, you are there": AS to RSS, June 22, 1927, ASA/YCAL.

176 "when I would like": RSS to PS, June 26, 1927, CCP.

176 "fat—prosperous": ibid.

177 "smiled with ineffable tenderness": RSS to AS, September 9, 1927, ASA/YCAL.

177 "one has a mania": GOK to AP, 1927[?], Giboire, ed., p. 275.

177 "It caused an uproar": GOK, quoted in Seiberling, "Horizons."

177 "there seems to be": AS to RSS, September 10, 1927, ASA/YCAL.

177 "The wires of mutual thought": RSS to AS, September 15, 1927, ASA/YCAL.

178 "I have missed the moment": ibid.

178 "Why can't we": RSS to PS, August 26, 1927, CCP.

178 "We are well": RSS to AS, October 7, 1927, ASA/YCAL.

178 "They sang and vibrated": RSS to AS, October 23, 1927, ASA/YCAL.

179 "You know that my interest": AS to PS, December 18, 1927, CCP.

180 "reactionary political attitudes": Norman, *Encounters,* p. 47.

181 "Is your sexual relationship": ibid., p. 56.

181 "If you do want any help": ibid., p. 57.

181 "to pursue her way": McBride, "Georgia O'Keefe's [sic] Recent Work," *New York Sun,* January 14, 1928; reprinted in Lynes, *O'Keeffe, Stieglitz, and the Critics,* p. 274.

182 "What you have done": GOK to McBride, May 11, 1928, Robinson, p. 304. O'Keeffe enclosed a check for $200 in the mistaken assumption that McBride needed financial aid. He returned the check, having understood her gesture as an innocent effort to help.

182 "Other causes": Norman, *Encounters,* p. 62.

182 "I never did like her": Tomkins GOK notes, MOMA.

182 "He glared at me": Norman, *Encounters,* pp. 54–56.

182 "neatifying": AS to RSS, March 27, 1928, ASA/YCAL.

182 "All it needs": AS to RSS, April 16, 1927, ASA/YCAL.

182 "rather individual" to "rhythms": *New York Tribune* [c. April 1928] and other undated, anonymous articles, Taos Historic Museums; cited in Campbell, pp. 180, 181.

183 "This designer, who has": Dorothy Teall, "Le Roi Est Mort," *The Survey* 67 (1932): 271–72.

184 "Artist Who Paints": *New York Times,* April 16, 1928; reprinted in Lynes, *O'Keeffe, Stieglitz, and the Critics,* pp. 284–85.

184 "Not a rouged": B. Vladimir Berman, "She Painted the Lily and Got $25,000 and Fame for Doing It!," *New York Graphic,* May 12, 1928.

184 "You must know how much": RSS to AS, May 13, 1928, ASA/YCAL.

184 "I am quite a normal being": GOK to Catherine O'Keeffe Klenert, May 29, 1928, Robinson, p. 307.

184 "I don't want to waste": AS to GOK, May 23, 1928, *MFO,* p. 383.

184 "It is as terrifically": GOK to AS, May 27, 1928, *MFO,* pp. 381–82.

184 "I look around and wonder": GOK to McBride, misdated May 11, 1928, evidently June 1928, YCAL; Whelan, *Alfred Stieglitz,* p. 501.

185 "I have robbed you": AS to GOK, July 12, 1928, *MFO,* pp. 386–87.

185 "The beginning of our togetherness": AS to GOK, July 12, 1928, *MFO,* p. 389.

185 "a sort of Bible": AS, quoted in Seligmann, p. 135.

185 "It's a powerful book": AS to GOK, July 25, 1928, *MFO,* pp. 397–98.

185 "not a thought in my head": GOK to Florine Stettheimer, September 21, 1928, YCAL; cited in Drohojowska-Philp, p. 290.

186 "Perhaps more than anyone": PS, "Marin Not an Escapist," *The New Republic,* July 5, 1928, pp. 254–55.

186 "Am glad it's in print": AS to PS, July 20, 1928, CCP.

186 "projections of an elemental vision": PS, "Lachaise," *The Second American Caravan,* pp. 650–58.

186 "reads splendidly": AS to PS, October 11, 1928, CCP.

186 "I felt you must walk": RSS to AS, October 3, 1928, ASA/YCAL.

186 "It is just that nice": Hartley to RSS, October 14, 1928, RSJ/YCAL.

187 "good angel"; "almost selfless": Hartley to RSS, February 7, 1929, RSJ/YCAL.

187 "Something in me": PS to AS, July 24, 1928, ASA/YCAL.

187 "He felt for the first time": PS to AS, September 10, 1928, ASA/YCAL.

187 "The artist, by a sort": Harold Clurman, "Photographs by Paul Strand," *Creative Art,* October 1929, p. 735.

187 "a little talk": RSS to AS, July 30, 1928, ASA/YCAL.

187 "I really feel": ibid.

188 "The average I think": PS to AS, September 22[?], 1928, ASA/YCAL.

188 "felt Lawrence had become": PS to AS, September 10, 1928, ASA/YCAL.

188 "the America that was pirating": PS to AS, October 30, 1928, ASA/YCAL.

188 "to challenge the entire country": AS, quoted in Seligmann, p. 135.

189 "indelicate": Mabel Dodge Luhan, "The Art of Georgia O'Keeffe," typescript, Mabel Dodge Luhan Archive, YCAL.

189 "as I have never dreamed": Norman, *Encounters,* pp. 71–72.

189 "She always looks at me": Norman to AS, December 10, 1928, Dorothy Norman Papers, YCAL; *MFO,* p. 380.

CHAPTER 14: HOW CLOSELY WE 4 HAVE GROWN TOGETHER

190 "That I haven't thought": GOK to Mitchell Kennerley, 1929, Mitchell Kennerley papers, New York Public Library; Drohojowska-Philp, p. 293.

190 Georgia ordered: The garments in question may be those featured in Corn, *Georgia O'Keeffe,* pp. 50–53, where they are attributed to GOK.

190 "the gayest note": Hartley to RSS, January 26, 1929, RSJ/YCAL.

190 "The thing I enjoy": GOK to MK, January 20, 1929, Cowart and Hamilton, p. 187.

191 "The barn is a very healthy": ibid.

191 The remarks of some critics: For reviews of GOK's 1929 exhibition, see Lynes, *O'Keeffe, Stieglitz, and the Critics,* pp. 294–306.

191 "I must get back": GOK to Ettie Stettheimer, August 24, 1929, ASA/YCAL.

191 "truant artists": Henry McBride, "American Expatriates in Paris," *The Dial,* April 1929; reprinted in McBride, *The Flow of Art,* pp. 255–57.

191 "I want to get into": Hartley to RSS, March 26, 1929, RSJ/YCAL.

192 "If I can keep my courage": GOK to Blanche Matthias, April 1929, ASA/YCAL; Robinson, p. 319.

192 "precise, clear, fundamental": Gaston Lachaise, in *Paul Strand, New Photographs* (New York: Intimate Gallery, 1929), unpaginated.

192 "to the vegetable kingdom": "Photo Art: Many Experiments Enliven Current Exploits," *New York Times,* March 24, 1929.

192 "arrangements of matter": M.P. [Murdock Pemberton], "The Galleries," *The New Yorker,* March 30, 1929, p. 80.

193 "I'm afraid you have": AS to PS, March 31, 1929, ASA/YCAL.

193 "I can't help it": RSS to PS, April 27, 1920, CCP.

193 "Well we did it ourselves": GOK to AS, April 27, 1929, *MFO,* p. 409.

193 "The difficulty in getting out": GOK, quoted in Tomkins GOK notes, MOMA.

193 "All my American": RSS to PS, Monday [late April], 1929, CCP.

194 "We are here": GOK to AS, April 30, 1929, *MFO,* p. 411.

194 "began working on us": RSS to PS, May 2, CCP.

194 "a terrible yearning": RSS to PS, May 2, 1929, CCP.

195 "This really isn't like": GOK to AS, May 2, 1929, *MFO,* pp. 411–12.

195 "I wish I could tell you": GOK to AS, May 7, 1929, *MFO,* p. 416.

195 "That's why I'm here": GOK to AS, May 4, 1929, *MFO,* p. 416.

195 "astral bodies": RSS to PS, May 8, 1929, CCP.

195 "the whole landscape has": RSS to PS, May 7, 1929, CCP.

195 "It is as though I fall": GOK to AS, May 21, 1929, *MFO,* p. 424.

195 "I just feel so like expanding": GOK to AS, June 13, 1929, *MFO,* p. 434.

195 "a resonance that banged": RSS to PS, May 8, 1929, CCP.

196 "Georgia looked at my pastels": RSS to PS, May 12, 1929, CCP.

196 "She makes a fierce face": GOK to AS, May 22, 1929, *MFO,* p. 426.

196 "Georgia is extremely": RSS to PS, Thursday [May 23, 1929], CCP.

197 "This seems to be": GOK to AS, June 14, 1929, *MFO,* p. 434.

197 "I wish you could": RSS to PS, May 5, 1929, CCP.

197 "My night is so different": GOK to AS, June 15, 1929, *MFO,* p. 437.

197 "She must be looking": AS to GOK, June 21, 1929, *MFO,* p. 438.

197 "We both say": RSS to PS, Thursday [May 23, 1929], CCP.

197 "He doesn't know": GOK to AS, May 29, 1929, *MFO,* p. 428.

197 "He feels he has": RSS to PS, May 31, 1929, CCP.

197 "the transformation": DeWitt, p. 8.

198 "I know that artificial": RSS to PS, May 21, 1929, CCP. Robinson notes, "Georgia encouraged Beck to work, but it was Beck who recognized as subjects some of the things for which Georgia would become famous" (p. 332).

198 "G & I get into": RSS to PS, June 1, 1929, CCP.

199 "The miracle of Georgia's": RSS to PS, June 1, 1929, CCP.

199 "a million years old": AS to GOK, June 6, 1929, *MFO,* p. 431.

199 "My photographs are a picture": AS, quoted in Norman, *Alfred Stieglitz,* p. 161.

200 "The best thing": GOK to AS, June 30, 1929, *MFO,* p. 449.

200 "welded together": GOK to Mabel Dodge Luhan, June 29, 1929, MDL/YCAL; *MFO,* p. 448, n. 86.

200 "much more clear": GOK to Mabel Dodge Luhan, July 6, 1929, MDL/YCAL; *MFO*, pp. 450–51.

200 "I made up my mind": GOK to AS, July 2, 1929, *MFO*, p. 452.

200 "I had a terrific erection": AS to GOK, July 6, 1929, *MFO*, p. 457.

201 "a long discourse": Clurman, p. 56.

201 "Never have I seen": PS to GOK, July 11, 1929, YCAL; *MFO*, p. 474, n. 120.

201 "letting it become": PS to GOK, July 14, 1929, YCAL; *MFO*, p. 508, n. 156.

201 "For seven years": RSS to AS, August 8, 1929, ASA/YCAL. Beck added, "He did too—for me."

201 "I must see you": AS to GOK, July 16, 1929, *MFO*, p. 483.

202 "I have been thinking entirely": AS to RSS, July 19, 1929, *MFO*, p. 485.

202 "We do such things here": GOK to Henry McBride, July 1931, Robinson, p. 330.

202 "We have had a beautiful relationship": RSS to PS, June 19, 1929, CCP.

203 "How closely": RSS to AS, July 17, 1929, ASA/YCAL.

203 "going to pieces": Leopold Stieglitz to GOK, July 20, 1929, YCAL; *MFO*, p. 491, n. 138.

203 "You are absolutely": AS to RSS, July 21, 1929, ASA/YCAL.

203 "You have lived very close": ibid.

203 "I don't know": AS to GOK, July 28, 1929, *MFO*, p. 499.

203 "One night gone": RSS to GOK, July 27, 1929, YCAL.

203 "I will be glad": RSS to GOK, Sunday [July 28, 1929], ASA/YCAL.

203 "I took a lot of pretty awful punishment": RSS to GOK, August 2, 1929, ASA/YCAL.

204 "The suffering not": PS to AS, Saturday [August 3, 1929], ASA/YCAL.

204 "Now that some other": RSS to AS, August 8, 1929, ASA/YCAL.

204 "The cataclysm comes": PS to AS, August 19, 1929, ASA/YCAL.

204 "the most perfect thing": GOK to Mabel Dodge Luhan [September 1929], MDL/YCAL; Cowart and Hamilton, p. 196.

205 "The Room is an admission": Norman to AS [October] 1929, Drohojowska-Philp, p. 313

205 "In spite of its pathos": PS to AS, August 19, 1929, ASA/YCAL.

206 "To start anything": AS to RSS, October 24, 1929, ASA/YCAL.

206 "The summer had brought me": GOK to Mabel Dodge Luhan [letter 1, September 1929], MDL/YCAL; Whelan, *Alfred Stieglitz*, p. 516.

206 "With the smash up": AS to Dorothy Norman, October 21, 1929, YCAL; Drohojowska-Philp, p. 312.

206 "This has been a trying": PS to AS, Sunday [October 1929], YCAL.

207 "It seems to me": GOK to RSS, November 5, 1929, YCAL; Cowart and Hamilton, p. 199.

CHAPTER 15: NEW YORK IN NEW MEXICO

208 "American it is": Edward Alden Jewell, "New Marin Water-Colors," *New York Times,* January 4, 1930.

218 "There is something about": GOK to AS, May 1, 1931, *MFO*, p. 558.

219 "Wall Street is frightful": AS to GOK, June 2, 1931, *MFO*, p. 572.

219 "so Paul & all others": AS to RSS, March 18, 1931, ASA/YCAL.

219 "You will find in it": RSS to AS, April 8, 1931, ASA/YCAL.

219 "If nothing comes": PS to AS, June 18, 1931, ASA/YCAL.

219 "You would not have written": AS, quoted in Clurman, p. 58.

219 "I remember you": Clurman to PS, c. 1934, CCP; Yates, "The Transition Years," in Stange, ed., p. 90.

219 "Stieglitz's photograph": Clurman, pp. 267–68.

220 "I think I am": PS to Herbert Seligmann, July 29, 1931, ASA/YCAL Greenough, *Paul Strand*, unpaginated (opposite plate 77).

220 "The days slip by": PS to AS, August 22, 1931, ASA/YCAL.

220 "I seem to be hunting": GOK to AS, May 30, 1929, *MFO*, p. 430.

220 "this very sober": Dorothea Lange, "The Making of a Documentary Photographer," interview conducted by Suzanne Riess, oral history transcript, Bancroft Library, University of California, Berkeley, 1968, pp. 138–39.

222 "the people who lived there": PS interview with Milton Brown and Walter Rosenblum, 1971, in Busselle, p. 97.

222 "a curious kind": GOK to McBride, July 1931, Cowart and Hamilton, pp. 202–3.

222 " 'Wonderful' was a word": Mabel Dodge Luhan, "Georgia O'Keeffe in Taos," *Creative Arts,* June 1931, pp. 407–10.

222 "It hurt Strand mightily": GOK to AS, June 28, 1931, *MFO*, p. 587.

222 "They sat there": Frieda Lawrence, quoted in Pollitzer, pp. 201–2.

223 "Beck is reveling": AS to GOK, June 27, 1931, *MFO*, pp. 586–87.

223 "utterly one": Norman to AS, July 2, 1931, ASA/YCAL; *MFO*, p. 591.

223 "the problem between": RSS to PS, June 11, 1931, CCP. See also RSS to PS, June 15, 1931, CCP.

223 "a good combination": AS to GOK, July 9, 10, 1931, *MFO*, pp. 593–94.

223 "I am feeling a bit disgruntled": GOK to Russell Vernon Hunter [August 1931], ASA/YCAL.

224 "In spite of our 'failures' ": AS to GOK, August 26, 1931, *MFO*, pp. 597–98.

224 "I sometimes wonder": GOK to RSS, August 9, 1931, RSJ/YCAL.

224 "I feel perfect": GOK to RSS [September 1931], RSJ/YCAL.

CHAPTER 16: DIVIDED SELVES

225 "the best ever": RSS to AS, October 6, 1931, ASA/YCAL.

226 "The house is full": AS to RSS, August 2, 1931, ASA/YCAL.

226 "but they do not actually": AS to GOK, October 18, 1931, *MFO*, p. 602. AS remarks on their "fluffing" in a number of letters to GOK that fall.

227 "I have been photographing": AS to Herbert Seligmann, October 6, 1931, ASA/YCAL.

227 "It'll be funny": AS to RSS, October 1, 1931, ASA/YCAL.

227 "appalled by the force": Levy, pp. 50–51.

208 "I am very chipper": RSS to Mabel Dodge Luhan, January 5, 193⟨
 YCAL.

208 "I saw the crosses": GOK, *Georgia O'Keeffe*, unpaginated.

209 "Georgia O'Keeffe went": McBride, "O'Keeffe in Taos," *New York St*
 ary 8, 1930; reprinted in McBride, *The Flow of Art*, pp. 260–62.

209 "The pictures look perfectly": Edward Alden Jewell, "New O'Ke⟨
 tures," *New York Times*, February 9, 1930.

210 "My little capital": AS to Arthur Dove, May 8, 1931, Whelan, *Alfred*
 p. 525.

211 "Her face, unadorned": Quotes from the debate (through "bad art⟨
 in Gladys Oaks, "Radical Writer and Woman Artist Clash on Propag⟨
 Its Uses," *New York World*, March 16, 1930; Lisle, pp. 237–39.

211 "I have made three paintings": RSS to Mabel Dodge Luhan, Januar⟨
 MDL/YCAL.

212 "I couldn't decide": GOK to Dorothy Brett, April 1930, MFO, p. 526

212 "You must paint": Marsden Hartley to RSS [June 1930], RSJ/YCAL.

212 "May the summer": AS to RSS, June 24, 1930, ASA/YCAL.

212 "You must not set": AS to GOK, July 13, 1930, MFO, p. 543.

212 "so beautiful": GOK to Dorothy Brett, October 12[?], 1930, ASA/YC⟨

213 "Strand likes it much": GOK to AS, July 29, 1930, MFO, p. 546.

213 "I hate the back": GOK to AS, July 9, 1930, MFO, p. 541.

213 "in the quick seizure": PS, quoted in Steve Yates, "The Transition Yea⟨
 Mexico," in Stange, ed., p. 96.

213 "The only thing": PS to AS, August 27, 1930, ASA/YCAL.

214 "Beck has done some": PS to Kurt and Isabel Baasch, September ⟨
 CCP.

214 "I hope you are": AS to RSS, August 3, 1930, ASA/YCAL.

215 "as little as possible": GOK to AS, August 3, 1930, MFO, p. 548.

215 "Whenever I come back": GOK to RSS, September 4, 1930, RSJ/YC⟨

215 "The vision ahead": GOK to Dorothy Brett, October 12[?], 1930, Cov⟨
 Hamilton, p. 201.

215 "I cannot resist": PS to AS, August 24, 1930, ASA/YCAL.

216 "I can not tell you": RSS to AS, October 19, 1930, ASA/YCAL.

216 "itching to be": AS to RSS, October 21, 1930, ASA/YCAL.

216 "Back from her second": Edward Alden Jewell, "Museum of Fren⟨
 New York Times, January 25, 1931.

216 "with a fervor": ibid. The review was illustrated with both artists' pain⟨
 slave masters whipping African slaves.

217 "You are preoccupied": Norman to GOK, February 13, 1931, ASA⟨
 Drohojowska-Philp, p. 327. O'Keeffe did not reply to Norman.

217 "One is easy with her": Clurman letter in Norman, *Encounters*, p. 9⟨

217 "To have a complete": Norman, *Encounters*, pp. 71–72.

217 "Any young woman": Norman, quoted in Drohojowska-Philp, p. 286

217 "Strand's and Stieglitz's prints": Norman, *Encounters*, pp. 102–3.

218 "You owe it": AS to GOK, May 25, 1931, MFO, p. 568.

227 "many funny things": GOK to AS, October 20, 1931, *MFO*, p. 604.

227 "I thought of the city men": GOK, *Georgia O'Keeffe*, unpaginated.

228 "makes me laugh": GOK to AS, November 6, 1931, *MFO*, p. 613.

228 "I really don't know": GOK to AS, November 25, 1931, *MFO*, p. 618.

228 "As well as death": Robinson, p. 367.

228 "her country": GOK, quoted in Levy, p. 54.

228 "This is probably": Edwin Alden Jewell, "Synthetic View on Photography," *New York Times*, November 3, 1931.

228 some biographers say that Dorothy was naked: See accounts by Lowe, Whelan, and Drohojowska-Philp.

228 "Talking in this way": GOK to AS, October 24, 1931, *MFO*, p. 607.

229 "fluffed beautifully": AS to GOK, October 24, 1931, *MFO*, p. 605.

229 "at the average value": AS to PS, December 1, 1931, CCP.

229 "to breathe a bit of life": AS to PS, December 13, 1931, CCP.

230 "I think his show": GOK to Russell Vernon Hunter [January 1932], Cowart and Hamilton, pp. 204–5.

230 "I imagine that she saw": Henry McBride, "Skeletons on the Plain," *New York Sun*, January 1, 1932.

230 "a new way of trying": GOK to Russell Vernon Hunter [January 1932], Cowart and Hamilton, p. 205.

230 "memory or dream thing": GOK to Dorothy Brett [mid-February 1932], Cowart and Hamilton, p. 208.

230 "I hope Taos": AS to RSS, February 6, 1932, ASA/YCAL.

231 "visualizations, as Mr. Stieglitz": Edwin Alden Jewell, "Stieglitz—Master of the Lens," *New York Times*, February 17, 1932.

231 a different vision of the feminine: Following a visit to the Place the poet Lola Ridge wrote, "I note Georgia O'Keeffe's cold rather beautiful face, but find something in it I reject. . . . I'd rather have Rebecca Strand's simple wistful seeking face. It is still in the process of what Spengler would call 'be coming.' G. OK's has become." (Ridge to David Lawson, February 16, 1932, private communication to the author from Terese Svoboda).

231 "If speculations about Alfred": Lowe, p. 317.

231 "The place is the most beautiful": GOK to Dorothy Brett [mid-February 1932], Cowart and Hamilton, p. 206.

231 "Showing or not showing": ibid.

232 "saddled with a large stock": James, *Allow Me to Present*, pp. 34–35.

233 "hardy pioneer ancestors": ibid.

233 "unflinching integrity": Elizabeth McCausland, "Paul Strand's Photographs Show Medium's Possibilities," *Springfield Sunday Union and Republic*, April 17, 1932.

233 "One of the early pupils": Murdock Pemberton, "The Art Galleries," *The New Yorker*, April 23, 1932, p. 46.

233 "a suave sense of finish": McCausland, "Paul Strand's Photographs . . . ," April 17, 1932.

234 "The day I walked": PS to RSS, December 13, 1966, CCP.

234 "Isn't there something": RSS to AS, December 19, 1933, ASA/YCAL.

234 "to paint something": GOK to Blanche Matthias [April 1929?], Robinson, p. 371.

235 "You are wise": GOK to Russell Vernon Hunter [spring 1932], Cowart and Hamilton, p. 207.

235 "It is very difficult": GOK to ASS [June 1, 1932], *MFO*, p. 624.

235 "I haven't felt": GOK to AS, August 1, 1932, *MFO*, p. 635.

235 "spiritual togetherness": AS to Norman, June 26, 1932, YCAL; *MFO*, p. 632.

235 "that would be adultery": AS to Norman, July 13, 1932, YCAL; *MFO*, p. 633.

235 "Makes me feel that my grandfather": GOK to RSS, October 6, 1932, RSJ/YCAL.

235 "On the Gaspé": GOK, quoted in Kuh, p. 202.

236 "Everyone dislikes the Idea": GOK to Dorothy Brett [September 1932], Cowart and Hamilton, pp. 209–10.

236 "I can't paint a room": ibid.

236 "who have to struggle": GOK to RSS, October 6, 1932, RSJ/YCAL.

236 "So I've told them": GOK to RSS [October 1932], RSJ/YCAL.

237 "a fever to do a room": GOK to Russell Vernon Hunter [October 1932], YCAL; Cowart and Hamilton, p. 211.

237 "I know how difficult": AS to GOK, November 6, 1932, *MFO*, p. 654.

237 "There isn't an idea": GOK to AS [November 9, 1932], *MFO*, p. 657.

237 "I did feel miserable": AS to GOK, November 18, 1932, *MFO*, p. 666, n. 522.

237 "You must not worry": AS to GOK, February 1, 1933, *MFO*, p. 676.

238 "by inches and minutes": GOK to Russell Vernon Hunter [early February 1933], YCAL; Cowart and Hamilton, p. 212.

238 "Getting over whatever": GOK to RSS, March 1933, YCAL.

238 "soul reflection": Henry McBride, "Georgia O'Keeffe's Exhibition," *New York Sun*, January 14, 1933.

238 "Couldn't stay but": GOK to RSS, March 1933, RSJ/YCAL.

238 "I like Margery": ibid.

CHAPTER 17: DON'T LOOK AHEAD OR BEHIND

239 "I did pick myself up": GOK to RSS, April 1933, RSJ/YCAL.

239 "The doctor is insistent": GOK to RSS, June 7, 1933, RSJ/YCAL.

240 "Perhaps she will find": Clurman to PS, November 21, 1932, CCP.

240 "Beck 'broke down' ": Clurman to PS, February 28, 1933, CCP.

241 "With the show": PS, quoted in Tomkins, "Profile: Look to the Things Around You," *The New Yorker*, September 16, 1974, p. 44.

241 "I put myself in Chavez' hands": PS to AS, February 5, 1933, ASA/YCAL.

241 "Too cruel": PS to AS, February 5, 1933, ASA/YCAL.

242 "These people have": DeWitt, pp. 73–74.

243 "the Indians live": PS to Marin, September 1, 1933, Greenough, *Paul Strand*, p. 88.

243 "I made a series": PS to Irving Browning, September 29, 1934, in ibid., p. 96.

244 "serious and poignant": Augustín Chávez, catalog statement for "31 Paintings

on Glass by Rebecca Salsbury Strand" (Museum of New Mexico, July 16–August 17, 1934), which distinguishes the works discussed in this paragraph as having been made in Mexico.

244 "a very fine little gentleman": RSSJ to the Baasches, January 7, 1937, CCP.

244 "So you are a real Mexican": AS to RSS, March 14, 1933, ASA/YCAL.

244 "It is warm and slow": GOK to RSS, April 1933, RSJ/YCAL.

245 "It was I": PS to Kurt Baasch, November 26, 1933, CCP.

245 "exposed, vulnerable": RSS to PS, August 28, 1933, CCP.

245 "a godsend": RSS to PS [August 29, 1933], CCP.

245 "pathetic": AS to Arthur Dove, June 25, 1933, ASA/YCAL.

245 "a great deal of knowledge" and "Religious Ecstasy": Paul Rosenfeld and Dorothy Brett, quoted in Norman, *Encounters*, pp. 110–11.

246 "I have done nothing": GOK to Russell Vernon Hunter, October 21, 1933, ASA/YCAL.

247 "I just sit": GOK to RSS [August?], 1933, RSJ/YCAL.

247 "the garbage carriers": GOK to RSS [1933], RSJ/YCAL.

247 "Try not to take it": GOK to RSS, November 25, 1933, RSJ/YCAL.

248 "I am supposed": RSS to PS, November 6, 1933, CCP.

248 "If one were tempted": Donald J. Bear, "In Unique Exhibition of Paintings on Glass," *Rocky Mountain News* [Dec. 17?], 1933, YCAL.

248 "I do manage": RSS to AS, December 19, 1933, ASA/YCAL.

248 "I see very clearly": AS to RSS, December 22, 1933, ASA/YCAL.

249 "I feel as if I'm waking": GOK to RSS, November 25, 1933, RSJ/YCAL.

249 "I said nothing": GOK to RSS, December 1933, RSJ/YCAL.

249 "The principal things" to "I really wish": GOK to PS, December 26, 1933, CCP.

249 "The greatest Christmas": AS to GOK, December 26, 1933, *MFO*, p. 736.

249 "I never saw such a performance": GOK to Toomer, January 10, 1934, YCAL.

250 "I seem to have come out": GOK to Toomer, January 2, 1934, YCAL.

250 "in such a quiet": GOK to Toomer, January 3, 1934, YCAL.

CHAPTER 18: ANOTHER WAY OF LIVING

251 "Oh Georgia": AS to GOK, January 1, 1934, *MFO*, pp. 738–39.

251 "I hope 1934": AS to RSS, December 22, 1933, ASA/YCAL.

251 "solidarity": PS to Kurt and Isabel Baasch, November 23, 1933, CCP.

252 "These are critical years": PS to Adams, October 14, 1933, Busselle and Stack, p. 96.

252 "In a world": PS, quoted in Robert Stebbins, "Redes," *New Theatre*, November 1936; Krippner et al., p. 371.

252 "always a little": Rodakiewicz, quoted in Tomkins PS notes, MOMA.

253 "the most doctrinaire": Zinnemann, quoted in Mike Weaver, "Dynamic Realist," in Stange, ed., p. 199.

253 "There is plenty of Trickiness": PS to Carlos Chávez, November 4, 1934, James Krippner, "Traces, Images and Fictions: Paul Strand in Mexico," *The Americas* 63, no. 3 (2007): 380.

254 "If H[enwar] is not interested": RSS to PS, November 6, 1933, CCP.

254 "By that time": RSS to PS, November 16, 1934, CCP.

254 "truly I <u>don't want</u> to marry": ibid.

254 "There is a decided balking": RSS to MDL, Thursday [1934], MDL/YCAL.

255 "Yours is a repulsive spirit": RSS to MDL, n.d. [1934], ibid.

255 "She had begun": Spud Johnson, "Becky," *Taos News,* July 12, 1968; Campbell, p. 309.

255 "The innocence," "spiritual honesty," and "There is much room": catalog statements for "31 Paintings on Glass by Rebecca Salsbury Strand" (Museum of New Mexico, July 16–August 17, 1934).

255 "During dinner": Jadwiga Monkiewicz, "Tales from Taos," *Albuquerque Journal,* July 28, 1934; Campbell, p. 276.

257 "I started to paint": GOK to Toomer, January 7, 1934, YCAL; Cowart and Hamilton, p. 216.

257 "These pictures are not derivations": Lewis Mumford, *The New Yorker,* February 10, 1934, pp. 48–49.

257 "I do not particularly enjoy": GOK to Toomer, February 8, 1934, YCAL; Cowart and Hamilton, pp. 218–19.

257 "There were talks": GOK to Toomer, February 14, 1934, YCAL.

257 "another way of living": GOK to Toomer, March 5, 1934, YCAL; Cowart and Hamilton, p. 219.

258 "I begin to think": GOK to RSS, April 26, 1934, RSJ/YCAL.

258 "I like it very much": GOK to Toomer, May 11, 1934, YCAL; Cowart and Hamilton, p. 221.

258 "I really have to move": GOK to RSS, April 26, 1934, RSJ/YCAL.

259 "I like you Mabel": GOK to MDL, n.d. [1934], MDL/YCAL.

259 "I don't know what state": AS to GOK, July 13–14, 1934, ASA/YCAL.

259 "The last year": GOK to AS, July 26, 1934, Haskell, ed., pp. 204–5. O'Keeffe added, "The difference in us is that when I felt myself attracted to someone else I realized I must make a choice—and I made it in your favor. . . . You seemed to feel there was no need to make a choice—when a similar situation arose for you."

259 "the same in spite of": GOK to Ettie Stettheimer, August 7, 1934, YCAL; courtesy of Wanda Corn.

261 "A red hill": GOK, catalog statement for "Georgia O'Keeffe: Exhibition of Oils and Pastels" (An American Place, January 22 to March 17, 1939).

261 "in imperfect condition": AS, catalog statement for "Alfred Stieglitz: Exhibition of Photographs (1884–1934)" (An American Place, December 11, 1934–January 17, 1935).

262 "The book at once clarifies": Van Doren, in AS, *Alfred Stieglitz: Exhibition,* unpaginated.

262 "a Wonder": AS to Arthur Dove, December 20, 1934, ASA/YCAL.

262 "profound significance": Edward Jewell, "In the Realm of Art," *New York Times,* December 16, 1934.

262 "a sort of half-idolatrous": Edward Jewell, "Alfred Stieglitz and Art in America," *New York Times,* December 23, 1934.

263 "the most virile": "Arts: U.S. Scene," *Time,* December 24, 1934, p. 25.

263 "a Hoboken Jew": Thomas Craven, *Modern Art: The Men, the Movements, the Meaning* (New York: Simon & Schuster, 1934); quoted in Whelan, *Alfred Stieglitz,* p. 554.

263 "a mania": Thomas Hart Benton, "American and/or Alfred Stieglitz," *Common Sense,* January 1935, p. 22.

263 "a dilapidated house": GOK, quoted in Calvin Tomkins, "The Rose in the Eye Looked Pretty Fine," *The New Yorker,* pp. 48, 50.

263 "the increasing gangsterism": Dorothy Norman, "Alfred Stieglitz Speaks and Is Overheard," *The Art of Today* 6 (February 1935); quoted in Brennan, pp. 206–7. See Brennan's persuasive discussion of Stieglitz's relations with Benton, pp. 202–31.

263 "a portentous and heavy document": John Chamberlain, "Books of the Times," *New York Times,* December 31, 1934.

263 "What one took": E. M. Benson, "Alfred Stieglitz: The Man and the Book," *American Magazine of Art,* January 1935, p. 40.

264 "perfidious": RSS to PS, November 16, 1934, CCP.

264 "I have come": PS to Ted Stevenson, October 7, 1934, in Busselle and Stack, p. 107.

264 "Aside from my fondness": GOK to McBride, early 1940s, YCAL; Cowart and Hamilton, p. 244.

ALFRED

266 "as the father": Cunningham to AS, December 18, 1934, quoted in Lorenz, p. 21.

267 "rock-steady": AS to Cunningham, February 3, 1935, Lorenz, p. 22.

267 "the camera's almost legendary" and "Fifty-one years": *Vanity Fair,* March 1935, pp. 42, 15.

267 "climactic": Mumford, "The Art Galleries," *The New Yorker,* December 22, 1934, p. 30. Mumford wrote that *Dualities,* the portrait of Dorothy Norman, was "almost diabolic both in its symbolism and its technical perfection."

267 "That's the one thing": AS to Dove, January 2, 1935, ASA/YCAL.

267 "I would not have": AA to PS, September 12, 1933, CCP.

268 "I have done one": AA to AS, March 15, 1936, Hoffman, *Alfred Stieglitz,* p. 296.

268 "I open 1936–1937": AS to RSS, September 27, 1936, ASA/YCAL.

268 "queer": AS to RSS, October 14, 1936, ASA/YCAL.

268 "She has a penthouse": AS to AA, April 6, 1936, YCAL.

268 "I haven't been well": AS to AA, July 30, 1936, YCAL.

269 "an all-enfolding armor": AA to AS, October 23, 1933, YCAL; quoted in Greenough, *Alfred Stieglitz,* p. 236.

269 "The Place": AA to AS, November 29, 1936, Gray, p. 35.

269 "brawnier and at the same time": H.D., "Late Oil of Demuth Seen at Art Show," *New York Times,* November 28, 1936.

269 "much admired": AS to RSS, January 7, 1937 [misdated by AS "36"], ASA/YCAL. Beck's oil sold for $125, from which Alfred deducted $31.25 for expenses.

269 "Will you and I": AS to Weston, September 3, 1938, YCAL; quoted in Greenough, *Alfred Stieglitz,* pp. 218–19.

269 "a dry open space": GOK to William Einstein, July 1937, YCAL; quoted in Robinson, p. 425.

270 "If I had met him": Henry Miller, *Twice a Year,* no. 8/9 (1942): 153.

270 "politics & the social": AS to AA, October 20, 1933, YCAL; quoted in Whelan, *Alfred Stieglitz,* p. 565.

270 "So little vision": AS to Weston, September 3, 1938, YCAL; quoted in Greenough, *Alfred Stieglitz,* pp. 218–19.

271 "All seems so peaceful": GOK to AS, June 26, 1941, YCAL; quoted in Hoffman, *Alfred Stieglitz,* p. 403.

271 "You would have gone": AS to GOK, August 22, 1941, YCAL; quoted in ibid., p. 404.

272 "Correspondence dispensed with": Lowe, p. 338.

272 "It was really beautiful": Norman to PS, November 4, 1940, CCP.

272 "he could not accept": Lowe, p. 363.

272 "his courageous pioneering": D[avid] H. Mc[Alpin], "The New Department of Photography," *Bulletin of the Museum of Modern Art* 2, no. 8 (December 1940–January 1941): 2.

273 "I see Alfred": GOK to McBride, early 1940s, YCAL; Cowart and Hamilton, p. 244.

273 "the heritage stemming": Steichen, "The Fighting Photo-Secession," *Vogue,* June 15, 1941, p. 22.

273 "bowled over": AS to Steichen, June 15, 1941, Edward Steichen Papers, MOMA.

273 "I'm managing": AS to Dove, July 31, 1941, YCAL; quoted in Whelan, *Alfred Stieglitz,* p. 567.

274 "If I have the misfortune": AS, quoted in Newhall [January 27, 1942], p. 122.

274 "The beautiful living things": Newhall, p. 123.

274 "What a lucky man": AS to Arthur Dove, September 11, 1943, YCAL; quoted in Whelan, *Alfred Stieglitz,* p. 568.

274 "whom the younger" to "the great old man": Nelson Morris, "Alfred Stieglitz: A Color Portrait and Notes on Photography's Grand Old Man," *Popular Photography,* March 1944, p. 53.

275 "suffering from a heart attack": Thomas Craven, "Stieglitz—Old Master of the Camera," *The Saturday Evening Post,* January 8, 1944, p. 14.

275 "He started" to "It doesn't seem": "Weegee Meets a Great Man," *PM,* May 7, 1944. Weegee published a slightly different account of their meeting in *Naked City* (New York: Da Capo, 1945), pp. 233–35.

276 "Over the past": Lowe, p. 374.

276 "steeling": AS to GOK, April 16, 1944, YCAL.

276 "It is a glorious": AS to James Johnson Sweeney, July 3, 1946, YCAL; Pollitzer, p. 247.

276 "perhaps the greatest": James Thrall Soby, "The Fine Arts: To the Ladies," *The Saturday Review*, July 6, 1946, pp. 14–15.

276 "How beautiful": AS to GOK, June 4, 1946, YCAL; Pollitzer, p. 250.

277 "You need what": AS to GOK, June 5, 1946, YCAL: Pollitzer, p. 250.

277 "Ever surprised": AS to GOK, June 6, 1946, YCAL; Pollitzer, p. 250.

277 "Georgia accepted condolences": Lowe, p. 377.

277 "unless—maybe to stand": GOK to William Howard Schubart, August 8, 1950, YCAL; Cowart and Hamilton, p. 254.

277 "strained but under control": PS to the Newhalls, n.d., Whelan, *Alfred Stieglitz*, p. 573.

278 "absolutely disgusting": Nancy Newhall to Adams, July 15, 1946, Mary Street Alinder and Andrea Gray Stillman, eds., *Ansel Adams: Letters and Images, 1916–1968* (Boston: Little, Brown, 1988), p. 176.

REBECCA

280 "I first knew Stieglitz": RSJ, in Norman, ed., *Stieglitz Memorial Portfolio*, p. 25.

280 "more or less to hell": RSSJ to the Baasches, April 13, 1938, CCP.

280 "I'd much rather": RSSJ to the Baasches, January 7, 1937, CCP.

280 "I expected to find": RSSJ to the Baasches, April 13, 1938, CCP.

281 "artists, writers, truck drivers": James, *Allow Me to Present*, p. 49.

281 "Becky shunned": Waters, pp. 33–34.

281 "This is decidedly": RSSJ, "Letters to the Editor," *The Taos Review and the Taos Valley News*, January 12, 1939; Campbell, p. 284.

281 "noted artist": "Display Recalls Buffalo Bill Wild West Show," *Houston Chronicle*, February 12, 1938.

281 "a tremendous character": Nate Salsbury III, interview with the author, July 26, 2011.

281 "Becky linked two": Morrill, p. 129.

282 "I am glad I": RSJ to PS, July 2, 1940, CCP.

283 "cruel": GOK to RSJ, n.d. [spring 1945], RSJ/YCAL.

283 "I feel you get": RSJ to PS, May 14, 1945, CCP.

283 "I . . . have philosophically": ibid.

283 "These scenes made me": RSJ, in *Rebecca Salsbury James*, exhibition catalog (Santa Fe: Museum of New Mexico, 1991), unpaginated.

284 "The paintings on glass": Luhan, *Taos and Its Artists*, p. 30.

284 "the best-known": ibid., p. 12.

284 "Taos is going": ibid., p. 43.

284 "but not with brush": James, *Allow Me to Present*, p. 13.

285 "because they felt": ibid., p. 58.

285 "dark and cool" and "There was always": Florence Ilfeld Beier, interview with the author, August 19, 2011.

286 "I have to smile": RSJ to PS, July 2, 1940, CCP.

286 "one didn't talk": ibid.

286 "This, I thought": RSJ, "Paintings in Yarn," *Woman's Day,* April 1, 1964, p. 40.

287 "the most free-wheeling": RSJ, *Embroideries by Rebecca James* (Santa Fe: Museum of International Folk Art, 1963), p. 8.

287 "Both the painter": ibid., p. 9.

287 "Mrs. James demonstrates": E. Boyd, foreword, in *Embroideries by Rebecca James,* p. 3.

288 "New York seems": RSJ to GOK, September 16, 1950, RSJ/YCAL.

288 "The end of an era": RSJ to PS, September 14, 1950, CCP.

288 "hushed": Alfred Frankenstein, "New Gallery Shows Young Artist's Work," *San Francisco Chronicle,* February 4, 1951; Campbell, pp. 297–98.

288 "The Painter on Glass": *El Crepusculo,* January 25, 1951, RSJ/YCAL.

288 "for seeing and leaving": James, *Camposantos,* p. 8, speaking of her friend Dorothy Benrimo's photographs of New Mexican burial grounds.

288 "a stiff little piece": RSJ, quoted in Frieda Lawrence, "Rebecca James' Embroideries," *El Palacio* 59, no. 5 (May 1952): 160.

289 "A tiny cluster": Ina Sizer Cassidy, "Art and Artists of New Mexico," *New Mexico Magazine* 30, no. 7 (July 1952): 45, 47, 33.

289 "intimate": Elizabeth McCausland, in *Rebecca Salsbury James, Paintings on Glass,* exhibition catalog (New York: Martha Jackson Gallery, 1954).

289 "the Far West": S.P., "About Art and Artists," *New York Times,* September 22, 1954.

290 "The things—which are austere": RSJ to PS, February 12, 1955, CCP.

290 "a rich and warm": RSJ to Isabel Lachaise, October 14, 1945, roll 26, Archives of American Art, Smithsonian Institution, Washington, D.C. This letter was brought to my attention by Paula R. Hornbostel in an e-mail, July 30, 2015.

291 "a slightly known": RSJ to GOK, January 6, 1950, YCAL.

291 "I wish you would": GOK to RSJ, n.d., RSJ/YCAL.

291 "She looks well": RSJ to PS, December 24, 1952, CCP.

291 "She is a notoriously bad": RSJ to PS, October 30, 1956, CCP. She added, "I doubt if she would ever answer any letter from you."

291 "Here we are": RSJ to GOK, n.d. [1963], YCAL. Beck sent this note to Georgia with a copy of the Currier Gallery's announcement of exhibitions for 1964.

291 "As you used to say": RSJ to GOK, August 5, 1963, YCAL.

292 "carry over": James, *Camposantos,* p. 5.

292 "I am still plagued": RSJ to PS, June 19, 1960, CCP.

292 "I know you would": RSJ to PS, February 8, 1962, CCP.

292 "I cannot realize": RSJ to PS, December 13, 1961, CCP.

292 "What a worker": RSJ to PS, September 8, 1962, CCP.

293 "no buttons": RSJ to GOK, September 21, 1962, YCAL.

293 "If I leave": RSJ to GOK, December 26, 1962, YCAL.

293 "like a lady convict": RSJ to GOK, March 4, 1963, YCAL.

293 "My experience": RSJ to Harold M. Jones, November 29, 1966, included in RSJ to PS, n.d. [1966], CCP.

293 "irresponsible guesswork": RSJ to V. D. Coke, May 16, 1963, included in RSJ to PS, May 24, 1963, CCP.

294 "Georgia came from Abiquiu": RSJ to PS, May 24, 1963, CCP.

294 "I'm not 'up' ": RSJ to PS, June 11, 1963, CCP.

294 "to know, in spite of": RSJ to PS, July 23, 1963, CCP. Strand owned five of Rebecca's colchas: *New England Still Life, Imagined Landscape, El Campo Santo, The Sacred Heart,* and *Dove on a Bough.*

294 "I am pleased": RSJ to PS, September 5, 1963, CCP.

295 "a very true person": RSJ to PS, July 5, 1964, CCP.

295 "neat and 'scholarly' ": RSJ to PS, October 16, 1965, CCP.

295 "in the strict sense": *The Collection of William and Rebecca James* (Albuquerque: University of New Mexico Art Museum, 1969), p. 1.

295 "from the Pink House Days": RSJ to GOK, September 24, 1966, YCAL.

296 "I am getting into": RSJ to Nate Salsbury III, February 24, 1966, SFC.

296 "to capture in some": James, *Camposantos,* pp. 5–6, 8.

296 "I do not know": RSJ to PS, October 20, 1967, CCP. A cenotaph was erected for him in the family plot in Denver's Fairmount Cemetery.

297 "more than satisfactory": RSJ to PS, November 24, 1967; January 14, 1968, both CCP.

297 "We were much moved": PS to RSJ, July 18, 1968, CCP.

297 "I can no longer live": RSJ to Nate Salsbury III, n.d. [July 1968], SFC.

297 "She was tough": "Mrs. James Succumbs," *Taos News,* July 11, 1968; Spud Johnson, "Becky," July 12, 1968, Campbell, pp. 308–9.

297 "There are hundreds": James, *Camposantos,* p. 8.

PAUL

298 "What has gone out": Norman, "Introductory Note—America Without Stieglitz," in *Stieglitz Memorial Portfolio,* ed. Norman, p. 7.

298 "devote themselves": Seligmann, "For the Living," in ibid., p. 14.

299 "men everywhere": PS, "Alfred Stieglitz: 1864–1946," in ibid., p. 13.

299 "It was just fantastic": PS, quoted in Tomkins PS notes, MOMA.

300 "a pretty picture": PS, quoted in William Alexander, "Paul Strand as Film-maker," in Stange, ed., p. 153.

300 "We were very concerned": PS, quoted in Tomkins PS notes, MOMA.

300 "an interesting photographic": Frank S. Nugent, "The Screen: At the Filmarte," *New York Times,* April 21, 1937.

300 "He had the feeling": Leo Hurwitz, quoted in Alexander, "Paul Strand as Film-maker," in Stange, ed., p. 155.

300 "Strand was a kind of": Rudy Burckhardt, quoted in Anne Tucker, "Strand as Mentor," in Stange, ed., p. 123.

301 "I was made aware": Virginia Stevens, in John Walker's documentary film *Strand: Under the Dark Cloth.*

301 "Craftsmanship is built": PS, *Photographs of Mexico,* unpaginated.

301 "volcanic angers": Virginia Stevens, quoted in Tomkins PS notes, MOMA.

301 "his best effort": Leo Hurwitz, quoted in *Photographs of Mexico*, unpaginated.

302 "forced": Newhall, pp. 131–32.

302 "The work of Paul Strand": Nancy Newhall, "Paul Strand," in *Paul Strand: Photographs, 1915–1945* (New York: Museum of Modern Art, 1945), pp. 3–7.

302 "well illustrated": Edward Jewell, "Photos by Strand Placed on Display," *New York Times*, April 25, 1945.

303 "The problem was": PS, quoted in Tomkins PS notes, MOMA.

303 "freedom of the individual": PS, "Photographer's Foreword," in *Time in New England*, reprinted in *Paul Strand*, p. 139.

304 Strand's activism: On this period, see Mike Weaver, "Dynamic Realist," in Stange, ed., p. 200.

305 "He did not insinuate": Claude Roy, "Preface" to *La France de Profil*, in PS, *Paul Strand*, p. 164.

305 "The house": Roy, in PS, *La France de Profil*, p. 65 (author's translation).

305 "tell me you are": RSJ to PS, December 24, 1952, CCP.

305 "The stubborn preoccupation": Pierre-François Lacôme, "Un Photographe de l'éternel," *Bulletin Guilde du Livre*, September 1955, pp. 362–63 (author's translation).

306 "the plainness": PS, quoted in Tomkins PS notes, MOMA.

306 "Scared of this very": Angela Secchi, in "I Posed for Paul Strand," *The Guardian*, March 6, 2016.

306 "lesson in humanity": Italo Zannier, quote from *Foto/Film*, 1967, in PS, *Paul Strand*, p. 226.

307 "reconciliation of Strand's": Maria Caruso, *Italian Humanist Photography from Fascism to the Cold War* (London: Bloomsbury, 2016), p. 128.

307 "the common denominator": PS, Application for Fulbright Fellowship, 1949[?], in Greenough, *Paul Strand*, p. 48.

307 "the plain people": PS, quoted in Tomkins, *Paul Strand*, p. 32.

307 "Talking about it": Catherine Duncan, "An Intimate Portrait," in Duncan and Eskildsen, unpaginated.

307 "Whether I like": PS, quoted in Tomkins PS notes, MOMA.

308 "Here are fine people": PS to Basil Davidson, May 2, 1957, quoted in Davidson, "Working with Strand," in Stange, ed., p. 216.

308 "a montage problem": PS to the Newhalls, October 28, 1954, Greenough, *Paul Strand*, p. 134.

308 "on the human material": James Aldridge, "Introduction," in PS, *Living Egypt*; reprinted in PS, *Paul Strand*, p. 286.

308 "The sentiment": Mohammed Auda, "Love and Understanding, *Al Gomarihya*, April 17, 1969; reprinted in PS, *Paul Strand*, p. 296.

309 "a wider meaning": Davidson, in PS, *Ghana: An African Portrait*; reprinted in PS, *Paul Strand*, p. 310.

309 "Over the past twenty years": dedication in vol. 2 of PS, *Paul Strand*.

309 "Once Paul gets": Hazel Kingsbury, quoted in Tomkins, *Paul Strand*, p. 33.

309 "wear and tear": Davidson, "Working with Strand," in Stange, ed., pp. 212,

219, 218, 224, where Davidson quotes Mark Haworth-Booth's words, *Paul Strand*, p. 7.

310 "I seem to move": RSJ to PS, January 14, 1968, CCP.

311 "Paul Strand is one": Hilton Kramer, "Paul Strand Photo Show Opens Here," *New York Times*, February 10, 1973.

311 "the beauty of soberness": Sanford Schwartz, "The Strand Retrospective," in *The Art Presence* (New York: Horizon, 1982), pp. 164–66.

311 "a very easy way": PS, "Much Looking, Much Simple Being There," *The New Yorker*, March 17, 1973, pp. 29–31.

311 "It's what *you* see": John Walker interview with the author, May 8, 2017.

312 "I don't want to give": PS, quoted in Hill and Cooper, eds., p. 8.

312 "He has a one-track mind": Walter Rosenblum to Calvin Tomkins, August 7, 1973; Tomkins PS notes, MOMA.

312 "As we worked": Catherine Duncan, "The Years in Orgeval," in Stange, ed., p. 238.

312 "We couldn't get": Richard Benson interview with the author, May 30, 2013.

313 "Rebecca's torso": Duncan and Eskildsen, p. 22.

313 "Spurred on": Richard Benson interview with the author, May 30, 2013.

313 "When you come": Tomkins, *Paul Strand*, p. 35.

313 *"All my books!"*: Duncan and Eskildsen, p. 23.

313 "It turns out": John Walker, in Marc Glassman, "The POV Interview: John Walker, Part One," *Point of View*, no. 72 (Winter 2008), povmagazine.com/articles/view/john-walker-the-pov-interview.

314 "He didn't have much": Fred Zinnemann, in John Walker's documentary film *Strand: Under the Dark Cloth*.

314 "They were his women": Hazel Strand, in ibid.

GEORGIA

316 "I am going a bit": GOK to RSJ, April 1947, RSJ/YCAL.

316 Jewell's review: Edward Alden Jewell, "Hail and Farewell," *New York Times*, June 15, 1947.

316 "slushiness": Doris Bry interview with the author, May 30, 2013.

317 "Stieglitz often said": GOK, "Stieglitz: His Pictures Collected Him," *New York Times*, December 11, 1949.

317 "Kindly print": GOK to Lester Markel, October 14, 1949, YCAL; quoted in Drohojowska-Philp, p. 467.

317 "an abstract double": Sarah Whitaker Peters, p. 22.

317 "calling—as the distance": GOK, *Georgia O'Keeffe*, unpaginated, speaking of the line of the Blue Ridge Mountains.

317 "I still have": GOK to AP, December 13, 1949, Giboire, ed., p. 286.

318 "You make me feel": GOK to RSJ, n.d. [September 1950], RSJ/YCAL.

318 "an enigmatic": Lisle, p. 292.

318 "Admirers of the decorative art": Howard Devree, "The Carnegie: 1950," *New York Times*, October 22, 1950.

318 "an increased urge": Henry McBride, "Georgia O'Keeffe of Abiquiu," *Art-news* (November 1950), p. 57.

318 "I have always been": GOK to William Howard Schubart, July 28, 1950, Cowart and Hamilton, p. 253.

318 "I can not tell you": GOK to William Howard Schubart, October 26, 1950, ibid., pp. 255–56.

318 "All my association": GOK, quoted in Seiberling, p. 45.

319 "I loved walking": GOK to the Stettheimers [April–May 1944], Cowart and Hamilton, p. 238.

319 "We manage": GOK to the Stettheimers, [August? 1943], ibid., p. 234.

319 "It was a bright": GOK to Caroline Fessler, March 21, 1944, Robinson, p. 450.

319 "I don't want to know": GOK, quoted in Tomkins GOK notes, MOMA.

319 "You told me honestly": Chabot to GOK, January 12, 1944, Drohojowska-Philp, pp. 405–6.

320 "I would not say": Maria Chabot, quoted in ibid., p. 433.

320 "I wish you could see": GOK to Arthur Dove, September 1942, Cowart and Hamilton, p. 233.

320 "The wall with the door": GOK, *Georgia O'Keeffe,* unpaginated.

320 "lots of startling poppies": GOK to Henry McBride, August 19, 1948, Cowart and Hamilton, p. 248.

320 "It has surprised me": GOK to Russell Vernon Hunter, October 30, 1948, ibid., p. 249.

320 "If you haven't": GOK to RSJ, December 13, 1949, RSJ/YCAL.

320 "stimulating and satisfying": Spud Johnson, quoted in Lisle, p. 356.

320 "as comfortable": AP to AS, August 1, 1945, Giboire, ed., p. 285.

320 "There are so many": GOK, quoted in Anita Pollitzer, "That's Georgia," *The Saturday Review,* November 4, 1950, p. 43.

321 "A solitary person": ibid., p. 41.

321 "odd feeling": GOK to AP, October 1950, Giboire, ed., p. 296.

321 "You seem to be": GOK to AP, December 7, 1950, ibid., p. 297.

321 "I wrote to him": GOK to Margaret Kiskadden, September 3, 1950, Cowart and Hamilton, p. 255.

321 "The painting is like": GOK, quoted in Lisle, p. 398.

322 "I'm conceited enough": GOK, quoted in Ralph Looney, *O'Keeffe and Me: A Treasured Friendship* (Boulder: University Press of Colorado, 1995), p. 41.

322 "the murals the boys": GOK to William Schubart, March 27, 1951, Cowart and Hamilton, p. 260.

322 "I was very excited": GOK, quoted in Tomkins GOK notes, MOMA.

322 "unbelievable": ibid.

322 "Most of what I see": GOK to William Schubert, April 2, 1953, Cowart and Hamilton, p. 263.

323 "I have been working": GOK to AP, May 31, 1955, Giboire, ed., p. 298.

323 "It looked like a Persian miniature": David McIntosh, quoted in Robinson, p. 492.

323 "They just stopped": GOK to Caroline Fesler, February 5, 1956, Cowart and Hamilton, p. 266.

324 "We probably all": GOK to AP, January 17, 1956, Giboire, ed., p. 305.

324 "You not only speak": AP to GOK, January 28, 1956, Giboire, ed., p. 306. Pollitzer paraphrased remarks by F. S. C. Northrop in *The Meeting of East and West* (1946).

324 "How good it has been": RSJ to GOK, December 26, 1962, YCAL.

324 "Such a size": GOK, on *Sky Above Clouds IV,* in "About this Artwork," at Art Institute of Chicago Web site: http://www.artic.edu/aic/collections/artwork/100858.

325 "What other place": GOK, quoted in Lisle, p. 372.

325 "Oh, Georgia": Halpert, quoted in Drohojowska-Philp, p. 480.

325 "implies some casting about": Robert M. Coates, "The Art Galleries," *The New Yorker,* April 22, 1961, pp. 160, 163.

325 "from which she pared": Brian O'Doherty, "Art: O'Keeffe Exhibition," *New York Times,* April 11, 1961.

326 "a phenomenon": E. C. Goossen, "O'Keeffe—Her Extraordinary Contribution to Twentieth-Century Art . . . Obscured by her Fame," *Vogue,* March 1, 1967, p. 174.

326 "She looks like": John Loengard, in "Rattlesnakes and Ladders: The Inside Story of a Visit with Georgia O'Keeffe," *Time,* March 31, 2017, time.com/4702372/georgia-okeeffe-photographs-story/.

326 "It is a very sentimental": GOK to AP, February 28, 1968, Giboire, ed., p. 320.

326 "I do not like the idea": GOK to AP, n.d., Giboire, ed., p. 324.

327 "appropriated the 19th century idea": Robert Hughes, "Loner in the Desert," *Time,* October 1970, p. 64.

327 "a clear, cool essence": John Canaday, "O'Keeffe Exhibition: An Optical Treat," *New York Times,* October 8, 1970.

327 "really talking about": GOK, "It's Just What's in My Head . . . ," *New York Times,* October 18, 1970.

327 "Write about women": Tom Zito, "Georgia O'Keeffe," *Washington Post,* November 9, 1977; quoted in Robinson, p. 509.

328 "When you get so old": GOK, quoted in Andy Warhol, "New Again: Georgia O'Keeffe," *Interview,* September 1983, https://www.interviewmagazine.com/art/new-again-georgia-okeeffe.

328 "No one is ever": Virginia Robertson quoting GOK, Robinson, p. 517.

328 "must maintain": C. S. Merrill, *Weekends with O'Keeffe* (Albuquerque: University of New Mexico Press, 2010), unpaginated, September 11, 1973.

329 "flirted imperiously": Calvin Tomkins interview with the author, April 15, 2013; Tomkins GOK notes, MOMA.

330 "I am not going": Jerrie Newsom, quoted in Robinson, p. 527.

330 "near to sculpture": GOK, *Georgia O'Keeffe,* unpaginated.

330 "how much O'Keeffe": Sanford Schwartz, "Georgia O'Keeffe Writes a Book," *The New Yorker,* August 28, 1978, pp. 87–93.

331 "There is prejudice": Juan Hamilton, quoted in Kristin McMurran, "A $13

Million Lawsuit over Georgia O'Keeffe Highlights a Portrait of the Artist's Young Man," *People,* February 12, 1979, https://people.com/archive/a-13-million-lawsuit-over-georgia-okeeffe.

331 "Just don't cross her": Perry Miller Adato, *A Life in Film,* "Chapter 11: Georgia O'Keeffe (1977)," at https://www.youtube.com/watch?v=z8yNFVjpkPQ.

331 "a photographic diary": Juan Hamilton quoted in Grace Glueck, "Art People," *New York Times,* November 17, 1978.

331 "the story of a love affair": Hilton Kramer, "Stieglitz's 'Portrait of O'Keeffe' at Met," *New York Times,* November 24, 1978.

332 "a kind of idol": GOK, in John Walker's documentary film *Strand: Under the Dark Cloth.*

333 "You can use me": Andy Warhol, "Georgia O'Keeffe & Juan Hamilton," *Interview,* September 1983; republished November 12, 2014.

333 O'Keeffe cried out: Patten quoting GOK, Drohojowska-Philp, p. 541.

334 "Her health wasn't": Juan Hamilton, quoted in Grace Glueck, "Friend of O'Keeffe Glad Fight's Over," *New York Times,* August 1, 1987. See Robinson, pp. 551–59 passim.

334 "The letters poignantly reveal": Sarah Greenough, "From the Faraway," in Cowart and Hamilton, p. 138.

334 "make it beautiful": GOK, instructions to Sarah Greenough, *MFO,* p. xiv.

334 "touch the center": *MFO,* xiv.

ENVOI

337 "peeping over the rim": GOK to AS, October 3 [?], 1937, *MFO,* p. xiv.

337 "He could not help": PS, quoted in Newhall, p. 131.

338 "All good art": PS, *Rebecca,* unpaginated.

338 "really very good": GOK, quoted in Tomkins GOK notes, MOMA.

338 "He gave a flight": GOK, in Alfred Stieglitz, *Georgia O'Keeffe: A Portrait,* unpaginated.

338 "His eye was in him": ibid.

Selected Bibliography

SELECTED CORRESPONDENCE

Greenough, Sarah, ed. *My Faraway One: Selected Letters of Georgia O'Keeffe and Alfred Stieglitz*, Volume 1, 1915–1933. New Haven: Yale University Press, 2011.

ALFRED STIEGLITZ

PUBLICATIONS BY STIEGLITZ

Stieglitz, Alfred. *Camera Work: A Pictorial Guide*. Edited by Marianne Fulton Margolis. New York: Dover Publications, 1978.

———. *Georgia O'Keeffe: A Portrait*. New York: Metropolitan Museum of Art, 1978.

———. *Camera Work: The Complete Illustrations, 1903–1917*. Köln: Taschen, 1997.

———. *Stieglitz on Photography: His Selected Essays and Notes*. Edited by Richard Whelan, with contributions by Sarah Greenough. New York: Aperture, 2000.

———. *Alfred Stieglitz: The Key Set, the Alfred Stieglitz Collection of Photographs*. 2 vols. Edited by Sarah Greenough. Washington, D.C.: National Gallery of Art; New York: Abrams, 2002.

ABOUT STIEGLITZ

Bry, Doris. *Alfred Stieglitz: Photographer*. Boston: Museum of Fine Arts, 1965.

Frank, Waldo David, et al., eds. *America & Alfred Stieglitz: A Collective Portrait*. New York: Literary Guild, 1934.

Greenough, Sarah, ed. *Modern Art and America: Alfred Stieglitz and His New York Galleries*. Washington, D.C.: National Gallery of Art, 2000.

Greenough, Sarah, and Juan Hamilton. *Alfred Stieglitz: Photographs & Writings*. Washington, D.C.: National Gallery of Art; New York: Calloway Editions, 1983.

Hoffman, Katherine. *Stieglitz: A Beginning Light*. New Haven: Yale University Press, 2004.

———. *Alfred Stieglitz: A Legacy of Light*. New Haven: Yale University Press, 2011.

Homer, William Innes. *Alfred Stieglitz and the American Avant-Garde*. Boston: New York Graphic Society, 1977.

Lowe, Sue Davidson. *Stieglitz: A Memoir/Biography*. New York: Farrar, Straus and Giroux, 1983.

Naef, Weston. *The Art of Seeing: Photographs from the Alfred Stieglitz Collection*. New York: Metropolitan Museum of Art, 1978.

————. *The Collection of Alfred Stieglitz: Fifty Pioneers of Modern Photography.* New York: Viking Press, 1978.

————, ed. *Alfred Stieglitz.* In Focus Series. Los Angeles: J. Paul Getty Museum, 1995.

Norman, Dorothy. *Alfred Stieglitz: An American Seer.* Millerton, NY: Aperture, 1973.

————, ed. *Stieglitz Memorial Portfolio, 1864–1946.* New York: Twice a Year Press, 1947.

Seligmann, Herbert. *Alfred Stieglitz Talking: Notes on Some of His Conversations, 1925–1931.* New Haven: Yale University Library, 1966.

Szarkowski, John. *Alfred Stieglitz at Lake George.* New York: Museum of Modern Art, 1995.

Whelan, Richard. *Alfred Stieglitz: A Biography.* New York: Little, Brown, 1995.

Yochelson, Bonnie. *Alfred Stieglitz, New York.* New York: Skira Rizzoli, 2010.

PAUL STRAND

PUBLICATIONS BY STRAND

Strand, Paul. "Photography." *Seven Arts,* vol. 2 (August 1917): 524–25. Reprinted in *Photographers on Photography: A Critical Anthology.* Edited by Nathan Lyons. Englewood Cliffs, NJ: Prentice-Hall, 1966.

————. "What was '291'?" Unpublished Manuscript, October 1917. Alfred Stieglitz/ Georgia O'Keeffe Archive, Beinecke Rare Books and Manuscript Library, Yale University, New Haven, Connecticut.

————. "Alfred Stieglitz and a Machine." New York: privately printed, February 1921. ASA/YCAL. Revised for *America and Alfred Stieglitz,* Waldo Frank, ed., pp. 281–85.

————. "Photography and the New God." *Broom* 3, no. 4 (November 1922): 138–44. Reprinted in *Photographers on Photography: A Critical Anthology.* Edited by Nathan Lyons. Englewood Cliffs, NJ: Prentice-Hall, 1966.

————. "Georgia O'Keeffe." *Playboy: A Portfolio of Art and Satire,* no. 9 (July 1924): 16–20.

————. "Lachaise Sculpture." In *The Second American Caravan: A Yearbook of American Literature,* edited by Alfred Kreymborg, Lewis Mumford, and Paul Rosenfeld. New York: Macaulay, 1928.

————. "Marin Not an Escapist." *The New Republic,* July 1928, pp. 254–55.

————. "The Art Motive in Photography." *British Journal of Photography* 70 (October 1932): 129–32. Reprinted in *Photographers on Photography: A Critical Anthology.* Edited by Nathan Lyons. Englewood Cliffs, NJ: Prentice-Hall, 1966.

————. *Photographs of Mexico.* New York: Virgina Stevens, 1940, second edition: *The Mexican Portfolio.* New York: Da Capo Press, 1967.

————. "Alfred Stieglitz: 1864–1946." *New Masses,* August 1946, pp. 6–7.

————. "Stieglitz: An Appraisal." *Popular Photography* 21 (July 1947): 62, 88–98.

————. *Time in New England.* Edited by Nancy Newhall. New York: Oxford University Press, 1950.

————. *La France de Profil.* Edited by Claude Roy. Lausanne: Guilde du livre, 1952.

————. *Un Paese: Portrait of an Italian Village.* Turin: Guilio Einaudi, 1955.

————. *Tir a'Mhurain: Outer Hebrides.* London: MacGibbon and Kee, 1962.

————. *Living Egypt.* Text by James Aldridge. New York: Horizon Press, 1969.

————. *Paul Strand: A Retrospective Monograph.* 2 vols. New York: Aperture, 1971.

————. *Ghana: An African Portrait.* Text by Basil Davidson. Millerton, NY: Aperture, 1976.

————. *On My Doorstep: A Portfolio of Eleven Photographs, 1914–1973.* New York: Michael E. Hoffman, 1976.

————. *The Garden: A Portfolio of Six Original Photographs.* New York: Michael E. Hoffman, 1976.

————. *Rebecca.* New York: Robert Miller Gallery, 1996.

ABOUT STRAND

Barberie, Peter, ed., with Amanda N. Block. *Paul Strand: Master of Modern Photography.* Philadelphia: Philadelphia Museum of Art, 2014.

Brown, Milton. "Interview with Paul Strand, 1971." In *Photography in Print: Writings from 1816 to the Present.* Edited by Vicki Goldberg. New York: Simon & Schuster, 1971.

Busselle, Rebecca, and Trudy Wilner Stack. *Paul Strand Southwest.* New York: Aperture, 2004.

Duncan, Catherine, and Ute Eskildsen. *Paul Strand: The World on My Doorstep: An Intimate Portrait.* New York: Aperture, 2005.

Fleischmann, Kapar, ed. *Paul Strand.* Zurich: Gallerie Zur Stockeregg, 1987.

Greenough, Sarah. *Paul Strand: An American Vision.* Washington, D.C.: National Gallery of Art, 1990.

Hambourg, Maria Morris. *Paul Strand, Circa 1916.* New York: Metropolitan Museum of Art, 1998.

Haworth-Booth, Mark. *Paul Strand.* New York: Aperture, 1987.

Hemingway, Andrew. "Paul Strand and Twentieth-Century Americanism: Varieties of Romantic Anti-Capitalism." *Oxford Art Journal* 38, no. 1 (2015): 37–53.

Hill, Paul, and Thomas Cooper, eds. "Interview with Paul Strand." In *Dialogue with Photography.* New York: Farrar, Straus and Giroux, 1979, pp. 1–8.

Homer, William. "Paul Strand Interviews" (1971, 1974). William Innes Homer Papers, Georgia O'Keeffe Museum Research Center, Santa Fe, New Mexico.

Krippner, James, et al. *Paul Strand in Mexico.* New York: Aperture, 2010.

Lyden, Anne M., ed. *Paul Strand: Photographs from the J. Paul Getty Museum.* In Focus Series. Los Angeles: J. Paul Getty Museum, 2005.

Rathbone, Belinda. "Portrait of a Marriage: Paul Strand's Photographs of Rebecca." *The J. Paul Getty Museum Journal* 176 (1989): 83–98.

Rosenblum, Naomi. "Paul Strand: The Early Years, 1910–1932." Ph.D. diss., City University of New York, 1978.

Stange, Maren, ed. *Paul Strand: Essays on His Life and Work.* New York: Aperture, 1990.

Tomkins, Calvin. "Profiles: Look to the Things Around You." *The New Yorker,* September 16, 1974, pp. 44–94.

———. *Paul Strand: Sixty Years of Photographs.* Millerton, NY: Aperture, 1976.

Walker, John. *Strand: Under the Dark Cloth* (documentary film). John Walker Productions, 1989.

Weaver, Mike, and Anne Hammond. "Paul Strand and Ansel Adams: Native Land and Natural Scene." *The Archive* 27 (1990). Tucson: Center for Creative Photography.

GEORGIA O'KEEFFE

PUBLICATIONS BY O'KEEFFE

O'Keeffe, Georgia. *Some Memories of Drawings.* Edited by Doris Bay. Albuquerque: University of New Mexico Press, 1974.

———. *Georgia O'Keeffe: A Portrait by Alfred Stieglitz.* New York: Viking Press, 1978.

ABOUT O'KEEFFE

Coe, Erin B., Gwendolyn Owens, and Bruce Robertson. *Modern Nature: Georgia O'Keeffe and Lake George.* New York: Thames & Hudson, 2013.

Corn, Wanda M. *Georgia O'Keeffe: Living Modern.* Brooklyn, NY: Brooklyn Museum; DelMonico Books/Prestel, 2017.

Cowart, Jack, and Juan Hamilton, with contributions by Sarah Greenough. *Georgia O'Keeffe: Art and Letters.* Washington: National Gallery of Art; Boston: New York Graphic Society Books, 1987.

Danly, Susan. *Georgia O'Keeffe and the Camera: The Art of Identity.* New Haven: Yale University Press, in association with the Portland Museum of Art, 2008.

Drohojowska-Philp, Hunter. *Full Bloom: The Art and Life of Georgia O'Keeffe.* New York; London: W. W. Norton, 2004.

Eldredge, Charles C. *Georgia O'Keeffe.* New York: Abrams, in association with the National Museum of American Art, Smithsonian Institution, 1991.

———. *Georgia O'Keeffe: American Modern.* New Haven: Yale University Press, 1993.

Giboire, Clive, ed. *Lovingly, Georgia: The Complete Correspondence of Georgia O'Keeffe & Anita Pollitzer.* New York: Simon & Schuster, 1990.

Haskell, Barbara, ed., with contributions by Sasha Nicholas. *Georgia O'Keeffe: Abstraction.* New Haven: Yale University Press, 2009.

Lisle, Laurie. *Portrait of an Artist: A Biography of Georgia O'Keeffe.* New York: Pocket Books, 1986.

Lynes, Barbara Buhler. *Georgia O'Keeffe: Catalogue Raisonné.* 2 vols. New Haven: Yale University Press; Washington: National Gallery of Art; Abiquiu, NM: Georgia O'Keeffe Foundation, 1999.

Merrill, Christopher, and Ellen Bradbury, eds. *From the Faraway Nearby: Georgia O'Keeffe as Icon.* Reading, MA: Addison-Wesley, 1992.

Peters, Sarah Whitaker. *Becoming O'Keeffe: The Early Years.* New York: Abbeville Press, 1991.

Pollitzer, Anita. *A Woman on Paper: Georgia O'Keeffe.* New York: Simon & Schuster, 1988.

Robinson, Roxana. *Georgia O'Keeffe: A Life.* New York: Harper & Row, 1989.

Seiberling, Dorothy. "Horizons of a Pioneer." *Life,* March 1, 1968.

Tomkins, Calvin. "The Rose in the Eye Looked Pretty Fine," *The New Yorker,* March 4, 1974, pp. 40–44, 47–48, 50, 53–54, 56, 60–62, 64, 66.

Turner, Elizabeth Hutton, with contributions by Marjorie P. Balge-Crozier. *Georgia O'Keeffe: The Poetry of Things.* Washington D.C.: Philips Collection; New Haven: Yale University Press, 1999.

Udall, Sharyn R. *O'Keeffe and Texas.* San Antonio, TX: Marion Koogler McNay Art Museum; New York: Abrams, 1998.

REBECCA SALSBURY (STRAND) JAMES

PUBLICATIONS BY SALSBURY JAMES

Salsbury, Rebecca, and Nate Salsbury. *A Book of Children's Songs.* New York: H. W. Gray, 1917.

Salsbury, Rebecca. *At the World Peace Table* (play). New York: Institute for Public Service, 1919.

———. *Liberty the Giant Killer.* Text by William Allen. New York: Institute for Public Service, 1919.

James, Rebecca. *Days Gone By in Taos* (translation of Samuel M. Lavadie, *Los Dias de Cuanto Hay*). Published as a series of articles in *El Crepúsculo* (Taos, N.M.), November 10, 1949–March 16, 1950.

———. *Allow Me to Present 18 Ladies and Gentlemen and Taos, N.M., 1885–1939.* Taos, N.M.: El Crepúsculo, 1953.

———. *Camposantos* (text), with photographs by Dorothy Benrimo. Fort Worth: Amon Carter Museum of Western Art, 1966.

ABOUT SALSBURY JAMES

Campbell, Suzan. "In the Shadow of the Sun: The Life and Art of Rebecca Salsbury James." Ph.D. diss., University of New Mexico, 2002.

GENERAL

Abrahams, Edward. *The Lyrical Left: Randolph Bourne, Alfred Stieglitz, and the Origins of Cultural Radicalism in America.* Charlottesville, VA: University Press of Virginia, 1986.

Allen, Frederick Lewis. *Only Yesterday: An Informal History of the Nineteen-Twenties.* New York: Harper & Brothers, 1931.

———. *Since Yesterday: The Nineteen-Thirties in America.* New York: Harper & Brothers, 1940.

Baca, Elmo. *Mabel's Santa Fe and Taos: Bohemian Legends, 1900–1950.* Salt Lake City: Gibbs-Smith Publishers, 2000.

Barr, Alfred H. *Matisse.* New York: Museum of Modern Art, 1951.

Brennan, Marcia. *Painting Gender, Constructing Theory: The Alfred Stieglitz Circle and American Formalist Aesthetics.* Cambridge: MIT Press, 2001.

Bulliet, C.J. *Apples and Madonnas.* New York: Covici, Friede, 1930.

Burns, Cherie. *Searching for Beauty: The Life of Millicent Rogers.* New York: St. Martin's Press, 2011.

Caffin, Charles H. *Photography as a Fine Art.* New York: Doubleday, Page & Co., 1901.

Cline, Lynn. *Literary Pilgrims: The Santa Fe and Taos Writers' Colonies, 1917–1950.* Albuquerque: University of New Mexico Press, 2007.

Clurman, Harold. *All People Are Famous.* New York: Harcourt Brace Jovanovich, 1974.

Coke, Van Deren. *Taos and Santa Fe: The Artist's Environment, 1882–1942.* Albuquerque: University of New Mexico Press, 1963.

Corn, Wanda M. *The Great American Thing: Modern Art and National Identity, 1915–1935.* Berkeley: University of California Press, 1999.

Daniel, Malcom. *Stieglitz, Steichen, Strand: Masterworks from the Metropolitan Museum of Art.* New York: Metropolitan Museum of Art, 2010.

DeWitt, Miriam Hapgood. *Taos: A Memory.* Albuquerque: University of New Mexico Press, 1992.

Dyer, Geoff. *The Ongoing Moment.* New York: Pantheon, 2005.

Eisler, Benita. *O'Keeffe and Stieglitz: An American Romance.* New York: Doubleday, 1991.

Frank, Waldo David. *Our America.* New York: Boni and Liveright, 1919.

———. *Memoirs of Waldo Frank.* Amherst: University of Massachusetts Press, 1973.

Fryd, Vivien Green. *Art and the Crisis of Marriage: Edward Hopper and Georgia O'Keeffe.* Chicago: University of Chicago Press, 2003.

Gray, Andrea. *Ansel Adams: An American Place, 1936.* Tucson: Center for Creative Photography, University of Arizona, 1982.

Green, Jonathan, ed. *Camera Work: A Critical Anthology.* Millerton, NY: Aperture, 1973.

Hapgood, Hutchins. *A Victorian in the Modern World.* New York: Harcourt, Brace, 1939.

Hartley, Marsden. *Adventures in the Arts.* New York: Boni and Liveright, 1921.

———. *Somehow a Past: The Autobiography of Marsden Hartley.* Edited by Susan Elizabeth Ryan. Cambridge: MIT Press, 1997.

Hill, Paul, and Thomas Cooper, eds. *Dialogue with Photography.* New York: Farrar, Straus and Giroux, 1979.

Hughes, Robert. *American Visions: The Epic History of Art in America.* New York: Alfred A. Knopf, 1997.

Kerman, Cynthia Earl, and Richard Eldridge. *The Lives of Jean Toomer: A Hunger for Wholeness.* Baton Rouge: Louisiana State University Press, 1987.

Kreymborg, Alfred. *Troubadour.* New York: Sagamore Press, 1957.

Kuh, Katherine. *The Artist's Voice: Talks with Seventeen Artists.* New York: Harper & Row, 1962.

Kuhl, Nancy. *Intimate Circles: American Women in the Arts.* New Haven: Beinecke Rare Books and Manuscript Library, Yale University, 2003.

Kushner, Marilyn Satin, and Kimberly Orcutt, *The Armory Show at 100: Modernism and Revolution.* New York: New York Historical Society, 2013.

Levy, Julien. *Memoirs of an Art Gallery.* New York: G. P. Putnam's Sons, 1977.

Lorenz, Richard. *Imogen Cunningham: Portraiture.* Boston: Bulfinch Press, 1997.

Luhan, Mabel Dodge. *Winter in Taos.* New York: Harcourt, Brace, 1935.

———. *Intimate Memories.* Vol. 4, *Edge of Taos Desert: An Escape to Reality.* New York: Harcourt, Brace, 1937. Reprint, Albuquerque: University of New Mexico Press, 1987.

———. *Taos and Its Artists.* New York: Duell, Sloan and Pearce, 1947.

Lynes, Barbara Buhler, Sandra S. Philips, and Richard B. Woodward. *Georgia O'Keeffe and Ansel Adams: Natural Affinities.* New York: Little, Brown, 2008.

Lynes, Barbara Buhler. *O'Keeffe, Stieglitz, and the Critics, 1916–1929.* Ann Arbor: University of Michigan Press, 1989.

Lyons, Nathan, ed. *Photographers on Photography: A Critical Anthology.* Englewood Cliffs, N.J.: Prentice-Hall, 1966.

Malcolm, Janet. *Diana & Nikon: Essays on Photography.* New York: Aperture, 1997.

McBride, Henry. *An Eye on the Twentieth Century: Selected Letters of Henry McBride.* Edited by Steven Watson and Catherine J. Morris. New Haven: Yale University Press, 2000.

———. *The Flow of Art: Essays and Criticisms of Henry McBride.* Edited by Daniel Catton Rich. New York: Atheneum, 1975.

Morrill, Claire. *A Taos Mosaic: Portrait of a New Mexico Village.* Albuquerque: University of New Mexico Press, 1982.

Newhall, Nancy. *From Adams to Stieglitz: Pioneers of Modern Photography.* New York: Aperture, 1989.

Niven, Penelope. *Steichen: A Biography.* New York: Clarkson Potter, 1997.

Norman, Dorothy. *Encounters: A Memoir.* New York: Harcourt Brace Jovanovich, 1987.

———. *Intimate Visions: The Photographs of Dorothy Norman.* San Francisco: Chronicle Books, 1993.

O'Brien, Kathryn E. *The Great and the Gracious on Millionaires' Row: Lake George in Its Glory.* Utica, N.Y.: North Country Books, 1978.

Pyne, Kathleen. *Modernism and the Feminine Voice: O'Keeffe and the Women of the Stieglitz Circle.* Berkeley: University of California Press, 2008.

Rosenfeld, Paul. *Men Seen: Twenty-Four Modern Authors.* New York: Dial Press, 1925. Reprint, Freeport, N.Y.: Books for Libraries Press, 1967.

———. *Port of New York: Essays on Fourteen American Moderns.* Urbana: University of Illinois Press, 1961. Reprint, 1966.

Rudnick, Lois Palken. *Mabel Dodge Luhan: New Woman, New Worlds.* Albuquerque: University of New Mexico Press, 1984.

———. *Utopian Vistas.* Albuquerque: University of New Mexico Press, 1996.

Sussman, Elisabeth, Barbara J. Bloemink, and Linda Nochlin. *Florine Stettheimer: Manhattan Fantastica.* New York: Whitney Museum of American Art, 1995.

Thomas, D. H. *The Southwestern Indian Detours.* Phoenix: Hunter Publishing, 1978.

Tolbert, Mildrid. *Among the Taos Moderns.* Santa Fe: Bell Tower Editions, 2006.

Toomer, Jean. *Cane*. New York: Boni & Liveright, 1923. Reprint, W. W. Norton, 1988.

Wagner, Anne Middleton. *Three Artists (Three Women): Modernism and the Art of Hesse, Krasner, and O'Keeffe*. Berkeley: University of California Press, 1996.

Warren, Louis S. *Buffalo Bill's America: William Cody and the Wild West Show*. New York: Vintage Books, 2006.

Waters, Frank. *Of Time and Change: A Memoir*. Denver: MacMurray & Beck, 1998.

Whalan, Mark, ed. *The Letters of Jean Toomer, 1919–1924*. Knoxville: University of Tennessee Press, 2006.

Wolff, Justin P. *Thomas Hart Benton: A Life*. New York: Farrar, Straus and Giroux, 2012.

Index

Page numbers in *italics* refer to illustrations.

Illustration Credits

196 Courtesy of the Nate Salsbury Trust
198 Courtesy of Beinecke Rare Book & Manuscript Library
209 Georgia O'Keeffe; gift to NGA, 1980. © Board of Trustees, National Gallery of
 Art, Washington, Alfred Stieglitz Collection
221 © Paul Strand Archive/Aperture Foundation
226 Georgia O'Keeffe Museum. © Josephine B. Marks
232 Courtesy of the Nate Salsbury Trust
246 Georgia O'Keeffe; gift to NGA, 1980. © Board of Trustees, National Gallery of
 Art, Washington, Alfred Stieglitz Collection
253 The Ned Scott Archive
256 Courtesy of the Nate Salsbury Trust
260 Collection Center for Creative Photography, University of Arizona © The
 Ansel Adams Publishing Rights Trust
266 The J. Paul Getty Museum, Los Angeles
279 Courtesy of the Nate Salsbury Trust
298 © Paolo Gasparini
315 © Todd Webb Archive, Portland, Maine USA

INSERT FOLLOWING PAGE 116

1: National Gallery of Art, Washington, Alfred Stieglitz Collection
2 top & bottom: National Gallery of Art, Washington, Alfred Stieglitz Collection
3 top & bottom: National Gallery of Art, Washington, Alfred Stieglitz Collection
4 top & bottom: National Gallery of Art, Washington, Alfred Stieglitz Collection
5 top & bottom: © Paul Strand Archive/Aperture Foundation
6 top & bottom: © Paul Strand Archive/Aperture Foundation
7 top & bottom: © Paul Strand Archive/Aperture Foundation
8 top & bottom: Courtesy of the Georgia O'Keeffe Museum, gift of The Burnett
 Foundation. © Private Collection

INSERT FOLLOWING PAGE 212

1 top & bottom: National Gallery of Art, Washington, Alfred Stieglitz Collection
2 top: © Edward Owen/Art Resource, NY
2 bottom: National Gallery of Art, Washington, Alfred Stieglitz Collection
3 top: © Paul Strand Archive/Aperture Foundation
3 bottom: The Georgia O'Keeffe Museum, Santa Fe/Art Resource, NY
4 top: San Francisco Museum of Modern Art, Purchase, Alfred Stieglitz Collection.
 Photograph: Don Ross
4 bottom: Philadelphia Museum of Art, Bequest of Georgia O'Keeffe for the Alfred
 Stieglitz Collection
5 top: Alfred Stieglitz Collection, co-owned by Fisk University, Nashville, Tennessee,
 and Crystal Bridges Museum of American Art, Bentonville, Arkansas. Photog-
 raphy by Edward C. Robison III
5 bottom: National Gallery of Art, Washington, Alfred Stieglitz Collection
6 top & bottom: © Paul Strand Archive/Aperture Foundation
7 top & bottom: National Gallery of Art, Washington, Alfred Stieglitz Collection

8 top: Collection of the Frederick R. Weisman Art Museum at the University of Minnesota, Minneapolis. Museum Purchase, 1937

8 bottom: Courtesy of Sotheby's, Inc. © Private Collection

INSERT FOLLOWING PAGE 308

1 top & bottom: © Paul Strand Archive/Aperture Foundation

2 top & bottom: © Paul Strand Archive/Aperture Foundation

3 top: Georgia O'Keeffe, *Yellow Cactus*, 1929. Image courtesy of Dallas Museum of Art, the Patsy Lacy Griffith Collection, bequest of Patsy Lacy Griffith. © The Georgia O'Keeffe Foundation/Artists Rights Society (ARS)

3 bottom: Georgia O'Keeffe, *The Lawrence Tree*, 1929. Image courtesy of Wadsworth Atheneum Museum, The Ella Gallup Sumner and Mary Catlin Sumner Collection Fund. © Georgia O'Keeffe Museum/Artists Rights Society (ARS)

4 top: The Art Institute of Chicago/Art Resource, NY

4 bottom: Image courtesy of Brauer Museum of Art, Valparaiso University, Sloan Fund Purchase. © 2018 Georgia O'Keeffe Museum/Artists Rights Society (ARS)

5: Courtesy of the Georgia O'Keeffe Museum © Private Collection

6 top: Rebecca James, *Walking Woman, Taos, a.k.a. Spring in New Mexico*, 1946. Image courtesy of the Harwood Museum of Art. © Nate Salsbury Trust

6 bottom: Courtesy of the Nate Salsbury Trust

7 top: Image courtesy of Blake Hotel Collection, Taos. © Nate Salsbury Trust

7 bottom: Courtesy of the Nate Salsbury Trust

8 top & bottom: Courtesy of the Nate Salsbury Trust

A NOTE ON THE TYPE

This book was set in Fairfield, a typeface designed by the distinguished American artist and engraver Rudolph Ruzicka (1883–1978). In its structure Fairfield displays the sober and sane qualities of the master craftsman whose talents were dedicated to clarity. Ruzicka was born in Bohemia and came to America in 1894. He designed and illustrated many books, and was the creator of a considerable list of individual prints in a variety of techniques.

Composed by North Market Street Graphics, Lancaster, Pennsylvania

Printed and bound by Berryville Graphics, Berryville, Virginia

Designed by Iris Weinstein